AA

VICTORIAN & EDWARDIAN PAINTINGS

IN THE WALKER ART GALLERY & AT SUDLEY HOUSE

VICTORIAN & EDWARDIAN PAINTINGS
IN THE NATIONAL MUSEUMS & GALLERIES ON MERSEYSIDE:
VOLUME 2

VICTORIAN & EDWARDIAN PAINTINGS

IN THE WALKER ART GALLERY

AND AT SUDLEY HOUSE

*British artists born after 1810
but before 1861*

Edward Morris

LONDON: HMSO

© *Crown copyright 1996*
Applications for reproduction should be made to
HMSO Copyright Unit

ISBN 0 11 290543 9

British Library Cataloguing in Publication Data
A CIP catalogue record for this book
is available from the British Library

Design by HMSO

Published by HMSO and available from:

HMSO Publications Centre
(Mail, fax and telephone orders only)
PO Box 276, London SW8 5DT
Telephone orders 0171 873 9090
General enquiries 0171 873 0011
(queuing system in operation for both numbers)
Fax orders 0171 873 8200

HMSO Bookshops
49 High Holborn, London WC1V 6HB
(counter service only)
0171 873 0011 Fax 0171 831 1326
68–69 Bull Street, Birmingham B4 6AD
0121 236 9696 Fax 0121 236 9699
33 Wine Street, Bristol BS1 2BQ
0117 9264306 Fax 0117 9294515
9–21 Princess Street, Manchester M60 8AS
0161 834 7201 Fax 0161 833 0634
16 Arthur Street, Belfast BT1 4GD
01232 238451 Fax 01232 235401
71 Lothian Road, Edinburgh EH3 9AZ
0131 228 4181 Fax 0131 229 2734
The HMSO Oriel Bookshop
The Friary, Cardiff CF1 4AA
01222 395548 Fax 01222 384347

HMSO's Accredited Agents
(see Yellow Pages)

and through good booksellers

Printed in the United Kingdom for HMSO
Dd 297428 C15 3/96

Contents

FOREWORD

*T*he Walker Art Gallery first opened to the public in 1877; the Victorian and Edwardian paintings in its collection are the works which most closely reflect the early history of the Gallery, the ideals and aspirations of its founders and the taste of the mercantile class which made Liverpool a rich, powerful and cultured city in the late 19th and early 20th centuries.

The Walker has always been a partnership between public authority and private initiative. The Walker was built with a private donation; the first paintings the Gallery collected were purchased with funds from exhibition sales, and the collection was subsequently enriched through gifts and bequests from private citizens; but the Walker was owned and maintained by the City of Liverpool. Shipping and alcoholic beverages played as important a part in the story of the Gallery as did municipal idealism and Ruskinian notions of the moral value of art to society. The costs of building the Walker (1873–77) and extending it (1884–6) were paid for by Sir Andrew Barclay Walker, a brewer, and two of the most important gifts of Victorian art came from James Smith of Blundellsands, a wine importer (1923), and George Audley, an exporter of beer and whisky (1930). Other benefactors include Emma Holt, of the shipowning family, who in 1944 presented her father's picture collection along with Sudley, the house where it remains on view.

The element of municipal and Ruskinian idealism was provided by Philip Henry Rathbone, a Liberal Councillor, who, with the Tory Councillor Edward Samuelson, dominated the early history of the Walker. Rathbone's family, whose fortune was based on shipping, trade and insurance, was a force for reform and philanthropy in the city, but his own passion was art and it is to him that we owe many of the most adventurous and controversial acquisitions, often the work of young unknown painters who later became famous. On the other hand, an effort was also made to buy work of a popular kind to appeal to the new mass urban audience which visited the Gallery in large numbers in its early days.

The result is a collection typical of most aspects of late Victorian and Edwardian taste, especially strong in 'high art', works of an ambitious and edifying character: the high points amongst the Victorian and Edwardian pictures are works of considerable distinction which have achieved classic status. All facets of the collection are ably described by the compiler of this catalogue, Edward Morris, Curator of Fine Art, both in his fascinating introductory essay about the early history of the Gallery and in his detailed and scholarly catalogue entries. We owe him a considerable debt of gratitude for so meticulously documenting the works in our care.

The quality and importance of the Victorian and Edwardian paintings in the collection were attributes which influenced the Government's decision in 1986 to designate the Walker as a national institution together with the other museums and galleries; these all became the responsibility of the Trustees of the National Museums and Galleries on Merseyside in that year.

The Trustees of the National Museums and Galleries on Merseyside believe that scholarship is at the heart of its mission. This volume is one of a series which will eventually cover all the paintings at the Walker Art Gallery, Sudley House and the Lady Lever Art Gallery, the three collections which together form the Art Galleries division of the National Museums and Galleries on Merseyside. Although this volume is directed at the specialist, its findings will inform education programmes, labels and interpretative material for the future, and so will reach the many individual visitors who come to the Gallery to enjoy its collections.

Richard Foster
Director, National Museums and Galleries on Merseyside

Julian Treuherz
Keeper of Art Galleries

PREFACE

This catalogue contains all the oil paintings in the Walker Art Gallery and at Sudley House by artists born after 1810 but before 1861 except:

1 Works by foreign artists (including foreign artists working in Britain), which can be found in the Walker Art Gallery's *Foreign Catalogue*, 1977, 2 vols, by Edward Morris and Martin Hopkinson, and in the Walker Art Gallery's *Supplementary Foreign Catalogue*, 1984, by Edward Morris and Mark Evans.

2 Works by the early Pre-Raphaelites (that is John Brett, Ford Madox Brown, William Dyce, Arthur Hughes, William Holman Hunt, R.B. Martineau, J.E. Millais, D.G. Rossetti, Frederick Sandys and Henry Wallis), which can be found in *Artists of the Pre-Raphaelite Circle: The First Generation: Catalogue of Works in the Walker Art Gallery, Lady Lever Art Gallery and Sudley Art Gallery*, 1988, by Mary Bennett.

3 Works by Merseyside artists, paintings representing Merseyside places and portraits of Merseyside people, which can be found in the Walker Art Gallery's *Merseyside: Painters, People and Places*, 1978, 2 vols, by Mary Bennett.

Some Victorian and Edwardian paintings by artists born before 1811 or after 1860 are therefore excluded and some paintings done before 1837 or after 1910 by artists born after 1810 or before 1861 are included.

ACKNOWLEDGEMENTS

*T*he British oil paintings in the Walker Art Gallery and at Sudley House were first surveyed and inventoried in detail by Mary Bennett between about 1956 and 1960. She also wrote fairly brief catalogue entries for a few of the paintings in this volume. This catalogue leans heavily on her work. The staff at the Liverpool City Libraries have also been most helpful, and the compiler would like to express his appreciation of the work of both past and present librarians, especially Keith Andrews and Antony Symons, for building up a superb art and general library despite heavy war losses. There can be few English provincial public or university libraries to match its holdings in art history. The compiler has also received assistance from a wide variety of scholars, curators, archivists and private individuals, whose names are recorded throughout the catalogue; to these he extends his thanks. In particular, Martin Greenwood, Martin Hopkinson and Dr. J.W.M. Hichberger assisted with contemporary reviews of the paintings. Lynda Rea typed the final draft of the catalogue with her usual efficiency and accuracy. Alex Kidson and Sandra Penketh checked many signatures and dates in connection with their own work on the *Concise Illustrated Catalogue of British Paintings in the Walker Art Gallery and at Sudley* (ed. Sandra Penketh, 1995). The Friends of the Courtauld Institute generously awarded the compiler a bursary towards the costs of his research in London at the Institute and elsewhere; for this he was most grateful.

EXPLANATORY NOTES TO THE CATALOGUE

*A*ll unpublished manuscripts, typescripts, letters, inventories, lists, etc., are in the Walker Art Gallery unless otherwise stated. All dimensions are in centimetres unless otherwise noted. All exhibitions and sales took place in London unless otherwise stated. Exhibitions that took place before each picture entered the Walker Art Gallery are listed in full; later exhibitions are listed selectively. The only reproductions of each painting specifically mentioned are those made very soon after it was painted; they are in black and white unless otherwise stated. Italics are used in inscriptions, labels, etc., to indicate *verbatim* wording. A question mark against particular sales, owners, exhibitions, etc., in the sections relating to provenances and exhibitions means that it is uncertain whether or not the Walker Art Gallery painting was in that sale, collection or exhibition. A question mark against the transcription or record of a particular signature, inscription or label means that the reading in the catalogue is the best and most plausible available but that its accuracy should be accepted with caution.

HISTORY OF THE COLLECTION

The Walker Art Gallery was founded in 1873, primarily to display and collect contemporary art, and this remained its principal role until the 1930s. The history of its Victorian and Edwardian paintings is therefore, to a large extent, the history of the Gallery's early years. Liverpool had enjoyed a semi-public gallery of old master paintings since 1819, when a substantial part of William Roscoe's collection was placed on permanent display at the Liverpool Royal Institution – to which it had been presented by a group of subscribers, mainly his friends, after his bankruptcy.[1] This collection was rich in 14th- to 16th-century Italian and Netherlandish paintings; some rather later paintings, a group of old master drawings and some casts after the antique were added mainly by gift, and in 1843 a new purpose-built art gallery was erected adjacent to the Royal Institution. In 1850–1 the Liverpool Town Council tried to take over this gallery and its collections in order to ensure that it should be open to the public regularly and free of charge, instead of the occasional fee-paying access permitted by the Royal Institution. The attempt failed, although the Liverpool Academy's diploma collection (see pp. **76, 81, 111, 234, 276, 354**) was acquired by the Council and eventually, in 1893, all the Royal Institution's art collections were placed on long-term loan at the Walker Art Gallery.[2] Thus in mid-19th-century Liverpool, art of the past was the responsibility of the Royal Institution, while contemporary art was looked after by the Liverpool Academy, which had held annual exhibitions of paintings and sculpture for sale since 1810 – except for a few years early in this period when premises or funds were not available. The Town Council gave modest annual grants to the Royal Institution and paid the rent of the gallery used by the Academy for its exhibitions, so there was an element of public interest and accountability in the work of both bodies. In the 1850s the artists on the Academy Council awarded its annual prize for the best painting in its exhibitions consistently to Pre-Raphaelite artists, and in 1858 the Liverpool Society of Fine Arts opened a rival exhibition of contemporary art for sale.[3] The new society was controlled by patrons and collectors, not by artists, in the belief that this would result in a fairer

1

selection of pictures for display and a more representative allocation of prizes. The profits from the Society's annual exhibitions were eventually to provide a permanent art gallery and a permanent collection – an ambition to which the Liverpool Academy never laid claim.[4] In practice, however, competition between the Academy and the Society resulted in the collapse of both exhibiting bodies, and the Academy held its last open exhibition in 1867.

In 1860, however, thanks to the generosity of the Liverpool merchant William Brown (1784–1864) and to the passage of various Acts of Parliament permitting local councils to spend money on public libraries, museums and art galleries, the William Brown Library and Museum was opened as the public museum and library for Liverpool under the control of the Library, Museum and Arts Committee of the Liverpool Town Council. At a special meeting of this committee on 14 December 1870, it was decided to hold during the following autumn an exhibition of contemporary paintings and sculpture for sale in the William Brown Library and Museum. A sub-committee was formed to superintend the exhibition; Edward Samuelson (1823–1896; fig. 1), the deputy chairman of the parent committee, was made chairman and Philip Henry Rathbone (1828–1895) was appointed treasurer on 11 March

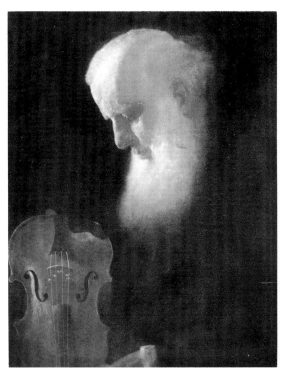

1871. Three local artists and two London artists were retained by the sub-committee as consultants. The 1871 *Annual Report* of the parent committee reported the results:[5]

A new feature has been introduced since the date of the last report, in the Exhibition of Pictures during the Autumn. The cessation of the Annual Exhibitions which formerly were held in the town had for a long time been a source of regret to all lovers of Art.

This Institution, in the Act of Parliament under which it has been established, is denominated 'The Library, Museum, and Gallery of Arts'; and although the last object has hitherto, owing to deficient means, not been carried out to any extent in relation to modern pictorial art, yet it has never been lost sight of.

Fig. 1 Old Friends *by David Woodlock (1842–1929). Alderman Edward Samuelson with his favourite Amati violin (WAG 2423)*

In considering this subject, it appeared to the Committee that the time had arrived when an effort ought to be made to wipe off the reproach which had attached to the town for its neglect of a public recognition and encouragement to the living and working artists of the day. It was also thought that this could be more easily carried out under Corporate sanction than by the efforts of private individuals. Some risk had necessarily to be run; but the Committee were of opinion that a portion of the funds at their disposal could not be better applied than in providing a guarantee for any possible loss which might be sustained in making the experiment.

Happily, this has not been necessary. The success of the Exhibition has been beyond their most sanguine expectations. The expenses, which were necessarily heavy, have been defrayed, leaving in hand a handsome surplus to be devoted to the purposes of Art.

Four rooms were appropriated to the Exhibition, two of them abstracted for a time from the Museum. It is satisfactory to state that, in point of light and arrangement, the rooms were everything which could be desired.

It would be too much to expect that every exhibiting artist should be quite satisfied with the position of his Pictures; but on the whole, the number of complaints were exceedingly few – the amount of sales having been very satisfactory.

The following particulars may be interesting. The Exhibition opened on Saturday, September 2nd, and closed on Sunday, November 18th. During this time it was attended by 22,725 persons, besides holders of season tickets, numbering 313. The number of Pictures exhibited was 887, of which were sold 235, at prices amounting in the whole to £6,395.2s.6d.

The Committee have purchased, on behalf of the Institution, for the Permanent Gallery, Pictures to the value of £500, and are prepared to devote a larger sum for the same purpose next year.

It is gratifying to record the valuable assistance which has been rendered by many of the Artists, and the general satisfaction expressed at the conduct of the Committee, whose only object has been to render the Exhibition subservient to the interests of Art.

Subsequent annual exhibitions were no less successful, and the profits accruing from admission fees and from commis-

sion on the sale of pictures, together with modest subsidies from the Town Council, went towards the purchase of paintings from the exhibitions for the Council's permanent collection – that is from 1873 onwards for the Walker Art Gallery's collection. In 1874 the sub-committee was able to report that 335 works of art had been sold for a total of £9,484 from the 1874 Autumn Exhibition and that this was the largest amount ever achieved by any provincial art exhibition.[6] In 1877 the opening of the Walker Art Gallery – given to the Council in 1873 by Alderman Andrew Barclay Walker (1824–1893) – provided a permanent home for the exhibitions, which no longer had to dislocate the Museum's displays each autumn.

Although the Liverpool Autumn Exhibitions and the acquisitions resulting from them involved little public subsidy – indeed at this time Liverpool was probably behind many other British provincial cities in accepting the principle of generous financial support for art galleries and museums from the municipal rates – they were probably the first series of exhibitions of contemporary art for sale in Britain to be controlled and promoted by a public authority, although this principle was soon followed by many other municipalities.[7] Similarly the purchases made from them represented the first systematic attempt by a British public body to buy contemporary art for display in a museum or art gallery.

Other institutions had of course acquired modern paintings earlier in the century; national and provincial academies of art and other exhibiting bodies had their artists' diploma pictures and occasionally bought more widely – for example, the paintings by William Etty (1787–1849) purchased by the Royal Scottish Academy in 1829–31; the British Institution in London and similar provincial institutions, organized and financed by wealthy patrons, bought contemporary paintings on a modest scale – notably the Royal Manchester Institution and the Royal Institution for the Encouragement of the Fine Arts in Scotland – but, although often aided from public funds, these were technically private bodies and their influence and power were declining sharply by the middle of the century; some Art Unions – essentially legalized lotteries awarding modern paintings as prizes – bought contemporary pictures for

public art galleries – the Edinburgh Royal Association for the Promotion of the Fine Arts in Scotland was conspicuous; lastly in 1876 the Trustees of the Chantrey Bequest started buying modern paintings and sculpture for the future Tate Gallery, while a little earlier, in 1871, Birmingham's 'Public Picture Gallery Fund' – relying entirely on private gifts – started buying a very few contemporary pictures for its future art gallery. Abroad the French government had for many years been buying modern art regularly from the Paris Salons for national and provincial museums of art in France, and these provincial museums had been purchasing contemporary paintings from exhibitions organized in their regions by their local artistic societies,[8] but in Britain the priority of Liverpool cannot be denied. The City Councils of Manchester (in 1882) and Leeds (in 1888) soon followed Liverpool's example by starting their own annual exhibitions of contemporary paintings and making purchases from them for their own art galleries.

There had of course been an element of municipal subsidy in the earlier Liverpool Academy exhibitions – the Town Council paid the rent of the gallery involved (a very unusual use of public funds at the time) – and in other respects, too, the Autumn Exhibitions carried on the methods of the Liverpool Academy exhibitions. A deputation from the organizing committee used to visit the London studios of most major artists around March each year to see the paintings going to the Royal Academy exhibition of that year and (if they were of sufficiently high quality) to ask the artists to send these pictures on to the Liverpool Autumn Exhibition after the closure of the Royal Academy in August. Paintings invited in this way would be sent to and from Liverpool at the expense of the Liverpool organizers and would not need the approval of the Liverpool jury. Many London artists would agree, even if they were reasonably confident that their pictures would be sold at the Royal Academy at its opening in May, as they had little to lose by committing their works to Liverpool. In this way the organizers, both of the earlier Liverpool Academy exhibitions and of the Liverpool Autumn Exhibitions from 1871 onwards, avoided the accusation that their shows contained only paintings and sculptures which remained unsold after the London summer exhibitions[9] – although considerable effort and expenditure were required from the Liverpool

committee as they were competing for the same pictures with deputations from other provincial exhibitions.

The only substantial differences between the earlier Liverpool Academy exhibitions and the later Liverpool Autumn Exhibitions were firstly the absence of the prizes which had caused such acrimony in the Academy shows of the 1850s, secondly the official and public status of the Autumn Exhibitions organized by the Town Council (from 1881 the City Council) and thirdly the acquisitions made from them for the Walker Art Gallery's permanent collection. Between 1871 and 1910, about 150 contemporary (or near contemporary) oil paintings were purchased from the artists by the Walker Art Gallery; most of them came from the Autumn Exhibitions, largely because the exhibition profits provided a large part of the purchase money required. Most of these 150 paintings are included in this catalogue, which will therefore permit some assessment of the success of this pioneering public patronage of contemporary British art. Some such judgments have been harsh, but it should be remembered that the committee responsible for the selection of the acquisitions relied for their resources primarily on admission charges to the Autumn Exhibitions and therefore felt obliged to respect popular taste. The Gallery Curator wrote in 1888:[10]

While endeavouring to secure works of the highest technical skill the fact has not been lost sight of that the public, for whose edification and instruction the institution in a great measure exists, delight in subjects of a popular character, and with this end in view pictures have from time to time been added which, by appealing to common feelings and sentiments of our daily life, have afforded a fine moral lesson, and given great pleasure to the numerous visitors to the Gallery who are uninitiated in the higher forms of art.

During the first twenty-five years of existence of the Arts and Exhibitions Sub-committee,[11] which in effect ran the Walker Art Gallery and the Autumn Exhibitions, the two chairmen were Edward Samuelson, a long-serving Tory Councillor and tobacco broker, and a Liberal Councillor, Philip Henry Rathbone (fig. 2). Samuelson's Tory contacts were valuable to Rathbone in predominantly Conservative Liverpool, while Rathbone had the artistic expertise; and the success of the exhibitions was generally attributed to the

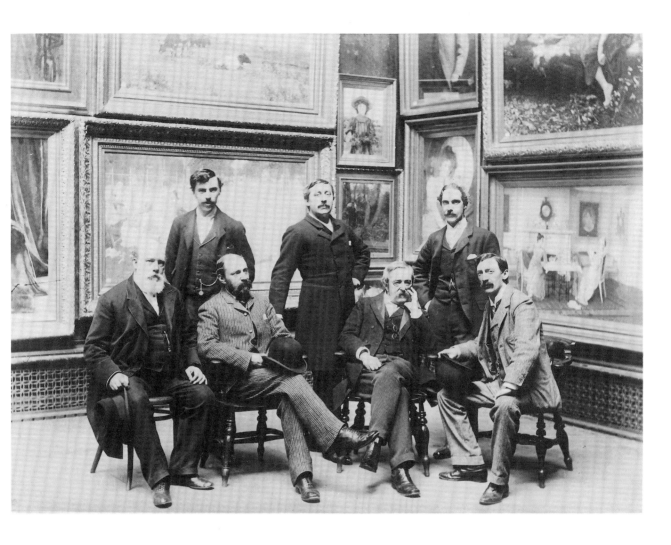

Fig. 2 The Hanging Committee at the 1892 Liverpool Autumn Exhibition. Seated, left to right, Charles Dyall (Gallery Curator), James T. Watts (artist), P. H. Rathbone (Gallery Chairman and Chairman of the Committee), Stanhope A. Forbes (artist). Standing, left to right, J. H. Ward (Gallery Assistant), William Stott of Oldham (artist), H. Frazer (Gallery Assistant)

harmony between the two men. In 1878, however, a personal quarrel developed between them. Its causes are obscure, but it is certain that at the Town Council meeting of 16 October 1878, Samuelson accused Rathbone (and also, by implication, the great James Picton (1805–1889), Chairman of the Library, Museum and Arts Committee) of manipulating the accounts of that committee in order to deceive the public. In any event, Rathbone replaced Samuelson as Chairman of the Arts and Exhibitions Sub-committee, and a new group of London and Liverpool artists were appointed to assist the Sub-committee.[12] The significance of these changes may not have been great because Rathbone seems to have been the dominant personality from the start, irrespective of his formal status. However, the 1878 exhibition was generally thought to have been the best so far.[13]

Fortunately, only a few years later, the two men seem to have been working together again – indeed Samuelson resumed the chairmanship of the Arts and Exhibitions Sub-committee for some years in the early 1880s; in particular, he continued to assist Rathbone in preventing Liverpool artists from gaining any special privileged access to the Autumn Exhibitions or any control over them – a contentious issue as the Autumn Exhibitions were seen from the outset as national exhibitions, whereas the Liverpool Academy exhibitions were primarily intended (in theory at least) for local artists.

Philip Henry Rathbone[14] was a younger son of one of Liverpool's most distinguished and successful merchant families. In origin the family was Nonconformist and Radical, although Rathbone himself was a high Anglican and on the conservative wing of the Liberal party. He inherited from his father shares in the insurance business of Rathbone, Martin and Co. and spent his early life as an underwriter and loss adjuster. Like most of his family, however, he was not primarily interested in the creation of wealth; and, whereas philanthropy and social reform were the principal Rathbone concerns, his enthusiasm was art. He joined the Town Council and its Library, Museum and Arts Committee in 1867 and soon controlled most of its proceedings related to art. From this position he was able to dominate institutional art in Liverpool during the last thirty years of the century. He played a leading role in the establishment of a professorship in art at Liverpool University in 1885 and in the foundation of the National Association for the Advancement of Art and its Application to Industry in 1888. The Liverpool University Chair did not last long, but its two occupants, Martin Conway (1856–1937) and R.A.M. Stevenson (1847–1900), were of the highest calibre. The National Association was even more short-lived, but the published proceedings of its three conferences in Liverpool (1888), Edinburgh (1889) and Birmingham (1890) – conferences in which most major artists and art critics participated – remain among the most important sources of information about the social context of art in late 19th-century Britain.

Rathbone himself was a prolific writer of articles, pamphlets and speeches[15] in which he insisted on the moral, educational, political and economic value of art to the community

– clearly reflecting the influence of Ruskin and Morris. He used to boast that both Ruskin and Whistler came to stay with him, but he showed little enthusiasm for aestheticism or art for art's sake, and his sympathies plainly lay with Ruskin, not Whistler. His most enduring achievement, however, apart from the purchase of the Walker Art Gallery's Victorian paintings, was the commissioning – at first by the City Council and then by himself personally – of Thomas Stirling Lee's reliefs, the *Progress of Justice*, on the east side of St George's Hall.[16] Their poetic realism makes them among the most important architectural reliefs of the *New Sculpture*; Rathbone played a considerable part in persuading the Council to commission reliefs on St. George's Hall and then, when the Council – appalled by Lee's realism in the figure of a nude young girl – withdrew from the contract, he paid for the rest of the sculpture himself. He was, above all, much more than curator or private patron; he was an 'art organizer' of exceptional ability. Martin Conway did not remain long as Professor of Art at Liverpool University, but his description of Rathbone in a private 1883 letter to his father-in-law,[17] despite containing the obvious prejudices of a thrusting young Cambridge art historian, is worth quoting:

Then there is the Rathbone family, the leading folk in the town, eight generations old as merchants. They are the best type of cultured English buy-and-seller. Philip Rathbone is a queer man, retired now from the Insurance business (where he used to insure pictures cheap never having heard of any being destroyed except by picture cleaners), a man always trying to be epigrammatic and sometimes succeeding (tho' seldom); a good lot of common sense larded with the unpleasant cant of continual posing for effect. He trundles the Art Machine about Liverpool and generally works public galleries and the like; lives in a bit of a house negotiating his way about among all manner of nice things packed together like stars in the Milky Way.

The Liverpool Town Council started buying contemporary paintings from the Autumn Exhibitions in 1871 – as soon as they began and without waiting for the building of the Walker Art Gallery, which was eventually to house the exhibitions and the pictures. In the early years about £700, derived partly from the rates and partly from the profits of the Autumn Exhibitions, were spent each year mainly on relatively minor paintings, although the actual amount

9

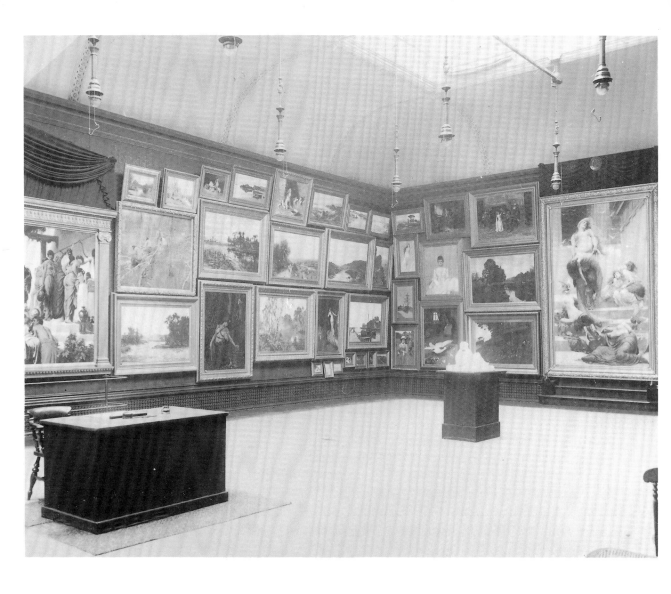

Fig. 3 The 1888 Liverpool Autumn Exhibition. At the extreme left, Captive Andromache *by Frederic Leighton and on the right* Niobe *by Solomon J. Solomon.*

expended could fluctuate sharply from year to year. In 1878, however, the year in which Rathbone became Chairman of the Arts and Exhibitions Sub-committee, £2,994 was spent on ten paintings, which included two such dissimilar works as *And when did you last see your father?* by Yeames (see p. **524**) and *Eventide: A Scene in the Westminster Union* by Herkomer (see p. **212**). That, however, was an exceptional year, and Rathbone was never in the happy position of Manchester City Art Gallery, to which the City Council provided £2,000 each year between 1882 and 1902 from the rates for the acquisition of works of art – and this amount came over and above any profits from their autumn exhibitions. The disparity between the resources of the two art

galleries was displayed in a manner humiliating to Rathbone and to Liverpool when, in 1888, Liverpool's Library, Museum and Arts Committee agreed to buy Frederic Leighton's great *Captive Andromache* (fig. 3) for £4,000, only to have the agreement overturned by the City Council; the Manchester art gallery committee then decided to buy the painting in place of Liverpool for the same sum; the issue was referred to a full meeting of the Manchester City Council on 6 March 1889, and by fifty-two votes to six Manchester ratified the deal which Liverpool had repudiated. This outcome was particularly unfortunate as Leighton sent most of his paintings to Liverpool – rather than to any other provincial exhibition – after the closure of the Royal Academy; and in 1872 and 1873 Leighton had even painted two pictures to be shown first in Liverpool – even before any London showing. However, even after the *Captive Andromache* disaster, he continued to favour Liverpool for provincial showings of his paintings – he had after all two important patrons in the city, George Holt and Andrew Kurtz, and some of their Leighton paintings are now in the Walker Art Gallery or at Sudley House (see pp. **264 ff.**).[18] Similarly, in 1891, Rathbone failed to secure Whistler's *Arrangement in Black and Brown: The Fur Jacket* (now Worcester Art Museum, Massachusetts) when it was at the 1891 Autumn Exhibition and available for £1,700 – and this despite the promptings of R.A.M. Stevenson.[19] In 1880–1, he was successful in buying D.G. Rossetti's *Dante's Dream* from the artist but, having offended Rossetti, he had to delegate the negotiations to Samuelson.[20]

Rathbone's expertise lay not in the acquisition of major masterpieces by established artists for large sums – which for the most part he did not possess – but in buying for small amounts paintings by young unknown artists of great promise and future distinction. In 1882 the Walker Art Gallery bought *A Street in Brittany* by Stanhope Forbes (see p. **144**); in 1886 Frederick Brown's *Hard Times* (see p. **54**) was purchased; in 1892 Rathbone overcame strong resistance to acquire Hornel's *Summer* and in 1894 he bought Charles Gere's *Finding of the Infant St. George*. Thus within fourteen years Rathbone had acquired for Liverpool key early works of the Newlyn School, the New English Art Club movement, the Glasgow School and the Birmingham School. At the time of purchase Stanhope Forbes was aged 25, Brown

was 35 but still virtually unknown, Hornel was 28 and Gere was 25 years old. The total cost of the four paintings, all bought directly from the artists, was £373.10s. Forbes was so encouraged by the Gallery's purchase of his painting that he abandoned his idea of becoming a mere portrait painter and persisted with open-air work.[21] The acquisition of Brown's *Hard Times* from the first exhibition of the New English Art Club gave a crucial stimulus to the Club just when its future seemed in doubt.[22] Hornel's *Summer* was the first work by any of the 'Glasgow Boys' to enter a public collection, apart from official portraits.[23] The battle within the Liverpool press and City Council over the purchase of Hornel's *Summer* – and to a lesser extent over William Stott's *Alps by Night* (see p. **437**), which was acquired at the same time – illustrates Rathbone's difficulties and persistence in getting these works by young, unknown artists into the Walker Art Gallery's collection.[24] The Hornel purchase was first attacked in the *Porcupine* of 10 September 1892; it was stated that the Glasgow School (and the Impressionists) were too experimental and did not paint real objects. Rathbone replied, in a letter published in the following issue (17 September), that critics had often been wrong in the past when they denounced new movements and that new departures in art were always unpopular; that crude naturalism may be unacceptable, but Hornel's *Summer* has the beautiful design of a fine Persian carpet. At the City Council meeting of 5 October 1892, the Council referred back to the Library, Museum and Arts Committee the purchase of both Hornel's and Stott's paintings on the grounds that they were too experimental. Even Samuelson abandoned Rathbone and denounced Hornel in particular. Rathbone replied to the debate by declaring that he had always tried to buy pictures before their artists were recognized and that the Glasgow School were admired in Paris and Munich if not in London, but his speech was constantly interrupted by laughter. In his talk at the private view of the Autumn Exhibition of 7 October, Rathbone again defended Hornel's beautiful 'schemes of colour' found by the 'Glasgow Boys' in nature. On 13 October he wrote a letter, published in the *Liverpool Daily Post*, stating that the Walker Art Gallery had that year acquired W. B. Richmond's *Venus and Anchises* (see p. **378**), which was 'easily understood of the people', but that the Gallery should also buy more advanced art. The Library, Museum and Arts Committee stood behind Rathbone, and

the issue went back to the City Council at their meeting of 26 October. Again, Samuelson and others attacked the paintings, but this time Rathbone made the debate one of confidence; he would resign if the purchase was not approved; in order to get the Autumn Exhibitions together, he had 'to spend eight to ten hours a day in going about in a cab visiting the artists' studios and getting no lunch'; he won by forty-three votes to five.

During this struggle George Moore (1852–1933) was reviewing the collections of the Walker Art Gallery and the Manchester City Art Gallery in the *Speaker*.[25] Despite the presence of some good pictures in both galleries, he was generally unimpressed, finding in particular the malignant influence of the Royal Academy in both cities. Describing the arguments over the paintings by Hornel and Stott in Liverpool, he deplored the fact that acquisitions were determined by City Council debates in which the participants knew nothing of art but spoke at great length about it. He went on to argue that what was needed was a professional art gallery director of taste and distinction, with total control over purchases. Rathbone wrote a letter to the editor in reply:[26]

In your last issue of October 29th, and in the Spectator *[sic] of the previous week, it is argued that a Corporation should not have the management of the municipal picture-gallery, and should have no voice in the choice of the pictures. Permit me to offer a few words on the other side.*

Logically, I am perfectly willing to admit that the practice is indefensible, but the British Constitution is, logically, absurdly indefensible. Practically, the management of corporations has been found the best way of establishing picture galleries for our great towns. Many years ago Liverpool had its annual exhibition managed by the Liverpool Academy of Arts, but a rupture took place in consequence of the prizes all being given to one school of artists, and in consequence two exhibitions were held: one managed by artists, and one by outsiders. Neither was successful, and both fizzled out. Seven years passed without any exhibition at all. In 1870 an exhibition was established by the library and museum committee of the corporation, managed by an art sub-committee, which at once succeeded, and has gone on with increasing success up to the present time. Out of the profits of that exhibition, assisted by gifts from individuals, the

permanent collection has been formed which now fills the splendid galleries so munificently presented by Sir Andrew Walker on the occasion of his being made Mayor.

Although your critic does not approve of the choice of the pictures bought, yet, on the principle that half a loaf is better than no bread, I think it must be conceded that the Liverpool Corporation have been more successful than the Liverpool Academy, who never made any attempt to establish a permanent gallery at all. Having been a humble member of the committee for the last twenty-two years, may I give a few reasons for its comparative success? First, the people have supported it because they felt it belonged to them, and I would venture to say there is no professional gallery which excites so much interest as to which pictures are bought. There have been two long and heated debates in the council over the purchase of a single picture, and that has created an interest in the town which is in itself an education in art. George Moore is himself not satisfied with the selection of the Chantrey purchases, and yet they are selected by professional artists chosen for their eminence in art, whether justly deserved or not. Now the great safeguard in our administration is its impartial ignorance, which leads it to seek the very best advice of the very best authorities, and to select according to that advice. This has saved us from being run away with by preconceived prejudices, and has given us the necessary courage to select pictures without regard to name, and by unknown artists who have since risen to unquestioned eminence. No doubt an ideal autocracy might avoid making mistakes but it would have this danger . . . the public, having no voice in the purchase of pictures, would lose all interest. Now, municipal galleries are not museums, but educational institutions for the citizens generally, and a popular interest is a necessary element of their success in this direction.

Rathbone was often reproached for enjoying (and buying) esoteric and recondite pictures which the public could not appreciate, but with his Ruskinian belief in the value of art to the community and in art as the expression of the community's life he could not ignore public taste in his acquisitions policy – quite apart from his financial dependence on admission charges and on ratepayers. He could not buy any of the early Italian paintings he most admired, and he must have felt obliged to buy many contemporary paintings he despised. It is therefore not surprising that George Moore failed to appreciate many of the pictures bought by Rathbone and his colleagues for the Walker Art

Gallery. Rathbone may have been too ready to compromise and was widely seen as politically unreliable, absurdly absent-minded and rather a 'poseur', but he was also a great chairman and Moore's final judgment is right:[27]

Mr. Rathbone I have always understood to be the life and soul of the Liverpool art gallery. It is owing to his enthusiasm and his industry that Liverpool is able to bring together every year so much various and interesting art. Without Mr. Rathbone Liverpool exhibitions would drop into the ordinary jog-trot of other provincial exhibitions – a mere extension of the commercial system of the Academy. But with Mr. Rathbone the Liverpool exhibition has reached an extraordinarily high level of excellence, and I have no hesitation in saying that the present show is finer than anything we have seen in London during the present year. Liverpool owes much to Mr. Rathbone, and it seems a poor return for his enthusiasm and intelligence to allow a crew of noisy councillors to interrupt his administration with foolish argument, and to render it abortive by refusal to sanction the purchase of the pictures which he recommends. Though his reply to Alderman Samuelson was full of concessions to the ignorance of his audience, it was clear after reading the opening lines that he was the one man who possessed a more than casual acquaintance with art. He reminded the alderman of the mistakes they had made in the past, and impressed upon them the fact that what had brought visitors to Liverpool was the Glasgow school, which they so contemptuously repudiated.

Rathbone died in 1895 and his successors as chairmen of the Arts and Exhibitions Sub-committee were not of his calibre. The domination of the Royal Academy over the choice of acquisitions – so much deplored by George Moore – became even more intense, and in 1901 Harold Chaloner Dowdall (1868–1955) a Liverpool barrister and future Lord Mayor, but also a close friend of Augustus John (1878–1961) – attacked the Walker Art Gallery's purchasing policy on the grounds that 'it is the opinion of many competent critics that the work associated with the Royal Academy at the present time is not likely to take any prominent place in the permanent progress of art'.[28] Dowdall widened the argument to contend that the City Council should look beyond the Autumn Exhibitions, which inevitably reflected current fashions set by the Royal Academy, to major masterpieces by established artists such as George Frederic Watts. John Lea (1850–1927), then Chairman of the Arts and Exhibitions Sub-committee, replied to him in June 1901:[29]

I would like to explain the position as to the purchase of pictures. There is an unwritten law that the artists shall benefit by the purchase of pictures out of the [Autumn] Exhibition and you can quite well understand that if the Committee were to go to Agnew's and purchase say a Watts as named by you for a large amount that the following spring the visiting deputation [to artists' studios] would be directed to Agnew's for work to form our [Autumn] Exhibition. In many cases the hopes of a sale secures us the picture and it would be rather rough to make a large profit out of borrowed pictures and put the same into the hands of the dealers.

In other words a profit could only be safely made from the Autumn Exhibitions if most of it was paid over to the artists by purchasing their paintings from the Exhibitions. Rathbone had been able to buy beyond the confines of the Autumn Exhibitions – occasionally by artificially including his chosen painting in the Autumn Exhibition of the year. Now, with the Autumn Exhibitions faltering, this option was no longer open.[30] In 1904 Charles Dyall retired as Curator of the Gallery and Dowdall, with the help of two Liverpool University professors, Richard Caton and Oliver Elton, tried to get D.S. MacColl appointed to a new post combining the Curatorship with a new University Chair in Art History.[31] MacColl, writing in the *Spectator*, had attacked the Royal Academy and defended the artists of the New English Art Club – thus following the example of George Moore in the *Speaker* – and was now looking for an art gallery post; this he eventually obtained at the Tate Gallery two years later. Neither campaign was successful, and indeed the changes desired by Dowdall were not finally accomplished until Vere Cotton (1888–1970) launched a similar programme in 1931. On that occasion Dowdall described his earlier vain efforts to Cotton:[32]

Thirty years ago when I was on the Arts and Exhibitions Sub-committee I had a go at it. Charles Dyall was then curator; Alderman Lea chairman of the gallery and Sir William Forwood of the whole committee. D.S. MacColl backed me up in the Spectator *and Sir William was mildly sympathetic, but they were too strong for me. Prominent Royal Academicians, who are past their not really very distinguished prime and losing their market, butter up the Arts and Exhibitions Sub-committee who in return buy a worthless picture and meet criticism by invoking the prominent Academicians whose names are well known and whose pictures are popular with the semi-educated*

public. When Dyall retired in 1904, I had another go and pointed out that Birmingham was collecting a valuable lot of pictures free of charge because Wallis (their curator) was efficient and the rich citizens found that in following his advice they were backing winners and so gave freely. I happened to know a top hole man who would come for £500 (he is still alive and everyone knows his great position now so I can't mention his name) . . .

Fortunately the Gallery's holdings of Victorian and Edwardian paintings did not depend solely on purchases. George Holt (1825–96; fig. 4)[33] was one of many Liverpool merchants and shipowners to form a collection of contemporary pictures in the late 19th century, but his collection is the only one to survive in the house for which much of it was assembled – Sudley in south Liverpool. He started collecting in middle age, around the late 1860s, and bought principally from Thomas Agnew and Sons Ltd. then based in Manchester but soon to move to London; however he also bought directly from artists at the Liverpool Autumn Exhibitions and at other London and provincial displays, as well as through some Liverpool dealers and at auction. His taste for Thomas Creswick (see pp. **88 ff.**) may have been inherited from his father, who bequeathed to him the important *Evening: The West still glimmers with some Streaks of Day*, but he also bought some

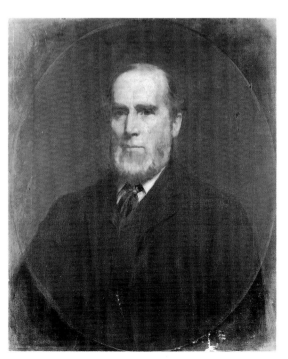

Fig. 4 George Holt by R.E. Morrison (1851/2–1924) (WAG 275)

other similar, rather old-fashioned landscapes by slightly later artists, among them George Vicat Cole (see pp. **78–9**) and Keeley Halswelle (see pp. **200 ff.**) – his two great landscapes by Turner fixed his standards in this area. Similarly his genre paintings by Luke Fildes (pp. **134–5**), Henry Stacy Marks (pp. **296–9**), J.C. Hook (pp. **225–6**), Frederick Goodall (pp. **178–83**) and others carry on a tradition established by Wilkie and Mulready, who were also represented in his collection. Again, when buying from Leighton (pp. **264–8**) it was only small scenes from everyday life that interested him; Sudley House is modest in size with small rooms, and there was no space for large history paintings. Towards the end of his life Holt followed the fashion of the period for late 18th-century British portraits and landscapes and largely abandoned the purchase of con-

17

temporary paintings. However, although never a major Pre-Raphaelite patron, he bought one painting by J.M. Strudwick (pp. **439–46**) in 1890 and then commissioned three more over the following five years. He may have been influenced by William Imrie, another Liverpool shipowner and a neighbour of Holt in Mossley Hill; Imrie was an important patron of Strudwick and of his master, Burne-Jones (pp. **439–40**). Holt rarely commissioned paintings, but the surviving correspondence between him and Strudwick reveals on Holt's part a real concern for the meaning and function of art. In 1944 Holt's daughter, Emma, bequeathed her father's paintings, together with Sudley House, where they still hang, to the Liverpool City Council.

The Holts and the Rathbones were long-established representatives of Liverpool's mercantile aristocracy. Two other collectors, to whom the Gallery is also deeply indebted, belonged to quite different traditions. Like the Gallery's founder, Andrew Barclay Walker, both owed their wealth to alcohol. Chaloner Dowdall had mentioned in 1901 that G.F. Watts was not represented in the Walker Art Gallery. This omission was corrected by James Smith of Blundellsands (1831–1923), who during the 1920s bequeathed to the Gallery six sculptures by Rodin – four of which he had bought from the sculptor – five paintings by Adolphe Monticelli (1824–1886), many works by the Liverpool artists D.A. Williamson (1823–1903), and W.L. Windus (1822–1907) and twenty-eight paintings by Watts (see pp. **465–504**). Smith[34] arrived in Liverpool in 1851 and made a large fortune by being among the first substantial importers of light Mediterranean wines; politically he was a 'well informed and hearty Nonconformist Liberal'. In 1881, while on holiday in Moniaive in Dumfriesshire, he met James Paterson (see p. **345**), one of the 'Glasgow Boys', and became one of Paterson's first patrons. He was, however, attracted more by English idealism than by Paterson's Scottish blend of French realism and became one of Watts's most important patrons during the last fifteen years of the artist's life. He was first attracted to Watts's art by seeing one of the many versions of *Love and Death* (see p. **502–3**) and he wrote in the catalogue of his collection:[35]

This subject first drew my attention to Mr. Watts's work. It so seized me that I lost no opportunity of seeing his work. It gave me a new

interest in life and a desire to possess some of his work. I came to know and honour him; telling him one day of this he voluntarily said he would paint me a replica of the picture.

Smith bought two paintings by Watts in 1887 (see pp. **472–3**) and then seems to have tried to buy Watts's four *Horsemen of the Apocalypse* at the William Carver sale of March 1890 (see pp. **474–80**); however one was not at the sale at all and, of the other three, he bought only the *Rider on the Black Horse*. Smith wrote to the artist a few days after the sale, praising his work, asking to see his studio and telling him about the four *Horsemen*. Watts replied, inviting Smith to his studio and deploring the dispersal of the *Horsemen* – which in fact Smith tracked down over the next fifteen years, ultimately re-assembling the whole magnificent series. Over these years Smith bought about fifteen small paintings by Watts from the artist. Most were late versions of well-known earlier compositions and a few of these were painted specially for Smith; others were sketches which Watts completed or improved for his patron. Watts charged over £5,000 for these relatively insubstantial works and his letters to Smith, of which some sixty survive, are a remarkable blend of high-minded idealism and calculating avarice. Smith's most memorable paintings by Watts – the *Horsemen of the Apocalypse* themselves and the sketch for *Hope* given by the artist to Leighton (see pp. **487–8**) – were not among those he acquired directly from Watts, but visitors to the Watts Gallery at Compton might be interested to know that it was partly financed by a Liverpool importer of light Mediterranean wines.

The father of George Audley (1864–1932; fig. 5)[36] was an unsuccessful Liverpool shipbuilder, but the son specialized in the export of beer and later diversified into whisky. He was a strong Anglican and gave generously to the building of Liverpool Cathedral – as well as to the extension of the Walker Art Gallery in 1930. He provided replicas of George Frampton's *Peter Pan* and of Alfred Gilbert's *Eros* for Sefton Park, but his principal enthusiasm was the collection of Victorian paintings which he assembled at Birkdale Lodge, his home in Southport. Most of his buying seems to have been done around 1920–3, just as he was retiring from business. His collection was not exclusively Victorian but, for the most part, the pictures from other periods and schools

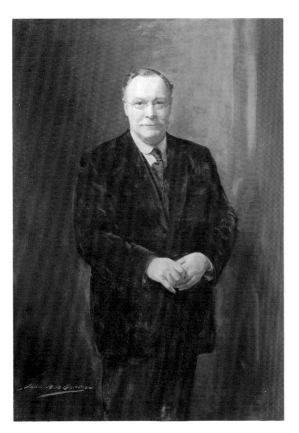

Fig. 5 George Audley *by J.A.A. Berrie (1887–1962) (WAG 3001)*

did not come to the Walker Art Gallery. His paintings by H.S. Tuke (pp. **450–2**), Stanhope Forbes (pp. **151–4**) and George Clausen (pp. **67–72**) are of exceptional importance, but were by no means representative of the collection as a whole – which was much richer in the work of less progressive artists, including Augustus Egg (pp. **118–25**), Vicat Cole (p. **78**), W.P. Frith (pp. **157–60**), Frederick Goodall (pp. **183–4**), Arthur Hacker (pp. **194–5**), Frank Holl (pp. **223–4**), J.C. Hook (pp. **226–7**), Frederic Leighton (pp. **262–73**), R.W. Macbeth (p. **291**), J.E. Millais (pp. **47–8**), Albert Moore (pp. **309–13**), David Murray (pp. **330–1**), John Pettie (pp. **352–4**), Marcus Stone (pp. **435–6**) and W.L. Wyllie (pp. **521–2**). Although Audley liked to visit artists' studios, his biographer noted that 'he was not in touch with any modern art movements which he was quite unable to appreciate'.[37] He seems to have bought most of his Victorian paintings at London auctions – using Sampson as his dealer – and paid very little for any of them; indeed, he did what public art galleries find very difficult to achieve – he bought unfashionable pictures of considerable quality at low prices. He gave most of his Victorian paintings to the Walker Art Gallery only a few years after he acquired them; public duty, rather than private pleasure, seems to have been his motive.

In the 1930s, under the guidance of Vere Cotton as Chairman and Frank Lambert as Director, the Gallery ceased for the first time to be preoccupied with contemporary art. Lambert's principal interest lay in the Camden Town artists, and Sickert (see pp. **391–9**) is well represented for this reason. Vere Cotton admired the work of Alfred Stevens, and the Gallery's large collection of his paintings, drawings, sculpture and furniture (see pp. **419–32**) is due to him. Generally, however, both men – and their successors – believed, reasonably enough, that Victorian and Edwardian art was already superbly represented in the Walker Art Gallery.

Notes

1 Edward Morris, 'The Formation of the Gallery of Art in the Liverpool Royal Institution 1816–1819', *Transactions of the Historic Society of Lancashire and Cheshire*, 1992, vol. 142, pp. 87–98.

2 H.A. Ormerod, *The Liverpool Royal Institution*, 1953, pp. 32–53.

3 H.C. Marillier, *The Liverpool School of Painters*, 1904, pp. 1–25.

4 *Liverpool Mercury*, 10 and 24 September 1858. This idea must have come from the British Institution in London, which had similar ambitions but was already in decline by 1858. See Peter Fullerton, 'Patronage and Pedagogy: The British Institution in the Early Nineteenth Century', *Art History*, 1982, vol. 5, pp. 59 ff.

5 Borough of Liverpool, *Nineteenth Annual Report of the Committee of the Free Public Library, Museum and Schools*, 1871, pp. 5–6.

6 Borough of Liverpool, *Twenty-second Annual Report of the Committee of the Free Public Library, Museum and Gallery of Art*, 1874, p. 8.

7 On the parsimony of Liverpool ratepayers towards public libraries, museums and art galleries, see B.D. White, *A History of the Corporation of Liverpool, 1835–1914*, 1951, pp. 79–81. In 1875 B.H. Grindley wrote a long pamphlet, *Exhibition of Pictures and Municipal Management*, justifying the new Liverpool principle that local authorities should hold exhibitions of contemporary art for sale. He observed that other major provincial cities, still relying on private societies and academies for their exhibitions, did not enjoy such good shows as Liverpool because their endeavours lacked the sanction of the whole community.

8 See Chantal Georgel, 'De l'art et des manières d'enrichir les collections' in Musée d'Orsay, *Jeunesse des Musées*, 1994, pp. 232–40. P.H. Rathbone wrote extensively about French art museums and art schools in the 1880s (see note 15).

9 The Annual Reports of the Library, Museum and Arts Committee in the early 1870s frequently drew attention to the number of major paintings first exhibited in Liverpool. For example, Frederic Leighton showed his *Weaving the Wreath* at the Liverpool Autumn Exhibition of 1872 (256) before it was shown in London (see p. **265**); similarly his *Antique Juggling Girl* went to the 1873 Autumn Exhibition (66) before it went on to the Royal Academy exhibition of 1874. When important paintings were first exhibited in Liverpool, the Holts and the Rathbones were quick to acquire them in order to encourage the practice. Thus Philip Rathbone and George Holt together acquired Val Prinsep's *Leonora di Mantua* in 1873 and promptly presented it to the Gallery (see p. **371**) and George Holt bought Leighton's *Weaving the Wreath* from the 1872 Liverpool Autumn Exhibition (see p. **265**). For Leighton's general support of, and reliance on, provincial exhibitions, see L. and R. Ormond, *Lord Leighton*, 1975, pp. 119–20.

10 Corporation of Liverpool, *First Decade of the Walker Art Gallery: A Report by Charles Dyall, Curator*, 1888, p. 5.

11 This Sub-committee frequently changed its name but this is its usual designation.

12 See the *Porcupine*, 7 July 1877, p. 216, for Samuelson's threat to resign if Charles Dyall, a 'smart' local man, was not appointed Curator of the Walker Art Gallery; the *Liverpool Argus*, 7 September 1878, for the new team in charge of the Autumn Exhibitions and the alleged scandals at the earlier exhibitions; the *Liverpool Evening Express*, 16 October 1878, for the scene in the Liverpool Town Council; the *Liberal Review*, 19 October 1878, for the rivalry between the two men – possibly related to political or artistic differences.

13 *Liverpool Daily Post*, 1–2 September 1878; *Porcupine*, 31 August 1878, p. 345; *Liverpool Argus*, 7 September 1878.

14 For Rathbone see particularly Edward Morris, 'Philip Henry Rathbone and the Purchase of Contemporary Foreign Paintings for the Walker Art Gallery, 1871–1914', *Annual Report and Bulletin of the Walker Art Gallery, Liverpool*, 1975–6, vol. 6, pp. 58–81. Also George Moore, *Modern Painting*, 1897, pp. 160–74; B.G. Orchard, *Liverpool's Legion of Honour*, 1893, pp. 577–9; H.M. Cundall, 'Liverpool's Walker Art Gallery', *Art Journal*, 1895, pp. 247–51; Obituaries in the *Liverpool Mercury*, the *Liverpool Daily Post* and the *Liverpool Courier* of 23 November 1895; Principal Rendall, 'In Memoriam: Philip Henry Rathbone', *Sphinx*, 1895, vol. 3, p. 54; A.J. Temple, *Painters in the Queen's Reign*, 1897, p. 379; Eleanor F. Rathbone, *William Rathbone: A Memoir*, 1905, pp. 460–1; Sir William B. Forwood, *Recollections of a Busy Life*, 1910, pp. 117–19; E.K. Muspratt, *My Life and Work*, 1917, pp. 230–58; G. P. Jacomb-Hood, *With Brush and Pencil*, 1925, pp. 37–8; William Rothenstein, *Men and Memories*, 1931, vol. 1, p. 113; Lord Conway of Allington, *Episodes in a Varied Life*, 1932, pp. 84–7; R. Whittington-Egan and G. Smerdon, *The Quest of the Golden Boy*, 1960, pp. 130–1; Sheila Marriner, *Rathbones of Liverpool 1845–1873*, 1961, pp. 220, 231; Joan Evans, *The Conways: A History of Three Generations*, 1966, pp. 69, 85; John Willett, *Art in a City*, 1967, p. 66; Peter Stansky, 'Art, Industry and the Aspirations of William Martin Conway', *Victorian Studies*, 1976, vol. 19, pp. 465 ff.; A. Hobson, *J.W. Waterhouse*, 1980, pp. 61–3; P.J. Waller, *Democracy and Sectarianism: A Political and Social History of Liverpool 1868–1939*, 1981, pp. 22, 68, 92, 98, 275, 507; D.S. Macleod, 'Mid-Victorian Patronage of the Arts', *Burlington Magazine*, 1986, vol. 128, p. 606.

15 'An apology for Shakespeare's Lady Macbeth', *Proceedings of the Literary and Philosophical Society of Liverpool*, 1861–2, vol. 16, pp. 69–77; *The Political Value of Art to the Municipal Life of a Nation: A Lecture at the Liverpool Free Library*, 1875; 'On the Promotion of Art – An Economic Necessity for England', *Transactions of the National Association for the Promotion of Social Science, Liverpool Meeting of 1876*, 1877, pp. 861–2; *Realism, Idealism and the Grotesque in Art: Their Limits and Functions*, 1877; 'The Mission of the Undraped Figure in Art', *Transactions of the National Association for the Promotion of Social Science: Cheltenham Meeting of 1878*, 1879, pp. 715–21, also published as a pamphlet; *The English School of Impressionists as illustrated in the Liverpool Autumn Exhibition*, 1883; *The Object and*

Scope of an Art Professorship, n.d.; 'The Place of Art in the Future Industrial Progress of the Nation', *Transactions of the National Association for the Promotion of Social Science: Birmingham Meeting of 1884*, 1885, pp. 749–51, but more fully published in 1884 as a pamphlet; *Report on the Proposed Gallery of Casts and the Parisian Schools of Art* made to the Liverpool City Council [1885]; 'Lessons from France as to Imperial and Municipal Encouragement of National Art', *Transactions of the National Association for the Advancement of Art and its Application to Industry: Liverpool Meeting of 1888*, 1888, pp. 390–8; 'The Encouragement of Monumental Forms of Art: A Political Necessity of Civilization', *Transactions of the National Association for the Advancement of Art and its Application to Industry: Edinburgh Meeting of 1889*, 1890, pp. 347–52; *Impressionism in Art: A Lecture at the Walker Art Gallery*, reprinted from the *Liverpool Citizen*, 1890; 'Presidential Address, Section of Museums and National and Municipal Encouragement of Art', *Transactions of the National Association for the Advancement of Art and its Application to Industry: Birmingham Meeting of 1890*, 1891, pp. 18–29; *The Depression of Trade in Liverpool, its Causes and some available Remedies: A Letter to J. Miles Esq.*, 1894. There are also reviews by Rathbone of the Liverpool Autumn Exhibitions in Liverpool's *University College Magazine*, 1886, vol. 1, pp. 286–92 and 1889, vol. 4, pp. 113–18, also in the *Sphinx*, 1893–4, vol. 1, pp. 66–7 and 1895–6, vol. 3, pp. 33–4. Rathbone's pamphlets and art criticism can be most easily found in the Liverpool City Libraries and in the Liverpool University Libraries.

16 See Susan Beattie, *The New Sculpture*, 1983, pp. 43–6 and Ann MacPhee, 'Philip Henry Rathbone, 1828–1895: His Involvement and Influence on the Sculptural Decorations on St. George's Hall', *Patronage and Practice*, ed. Penelope Curtis, 1989, pp. 63–6.

17 Evans, *op. cit.*, p. 85.

18 See Forwood, *op. cit.*, p. 119, and Ormond, *op. cit.*, pp. 119–20.

19 See particularly two undated MS letters from Stevenson to Whistler, now in Glasgow University Library (B.P.II 5/42–43). The compiler is grateful to Dr. Nigel Thorp and Mr. Roger Billcliffe for drawing his attention to these letters.

20 *Letters of Dante Gabriel Rossetti*, ed. Doughty and Wahl, 1967, vol. 4, pp. 1798, 1860, 1899, 1900, 1911; Rossetti referred to Rathbone as Ratsbone.

21 Newlyn Art Gallery, *Artists of the Newlyn School*, 1979, p. 56. Twelve years later the young Roger Fry received similar encouragement when Rathbone invited him to send his *Portrait of Edward Carpenter* to the Liverpool Autumn Exhibition – see *Letters of Roger Fry*, ed. Sutton, 1972, vol. 1, p. 159.

22 A. Thornton, *Fifty Years of the New English Art Club*, 1935, p. 4.

23 Roger Billcliffe, *The Glasgow Boys*, 1985, pp. 252–3.

24 This conflict can be most easily studied in the E.A. Hornel News-cuttings Book 1890–1894 (Hornel Trust, Kirkcudbright).

25 *Speaker*, 15 October 1892, pp. 446–7 and 22 October 1892, pp. 497–8. These two articles were reprinted in Moore's *Modern Painting*, 1897, pp. 160–74, but without the references to Rathbone and Samuelson.

26 *Speaker*, 5 November 1892, p. 563.

27 *Speaker*, 22 October 1892, p. 498.

28 Letter to the *Liverpool Courier*, 13 June 1901.

29 MS, Cotton Papers.

30 For the gradual decline of the Autumn Exhibitions, see Frank Lambert, 'The Walker Art Gallery: Growth of a Policy', *Liverpool Bulletin*, 1952, vol. 1, p. 3.

31 The MS correspondence is in the Cotton Papers. There is an account of this affair – probably very inaccurate – in C.H. Reilly, *Scaffolding in the Sky*, 1938, pp. 124–5.

32 Letter of 21 May 1931 (MS, Cotton Papers).

33 Sudley, Emma Holt Bequest, *Catalogue and History of the House*, 1971.

34 See Edward Morris, 'James Smith of Liverpool and Auguste Rodin', *Patronage and Practice*, ed. Penelope Curtis, 1989, pp. 67–73.

35 MS, Smith Papers.

36 See *Audley Pedigrees*, ed. A.L. Reade, 1929, pp. 307–12 and George Audley, *Collection of Pictures*, 1923.

37 Reade, *op. cit.*, p. 310.

CATALOGUE

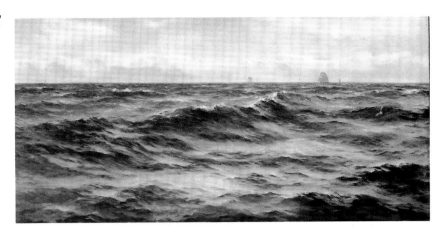

AITKEN, James (1853/4–1935)

In British Waters

WAG 693
Canvas: 64 × 128 cm
Signed: *James Aitken*

In British Waters may have been painted as late as 1934–5, towards the end of the artist's life, but most of his later work seems to have been painted in watercolour, and this painting, with its heavy dependence on the seascapes of Henry Moore, is more likely to be a work of 1909 than one of 1934–5.

PROV: Presented by J.E. Aitken[1] 1936.

EXH: (?) Liverpool Autumn Exhibition 1909 (103) as *In Home Waters*; Liverpool Autumn Exhibition 1935 (390).

1 Apparently the artist's son John Ernest Aitken, also an artist.

ALGIE, Jessie (1854–1927)[1]

Pinks and Sunflowers

WAG 469
Canvas[2]: 45.7 × 35.5 cm
Signed: *J. Algie*

PROV: Purchased from the artist 1906 (£7).

EXH: Liverpool Autumn Exhibition 1906 (148).

1 Her date of birth is generally given as 1859, but she died on 26 December 1927 aged 73; her Christian name was given as Jane on her death

In British Waters WAG 693

Pinks and Sunflowers WAG 469

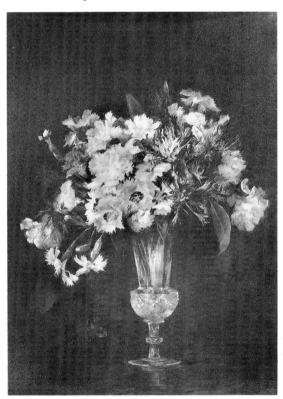

certificate and as Janet on her birth certificate (Jean Walsh, letter to the compiler, 7 January 1987).

2 Canvas stamp: Students Canvas, J. Barnard and Son, London W.

Seaward Bound WAG 163

ALLAN, Robert Weir (1851–1942)
Seaward Bound
WAG 163
Canvas: 122 × 183 cm
Signed: *Robert W. Allan*
Inscribed (on sail): *FR 708* (or possibly *703*)

The harbour in this painting has been provisionally identified as Findochty in north-east Scotland and the boats as 'Zulu'-type 'Duffing Lug' rigged fishing boats.[1] Rudolf Dircks[2] described it at the 1906 Royal Academy as 'quiet and effective in colour and composition, a harmonious and naturalistic transcript of a piece of coast scenery'.

REPR: *Art Journal*, 1906, p. 166; Pall Mall Gazette, *Pictures of 1906*, p. 52; *Royal Academy Pictures*, 1906, p. 36; Liverpool Autumn Exhibition catalogue, 1906, p. 71; T. Martin Wood, 'Robert W. Allan's Recent Paintings and Drawings', *Studio*, 1909, vol. 46, p. 100.

PROV: Purchased from the artist 1906 (£367.10*s.*).

EXH: Royal Academy 1906 (365); Liverpool Autumn Exhibition 1906 (44).

1 Garth Sterne, letter to the compiler, 27 November 1984. The harbour represented in WAG 163 may, however, also appear in the artist's *Rosehearty* (reproduced in T. Martin Wood, 'Robert W. Allan's Recent Paintings and Drawings', *Studio*, 1909, vol. 46, p. 89) and in his *Stormy Weather* (reproduced in Franco-British Exhibition, Shepherd's Bush, London, *Illustrated Souvenir*, 1908, p. 186, no. 632). The principal boat in WAG 163 has a Fraserburgh registration on its sail; the number is difficult to decipher, but if it is FR 708 it refers to *Hawthorn*, built in 1904 and owned by William Summers Robertson of 23 Shore Street, Fraserburgh; *Hawthorn* was a sailing lug of 98/100 tons (Records of the Fraserburgh Customs House). The artist specialized in Scottish fishing scenes, concentrating in particular on Mallaig harbour.

2 *Art Journal*, 1906, p. 167; there was also a brief favourable review by J. Dubouloz in *L'Art*, 1906, vol. 66, p. 136.

ANTHONY, Henry Mark (1817–1886)
The Croppie's Grave
WAG 1434
Canvas: 135.2 × 109.8 cm

This painting has hitherto been entitled *An Old Churchyard*, and a picture with this title was exhibited by Anthony at the Royal Society of British Artists in 1851, but reviews indicate that this was almost certainly not the Walker Art Gallery painting,[1] although it was apparently fairly similar in composition; John Grant Morris of Allerton Priory, Liverpool, owned *Old Churchyard, Erith*, 117 × 184 cm,[2] and M.H. Colnaghi also had an *Old Churchyard* by Anthony in 1897.[3]

The rosary held by the girl in this painting indicates that it may have been one of Anthony's Irish scenes of the 1840s, and it can probably be identified with *The Croppie's Grave*, no. 484 at the 1846 Society of British Artists. The catalogue of that exhibition had the following unidentified quotation against no. 484:

The dead here sleeps within his wild lone grave –
A ruined spot; few living things around:
The rank long grass – the sad winds slowly wave
O'er the dark tombs of this sepulchral ground.
A mournful hush is on the air and sky;
But woman's voice is heard in agony;
For, buried in the silence of the night,
The rebel Chieftain moulders in his sleep –
Brave but dishonoured – armed against the right.
Ah! who but she, the loved, shall care to weep
For him who perished in that fearful fray,
A bright false light, the meteor of a day.

The Croppies were the Irish Rebels of 1798 who sympathized with the principles of the French Revolution; they derived their name from their short hair and were of course usually strongly hostile to Britain.[4]

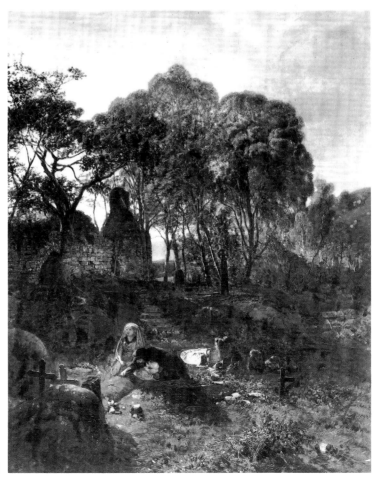

The Croppie's Grave WAG 1434

27

The *Art Union*[5] reviewed no. 484 at the 1846 Society of British Artists exhibition thus:

A very powerful work, executed from very slight materials. The scene is a churchyard in Ireland, in which are seen two women kneeling at a grave: the incident is affectingly told, and the sentiment is everywhere efficiently maintained. The picture is characterized by a singularly vigorous style and a decided touch, the freedom of which is carried into all objects alike – a circumstance which it is hoped will be modified.

The *Athenaeum*[6] praised 'the deviation from the beaten track and the attempt to render the wild poetry with which the history and the legends of the Sister Ireland abound', but had reservations about the painter's 'scattered lights'. *The Times*[7] praised the 'effectiveness with which the figures are brought out'.

In the autumn of 1846, Anthony exhibited *The Croppie's Retreat* at the Liverpool Academy (751) – presumably a different picture; his first Irish scenes seem to date from 1844. Many were exhibited in Liverpool rather than in London.

PROV: *The Croppie's Grave* was selected by Mrs. J.B. Pyne, one of the £100 prizeholders of the London Art Union, in 1846.[8] Presented by Henry Wallis of the French Gallery (120 Pall Mall), 1909.

EXH: (?) Society of British Artists 1846 (484); (?) Society of British Artists, *Exhibition of the Art Union Prizes*, 1846 (191).[9]

1 *Art Journal*, 1851, p. 136; *Athenaeum*, 29 March 1851, p. 358.

2 His sale, Christie's 23–25 April 1898, lot 245, bought Sampson (£16.16s.). See also F.G. Stephens's description of this picture in *Athenaeum*, 18 September 1884, p. 341; it inspired him to quote from Tennyson's *In Memoriam*. A note on the old Walker Art Gallery record card states that WAG 1434 was owned by John Grant Morris; perhaps it was confused with Morris's *Old Churchyard, Erith*.

3 Exhibited at Earls Court 1897 (311).

4 The word 'Croppy' normally seems to have been used as a term of abuse – the *Oxford English Dictionary* is not very clear over this. The anti-British feeling in WAG 1434 may perhaps explain

why its title was changed to *The Old Churchyard* – the title under which it was acquired by the Walker Art Gallery in 1909. Anthony may have shared the Irish Nationalist sentiments of his close friend, Ford Madox Brown.

5 *Art Union*, 1846, p. 130.

6 *Athenaeum*, 4 April 1846, p. 354.

7 *The Times*, 30 March 1846.

8 *Art Union*, 1846, pp. 167, 262; see also *Catalogue of the Pictures etc. selected by the Prizeholders of the year 1846 in the Art Union of London*, no. 191; *The Croppie's Grave* was priced at £120 at the 1846 Society of British Artists exhibition; Mrs. J.B. Pyne, presumably the wife of the artist J.B. Pyne, made up the difference.

9 *Art Union*, 1846, p. 262.

Evensong
WAG 1435
Canvas: 145.4 × 212.7 cm
Signed: *M. Anthony*

In a letter to the Curator of the Walker Art Gallery dated 21 February 1878, the artist explained his purpose in this painting thus:[1]

I have endeavoured to express in my painting of Evensong some of the feelings that may arise in the mind on visiting a time honoured sanctuary like the one represented, striving at the same time to reproduce it with all the fidelity in my power; so as, if possible, to make the spectator think he is on the spot portrayed.

There is always a mystery and beauty about a ruin at sunset, and the heart itself seems more impressible & sympathetic at that hour – and I seemed to feel this old church, ivy clad and lichen covered, rich with a thousand old memories, beautiful with a new beauty in its decay, standing grey and solemn with the coming shadows of night against the golden glow of the departing day – while the twittering of the swallows & the last song of the robin mingled with its gloom and grandeur united to form a hymn or prayer and thanksgiving to our Creator – an Evensong to giver of all good and beautiful things.

The old church painted is at Chingford in Essex & the body of Harold, tradition says, rested on the spot of its erection on its way to Waltham Abbey after the battle of Hastings.

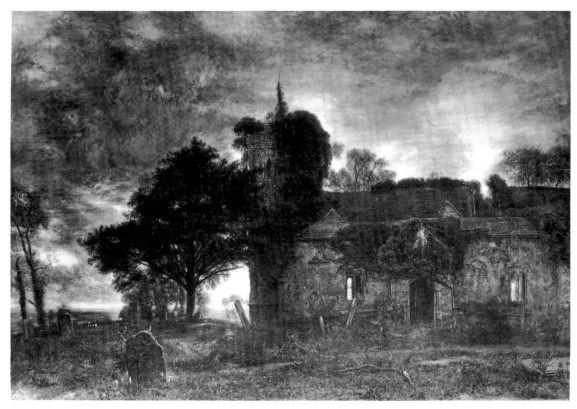

Evensong WAG 1435

The church is presumably All Saints Church, Chingford,[2] which was apparently disused during part of the 19th century; the same church seems to have been used by Anthony for the *Village Church* of 1842, now at Manchester City Art Galleries, for three paintings by him formerly at Wednesbury Art Gallery,[3] and for his *Deserted Church* lent by B.A. Butler to the 1857 Manchester *Art Treasures Exhibition* (536).[4]

This painting is listed in the 1903 edition of Bryan's *Dictionary of Painters and Engravers*[5] as 'one of his best pictures', but it attracted scant critical acclaim when first exhibited in 1873 – no doubt because it showed little change from Anthony's earlier work; the *Art Journal*[6] noted, however, that it was 'thought by many the finest picture' in the 1873 Liverpool Autumn Exhibition. A sketch for it was in a private collection in 1877.[7]

PROV: Bought from the artist 1873 (£420).

EXH: Royal Academy 1873 (662); Liverpool Autumn Exhibition 1873 (152).

1 MS Walker Art Gallery.

2 N. Pevsner, *Buildings of England, Essex*, 1965, p. 123. In its obituary of the artist the *Athenaeum*, 11 December 1886, p. 790, stated that WAG 1435 represented Chingford Church 'as of old'. Chingford Old Church also appears in Arthur Hughes's *Home from Sea* of 1857 (Ashmolean Museum, Oxford).

3 Wednesbury Art Gallery, *Catalogue*, 1930, nos. 86, 91 and 137. All were sold by the Gallery in 1949.

4 MS letter from the artist to the Curator of the Walker Art Gallery of 11 October 1877. The same picture was apparently lent by T. Horne to the Manchester *Royal Jubilee Exhibition*, 1887 (802).

5 Ed. G.C. Williamson, p. 44.

6 *Art Journal*, 1873, p. 334. For the artist's stylistic development see, however, A. Staley, *The Pre-Raphaelite Landscape*, 1973, pp. 179–80.

7 See note 4.

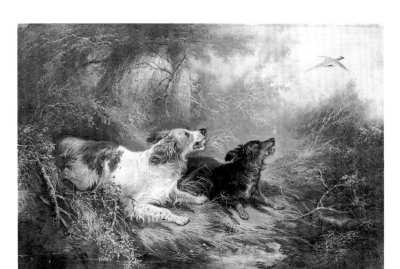

ARMFIELD, George[1]
(active about 1836–1875)

Two Springer Spaniels putting up a Pheasant

WAG 30
Canvas: 25.6 × 38.8 cm
Signed: *George Armfield*

Armfield exhibited many paintings of dogs hunting and similar subjects at the Royal Academy, the Royal Society of British Artists and the British Institution between 1836 and 1875. Works by Armfield comparable with this painting include: *Two Spaniels flushing a Mallard* (signed and dated 1861, Ellis Collection, Bramber, Sussex, 1975), *Raising a Pheasant* (formerly one of a pair, 8 × 12 in., Degenaar Collection, Woerden, Holland, 1975), *Raising a Pheasant* (one of a pair, 8¼ × 12 in., sold Sotheby's (Belgravia) 8 May 1973, lot 150) and *Two Spaniels flushing a Pheasant* (one of a pair, 12 × 16 in., formerly with Ackerman & Co.).

PROV: Walter Stone;[2] bequeathed by Miss Mary Stone 1944.

1 Between 1836 and 1839 Armfield exhibited under the name George Armfield Smith. He seems to have abandoned the use of his actual surname in 1840.

2 See *The Walter Stone Collection of Sporting Pictures at Whitton Hall, Westbury, Shropshire*, 1938, no. 8.

ARMITAGE, Edward (1817–1896)

Julian the Apostate presiding at a Conference of Sectarians

WAG 3071
Canvas: 174.6 × 271.8 cm

This painting was originally exhibited with the following quotation from Gibbon's *Decline and Fall of the Roman Empire*:[1]

Julian, who understood and derided their theological disputes, invited to the palace the leaders of the hostile sects, that he might enjoy the agreeable spectacle of their furious encounters. The clamour of controversy sometimes provoked the emperor to exclaim, 'Hear me! the Franks have heard me and the Alemanni!'; but he soon discovered that he was now engaged with more obstinate and implacable enemies; and, though he exerted the powers of oratory to persuade them to live in concord, or at least in peace, he was perfectly satisfied before he dismissed them from his presence that he had nothing to fear from the union of the Christians.

The extent of the quotation was explained by Armitage himself:[2]

If we now turn to the other subject, the conference of philosophers, how are we to express the purport of their conversation? What facial muscles are called into play when men are talking metaphysics or expounding their theories of evolution? It is clear that however exquisite the execution of the picture may be the subject of it will be unintelligible without explanation.

E. Wind[3] argues that Julian the Apostate – although seen in the 17th and 18th centuries variously as the type of the apostate from Protestantism to Catholicism, or as a pagan witness to Protestant truth, or as a supporter of toleration and freedom – was by the 19th century at least in England a subject no longer charged with political or religious significance, largely thanks to Gibbon's sceptical evaluation of him. But the *Art Journal*[4] in its review observed that the subject 'scarcely comes within our notions of a grateful one', and the bowdlerization of Gibbon (1826) together with Dean Milman's editions with their corrective notes and prefaces (1838–9, 1854–5, 1882–5) suggest that Gibbon's generally favourable interpretation of Julian the Apostate was still controversial, while the separation of Church and State was as much an issue in the 19th century as in the 18th or 17th centuries. Armitage in this painting certainly accepts Gibbon's interpretation; he separates Julian the Apostate from the arguing sectarians in philosophical detachment and places him conspicuously under the statue of Minerva, goddess of Wisdom. In the background work-

men are presumably repairing a pagan temple damaged under Constantine.

Armitage[5] himself observed that 'the likeness of Julian was taken from a gold coin at the British Museum. The sectarians who are disputing are supposed to represent the various churches of the period. They are not portraits and no likenesses of these jealous partisans are in existence.' It is not possible to identify the gold coins used by Armitage; from them he seems to have borrowed only Julian's beard, straight nose and the profile view of his head.[6] Blackburn[7] is certainly incorrect in stating that Armitage's painting 'is largely interesting both as a composition and from an archaeological point of view, every detail even to the portrait of Julian having been copied from ancient coins', and Armitage must have had this in mind when he observed[8] in his *Lectures* that:

The dresses of the time of Constantine and his successors are very little known. To some artists this is rather attractive as affording an opportunity of invention in costume which is denied to them in a better known period and it must be admitted that provided they keep to what was likely to have been

Julian the Apostate presiding at a Conference of Sectarians WAG 3071

worn no-one can prove them to be wrong . . . But there are a few coins and medals in existence which give some idea of the appearance of an emperor or great personage.

The *Times*[9] considered *Julian the Apostate* Armitage's best easel picture so far; other critics were rather less enthusiastic; there was, however, general respect for the artist's scholarship, for his powers of composition and expression and for his drawing; the *Saturday Review* commented that he had ennobled equally the figures of the arguing Christians and the figure of Julian himself, thus maintaining a judicious balance.[10] W.M. Rossetti's review in the *Academy*[11] was typical:

Opposite this hangs another of the large canvases, again a subject well chosen for popularity, and in itself approvable. Mr. Armitage portrays Julian the Apostate presiding at a Conference of Sectarians – Christian sectarians whose squabbles amused and disgusted the philosophic Emperor, and whom he scornfully but not hopefully invited to concord. An ironical smile severs the lips of Julian, the bearded stoic; a bronze statue of Pallas overlooks him, and the contentious votaries of the newfangled and self-conflicting faith. A black-haired fanatic is the present speaker: two other disputants oppose him – one stubbornly, the second vehemently. Another, with the theological shibboleth boiling over irrepressibly from his lips, breaks in, and makes the confusion worse confounded. A fourth approaches from behind, bringing rolls of papyrus, by whose authority the debate is to be settled, or rather re-entangled; he holds up his hand, bespeaking silence and reverence for his panacea. If the smile of Julian is sarcastic, those of his officers and counsellors are more broadly contemptuous: one of them, with a great oak-wreath about his head, may be introduced as representing a Romanised Teuton, and thus recalling the phrase which Julian addressed to the Christian zealots (as quoted in the catalogue from Gibbon) – 'Hear me! The Franks have heard me, and the Alemanni!' There is not, however, any very marked national character in this head, nor in any other: the countenances are expressive, but not interesting, and they tend towards a general ugliness. The colour, as usual with Mr. Armitage, is crude. The picture is one to be respected for its sound and sensible qualities – the planning-out of the subject, its composition, draughtsmanship, and narrative efficiency; to find keen pleasure in its art would be a different thing.

Ruskin[12] was much more critical, blaming contemporary irreligion and censuring both Gibbon and Armitage for their lack of sympathy with the early Church. He described the painting as 'a modern enlightened improvement on the Disputa del Sacramento'.

REPR: *Pictures and Drawings selected from the works of Edward Armitage R.A. Issued under the Authority of Mrs. Armitage*, 1898, plate XLIII.

PROV: Alderman William Bennett,[13] who presented it 1875.

EXH: Royal Academy 1875 (518); Liverpool Autumn Exhibition 1875 (172).

1 Edward Gibbon, *Decline and Fall of the Roman Empire*, first published in 1776, chapter xxiii (Everyman Edition, ed. Dawson, 1961, vol. 2, p. 372).

2 E. Armitage, *Lectures on Painting*, 1883 (Lectures given at the Royal Academy 1876–82), p. 207.

3 E. Wind, 'Julian the Apostate at Hampton Court', *Journal of the Warburg and Courtauld Institutes*, 1939–40, vol. 3, pp. 127 ff. See also J. Richer, *L'Empereur Julien*, 1981, pp. 79–80, where WAG 3071 is discussed.

4 *Art Journal*, 1875, p. 250. The *Illustrated London News*, 1 May 1875, p. 415, observed that 'Mr. Armitage points a moral of religious toleration that seems as difficult to get practically accepted nowadays as it has been in all ages and with all creeds.'

5 E. Armitage, letter to the Walker Art Gallery dated 1 November 1877.

6 G.K. Jenkins, letter to the compiler, 8 October 1968.

7 Henry Blackburn, *Academy Notes*, 1875, p. 36.

8 Armitage, *op. cit.*

9 *The Times*, 5 May 1875.

10 *Athenaeum*, 5 June 1875, p. 757; *Art Journal*, 1875, p. 250; *Saturday Review*, 8 May 1875, p. 596; *Architect*, 15 May 1875, p. 286; *Spectator*, 22 May 1875, p. 661; the *Architect* commented that WAG 3071 was the sole representative of historic art after academic pattern at the 1875 Royal Academy; the *Pall Mall Gazette*, 22 May 1875,

could only praise Armitage's learning and technique: 'We know not how a painter of undoubted technical resource could persuade himself that either the design or the manner of its execution were worthy of serious art.'

11 *Academy*, 8 May 1875, p. 486.

12 *Academy Notes* in *Works of John Ruskin*, ed. Cook and Wedderburn, 1904, vol. 14, pp. 268–9.

13 Bennett was a Liverpool ironmonger and ironfounder; see Walker Art Gallery, *Merseyside: Painters, People and Places*, 1978, vol. 1, p. 42.

Serf Emancipation

WAG 3072
Canvas: 179 × 312.4 cm

Serf Emancipation was originally exhibited with this sub-title: 'An Anglo Saxon Noble on his Death Bed gives Freedom to his Slaves'. Armitage gives this explanation of his painting:[1]

The dying Noble is supposed to have been brought into the courtyard of his castle for the purpose of giving his serfs their freedom. There seems to have been no special ceremony attached to emancipation. The only form I have been able to discover was the distribution of rude lances to the men after they had been set free. One of my men at arms in the background is holding a bundle of lances ready for distribution. The spectators who are crowding in the gateway are supposed to be the labourers and retainers attached to the estate but not serfs. Amongst the serfs you will be able to distinguish the woodman, the fisherman, the blacksmith, etc. and their wives and children. The scribe by the side of the couch is taking down the names. The dog was taken from a smooth St. Bernhard [sic] which is supposed by the best canine authorities to be very near akin to the old English mastiff. N.B. The serfs in England never had collars like the Roman slaves. The only badge of servitude was occasional branding with the initials of their master.

Armitage's source appears to be John Mitchell Kemble's *The Saxons in England* of 1849.[2] Armitage's painting may also refer to the emancipation of the serfs in Russia, begun in 1861 and made compulsory in 1881, but there is no evidence for this.

The *Art Journal*[3] in its review referred to Armitage's 'dry ascetic sort of brush', but believed that *Serf Emancipation* was painted with a 'mastery and breadth which Mr. Armitage has never excelled in any former composition'. The *Athenaeum*,[4] in a long review, praised the composition and learning in the picture but found its severe and monumental style incompatible with the mundane medieval costumes and accessories and also deplored its lack of emotion, while Quilter,[5] although praising its drawing and composition, found it 'like a Scotch sermon, too long, too ponderous and too dogmatic'.

REPR: H. Blackburn, *Academy Notes*, 1877, p. 20; H. Blackburn, *Illustrated Catalogue of the British Fine Art Section, Paris Universal Exhibition*, 1878, p. 12, no. 15; *Pictures and Drawings selected from the Works of Edward Armitage R.A. Issued under the Authority of Mrs. Armitage*, 1898, plate XLV.

Serf Emancipation WAG 3072

Gathering Bait WAG 1436

PROV: Alderman William Bennett,[6] who presented it 1877.

EXH: Royal Academy 1877 (168); Liverpool Autumn Exhibition 1877 (71); Paris, *Exposition Universelle*, 1878 (15).[7]

1 E. Armitage letter to the Walker Art Gallery dated 1 November 1877.

2 See vol. 1, pp. 216–25 and Appendix C: *The Manumission of Serfs*.

3 *Art Journal*, 1877, p. 199.

4 *Athenaeum*, 19 May 1877, p. 582. The *Spectator*, 12 May 1877, p. 598, and the *Architect*, 19 May 1877, p. 319, similarly praised the academic qualities of WAG 3072 but deplored its colour and lack of life – the *Architect* referring to the artist's 'disagreeable stringy manner'.

5 H. Quilter, *Preferences in Art Life and Literature*, 1892, pp. 332–3. W.M. Rossetti in the *Academy*, 19 May 1877, p. 443 also found WAG 3072 a picture to be read rather than enjoyed – while conceding that it was a 'large important and seriously treated historical work'.

6 For Bennett, see WAG 3071 above.

7 Where it was much admired, according to the *Magazine of Art*, 1878, p. 128.

AUMONIER, James (1832–1911)
Gathering Bait

WAG 1436
Canvas: 61 × 143 cm
Signed: *J. Aumonier 1878*

H.D. Rodee sees *Gathering Bait* as essentially a social realist painting and notes other pictures with a similar theme of the 1870s – E.J. Gregory's *Driftwood* of 1876 and W.Q. Orchardson's *Flotsam and Jetsam* of the same date.[1]

REPR: G.R. Halkett, *Notes to the Walker Art Gallery Exhibition*, 1878, p. 74.

PROV: Purchased from the artist 1878 (£150).

EXH: Liverpool Autumn Exhibition 1878 (372).[2]

1 H.D. Rodee, *Scenes of Rural and Urban Poverty in Victorian Painting 1850–1890*, 1975, p. 104.

2 The artist wrote to the Curator of the Walker Art Gallery on 31 March 1879: 'The *Gathering Bait* has never been seen anywhere out of Liverpool – it was painted for your gallery as its first place of exhibition, and fortunately for me has there become a fixture.'

BADEN-POWELL, Frank Smyth
(1850–1933)

Trafalgar Refought
WAG 2507
Canvas: 114.3 × 244 cm
Signed: *F. BADEN-POWELL 1881*

In the 1881 Royal Academy and Liverpool Autumn Exhibition catalogues, this painting had a quotation as its sub-title – the accentuation is that of the artist:

> *Hearts of oak were our ships,*
> *Jolly tars were our men – Old Song.*

In fact this is a deliberate misquotation from the song *Hearts of Oak* attributed to David Garrick:

> *Hearts of oak are our ships,*
> *Jolly tars are our men*
> *We always are ready, steady, boys, steady*
> *We'll fight and will conquer again and again.*

The artist's intention was presumably to depict a nostalgic recollection of Britain's past maritime greatness – although the event represented cannot have occurred long after the battle.

PROV: Bequeathed by William Imrie[1] 1907.

EXH: Royal Academy 1881 (1412); Liverpool Autumn Exhibition 1881 (331).

1 Imrie (1837–1906) was a Liverpool shipowner, a partner in Ismay, Imrie and Co. (White Star Line); as a collector he was best known for his works by Frederic Leighton, Edward Burne-Jones and J.M. Strudwick, see *Liverpool Courier*, 27 September 1906, and George Bernard Shaw, 'J.M. Strudwick', *Art Journal*, 1891, pp. 97 ff.

Nelson capturing a Spanish Ship at the Battle of St. Vincent
WAG 2647
Canvas: 152.4 × 91.5 cm

Nelson, then commanding the *Captain*, is seen here leading a boarding party on the Spanish ship, the *San Nicolas*, at the Battle of Cape St. Vincent on 13 February 1797; the two figures behind him are presumably Lieutenant Pearson of the 69th Regiment and Captain Berry; his exploits played a considerable part in the defeat of the Spanish fleet by the British fleet, commanded by Sir John Jervis.[1]

Nelson's capture of the *San Nicolas* and the *San Josef* at this battle was a very popular subject for British artists; there are paintings by Robert Cleveley (1798), William Allan (1845), Daniel Orme (1799), George Jones (about 1829), Nicholas Pocock (1808) and Richard Westall (1806) at the National Maritime Museum, Greenwich; the Victoria & Albert Museum has a watercolour by J.T. Serres; there is a fresco by W.A. Knell in the House of Lords and an oil painting by T.J. Barker at the Royal Hospital School, Holbrook.[2]

PROV: Bequeathed by William Imrie[3] 1907.

EXH: Liverpool Autumn Exhibition 1886 (43).

Trafalgar Refought
WAG 2507

1 The classic account of the action is in Robert Southey, *Life of Nelson*, 1813, chapter 4: 'A soldier from the sixty-ninth broke the upper quarter-gallery window, and jumped in, followed by the commodore [Nelson] himself, and by others as fast as possible.' Nelson's own account is in *The Dispatches and Letters of Vice Admiral Lord Viscount Nelson*, ed. Nicolas, 1845, vol. 2, pp. 338–48.

2 For further details, see the unpublished typescript catalogue of the pictures at the National Maritime Museum by E.H.H. Archibald.

3 For Imrie, see WAG 2507 above; WAG 2647 was not priced at the 1886 Liverpool Autumn Exhibition, so it was probably painted as a commission from Imrie.

Nelson capturing a Spanish Ship at the Battle of St. Vincent
WAG 2647

BARRAUD, Francis (1856–1924)
An Encore Too Many
WAG 2973
Canvas: 56 × 76.8 cm
Signed: *FRANCIS BARRAUD*

According to E.M. Barraud,[1] *An Encore Too Many* represents the death of a circus acrobat in the ring, but H.D. Rodee,[2] more plausibly, thinks that the performer has only collapsed. Francis Barraud's *Strolling Players*, which also

An Encore Too Many
WAG 2973

includes acrobats and jugglers, was sold at Sotheby's 15 June 1988, lot 168.

REPR: *Graphic*, Christmas Number, 1886.

PROV: Bought from the artist 1887 (£45).

EXH: Liverpool Autumn Exhibition 1887 (1122).

1 E.M. Barraud, *Barraud, the Story of a Family*, 1967, pp. 135–6; he goes on to say that the artist, with his brother Philip, had a photographic studio in Liverpool from about 1887 until 1893.

2 H.D. Rodee, *Scenes of Rural and Urban Poverty in Victorian Painting 1850–1890*, 1975, p. 215; Rodee also discusses other contemporary paintings of poor performers on the road.

BATES, David (1840–1921)
Interior of a Welsh Cottage
WAG 470
Canvas[1]: 46.1 × 61.3 cm
Signed: *David Bates 1873* (?)

The artist was known for his landscapes; very few interiors or genre scenes by him seem to be recorded.

PROV: Presented by A.M. Jones 1876.

EXH: (?) Liverpool Autumn Exhibition 1873 (123) as *A Welsh Cottage*.[2]

1 Canvas stamp: Geo Rowney and Co., Rathbone Place.

2 There is an MS label on the back of WAG 470: *21 Interior of a Welsh Cottage / David Bates / Henwick, Worcester.*

BAYLISS, Wyke (1835–1906)
The White Lady of Nuremberg
WAG 1773
Canvas[1]: 155 × 111.8 cm
Signed: *Wyke Bayliss*

This is a view of the Choir of S. Lorenz, Nuremberg, begun in 1439; in the centre is the Sakramentshaus (1493) designed by Adam Kraft; the artist has somewhat distorted the architecture to produce a sensation of soaring height.[2] The artist wrote a poem on the Sakramentshaus, first published in the Royal Society of British Artists 1887 exhibition catalogue against its entry for this painting:[3]

> *O Adam Kraft, and thy disciples twain,*
> *It needs strong shoulders and stout hearts to*
> *bear*
> *This burden, self-imposed; even Atlas fain*
> *Would rest sometime and get a friend to share*

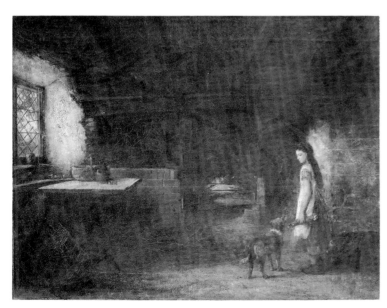

Interior of a Welsh Cottage
WAG 470

His labour; else perchance in sheer despair
 He had fallen, and let the world go all to
 wrack:
But neither he nor Heracles would care
 To poise a Church for ever on his back.

See now! the Incense climbs its snowy height!
 Can stone dissolve and vanish in a minute?
How like a ghost the thing slips out of sight –
 Ah no! 'tis but a dream, there's nothing in it:
The West door opens, puff! a little draught,
Vanish the smoke; and lo! poor Adam Kraft.

The artist's *Sakrament-Haus, St. Laurence, Nuremberg* was no. 348 at the 1885–6 exhibition of the Royal Society of British Artists;[4]

the catalogue again contained a brief poem written by the artist and inspired by the subject matter.

PROV: Bought from the artist 1887 (£120).

EXH: Royal Society of British Artists 1887 (126); Liverpool Autumn Exhibition 1887 (962); Paris, *Exposition Universelle*, 1889 (9); Guildhall Art Gallery 1897 (30).

1 Canvas stamp: Reeves, 113 Cheapside.

2 A modern photograph taken from much the same viewpoint as WAG 1773 is reproduced in Paul Frankl, *Gothic Architecture*, 1962, plate 130; for an

The White Lady of Nuremberg
WAG 1773

Goats: Outskirts of Cadiz WAG 2738

appreciation of WAG 1773 see A.G. Temple, *Artists in the Queen's Reign*, 1897, p. 374.

3 This poem also appeared in the Liverpool Autumn Exhibition catalogue, 1887, p. 57 against the entry for WAG 1773. It was republished in the artist's *The Enchanted Island*, 1888, p. 202, among his so-called *Studies for Pictures*, which he described (p. viii) as 'leaves from my sketch-book – notes in pen and pencil of subjects which have grown into pictures'; two of Bayliss's sketches of the Sakramentshaus are reproduced on pp. 201–2 and another poem inspired by it appears on p. 201. See also Bayliss's drawing of the Sakramentshaus reproduced in W. Bayliss, *Olives: The Reminiscences of a President*, 1906, opp. p. 224; p. 233–4 of this book describe the artist's reactions to the building and its meaning for him. According to the *Dictionary of National Biography* the artist thought WAG 1773 one of his best works.

4 The 1884 Dowdeswell and Dowdeswell exhibition, *Drawings and Pictures of Cathedral Churches by Wyke Bayliss* contained *The Church of St. Lorenz, Nuremberg* (8), *The Euchariuskapelle, Nuremberg* (17) and *St. Lorenz, Nuremberg* (36).

BEAVIS, Richard (1824–1896)
Goats: Outskirts of Cadiz
WAG 2738
Canvas[1]: 56.5 × 140.3 cm
Signed: *R. Beavis*

This was presumably one of the products from the artist's tour in Spain of around 1887.[2]

REPR: H. Blackburn, *Grosvenor Notes*, 1888, p. 32; Liverpool Autumn Exhibition catalogue, 1888, p. 114.

PROV: Presented by C. Sydney Jones and Ronald Jones on behalf of their father, C.W. Jones, 1908.

EXH: Grosvenor Gallery 1888 (117); Liverpool Autumn Exhibition 1888 (1157).

1 Canvas stamp: Charles Roberson prepared canvas.

2 See the catalogue of the 1888 Arthur Tooth and Sons exhibition, *Pictures and Studies by Richard Beavis representing a recent tour in Spain*. No. 22 at that exhibition was presumably the *Milch Goats, Granada*, sold Christie's 29 February 1980, lot 165; it is similar in type and composition to WAG 2738.

Bothwell Castle WAG 189

BOUGH, Samuel (1822–1878)

Bothwell Castle

WAG 189
Mill-board[1]: 17.8 × 25.4 cm
Inscribed on back of panel: *S. Bough /
Bothwell Castle* and on a label: *Bothwell Castle
from Uddingston, June [. . .] Sam B [. . .]*

Bothwell Castle is on the Clyde near Uddings-
ton, seven or eight miles from Glasgow. By
the 1840s there was a railway line at Bothwell
together with extensive ironworks and collier-
ies, all of which the artist has concealed in this
painting. The artist settled in Glasgow and its
neighbourhood, at Hamilton and Port Glas-
gow, in the late 1840s and early 1850s, paint-
ing landscape in the surrounding country. He
exhibited views of Bothwell Castle at the West
of Scotland Academy, Glasgow, in 1851 and
1852 (as *Bothwell Castle near Uddingston*) and in
1853 he exhibited a watercolour of the same
subject; in the same year he showed *Bothwell
Castle, near Uddingston* at the Royal Scottish

Academy[2] and his picture with the same title
appeared at the Liverpool Academy in 1854.

PROV: Bought by George Holt from G. Trow-
bridge, Upper Newington St., Cork St., London,
1876 (£16); bequeathed by Emma Holt 1944.

1 Winsor and Newton prepared mill-board.

2 Sidney Gilpin (George Coward), *Sam Bough,
 R.S.A.*, 1905, Appendix, pp. 211, 218.

BRAMLEY, Frank (1857–1915)

Among the Roses

WAG 1462
Canvas[1]: 54 × 45.7 cm
Signed: *Frank Bramley 1911*[2]

Around the late 1890s Bramley moved away
from Newlyn School social realism towards

40

decorative and symbolist works of this type.[3]

The head is taken almost literally from the head of Cupid in the artist's *'And mocks my loss of liberty' – Blake* of 1910,[4] but the wings have been removed.

REPR: Liverpool Autumn Exhibition catalogue, 1914, p. 7.

PROV: Presented by subscribers (through George Hall Neale) 1914.

EXH: White City, London, *Latin-British Exhibition*, 1912;[5] Liverpool Autumn Exhibition 1914 (1101).

1 Frame maker's label: H.W. Taylor, 61 Queen's Road, Bayswater.

2 The date is now barely legible but is noted in the Gallery's records.

3 See particularly C. Hiatt, 'Mr. Frank Bramley A.R.A. and his Work', *Magazine of Art*, 1903, pp. 54 ff.

4 Reproduced in *Royal Academy Pictures*, 1910, p. 26.

5 Also called the Anglo-Latin Exhibition; no catalogue seems to survive.

Among the Roses WAG 1462

BRITISH SCHOOL (early 19th century)
Waiting for Father
WAG 48
Canvas: 71 × 92.2 cm

An artist named Bates was mentioned in correspondence with the donor.[1]

PROV: Presented by Colonel William Hall Walker (later Lord Wavertree) 1915.

1 Letter from Colonel Hall Walker dated 31 January 1916 and letter from the Curator to Colonel Hall Walker dated 3 February 1916.

Waiting for Father WAG 48

Summer WAG 2276

Landscape with Inn: The Sign of the Magpie
WAG 5603
Canvas[1]: 48.2 × 61 cm

PROV: Found in the Gallery 1956.

1 Old label: *Cottage with figures / apparently unsigned / cleaned re-varnished with mastic 1907 W.N.J.*

BRITISH SCHOOL (*c.*1837)
Summer
WAG 2276
Canvas: 92 × 71 cm
Inscribed[1]: *W. Dyce 1850* (?)

The old attribution to Dyce does not seem to be acceptable.[2] Costume and style suggest a date around 1837.[3]

PROV: Presented by George Audley 1925.[4]

1 This signature is now illegible but was recorded in 1958.

2 Colin Thompson, letter to the Curator of the Walker Art Gallery, 14 March 1957. Dyce did exhibit a *Flora* at the 1830 Royal Scottish Academy exhibition (253).

3 Aileen Ribeiro, conversation with the compiler, 1994.

4 Since WAG 2276 does not appear in George Audley's, *Collection of Pictures*, 1923, he presumably acquired it between 1923 and 1925.

St. Andrew's Church,
Bebington WAG 7624

BRITISH SCHOOL (*c.*1839)

St. Andrew's Church, Bebington

WAG 7624
Canvas[1]: 34.3 × 48.3 cm

The architecture of the church suggests a date around 1838–40; there were alterations to the north porch in 1847.[2]

PROV: Joseph Mayer; presented by Bebington Corporation 1971.

1 There is a pencil inscription on the back of the frame: *Harding, Bebington.*

2 Janet Moore, letter to the compiler, 20 September 1994, giving the opinion of Mr. H. Kemp.

BRITISH SCHOOL (*c.*1842)

Portrait of a Man

WAG 2556
Canvas[1]: 92 × 71.8 cm

Portrait of a Woman

WAG 2555
Canvas[2]: 92 × 71 cm

Costume and style suggest a date around 1842.[3] Although the portraits are of the same

Portrait of a Man WAG 2556

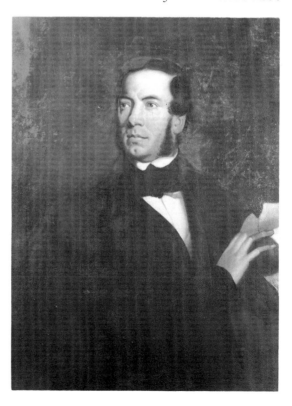

43

Portrait of a Woman WAG 2555

Woman with a Lap Dog WAG 5605

size the frames are not similar and they probably do not therefore necessarily represent a husband and wife.

PROV: Acquired from a doctor's house in Crosby around 1949.

1 Label on frame: John Clowes Grundy, Exchange Street, Manchester, printseller. Grundy died in 1867.

2 Label on frame: John Clowes Grundy, Exchange Street, Manchester, printseller. Label on stretcher: Henry Whaite, 4 Bridge Street, Manchester, frame maker.

3 Aileen Ribeiro, conversation with the compiler, 1994.

BRITISH SCHOOL (*c.*1844)
Woman with a Lap Dog
WAG 5605
Canvas: 29.2 × 24.7 cm

Costume indicates a date around 1844.[1]

PROV: Found in the Gallery 1961.

1 Aileen Ribeiro, conversation with the compiler, 1994.

BRITISH SCHOOL (1845)
Writer in 18th-century Dress seated at a Desk
WAG 2405
Canvas: 92.5 × 71.5 cm
Signed: *FG* (or *FC*) in monogram *1845*

This painting was described by the donor as *A Passing Thought* by Francis Grant, but neither the style nor the monogram is characteristic of this artist. The monogram has a capital F (or possibly E) above and a capital G (or possibly C); the G or C is enclosed within a heart.

PROV: Presented by George Audley[1] 1925.

1 George Audley, *Collection of Pictures*, 1923, p. 26, no. 66.

Entry of Queen Adelaide into Lisbon Harbour
WAG 9384

Writer in 18th-Century Dress seated at a Desk
WAG 2405

BRITISH SCHOOL (*c*.1847)
Entry of Queen Adelaide into Lisbon Harbour[1]
WAG 9384
Canvas: 33 × 43 cm

Queen Adelaide (1792–1849), wife of William IV, suffered from bronchitis during the last twelve years of her life. To seek relief she spent the winter of 1839 in Malta and in 1847 set off for Madeira for the same purpose. In this painting her frigate, the *Howe*, is being towed into the Tagus by the steam frigate, the *Terrible*, on Friday 22 October.[2]

PROV: Bequeathed by Mrs. Muriel Cameron Haynes Woosman-Jones 1979.

1 WAG 9384 used to be called *The Entry of Queen Adelaide into Malta Harbour*, referring to her journey of 1838, but the port in WAG 9384 seems to be Lisbon not Malta.

2 For further details, see Dr. John Doran, *Memoir of Queen Adelaide*, 1861, pp. 58–62.

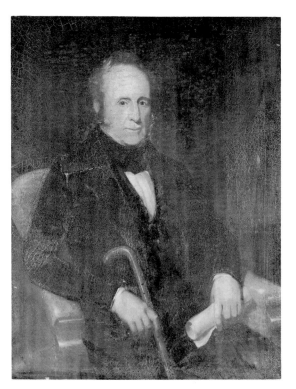

Portrait of a Man WAG 6656

Portrait of a Woman WAG 6657

BRITISH SCHOOL (*c*.1850)
Portrait of a Man
WAG 6656

Portrait of a Woman
WAG 6657
Canvas, each: 112 × 87 cm

These portraits are in the same style and in identical frames and so presumably represent a husband and wife. Style and dress indicate a date around 1850.[1]

PROV: Presented by Miss Porter 1953.[2]

1 Aileen Ribeiro, conversation with the compiler, 1994.

2 Miss Porter lived, apparently, at 1 Halsbury Road, Liverpool 6, the home and studio of the stained glass designer R.W. Warrington (1868–1953), from 1916 onwards. She is stated to have been his sister.

Portrait of a Man
WAG 7243

Portrait of a Woman
WAG 7199
Canvas,[1] each: 76 × 63.5 cm

These portraits are in the same style and in identical frames and so presumably represent a husband and wife. Style and costume indicate a date around 1850.[2]

PROV: Transferred from the Liverpool Museum 1970.

1 WAG 7199 has a label on the back: G.J. Keet, 88–90 Renshaw Street, artist's colourman. George James Keet is listed in street directories as a stationer, engraver, artist's colourman and photographer at 88–90 Renshaw Street between 1848 and 1864. He exhibited a painting *Heads or Tails* at the 1859 Liverpool Academy (no. 783). George Keet exhibited more widely at the Liverpool Academy between 1845 and 1847 (including portraits) and in 1846–7 gave his address as 88 Renshaw Street. The sitters therefore lived, presumably, in or near Liverpool.

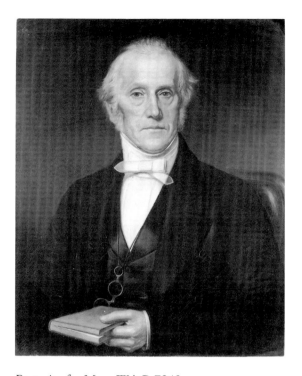

Portrait of a Man WAG 7243

Portrait of a Woman WAG 7199

Matilda in the Garden of Delight

WAG 2503
Canvas: 89 × 47 cm
Inscribed: *JM* or *JEM* (in monogram)

In Cantos 28 and 29 of the *Purgatorio*, Dante encounters Matilda tending her idyllic garden.

This painting was attributed to J.E. Millais by the dealer Sampson[1] – presumably on the strength of the monogram – but no picture of this subject by him is recorded, nor does the style resemble his work.

PROV: (?) Christina Rossetti.[2] Bought by George Audley from Sampson (£365); presented by him 1930.

47

EXH: Liverpool Autumn Exhibition 1929 (75).

1 George Audley, letter to the compiler,
 10 December 1929.

2 George Audley, *Collection of Pictures*, 1923, p. 39.

Ideal Portrait

WAG 2830
Panel: 54 × 45.7 cm
Inscribed: *JM* or *JEM* (in monogram)

This was stated to be a portrait of 'a well-known flower girl at Gloucester Road' by J.E. Millais and to have been purchased from that artist by John Inglis.[1] The real significance of the peacock feathers – which often represent pride – is unclear.

PROV: John Inglis sale, Christie's 6 April 1923, lot 101, bought Sampson (£52.10*s.*); bought by George Audley (£250);[2] presented by him 1930.

EXH: Liverpool Autumn Exhibition 1929 (74).

1 Inglis sale catalogue (see Provenance).

Ideal Portrait WAG 2830

2 George Audley, *Collection of Pictures*, 1923, p. 39 and letter from him dated 10 December 1929.

Portrait of a Man

WAG 2552
Canvas: 61 × 50.8 cm

Costume indicates a date around 1850.[1]

PROV: Found in the Gallery 1958.

1 Aileen Ribeiro, conversation with the compiler, 1994.

Portrait of a Man WAG 2552

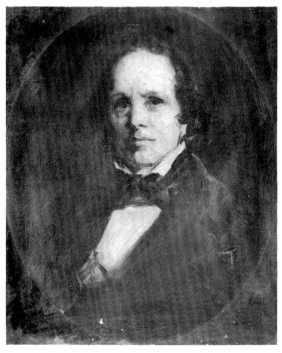

BRITISH SCHOOL (mid-19th century)
Alpine Landscape
WAG 6029
Canvas[1]: 55.5 × 84 cm

PROV: Found in the Gallery about 1964.

1 Label: W. Rosenberg and Co., picture frame manufacturers.

48

BRITISH SCHOOL (*c*.1855)
Portrait of a Woman
WAG 6658
Canvas[1]: 91.5 × 69 cm

Style and dress indicate a date around 1855.[2]

PROV: Presented by Miss Porter 1953.[3]

1 Canvas stamp: Charles Roberson, 52 Long Acre,
London, CR/1047. Roberson seems to have been
at this address between 1840 and 1853.

2 Aileen Ribeiro, conversation with the compiler,
1994.

3 For Miss Porter, see WAG 6656 and 6657 above.

BRITISH SCHOOL (*c*.1857)
Portrait of a Woman
WAG 2554
Canvas: 76.5 × 64 cm

Costume indicates a date around 1857.[1]

PROV: Found in the Gallery 1958.

1 Aileen Ribeiro, conversation with the compiler,
1994.

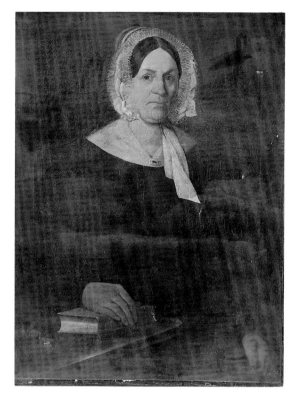

Portrait of a Woman WAG 6658

Portrait of a Woman WAG 2554

Alpine Landscape WAG 6029

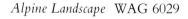

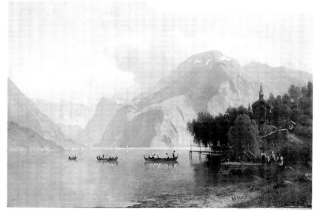

BRITISH SCHOOL (c.1870)

A Road through a Cutting

WAG 351
Panel: 28.2 × 22.7 cm
Signed: *FC* (in monogram)

This panel was presented to the Gallery by Henry Walker, brother of Frederick Walker, as that artist's work. The monogram,[1] however, does not seem to resemble that used by Frederick Walker, nor is the style close to his.

PROV: Presented by Henry Walker 1895.

1 See Peter Nahum, *Monograms of Victorian and Edwardian Artists*, 1976, p. 107.

A Road through a Cutting WAG 351

BRITISH SCHOOL (about 1875)

J.M. Whistler and the Family of F.R. Leyland at Speke Hall, Liverpool

WAG 9524
Canvas[1]: 42.8 × 63.5 cm

There seems to be no reason to doubt the accuracy of the title, the *Leyland Aunts*, originally given to this painting when owned by the Leyland family. The two male figures substantially resemble Leyland (at the left of the seated group) and Whistler (leaning backwards towards the right of this group). The female figure in the dark dress on Whistler's right could be Leyland's wife, Frances, born in 1834.[2] Three of the other female figures could be Leyland's daughters – Fanny, born in October 1857, Florence, born in September 1859 and Elinor, born in October 1861; another of them could be Mrs. Leyland's sister, Elizabeth Dawson, to whom Whistler was very attached and briefly engaged in 1872.[3]

Leyland began renting Speke Hall in September 1867[4] and he seems to have met Whistler at about the same time.[5] Subsequently Whistler spent considerable periods at Speke Hall, where he was particularly friendly with Leyland's family, until the two men quarrelled in 1876. The probable ages of the younger girls in this painting – if they are indeed Leyland's daughters – would indicate that it was painted towards the end of the period between 1867 and 1876. The billiard room had, however, been converted from an old kitchen by Leyland as early as 1867–8.[6] Whistler's casual and easy familiarity with the Leyland family is perhaps reflected in this very informal representation of a family game of billiards.

The identity of the artist is less easy to establish. Whistler himself rarely, if ever, painted portrait groups of this nature – although he might have done this canvas for the amusement of the family – but when he did work on this type of subject the result was very much less 'finished' than here.[7] Technical proficiency would also indicate that this is the work of a follower or imitator, of whom there were a considerable number by about 1875; it may, however, have been worked on by Whistler at some stage.

PROV: F.R. Leyland; by descent to Major Freddie Leyland,[8] from whom purchased 1979.

1 Canvas stamp: Prepared by Winsor and Newton, 38 Rathbone Place, London. Pin holes in the four corners of the canvas suggest that it had been painted informally, attached to a board – perhaps during the game of billiards.

2 Compare the portrait of her by Whistler in the Frick Collection, New York, and the drawings of

J.M. Whistler and the Family of F. R. Leyland at Speke Hall, Liverpool WAG 9524

her attributed to D.G. Rossetti, sold at Christie's (London) 9 November 1971, lot 151.

3 These identifications were first suggested by Robin Spencer, letter to the compiler, 2 April 1979. Margaret MacDonald, letter to the compiler, June 1979, broadly agreed and noted that the seated woman second from the left resembles Florence, to judge from the portrait of Florence by Whistler in the Portland Art Museum, Maine. For drawings of the Leyland family by Whistler, see Tate Gallery, *James McNeill Whistler*, 1994, nos. 68–79.

4 See Tony Tibbles, 'Speke Hall and Frederick Leyland', *Apollo*, 1994, vol. 139, p. 34.

5 There is a letter from Whistler to Leyland dated 5 October 1867 noting payment for a painting just begun (Whistler Collection, Glasgow

University LC4/3194–5). M. Susan Duval, 'F.R. Leyland, A Maecenas from Liverpool', *Apollo*, 1986, vol. 124, p. 111, states that the two men had met by the autumn of 1867.

6 Tibbles, *op. cit.*, p. 35. WAG 9524 almost certainly represents the Billiards Room at Speke Hall. The figures are seated on the bench fixed to the south wall of that room and the black upright beams exposed between the plaster panels are clearly visible in the background (Tibbles, letter to the compiler, 23 August 1994). Aileen Ribeiro, conversation with the compiler, 1994, confirms that the dress of the female figures indicates a date for WAG 9524 around 1875.

7 Spencer, *op. cit.* MacDonald, *op. cit.*, was sure that WAG 9524 was not by Whistler.

8 He was a great-grandson of F.R. Leyland.

51

BRITISH SCHOOL (1880–1881)
Frederick Richards Leyland (1831–1892)
WAG 9711
Canvas: 91.5 × 71.8 cm
Inscribed: *FREDERICK R. LEYLAND / AET. XLIX* and with coat of arms

Leyland[1] was a Liverpool shipowner who later moved to London. He was an important patron, most notably of D.G. Rossetti and J.M. Whistler.

This portrait, dating from 1880–1, was attributed to Luke Fildes by Major Freddie Leyland;[2] a version appears in the 1892 Bedford Lemere photograph of F.R. Leyland's study;[3] the artist might have been Val Prinsep, although his portrait of Leyland reproduced in the 1892 *Art Journal* differs from this portrait.[4]

Alternatively, the Walker Art Gallery portrait may have been based on one of D.G. Rossetti's two drawings of Leyland, both dating from 1879.[5]

PROV: By descent to Major Freddie Leyland, from whom purchased 1979.

1 See particularly M. Susan Duval, 'F.R. Leyland, A Maecenas from Liverpool', *Apollo*, 1986, vol. 124, pp. 110–5 and the *Rossetti-Leyland Letters*, ed. Fennell, 1978.

2 Letter to the compiler, 26 July 1977, presumably relying on family tradition; Major Freddie Leyland was a great-grandson of the sitter. WAG 2120 (see p. **137**) is generally said to have been Fildes's first portrait and it was painted in 1887, seven years after WAG 9711.

Frederick Richards Leyland (1831–1892) WAG 9711

3 Negative no. B.L. 11527 (Royal Commission on the Historical Monuments of England).

4 Val Prinsep, 'The Private Art Collections of London', *Art Journal*, 1892, p. 129; this is presumably the portrait exhibited at the 1886 Royal Academy (245). P.R. Morris exhibited a portrait of Mrs. F.R. Leyland at the 1878 Royal Academy (227), and a portrait of her son, F.D. Leyland, at the 1895 Royal Academy (839).

5 One of these drawings is in the Delaware Art Museum (Virginia Surtees, *The Paintings and Drawings of Dante Gabriel Rossetti*, 1971, p. 171, no. 346); the other was sold at Christie's 9 November 1971, lot 150, bought Fine Art Society and then again at Sotheby's 9 June 1993, lot 13; the compiler is indebted to Sarah Wimbush for details about these drawings.

BROOKS, Thomas (1818–1891)
The Village Schoolmaster
WAG 1778
Canvas: 95 × 145 cm
Signed: *T. Brooks 1849*

This painting was first exhibited at the 1849 Royal Academy and these lines, from Oliver Goldsmith's *Deserted Village* (1770),[1] were printed in the catalogue:

In arguing too, the pastor owned his skill,
For e'en, though vanquished, he would argue still,
While words of learned length and thundering sound
Amazed the gazing rustics ranged around,
And still they gazed, and still the wonder grew,
That one small head could carry all he knew.

The *Art Journal* critic[2] at that exhibition described it thus:

No. 403. 'The Village Schoolmaster', F. Brooks. This is the famous disputant of 'The Deserted Village' – 'in arguing, too, the pastor owned his skill', etc. His 'argument' is addressed to the pastor, and his positions are supported by earnest gesticulation; the vis verborum *is all on his side, and his opponent has the appearance of admitting himself to be worsted. The others who perfect the group are a knot of villagers, listening with the wonder ascribed to them in the text. They are assembled under one of the trees that Goldsmith describes, every figure being brought forward with the utmost attention to detail; but the work had been infinitely better with greater depth of shade.*

PROV: Presented by George Audley[3] 1925.

EXH: Royal Academy 1849 (403).

1 WAG 1778 was inspired by Frith's *Village Pastor* of 1845, which also illustrated Goldsmith's *Deserted Village* (see WAG 227, p. **158**). The poem

The Village Schoolmaster
WAG 1778

was probably an important source for those early 19th-century artists depicting rustic happiness in a contemporary or 18th-century setting. See also R.D. Altick, *Paintings from Books*, 1985, pp. 408–10.

2 *Art Journal*, 1849, p. 173.

3 George Audley, *Collection of Pictures*, 1923, p. 4, no. 12. G. Redford, *Art Sales*, 1888, vol. 2, p. 8 records that WAG 1778 was in the Grant sale of 14 November 1863; in fact it was not.

BROWN, Frederick (1851–1941)
Hard Times
WAG 2364
Canvas: 72 × 93 cm
Signed: *F. Brown 1886*

This painting was perhaps inspired by Hubert Herkomer's *Hard Times 1885*, now in the Manchester City Art Gallery and exhibited at the 1885 Royal Academy; it clearly belongs to the English social realist tradition of Herkomer, Frank Holl and Luke Fildes.[1] Its tonalism, its narrow brownish colour range, however, also perhaps link it to the imitators of Jules Bastien-Lepage.[2] *Hard Times* was favourably noted by the critic of *The Times*[3] at the first exhibition of the New English Art

Hard Times WAG 2364

54

Club: 'Mr. F. Brown's *Hard Times*, an unemployed workman in a squalid inn kitchen, his child crouching by the fire. This is a really artistic picture, perhaps the most artistic indeed of any in the Gallery.' When exhibited at Liverpool later that year, it was described thus by P.H. Rathbone:[4] '*Hard Times* is remarkable for deep but unforced pathos, the man sitting gloomily on the bench while the girl is trying to warm herself at the dying embers of a fire they cannot afford to replace, and forms a story simply but forcibly told.'

Thomas Smith, a friend of the artist, was the model for the man and his daughter, Margaret Smith, the model for the girl;[5] it seems that they modelled for the painting in Liverpool, where they lived.

REPR: Pall Mall Gazette, *Pictures of 1886*, p. 74; *Magazine of Art*, 1889, p. 52 (engraving by C. Carter).

PROV: Purchased from the artist 1886 (£60).[6]

EXH: New English Art Club 1886 (51); Liverpool Autumn Exhibition 1886 (241); Paris, *Exposition Universelle*, 1889 (13).

1 See particularly Bruce Laughton, *Philip Wilson Steer*, 1971, p. 23 and Manchester City Art Galleries, *Hard Times*, 1987, pp. 114–5, where Julian Treuherz suggests that WAG 2364 may have been inspired by Degas's *L'Absinthe* (Musée du Louvre), then in England. H.D. Rodee, *Scenes of Rural and Urban Poverty in Victorian Painting 1850–1890*, 1975, suggests that WAG 2364 may depict an actual event in Charles Dickens's *Hard Times* – Stephen Blackpool seeking work after his departure from Coketown – but this seems improbable to the compiler.

2 Laughton, *op. cit.*, saw in WAG 2364 the 'subtle tonal approach of Legros', but in 'Unpublished Paintings by Philip Wilson Steer', Apollo, 1985, vol. 122, p. 405, he endorsed D.S. MacColl's judgment that Brown was in WAG 2364 and in other early works imitating the mannerisms of Bastien-Lepage – albeit with 'precise and controlled drawing'. Brown was in Paris in 1883–4. The connection with Bastien-Lepage seems, however, to the compiler, rather tenuous.

3 *The Times*, 12 April 1886; this review was quoted in W.J. Laidlay, *The Origin and First Two Years of the New English Art Club*, 1907, p. 205. George Bernard Shaw writing in the *World*, 28 April 1886, p. 494, also described WAG 2364 as the best picture at the 1886 New English Art Club: 'It might be hung between a Meissonier and an Israels without eclipse.'

4 P.H. Rathbone, 'The Autumn Exhibition of Pictures', *University College Magazine*, Liverpool, 1886, p. 292. Rathbone dominated the Liverpool Autumn Exhibitions, and the Walker Art Gallery where they were held; see Edward Morris, 'Philip Henry Rathbone and the Purchase of Contemporary Foreign Paintings for the Walker Art Gallery, Liverpool', *Annual Report and Bulletin of the Walker Art Gallery*, Liverpool, 1975–6, vol. 6, pp. 59–81. He was probably largely responsible for the purchase of WAG 2364 by the Walker Art Gallery, although Clausen was on the hanging committee for the 1886 Liverpool Autumn Exhibition, and may also have urged its purchase. At that Liverpool Autumn Exhibition, WAG 2364 and some other paintings by artists associated with the New English Art Club were hung together in one room, known as the New English Art Movement Room or the Marlborough Room – after the name of the London gallery in which the New English Art Club held their first exhibition; *Off to the Fishing Ground* by Stanhope Forbes (see p. **147**) hung in the same room and was also purchased in that year for the Walker Art Gallery. Brown was not a well-known artist in 1886 and the purchase of WAG 2364 was a bold and far-sighted decision; see also *Daily Bread* by T.B. Kennington (p. **241**) and *A Street in Brittany* by Stanhope Forbes (p. **144**) for other examples of this purchasing policy.

5 Mrs. Sutton, Thomas Smith's granddaughter, conversation with the compiler, 1985, and Bill Wilkinson, great-grandson of Thomas Smith, letter to the compiler, 24 June 1992.

6 The purchase of WAG 2364 gave great encouragement to the New English Art Club, as the artist was closely identified with the Club, see A. Thornton, *Fifty Years of the New English Art Club*, 1935, p. 4.

The Old Hero WAG 471

BURGESS, John Bagnold (1829–1897)
The Old Hero
WAG 471
Canvas: 86.3 × 115.2 cm
Signed: *J.B. Burgess 1893*

The review of this painting in the *Athenaeum*[1] seems to have relied on information from the artist and is therefore worth quoting in full:

Among the genre and costume pieces in which this exhibition is more than usually rich none is more attractive than Mr. Burgess's characteristic contribution, The Old Hero (136) representing an incident witnessed by him during his sojourn in Spain. The scene is a street, we think in Seville, on the shady side of which a number of loungers are sitting on a bench or lolling against the wall in various well-designed and natural attitudes until the passing of an old revolutionary champion rouses their attention and calls forth their respectful salutations. The most important personage is the tall, grey-headed and grey-bearded old
man, who, lean, and erect as a soldier should be, responds to the salutations, and keeps firmly on his way, leaning on the arm of his comely daughter. The sedate but pleased expression and graceful air are excellent points sympathetically conceived and ably designed to increase our interest in a capital picture, which, especially because it shows more than usual firmness of touch and crisp handling – qualities not always conspicuous in the secondary figures and accessories of the compositions – we are inclined to rank with the best of Mr. Burgess's productions. It has agreeable colouring in the well-harmonised red, grey, and brown which the painter affects, thus adopting the traditions of the Spanish school.

REPR: *Royal Academy Pictures*, 1893, p. 7; H. Blackburn, *Academy Notes*, 1893, p. 53; Black and White, *Handbook to the Royal Academy*, 1893; Pall Mall Gazette, *Pictures of 1893*, p. 51; Liverpool Autumn Exhibition catalogue, 1893, p. 54.

PROV: Bought from the artist 1893 (£210).

56

EXH: Royal Academy 1893 (136); Liverpool Autumn Exhibition 1893 (89).

1 *Athenaeum*, 29 April 1893, p. 544; the reference to the hero as 'revolutionary' is obscure, unless he was involved in the military and constitutionalist rebellion against Queen Isabella in 1868–9.

BURNE-JONES, Edward Coley
(1833–1898)

Study for the Sleeping Knights
WAG 1634
Canvas[1]: 59.6 × 82.5 cm

According to John Christian,[2] this is a study for, or an unfinished version of, the first painting (*The Prince entering the Wood*) in the first Briar Rose Series of 1870–3[3] and can be dated to about 1870.[4] It differs substantially, however, from the first painting in both the first and second Briar Rose Series[5] – the prince is not represented[6] and the poses of the sleeping knights in the Liverpool version vary very considerably both from those in the version at Puerto Rico (from the first series) and from those in the version at Buscot (from the second series). The sleeping knights are of course those who have already tried unsuccessfully to reach the sleeping princess; the prince will succeed where they failed. As for the purpose of the Liverpool version, it may have been begun as a study from the nude but then been developed by the artist (particularly with the elaboration of the background) into a possible alternative version of the composition.[7]

Study for the Sleeping Knights WAG 1634

Other drawings and studies for the first composition in the Briar Rose Series include: (1) a watercolour dated 1889 sold at Sotheby's 18 June 1985, lot 26 (not closely related to the Walker Art Gallery version); (2) a black chalk drawing, 20.5 × 44.5 cm, with Agnew's in 1970; (3) a pencil drawing of the sleeping knights with J. Maas and Co. in 1970; (4) pencil nude studies for one of the knights sold at Christie's 17 June 1975, lot 152 and at Sotheby's 26 September 1990, lot 374 – the former is now in the Walker Art Gallery, inv. 8979; (5) a sketchbook in the Fitzwilliam Museum, Cambridge, inv. 1991b; (6) sketches in the Fitzwilliam Museum and in York City Art Gallery;[8] (7) an unfinished canvas of 1869 sold at Christie's 27 November 1987, lot 143, differing considerably in composition both from the Liverpool *Sleeping Knights* and from the corresponding versions in the two series. The artist made many studies of armour for the Briar Rose Series and also intensively studied specimens of wild roses collected for the purpose.[9]

PROV: The artist's executors' sale, Christie's 16 July 1898, lot 73, bought Wise (£84). Anon sale, Christie's 2 December 1905, lot 124, bought Sampson (£23.2s.). Presented by J.G. Legge 1914.

1 Stretcher stamped: *W. MORRILL/LINER* and incised *Mr. B. Jones 71.*

2 Arts Council of Great Britain, *Burne-Jones*, 1975, no. 178.

3 The three paintings from this first series are now in the Museum of Art, Ponce, Puerto Rico. According to Edward Burne-Jones, *List of my Designs, Drawings and Pictures* (MS Fitzwilliam Museum, Cambridge), this first series was begun in 1871 and completed in 1873. The subject was derived from Perrault's *Sleeping Beauty* of 1742 and from Tennyson's poem, *The Day Dream*, of 1842. The fairy tale was first used by Burne-Jones for a set of titles made by Morris, Marshall, Faulkner and Co. in 1864 as an overmantel for Birket Foster's house, The Hill, at Witley in Surrey. There is an extended analysis of both series in M. Harrison and W. Waters, *Burne-Jones*, 1973, pp. 149–53, and a definitive account of their creation in the Julian Hartnoll exhibition catalogue of 1988: *The Reproductive Engravings after Sir Edward Coley Burne-Jones with notes on each picture by John Christian*, pp. 42–5. The political

and sexual significance of the series is explored in K. Powell, 'Edward Burne-Jones and the Legend of the Briar Rose', *Journal of Pre-Raphaelite Studies*, 1986, vol. 6, pp. 15 ff.; she suggests that the knights in WAG 1634 have their backs arched and heads thrown back in attitudes of erotic pleasure and that the models for them were Mary Zambaco, Jane Morris and the artist's wife.

4 The Rome exhibition catalogue of 1986, pp. 161–2 (*Burne-Jones dal preraffaellismo al simbolismo*, Galleria Nazionale d'Arte Moderna) argues that WAG 1634 must date from just after the artist's Italian trip of 1871 as its style seems to depend heavily on Signorelli and Michelangelo.

5 The second Briar Rose Series is now at Buscot Park, Berkshire. E. Burne-Jones, *op. cit.*, states that the first painting in the second series was begun in the autumn of 1884 and completed in 1885.

6 For an ingenious but unconvincing explanation of the absence of the prince in WAG 1634, see L.D. Lutchmansingh, 'Fantasy and Arrested Desire in Edward Burne-Jones's Briar Rose Series', in *Pre-Raphaelites Reviewed*, ed. M. Pointon, 1989, pp. 123 ff.; Lutchmansingh sees WAG 1634 as a preparatory study, not as an alternative version.

7 As suggested in the Rome 1986 catalogue, see note 4. P. Burne-Jones, 'Notes on some Unfinished Works of Sir Edward Burne-Jones', *Magazine of Art*, 1900, pp. 159 ff., gives a detailed account of the artist's use of preliminary studies and sketches but does not assist over this problem. Perhaps more plausibly, John Christian describes WAG 1634 as an intermediate stage between the unfinished painting of 1869 and the first painting in the 1871–3 series, with the artist gradually evolving new poses for the sleeping knights (Julian Hartnoll 1988 exhibition catalogue, p. 42 – see note 3).

8 According to Powell, *op. cit.*, p. 23; the figures in the sketches are female.

9 Georgiana Burne-Jones, *Memorials of Edward Burne-Jones*, 1904, vol. 2, pp. 144–5. All these studies, however, seem to relate to the second series.

Auto da Fé – Spain in the Middle Ages WAG 2743

BURTON, William Shakespeare
(1824 or 1826–1916)
Auto da Fé – Spain in the Middle Ages[1]
WAG 2743
Canvas[2]: 112.3 × 143.5 cm
Signed: *W S B*
Inscribed: *JUSTITIA ET MISERICORDIA*

The artist[3] contributed this explanation of the subject: 'A condemned heretic being prepared for taking her place, with others, in the ecclesiastical and military procession through the streets to the place of execution; the Holy Inquisition having declared her guilty of heresy, and condemned her to be burnt alive.'

Bate discusses Burton's late religious and symbolist paintings,[4] noting that this painting 'is a very noteworthy picture, as strong in drawing as in sentiment'. Its date is not entirely clear; Bate, writing in 1899, describes it as recent, and it seems to have been first exhibited in 1897, but the MS label on the back bears the date 1893.[5]

The 16th–19th-century imagery of the *auto da Fé* – as seen both by Protestants and by Catholics – is analysed by Bethencourt;[6] Burton probably used one of these sources – in particular for his *sanbenito* (or 'costume of infamy'). One of the artist's daughters was apparently the model for the head of the condemned woman.[7]

REPR: Liverpool Autumn Exhibition catalogue, 1899, p. 107; Percy Bate, *The English Pre-Raphaelite Painters*, 1899, opp. p. 82. E.R. Dibdin, 'William Shakespeare Burton', *Magazine of Art*, 1899, p. 292.

59

PROV: Mrs. Burton (?);[8] Mrs. Silvester;[9] purchased from Wallis and Son (The French Gallery) 1915 (£25).

EXH: Earls Court, *Victorian Era Exhibition*, 1897 (141); Liverpool Autumn Exhibition 1899 (1121).[10]

1 This is the title published in the Liverpool Autumn Exhibition catalogue, 1899. An MS label on the back of WAG 2743 gives this title: *For Conscience's sake / preparing for the procession / of an Auto-da-Fé*. Percy Bate, *The English Pre-Raphaelite Painters*, 1899, p. 82, gives yet another alternative title: *Faithful unto Death*, while E.R. Dibdin, 'William Shakespeare Burton', *Magazine of Art*, 1899, p. 295, suggests *The Heretic* as the title of WAG 2743. At the Earls Court exhibition of 1897 (see above), WAG 2743 was entitled: *Faithful unto Death (Auto da Fé)*.

2 Winsor and Newton canvas stamp.

3 Liverpool Autumn Exhibition catalogue, 1899, no. 1121. He contributed a more detailed explanation to the Earls Court 1897 *Victorian Era Exhibition* catalogue:

 In the Auto da Fé procession of the condemned to the place of execution, those about to be burnt alive had to wear a san benito covered with forked flames shooting upwards, together with grotesque figures of demons. The Coroza was painted in a similar manner. 'Justitia et Misericordia' was the motto of the Holy Inquisition.

 Dibdin, *op. cit.*, described WAG 2743 as 'a moving illustration of old-time methods of conversion (now, happily, disallowed)'. The artist must have known J.E. Millais's *The Escape of a Heretic, 1559*, painted in 1857; Millais too had researched the costume and methods of the Spanish Inquisition; see J.G. Millais, *The Life and Letters of Sir John E. Millais*, 1900, vol. 1, pp. 319–20; Millais's picture is now in the Museo de Arte de Ponce, Puerto Rico, but a small version is in the Forbes Magazine Collection; for this small version and for Millais's anti-Catholicism, see Christopher Forbes, *The Royal Academy Revisited*, 1975, p. 106, no. 45; Burton's costume for the heretic is very similar to that used by Millais.

4 Bate, *op. cit.*; the juxtaposition of the lily and the flaming torch and of the pike and the crucifix, for example, presumably have symbolical significance. M.H. Spielmann, *The Times*,

7 February 1916, stated that the artist sent him a manuscript autobiography, which can perhaps be located among the Spielmann papers.

5 Bate, *op. cit.* The label gives the artist's address as Bradenham House, Bognor, Sussex; Kelly's Sussex Directories list him at that address between 1886 and 1899, but the 1878 and 1903 editions do not mention him; for his Bognor studio and contacts there with D.G. Rossetti, see Gerard Young, *History of Bognor*, 1983, p. 164 (R.J. Huse, letter to the compiler, 13 April 1987).

6 Francisco Bethencourt, 'The Auto da Fé: Ritual and Imagery', *Journal of the Warburg and Courtauld Institutes*, 1992, vol. 55, pp. 155–68.

7 Dibdin, *op. cit.*; he noted that his daughter's love 'contributed not a little to the happiness of the painter's later life'; a drawing of a woman apparently bound to a stake is reproduced by Dibdin, *op. cit.*, p. 294; it is described as a study from 'the painter's daughter', but does not correspond with the female figure in WAG 2743.

8 Bate, *op. cit.*, p. x, reproduced WAG 2743 by permission of Mrs. Burton, presumably the artist's wife; WAG 2743 was lent by the artist to the 1897 Earls Court exhibition, and was for sale at the 1899 Liverpool Autumn Exhibition, price £525.

9 A letter of Wallis and Son dated 28 September 1915 states that they acquired WAG 2743 from the trustees of a Mrs. Silvester, who was related to the artist and lived in Melbury Road; she died before 2 February 1914.

10 It seems almost certain that WAG 2743 was shown at this exhibition, but the dimensions are given in the catalogue as 15 × 21 in.

CALDERON, Philip Hermogenes (1833–1898)

'Her Eyes are with her Heart and that is far away'

WAG 196
Canvas[1]: 92.1 × 64.7 cm
Signed: *P.H. Calderon 1875* (in monogram)

This painting is listed in the artist's MS List of Paintings[2] under 1875. The title is a misquota-

tion from Byron's *Childe Harold*, canto 4, stanza 141.[3]

The *Art Journal* critic found the figure 'exquisitely drawn' and 'most poetic in idea'.[4] Calderon's *Spring-time* of 1896[5] also contained a single female figure in a classical dress surrounded by a dark romantic landscape.

A quarter-size watercolour replica of WAG 196 was in the collection of J.C. Bowring;[6] this was presumably the version shown at the Dudley Gallery watercolours exhibition of 1876 (312).

REPR: *Illustrated London News*, 3 November 1894, p. 565.

PROV: Bought by George Holt 1875 (£350);[7] bequeathed by Emma Holt 1944.

EXH: Liverpool Autumn Exhibition 1875 (106);[8] Guildhall Art Gallery 1894 (30).

1 According to the artist's MS List of Paintings (Anon sale, Sotheby's 6 February 1973, lot 325, now owned by Mr. Jeremy Maas) WAG 196 was 'painted on the raw or unprepared side of a canvas first in turpentine then with Roberson's Medium'.

2 See note 1.

3 Byron was, in fact, referring to the *Dying Gaul* or *Dying Gladiator*, a classical statue in the Capitoline Museum, Rome. Lawrence Alma-Tadema later used a similar misquotation from these lines of Byron as the title for a painting of 1897; his picture, last recorded at Sotheby's 21 June 1988, lot 29, also depicted a contemplative female figure.

4 *Art Journal*, 1875, p. 350.

5 Christie's 2 February 1979, lot 116. This painting illustrated a verse from the *Song of Solomon*.

6 The artist's MS List of Paintings (see note 1).

7 The artist's MS List of Paintings (see note 1) gives a price of £332.10*s*. against the entry for WAG 196; £350 is the price quoted in the Liverpool Autumn Exhibition catalogue.

8 The artist's MS List of Paintings (see note 1) implies that WAG 196 was first shown at this exhibition; the *Art Journal*, 1875, p. 350, similarly suggests that WAG 196 was painted especially for the 1875 Liverpool Autumn Exhibition.

'Her Eyes are with her Heart and that is far away'
WAG 196

Ruth and Naomi

WAG 114
Canvas[1]: 166.2 × 207.6 cm

Naomi is returning to her native land from Moab and is trying to dissuade her two daughters-in-law, Ruth and Orpah, both Moabite women, from accompanying her; Orpah, the figure on the right, stays behind in Moab, but Ruth, the central figure, insists on going with Naomi.[2] The pinkish tone was intended by the artist to represent the early morning of a hot day; the plant at the extreme left was supposed to be a prickly pear and in the distance are olive trees.[3]

Ruth and Naomi was reasonably well reviewed when first exhibited in 1886; however, inaccuracies in the representation of Old

Ruth and Naomi WAG 114

Testament figures and landscape were criticized by the *Art Journal*;[4] *The Times*[5] disliked Calderon's colours and execution; his landscape was found wanting by the *Illustrated London News*[6] and by the *Athenaeum*;[7] on the other hand, the figures, particularly Ruth, were praised by the *Illustrated London News*[8] and the *Athenaeum*.[9] The critic of the *Spectator*[10] was, however, devastating and deserves to be quoted:

It is our friend the conventional long-robed, sacred figure picture, with an Eastern landscape painted somewhere in the Hampstead Road, and from its own point of view, very well painted too. It is very clean, very bright, and very inoffensive, save to those who try and think whether these folk and their surroundings could ever have looked like this. And for those who

think of the matter from that point of view, all the prettiness and all the dexterity of the work go for nothing; it is essentially trivial in its main conception, and incomplete in its details; nor can one accept from a technical point of view its smooth, slab brushwork as good painting, its thin brightness as good colour, or its conventional arrangement as good composition. Well drawn from the Academic point of view and suitable for reproduction in some colour form, is the best word we can say for this picture.

Nevertheless, the popular plebiscite organized by the *Pall Mall Gazette* to identify the best religious picture at the 1886 Royal Academy named *Ruth and Naomi* as the winner.[11] The critics did not seem to see in it any general vindication of family ties over racial origins and there seems to be no reason for attributing

any such motives to the artist.

A copy, apparently by John Bernard Munns, was sold at Sotheby's (Belgravia) 22 September 1981, lot 266. J. Warrington Wood exhibited a marble group representing exactly the same subject (reproduced in H. Blackburn, *Academy Notes*, 1884, p. 77 and now in the Walker Art Gallery) at the 1884 Royal Academy, while Calderon showed *Ruth* at the 1897 Royal Academy (reproduced in *Royal Academy Pictures*, 1897, p. 67); it was a half-length figure not related to WAG 114.

REPR: H. Blackburn, *Academy Notes*, 1886, p. 18; Pall Mall Gazette, *Pictures of 1886*, p. 11; Royal Academy of Arts, *Official Illustrated Catalogue*, 1886, plate 2.

PROV: Purchased from the artist 1886 (£800).[12]

EXH: Royal Academy 1886 (21); Liverpool Autumn Exhibition 1886 (1040).

1 'All painted with Siccatif de Harlem [sic]' – according to the artist in the List of Paintings (MS sold Sotheby's 6 February 1973, lot 325, now owned by Mr. Jeremy Maas). See the *Portfolio*, 1875, p. 15, 'Technical Notes' (on Calderon): 'He gave up the use of copal in 1859, and since then has used the well-known foreign dryer Siccatif de Harlem from a belief that it is firmer than megilp.'

2 Ruth 1:16 was quoted in the Royal Academy catalogue, 1886, no. 21. The scene in WAG 114 is described in the artist's List of Paintings (see note 1); in this list WAG 114 appears as painted in 1886.

3 The artist's List of Paintings (see note 1); Colonel Yule wrote to the *Athenaeum* (12 June 1886, p. 788) to say that the prickly pear (*Opuntia ficus indica*) was introduced into Europe and Asia from America by the Spaniards and so was an anachronism in WAG 114. Dr. John Edmondson kindly confirmed this (letter to the compiler, 30 October 1985).

4 *Art Journal*, 1886, p. 185.

5 *The Times*, 1 May 1886. The *Portfolio*, 1886, p. 123, described the colour harmony in WAG 114 as based 'on the principle of some Oriental decoration'.

6 *Illustrated London News*, 8 May 1886, p. 480.

7 *Athenaeum*, 8 May 1886, p. 620.

8 *Illustrated London News*, op. cit.

9 *Athenaeum*, op. cit.

10 *Spectator*, 29 May 1886, p. 719. George Bernard Shaw in the *World*, 5 May 1886, p. 522 also detected a St John's Wood origin for WAG 114: 'No one, seeing her, need complain of having to turn his back on the salmon-coloured radiance of Mr. P.H. Calderon's "Ruth and Naomi", an Oriental scene which bears the stamp of the N.W. postal district in every touch.'

11 *Art Journal*, 1886, p. 320.

12 P.H. Rathbone, who dominated the Walker Art Gallery in the 1880s, contributed a review of WAG 114 to the *University College Magazine* (Liverpool), 1886, p. 288; Calderon's work, he wrote, 'is generally instinct with a depth of feeling and richness of humanity which are gifts of genius and which no education can give'.

CHARLES, James (1851–1906)
Spring Blossom at Ambersham[1]
WAG 855
Canvas: 56.4 × 53.5 cm
Signed: *JC* (in monogram)

Ambersham is very near to Graffham where H.H. La Thangue, Charles's close friend, lived from 1898 until 1926; this painting may therefore have been painted while Charles was staying with La Thangue and probably dates from after 1898. Charles's later works are often undated but *On a Sussex Farm* and *The Picnic* at the Warrington Art Gallery and Museum are both dated 1904 and are similar in style to *Spring Blossom at Ambersham* (and indeed to *In the Garden*, see below).

REPR: T. Martin Wood, 'The Paintings of James Charles', *Studio*, 1907, vol. 40, p. 49.

PROV: Bought by Mr. McKay from the Leicester Galleries 1907;[2] presented by the executors of Miss Dalziel McKay 1947.

EXH: Leicester Galleries, *Remaining Works of the late James Charles*, 1907 (39).

1 This title is derived from the 1907 Leicester Galleries catalogue (see Exhibited); WAG 855 has an old MS label confirming that it was no. 39 at that exhibition.

2 MS label on the back of WAG 855.

In the Garden

WAG 9789
Canvas: 37 × 54.5 cm
Signed: *J. Charles* (initials in monogram)

Like *Spring Blossom at Ambersham* (see above), *In the Garden* probably dates from about 1904.[1]

PROV: John Maddocks[2] sale, Christie's 30 April 1910, lot 17, as *Gathering Cabbages*, 13½ × 21 in.,

Spring Blossom at Ambersham WAG 855
(colour plate 1)

In the Garden WAG 9789

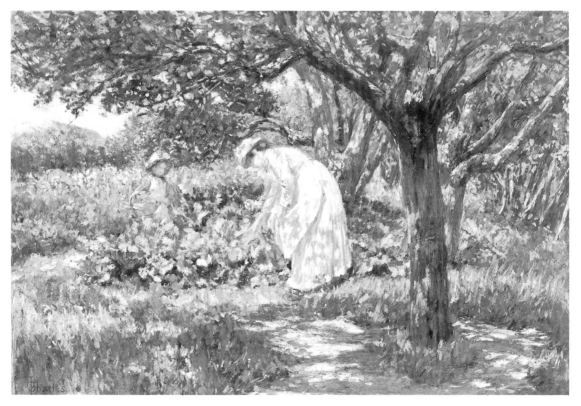

bought Agnew (£60.18s.); sold to E.A. Kolp, 31 January 1911. Bequeathed by the Countess of Sefton 1980.

EXH: Manchester City Art Gallery, *Paintings and Drawings by James Charles, George Sheffield, William Stott and D.A. Williamson*, 1912 (44), lent by E.A. Kolp Esq.

1 Butler Wood, 'The Maddocks Collection at Bradford', *Magazine of Art*, 1891, pp. 298 ff., 337 ff. does not mention WAG 9789, nor does it appear in the 1891 Bradford Public Art Museum, *Exhibition*, where much of Maddocks's collection was displayed; so WAG 9789 probably dates from after 1891.

2 Wood (*op. cit.*, p. 303) states that Maddocks usually purchased directly from artists rather than from other collectors or dealers; the 1891 Bradford catalogue lists some seventy paintings by Charles owned by Maddocks.

CLACY, Ellen (active 1872–1916)
The Old Poacher
WAG 1785
Canvas: 84.5 × 119.4 cm
Signed: *E. Clacy 1885*

The artist wrote a long letter to the Curator of the Walker Art Gallery in 1913 explaining the origin of *The Old Poacher*.[1] The model for the painting was a poacher called John, whom the artist met accidentally in a carpenter's shop of northern England. She was very struck by his appearance and the pose in which she first saw him. The poacher sat for her, retaining this pose, and this painting was the result. One of his arms had been shot off by a gamekeeper; ferrets were in his pocket and his lurcher sat at his feet. The carpenter gave the artist details about John; he was the illegitimate son of a gentleman but was concerned only with his freedom and his sport; he was now somewhat disillusioned; he was widely respected in the neighbourhood and his poaching fines were paid by the local gentry; he was an expert on

The Old Poacher WAG 1785

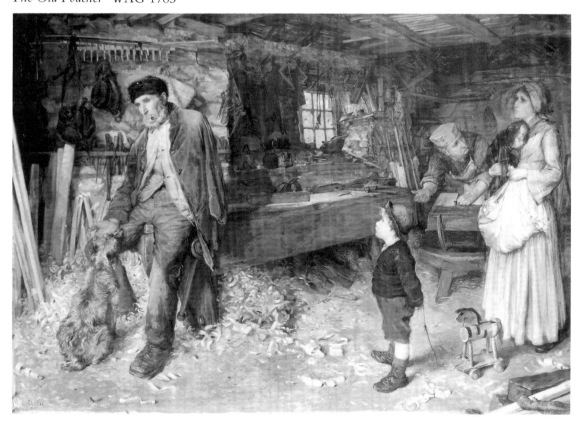

65

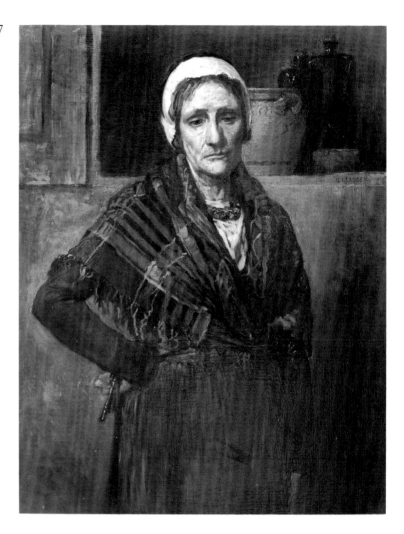

natural history. In *The Old Poacher* the carpenter in the background seems to be telling the poacher's story to the woman, just as in reality the north country carpenter gave John's history to the artist.

The critic of the *Athenaeum*[2] rather patronizingly praised the 'well considered spontaneous and expressive design'; he noted that the painting was 'cleverly but rather conventionally than spiritedly painted and the lighting lacks brightness; otherwise it is first rate'.

PROV: Bought from the artist 1885 (£100).

EXH: Royal Academy 1885 (415) as *Will Myers, Ratcatcher and Poacher*;[3] Liverpool Autumn Exhibition 1885 (18) with the same title.

1 Dated 4 May 1913 and now in the Gallery files.

2 *Athenaeum*, 10 May 1885, p. 765.

3 Will Myers was not his real name; this title – and indeed the composition – was no doubt intended by the artist to suggest that she was simply recording a local personality as he habitually appeared in his usual setting. Deborah Cherry (*Painting Women*, 1993, p. 168) notes that Ellen Clacy's language is that of a metropolitan tourist undertaking research and studies for her paintings in a distant and underdeveloped part of the country rather in the manner of a journalist or social scientist.

CLAUSEN, George (1852–1944)
Woman with a Key
WAG 1787
Canvas: 91.7 × 71.5 cm
Signed: *G. CLAUSEN*

This painting seems to be closely related to the untraced *Woman making Tea*[1] of 1881. Kenneth McConkey dates it to 1879–80;[2] Dr. R.J. Clausen, the artist's son, to a Dutch trip of the early 1870s.[3] The head-dress and shawl of the woman are Dutch in type, but it is not possible to date them or give them a more precise location; Clausen brought Dutch costume and furniture back to London after his many excursions to Holland of 1874–80 and was very free in his use of Dutch motifs, so the date of this painting must remain very uncertain.[4]

PROV: Bequeathed by George Audley 1932.[5]

EXH: (?) Royal Society of British Artists 1878–9 (6) as *Poor Old Woman* (£36.15s.).

1 Photograph in Witt Library.

2 Letter to the compiler, 8 June 1984.

3 Letter to the compiler, 25 February 1966; Clausen seems to have first visited Holland in 1874 and exhibited Dutch subjects until 1883 (Bradford Art Galleries, *Sir George Clausen*, 1980, p. 15).

4 Ms drs Jorien Jas, letter to the compiler, 25 March 1993. For more details of Clausen in Holland see Zuiderzee Museum, Enkhuizen, *Vreemde Gasten, Kunstschilders in Volendam 1880–1914*, 1986, pp. 8–9. He seems to have spent most of his time in Marken and Volendam.

5 Not in his *Collection of Pictures* (1923) so presumably acquired by him between 1923 and 1932.

A Straw Plaiter WAG 649 (colour plate 2)

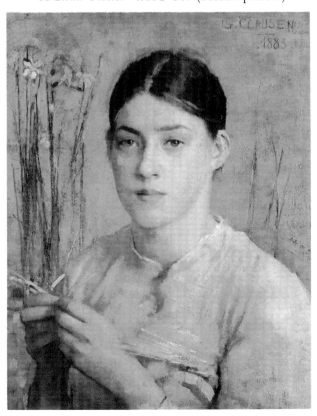

A Straw Plaiter
WAG 649
Canvas: 49.5 × 40.5 cm
Signed: *G. CLAUSEN 1883*

This painting was probably painted at St. Albans or Childwick Green,[1] where the artist settled in 1880; his wife, Agnes, exhibited a watercolour *Straw Plaiter* at the 1882–3 Royal Society of British Artists exhibition (638)[2] and a *Straw Plaiter, St. Albans* was painted in watercolour by Mrs. Allingham in 1880.[3]

Straw-plaiting was a Hertfordshire speciality and particularly strong in the St. Albans area; the work was primarily undertaken by women, and each area, sometimes each village, produced a special type of straw plait; in 1861, 603 men and 8598 women were engaged in the Hertfordshire straw-plaiting industry; it subsequently declined, largely due to foreign imports, and by 1914 had reached virtual extinction. The plaits were made into hats in the factories of St. Albans and Luton.[4]

PROV: Presented by George Audley 1925.[5]

EXH: Liverpool Autumn Exhibition 1924 (339).

1 Dr. R. J. Clausen, letter to the compiler, 25 February 1966. Negatives of some twenty-six photographs taken by Clausen at Childwick Green are now in the Royal Photographic Society. (M.E.R.L. neg. nos. 35/6951–6976); some show female farm labour but none is closely related to WAG 649.

2 In 1966 it was still in the family collection (Clausen, *op. cit.*); it showed an old lady plaiting straw in a cottage interior.

3 H.D. Rodee, *Scenes of Rural and Urban Poverty in Victorian Painting 1850–1890*, 1975, p. 100.

4 Victoria County History, *Hertfordshire*, 1914, vol. 4, pp. 251–6.

5 Not in his *Collection of Pictures* (1923), so presumably acquired by him between 1923 and 1925.

The Shepherdess

WAG 434
Canvas: 64.7 × 46 cm
Signed: *G. CLAUSEN 1885*

According to Dr. R.J. Clausen, *The Shepherdess* was painted at Cookham Dean, Berkshire;[1] the artist had rented Grove House in that village in May 1885;[2] the picture was completed by 22 June 1885.[3] The model was perhaps Polly Baldwin, the nursery maid to the artist's family, who also appeared in other paintings by Clausen.[4] There are two other oil studies of the same orchard by Clausen, one in the National Museum of Wales, dated 1885, the other in the Usher Art Gallery, Lincoln, undated but presumably also painted in 1885.[5] The drawing made for the illustration of the Walker Art Gallery painting – in the *Pall Mall Gazette* of 1886 – is now in the Royal Academy.[6] The composition and handling is very similar to that in Clausen's *In the Orchard* of 1881 (Salford Art Gallery).[7]

At the New English Art Club, the *Magazine of Art* found *The Shepherdess* 'veracious and forcible'.[8] When it was exhibited at Bradford in 1891, Butler Wood, writing in the same magazine,[9] described it as 'an admirable specimen of Mr. Clausen's best manner' displaying 'feeling and atmosphere'; 'his colour scheme', Wood continued, 'is simple yet satisfactory and skilfully elaborated. The girl's figure is modelled with almost sculpturesque strength, and the face painted with that ruddy glow of health which he is so clever in rendering.' The painting owes some debt to the work of Jules Bastien-Lepage, which Clausen first saw at the Grosvenor Gallery in 1880, particularly in the brushwork, the shallow foreground field in which the figure stands and the ambiguities of space and perspective.[10]

REPR: Pall Mall Gazette, *Pictures of 1886*, p. 72.

PROV: Acquired by John Maddocks in 1885;[11] his sale, Christie's 30 April 1910, lot 34, bought Harris (£71.8s.). Bequeathed by George Audley 1932.[12]

EXH: New English Art Club 1886 (43); Bradford Public Art Museum, *Exhibition*, 1891 (50); Bradford Art Galleries, *Sir George Clausen*, 1980 (38).

1 R.J. Clausen, letter to the compiler, 25 February 1966.

2 Bradford Art Galleries, *Sir George Clausen*, 1980, p. 33.

3 Artist's MS Account Book, Royal Academy; the compiler is indebted to Kenneth McConkey for this reference.

4 Clausen, *op. cit.*; she died in 1958; see Bradford Art Galleries, *op. cit.*, pp. 44 and 54 for further details; she would have been either twelve or fourteen in 1885 – her exact date of birth is not known.

5 Bradford Art Galleries, *op. cit.*, pp. 42–3, nos. 40 and 41.

6 Bradford Art Galleries, *op. cit.*, p. 42, no. 39. WAG 434 was reproduced in the Pall Mall Gazette, *Pictures of 1886*, p. 72.

7 Bradford Art Galleries, *op. cit.*, p. 34, no. 23a. *In the Orchard* was bought from the artist by C.J. Galloway before 1892, see *Catalogue of Paintings and Drawings collected by C.J. Galloway*, 1892, no. 209 (repr.); Maddocks also appears to have owned this painting (lot 35 in his sale of 30 April 1910) as well as WAG 434, although his ownership is not mentioned in the Bradford Art Galleries catalogue.

The Shepherdess WAG 434

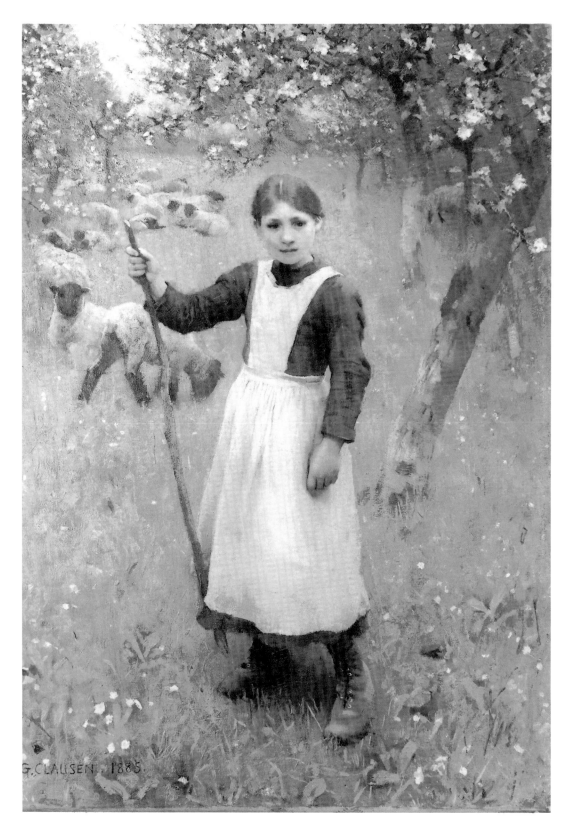

8 *Magazine of Art*, 1886, p. xxx. The *Saturday Review*, 17 April 1886, p. 705, described WAG 434 as 'true and forcible, and much more elegant than usual'.

9 Butler Wood, 'The Maddocks Collection at Bradford', II, *Magazine of Art*, 1891, p. 338 (repr.). By 1891 Maddocks owned eleven paintings by Clausen.

10 K. McConkey, 'The Bouguereau of the Naturalists; Bastien-Lepage and British Art', *Art History*, 1978, vol. 1, p. 377. McConkey singles out WAG 434 as especially influenced by Bastien-Lepage; to the compiler this influence does not seem to be as overwhelming in WAG 434 as McConkey suggests.

11 See note 3; WAG 434 was sent to Maddocks by Clausen on 22 June 1885 and the price was £50.

12 Not in his *Collection of Pictures* (1923), so presumably acquired by him between 1923 and 1932.

Mrs. Herbert Roberts, later Lady Clwyd

WAG 10679
Canvas[1]: 107 × 84 cm
Signed: *G. Clausen 1894*

The sitter (died 1951) was born Hannah Rushton Caine, the daughter of William Sproston Caine (1842–1903). By 1891 Caine[2] had already acquired three works by Clausen and in 1893 he asked the artist to paint his daughter who, in the same year, married J. Herbert Roberts, later the first Baron Clwyd; sittings began in London on 7 November and by August 1894 the portrait was finished and paid

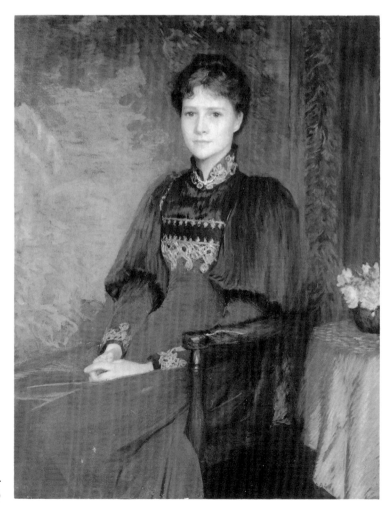

Mrs. Herbert Roberts, later Lady Clwyd WAG 10679

for by the sitter's husband.[3] Mr. and Mrs. Roberts entertained Clausen frequently at their home, Bryngwenallt, near Abergele and in 1898 they bought his painting *The Harrow*.[4]

Portraiture was not Clausen's first concern in the 1890s, but this portrait was well reviewed at the 1895 Royal Academy. George Moore[5] began his review of the exhibition with a discussion of it:

In the first room you'll find a charming portrait by Mr. George Clausen, Mrs. Herbert Roberts. Strange, but no one would know it was a Clausen. It looks more like a Fantin Latour than anything else. So much for the experts who pretend they can distinguish with unerring accuracy between the slightest works of the old masters. No expert would know this picture was a Clausen. But that by the way. A pretty little woman, too, is Mrs. Herbert Roberts, a calm, demure little person dressed in a quiet mouse-coloured dress; her hands are in her lap, a pale tapestry is behind her, and a few red flowers are in a bowl on the table beside her. We seem to know Mrs. Herbert Roberts; she looks like one of our friends, her pretty, open face, her fair, wavy hair, as portrayed by Mr. Clausen, are unforgettable. I like the intimacy of this portrait; we seem to see into the very heart of her life; into her very mind, and so it charms us, as the large satin draperies of Mr. Sargent and Mr. Shannon never have done . . . Manet would have stopped to look at this portrait, and it would not surprise me if this portrait started a fashion for intimate portraiture. For surely the dressmaker-portraits have about run their course.

PROV: By descent to John Trevor Roberts, second Baron Clwyd, who bequeathed it 1987.

EXH: Royal Academy 1895 (57)

1 Canvas stamp: *L. CORNELISSEN AND SON / 22 GT QUEEN ST / LONDON W.C.* and printed label of The Rowley Gallery, Frame makers, Gilders, Colourmen, 115 Kensington Church Street, London W.8.

2 For a long biography of Caine, a Liverpool iron merchant and Radical politician, see B. Guiness Orchard, *Liverpool's Legion of Honour*, 1893, pp. 223–7. His taste in art seems to have been very eclectic; he owned William Davis's *The Rainbow*, now in the Walker Art Gallery, and his first collection was sold at Foster's 21 May 1873; many of his paintings are still owned by his descendants. Caine's biographer, John Newton, wrote that he admired Impressionism 'in the limited sense of the thoroughness, say, of Clausen's later work' (*W.S. Caine M.P.*, 1907, p. 40).

3 Bradford Art Galleries, *Sir George Clausen*, 1980, no. 78.

4 Bradford Art Galleries, *op. cit.*

5 The *Speaker*, 11 May 1895, pp. 515–16. Other reviews appeared in the *Graphic*, 1 June 1895, p. 649; *Magazine of Art*, 1895, p. 323; *Spectator*, 1 June 1895, p. 753 (by D.S. MacColl) and *The Times*, 18 May 1895, p. 17; they were largely favourable and some are quoted in Bradford Art Galleries, *op. cit.*

Kitty

WAG 648
Canvas: 44 × 36.2 cm
Signed: *G. CLAUSEN*

The sitter is Katherine Frances Clausen (1886–1936), the artist's second daughter; she studied art at the Regent Street Polytechnic, at

Kitty WAG 648

the St. John's Wood Art School and at the Royal Academy Schools; she exhibited at the Royal Academy in the 1920s; in 1928 she married the Irish adventurer Conor O'Brien.[1] Portraits of her by Clausen include one of 1892,[2] one of 1893 owned by P.G. Clausen,[3] one of 1902 formerly owned by W. Marchant and Co.[4] and an undated portrait formerly owned by Mrs. F.A. Girling;[5] portraits of her by Clausen were exhibited in 1898, 1904, 1910 and 1925.[6]

Katherine Clausen seems here to be about fourteen years old, giving the picture a date around 1900.

PROV: Charles Thomas Taylor and T. Stephenson sale, Brown and Brown's (Liverpool) 18 November 1925, lot 61 (£9.9s.); presented by George Audley 1925.

EXH: Liverpool Autumn Exhibition 1926 (277).

1 Bradford Art Galleries, *Sir George Clausen*, 1980, p. 58, no. 67; Dr. R.J. Clausen, son of the artist, letter to the compiler, 25 February 1966.

2 Anon sale, Christie's 11 June 1909, lot 230, 23½ × 19½ in.; bought Willis (£94.10s.).

3 Bradford Art Galleries, *op. cit.*, 7⅞ × 6 in.

4 Photograph in the Witt Library, London, and reproduction in Charles Holme, *Representative Art of our Time*, 1903, p. 50; this was presumably the *Kitty*, catalogue no. 13 at Clausen's Goupil Gallery exhibition of 1902; Clausen's 1902 Account Book has this entry for 29 October: 'Marchant bought pictures of Kitty for one hundred pounds' – the compiler is indebted to Kenneth McConkey for this reference.

5 Sotheby's 13 March 1974, lot 26, 14 × 9 in.

6 Goupil Gallery, *Selected Works by Painters of the English, French and Dutch Schools*, 1898 (48); Goupil Gallery, *George Clausen*, November–December 1904 (49); International Society of Sculptors, Painters and Gravers, *Third Exhibition of Fair Women*, 1910 (56); Royal Academy, 1925 (510) as *Little Kitty*.

The Golden Barn

WAG 1808
Canvas: 123.2 × 108 cm
Signed: *G. CLAUSEN 1901*[1]

This is one of a series of paintings of barn interiors dating from about 1897 until around 1921 – although *Watson's Barn*, now in the Art Gallery of New South Wales (inv. 781), is as late as 1931 (but is in a very different style). An undated *Golden Barn* at Rochdale Art Gallery is very close to the Walker Art Gallery painting; the figure at the back of the barn in the Liverpool version is very similar to the figure in Clausen's *The Farmer's Boy* of 1895.[2] There is a squared-up compositional drawing for the Liverpool *Golden Barn* at the Walker Art Gallery (WAG 6496), and there are three drawings at the Bristol City Art Gallery for the left-hand figure scooping grain (K 2697–K 2699). The barn depicted is more likely to be Markwell's Farm, Widdington, than Deer's Farm, Clavering, where the artist also worked.[3]

The Golden Barn was well received by the critics – apart from D.S. MacColl,[4] who described it as a half success and a respectable effort: 'Mr. Clausen hatching at the dusty lights in a barn'. Frank Rinder in the *Art Journal*[5] wrote:

The timber roof is haunted with luminous shadow; the light that gains ingress, whether through the gap beneath the eaves to the left or elsewhere, is sensitively controlled; this raftered structure, from whose floor the bending lad with red neckerchief gathers the grain of gold and green, is full of atmosphere, of the poetry that issues when form and colour are harmoniously blent. It is a reticent, a good Clausen.

The *Athenaeum* critic[6] was rather less enthusiastic, and observed that:

Whatever the artist's shortcomings, he is intensely sincere in his poetic feeling about certain aspects of country life, and his work gives evidence of serious research. 'The Golden Barn' is a theme he has treated before, but we think this is the best arrangement of the effect he has found. The lines of the great beams in the foreground, lit by the grey light which streams in from the door, give a sense of dignity and vastness to the composition, and the poses of the figures are admirably chosen.

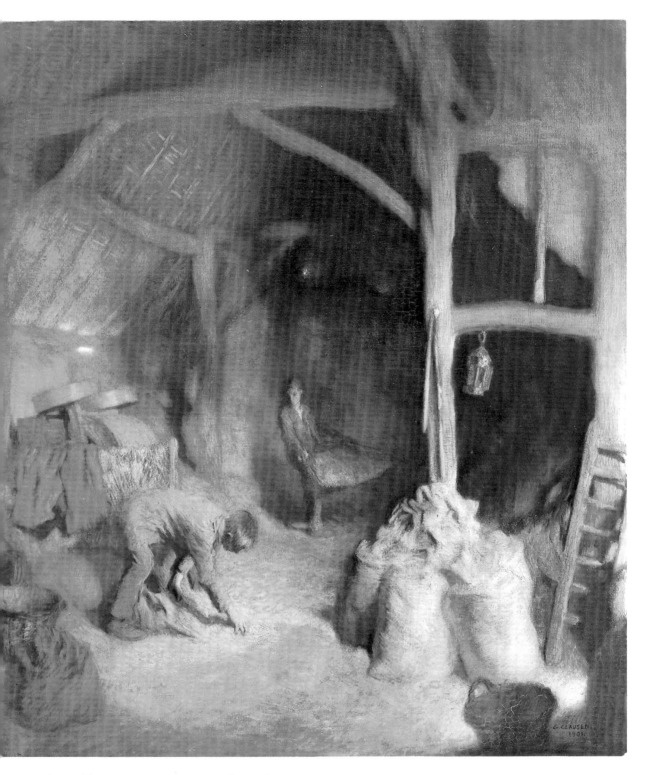

The Golden Barn WAG 1808 (colour plate 3)

REPR: Magazine of Art, *Royal Academy Pictures*, 1901, p. 3; *Academy Notes*, 1901, p. 42; *Art Journal*, 1901, p. 165; Pall Mall Gazette, *Pictures of 1901*, p. 57; Art Journal, *Academy Pictures*, 1901, p. 16.

PROV: Bought by W. Hamo Thornycroft 4 March 1904;[7] offered by him to the Walker Art Gallery in 1925 for £600;[8] bought by George Audley (£525); presented by him 1925.

EXH: Royal Academy 1901 (57) priced at £400;[9] Manchester City Art Gallery, *Autumn Exhibition*, 1901 (105) priced at £350; Royal Glasgow Institute of the Fine Arts 1902 (77) priced at £350; Munich, *Secession*, 1903; Berlin, *Schultze Gallery*, 1903;[10] Liverpool Autumn Exhibition 1925 (963); Bradford Art Galleries, *Sir George Clausen*, 1980 (90).

1 The back of the canvas is inscribed: *THE GOLDEN BARN G. CLAUSEN 1901.*

2 For the Rochdale picture see Bradford Art Galleries, *Sir George Clausen*, 1980, no. 91 (repr.). As WAG 1808 was exhibited at the Royal Academy in the year in which it was painted, the Rochdale version is likely to be later. Three paintings of barn interiors, all quite different from WAG 1808, are reproduced in *George Clausen*, ed. A. Rutherston, 1923, plates 1, 9 and 24. The 1895 *The Farmer's Boy* is reproduced in *Magazine of Art*, 1895, p. 234.

3 Dr. R.J. Clausen, the artist's son, letter to the compiler, 25 February 1966; the artist lived at Widdington, Essex, from 1891 until 1905.

4 *Saturday Review*, 18 May 1901, p. 632.

5 *Art Journal*, 1901, p. 165. *The Times*, 24 May 1901, also commented favourably on Clausen's command of atmosphere.

6 *Athenaeum*, 18 May 1901, p. 636.

7 W. Hamo Thornycroft, letter to the compiler, 7 May 1925 and the artist's MS Account Book, Royal Academy, entry for 4 March 1904: 'Recd. from Thornycroft £50 for *The Golden Barn*'; this was perhaps just a down payment. The compiler is indebted to Kenneth McConkey for this reference. Thornycroft and Clausen were both, in very different ways, pioneers in the representation of agricultural labour on a heroic scale.

8 Henry Cole wrote on 26 May 1925 that he was 'doubtful if the Committee will agree to the Clausen picture'; Audley bought it to secure it for the Walker Art Gallery.

9 Artist's MS Account Book, 5 April 1901; see note 7.

10 Artist's MS Account Book, 31 August 1903; see note 7.

CLAY, Alfred Borron (1831–1868)
Charles IX and the French Court on the Morning of the Massacre of St. Bartholomew
WAG 2508
Canvas: 135 × 203 cm
Signed: *Alfred B. Clay 1864.5*

The 1865 Royal Academy catalogue contained this explanation of the events in this painting:

The king would gladly have stopped the massacre; but he was withheld by the entreaties of Catherine de Medicis, the endearments of Marie Touchet, and the arguments of Cardinal Guise, with such success, that he was at last prevailed on to fire on the fugitive Huguenots as they endeavoured to gain the bridges that crossed the Seine . . . The Queen of Navarre had nearly fallen a victim in the general slaughter, had she not been borne by a captain of the guard to the apartments of the Duchess of Orleans; while her husband, Henri of Navarre, as well as the Prince of Condé, could only deem themselves safe by remaining in the immediate vicinity of Charles and the Queen Mother.

Agrippa d'Aubigné and the Abbé de Brantôme asserted that during the massacre of St. Bartholomew on 24 August 1572, Charles IX fired from a window in the Louvre on the fleeing Huguenots in the Seine; during the French Revolution a plaque with an inscription to this effect was placed near one of the windows of the Petite Galerie.[1]

Of the figures in Clay's painting, Charles IX can be identified holding the arquebus; Cardinal Guise of Lorraine is the tall figure in ecclesiastical dress; Catherine de Medici stands next to him on his left; perhaps his mistress, Marie Touchet, is the woman pointing out of the window at, presumably, the unfortunate Huguenots.

F.T. Palgrave[2] reviewed the picture at the Royal Academy sympathetically:

A name new to us in this style ['semi-historical'] is that of Mr. Clay. In his large interior, The French Court watching the Massacre of Saint Bartholomew, *the artist appears to have introduced more material than he could successfully penetrate with the dramatic intensity of the moment, but there is evidence of much pains and unaffected grasp of attitude, although the work is hung too high for seeing how the heads are painted. The figures stand back in a row from the opened window, through which comes the uproar of the massacre; a lady's pet-dog smells a stain of blood on the floor in suspicious contiguity to Cardinal Guise – a well-imagined incident.*

The *Art Journal*[3] was, however, less kind:

The faults we have pointed out in [HAYLLAR'S] Queen Elizabeth's Toothache *[polished evenness of execution destructive of emphasis; lack of concentration of composition; colours killing adjoining colours] are to be lamented over just as much in an otherwise clever picture,* Charles IX and the French Court on the Morning of the Massacre of St. Bartholomew. *This work, like the last, has forfeited a right to the line, because in composition, colour, light and shade, it is without governing intent.*

The *Reader*[4] was equally scathing, describing the painting as 'represented as if all the actors had been drilled to the performance of their parts by a stage manager'.

PROV: William Cottrill sale, Christie's 25 April 1873, lot 277, bought Earl (£288.15s.). W.J. Alt sale, Christie's 2 March 1878, lot 125, bought in (£168). Presented by Samuel Henry Thompson 1884.

EXH: Royal Academy 1865 (365).

1 See Christine Aulanier, *Histoire du Palais et du Musée du Louvre: Le Pavillon du Roi*, n.d., pp. 25–7, and *La Petite Galerie*, n.d., pp. 11–14. In fact, the Petite Galerie had not even been built by 1572 and if in fact Charles IX fired the shot, it must have been from one of the windows in the Pavillon du Roi blocked up in the 17th century. The events surrounding the king's action were popularized in the 19th century by Prosper Mérimée's *Chronique du règne de Charles IX*, 1832 (translated into English in 1853) and by Giacomo Meyerbeer's opera *Les Huguenots*, 1836, Act V; the precise source used by Clay has not been traced. P.H. Calderon had contributed *The British Embassy in Paris on the Day of the Massacre of St. Bartholomew* to the 1863 Royal Academy (378).

2 *Saturday Review*, 27 May 1865, p. 636, reprinted in *Essays on Art*, 1866, pp. 103–4.

3 *Art Journal*, 1865, p. 164.

4 *Reader*, 27 May 1865, p. 606.

COBBETT, Edward John (1815–1899)

A Country Lane

WAG 475
Board: 41 × 50.9 cm

PROV: Presented by the artist to Philip Westcott 2 July 1845;[1] presented by Philip Westcott to the Liverpool Academy 1846;[2] presented by the Liverpool Academy to the Liverpool Town Council 1851;[3] transferred to the Walker Art Gallery 1948.

1 Old inscription on the back of WAG 475; Philip Westcott was a Liverpool picture restorer and portrait painter; he was a member of the Liverpool Academy of Arts and was treasurer from 1847 until 1853.

2 Liverpool Academy, *Minutes of Proceedings*, 5 June 1846.

3 The ownership of the Liverpool Academy's so-called Diploma pictures has caused much confusion. In 1851 the Liverpool Town Council intended to take over the Liverpool Royal Institution's collection of paintings and sculptures to create a new permanent municipal art gallery. The Liverpool Academy presented its Diploma pictures to this new proposed gallery at its meeting of 14 April 1851 (*Minutes of Proceedings*). However, negotiations between the Royal Institution and the Town Council collapsed and the new permanent municipal art gallery was, in practice, not formed until the Walker Art Gallery opened in 1877. But the Liverpool Academy clearly intended to give its pictures to the Town Council on 14 April 1851; their proceedings on that date make this certain and at their meeting on 23 December 1853 (*Minutes of Proceedings*) – after the breakdown of the negotiations for the new permanent gallery – they again referred to their gift to the Town Council. Despite this, however, the Liverpool Royal Institution catalogues of 1851 (p. 29) and 1859 (p. 72) stated that the pictures had been presented to the Royal Institution and this claim was even repeated in the Walker Art Gallery, *Catalogue of the Roscoe Collection*, 1928, pp. 21, 26, 30, 31, 32, 44, 45 and 52. More recently it has been claimed that since the proposed 1851 permanent gallery was never created, the gift of that year was legally void and the pictures remained with the Academy.

Women carrying Heather

WAG 6660
Canvas: 65.5 × 105 cm
Signed: *E.J. Cobbett 1855*

Reviewing this painting at the 1856 Royal Society of British Artists' exhibition, the *Art Journal*[1] critic wrote: 'Those who are thus moving homeward are a group of cottage children laden with fern. The figures are distinguished by much sweetness and simplicity.'

A Country Lane WAG 475

Women carrying Heather
WAG 6660

The Showman WAG 1458

The *Athenaeum*[2] reviewer noted that Cobbett's painting was only a furniture picture, but 'an advance on former works' so far as Cobbett was concerned.

PROV: Presented by G.C. Schwabe to the Liverpool City Museums; transferred to the Walker Art Gallery 1968.

EXH: (?) Royal Society of British Artists 1856 (479) as *Home through the Heather.*

1 *Art Journal*, 1856, p. 136.

2 *Athenaeum*, 29 March 1856, p. 396.

The Showman

WAG 1458
Canvas: 76.5 × 102.4 cm
Signed: *E.J. Cobbett 1855*

PROV: Walter Thompson[1] sale, J.F. Griffiths (Liverpool) 28 March 1860, lot 31 as *The Peep Show in the Village*, bought Walker (£120.15s.); presented by Colonel W. Hall Walker (later Lord Wavertree) 1913.

1 There is an Agnew's Manchester label on the back of WAG 1458, indicating that this firm may have owned the picture before 1860.

On the Arun WAG 165

COLE, George Vicat (1833–1893)
On the Arun
WAG 165
Canvas: 55 × 89 cm
Signed: *Vicat Cole 1865*

The River Arun in Sussex was a favourite subject for the artist; this is one of his first paintings of the river.[1]

PROV: Presented by George Audley 1925.[2]

1 If indeed WAG 165 does represent the River Arun. According to Portsmouth City Museum and Art Gallery, *The Cole Family*, 1988, p. 92, Cole's 'intensive work on the Arun' began in the late 1860s; Robert Chignell, *Life and Paintings of Vicat Cole R.A.*, 1898, vol. 1, pp. 103 ff., includes many Arun scenes from 1869 onwards.

2 George Audley, *Collection of Pictures*, 1923, p. 6.

Abinger, near Dorking
WAG 197
Canvas[1]: 50.4 × 75.8 cm
Signed: *1877* with monogram

Abinger church is just visible and the lane below the cornfield is Abinger Lane; the most prominent of the hills on the right is probably Holmbury Hill.[2] The artist began working around Abinger in the summer of 1859 and often returned there; by the 1860s he had already become well known for his cornfields.[3]

Abinger had first been popularized as a sketching ground in 1853 by J.C. Hook and Richard Redgrave; Vicat Cole, G.P. Boyce and (rather later) B.W. Leader followed their example; the scenery was similar to that of the area around Barbizon in France.[4]

PROV: Bought from the artist by Agnew's 28 September 1877; sold to George Holt 6 October 1877 (£288.15*s.*); bequeathed by Emma Holt 1945.

1 Canvas stamp: *Prepared by Winsor and Newton, Rathbone Place.*

2 Reverend John Venus, letter to the compiler, 18 May 1988.

3 Robert Chignell, *Life and Paintings of Vicat Cole R.A.*, 1898, vol. 1, pp. 66, 68, 69 and Portsmouth City Museum and Art Gallery, *The Cole Family*, 1988, p. 75.

4 See particularly, P. Brandon, 'Wealden Nature and the Role of London in Nineteenth-Century Artistic Imagination', *Journal of Historical Geography*, 1984, vol. 10, p. 59.

COOKE, Edward William (1811–1880)
Dutch Boats beating into the Scheldt[1]
WAG 319
Canvas: 43.2 × 53.5 cm

The flag on the foreground ship is Dutch (blue/white/red) and John Munday[2] notes the evident influence in this painting of Dutch 17th to 18th-century marine painting, characteristic of Cooke's early work. He identifies the two ships in the background on the left as 18th-century in type.

Dutch Boats beating into the Scheldt WAG 319

PROV: Purchased by George Holt Senior from the Liverpool Academy Exhibition 1842 (£31.10s.);[3] George Holt;[4] bequeathed by Emma Holt 1944.[5]

EXH: Liverpool Academy 1842 (25).

1 This is the title given to the painting in the artist's MS Register of his works, now in the Royal Academy Library (p. 10).

2 John Munday, letters to the compiler, 16 November and 9 December 1964.

3 The original invoice of 27 December 1842, issued by the Liverpool Academy to George Holt Senior, is now among the R.D. Holt Papers in the Liverpool City Libraries. The artist's Register, *op. cit.*, reveals that he had to pay £1.1s. commission back to the Academy. George Holt Senior and the artist were personal friends; they dined together on 17 October 1849 at Holt's house in Liverpool and Holt also bought Cooke's *Egremont on Sea, North Coast of Holland* from the 1844 Liverpool

Academy (John Munday, letters to the compiler, 22 October and 9 December 1964, relying on the artist's unpublished diaries).

4 George Holt Junior listed WAG 319 simply as a *Sea Piece* inherited from his father (MS Catalogue of his paintings).

5 WAG 319 was not listed in the formal bequest but seems to have passed to the Walker Art Gallery with all the other Holt pictures in 1945.

Breaming a Calais Lugger at Low Water
WAG 2744
Board: 45 × 61 cm
Signed: *E.W. Cooke 1848*

This was painted at Barnes, where the artist lived until 1849.[1] 'Breaming' involved first cleaning the bottom of a ship (removing weeds

and shells by burning reeds under it to soften the pitch) and then re-coating it with tar to render it watertight; the artist had a particular interest in maritime procedures and technology of this type. Cooke's painting[2] depicts the main channel of Calais harbour from the south towards the north. The two jetties are visible, the western one at the left with Fort Rouge and the eastern one at the right. In the foreground on the left is Fort Risban. The ship is aground on the bank known as 'de la baleine'. Cooke's *Calais from the Sea* (1839) is in the Calais Museum.[3]

PROV: Purchased from the Liverpool Academy 1849 exhibition by the Academy Council with their Art Union Prize (£25);[4] presented by the Liverpool Academy to the Liverpool Town Council 1851;[5] transferred to the Walker Art Gallery 1948.

EXH: Liverpool Academy 1849 (13).

1 The artist's MS Register of his works, now in the Royal Academy Library. The painting was completed on 17 July 1848 (John Munday, letter to the compiler, 17 February 1989, relying on the artist's unpublished diaries).

2 All the topographical details are derived from a letter to the compiler dated 28 February 1989 from Patrick Le Nouene.

3 Cooke had connections with France particularly through his friendship with T.S. Boys and this may explain his views of Calais, through which he must have frequently travelled; see M. Pointon, *The Bonington Circle*, 1985, pp. 131 ff.

4 Liverpool Academy, *Minutes of Proceedings*, January 1850. The artist's MS Register, *op. cit.*, confirms the amount.

5 Liverpool Academy, *Minutes of Proceedings*, 14 April 1851; for further details see p. **76** under Cobbett.

Breaming a Calais Lugger at Low Water
WAG 2744

Venetian Fishing Craft (Bragozzi) caught in a 'Borasca' in the Adriatic, off Fort St. Andrea

WAG 1795
Canvas[1]: 88.3 × 139.4 cm
Signed: *E.W. Cooke RA 1873*

This was painted at the artist's home, Glen Andred, Groomsbridge, in 1873.[2] A *borasca* or *burasca* is a violent and sudden squall frequent in the Mediterranean. Fort St. Andrea is on the island of Le Vignole overlooking the Porto di Lido and guards the main entrance into the Venetian Lagoon from the Adriatic. It was built by Sanmicheli in 1543. The artist painted a very similar subject in 1856: *Chioggian fishing vessels, etc. running into the Lagune of Venice on the approach of a borasco or violent squall on the Adriatic* (now in the Mariner's Museum, Newport News, Virginia). The *bragozzo* was in origin an Adriatic fishing vessel found in Chioggia; it had a flat bottom, a high prow, a large deep rudder and one or two masts; it was also famous for its painted multi-coloured sails.[3] The *bragozzi* in both paintings by Cooke have the elaborate *pinella* or masthead vane representing subjects from the Crucifixion[4] and were painted with great accuracy in every detail.[5]

Few reviewers at the 1873 Royal Academy noticed Cooke's painting, but the *Athenaeum*[6] observed:

The conscientious workmanship of Mr. E.W. Cooke is honourable to him, however far it may be from satisfying the requirements of art proper. His Venetian Fishing Craft (Bragozzi) caught in a 'Borasca' in the Adriatic, off Fort St. Andrea, *besides possessing a title which is half as long again as it ought to be, is elaborate without being artistic, and even without being faithful to nature in colour or in atmospheric effect; for Mr. Cooke will never persuade any one that waves resemble these combinations of iron with ice, or that Italy, except in his eyes, has skies like painted iron. Nevertheless, as a design, there is not a little 'go' in this work: the large luggers, with the painted sails, which Mr. Cooke, and Turner before him, have so often painted, their almost Dutch build, are fairly represented here, with the well-filled sails, the nets hoisted high out of the water and swaying against the mast. In fact, the whole gives a sense of motion which is not common.*

A pastel with exactly the same title as the Walker Art Gallery painting, but signed and

Venetian Fishing Craft (Bragozzi) caught in a 'Borasca' in the Adriatic, off Fort St. Andrea WAG 1795

dated 1869 and measuring 16.5 × 25.5 cm, was sold at Christie's on 18 September 1979, lot 236. A photograph of an unlocated sketch for the composition – apparently in ink or pencil – has recently been discovered.[7]

PROV: Bought from the artist by Agnew's 4 April 1873; sold to H.A. Brassey 9 April 1873 (£787.10s.); his sale, Christie's 23 February 1901, lot 140, bought Lister (£231). Presented by Colonel R. Montgomery 1906.

EXH: Royal Academy 1873 (310).

1 Canvas stamp: W. Eatwell, Dorset Street. The artist's MS Register of his works, now in the Royal Academy Library, lists the frame maker as Guillet, whom Cooke normally used at this period.

2 The artist's Register, *op. cit.*

3 For further details, see Mario Marzari, *Il Bragozzo*, 1982, and the same author's 'Vecchie Barche Adriatiche', *Rivista Marittima*, Rome, 1984; the compiler is indebted to John Munday

for these references. Horatio Brown's *Life on the Lagoons*, 1884, also contains much information on bragozzi, but Cooke could not have known the author, who first arrived in Venice in 1879.

4 A long description of the *pinella* in the artist's hand survives, and a photocopy was kindly supplied by John Munday, letter to the compiler, 17 February 1989.

5 John Ruskin commended the accuracy of Cooke's representations of Venetian fishing boats in his later works (see Ruskin's *Works*, ed. Cook and Wedderburn, 1904, vol. 13, p. 163). Cooke was very attracted by boats which conspicuously displayed local pecularities of design, construction and decoration – see for example his *Bay of Tangier* in the Salford Museum and Art Gallery.

6 *Athenaeum*, 24 May 1873, p. 666.

7 John Munday, letter to the compiler, 18 October 1994.

82

COPE, Charles West (1811–1890)

Osteria di Campagna between Rome and Ancona: Vettura Travellers Repast; German Pedestrian Students in the Background

WAG 1809
Canvas: 105.5 × 173.4 cm
Signed: *C W Cope fec 1838*

The artist moved into 1 Russell Place, Fitzroy Square, London in 1836–7 and wrote in his memoirs:[1] 'Here I painted some of my best pictures: "The Osteria", a recollection of Italian travels, in which Miss Kiallmark sat for the principal female, I sold to Mr. Villebois of Benham for 150 guineas, to me at that time a large sum.' Miss Kiallmark was the sister of his landlord.

The artist did not identify which inn he used for this painting but, like most English visitors to Italy of the period, he relied on Mariana Starke's guidebooks. She recommended the following establishments on the road between Rome and Ancona:[2] (1) the Post House at Macerata; (2) La Posta at Spoleto; (3) La Posta and the Hotel d'Europe at Terni; (4) La Croce Bianca at Civita Castellana; (5) La Posta at Foligno. The Vettura travellers will have arrived together by coach; German students in Italy in the early 19th century were notoriously poor[3] and so arrived on foot.

Anna Jameson[4] noted that Cope's picture was 'very dramatically treated, with much character and truth, and painted in a rich and lively tone of colour', but other reviewers were more interested in the subject-matter. The critic of the *Athenaeum*[5] wrote:

The humours of this resting-place for travellers – where English magnificos, and German burschen, and travelling friars, and wandering minstrels, are assembled – are touched with a firm but a fine hand: the work is eminently picturesque without nature being strained one hair's breadth. We know not whether to prefer the little lady, charmed by the music of the vagabonds, and looking at the dark-eyed child who approaches her for reward, with a sweet but grave curiosity, or the pair who are making the melody, – the woman with her piquant gipsy-like head-dress (we know the very tune she is singing), and the man who stands behind her, with eyes upraised, poor and profligate though he seem, having, in his look and

Osteria di Campagna between Rome and Ancona: Vettura Travellers Repast; German Pedestrian Students in the Background WAG 1809

figure, an echo of the improvisatore and artist of ancient Italy. Then there are, in the background, the fair-haired jovial troop of Teutonic pedestrians, in their comfortable blouses, with their eternal pipes, jingling their glasses in noisy good fellowship, – but it may be, in their freedom of untrimmed beards and familiar speeches, no less affected and theatrical than the English youth, who stares about him lack-a-daisically through his glass – and who, though true to nature, intrudes disagreeably upon the scene. We returned to this delightful picture more than once. Mr. Cope need but advance a little farther, to become one of the most distinguished ornaments of modern British art.

In a similar vein, the reviewer in the *Literary Gazette*[6] recorded:

Sometimes classic, sometimes familiar, the paintings of this able artist always claim attention, not more for their skilful execution than for their admirable development of character. The present scene exhibits a great variety of national temperament, in which we are sorry to say the wrangling and disputatious disposition of our own countrymen, when in foreign lands, is but too painfully prominent, and is rendered still more so by the social bearing of the German students who are carousing in the background.

An Italian Hostelry of 1849 by Robert McInnes is in the Glasgow Art Gallery and Museum. McInnes, however, was more interested in the staff and their activities than in the guests.

PROV: Sold by the artist to Mr. Villebois of Benham (£157.10s.); Mrs. Villebois; Anon sale,[7] Christie's 12–14 May 1860, lot 99, bought Flatow (£131.5s.). Presented by Thomas Harding 1878.

EXH: Royal Academy 1838 (386);[8] Manchester, *Art Treasures Exhibition*, 1857 (316).[9]

1 C.W. Cope, *Reminiscences*, ed. C.H. Cope, 1891, p. 121; the editor added that this painting was eventually acquired by the Walker Art Gallery, indicating that it must indeed be WAG 1809; in the list of Cope's works published as an appendix to this book (pp. 376–7) the editor states that WAG 1809 might have been painted in 1836 or 1838, indicating that it may have been begun as early as 1836.

2 Mariana Starke, *Information and Directions for Travellers on the Continent*, 1829, pp. 397–9 and *Travels in Europe*, 1833, pp. 599–600.

3 See F. Noack, *Das Deutschtum in Rom seit dem Ausgang des Mittelalters*, 1927, vol. 1, pp. 498–500.

4 'The Exhibition of the Royal Academy', *Monthly Chronicle*, June 1838, pp. 348 ff.

5 *Athenaeum*, 1838, p. 347.

6 *Literary Gazette*, 26 May 1838, p. 329.

7 According to the *Athenaeum*, 19 May 1860, p. 691, the vendor was Mr. Briscoe of Wolverhampton.

8 Where it 'hung under the line in the first room' (Cope, *op. cit.*, p. 377).

9 Lent by Mrs. Villebois.

Yes or No?

WAG 1145
Panel[1]: 76.8 × 63.5 cm
Signed: *CWC* (in monogram) *1872*

The artist[2] described *Yes or No?* as 'a girl kneeling at a table in doubt what answer to

Yes or No? WAG 1145

return to a "proposal"' – that is a proposal of marriage.

The critic of the *Athenaeum*[3] wrote:

Mr. Cope contributes a design which is more successful than his scriptural picture, Yes or No?, *a modern young lady, half-kneeling, half-sitting – so we read the attitude – but the drapery on her limbs is not explicit enough to enable us to settle the point: however this may be, she is certainly writing a letter at a desk; a messenger appears at an open doorway. The effect of bright daylight is rendered with much truth, and his treatment of the accessories is so pleasant that it goes far towards redeeming the obscurity of the drawing. The flesh is bright, but suffers from an excess of needless yellow.*

PROV: Sold by the artist to Evans Lees of Wood-field, Oldham.[4] Presented by George Audley 1925.

EXH: Royal Academy 1873 (175).

1 Label on back of panel: Charles Roberson and Co., Artist's Colourman, 99 Long Acre, London.

2 C.W. Cope, *Reminiscences*, ed. C.H. Cope, 1891, p. 276.

3 *Athenaeum*, 24 May 1873, p. 666.

4 Cope, *op. cit.*, p. 387.

COTMAN, Frederick George (1850–1920)
One of the Family
WAG 1029
Canvas: 102.6 × 170.2 cm
Signed: *F.G. Cotman 1880*

The artist's grandson[1] wrote in 1967:

On one of my many visits to my grandmother, the artist's widow, between 1920 and 1930, I once wrote down a number of things she told me concerning some of grandfather's pictures. Pointing to a book called The Hundred Best British Artists *in which* One of the Family *was illustrated, she told me that the little boy on the right of the picture was my father. The picture was painted at the Black Boy Inn at Hurley on Thames, and the inn keeper, a Mr. Street by name, was also a miller, and that is him hanging up the horse's harness. His wife is the young good looking woman on the right, and her mother, the old*

One of the Family WAG 1029

85

lady, was a German. 'The poor old dear drowned herself. Very sad'. You may notice that, being a German, she is cutting the bread for the family in the continental way. The children are Mrs. Street's children. 'The horse always used to come to the doorway every day just like that'. 'You see that pie there', pointing to the lovely looking pie on the table, 'artists are sometimes dilatory people and a made pie would not last, so I wondered what to do. A bright idea came to me – I stuffed it with coke and that's what it's full of'. I had noticed that the cut portion was turned away from view in the picture.

This was the first important painting by Cotman to be acquired by a public institution.[2] Professional London reviewers were hostile. The Times[3] wrote:

F.G. Cotman's One of the Family, a favourite horse putting in his head over the half-hatch to a farmer's family at their meal, in which the details of the table, which in a cabinet picture might have been agreeable enough, on the scale the painter has adopted are felt to be both obtrusive and vulgar.

The Liverpool press was, however, more favourable, commenting on the cheerful sentiment and arguing that it commended good treatment for animals.[4] There is a copy in Lytham St. Anne's Town Hall; it is signed by Louise Dyson.

REPR: H. Blackburn, Academy Notes, 1880, p. 32; G.R. Halkett, Notes to the Walker Art Gallery, 1880, p. 52.

PROV: Bought from the artist 1880 (£262.10s.).

EXH: Royal Academy 1880 (304); Liverpool Autumn Exhibition 1880 (439).

1 Alec M. Cotman, letter to the compiler, 19 October 1967. However, Mr. A.A. Wymark wrote from The Black Boy, Hurley, Maidenhead on 3 August 1976, that the kitchen as it existed in 1976 did not resemble the room visible in WAG 1029.

2 Norma Watt, 'F.G. Cotman – A Man of more than ordinary Strength of Personality', Norfolk Fair, May 1984, p. 58. A.L. Baldry, 'An East Anglian Painter: Frederick George Cotman', Studio, 1909, vol. 47, pp. 167 ff., mentions WAG 1029 but is more concerned with Cotman's landscapes.

3 The Times, 28 June 1880. The Illustrated London News, 29 May 1880, p. 531, similarly found WAG 1029 'vigorously manipulated but glaring in effect, and painted on a canvas absurdly large for the subject'.

4 Porcupine, 2 October 1880, p. 426; Argus, 25 September 1880, p. 795; on 30 October 1880 (p. 869), the Argus added: 'As for Mr. Cotman's One of the Family it certainly possesses qualities to commend it to popular taste, and it conveys a lesson of kindliness to the lower animals – a circumstance that may have weighed with the Arts Committee in choosing a somewhat comonplace and illustrated-periodical sort of picture.'

CRANE, Walter (1845–1915)
The Triumph of Spring
WAG 1802
Tempera on plaster, mounted on panel:
40.3 × 147.2 cm
Signed and dated, lower left corner:
WALTER. CRANE. 1879

Between 1878 and 1880 the artist designed illustrations to a masque, The First of May by his friend J.R. Wise, which was published in 1881.[1] About the same period he was turning his attention to tempera painting. In his Reminiscences Crane noted for this period: 'I also enlarged and carried out in the same method [tempera] one of the designs in The First of May, using a wet plaster ground. This work I called "The Advent of Spring".'[2] The Walker Art Gallery's The Triumph of Spring approximates in general terms to plate XIX in the published masque, where Angelica, Queen of the Fairies, is shown drawn by four does in a triumphal car in a procession of fairies. Every detail in it is, however, entirely different, and the accompanying figures do not appear to match any of those in the masque.

Isobel Spencer[3] sees this Triumph of Spring as evidence that Crane was moving away from dependence on Italian 15th-century art towards a more mature classicism. Greg Smith[4] discusses the painting in terms of Crane's symbolic language of nature, noting that the artist held that all systems of belief depended on a 'foundation of natural mythology' and that they were in origin 'nothing but figurative systems – personifications and sym-

The Triumph of Spring WAG 1802

bols of the forces of nature'; universal art must therefore rely on 'pictorial emblem, symbol or allegory' which 'can express some sense of the great powers of nature'. Smith went on to note that Crane's symbolism was more successful in the context of decorative art than in that of easel paintings, and contemporary critics were scathing when *The Triumph of Spring* was first exhibited in 1880. The reviewer in the *Spectator*[5] wrote:

Considering the reputation and undoubted skill in design of its author the worst thing in this exhibition is a picture called 'The Triumph of Spring' by Walter Crane. This is bad in every way, the colour is harsh and ill-assorted, the painting of flesh and drapery so bad as to be beneath criticism, and the drawing and anatomy of the figures feeble, where they are not wrong.

The *Saturday Review*[6] was no kinder: 'People who have been delighted with Mr. Walter Crane's book illustrations cannot but be disappointed with his "Triumph of Spring", which is unsatisfactory alike in drawing, colour, and design.'

An earlier picture of the same subject but of different design dates from 1873.[7] P.G. Konody[8] discusses a tempera *Triumph of Spring* of 1884, apparently begun in Rome around the winter of 1882–3 and painted 'in the spirit of Mantegna'; he may have confused this painting with the Walker Art Gallery's *The Triumph of Spring*.

PROV: Bought from Lionel T. Crane 1933.

EXH: Grosvenor Gallery 1879–80 (96).

1 *The First of May, A Fairy Masque, Presented in a Series of 52 Designs by Walter Crane*, London, Henry Sotheran & Co., 1881; Walter Crane, *An Artist's Reminiscences*, 1907, pp. 204–5.

2 Crane, *op. cit.*, p. 217.

3 Isobel Spencer, *Walter Crane*, 1975, p. 75. Earlier and much less classical processional paintings included his *Coming of May* of 1873 (Sotheby's (New York) 26 May 1993, lot 91) and his *Death of the Year* of 1872 (Peter Nahum Gallery, *The Pre-Raphaelites and their Century*, 1989 (119)).

4 Whitworth Art Gallery, Manchester, *Walter Crane*, 1989, p. 14, quoting extensively from Crane's *Claims of Decorative Art*, 1892.

5 *Spectator*, 31 January 1880, p. 144.

6 *Saturday Review*, 10 January 1880, p. 51. Similarly the *Illustrated London News*, 3 January 1880, p. 22, described the painting as 'a well considered and arranged decorative design which we may call Roman Antique in style, though the figure drawing is defective'.

7 Crane, 1907, *op. cit.*, pp. 149, 150, 155. This was also a processional picture entitled *The Advent of Spring* by Crane – a title which he gave, confusingly, to WAG 1802.

8 P.G. Konody, *The Art of Walter Crane*, 1902, pp. 98, 134. The many errors in Konody's book were noted by Crane himself; see Crane, *op. cit.*, pp. 485–6.

CRESWICK, Thomas (1811–1869)

Hartlepool

WAG 214

Panel[1]: 17.8 × 25.2 cm

This was painted by Creswick from a sketch by G. Balmer for the engraving cited below. Full topographical details can be found in W. and E.F. Finden's *Views of the Ports, Harbours and Watering Places of Great Britain* of 1838 (continued by W.H. Bartlett).[2]

REPR: W. Finden, in W. and E.F. Finden's *Views of the Ports, Harbours and Watering Places of Great Britain*, published by Charles Tilt, 1837 (engraving).

PROV: Bought from Agnew's (Liverpool) by George Holt February 1888 (£50); bequeathed by Emma Holt 1944.

1 Panel stamped: *BROWN/HOLBORN.*

2 Vol. 2, pp. 93–4.

Comme Dhuv, the Black Valley, Kerry

WAG 204

Panel, painted oval[1]: 23 × 17.6 cm

Inscribed: (indistinctly) . . . *THE BLACK VALLEY* . . .

Comme Dhuv, the Black Valley, Kerry WAG 204

REPR: A. Hill in L. Ritchie, *Ireland, Picturesque and Romantic*, Heath's *Picturesque Annual*, 1838, p. 242 (engraving); A. Hill in Mr. and Mrs. S.C. Hall, *Ireland*, 1841–3, vol. 1, p. 208 (engraving); *Picturesque Scenery in Ireland*, drawn by Thomas Creswick, n.d., p. 69.

PROV: Anon. (Watson) sale, Christie's 18 June 1892, lot 68, bought Agnew (£42); bought by George Holt November 1892 with other pictures; bequeathed by Emma Holt 1944.

1 Panel stamped: *BROWN/HOLBORN*. The panel is marked around the edge for squaring up.

The Gap of Dunloe WAG 205

The Gap of Dunloe

WAG 205
Composition board, painted oval:
25.2 × 20.2 cm

REPR: S. Bradshaw in L. Ritchie, *Ireland, Picturesque and Romantic*, Heath's *Picturesque Annual*, 1838, p. 241 (engraving with considerable alterations); S. Bradshaw in Mr. and Mrs. S.C. Hall, *Ireland*, 1841–3, vol. 1, p. 206 (engraving); *Picturesque Scenery in Ireland*, drawn by Thomas Creswick, n.d., p. 67.

PROV: Probably purchased by George Holt from T.T. Lachlan, 14 Tithebarn Street, Liverpool, 1884 with WAG 206 (£50);[1] bequeathed by Emma Holt 1944.

1 MS label on back is inscribed *5622 a pr.* Agnew's Liverpool label is also on the back, but this may refer to framing.

Kilkenny Castle

WAG 206
Board, painted oval: 25.5 × 18.4 cm

REPR: R. Wallis in L. Ritchie, *Ireland, Picturesque and Romantic*, Heath's *Picturesque Annual*, 1838, p. 223 (engraving); R. Wallis in Mr. and Mrs. S.C. Hall, *Ireland*, 1841–3, vol. 2, p. 7 (engraving).

PROV: Probably purchased by George Holt from T.T. Lachlan, 14 Tithebarn Street, Liverpool 1884

Kilkenny Castle WAG 206

with WAG 205 (£50);[1] bequeathed by Emma Holt 1944.

1 MS label on back is inscribed *5692 a pr.* Agnew's Liverpool label is also on the back, but this may refer to framing.

Waterloo Bridge

WAG 207
Panel, painted oval: 22.5 × 17.5 cm
Inscribed: *Waterloo Bridge Cork/1836*

REPR: R. Wallis in L. Ritchie, *Ireland, Picturesque and Romantic*, Heath's *Picturesque Annual*, 1838, p. 258 as *Waterloo Bridge, Cork* (engraving); R. Wallis in Mr. and Mrs. S.C. Hall, *Ireland*, 1841–3, vol. 1, p. 19, as *St. Patrick's Bridge, Cork* (engraving).

PROV: Andrew G. Kurtz sale, Christie's 9 May 1891, lot 46, bought Agnew (£36.15s.) for George Holt (£38.11s.9d.); bequeathed by Emma Holt 1944.

The Lower Lough Erne

WAG 208
Panel, painted oval[1]: 22.2 × 17.5 cm

REPR: R. Wallis in L. Ritchie, *Ireland, Picturesque and Romantic*, Heath's *Picturesque Annual*, 1838 (title page) (engraving); R. Wallis in Mr. and Mrs. S.C. Hall, *Ireland*, 1841–3, vol. 3, p. 178 (engraving); *Picturesque Scenery in Ireland*, drawn by Thomas Creswick, n.d., p. 90.

PROV: Bought by George Holt from T.T. Lachlan 1886 (£65); bequeathed by Emma Holt 1944.

1 Panel stamped: *BROWN/HOLBORN.*

The five small panels described above (WAG 204–208) were presumably painted in Ireland in 1836–7 in order to be engraved in L. Ritchie's, *Ireland, Picturesque and Romantic* of 1838 – one of Heath's *Picturesque Annuals*. Ritchie's introduction (p. iv) states that the drawings for the engravings were done by Creswick on the spot; this statement probably refers to these panels, but there may also have been preliminary drawings.

Waterloo Bridge WAG 207

The Lower Lough Erne WAG 208

The Castalian Spring WAG 210

Waterfall beneath a High Bridge
WAG 209
Panel, painted oval[1]: 22.8 × 17.8 cm

PROV: Probably bought by George Holt from T.T. Lachlan, 14 Tithebarn Street, Liverpool, 1882 (£40); bequeathed by Emma Holt 1944.

1 Panel stamped: *BROWN/HOLBORN.*

Waterfall beneath a High Bridge WAG 209

The Castalian Spring
WAG 210
Panel, painted oval[1]: 22.8 × 17.7 cm

The Castalian Spring on Mount Parnassus was sacred to the Muses. Classical allusions are rare in Creswick's work; although Creswick's *Landscape with Classical Ruins* in the Victoria & Albert Museum is an Italianate landscape with figures in classical costume.
 The painting is numbered round the edge for squaring up.

PROV: Bought from Agnew's (Liverpool) by George Holt June 1886 (£25); bequeathed by Emma Holt 1944.

1 Panel stamped: *BROWN/HOLBORN.*

Wilkesbarre, Pennsylvania
WAG 211
Panel[1]: 17 × 25.1 cm

This view was painted by Creswick from a sketch by W.H. Bartlett for the engraving cited below, first published in 1838.
 Creswick does not seem to have ever visited America, but there are other American views by him in the Yale Center for British Art, New Haven (*Figures on a Balcony, Westpoint* and *View on the Hudson River*) and in the

Victoria & Albert Museum (*Mount Tom, Massachusetts*); the latter was also engraved by Willmore for Willis's *American Scenery*.[2]

REPR: J.T. Willmore in N.P. Willis, *American Scenery*, 1840, p. 134 (engraving).

PROV: David Price sale, Christie's 2 April 1892, lot 207, bought Agnew (£52.10*s.*) for George Holt (£57.15*s.*); bequeathed by Emma Holt 1944.

1 Panel inscribed: *BROWN/HOLBORN.*

2 Ronald Parkinson gave the compiler much assistance with this entry.

Moorland Scenery

WAG 1803
Canvas: 77.5 × 122 cm
Signed: *THO CRESWICK 1842*

Romantic landscapes without human presence or incident and without obvious compositional devices are rare in Creswick's work.

A long review of *Moorland Scenery* appeared in a Liverpool newspaper;[1] it is naive and uncritical and possibly intended primarily to assist the sale of the painting, but its style is typical of provincial art crticism in the first half of the 19th century:

In no. 51 we have one of Mr. Creswick's masterly landscapes, executed in bold dependence upon the powers of the pencil alone. Nothing is borrowed from nature in the way of ornament, nor from anything that art may have done in improving nature. Genius thus delights sometimes in creating difficulties for itself, for the sake of showing how easily it can overcome them. But though Mr. Creswick has chosen one of the most uninviting or even unsightly spots in nature's domain, he has shown it under one of those peculiar aspects of elementary enchantment which even desolation itself may sometimes wear, and which are the more noticed and admired on account of the general blankness of the scene: just as the charm of a smile is often more remarked in the transformation which it effects upon a plain countenance than in the added loveliness which it imparts in a handsome one. In the view before us we have a few blocks of dirty-coloured stone, standing out amidst the coarse wild verdure of a hillock which forms part of a large tract of rugged moorland scenery, the expanse beyond being unrelieved by tree, or house, or living being. But there is a gleam of sunshine passing over it, which plays along the edge of one of the rude breaks in the ground, and lights up the whole, supplying at once an object of interesting contemplation and giving character, and beauty, and poetry in the view. From such simple elements do master-minds educe the grandest effects. We must not be understood, however, as limiting the merits of the painting to this single feature. The management of the distance, the aerial keeping, and the handling of the broken clouds that are still struggling to obscure the blue firmament which their disruption has partially disclosed, indicate a talent for observing and depicting nature in all her infinite variety which challenges unqualified admiration.

Moorland Scenery WAG 1803

PROV: Bequeathed by Mrs. Margaret Harvey 1878.

EXH: British Institution 1843 (147);[2] Liverpool Academy 1843 (51).

1 *Liverpool Courier*, 20 September 1843.

2 The catalogue gives the framed dimensions as 43 × 61 in. (109 × 155 cm).

The Way across the River
WAG 1804
Canvas: 87 × 122.5 cm
Signed: *THOS CRESWICK 1843*

PROV: Bequeathed by Mrs. Margaret Harvey 1878.

EXH: British Institution 1843 (105);[1] Liverpool Academy 1843 (67).

1 The catalogue gives the framed dimensions as 48 × 62 in. (122 × 157.5 cm).

Lake Windermere
WAG 320

Llanberis Lake
WAG 321

Glendalough, Ireland
WAG 322

Lake Lucerne, Switzerland
WAG 323

Lago Maggiore, Italy
WAG 324

93

The Way across the River WAG 1804

Lake Windermere WAG 320; *Loch Katrine, Scotland* WAG 325; *Glendalough, Ireland* WAG 322;
Lake Lucerne, Switzerland WAG 323; *Llanberis Lake* WAG 321; *Lago Maggiore, Italy* WAG 324

Loch Katrine, Scotland

WAG 325
Panel[1]: each 10.1 × 15.2 cm

Barlow[2] dates *Glendalough* to 1837 and *Lago Maggiore* to 1846.

PROV: John Gibbons[3] sale, Christie's 26 May 1894, lots 10–15, bought Agnew (£136.10*s*.) for George Holt (£143.6*s*.6*d*.); bequeathed by Emma Holt 1944.

EXH: International Exhibition 1873 (1481, 1477, 1497, 1495, 1482, 1478).

1 The six lake views seem to have been first framed together for George Holt by Agnew's in 1894.

2 T.O. Barlow, *Catalogue of the Works of Thomas Creswick*, 1873, nos. 10, 19, 97, 101, 102, 103.

3 A label on the back of WAG 320–325, states that the six panels were purchased from the artist by Gibbons. They were lent to the 1873 International Exhibition by Mrs. Gibbons. John Gibbons was an important patron of Bristol School and other contemporary artists, particularly in the 1840s; see Tate Gallery, *Francis Danby*, 1988, p. 23.

Evening: 'The West yet glimmers with some Streaks of Day'[1]

WAG 215
Canvas: 97 × 127.6 cm
Signed: *T. CRESWICK 1850*

This landscape is listed by Barlow.[2]

PROV: George Holt Senior and thence by descent to Emma Holt, who bequeathed it 1944.

Evening: 'The West yet glimmers with some Streaks of Day' WAG 215

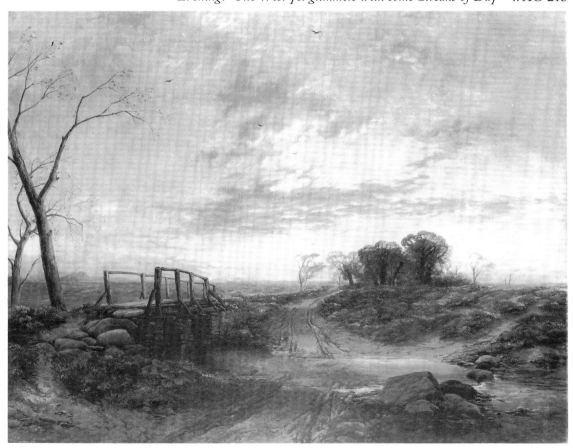

95

EXH: Liverpool Academy 1850 (142); International Exhibition 1873 (1390); Walker Art Gallery, Liverpool, *Grand Loan Exhibition*, 1886 (42) as *Landscape Evening*; Manchester, *Royal Jubilee Exhibition*, 1887 (87).

1 *Macbeth*, Act 3 Scene 3.

2 T.O. Barlow, *Catalogue of the Works of Thomas Creswick*, 1873, no. 28.

The Windmill

WAG 212
Canvas[1]: 58.9 × 89.3 cm
Signed: *T. CRESWICK*

PROV: William Cottrill (Manchester) sale, Christie's 25 April 1873, lot 211, bought Herbert (£320.5*s*.); bought from W.G. Herbert by George Holt June 1873 (£336); bequeathed by Emma Holt 1944.

EXH: Walker Art Gallery, Liverpool, *Grand Loan Exhibition*, 1886 (37).

1 Canvas stamp of J. Taylor, 15 Brazenose Street, Manchester, and stretcher incised:
W. MORRILL/Liner.

Landscape, Morning (Crossing the Stream)

WAG 213
Canvas[1]: 101.8 × 128.3 cm

The painting entitled *Crossing the Stream* at the 1863 Royal Academy exhibition is probably to be identified with the work owned by Sir Henry Thompson in 1873 and not with this painting; Sir Henry Thompson's painting measured 71 × 53.2 cm.[2]

PROV: John Marsh (Liverpool) sale, Christie's 29 April 1876, lot 130, bought Agnew (£522.10*s*.); bought from Agnew by George Holt 10 May 1876 (£606.7*s*.6*d*.); bequeathed by Emma Holt 1944.

EXH: Walker Art Gallery, Liverpool, *Grand Loan Exhibition*, 1886 (41); Glasgow International Exhibition 1888 (202).

The Windmill WAG 212

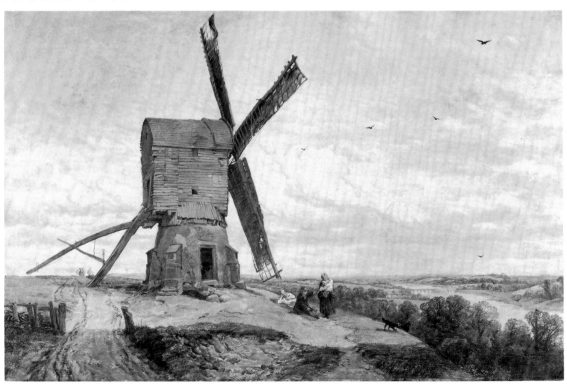

Landscape, Morning (Crossing the Stream)
WAG 213

1 Canvas stamp of Charles Roberson, Long Acre.

2 T.O. Barlow, *Catalogue of the Works of Thomas Creswick*, 1873, no. 46. The review of the 1863 Royal Academy painting in the *Athenaeum*, 16 May 1863, p. 657, indicates that it did not have the same composition as WAG 213.

CRESWICK, Thomas (1811–1869) **and ANSDELL, Richard** (1815–1885)
Forest Glade with Deer: The King of the Forest
WAG 366
Canvas[1]: 71 × 91.6 cm

Ansdell painted animals into Creswick's landscapes on a number of occasions.[2]

Forest Glade with Deer: The King of the Forest WAG 366

PROV: William Sharp sale, Christie's 9 July 1881, lot 65, bought Agnew (£630) for George Holt (£693); bequeathed by Emma Holt 1945.

EXH: Walker Art Gallery, Liverpool, *Grand Loan Exhibition*, 1886 (1189); Hulme Hall, Port Sunlight, *Art Exhibition to Celebrate the Coronation*, 1902 (82).

1 Canvas stamp of Charles Roberson, 51 Long Acre, London with *CR/488* in a box. Frame maker's label of Haywood and Son, 88 Newgate Street.

2 For example, the *Landscape with Deer (Animals by Ansdell)* lent by Mr. A. Brogden to the International Exhibition 1873 (1386); according to T.O. Barlow, *Catalogue of the Works of Thomas Creswick*, 1873, no. 35, it measured 46 × 152.5 cm. Other animal painters who collaborated with Creswick included T.S. Cooper and J.W. Bottomley.

CRESWICK, Thomas (1811–1869) and ELMORE, Alfred (1815–1881)

Dorothy Vernon's Doorway, Haddon Hall

WAG 770
Panel: 49.7 × 43.1 cm
Signed: *A ELMORE / T. CRESWICK*[1]

According to an early 19th-century tradition, Dorothy Vernon escaped in 1558 through this door and down these stairs in order to elope with Sir John Manners, second son of Thomas, first Earl of Rutland. Dorothy Vernon was co-heir of Sir George Vernon of Haddon and as a result of her marriage Haddon Hall passed to the Manners family on his death in 1567.[2]

The landscape and architecture are by Creswick with the figure by Elmore;[3] Creswick

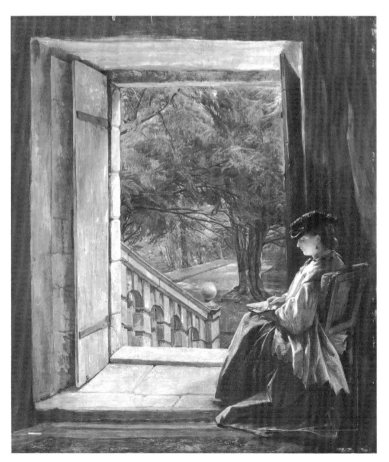

Dorothy Vernon's Doorway, Haddon Hall WAG 770

collaborated both with figure and animal painters, notably W.P. Frith, Richard Ansdell, T.S. Cooper and J.W. Bottomley.

Dorothy Vernon's Doorway is dated by Barlow to 1865[4] and the costume of the female artist broadly confirms this dating. Creswick seems to have made no attempt to exhibit or sell the painting, indicating that possibly the female figure is a portrait of one of his friends or relatives and that the painting may perhaps record a visit to Haddon Hall by the artists and their friends. Creswick exhibited a number of other Haddon Hall views in the 1840s and 1850s.

PROV: Thomas Creswick sale, Christie's 6 May 1870, lot 332, bought Fitzpatrick (£173.5s.). W. Ward. Bequeathed by George Audley 1932.[5]

EXH: International Exhibition 1873 (1368a).

1 The signatures look suspicious, but there is no reason to doubt the attribution of WAG 770 to Elmore and Creswick.

2 The marriage is fact, the elopement legend. An anonymous three volume novel of 1823, *The King of the Peak*, invented or popularized the story and *The History and Antiquities of Haddon Hall* by S. Rayner with illustrations after George Cattermole, published in 1836, promoted the visual attractions of Haddon Hall. The Hall was largely uninhabited but was maintained in the 19th century; thus it became a major tourist attraction. Henry James visited Haddon Hall in 1872 and reported that his guide considered Dorothy Vernon's doorway the major attraction of the Hall; he wrote:

As I stood in the luminous dusk weaving the romance of the spot I recognized the inevitability of a Dorothy Vernon and quite understood a Lord John. It was of course on just such an evening that the romantic event came off, and, by listening with the proper credulity, I might surely hear on the flags of the castle court ghostly footfalls and feel in their movements the old heart-beats.

(*English Hours*, ed. Lowe, 1963, p. 52). The doorway and stairs still exist and were painted by Creswick with considerable accuracy.

3 This division of labour was first recorded in the Creswick sale catalogue of 6 May 1870 (see Provenance).

4 T.O. Barlow, *Catalogue of the Works of Thomas Creswick*, 1873, no. 51.

5 George Audley, *Collection of Pictures*, 1923, p. 11, no. 31.

CROFTS, Ernest (1847–1911)
On the Evening of the Battle of Waterloo
WAG 747
Canvas: 113.7 × 226.7 cm
Signed: *E. Crofts 79*

Napoleon is leaving his carriage at Genappe as he hastens south to Paris after his defeat at Waterloo; his Guard are protecting him from the pursuing Prussians. This subject originated from the account of the taking of the carriage given by Major Eugen von Keller, the Prussian officer who captured it from the French after the battle. Keller asserted that while he and his soldiers were attacking the carriage from one side, Napoleon escaped from the other, dropping his hat, coat and sword in his rush to safety.[1] Keller's report is almost certainly untrue and was probably written to promote interest in the carriage, which he sold to the British Government, who promptly passed it on to William Bullock for display in his London Museum; in 1842 it was acquired by Mme. Tussaud for the Napoleon Room in her Museum and it remained there until it was destroyed by fire in 1925.[2] Crofts no doubt saw the carriage in her Museum[3] and he has represented it fairly faithfully in this painting. Even Keller's dramatic report does not mention Napoleon's Guard holding off the Prussians; this is the painter's own invention and is at variance with most accounts of the scene at Genappe that night, which suggest that there was little sustained resistance by any part of the French army.[4]

Crofts was the principal rival to Lady Butler as a military artist in the 1870s and he specialized in Waterloo scenes, of which the most important were *On the Morning of Waterloo* (Royal Academy, 1876, no. 1253), *Wellington's March from Quatre Bras to Waterloo* (Royal Academy, 1878, no. 609) and this painting.[5] R.A. Hillingford became another specialist in Waterloo scenes and in 1898 he painted *The Capture of Napoleon's Carriage at Genappe*,

On the Evening of the Battle of Waterloo WAG 747

which also shows Napoleon just after he had climbed out of the carriage.[6]

There are two drawings for *On the Evening of the Battle of Waterloo* in the Anne S.K. Brown Military Collection, John Hay Library, Brown University Library, Providence, Rhode Island; one relates to the figure holding the horse just to the left of Napoleon, the other to the soldier slumping downwards at the left of the row of soldiers standing at the right of the composition. Two other studies in the same collection – of a mounted soldier seen from behind – may relate to the mounted soldier at the extreme left of the painting.[7]

The critics at the 1879 Royal Academy exhibition did little more than explain the subject of Crofts's picture. The *Athenaeum*[8] complained about a 'lack of spontaneity in the design', and noted that Crofts had used the carriage then at Mme. Tussaud's Museum; the *Magazine of Art*[9] found a 'lack of expressiveness', but there was general praise for the composition and for the wealth of incident; the *Saturday Review* deplored the feebleness of the figure of Napoleon.[10]

PROV: Purchased from the artist 1879 (£630).

EXH: Royal Academy 1879 (613); Liverpool Autumn Exhibition 1879 (129); Manchester, *Royal Jubilee Exhibition*, 1887 (360).

1 See London Museum, Piccadilly, *A Description of the Military Carriage of the late Emperor of France taken on the evening of the Battle of Waterloo with the circumstances of the capture accurately described by Major Baron von Keller*, 1816, pp. 11–20. Crofts himself provided this explanation of his picture in the 1879 Royal Academy catalogue:

At Genappe, the first important defile through which the French army retired, an immense number of carriages and waggons of all kinds had been collected together, which presented a rich booty to the Prussians, but the most valuable and most interesting object consisted of Napoleon's travelling carriage, which, with all its contents, fell into the hands of the 15th Regiment. He himself had only quitted it a few minutes previously in such haste as to leave behind his hat, which was found inside. – See Siborne's 'History of the War in France and Belgium'.

In fact Siborne's account (Captain W. Siborne, *History of the War in France and Belgium in 1815*, 1844, p. 384) does not mention Napoleon's precipitate departure from his carriage, but there were no doubt many other sources for the story available to Crofts.

2 E.J. Poynter condemned the notion of realism contained in the idea that 'one should paint the flight of Napoleon from Waterloo and make the interest of the picture depend on the fact that the

coach is painted from the real original at Madame Tussaud's' (*Ten Lectures on Art*, 1879, p. 38). For detailed accounts of the taking (or more exactly the looting) of the carriage, see Anthony de la Poer, 'The Mystery of Napoleon's Waterloo Carriage', *Military Illustrated*, February 1991, pp. 14 ff., March 1991, pp. 13 ff., and Max Terrier, 'Le Landau de Napoleon', *La Revue du Louvre*, 1975, pp. 105–16, no. 2; the carriage formerly with Mme. Tussaud is reproduced by de la Poer, *op. cit.*, February 1991, p. 16; Henry Houssaye, *1815: Waterloo* (translated Mann), 1900, p. 241, was probably the last reputable historian to accept Keller's account.

3 Peter Harrington, *British Artists and War*, 1993, p. 241.

4 See particularly Siborne, *op. cit.*, and Houssaye, *op. cit.* Much earlier than Crofts's painting, however, is Sir Richard Westmacott's marble relief of about 1825 showing a yet more dramatic struggle between French and Prussian soldiers as Napoleon escapes from his carriage; the relief was intended for the Marble Arch but was never installed; ultimately it was sold at Sotheby's 12 May 1995, lot 180; see Marie Busco, *Sir Richard Westmacott*, 1994, pp. 57–62.

5 The two earlier paintings are both in the Mappin Art Gallery, Sheffield. See National Army Museum, *Lady Butler*, 1987, pp. 170–1, and Austin Chester, 'The Art of Mr. Ernest Crofts', *Windsor Magazine*, 1908–9, vol. 29, p. 468. A version of *Wellington's March from Quatre Bras to Waterloo* of 1881, was sold at Sotheby's (Belgravia) 29 June 1976, lot 120. Other Waterloo pictures by Crofts include *Napoleon at Ligny* (1875), *Near La Belle Alliance at Dawn 18 June 1815* (1902), *Napoleon and the Old Guard before Waterloo* (date unknown), *The Morning of Waterloo: Napoleon's Headquarters* (1891), *At the Farm of Mont St. Jean* (1882), *The Attack on the Chateau of Hougoumont* (1882 and 1897), *Capture of a French Battery by the 52nd (Oxfordshire Light Infantry) at Waterloo* (1896), *Wellington on the Heights of Hougoumont* (1874), *Defeat of Napoleon's Last Grand Attack at Waterloo* (1895) (Cavalry and Guards Club sale, Sotheby's 16 March 1988, lot 137). *Napoleon: The Morning of Waterloo* (1884), *Wellington: The Morning of Waterloo* (1884) and *Napoleon: The Eve of Waterloo* (1896) were all formerly in the E.A. Bennett Collection. The compiler is indebted to Mr. Peter Harrington for help in preparing this list.

6 Sold at Sotheby's 27 March 1973; reproduced in the *Connoisseur*, September 1975, pp. 50–5. See Harrington, 1993, *op. cit.*, p. 330.

7 Peter Harrington, letters to the compiler, 14 March and 5 April 1988.

8 *Athenaeum*, 17 May 1879, p. 637.

9 *Magazine of Art*, 1879, p. 245.

10 *Saturday Review*, 24 May 1879, p. 649; other reviews appeared in the *Art Journal*, 1879, pp. 173–4 and in *The Times*, 12 May 1879; *The Times* considered WAG 747 about Crofts's worst picture so far.

CROWE, Eyre (1824–1910)
The Founder of English Astronomy
WAG 1805
Canvas[1]: 76.2 × 100.3 cm
Signed: *E. Crowe*

Jeremiah Horrocks (or Horrox) (1617–1641) correctly predicted that Venus would pass in front of the sun on Sunday 24 November 1639 (old style). He observed this transit by projecting the sun's rays through a carefully positioned and focused telescope on to a piece of paper with a diameter of six inches.[2] This took place in a room within his own lodgings at Hoole, near Preston, where he was employed as curate and schoolmaster. Venus appeared on the sheet of paper as a dark round disc and he was able to make measurements of scientific importance as the disc moved across the specially ruled sheet. He had been anxiously watching his experiment as early as the day before, but had apparently been called out to take a service at the church around midday on 24 November. The transit was visible at Hoole from about 3.15 p.m. on that day. Crowe has represented him returning expectantly to his room after the service to find the transit just about to start.[3] Indeed, the artist has followed the account of the experiment in A.B. Whatton's book fairly carefully, although the projection of the sun's rays seems to have been perpendicular not horizontal, and Horrocks's return at the critical moment appears to have been the artist's invention. Crowe, however, visited Horrocks's lodgings near Hoole (Carr

101

The Founder of English Astronomy WAG 1805

House, Bretherton) in order to depict them accurately in this painting.[4]

Perhaps inevitably Crowe's composition follows fairly closely Ford Madox Brown's *Crabtree watching the Transit of Venus* of 1882–3 in the Manchester Town Hall.[5]

REPR: Pall Mall Gazette, *Pictures of 1891*, p. 82.

PROV: Presented by Charles William Jones 1891.[6]

EXH: Royal Academy 1891 (550); Liverpool Autumn Exhibition 1891 (856).

1 Frame maker's label: Smith and Uppard, Mortimer Street, London.

2 The standard account of Horrocks's experiment is in A.B. Whatton, *Memoir of the Life and Labours of Reverend Jeremiah Horrox*, 1859, pp. 44 ff. Whatton also prints Horrocks's own description

of the experiment (pp. 117 ff.). Horrocks's sheet of paper is reproduced as a diagram opposite page 122; it could be no larger due to the size of Horrocks's room. Horrocks was evidently using his telescope as a camera obscura; for this see John H. Hammond, *The Camera Obscura: A Chronicle*, 1981, pp. 21–2.

3 The artist wrote this description of his painting for the 1891 Royal Academy catalogue:

Jeremiah Horrocks, curate at Hoole, Lancashire, having attended first to his religious duties on Sunday, November 24, 1639, and after having previously prepared his instrument for the observation of the transit of Venus, returns just in time to witness the event, which he alone had correctly predicted as going to take place.

4 W.H. Watts, 'Jeremiah Horrocks and the Transit of Venus of 1639', *North Western Naturalist*, March–June 1940, p. 16. Carr House is illustrated

in Peter Fleetwood Hesketh, *Murray's Lancashire*, 1955, p. 33. It is, however, by no means certain that Horrocks ever actually lived at Carr House or observed the transit from there. Tradition, however, asserts that he used the window immediately over the doorway.

5 William Crabtree was a friend of Horrocks and observed the transit from Manchester, but he was so amazed by the event that he failed to make any useful measurements. For further details of the mural by Ford Madox Brown, see Julian Treuherz, 'Ford Madox Brown and the Manchester Murals', *Art and Architecture in Victorian Manchester*, ed. J.H.G. Archer, 1985, pp. 179, 197, plate 85.

6 Horrocks was born in Liverpool; this probably explains the presentation of WAG 1805 to the Walker Art Gallery.

CUBLEY, William Harold (1816–1896)
Llyn Idwal
WAG 1811
Canvas: 111 × 187.7 cm
Signed: *W.H. Cubley 1872*

The artist has painted the south end of the lake, situated in Snowdonia. The Glyder range of mountains rises sharply from the lake. A bull seems to be an improbable feature of this landscape, which is at over 1100 feet and is generally grazed by sheep.

PROV: Presented by H.J. Spencer 1916.[1]

EXH: London International Exhibition 1873 (741), price £200; Central School of Art, Derby, *Fine Arts Exhibition*, 1877 (240).[2]

1 He was headmaster of University College School, London.

2 It was lent to this exhibition by the artist.

DANBY, Thomas (about 1821[1]–1886)
The Lake of Lucerne
WAG 1709
Canvas: 37 × 61 cm

This was probably not the *Lake of Lucerne* exhibited by the artist at the 1856 Royal Academy.[2] He was with his father in Switzerland between 1831 and 1836 and the sketches for at least this *Lake of Lucerne* may date from that period.

This painting was severely damaged by damp in the 1950s and considerable paint losses occurred, particularly in the lower areas.

PROV: F.W. Topham sale, Christie's 30 March 1878, lot 157, bought for the Walker Art Gallery (£120.15*s*.).

Llyn Idwal WAG 1811

1 1817 or 1818 are the dates usually given, but see
 Tate Gallery, *Francis Danby*, 1988, p. 73.

2 See the review of the 1856 painting in *Art Journal*,
 1856, p. 171.

The Evening Star WAG 218

DAVIS, Henry William Banks (1833–1914)
The Evening Star
WAG 218
Canvas[1]: 77.1 × 122.8 cm
Signed: *H.W.B. Davis 1881* (?)

The Royal Academy critic of the *Athenaeum*[2]
wrote:

Mr. H.W.B. Davis has sent two pictures that represent perfectly the contrasted motives of many of his works. We prefer The Evening Star *because, while in execution equal to its fellow, it embodies much of that sentiment which imparts pathos to a landscape and gives it human interest, and it is in itself a fine, broad, and warm picture. It is a scene in Picardy, and comprises, with an evening effect, a rolling country, partly clad with trees, and a pool that gleams brighter than the sky, because the illuminated parts of its surface contrast with the blackness of those which reflect the banks above them, and shine in the lustre borrowed from the sky behind us. A single star rises above the dusky gold and ruddy haze of the horizon: the distant heights grow bluer and bluer as night deprives them of the sun, the air grows chill and the birds go home.* Noon *was designed to contrast with* The Evening Star*, and it shows cattle in the fullness of daylight gathered in a rough pasture on a cliff, whence we look on the sea half shrouded in summer haze.*

Solemn evening cattle scenes in Picardy were a favourite subject for Davis; he used a house near Boulogne for his sketching expeditions.[3]

PROV: Bought from the artist by Agnew's 1881; sold to C. Neek March 1881 but bought back by Agnew's May 1881; bought from Agnew's by George Holt January 1883 (£500);[4] bequeathed by Emma Holt 1944.

EXH: Royal Academy 1881 (1416); Agnew's Exchange Gallery, Liverpool, 1882–3 (51).

1 Canvas stamp: Prepared by Winsor and Newton.

2 *Athenaeum*, 30 April 1881, p. 599. The *Saturday Review*, 21 May 1881, p. 549, described WAG 218 as a 'harmonious and serene night landscape', while for the *Art Journal*, 1881, p. 231, it was a 'most delightful and poetical landscape'.

3 See M.P. Jackson, 'Henry William Banks Davis', *Magazine of Art*, 1881, p. 126.

4 Holt also owned *Landscape, Sunset* by Davis; he bought this painting from Agnew's in 1883, but it was subsequently sold.

DAWSON, Henry Thomas (born 1841)
Thames from Deptford
WAG 2271
Canvas: 76.8 × 108.5 cm
Signed: *HTD* (in monogram) *June 1877*

The scene does in a general way resemble Deptford, but none of the buildings can be precisely identified.[1]

PROV: Purchased 1883 (£100).[2]

1 Mireille Galinou, letter to the compiler, 10 October 1984.

2 Existing Gallery records give no further details.

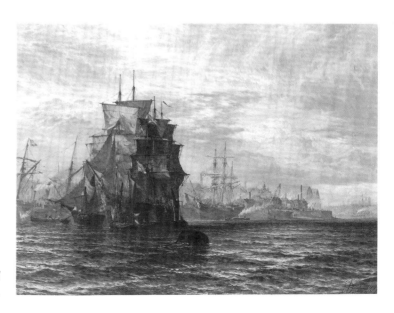

Thames from Deptford
WAG 2271

DE MORGAN, Evelyn (1855–1919)

Life and Thought emerging from the Tomb[1]

WAG 3074
Canvas[2]: 167.7 × 297.2 cm
Signed: *E de M 1893*
Inscribed: *NON.DIU.O.VITA.IN. CARCERE.TENEBRIS.NEC.TU.O. MENS.IN.FAUCIBUS.SEPULCRI. VOBIS.ENIM.DABITUR.TUERI. ANGELOS.DEI.EORUMQUE.TECTA. VIDEBITIS.ET.URBES.*

The subject of this painting is taken from Alfred Tennyson's early poem *The Deserted House*, first published in 1830.[3] Starting with the image of a corpse as a tenantless, empty house, this poem relates how Life and Thought have left the deserted house (or corpse) for a 'great and distant city' (or immortality). The artist has turned Tennyson's gloomy and doomed 'deserted house' into a magnificent tomb, and a group of angels (again not to be found in Tennyson's poem) are about to lead Life (the male figure, armed and ready for action) and Thought (the female figure with a book) towards Tennyson's 'great and distant city', which appears as in a vision in the centre of the painting.[4]

The symbolism ought to relate to immortality, eternity and to life after death; the peacock, the butterfly, the carved snakes on the tomb and the bird emerging from the egg can all carry this meaning, and the doves can at least refer to the soul after death. The Latin inscription may be translated: 'Not long O Life shall you remain in the prison of darkness, nor you O Thought in the jaws of the tomb, for to you it will be given to behold the angels of God, and you shall look upon their dwellings and cities.'[5]

Although directly based on Tennyson's poem, this painting must reflect the Spiritualist convictions of the artist and her husband, William De Morgan:

For the motif dominant in all these letters likewise permeates De Morgan's fiction; the belief that this life is but one phase of a great whole, one stage in a continuous progression and that the growth of a soul is the greatest good; while the same message Eveyln passed on to the world in glowing colours and fair fancies. In most of her later pictures can be traced that paramount idea of struggle and of growth, the battle for attainment to a rarer atmosphere, a finer development.[6]

In 1893 the artist and her husband began to spend substantial parts of each year in Flor-

Life and Thought emerging from the Tomb WAG 3074 (colour plate 4)

ence, which they already knew well,[7] and this may explain the eight-year gap between the execution of this painting and its first appearance at an exhibition – the New Gallery of 1901.[8] At that exhibition *The Times* critic noted that it inspired 'respect' but not 'a very lively interest',[9] while the *Art Journal* merely observed that visitors to the New Gallery could hardly fail to notice the picture.[10] The New Gallery of 1901 was dominated by works by J.S. Sargent and J.J. Shannon; Evelyn De Morgan's work must have looked very old-fashioned.

REPR: Liverpool Autumn Exhibition catalogue, 1901, p. 53.

PROV: Purchased from the artist 1901 (£600).

EXH: New Gallery 1901 (402); Liverpool Autumn Exhibition 1901 (47).

1 WAG 3074 was listed in the New Gallery catalogue of 1901 (402) without a title but with a quotation from Tennyson's *Deserted House*:

> *Life and Thought have gone away*
> *Side by side . . .*
> *. . . for Life and Thought*
> *Here no longer dwell:*
> *But in a city glorious –*
> *A great and distant city – have bought*
> *A mansion incorruptible.*

This title is taken from A.M.W. Stirling, *William De Morgan and his Wife*, 1922, p. 192.

2 Frame maker's label: Charles Roberson – with the artist's address, The Vale, Chelsea.

3 The poem is not now highly regarded but its subject and style anticipate *In Memoriam*.

4 Mulready's illustration in the Edward Moxon edition of Tennyson's poems published in 1857 (p. 43) is much closer to Tennyson; a shrouded corpse is in the foreground and Life and Thought, conceived as two winged putti, are flying out of the window of an ordinary house.

5 The source for this quotation has not been traced.

6 Stirling, *op. cit.*, pp. 356 ff. For the background to this interest in spiritualism on the part of British late 19th-century symbolist artists, see David Stewart, 'Theosophy and Abstraction in the Victorian Era', *Apollo*, 1993, vol. 139, pp. 300–2.

7 There are clear influences from Florentine late 15th-century art (particularly Botticelli) in WAG 3074 as in most paintings by Evelyn De Morgan.

8 The artist had to sell her paintings to support her husband's struggling pottery in the 1890s and the early years of the 20th century. The Boer War period (from around the winter of 1899–1900) was particularly bad for the fortunes of the business (see Stirling, *op. cit.*, p. 223).

9 *The Times*, 20 April 1901.

10 *Art Journal*, 1901, p. 186.

Mail Coach in the Snow with a Fallen Leader
WAG 2308

DE PRADES, A.F. (*c*.1840–*c*.1895)

Mail Coach in the Snow with a Fallen Leader

WAG 2308
Canvas[1]: 41 × 67 cm
Signed: *A.F. de Prades 1883*

PROV: Walter Stone;[2] bequeathed by Miss Mary Stone 1944.

1 Canvas stamp: A. Rayner, Frances Street, Tottenham Court Road.

2 *The Walter Stone Collection of Sporting Pictures*, 1938, p. 19, no. 19.

DICKSEE, Francis Bernard (1853–1928)
A Reverie
WAG 2280
Canvas: 106 × 138.5 cm
Signed: *FRANK DICKSEE 1895*

A Reverie was derived from a sketch made by the artist at the Langham Sketching Club, which he joined in 1870;[1] in conception and subject it is, however, very close to his *Memories* of 1886, in which a woman, by playing on the piano, seems to suggest memories of the past to another seated woman;[2] in both paintings the precise subject was only indicated by a quotation – that for *A Reverie* being: 'In the years fled / Lips that are dead / Sang me that song'.[3] Critics were anxious to complete the story as the artist no doubt intended; the most plausible attempt was perhaps that of M.H. Dixon,[4] who speculated that the music of a 'calm, complacent' wife conjured up to the husband a vision of a 'beautiful woman who passed out of his life before it became the commonplace, conventional thing it now is'; another commentator[5] suggested that the piano-playing wife was 'young, pretty, undistinguished and – we may hazard – rich', while for yet another critic[6] the male figure was the father not the husband of the musician. As for the quality of the painting, its sentimentality was generally censured[7] but otherwise criticism was broadly favourable; M.H. Spielmann[8] liked its 'virile handling and natural dramatic instinct' and went on:

The work is treated with great skill. Painted in a ruddy lamplight scheme, it is not for that reason 'hot'. The subject, dangerous enough in itself, does not fail, as it well might, by becoming theatrical; the figures keep their places, and the sentiment does not unduly interpose itself between the painting and the spectator. The mind of the beholder naturally reverts to earlier pictures of the painter which practically handled the same subject, sentiment, or treatment; but we have here a great artistic advance, a greater breadth and grip.

By contrast the *Athenaeum*[9] found the picture only clever:

The sentiment of the next picture we come to is neither fresh nor profound, but its execution is well calculated to attract many who are not learned in art nor critical in design. Showily effective, too sentimental to be sincere, too obvious in design to be a novelty, much

too dexterous and facile to gratify educated eyes, and in some respects so thoroughly commonplace as to be an absolute antithesis of whatever is really touching, the Reverie *of Mr. F. Dicksee is extremely clever. It is, moreover, remarkable as the most complete representative we have seen for many years of a sort of art which used to be highly popular, and we are not sorry to feel that, with all its cleverness and sentimentality,* Reverie *is an anachronism now.*

A study for the head of the ghostly figure at the extreme left was reproduced in the *Magazine of Art*, 1895, p. 244.
 A Reverie was returned to the artist for restoration in 1915 and 1924 after severe cracking appeared in the surface of the paint.

REPR: *Royal Academy Pictures*, 1895, p. 115; Pall Mall Gazette, *Pictures of 1895*, p. 77; H. Blackburn, *Academy Notes*, 1895, p. 34; Berlin Photographic Company, 1896 (photogravure); R.W. Macbeth, 1900 (etching).

PROV: Purchased from the artist 1895 (£800).

EXH: Royal Academy 1895 (46); Liverpool Autumn Exhibition 1895 (992); Florence 1896; Guildhall Art Gallery 1900 (14).

1 E.R. Dibdin, 'Frank Dicksee', *Art Annual*, 1905, pp. 4 and 26; for the origins of this society, see N.N. Solly, *Life of William James Muller*, 1875, p. 93; the society is also described in J.G. Marks, *Life and Letters of Frederick Walker*, 1896, pp. 10–11 and in *Art Journal*, 1895, pp. 1 ff., 54 ff.; the society was devoted partly to drawing from life, partly to sketching a set subject for a fixed time.

2 Reproduced in Dibdin, *op. cit.*, p. 18. The story is less enigmatic in *Memories* than in WAG 2280; in the former the seated woman is presumably a widow thinking of her late husband, see Sydney Hodges, 'Mr. Frank Dicksee', *Magazine of Art*, 1887, p. 220. J.E. Millais's *Speak! Speak!* of 1894–5 (Tate Gallery) shows the (dead?) bride of a young Roman miraculously appearing to him as he reads her letters one night – the painting was conceived as early as 1854. W.Q. Orchardson's *Her Mother's Voice*, 1888 (Tate Gallery) has a very similar subject; a girl playing the piano and singing reminds her father of her dead mother; Claude Calthrop's *His Favourite Song*, also of 1888, has much the same subject; see National Gallery of Scotland, *Masterclass*, 1983, p. 101,

A Reverie WAG 2280

no. 116, where Dicksee's 'overt sentimentality' is contrasted with Orchardson's 'lighthandedness'.

3 The song is attributed by Sir Gurney Benham, *Book of Quotations*, 1948, p. 476b, to Mrs. R.A.M. Stevenson (née Louisa Pyrland) but she does not otherwise appear as a poet or song writer.

4 'A Painter of Modern Life', *Ladies Realm*, 1904–5, vol. 17, pp. 567–8. The critic of the *Athenaeum* was rather more specific and referred to 'Mr. Dicksee's ghost of a lost mistress appearing to her former lover' – *Athenaeum*, 4 May 1895, p. 574.

5 *Art Journal*, 1895, p. 171.

6 Claude Phillips in the *Academy*, 25 May 1895, p. 449.

7 A selection from the newspaper reviews was published in a supplement to the *Artist*, June 1895;

Phillips, *op. cit.*, pointed out that sentimentality was almost inevitable with a subject like this.

8 *Magazine of Art*, 1895, p. 244; for the *Art Journal*, *op. cit.*, WAG 2280 was 'in theme, treatment and loose free handling an expression of extreme modernity'.

9 *Athenaeum*, 18 May 1895, p. 647.

'This for Remembrance'
WAG 1628
Canvas: 94 × 124.5 cm

The subject – presumably a husband painting his dying wife – was to some extent anticipated in Dicksee's *The Crisis* of 1891, now in the National Gallery of Victoria, Melbourne; in this painting a man (husband or father?) sits at the bedside of a young woman. The head of

'This for Remembrance' WAG 1628

the male figure in *'This for Remembrance'* was suggested by the artist's brother.[1]

REPR: Royal Academy Illustrated, 1924, p. 19.

PROV: Presented by Frederick C. Bowring 1924.[2]

EXH: Royal Academy 1924 (119); Liverpool Autumn Exhibition 1924 (900).

1 *Connoisseur*, 1928, vol. 82, p. 243.

2 The Curator of the Walker Art Gallery sent a telegram to the artist on 13/15 December 1924: 'Moon maiden purchaser Mr. Bowring'. In 1924 Bowring was Deputy Chairman of the Libraries, Museums and Arts Committee, which then controlled the Walker Art Gallery.

DICKSEE, Thomas Francis (1819–1895)
Ideal Portrait of Lady Macbeth[1]
WAG 3060
Canvas: 128.2 × 102.5 cm
Signed: *T.F. Dicksee / 1870*

The Royal Academy catalogue for 1870 had the following quotation from Shakespeare's *Macbeth*, Act 1 Scene 5, against this painting:

Glamis thou art, and Cawdor; and shalt be
What thou art promised.

Lady Macbeth has just read a letter from her husband giving an account of the witches' prophecies relating to his future greatness.

The critic of the *Art Journal*[2] observed: 'Mr. Dicksee makes an unusual effort in Lady Macbeth: the figure is eminently tragic and theatric, and that not wholly in a bad sense: the

face is modelled according to ideal preconceptions, and the cast of the drapery is broad, symmetric and effective.'

PROV: H. Wallis (French Gallery) sale, Christie's 24–25 March 1871, lot 217, bought Hooper (£157.10s.). Presented by Andrew George Kurtz[3] 1878.

EXH: Royal Academy 1870 (929).

1 The title presumably signifies simply that WAG 3060 is not intended to be a portrait of any particular actress.

2 *Art Journal*, 1871, p. 169. There is another review in the *Illustrated London News*, 28 May 1870, p. 562: 'Mr. T.F. Dicksee's life size half length of Lady Macbeth is larger and more manly in style than any previous work we had seen by the artist.'

3 For further details about Kurtz, see p. **271** (under Leighton). Kurtz was a friend of Dicksee and his

unpublished Diaries and Journals, now in the Liverpool City Libraries (H 920 KUR), record his admiration for Dicksee's work.

DIGHTON, William Edward (1822–1853)
A Stormy Day
WAG 2272
Canvas: 62 × 102.3 cm

This painting was warmly praised by the *Art Union*:[1] 'A most excellent work; full of nature; "true to the letter" and manifesting skill and power in execution. The artist has other works in the collection, which amply sustain a growing reputation and make its usual accompaniments sure.'

PROV: Presented by the Liverpool Academy to the Liverpool Town Council 1851;[2] transferred to the Walker Art Gallery 1948.

Ideal Portrait of Lady Macbeth
WAG 3060

A Stormy Day WAG 2272

EXH: Liverpool Academy 1845 (361).[3]

1 *Art Union*, 1845, p. 345; WAG 2272 was *A Stormy Day*, no. 361 at the 1845 Liverpool Academy; the titles are the same and WAG 2272 was called *A Stormy Day* as early as 1851 (Liverpool Royal Institution, *Catalogue of the Pictures, Drawings and Casts*, 1851, p. 29). The Liverpool Academy itself bought WAG 2272 from their 1845 exhibition for 45 guineas (Mayer Papers Hf 221, Vol. 1, Liverpool City Libraries)

2 Liverpool Academy, *Minutes of Proceedings*, 14 April 1851; for further details see p. **76** (under Cobbett). Many of the paintings acquired by the Academy were by Liverpool artists; N.N. Solly, *Life of William James Muller*, 1875, p. 103, records that many of Dighton's patrons lived in Liverpool; whether the presence of WAG 2272 in the Academy's collection was the cause or the result of Dighton's popularity in Liverpool is not clear.

3 See note 1; WAG 2272 was not *Scene on the Banks of the Medway – A Stormy Day*, no. 337 at the 1845 Royal Academy – see the review in *Art Union*, 1845, p. 187.

DOBSON, William Charles Thomas
(1817–1898)

The Virgin
WAG 2277
Canvas[1]: 120 × 61.5 cm
Signed: *18 WCTD 76/R* (in monogram)[2]

The Virgin is carrying the two turtle doves mentioned in Luke 2:24; she is therefore presumably going to Jerusalem for the Presentation in the Temple.[3]

Table d'Hote at a Dogs' Home WAG 2275

This painting does not seem to have been exhibited and it may have been commissioned by the Scarisbricks, who were Catholics.

PROV: Sir Charles Scarisbrick sale,[4] Scarisbrick Lodge, J. Hatch, Sons and Fielding (Southport) 12–19 March 1923, lot 807. Presented by George Audley 1925.

1 Winsor and Newton prepared canvas (stamp).

2 The monogram is very similar to that recorded in P. Nahum, *Monograms of Victorian and Edwardian Artists*, 1976, p. 218. The capital *R*, however, is unusual – unless it should read *R.A.* – the artist was elected a member of the Royal Academy in 1871.

3 Doves sometimes appear in representations of the Presentation in the Temple and the Circumcision – for example in Guido Reni's paintings, now in the Louvre and in the Church of San Martino, Siena.

4 Sir Charles Scarisbrick (1839–1923) was the younger, illegitimate son of Charles Scarisbrick (1801–1860), the great collector and early patron of A.W.N. Pugin.

DOLLMAN, John Charles (1851–1934)
Table d'Hote at a Dogs' Home
WAG 2275
Canvas: 75 × 129 cm
Signed: *J.C. Dollman 1879*

The *Magazine of Art*[1] commented on this painting: 'Mr. Dollman has made the most of a happy subject in his *Table d'Hote in a Dogs' Home*.'

REPR: H. Blackburn, *Academy Notes*, 1879, p. 46.

PROV: Purchased from the artist 1880 (£70).[2]

EXH: Royal Academy 1879 (455); Liverpool Autumn Exhibition 1880 (579).

1 *Magazine of Art*, 1879, p. 217.

2 The money for this acquisition was apparently given by James A. Picton. The *First Decade of the Walker Art Gallery: A Report by Charles Dyall, Curator* (1888, p. 5) puts in context:

The Virgin WAG 2277

While endeavouring to secure works of the highest technical skill, the fact has not been lost sight of that the public, for whose edification and instruction the institution in a great measure exists, delight in subjects of a popular character, and with this end in view pictures have from time to time been added which, by appealing to common feelings and sentiments of our daily life, have afforded a fine moral lesson, and given great pleasure to the numerous visitors to the Gallery who are uninitiated in the higher forms of Art.

113

DOW, Thomas Millie (1848–1919)
Eve
WAG 2281
Canvas: 141 × 114.3 cm
Signed: *T.M.D.*

Angel with Cymbals
WAG 10683
Canvas: 140.5 × 51.5 cm
Signed: *T.M.D.*

Angel with a Lyre
WAG 10684
Canvas: 140.5 × 51.5 cm
Signed: *T.M.D.*

114

Eve was reproduced in the *Studio* of 1897 as an unfinished painting;[1] it was then exhibited at the Royal Glasgow Institute of 1898 in a more advanced condition and with the addition of the two wings, *Angel with Cymbals* and *Angel with a Lyre*, representing good and evil angels;[2] it was finally exhibited in 1906 at Liverpool with yet more detail, particularly in the foreground, and without the wings.[3]

The meaning of the triptych was explained in 1898 thus:[4]

A triptych of Eve, symbolical of the Fall. Eve occupies the centre, and on either side are a sorrowing good angel and an exultant bad one, personifying the struggle between good and bad influences which ended

Left:
Angel with Cymbals
WAG 10683

Centre:
Eve WAG 2281

Right:
Angel with a Lyre
WAG 10684

REPR: N. Garstin, 'The Work of T. Millie Dow', *Studio*, 1897, vol. 10, p. 144 (WAG 2281 only); *Magazine of Art*, 1898, p. 334; Liverpool Autumn Exhibition catalogue, 1906, p. 108.

PROV: (WAG 2281) purchased from the artist 1906 (£300);[8] (WAG 10683–10684) the artist's family, purchased from Christie's (Glasgow) 10 December 1987, lot 44 (£2,358).

EXH: Royal Glasgow Institute of the Fine Arts 1898 (157); Munich, *Secession*, 1899;[9] London, *International Society of Sculptors, Painters and Gravers*, 1904 (192);[10] Leeds, City Art Gallery, *Spring Exhibition*, 1905 (585), priced at £400; Paris, *Société Nationale des Beaux Arts*, 1906 (410); Liverpool Autumn Exhibition 1906 (811).

1 N. Garstin, 'The Work of T. Millie Dow', *Studio*, 1897, vol. 10, p. 144. D. Martin, *The Glasgow School of Painting*, 1897, p. 14, also saw it in this unfinished condition.

2 In this state it was reproduced in *Magazine of Art*, 1898, p. 334. The triptych was not priced in the 1898 Glasgow catalogue, indicating perhaps that a prospective buyer had been found.

3 It was reproduced thus in the Liverpool Autumn Exhibition catalogue; presumably the extra work was done on WAG 2281 and the wings (WAG 10683–10684) were removed between the 1899 Munich exhibition and the 1904 London exhibition. It is just possible that WAG 2281 is not the central part of the triptych exhibited at Glasgow in 1898 but another version of it; this seems, however, unlikely.

4 The Studio, *Art in 1898*, pp. 65–6.

5 *Art Journal*, 1898, p. 128.

6 J.L. Caw, *Scottish Painting*, 1908, p. 409. The criticism of WAG 2281 in U. Thieme and W. Becker, *Künstler-Lexikon*, 1913, vol. 9, p. 524, follows similar lines. Caw and Thieme–Becker both disliked the wings; they identified the subjects of the wings as the good and evil angels but failed to explain the source of this iconography. Roger Billcliffe, *The Glasgow Boys*, 1985, pp. 103 ff., discusses Dow's conversion to allegory and symbolism which, with WAG 2281, was virtually complete – although at first the artist retained some naturalistic elements.

in her surrender to temptation. The conventional serpent is not used as the explanation of the pictorial motive is complete without it.

The *Art Journal* critic found the painting 'beautiful in colour and refined decorative treatment';[5] J.L. Caw, however, noted that 'charming as the triptych of Eve is in many respects the principal figure is a graceful slip of a girl and not "a mother, a mother of men"', while the two angels 'are not greatly moved themselves and leave one unthrilled'.[6] The Irwins point to the influence of J.L. Gerome in Dow's nudes;[7] Dow's friend, William Stott of Oldham, seems a more general source.

7 D. and F. Irwin, *Scottish Painters at Home and Abroad*, 1975, p. 391.

8 The Curator and Chairman of the Walker Art Gallery saw WAG 2281 at the Paris Société Nationale des Beaux Arts exhibition in early 1906 and invited the artist to send it to the Liverpool Autumn Exhibition (letter from the Curator to the artist of 24 May 1906).

9 For the exhibition of Glasgow paintings at Munich from 1890 onwards, see particularly Caw, *op. cit.*, pp. 359 ff.

10 At this and subsequent exhibitions it seems that only WAG 2281 was on display.

EARL, George (active 1856–1883)
Interior, North Wales
WAG 2811
Canvas: 66.3 × 92 cm

PROV: Presented by Wallace Smith 1933.

EXH: (?) Royal Academy 1857 (90).

EAST, Alfred (1849–1913)
Gibraltar from Algeciras
WAG 2812
Canvas: 102.2 × 153 cm
Signed: *ALFRED EAST*

The artist returned from Egypt in 1900 by way of Spain and this was one of the paintings resulting from that visit.[1]

The *Art Journal*[2] reviewed *Gibraltar from Algeciras* favourably at the 1902 Royal Academy:

Yet more worthy of remark, perhaps, is 'Gibraltar from Algeciras'. As to design, we note the happy repetition of the bend in the foreground stream by the elliptical shape of the bay, balancing it to the left; note how the piers of the beautiful Moorish aqueduct have their correspondence in the slender poplars of the mid-distance; note how true is the poise between mass and mass, and how admirably placed is the town, rising from almost sea-level. And the congregation of white houses is indubitably part of a colour-scheme that embraces the gold-green trees, the faint blue bay, dominated by the Rock of Gibraltar, and the more assertive tones of the foreground. This is a decorative landscape of worth.

The view was taken from the hills on the outskirts of Algeciras near a place called El Cobre; the village on the left is the old town of Algeciras and the river in the foreground is La Miel.[3]

Interior, North Wales
WAG 2811

Gibraltar from Algeciras WAG 2812

REPR: *Art Journal*, 1902, p. 217; *Royal Academy Pictures*, 1902, p. 120; Alfred East, *Art of Landscape Painting*, [1906], p. 18.

PROV: Bought from the artist 1902 (£400).

EXH: Royal Academy 1902 (733).

1 Obituary of East in *Manchester Guardian*, 29 September 1913. Another painting presumably derived from the same excursion was East's *Algeciras, Spain*, dated 1904–5, exhibited at the Royal Academy 1906 (544) and in Roy Miles, *The Victorian Ideal*, 1978 (repr.). *Algeciras, Spain* shows more or less the same view as WAG 2812 but, apparently, from a point slightly nearer the sea. The watercolour entitled *Algeciras, Spain* and reproduced in Alfred East, *Brush and Pencil Notes in Landscape*, 1914, opp. p. 84, is perhaps closer to the 1904–5 painting than to WAG 2812. Another watercolour by East, *The Viaduct, Algeciras*, now in the Victoria & Albert Museum (P 12–1920), is a close-up view of the viaduct.

2 *Art Journal*, 1902, p. 214.

3 Joaquin Bensusan, letter to the compiler, 14 October 1986.

EATON, George Clayton (1834–1944)

Alfred Stevens in his Library at Eton Road, Haverstock Hill

WAG 1897
Canvas[1]: 76.5 × 63.8 cm

The artist was a pupil of Stevens for four months in 1858[2] and MacColl dated this portrait to that year for this reason:[3] however, Stevens's combined house and studio at Eton Road, Haverstock Hill, only 'began to take shape' in 1866[4] and was not completed on Stevens's death in 1875. The house, together with its furniture and fittings, was designed by Stevens. The library, which also served as

Alfred Stevens in his Library at Eton Road, Haverstock Hill WAG 1897

George Clayton Eaton, notes by Frederick Ray Eaton (the artist's son), 1958, typescript, Castle Museum, Norwich.

3 MacColl, *op. cit.*; moreover Frederick R. Eaton wrote the following label, which is still attached to WAG 1897: 'This picture was painted by my father George Clayton Eaton of Norwich as a "study" when a pupil of Alfred Stevens in a room in his house at Haverstock Hill.' F.R. Eaton also contributed a further note about WAG 1897 to the MacColl MS (Victoria & Albert Museum): 'This was painted by Mr. George Clayton Eaton when once staying with Stevens. It was done as a study and I believe won some prize for perspective (perhaps at the Academy) but of this I have no written note.'

4 Hugh Stannus, *Alfred Stevens and his Work*, 1891, p. 27.

5 Royal Institute of British Architects, *Catalogue of the Drawings Collection: Alfred Stevens*, 1975, p. 48; the house was demolished in 1964; there are a large number of drawings by Stevens for the house and furniture; most are in the Victoria & Albert Museum and at the Royal Institute of British Architects, but the Walker Art Gallery has three drawings for this project (inv. nos. 1921–1923).

6 K.R. Towndrow, *Alfred Stevens*, 1939, p. 214.

a dining room, was on the ground floor; the two bookcases and chimneypiece visible here were removed from the house in 1920 and are now in the Walker Art Gallery;[5] these bookcases differ quite considerably, however, from their appearance in this portrait, and it is possible that this was painted using designs for the bookcases (and perhaps for the rest of the furniture) rather than from the completed articles.

According to Towndrow, Stevens's face does not appear here because he disliked sitting for his portrait.[6]

PROV: Bought from Frederick R. Eaton, the artist's son, 1946 (£150, with other items).

EXH: Tate Gallery, *Alfred Stevens*, 1911 (144); Mappin Art Gallery, Sheffield, *Alfred Stevens*, 1912 (25).

1 Charles Roberson canvas stamp and Charles Roberson, 99 Long Acre, label.

2 D.S. MacColl, 'A Portrait by Alfred Stevens', *Burlington Magazine*, 1911–12, vol. 20, p. 209;

EGG, Augustus Leopold (1816–1863)

The Introduction of Sir Piercie Shafton to Halbert Glendinning

WAG 1617
Canvas[1]: 108 × 169 cm
Signed: *Augt. Lo. Egg 1843*

The subject is taken from chapter 14 of Walter Scott's *The Monastery*, first published in 1820.[2] The figures are presumably, from left to right, Tibb Tacket and Dame Glendinning, both standing; Sir Piercie Shafton, Hob Miller (or Happer), Mysie Happer and Edward Glendinning, all four seated; Mary Avenel and Halbert Glendinning, both standing; and at the extreme right, Christie of the Clint-hill and Martin the shepherd. Mary Avenel is introducing Halbert Glendinning to Sir Piercie Shafton; the two men will later fight a duel,

partly on her account. With the different poses of the two men the artist is presumably contrasting English sophistication (Sir Piercie Shafton) with Scottish simplicity (Halbert Glendinning); similarly Sir Piercie Shafton's decorative and frivolous dog is contrasted with the more useful and simpler bloodhound – in the same way that the two dogs in Egg's *Launce's Substitute for Proteus's Dog* (Leicestershire Museum and Art Gallery) of 1849 reflect the characters of their owners, although those dogs were painted by Ansdell. However, at present, Sir Piercie Shafton's erudite conversation is fascinating Mysie Happer.

This painting may be regarded as Egg's first major work, and it was described thus by Holman Hunt.[3]

In '43 appeared 'The Introduction of Sir Piercie Shafton to Halbert Glendinning'. This may be regarded as an excellent illustration of the manner of his advance. The drawing in it was wonderfully better than in the earlier pictures we have noticed; and the colour was beginning to indicate a greater reliance upon himself than before. Many things could be found in it suggested by other works; but he had made them his own by the manner in which he had adopted them, and by their relation to points entirely original. Halbert Glendinning, for example, was in the pose of an antique figure – the Antinous; but it was so well chosen, and with such strong marks of control in his treatment of it, that it looked as proper to the place and circumstances as some of the figures and groups in the cartoons of Raffaello seem, which are taken from the antique. Sir Piercie Shafton, too, it is said, was strikingly like a figure designed by an artist of his own standing in a picture of the previous year. This, however, in its supercilious bearing, was as true to the character represented as the former figure was in its silent resentment of insolence. Of the Halbert Glendenning, we know the original; and we can see how far alterations have been made so that the expression

The Introduction of Sir Piercie Shafton to Halbert Glendinning WAG 1617

of modesty for which it is distinguished might become that of impatient offended pride. The left foot may be taken as the most available example in the antique; it is turned outwards with graceful ease: the adaption has the foot drawn laterally nearer to that on which the figure stands, and turned inwards, with a somewhat gauche air. Doubtless in the Sir Piercie there were similar marks of there being a strongly defined image of the character in the painter's mind which made his plagiarism other than that of one who makes up his work of unconsidered trifles, like a modern Gothic architect, with nothing of his own but his 'Remains of the Middle Ages'. The less important figures are free from any trace of the works of others. These are all original, appropriate in expression, and characteristically costumed. The background, too, is admirably arranged and free from any look of having been made up. The colour had even stronger marks of originality than the design; so that, altogether, the picture deserved to take a high rank as a young man's picture.

Egg's painting was badly hung at the 1843 Royal Academy exhibition, but it was noticed by the *Art Union*:[4]

No. 640. 'The Introduction of Sir Piercie Shafton to Halbert Glendinning', A. Egg. Every part of this excellent production declares the finest feeling for the most attractive beauties of Art, and a power of hand equal to their accomplishment. The Halbert Glendinning is accurately read from the text; but the bearing and presence of Sir Piercie is scarcely brought up to the intention of Scott. The drawing and painting in every part are those of one gifted with the rarest abilities; one who is as sure to make his way to the highest place in Art, as years are to pass over his head. He has been doomed to do penance in this hole – for the crime of painting an admirable picture; but his work has found a purchaser nevertheless. He will soon have more commissions than he can execute, or we shall eschew prophecy.

The critic of the *Spectator*[5] observed: 'the contrast between the character of the fantastic knight and the manly-spirited youth is strikingly shown in physiognomy, dress and attitude of each'; he went on, however, to request that artists should cease painting subjects from books but should instead concentrate on events from life or from their own experience.

Scott's novel was set in the Scottish borders during the mid-16th century and Hilarie Faberman[6] argues that Egg's antiquarian details (architecture, costume, furniture, etc.) are derived from publications such as Joseph

Nash's *The Mansions of England in the Olden Time*, 1839–49 and the Reverend Richard Cattermole's *The Great Civil Wars of Charles I and Parliament*, 1841–5.

Another version of this composition seems to have been exhibited at the 1853 Liverpool Academy (73) and this version may have been in the W.P. Frith sale, Christie's 14 June 1884, lot 35, bought Rhodes (£10.10s.) as *Scene from the Monastery*.

There can, however, be little doubt that the Walker Art Gallery version is the first version as there are numerous pentimenti in the lower parts of the dresses of the figures on the left, in the area around the antlers on the left and in the paint around the extreme right of the table.

REPR: *Art Union Prize Annual*, 1845, no. 146, plate 29.

PROV: J.S. Bywater.[7] John Hargreaves sale,[8] Christie's 5–7 June 1873, lot 300, bought Agnew (£519.15s.) (as the painting exhibited at the Royal Academy); sold by Agnew's to Colonel John Hargreaves 17 June 1873; Colonel John Hargreaves sale, Christie's 2 May 1896, lot 46, bought Shepherd (£60.18s.) (41½ × 66 in., 1843). Sir A. Guiness. T. Lumley sale, Christie's 11 December 1922, lot 86, bought Mitchell (£51.9s.) (41½ × 66 in., Royal Academy 1843). Presented by George Audley 1925.[9]

EXH: Royal Academy 1843 (640); Society of British Artists, *Exhibition of the Art Union Prizes*, 1843 (100);[10] (?) Liverpool Academy 1853 (73).

1 The dimensions of WAG 1617 do not exactly correspond with those recorded for the painting in the *Art Union Prize Annual* of 1845 (see Reproduced above), where the height is given as 101.5 cm and the length as 152.5 cm.

2 For the subject of WAG 1617, see R.D. Altick, *Paintings from Books*, 1985, pp. 64, 433–5; he notes that *The Monastery* was not one of the most popular of Scott's novels among artists – particularly later in the 19th century; see also Catherine M. Gordon, *British Paintings of Subjects from the English Novel*, 1988, p. 325; she notes J. Absolon's *Scene with Mysie Happer and Sir Piercie Shafton* of 1841 (p. 322). Henry Liverseege's *Sir Piercie Shafton and Mysie Happer* of 1831 (versions at Chatsworth and at Manchester City Art Galleries) does not represent quite the same scene as WAG 1617.

3 W. Holman Hunt, 'Notes on the Life of Augustus L. Egg', *Reader*, 16 May 1863, pp. 486–7. The Antinous to which Hunt referred was presumably the Capitoline Antinous now in the Capitoline Museum, Rome, and widely copied in the 18th and 19th centuries. The painting of 1842 from which Egg is supposed to have taken the figure of Sir Piercie Shafton is unidentified.

4 *Art Union*, 1843, p. 176.

5 *Spectator*, 27 May 1843, p. 499; the critic also noted that WAG 1617 was hung 'in the old dark hole called the Octagon Room'.

6 Hilarie Faberman, *Augustus Leopold Egg*, Yale University Ph.D. thesis, 1983, pp. 78–80.

7 J.S. Bywater of Grosvenor Street won £100 prize at the 1843 Art Union of London lottery, and he selected WAG 1617, which was priced at £140 (*Art Union*, 1843, pp. 126, 140; *Art Union Prize Annual*, 1845, no. 146, plate 29). See also *Catalogue of the Pictures etc. Selected by the Prizeholders of the Year 1843 in the Art Union of London*, no. 100. Egg sold a number of other pictures through the Art Union; see Faberman, *op.cit.*, p. 50.

8 Christie's stencil for this sale (146A) is on the back of WAG 1617.

9 George Audley, *Collection of Pictures*, 1923, p. 16.

10 As one of the pictures selected by the Art Union of London prizewinners (*Art Union*, 1843, pp. 242–3).

Charles I raising his Standard at Nottingham[1]

WAG 1490
Canvas: 34.5 × 44 cm
Signed: *Aug Egg*

This can almost certainly be identified with 'the sketch of Charles the First raising his Standard at Nottingham', described at some length by Holman Hunt in the *Reader*[2] of 1863:

It was done by invitation of the Royal Commissioners as a design for a wall-painting in the House of Lords.

We remember how deeply he was interested in this subject. The account of the fact is so impressive – the gloominess of the morning, the futile attempt to make a royal demonstration of the event, the evil omen in the fact of the wind blowing down the crazily-erected banner of the Cavaliers, and the no conqueror's genius to convert it into a good one – all of these circumstances concurred to make it an acceptable subject for his invention. Never was the sentiment of an incident better given. There was no straining after Academic postures. The king was sitting cheerlessly on his horse; the mattock and the spade had just been laid aside, and the men were employed in planting the standard anew; the trumpeters were just about to sound their blast of triumph to the heavy clouds. The picture would have been a worthy memorial of the event; but, alas! the royal and noble connoisseurs rejected it! What can come of Government Art in this country when the patronage is confided to men who have no other claim to judgment than that they are born with? It is almost at this time sacrilegious to impugn the taste of his late Royal Highness, the then president of his commission; but surely it is too much to expect that a man, because he is a good prince, is also a just critic of Art. Nature deals not in this way with its children: it requires that a man, be he prince or plebeian, shall work for his acquirements. And the good prince had attained no eminence as a critic, except in the mind of such sycophants as those who before them had bowed to the decision of George the Third and his graceless successor in such matters. Let good and wise princes exercise their beneficial influence upon the social and political questions of the day; but do not let them, until they are specially prepared for this also, tamper with such an enduring thing as Art! Egg – modest, self-suspicious man as he was – merely said, with a shrug of the shoulders and a sigh together, 'I suppose one cannot judge of one's own work.'

The history of this abortive commission can be traced in some detail. In the autumn of 1849, E.M. Ward and Egg had been asked to paint eight scenes from British history for the Houses of Parliament, but Egg declined due to his poor health.[3] However, in 1852, he did supply sketches for the Peers' Corridor (the Walker Art Gallery painting among them) to the Fine Arts Commission (or Royal Commission on the Fine Arts); indeed on 21 May 1852 Egg wrote to Charles Eastlake, secretary of the Royal Commission on the Fine Arts, saying that as the Commissioners had made 'suggestions' about his sketch [subject unspecified], he would start a new one, complete it

Charles I raising his Standard at Nottingham WAG 1490

in a few days and then send old and new sketches to Eastlake. On 4 August 1852 Eastlake wrote to Egg asking him if he wanted any remuneration 'for your time in preparing the sketch for the subject of Charles I at Nottingham'; he wrote again on 7 August, telling Egg that he could have £50, but no more without further reference to the Commissioners, and on 16 August he made arrangements to pay the £50 to Egg.[4]

The subject of this painting was one of the scenes from English 17th-century history planned in 1847 for each of the eight compartments in the Peers' Corridor of the Houses of Parliament; various artists, including Egg, provided the Royal Commission on the Fine Arts with sketches for these compartments (each about 7 ft. high × 9 ft. 6 in. wide) but eventually the entire commission was awarded in 1853 to C.W. Cope, who executed his eight

paintings there between 1854 and 1869.[5]

Charles I raised his standard at Nottingham in the early evening of 22 August 1642, thus formally beginning the Civil Wars. Clarendon wrote a famous account of the event, noting that the bad weather symbolized the low morale of the King's few supporters.[6]

PROV: (?) The artist's sale, Christie's 18 May 1863, lot 100 as *Raising the Standard*, bought Wingfield (£34.13s.). (?) Property of a Lady sale, Puttick's 19 July 1922, lot 43 (as the *Night before Naseby*, 15½ × 19 in., 1859), bought Evans (£6.6s.). Presented by J. Carlton Stitt 1929.

1 WAG 1490 was presented to the Walker Art Gallery as the *Night before Naseby*. This however, is the subject of Egg's 1859 painting, now in the Royal Academy Diploma Collection; it depicts Cromwell in his tent.

122

2 W. Holman Hunt, 'Notes on the Life of Augustus
 L. Egg', *Reader*, 25 July 1863, p. 91. Hunt was,
 however, incorrect in identifying the sketch for
 Charles I raising his Standard at Nottingham with the
 Study exhibited by Egg as no. 227 at the 1854
 Royal Academy. This *Study* was a small half-
 length female figure in 16th-century costume (*Art
 Journal*, 1854, p. 163; *Athenaeum*, 20 May 1854,
 p. 627).

3 James Dafforne, *Life and Works of Edward Matthew
 Ward*, 1879, pp. 33–4.

4 Westminster Palace Decorations, Letters to Sir
 Charles Eastlake, 1840–1861, MS Victoria &
 Albert Museum Library, 86 M 3; Official
 Correspondence of Sir Charles Eastlake, Secretary
 of Her Majesty's Commissioners on the Fine
 Arts, 1852–1860, MS Victoria & Albert Museum
 Library, 86 cc 47.

5 David Robertson, *Sir Charles Eastlake*, 1978,
 p. 334; T.S.R. Boase, 'The Decoration of the
 New Palace of Westminster', *Journal of the
 Warburg and Courtauld Institutes*, 1954, vol. 17,
 pp. 341 ff. Irish University Press, series of *British
 Parliamentary Papers: Education: Fine Arts*: vol.2:
 Sessions 1841–1847, 1971, pp. 576–7. See also the
 Walker Art Gallery exhibition catalogue, *And
 when did you last see your father?*, 1992, by Edward
 Morris and Frank Milner, p. 47, no. 7.
 F.R. Pickersgill's sketch contributed to the 1851
 Royal Academy, *The Raising of the Standard of
 Charles I at Nottingham. A Sketch for a Picture* was
 presumably also painted to secure for the artist a
 commission to contribute to the decoration of the
 Peers' Corridor, but Henry Dawson's huge
 *Nottingham Castle in the 17th Century: Charles I
 raising his Standard* (now Castle Museum,
 Nottingham) was painted in 1847 and so was
 perhaps unrelated to the Houses of Parliament
 commissions; it is reproduced in A. Dawson, *The
 Life of Henry Dawson*, 1891, opp. p. 20, and is
 effectively a landscape. Hilarie Faberman in
 Augustus Leopold Egg, Yale University Ph.D.
 thesis, 1983, p. 194, notes similarities between
 WAG 1490 and: (1) John Renton's lost *King
 Charles Setting up his Standard at Nottingham* of
 1816 (Royal Academy 1827) – a photograph is at
 the National Portrait Gallery; (2) *The Raising of
 the Standard* by J.T. Willmore for Reverend
 Richard Cattermole's historical annual *The Great
 Civil War of Charles I and Cromwell* of 1841–5 and
 (3) *The King's Declaration* by Peter Tillemans
 (engraved by Vandergucht in 1728).

6 *History of the Rebellion and Civil Wars in England*,
 ed. Macray, 1958, vol. 2, pp. 290–1.

Scene from Thackeray's 'History of Henry Esmond, Esq.' Esmond returns after the Battle of Wynendael[1]

WAG 909
Canvas: 87 × 117.8 cm
Signed: *Aug tus Egg / 1857*

The subject is taken from book 2, chapter 15
of Thackeray's *Henry Esmond*, first published
in 1852. Beatrix is untying the knot of
Esmond's scarf; the Dowager Viscountess
Castlewood sits with her back to the spectator
and Beatrix's mother, Lady Castlewood, looks
on at the right; Esmond was – at different
times – in love with both mother and daughter
and has just rescued Beatrix's brother, Frank,
from probable death. In fact, the precise scene
shown in this painting does not occur in
Thackeray's novel, although Esmond was
warmly welcomed by the three women on his
return after the battle.[2]

Egg's *Beatrix knighting Esmond*, exhibited at
the 1858 Royal Academy and now in the Tate
Gallery, was presumably painted as a pendant
to the Walker Art Gallery painting – both
paintings have the same size characters,
background[3] and format and both depict
scenes from book 2, chapter 15 of the novel.

The *History of Henry Esmond* was the only
one of Thackeray's novels to attract substantial
interest among artists – about ten or twelve
paintings are recorded.[4]

The *Athenaeum*[5] praised Egg's narrative
power in the Walker Art Gallery painting:

*Mr. Egg's illustration of Thackeray's Queen Anne's
novel is remarkable for strong yet sober colour, dra-
matic power, and subdued strength. About all this
excellent painter does there is a quiet tragic force, a
certainty and clenched strength, which is most satisfy-
ing and remarkable. The composition is fine, but
ostentatious, – the Art rather felt than seen, – the
colour not gay, but good, and full of a fine meditative-
ness, a rich-blooded melancholy worthy of the sym-
pathy of large-hearted men. About this picture rests a
grave sternness which comes quite like a tonic after the
sickliness of wax-doll eyes in half the pictures that
surround us. The proud, ambitious heroine of the
novelist, who would rather be a great man's mistress
than a poor man's wife, stoops with the haughty*

condescension of a Beatrice [sic] to hoop and knot the scarf of the young soldier. The old lady, with the nose peculiar to the aristocracy, and tower of lace, sits with her back towards us and looks on, while the softer-hearted lady watches the scene in a side way. Esmond's face is an admirable study of conflicting passions, ashamed to be real and natural, bent and kept in and curbed. The stiff red-skirted dress, the long square-toed cavalry boots, the very action of the hand, help to tell the story. There is beautiful unaffected painting in the Turkey carpet, the table-cloth, and old-fashioned chairs.

The Times,[6] however, doubted the artist's ability to render the intricacies of the scene:

Mr. Egg barely does justice to his own subtle sense both of beauty and humour in his scene from 'Esmond'. Who could paint that mixture of fiend and fairy, of demon and Delilah, Beatrice? Above all, what painter can grapple with the difficulty of representing Lady Castleford and Beatrice in the same picture without either making the mother too old to be a possible rival of the daughter, or softening her down into something too young for the chronology of the story? If the writer had been under the same matter of fact necessity of outward embodiment which lies upon the painter, Mr. Thackeray, courageous as he is and consumate workman, would scarcely have managed to bring the tale to its present termination. The best head in Mr. Egg's picture is the poor lady of Esmond's later love; and the painter has managed the likeness of mother and daughter very skilfully, without making Beatrice too childish, in order to save her mamma's good looks, or Lady Castleford too old to awaken and justify the love of Esmond. Colonel Esmond, himself stands stiffly up, trying to keep down, under a soldierly hardiness of bearing, the throb of his heart, as Beatrice's white hands are busy with the knot of his scarf; the humorous and stately old dowager, with her keen frosty face and hawk eye, is a capital conception, and the solidest and best bit of painting in the picture. We are not satisfied with either the attitude or the face of Beatrice. But to have created Beatrice in the book

Scene from Thackeray's 'History of Henry Esmond Esq.' Esmond returns after the Battle of Wynendael
WAG 909

was the triumph of a first-rate literary craftsman. We have no right to expect the painter to give vitality to so complex and cunning a combination of contradictions.

The *Art Journal*[7] was even more dismissive: 'No. 331, "Scene from Thackeray's History of Henry Esmond, Esq. – Esmond returns after the Battle of Wynendael", A. EGG, A. There is nothing attractive in this subject; there are excellent qualities in the working of the picture, but the figures and their disposition tell no story.'

William Holman Hunt noted a 'simplicity and largeness of masses and of colour and form unusual in the English School' in the Walker Art Gallery painting and in the Tate Gallery picture; he attributed these to Egg's period in Italy during 1853 – although generally he believed that Egg was influenced only by the 'mechanical points' of Italian art.[8] However, in a letter to Edward Lear of 16 April 1857,[9] he also found both paintings 'excellent pictures, but of unworthy subject, unworthy for such a true and perfect painting as he [Egg] put into it'. Thackeray himself, however, praised the paintings in a speech at the Royal Academy Banquet of 1858, referring to 'my talented friend Mr. Egg's translation' of his novel.[10]

PROV: Sold by Richard Newsham to Agnew's 3 October 1864; sold by Agnew's to Ralph Brocklebank,[11] 20 October 1865; his sales, Christie's 29 April 1893, lot 59, bought in (£141.15s.), and Christie's 7 July 1922, lot 54, bought Sampson (£9.9s.); presented by George Audley 1925.[12]

EXH: Royal Academy 1857 (331); Leeds National Exhibition 1868 (1182); London International Exhibition 1874 (146).

1 Ever since the 1922 Ralph Brocklebank sale, WAG 909 has been wrongly described as the *Knighting of Esmond*. This error derives from R. Radcliffe Carter, *Pictures at Haughton Hall in the Possession of Ralph Brocklebank*, 1904, p. 71, no. 58, where WAG 909 is described as *The Knighting of Esmond* and is dated to 1858. This is the subject of Egg's 1858 painting from *Henry Esmond* now in the Tate Gallery. Egg's *Esmond* (10 × 14 in.) last recorded in the Robert Rankin sale, Christie's 14 May 1898, lot 25, and his *Esmond: A Sketch for the Large Picture with Variations* in the artist's sale, Christie's 18 May

1863, lot 107, bought Cox (£19.8s.6d.), may have been sketches for WAG 909 or for the Tate Gallery picture.

2 R.D. Altick, *Paintings from Books*, 1985, p. 242. George Du Maurier's illustration to this chapter, which appeared in numerous editions of the *History of Henry Esmond* from 1868 onwards, in fact shows Esmond bowing low before Beatrix and kissing her foot. The sexual tension in WAG 909 is analysed by Hilarie Faberman, *Augustus Leopold Egg*, Yale University Ph.D. thesis, 1983, pp. 239–41.

3 The architecture in WAG 909 (and in the Tate Gallery picture) was apparently taken from 'a house in Kensington' (*Art Journal*, 1858, p. 162). Thackeray's novels – and presumably their illustrators – are often seen as precursors of the 'Queen Anne' revival later in the 19th century.

4 Altick, *op. cit.*, p. 468.

5 *Athenaeum*, 9 May 1857, p. 602.

6 *The Times*, 4 May 1857. The *Literary Gazette*, 9 May 1857, p. 450, also criticized the figure of Beatrix in WAG 909 as lacking expression, but found in all other respects 'renewed proofs of Mr. Egg's conspicuous powers and resources as an artist'; their critic described WAG 909 as another monograph. There are further reviews in the *Examiner*, 2 May 1857, p. 278, the *Spectator*, 2 May 1857, p. 463 and the *Saturday Review*, 6 June 1857, p. 52.

7 *Art Journal*, 1857, p. 171.

8 W. Holman Hunt, 'Notes on the Life of Augustus L. Egg', *Reader*, 9 January 1864, p. 57.

9 Faberman, *op. cit.*, p. 236. The letter is in the John Rylands Library, Manchester, (English MS 1214/21).

10 *The Times*, 3 May 1858; quoted by Faberman, *op. cit.*, p. 241.

11 See note 1.

12 George Audley, *Collection of Pictures*, 1923, p. 16, no. 42. There is a frame maker's label on the back of WAG 909 inscribed: *From Mrs. Hugh Rathbone*, but there seems to be no reason for thinking that she ever owned WAG 909.

Romeo and Juliet WAG 2815

ELMORE, Alfred (1815–1881),
attributed to

Romeo and Juliet

WAG 2815
Canvas: 99.7 × 57.1 cm
Signed: (?) *A. Elmore 67* (*AE* in monogram)[1]

Both the attribution and the subject must be regarded as doubtful. The style is not characteristic of the artist's mature work and the warmth of the embrace would be surprising for a well-established Royal Academician. In Shakespeare's play Romeo and Juliet do not embrace in a woodland setting, and other paintings from this play showing the lovers

are very different in tone and in background.[2]

Generally speaking, this painting looks more like a work of the 1840s than of the 1860s.[3]

PROV: W. Lawson Peacock and Co. sale, Christie's 11 November 1921, lot 39, bought Lister (£28.7s.). Presented by George Audley 1925.[4]

1 The monogram does not closely resemble Elmore's recorded monogram (P. Nahum, *Monograms of Victorian and Edwardian Artists*, 1976, p. 70).

2 R.D. Altick, *Paintings from Books*, 1985, p. 296. WAG 2815 might just be the *Venetian Lovers* by Elmore, lot 187 in the John Guest sale, Christie's 6 June 1863. A *Scene from Romeo and Juliet* by Elmore was in the Thomas Greenwood sale, Christie's 12 March 1875, lot 312, bought Muirhead (£67.4s.).

3 Altick, *op. cit.*, however, argues that the sexual freedom in WAG 2815 suggests a date 'no earlier than the 1870s'. Elmore did exhibit some pictures with amorous subjects at the Liverpool Academy in the early 1840s.

4 George Audley, *Collection of Pictures*, 1923, p. 16, no. 43.

FAED, Thomas (1826–1900)

The Gamekeeper's Cottage

WAG 2606
Canvas: 56 × 42.5 cm
Signed: *F[– – –]* (on handkerchief)

This painting is probably to be identified with the *Keeper's Wife: Background by A. Fraser* included in the artist's List of Pictures Painted by T. Faed from the Year 1845 or 1846[1] under the general title 'don't remember the year when exhibited but painted as follows';[2] the provenance (see below) and the general context of the List of Pictures suggest that it was an early work.

PROV: Walter Thompson sale, J.F. Griffiths (Liverpool) 28 March 1860, lot 44 as *The Gamekeeper's Wife – The Background Accessories by Alexander Fraser*, 21 × 16 in. (£120.15s.).[3] Bequeathed by William Hall Walker (first Baron Wavertree) 1933.

1 MS National Gallery of Scotland, Edinburgh. WAG 2606 is, however, listed by M. McKerrow, *The Faeds*, 1982, p. 157, as the work, exclusively, of Thomas Faed. The comments in the artist's List of Pictures imply that the A. Fraser in question was Alexander Fraser (1786–1865), who also collaborated with David Wilkie.

2 The artist exhibited *The Keeper's Daughter* at the 1884 Royal Academy Exhibition, but the quotation in the catalogue suggests that this picture had an outdoor setting.

3 No buyer's name is recorded for lot 44, but lot 32 at this sale, Alexander Johnston's *The Introduction of Flora Macdonald to Prince Charles Edward Stuart* (see p. **235**, WAG 587), is listed as bought by 'Walker' and this picture, like WAG 2606, was given to the Walker Art Gallery by Lord Wavertree. WAG 587 and perhaps WAG 2606 were presumably acquired at the 1860 sale, either by Peter Walker (1795–1879) or by Sir Andrew Barclay Walker (1824–1893), respectively grandfather and father of the first Baron Wavertree.

The Gamekeeper's Cottage WAG 2606

In Time of War

WAG 2912
Canvas: 136 × 174 cm
Signed: *Thomas Faed 1876*

In Time of War was exhibited at the 1877 Royal Academy with a quotation in the catalogue from *Logan Braes* by Robert Burns (last two stanzas):

> *Within yon milk-white hawthorn bush,*
> *Amang her nestlings, sits the thrush;*
> *Her faithfu' mate will share her toil,*
> *Or wi' his song her cares beguile;*
> *But I, wi' my sweet nurslings here,*
> *Nae mate to help, nae mate to cheer,*
> *Pass widow'd nights and joyless days,*
> *While Willie's far frae Logan braes.*

> *O wae upon you, Men o' State,*
> *That brethren rouse to deadly hate!*
> *As ye make mony a fond heart mourn,*
> *Sae may it on your heads return!*
> *How can your flinty hearts enjoy*
> *The widow's tear, the orphan's cry?*
> *But soon may peace bring happy days,*
> *And Willie hame to Logan braes!*

It seems uncertain whether or not the pacifist message in painting and poem had any direct relevance to events of 1876–7; one reviewer suggested that it might relate to possible British involvement in the 1877–8 war between Russia and Turkey;[1] another was baffled by the title of *In Time of War*.[2]

Among reviewers the *Athenaeum*[3] offered a balanced judgment:

> In Time of War *is mannered in subject, style, and defects, yet it has not a few merits. The scene is a Scottish cottage, of course. A widow is sitting mourning by the side of a bed where two of her orphans sleep the sleep of innocence; a baby is in her arms asleep; the best point of design in this picture is the sympathetic action and expression of the dog who sits at the woman's feet, and looks puzzled, but is full of feeling. The painting of the basket of firewood is clever; the carnations lack cleanness, clearness and precision of touch.*

A small version was sold by the artist to Thomas Agnew and Sons in 1876[4] and this may be the version that appeared at the John Hargreaves sale, Christie's 2 May 1896, lot 48, bought Agnew (£315), and at Christie's (New

In Time of War WAG 2912

York) 28 October 1981, lot 240 (47.7 × 62.5 cm, signed and dated 1876); the Christie's (New York) version differs slightly from the Liverpool painting, particularly in the accessories. The artist exhibited a painting entitled *Logan Braes* at Earls Court in 1897 (609).

PROV: Bought from the artist by Ralph Brocklebank in 1877 (£2,100, without copyright);[5] his sale, Christie's 29 April 1893, lot 79, bought in (£771.15*s*.); presented by Brocklebank's three sons in his memory 1893.

EXH: Royal Academy 1877 (266); Royal Scottish Academy 1878 (228); Berlin Jubilee Exhibition 1886.

1 *Illustrated London News*, 19 May 1877, p. 674:

> *The work only misses the foremost rank among its companions through a vague irresolution of purpose which seems to have flitted across Mr. Faed's mind in scheming out his drama. It is as though the artist, ranging far afield to see what the open and what the covert would yield, had brought down the Russo-Turkish war, and the potential contingency of England being embroiled in that deplorable struggle, by a very long shot indeed.*

M. McKerrow, *The Faeds*, 1982, p. 107, states that WAG 2912 referred to the Crimean War, meaning presumably that Faed was warning against any repetition of that war. For Faed's enthusiasm for Burns, see McKerrow, *op. cit.*, pp. 88–9.

2 *Saturday Review*, 2 June 1877, p. 671.

3 *Athenaeum*, 26 May 1877, p. 675. The reviews in the *Spectator*, 12 May and 23 June 1877, pp. 599 and 792 were dismissive. *The Times*, 5 May 1877, noted the absence of realism in WAG 2912.

4 List of Pictures Painted by T. Faed from the Year 1845 or 1846, MS National Gallery of Scotland, Edinburgh.

5 List of Pictures Painted, *op. cit.*; E. Rimbault Dibdin, 'Mr. Brocklebank's Collection at Childwall Hall', *Magazine of Art*, 1891, pp. 88–9.

Free from Care

WAG 223
Canvas: 61.4 × 45.8 cm
Signed: *Thomas Faed 1878*

The artist recorded in his List of Pictures Painted by T. Faed from the Year 1845 or 1846[1] that in 1877–8 he painted *Summer in the Highlands* and a small picture entitled either *A Summer Flower* or *A Wild Flower*, and that in July 1878 he sold the former to Agnew's for 900 guineas and the latter to the same firm for 300 guineas. Agnew's records indicate, however, that in August 1878 they bought from Faed *Highland Flower* or *Her wee Brither*, which they sold to Robert Orr for £1,155 and *Free from Care*, which they sold to George Holt for £525. It would seem very likely therefore that *Free from Care* was originally entitled *A Summer Flower* or *A Wild Flower*. There is a further complication. The *Free from Care* exhibited by the artist at the 1879 Royal Academy exhibition (207) had a baby sleeping by the seated girl and the girl's shawl was bright yellow (not orange); but in other respects it was very similar to the Liverpool *Free from*

Free from Care WAG 223

129

Care.[2] It is impossible to be certain over the exact sequence of events. The artist, or Agnew's, may have changed the titles, or the titles may have been wrongly listed by either or both. There may have been two versions of *Free from Care* or only one version subsequently altered by the artist – perhaps at the request of Agnew's or of George Holt.

PROV: Bought by Agnew's (£315) from the artist;[3] bought by George Holt from Agnew's (Liverpool) 30 August 1878 (£525); bequeathed by Emma Holt 1944.

EXH: (?) Royal Academy 1879 (207) as *Free from Care.*

1 MS National Gallery of Scotland, Edinburgh. WAG 223 is listed by M. McKerrow, *The Faeds*, 1982, p. 153.

2 *Athenaeum*, 31 May 1879, p. 702. See also *Art Journal*, 1879, p. 149.

3 Copyright was not included. See above for a discussion about the identity of this painting.

When the Children are Asleep WAG 2816

When the Children are Asleep

WAG 2816
Canvas: 152.4 × 110.5 cm
Signed: *Thomas Faed 1885*

According to McKerrow this painting inspired many popular songs when first exhibited in 1885.[1] Of it, the *Art Journal*[2] critic wrote: 'Among more homely scenes in which pathos or humour plays a prominent part Mr. Faed is always to be found and . . . *When the Children are Asleep* recalls some of his best work.' The *Athenaeum*[3] described the scene and then added: 'All her costume and the accessories are painted with firmness and breadth unusual even with Mr. Faed. The background seems on the other hand to be less rich in colour and tone and less luminous than hitherto.' The artist wrote to an unidentified correspondent around 1885 about this painting:[4]

You object to the box bed as having the dimensions of a room. You are quite right and so am I – the bed is just a part of the room panelled off – in every way but in depth the same size – it is perhaps not wise to paint such a bed now but they still exist and I thought the peat brown panelling relieved my figures.

The figure of the reading woman re-appeared unaltered in Faed's *A Page of Burns* of 1888.[5]

REPR: Pall Mall Gazette, *Pictures of 1885*, p. 39.

PROV: Bought from the artist 1885 (£700).[6]

EXH: Royal Academy 1885 (225); Liverpool Autumn Exhibition 1885 (368); Paris, *Exposition Universelle*, 1889 (40).

1 M. McKerrow, *The Faeds*, 1982, p. 120.

2 *Art Journal*, 1885, p. 258. The *Illustrated London News*, 9 May 1885, vol. 86, p. 481, also admired the homely scene and the healthy sentiment but asked where the light in WAG 2816 came from as the mother had blown out the candle.

3 *Athenaeum*, 16 May 1885, p. 636.

4 MS Edinburgh University Library (Dc.4.101). The compiler is indebted to Helen Smailes for this reference.

5 Reproduced in *Royal Academy Pictures*, 1888, p. 15.

6 The artist's List of Pictures Painted by T. Faed from the Year 1845 or 1846 (MS National Gallery of Scotland, Edinburgh) has '£800–£700 Tooth', implying that Arthur Tooth was (or was intended to be) an intermediary.

FAED, Thomas, imitator of
Cottage Interior
WAG 222
Mill-board[1]: 24.1 × 30.4 cm
Inscribed: *T. Faed*

Although the attribution of this painting is accepted by McKerrow,[2] its quality suggests that it may not be autograph.[3]

PROV: Bought by George Holt from the dealer J. Polak 28 April 1876 (£260 with other items); bequeathed by Emma Holt 1944.

1 Winsor and Newton prepared mill-board (label).

2 M. McKerrow, *The Faeds*, 1982, p. 157.

3 See McKerrow, *op. cit.*, p. 123, for early forgeries of Faed's work.

FARQUHARSON, David (1839–1907)
Between Tarbet and Falkirk
WAG 376
Canvas: 57 × 92 cm
Signed: *D. Farquharson × 4–5*[1]

Tarbet is on the west shore of Loch Lomond and this landscape may portray one of the drove roads which ran through Tarbet and then down to the south side of Loch Lomond before going east to Falkirk; in this case the southern end of the loch would be visible.[2] The artist exhibited his later work principally at Arthur Tooth and Sons, but this painting does not seem to have appeared there.

PROV: Bequeathed by C.E. Ashworth 1932.

1 This means 1884–5; the artist wrote eights as the letter X in his dates; for example, he signed his *Herring Fleet leaving the Dee* (now in Aberdeen Art Gallery): *David Farquharson XX* meaning that it was painted in 1888. The compiler is indebted to Dr. Lindsay Errington for assistance over this.

Cottage Interior WAG 222

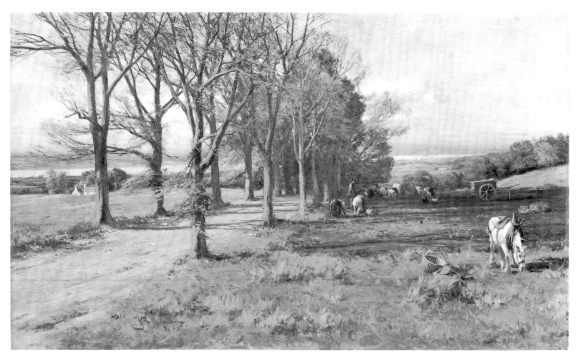

Between Tarbet and Falkirk WAG 376

2 John Sanderson, letter to the compiler, 3 June
1985. Dr. Lindsay Errington, letter to the
compiler, 9 September 1991, doubts that WAG
376 could represent any view between this Tarbet
and Falkirk. She prefers to read the title as
Between Larbert and Falkirk, but Mr. Sanderson
denies that WAG 376 could depict any site
between those two places.

FARQUHARSON, Joseph (1847–1935)
And all the air a solemn silence holds
WAG 703
Canvas: 107.7 × 153 cm
Signed: *J. Farquharson*

This was probably the *And all the air a solemn silence holds* exhibited at the 1900 Royal Academy,[1] but the photograph of it in the artist's four-volume record of his pictures[2] is annotated *When Winter Holds his Sway* and it has a label on its back *And all the world a silence holds*. The critic of the *Athenaeum*[3] reviewed the painting at the 1900 Royal Academy exhibition without enthusiasm:

All the air a solemn silence holds *owes its undeniable attractiveness to its being bright and happily composed, as a snow-piece, expansive and homogeneous, well massed and poetically suggestive in a very high degree. Yet a glance at any part of it, such as the foreground on our left, or the middle distance in the centre, gives the student a kind of shock, because the part examined is destitute of solidity and the fruits of sincere research and trained skill stringently and faithfully exercised; at the best it is an instinct with the lamp and 'chic' carried to a high pitch. It must be remembered, too, that the best kind of 'chic' has been truly described as a sort of artistic shorthand – a digest, so to say, of knowledge and research in the smallest compass. Here, however, the 'chic' is a digest of nothing, and aims at delusion only on the easiest terms.* All the air *belongs to the same category of delusion as Mr. Leader's* Hill, Vale, and Stream *but, though quite as fallacious, it is a great deal cleverer, and, in its way, artistically delusive, which cannot be said of Mr. Leader's performances.*

PROV: The late C.H. Morgan Griffiths sale, Christie's 1 May 1936, lot 33, bought R. MacConnal (£69.6*s*.); bought by Robert Gladstone through Grindley and Palmer April 1938 (£157.10*s*.); presented by Robert Gladstone 1938.

And all the air a solemn silence holds WAG 703

EXH: Royal Academy 1900 (339).

1 As asserted in Aberdeen Art Gallery, *Joseph Farquharson of Finzean*, 1985, p. 28, no. 48. The Christie's catalogue of 1 May 1936 also states that WAG 703 was exhibited at the 1900 Royal Academy. This title is a misquotation from Thomas Gray's *Elegy Written in a Country Churchyard*, stanza 2; Gray has 'stillness' in place of 'silence'. G.F. Watts used this quotation for a painting of 1868 (New Gallery, *G.F. Watts*, 1896–1897 (30)).

2 For further details of this record see Aberdeen Art Gallery, *op. cit.*, p. 38, no. 89.

3 *Athenaeum*, 16 June 1900, p. 758.

Dawn

WAG 143
Canvas: 102.1 × 153.2 cm
Signed: *J. Farquharson*

There seems to be no evidence that the heron flying low over the water illuminated by the dawn light has any particular symbolic purpose and *Dawn* may just be one of the artist's characteristic exercises in unusual – and technically demanding – effects of light and shadow.[1] A reduced replica dated 1904 and inscribed *Sophia Muller* was sold at Christie's and Edmiston's (Glasgow) 3 July 1980, lot 106 (now in a Glasgow private collection),[2] while Farquharson's *Heron at Sunset*, sold at Sotheby's (Hopetoun House) 16 November 1981, lot 613, has a heron identical to that in *Dawn*. Yet another version, signed and dated 1910, is in a private collection in North Wales; it measures about 86 × 106 cm.

At the 1903 Royal Academy, *Dawn* received little attention from the critics, who preferred Farquharson's *The Shortening Winter's Day is near a Close* (Lady Lever Art Gallery, Port Sunlight) which was on view at the same exhibition.[3]

PROV: Presented by Mrs. George Holt and Miss E.G. Holt 1903.

EXH: Royal Academy 1903 (398); Liverpool Autumn Exhibition 1903 (114).

1 The artist must, however, have intended some symbolism in his *The Shepherd* of 1911, in which the shepherd is profiled against a dramatic sunrise forming a halo around him (reproduced in W.D. Sinclair, 'Joseph Farquharson', *Art Annual*, 1912, p. 24). J.L. Caw, *Scottish Painting*, 1908, p. 306, saw the artist as preoccupied by a scientific study of nature and 'wanting in glamour, in poetry and in that personal perception of reality . . .' Perhaps Farquharson knew G.F. Watts's *Return of the Dove* of 1869 (Buscot Park), which has a composition similar to that of WAG 143.

Dawn WAG 143

2 Mrs. George Holt, one of the donors of WAG
 143, wrote to the artist in 1911 asking him to do
 another replica of the painting; he declined as he
 then had no sketch or study of the painting but
 only a photograph. The photograph in question
 was presumably the one in the four volumes kept
 by the artist containing records of his pictures (for
 further details see Aberdeen Art Gallery, *Joseph
 Farquharson of Finzean*, 1985, p. 38, no. 89). This
 photograph was inscribed by the artist *1903
 Dawn*.

3 A.L. Baldry in *Art Journal*, 1903, p. 178.

FILDES, Samuel Luke (1844–1927)
A Venetian Flower Girl
WAG 225
Panel: 42.1 × 28.2 cm
Signed: *Luke Fildes 86*

Fildes exhibited a *Venetian Flower Girl* at the
1884 Royal Academy (747), and at the 1886
Royal Academy he exhibited a *Flower Girl*
61) and a *Daughter of the Lagoons* (288). This
A Venetian Flower Girl cannot, however, be
identified with any of these paintings, nor does
it seem to be a variant or version of any of
them.[1]

PROV: Bought from the artist by Agnew's 18 June
1886 as a *Flower Seller*; sold to George Holt 17
August 1886 (£175); bequeathed by Emma Holt
1944.

EXH: Walker Art Gallery, *Historical Exhibition of
Liverpool Art*, 1908 (59).

1 Compare the reviews and reproductions of the
 three Royal Academy paintings in Henry

Blackburn, *Academy Notes*, 1884, p. 59, in the *Art Journal*, 1884, p. 242, in the *Athenaeum*, 8 May 1886, pp. 620 and 622, in Henry Blackburn, *Academy Notes*, 1886, pp. 22 and 46, and in the *Art Journal*, 1886, p. 186; the girl was standing in all these pictures. The 1884 Royal Academy *Venetian Flower Girl* was lent to the Royal Academy, *Winter Exhibition*, 1928 (278) by Lady Waechter and measured 74 × 46½ in.; the 1886 Royal Academy *Daughter of the Lagoons* is in Warrington Art Gallery and Museum, while the 1886 Royal Academy *Flower Girl* is now in the Hamburg Kunsthalle (Hamburger Kunsthalle, *Katalog der Meister des 19. Jahrhunderts*, 1969, p. 68, which states that the Hamburg painting is a replica of an 1884 picture – presumably not the 1884 Royal Academy *Venetian Flower Girl* as replicas of pictures already exhibited in London would not have been admissible in Royal Academy exhibitions). The two *Flower Girls* are also reproduced in D.C. Thomson, 'Luke Fildes, R.A.', *Art Annual*, 1895, pp. 15 and 18. Another *Venetian Girl* is in the Russell-Cotes Art Gallery and Museum, Bournemouth. It is dated 1902.

A Venetian Flower Girl
WAG 225

136

Fanny, Lady Fildes (died 1927)

WAG 2120
Canvas: 143.5 × 97.2 cm
Signed: *Luke Fildes 1887*
Inscribed: *Mrs. Luke Fildes by Luke Fildes*

The sitter was the artist's wife, born Miss Fanny Woods; she was the sister of the artist's close friend Henry Woods and herself an artist; she married Luke Fildes in 1874. The portrait was begun in May 1886 after the artist had visited the Paris Salon, where he had been impressed by Carolus Duran's *Portrait de Miss*ˣˣˣ (444).[1]

This was one of the artist's first portraits and marked his transition from social realist and painter of Venetian genre to portrait painter;[2] it is said to have had 'some bearing on his election as a Royal Academician'[3] in March 1887.

The portrait was well received by the critics, although the *Saturday Review*[4] saw it as not as 'strong' or as 'thoroughly modelled' as some of its competitors and the *Academy*[5] criticized the 'too even quality of the flesh'. Claude Phillips in the *Academy* went on: 'The figure, which is placed with an unrestrained grace of peculiar charm is further remarkable for delicate truth of characterization and for the suggestion of a temperament of natural vivacity', and he then identified Alfred Stevens as the source for Fildes's colour scheme and Frank Holl as the inspiration behind Fildes's move to portraiture. The *Magazine of Art*[6] described the colours as 'bright and assertive' and noted that 'the grouping of kindred orange and tawny hues' was 'daring and unconventional'.

The portrait was shown extensively in international exhibitions as it was one of the few works that Fildes retained and thus was easily available for loan exhibitions.[7] Most notably it appeared at the 1889 Paris *Exposition Universelle*, where, according to the *Art Journal*,[8] it 'elicited nothing but praise; the canvas was well filled, largement traité, d'une ordonnance fort élégante'.

REPR: J. Maas, *The Victorian Art World in Photographs*, 1984, p. 30 (while still in the artist's studio).

PROV: Presented by Luke Fildes, son of the artist, 1952.

Fanny, Lady Fildes (died 1927) WAG 2120

EXH: Royal Academy 1887 (185); Glasgow International Exhibition 1888 (98); Paris, *Exposition Universelle*, 1889 (43); Brussels International Exhibition 1897; Campden House Exhibition 1898; Guildhall Art Gallery 1900 (29); London, *Franco-British Exhibition*, 1908 (113); Royal Academy, *Winter Exhibition*, 1928 (271).

1 Luke V. Fildes, *Luke Fildes, R.A.*, 1968, pp. 103–4; Carolus Duran was the only French artist by whom Fildes was influenced – according to his own account; see Fildes, *op. cit.*, p. 69. On 23 August 1886 Fildes wrote to Henry Woods: 'Fanny's portrait promises first rate' (MS Victoria & Albert Museum Library 86 PP3). WAG 2120 was, however, certainly being painted as late as February/March 1887, as the artist wrote to Henry Woods in Venice during February asking for 'an artistic silver [bracelet] after the style and character of that beautiful clasp you gave to Fanny'; the bracelet was to be incorporated into WAG 2120, but in the end it was never sent and Fildes did without it (MS Victoria & Albert Museum Library 86 PP3).

2 D.C. Thomson, 'Luke Fildes, R.A.', *Art Annual*, 1895, p. 18:

It will be readily admitted that it was an eminently natural proceeding for Mr. Fildes to become a painter of portraits, and the wonder is not that he has become one, but rather that he did not paint portraits from the beginning. Yet it was only in 1887 when he had reached the fulness of his powers and as a Royal Academician that he painted a portrait, and his wife was the first subject.

Whether or not WAG 2120 was painted as a demonstration to future sitters of Fildes's skill as a portrait painter is uncertain; significantly Henry Woods wrote to Fildes on 19 June 1887, while WAG 2120 was on display at the Royal Academy: 'Such a notice as you had on Fanny's portrait was very much more valuable – it would bring you sitters if you wanted them.' (MS Victoria & Albert Museum Library 86 PP3)

3 Luke V. Fildes, letter to the curator 27 May 1952. The review of WAG 2120 in the *Art Journal*, 1887, p. 246, also suggests that this portrait contributed towards Fildes's election to the Royal Academy – or did he become a portrait painter once he had secured election to the Royal Academy? The correspondence between Fildes and Henry Woods of March 1887 (MS Victoria & Albert Museum

Library 86 PP3) does not indicate that WAG 2120 played any part in Fildes's election, which took place on 10 March before the completion of WAG 2120.

4 *Saturday Review*, 21 May 1887, p. 733. *The Times*, 30 April 1887, offered the most enthusiastic review: 'the black evening dress is painted with all the power and mastery of the best French painters'; but it would have liked a deep grey blue background rather than a dark red one. George Bernard Shaw in the *World*, 4 May 1887, p. 562, found WAG 2120 'irresistible'.

5 *Academy*, 28 May 1887, pp. 383–4.

6 *Magazine of Art*, 1887, p. 271; the colours in WAG 2120 have presumably darkened considerably; an early photograph was reproduced in A.G. Temple, *The Art of Painting in the Queen's Reign*, 1897, p. 342.

7 Fildes, 1968, *op. cit.*, p. 128. Gladys Storey saw WAG 2120 in the artist's studio just before he died and noted that it was painted when Lady Fildes 'possessed quantities of beautiful red hair' (Gladys Storey, *All Sorts of People*, 1929, p. 217).

8 *Art Journal*, 1889, p. xii.

The Widower

WAG 1627
Canvas: 66.3 × 94 cm
Signed: *Luke Fildes*

This is a reduced copy after the original painting of 1875, now in the National Gallery of New South Wales, Sydney; it was painted by the artist at Broadstairs in October–December 1902.[1] It is essentially identical to the Sydney painting but the technique is somewhat blander and more smooth.

PROV: Commissioned from the artist by Agnew's and entered on their books on 19 January 1903;[2] bought 1904 (£1050).

EXH: Liverpool Autumn Exhibition 1904 (1217).

1 Letters from the artist to Henry Woods of 10 October and 12 November 1902; the artist described WAG 1627 variously as a copy and as a replica (MS Victoria & Albert Museum Library 86 PP4). The artist, however, wrote to Agnew's on 15 January 1905 (MS Walker Art Gallery):

 I had a feeling that it [The Widower at Sydney] was in a sense exiled from my artistic surroundings and I conceived the idea of painting this smaller version [WAG 1627] as the probability is the larger picture would never come to England again. Though in no obvious way is this version a departure from the larger one yet it is a completely independent production from memory, assisted by the sketches I made in 1875.

 The statements in this letter may not have been entirely accurate. WAG 1627 seems too close to the original to have been painted from memory,

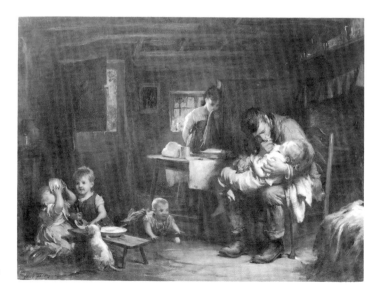

The Widower WAG 1627

even with the assistance of early sketches. Studies for the original painting were reproduced in D.C. Thomson, 'Luke Fildes R.A.', *Art Annual*, 1895, pp. 3, 4, 6, and an etching by G.W. Rhead, after one of these sketches, is reproduced in P.G. Hamerton, *Man in Art*, 1892, pp. 90–1; one of these sketches was owned by Dr. P.A. Campbell of Deansfield, Tarporley, Cheshire, in 1966 and another was no. 75 in Manchester City Art Galleries, *Hard Times*, 1987 (later sold at Christie's 13 March 1992, lot 166); any of these studies might have been used for WAG 1627; most of them seem to have been in the artist's sale, Christie's 24 June 1927, lots 18, 19, 22 and 26; lot 26 is listed as a version of the composition. The original painting itself was engraved in the *Magazine of Art*, 1882, p. 309, and etched in 1883 by Leopold Flameng for the Fine Art Society. Copyright may explain the artist's rather disingenuous letter; D.C. Thomson, *op. cit.*, was unable to reproduce the original version for reasons of copyright and the artist retained his copyright in WAG 1627 when it was acquired by the Walker Art Gallery (Agnew's letter to the Curator of the Walker Art Gallery, 21 February 1905), presumably on the grounds that 'a completely independent production from memory assisted by sketches' created a new copyright. For the 1875 version, conceived in 1874, see: Thomson, *op. cit.*, pp. 3–8; L.V. Fildes, *Luke Fildes*, 1968, pp. 25, 38–43; Art Gallery of New South Wales, Sydney, *Victorian Social Conscience*, 1976, pp. 33–4, which quotes some of the reviews when it was exhibited at the Royal Academy and Art Gallery of New South Wales, *Catalogue of British Paintings* (by Renée Free, not dated) pp. 58–9, which describes WAG 1627 as a smaller version – see also Manchester City Art Galleries, *op. cit.*, pp. 85–6, 148. The original 1875 version was acquired by the Art Gallery of New South Wales from the Tom Taylor sale, Christie's 28 April 1883, but came back to the artist in England for repair in 1890–1. A replica of *The Doctor* was no. 20 in the *Exhibition of Pictures painted especially for Thomas Agnew and Sons* 1900, and the Tate Gallery has a late replica of Fildes's *Applicants for Admission to a Casual Ward* (T 01227); this last replica was painted after 1908; it is not clear why, at the end of his career, Fildes was painting these replicas of his early social realist paintings; the Tate Gallery replica is much less finished than WAG 1627.

2 Agnew's Stock Books, where WAG 1627 is described as a study.

George V

WAG 7027
Canvas[1]: 279.9 × 182.7 cm
Signed: *Luke Fildes 1913*

This is a replica of the state portrait commissioned on the accession of George V in 1911 and completed in 1912.[2]

The commission for this replica caused considerable dissension between the artist and the Liverpool City Council.[3] Emboldened by the King's rather vague offer in August 1911 of some sittings in the future for the Liverpool portrait, the Council hoped that Fildes, who had replaced A.S. Cope, the King's first choice as artist (partly through his Liverpool connections) would paint an original portrait fairly quickly and not just supply in due course a

George V WAG 7027

replica of the state portrait which he had also been commissioned to paint. Fildes, however, only agreed to introduce some variations into a replica of the state portrait for his agreed fee, and completion was delayed into 1913 as the state portrait only became available for copying when the engraver had finished with it. Fildes explained that his fee was totally inadequate for an original portrait but that in doing replicas he always varied the extent of his own intervention according to the size of his fee and that Liverpool's fee would ensure for them substantial work on his part on the portrait. The City Council attempted to repudiate the commission but ultimately accepted Fildes's offer; there are no significant variations between the Liverpool portrait and the state portrait.[4]

PROV: Commissioned by Liverpool City Council August 1911 (£550 excluding the frame); transferred from the Liverpool Corporation Estates Committee to the Walker Art Gallery 1968.

1 Framemaker's stamp: John (?) Smith, 117 (or 127) Hampstead Road, N.W. London.

2 L.V. Fildes, *Luke Fildes*, 1968, pp. 193–7. Fildes had also painted the state portrait of Edward VII on his accession to the throne in 1901. W.A. Menzies was Fildes's regular copyist at this time; for example, he copied the portrait of Edward VII in August 1910 (MS letters from Fildes to Menzies in the Victoria & Albert Museum Library 86 HH, Box III).

3 Fildes sent copies of all the correspondence which had passed between him and the City Council to the King's private secretary in November 1912. These copies are still in the Royal Archives at Windsor Castle (RA GV 2897 (1–32)). The compiler acknowledges the gracious permission of Her Majesty the Queen to make use of this material and is indebted to Mr Charles Noble for drawing his attention to it.

4 The City Council commissioned from William Llewellyn a replica of his state portrait of Queen Mary at the same time that they commissioned WAG 7027 (see WAG 7028, p. **283**). This commission seems to have caused no problems and he did introduce a noticeable variation between his two portraits – the crown is missing in the Liverpool version.

FISHER, Samuel Melton (1859–1939)
Flower Makers
WAG 771
Canvas[1]: 56.4 × 43.7 cm
Signed: *SMF* (in monogram)

This is a version of the left-hand half of Fisher's *Clerkenwell Flower Makers* of 1896;[2] there are small differences between it and the original. Artificial flower production seems to have been a popular subject among late 19th-century artists. Alexander Mann's *Artificial Flower Makers* (now Fine Art Society) was painted in Paris in 1884[3] and *The Flower Maker* by Harriet Campbell Foss was exhibited at the 1892 Société Nationale des Beaux Arts exhibition in Paris.[4] Decorative appeal rather than social realism seems to have been the artist's motive.[5]

PROV: Anon sale, Christie's 17 March 1922, lot 103, bought Sampson (£9.9s.). Presented by George Audley[6] 1925.

EXH: Liverpool Autumn Exhibition 1924 (69).

1 Canvas stamp: Reeves and Sons, Cheapside.

2 For the 1896 picture, see A.C.R. Carter, 'Mr. Melton Fisher and his Work', *Art Journal*, 1899, pp. 237–8 (repr.) and A.L. Baldry, 'The Paintings of S. Melton Fisher', *Studio*, 1907–8, vol. 42, pp. 174–5 (repr.); the painting was based on the Water-Cress and Flower Girls' Mission founded in Clerkenwell by Baroness Burdett-Coutts; Fisher visited the Mission and observed the artificial flower makers at work; some of the resulting studies are reproduced in Carter, *op. cit.*, pp. 235–6. Fisher had begun his career as a follower of the Neo-Venetians and, on his return to London around 1895, sought similar subject matter there; see for example, the review in the *Athenaeum*, 23 May 1896, p. 690. The 1896 painting was reproduced in *Royal Academy Pictures*, 1896, p. 47 and in H. Blackburn, *Academy Notes*, 1896, p. 82.

3 Fine Art Society, *Alexander Mann*, 1983, no. 13 (reproduced in colour).

4 Reproduced in L.M. Fink, *American Art at the Nineteenth Century Paris Salons*, 1990, p. 223.

5 See Fink, *op. cit.*, for an opposing view.

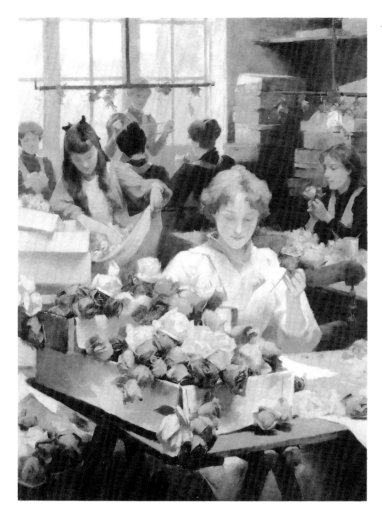

6 George Audley, *Collection of Pictures*, 1923, p. 19.

The Chess Players

WAG 2121
Canvas[1]: 132.7 × 101.7 cm
Signed: *S. Melton Fisher*

The Chess Players was praised by both M.H. Spielmann[2] and A.L. Baldry[3] when it was exhibited at the 1903 Royal Academy. The former wrote: 'Mr. Melton Fisher's pretty group, "The Chess Players", is delightfully vivacious in colour, and is distinguished by all his accustomed freshness of brushwork and delicacy of tone graduation.' The latter observed: 'Costume, no doubt, judiciously used, is of vast assistance in the composition of an attractive work – as we see in the gracious picture of that ever-refined and distinguished painter, Mr. Melton Fisher, "The Chess Players"; but we may find in artistic motive a delight for which no accessory can be a substitute.'

REPR: *Royal Academy Pictures*, 1903, p. 96; H. Blackburn, *Academy Notes*, 1903, p. 69; Liverpool Autumn Exhibition catalogue, 1903, p. 99.

PROV: Bought from the artist 1903 (£250).

EXH: Royal Academy 1903 (221); Liverpool Autumn Exhibition 1903 (859); St. Louis International Exhibition 1904 (60).

1 Label: Dolman and Sons, Compton Street.

2 *Magazine of Art*, 1903, p. 388.

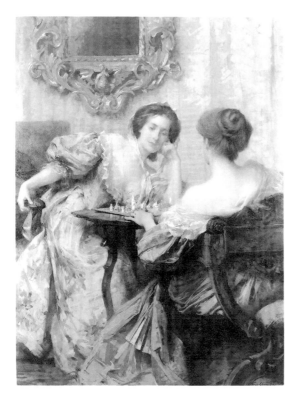

The Chess Players WAG 2121

3 *Art Journal*, 1903, p. 170. In his slightly later article on Fisher, 'The Paintings of S. Melton Fisher', *Studio*, 1907–8, vol. 42, p. 181, Baldry cites WAG 2121 as an example of the artist's gradual abandonment of realism and of scenes from everyday life in favour of a more abstract grace and colour and of 'those dainty fancies by which he is best known today'.

The Swing

WAG 3066
Canvas: 229 × 127.5 cm
Signed: *S. Melton Fisher*

REPR: *Royal Academy Pictures*, 1908, p. 120.

PROV: Presented by George Audley[1] 1925.

EXH: Royal Academy 1908 (408); Liverpool Autumn Exhibition 1924 (343).

1 WAG 3066 was listed by George Audley in his *Collection of Pictures*, 1923, p. 19, as *Restful Moments*, and it was presented to the Walker Art Gallery with that title; there is a MS label on the back of WAG 3066 reading: *No. 1 . . . the Shepherdess . . .*

The Swing WAG 3066

Blackberry Gathering WAG 1520

FORBES, Elizabeth Adela (1859–1912)
Blackberry Gathering
WAG 1520
Canvas[1]: 83.9 × 99.8 cm
Signed: *E A FORBES* (initials in monogram)

Blackberry Gathering was described by the critic of the *Studio*[2] as 'a good example of the work of an artist who had charm of manner and true individuality of style'.

REPR: *Royal Academy Pictures*, 1912, p. 142 (as 40 × 50 in.); Black and White, *Handbook to the Royal Academy*, 1912, p. 110; Pall Mall Magazine, *Pictures of 1912*, p. 62; *Studio*, 1912, vol. 56, p. 131.

PROV: Bequeathed by William James Ladeveze Davies 1953.

EXH: Royal Academy 1912 (489).

1 There is a frame maker's label on the back of WAG 1520 – that of H.W. Taylor, 61 Queens Road, Bayswater.

2 'Royal Academy Exhibition 1912', *Studio*, 1912, vol. 56, p. 14; U. Thieme and F. Becker (*Künstler-Lexikon*, 1916, vol. 12, p. 201) describe WAG 1520 as a 'Highland landscape'.

FORBES, Stanhope Alexander
(1857–1947)

A Street in Brittany

WAG 509
Canvas: 104.2 × 75.6 cm
Signed: *STANHOPE A FORBES. / à Cancale. 1881*

A Street in Brittany was painted at Cancale, a small fishing village near St. Malo between July and October 1881.[1] The street in question is now named the Rue Kitchener. The artist worked on it in the open air using local inhabitants as models, and he had persistent problems with assimilating the ever-changing sunlight, with absenteeism among his models, with wind and dust and with over-curious children. As, however, the painting is set almost entirely in the shade, he could work on it whether or not the sun was shining, and he was also painting an interior scene on which he could concentrate if the weather was bad.[2] *A Street in Brittany* and the interior scene were the artist's first figure compositions[3] and his first attempt to render, precisely and directly, open-air effects as he saw them in front of his easel.[4] According to Mrs. Lionel Birch, the women in the painting are 'knitting blue jerseys for their fisher husbands'; the foreground woman holds the large needle traditionally used to repair nets and may be working on netting attached to her belt.[5]

A Street in Brittany and the interior scene were on exhibition in the artist's Paris studio during December 1881, and most visitors – except Forbes's Parisian master, Leon Bonnat – preferred the interior scene.[6] The artist himself wrote of *A Street in Brittany*: 'I fear from certain peculiarities it won't go down at all with the British public.' He was presumably referring to the obtrusive brushwork, to the blue tonality and to the fact that the foreground figure seems to be out of scale with the rest of the composition; but he may also have been alluding to the dispassionate, unsentimental rendering of the figures.[7] He was certainly correct so far as the critics at the 1882 Royal Academy were concerned; none seem to have mentioned the painting.[8]

A watercolour version (58.5 × 40.5 cm) is now in a Sussex private collection; it is signed and dated 1881 and is identical to the Walker Art Gallery painting, except that it lacks the foreground figure and the space in which she stands – that is the watercolour lacks about the first one-and-a-half metres into depth of the Liverpool picture; it must surely be later than the Liverpool painting and may have been done to answer criticism that the original foreground figure was out of scale with the rest of the composition.

PROV: Bought from the artist 1882 (£73.10s.).[9]

EXH: Royal Academy 1882 (104); Liverpool Autumn Exhibition 1882 (464); Newlyn Art Gallery, *Artists of the Newlyn School*, 1880–1900 (1); Royal Academy, *Post Impressionism*, 1979–80 (288).

1 H.H. La Thangue was with him at Cancale and may have painted his *The Boat-building Yard* there (now National Maritime Museum, Greenwich) – see Oldham Art Gallery, *H.H. La Thangue*, 1978, p. 8, fig. 3. La Thangue's picture was exhibited at the Grosvenor Gallery, 1882, no. 46, as *Study in a Boat Building Yard on the French Coast*. Norman Garstin in 'The Work of Stanhope Forbes', *Studio*, 1901, vol. 23, p. 86, states that La Thangue greatly influenced the technique and brushwork of Forbes's early paintings. Since La Thangue destroyed much of his early work, this assertion is hard to verify. Cancale seems to have already been popular with artists in 1881; J.S. Sargent was there in 1877 and versions of his *Oyster Gatherers of Cancale* (1878) are in the Boston Museum of Fine Art and the Corcoran Gallery, Washington; there were, however, apparently no other artists at Cancale in the summer of 1881 – except Forbes and La Thangue (Newlyn Art Gallery, *Artists of the Newlyn School 1880–1900*, 1979, p. 55). Cancale was mentioned for its oysters in John Murray, *A Handbook for Travellers in France*, 1879, vol. 1, p. 111, but not for its picturesque or tourist appeal; it was not on the railway, but access from St. Malo by omnibus was easy. For the appeal of Cancale to artists see particularly Denise Delouche, *Peintres de la Bretagne: Découverte d'une Province*, 1977, pp. 314 ff., and Denise Delouche, *Les Peintres de la Bretagne avant Gauguin*, 1978, vol. 2, pp. 704 ff.; for the appeal of Brittany generally to Irish artists (including Forbes) see Julian Campbell, 'Les Irlandais en Bretagne, 1860–1914', in Denise Delouche, *Arts de l'Ouest, Études et Documents, Pont Aven et ses Peintres*, 1986, pp. 37 ff. Cancale seems to have been less imbued with primitive Breton culture

A Street in Brittany WAG 509

STANHOPE A FORBES.

à Cancale. 1881.

145

and customs than other villages and towns further west and south; Forbes noted that the peasants no longer wore 'the regular Breton costume', a year later he found Quimperlé more thoroughly Breton (but very dull) – see Caroline Fox, *Stanhope Forbes and the Newlyn School*, 1993, p. 15; Henry Blackburn wrote in his *Breton Folk* of 1880 (p. 10): 'The fishermen of Cancale make money and save it and send their children to school by train to Rennes and the fisherman's daughter comes back in a costume that makes her neighbours envious.' The principal sources for information about WAG 509 are the letters written by the artist to his mother; they are now in the Tate Gallery and are extensively quoted in Newlyn Art Gallery, *op. cit.*, pp. 55 ff., 73 ff.; Michael Jacobs, *The Good and Simple Life*, 1985, pp. 70 ff., also discusses the artist's 1881 letters from Cancale. The compiler is indebted to Francis Greenacre and to the Tate Gallery Archives Department for the opportunity to study these letters.

2 Newlyn Art Gallery, *op. cit.*; Forbes had to abandon his first Cancale paintings when his models left him, so great was his adherence to literal representation (letter to his mother of July 1881); on 20 September 1881 he wrote to his mother: 'The Street is still going on but is nearing its termination. I think you will find it too improved.' On 1–2 October he reported to her: 'The street scene will I think please you. Unfortunately the sun's path is now so different from what it was when we came down that our effects have greatly changed.' Finally on 23 October 1881, he told his mother: 'The Street has gone by petite vitesse in a case with the Chantiers to Paris – and on the whole I am satisfied with it.' The interior scene seems to have been bought by John Maddocks (Newlyn Art Gallery, *op. cit.*, p. 69) but it does not appear in Maddocks' sale, Christie's 30 April 1910.

3 Wilfred Meynell, 'Mr. Stanhope A. Forbes', *Art Journal*, 1892, p. 66. Mrs. Lionel Birch, *Stanhope A. Forbes and Elizabeth Stanhope Forbes*, 1906, p. 22, wrote: 'It was interesting, too, as the first attempt Stanhope Forbes had made in what might be termed figure composition, if, indeed, a picture in which there is so little of arrangement in the grouping of the figures can be termed a composition.'

4 P.G. Hamerton in 'The Lighthouse', *Scribner's Magazine*, 1894, vol. 15, p. 689, wrote:

Mr. Forbes says: 'I was wild to attack this great problem of the open-air effect myself', so he started for Brittany, and arrived by chance at the quaint little village of Cancale, near St. Malo. There he chose a picturesque little street, set up his easel out-of-doors, and conscientiously painted from nature a picture full of figures, all from local models, who had posed for the young artist during the progress of his work.

The artist himself wrote to the Curator of the Walker Art Gallery on 8 January 1928 that WAG 509 was 'the very first out-of-door subject painting I painted and exhibited' (MS Walker Art Gallery).

5 Birch, *op. cit.*, p. 22. Hervé Joubeaux, letter to the compiler 23 May 1986.

6 Newlyn Art Gallery, *op. cit.*, p. 74; Bonnat did not approve of Forbes's interest in literal open-air painting but still remained generally sympathetic, see Hamerton, *op. cit.*, p. 690.

7 Later he wrote to his mother: 'I am most anxious to know if any of the critics noticed the disparity in size of the figure in the foreground and those further off and was it found too blue'; see Fox, *op. cit.*, p. 4 and Newlyn Art Gallery, *op. cit.*, p. 74. These aspects of WAG 509 are discussed in K. Bendiner, *Introduction to Victorian Painting*, 1985, pp. 108–9; Bendiner rightly sees no symbolical significance in the spatial detachment of the foreground figure. Delouche, 1978, *op. cit.*, pp. 705–6, also notes the exaggerated scale of the foreground in WAG 509 and its uncertain relationship with the sharp perspective of the background. Whether the awkwardness in scale and perspective was due to the artist's inexperience or to a deliberate stylistic innovation imitating idiosyncratically the shallow, detached foregrounds of Bastien-Lepage is uncertain – Plymouth City Art Gallery, *Stanhope Forbes*, 1964, p. 2, also notes the influence of Bastien-Lepage over WAG 509. The carefully contrived variations in brushwork and focus over the surface of WAG 509, together with the subdued lighting, may also reflect the influence of Bastien-Lepage.

8 Birch, *op. cit.*, p. 22, however, states that WAG 509 'attracted favourable attention' at the 1882 Royal Academy.

9 It was the purchase of WAG 509 from the 1882 Liverpool Autumn Exhibition that encouraged

the artist to establish himself as an open-air painter of peasant subjects rather than rely on the safer career of portrait painter (F. Dolman, 'Mr. Stanhope A. Forbes', *Strand Magazine*, November 1901, p. 491; Hamerton, *op. cit.*, pp. 689–90); 'it was the first real encouragement I had received' – the artist's letter to the Curator of the Walker Art Gallery of 8 January 1928, *op. cit.* The artist told W.B. Forwood that the purchase of WAG 509 was 'the turning point in his life and art work' (*Liverpool Daily Post*, 27 October 1892).

By late 1882 Forbes was known to two great collectors, his uncle, James Staats Forbes, and the Bradford collector John Maddocks. Maddocks owned La Thangue's *The Boat-Building Yard* (George Thomson, 'Henry Herbert La Thangue', *Studio*, 1896–7, vol. 9, p. 171, repr.); in 1882 he also acquired Forbes's *Old Convent, Quimperlé* of 1882 (reproduced in Birch, *op. cit.*, p. 22 and last recorded in the John Maddocks sale, Christie's 30 April 1910, lot 48), having persuaded the artist's uncle to forego his claim, and appears to have bought two Cancale paintings from Forbes as early as the autumn of 1881 (Newlyn Art Gallery, *op. cit.*, pp. 56, 69): neither of these two 1881 Cancale paintings seem, however, to have appeared in the above Maddocks sale or in the 1891 Bradford Museum and Art Gallery Loan Exhibition to which Maddocks lent a large part of his collection.

It is possible that these two collectors recommended Forbes to the Walker Art Gallery's committee, then dominated by P.H. Rathbone (for whom see Edward Morris, 'Philip Henry Rathbone and the Purchase of Contemporary Foreign Paintings for the Walker Art Gallery, Liverpool, 1871–1914', *Annual Report and Bulletin of the Walker Art Gallery, Liverpool*, 1975–6, vol. 6, pp. 59 ff.), but the acquisition of WAG 509 remains a bold and historic decision as the artist was certainly in 1882 completely unknown to the general public. *Hard Times* by Frederick Brown (see p. **54**) and *Daily Bread* by T.B. Kennington (see p. **241**) are further examples of works by young, unknown, Paris-trained artists which were purchased by the Walker Art Gallery in the 1880s. In fact Forbes always found his Breton subjects hard to sell and not very popular; this was one of his reasons for moving to Newlyn in 1884 (M.H. Dixon, 'Stanhope A. Forbes', *Magazine of Art*, 1892, p. 182 and Dolman, *op. cit.*, p. 492).

Off to the Fishing Ground

WAG 1638
Canvas: 119.5 × 156 cm
Signed: *STANHOPE A FORBES 1886* (twice)

This was the first large painting undertaken by Forbes after the success of his *Fish Sale on a Cornish Beach*[1] of 1885 and in a letter to his mother of 30 November 1885[2] – which seems to be the first of his letters to contain a clear reference to *Off to the Fishing Ground* – he expresses his anxiety and worry in undertaking a large painting and competing against former success; in the same letter he recorded that Walter Langley advised him to leave one figure out (at that date the painting appears to have been entitled *Outward Bound*); in other letters of November 1885 he complained of the ferocity of the wind, but he also had some grey days suitable for painting – 'the weather is grey enough now to please me'.[3] In December C.N. Hemy saw the unfinished picture on a visit to Newlyn, and Forbes wrote to his mother: 'I was very nervous of showing it to such a judge of marine subjects but am glad to say he likes it and pronounced it a better picture than the *Fish Sale*, from which opinion I must, however, continue to dissent.' Hemy advised Forbes to paint a rough sea and Forbes agreed to do so adding: 'Nice prospect of sea sickness.'[4] On 26 January 1886, just after returning to Newlyn after a period away from work, he noted that he would need the eight weeks left to him to complete the picture for the 1886 Royal Academy exhibition.[5] He found it hard to work on the painting in February as he needed grey days without sun, rain or excessive cold – but if the weather was too favourable the fishing boats went out and Forbes lost his models; indeed by 13 February the weather had made the artist 'nearly crazy with worry'.[6] At the end of February, with only a month left for the completion of the painting for the Royal Academy exhibition, one of his boy models refused to continue sitting, and the use of a new model would have involved the total repainting of the figure – 'surely you must know that a figure once begun must be finished from the same model or else unpainted'. A photograph of *Off to the Fishing Ground*, still unfinished, was taken between 28 February and 3 March 1886 and a print of it is among the Stanhope Forbes

Off to the Fishing Ground WAG 1638 (colour plate 5)

papers now in the Tate Gallery; the boy seated in the left foreground with his hands clasped over his knees seems to have been the least finished part.[7] The weather appears to have been more favourable for the completion of the painting in March, when he was certainly finishing this foreground boy and apparently shortening and moving the arm of this or another boy.[8] The painting was not finished on 16 March, but was 'all but finished' on 21 March.[9]

The artist's judgment on *Off to the Fishing Ground* varied:[10] 'it is really in no way inferior if not really superior to my last one'; and 'I think myself now you will like it quite as well as the *Fish Sale* though perhaps in detail it is not so good'. Arthur William North, another Newlyn artist, seems to have suggested that it was too sketchy and the artist reacted sharply:[11]

His remark on my picture is all bosh. If anything it is overworked. Serré means thoroughly painted all through, it applies of course to the technique alone and consists in a kind of absolute modelling of every part of the picture leaving nothing to accidental brushmarks

and haphazard effects – a very valuable quality but capable of being abused. It means in fact the very opposite of Orchardson's style of painting.

The artist was considering the sale of the painting as early as 20 December 1885, when he sent a sketch to his mother to show to the London dealers; in early February 1886, Dowdeswell, one of these dealers, expressed interest in the painting and asked for a photograph; later in the month other dealers including McLean, Wallis and Colnaghi were also approached. On 3 March photographs of the painting, still unfinished, were sent to Dowdeswell with instructions that customers must not see them, and Dowdeswell seems to have travelled to Newlyn to see the painting; the artist fixed the price at £400 with copyright (or 350 guineas without copyright), and in the middle of March Dowdeswell offered £325 with a promise to make the offer up to 350 guineas if he found a customer. Forbes rejected this offer, partly because he had had a better one from Arthur Bateman, another Newlyn artist, who later built studios for artists in the village; Bateman's price was, however, £350 not 350 guineas, and eventually neither he nor Dowdeswell acquired the picture – nor even did a certain Michael Gwiny who seems to have offered £400.[12]

Off to the Fishing Ground does not appear to have been noticed by the reviewers of the *Art Journal* or the *Magazine of Art* at the 1886 Royal Academy, and Claude Phillips in the *Academy*[13] compared it rather unfavourably with the artist's *Fish Sale on a Cornish Beach* of 1885 – as Forbes had feared would be the case:

Mr. Stanhope Forbes, in 'Off to the Fishing Ground', if he does not altogether disappoint the admirers he won last year, does nothing to enhance his suddenly acquired reputation. We have again the cool, harmonious grey tones founded on French models, the atmospheric effect, the freedom from affectation and sentimentality; but we have also the same want of mastery in rendering perspective, both linear and aerial, and what is more serious, the same lack of genuine individuality, in the absence of which we do not venture to hope great things of an already skilful painter.

The *Saturday Review*,[14] however, provided a more sympathetic if still critical account of WAG 1638:

Mr. Stanhope Forbes paints still more broadly, and with a still more marked and mannered style of handling, than these Venetians, and with a still wider and truer investigation of the aspects of light. His 'Off to the Fishing Grounds' is without any of the spottiness observable in most of the preceding pictures; and, with the exception of one or two hardnesses of tone and relief, his boat and its figures seem about as true a rendering of ordinary natural objects illuminated in an ordinary natural way as could be accomplished. The treatment is arrived at logically rather than impressionally; and it is easy to conceive that a less formal, more powerful, and more inventive handler – such, for instance, as Mr. Sargent – without any altering of the tones, could have easily given more fire and brio to the result.

P.H. Rathbone[15] was even more enthusiastic, and wrote (at first discussing Sydney Starr's *Paddington*):

It is true that the horizon is rather higher than will be found convenient when the picture comes to be hung over a sideboard, but it is workmanlike and sound, with movement, though of a restrained character, and the values and composition well felt out. Much the same may be said of Mr. Stanhope Forbes' 'Off to the Fishing Grounds', which hangs opposite. Mr. Forbes looks at nature through blue spectacles, very charming ones it is true, but it would be still more satisfactory if he now and then changed their hue. The workmanship is however good and thorough, the texture and movement of the sea is especially successful, and the boat and the fishermen full of life and stir.

Among later commentators, Wilfrid Meynell[16] criticized the composition: 'It is a good picture, that was much outdone by better successors. Life and light it has, but hardly the distinction of arrangement that makes "Soldiers and Sailors" for example, so elegant as well as excellent.'

The model for the captain, the figure standing near the mast with his 'oiler' over his shoulders, was 'Uncle Plummer', a well-known Newlyn nautical character.[17] A version of that section of the painting, including this figure, is owned by Mr. N.R. Purdie.[18]

REPR: Pall Mall Gazette, *Pictures of 1886*, p. 44; H. Blackburn, *Academy Notes*, 1886, p. 89; Royal Academy, *Official Illustrated Catalogue*, 1886, plate 129; *Art Journal*, 1892, p. 65 (etching by L. Muller). These reproductions indicate that the painting has darkened substantially since 1886.

PROV: Purchased from the artist 1886 (£350).[19]

EXH: Royal Academy 1886 (1021); Liverpool Autumn Exhibition 1886 (392).

1 Newlyn Art Gallery, *Artists of the Newlyn School, 1880–1900*, 1979, pp. 77–9.

2 A series of letters, mostly written to his mother, are now in the Tate Gallery; many are undated and can only be provisionally assigned to the winter of 1885–6. It may eventually be shown that some of the letters used in this catalogue entry did not in fact refer to WAG 1638 but to other paintings.

3 Letters to his mother, one undated and one dated 9 November 1885. In another letter Forbes wrote: 'I was blown about by the cold wind, my palette smashed in my hand actually by the force of it. I came to the conclusion that painting was all a mistake.' (Caroline Fox, *Stanhope Forbes and the Newlyn School*, 1993, p. 25)

4 Letter to his mother dated 13 December 1885.

5 Letters to his mother of 20 December 1885 and 26 January 1886. Mrs. Lionel Birch, *Stanhope A. Forbes and Elizabeth Stanhope Forbes*, 1906, p. 35, implies that most of the work on WAG 1638 was done in the early spring of 1886.

6 Letters to his mother of 9 and 19 November 1885, 1, 4, 13, 14, 28 February 1886 and undated letters. In Royal Cornwall Polytechnic Society, *Annual Report*, 1900 (Stanhope Forbes, 'Cornwall from a Painter's Point of View', pp. 54–5), the artist observed that pictures painted in difficult and uncomfortable conditions have a directness, freshness and spontaneity that is often lacking where circumstances are easier. There does not seem to be convincing evidence for the statement in W. Meynell, 'Mr. Stanhope Forbes', *Art Journal*, 1892, p. 68, that WAG 1638 was 'painted in the Bay of Penzance, the artist working in a boat'; however, the artist did write, possibly with WAG 1638 in mind (Stanhope Forbes, 'A Newlyn Retrospect', *Cornish Magazine*, 1898, vol. 1, p. 85): 'For off that pier head day after day for months I painted in a crazy old fishing boat which lay at anchor there and with unsteady hand endeavoured to dodge the motion of the waves.'

7 Letters to his mother of 28 February and 3 March 1886.

8 Undated letters to his mother, apparently written in early March.

9 Letters of 16 and 21 March 1886 to his mother.

10 Undated letters to his mother.

11 Undated letter to his mother. WAG 1638 must have been well known to Newlyn artists as H.S. Tuke was accused of imitating it in 1887 (Newlyn Art Gallery, *op. cit.*, p. 135).

12 Letters to his mother of 20 December, 3, 4, 13, 28 February, 3, 14, 16, 21, 24 March, 18 April and undated letters. Bateman was a personal friend of the artist and would have immediately tried to resell WAG 1638; Forbes seems to have been using his interest as a lever to force up Dowdeswell's offer; Forbes also believed that the Chantrey Bequest or the Birmingham City Art Gallery might buy WAG 1638, Birmingham artists being well represented at Newlyn; for Bateman, see Forbes, 1898, *op. cit.*, p. 87. Dowdeswell's interest in Newlyn artists eventually resulted in his 1890 exhibition: *Pictures by Artists Residing in or Painting at Newlyn . . .*

13 *Academy*, 15 May 1886, p. 351.

14 *Saturday Review*, 22 May 1886, p. 705.

15 'The Autumn Exhibition of Pictures', *University College Magazine*, Liverpool, 1886, p. 292.

16 Meynell, *op. cit.*, p. 68

17 Birch, *op. cit.*, p. 35; the artist wrote: 'fishermen in their working dress . . . are far from being as unpicturesque as the male portion of our race seem to delight in making themselves' (Forbes, 1898, *op. cit.*, p. 86).

18 This version has been described as a sketch for WAG 1638, but at least in 1886 the artist insisted on painting the final canvas directly from his models and condemned the use of intermediate sketches or studies – see particularly Forbes, 1898, *op. cit.*, p. 84: 'It was part of our artistic creed to paint our pictures directly from nature and not merely to rely upon sketches and studies which we could afterwards amplify in the comfort of a studio. It is a debatable practice . . .'

19 In early June, Tooth's, the London dealers, were wanting WAG 1638 for their winter exhibition,

but Forbes preferred to send it to Liverpool, where it was purchased from the Autumn Exhibition (letter from the artist to his mother of 3 June 1886). On 24 July 1885, Forbes told his mother that he would send his *Fish Sale on a Cornish Beach* to the Liverpool exhibition in the autumn because there was no hope of selling it at the Birmingham or Manchester exhibitions.

By Order of the Court

WAG 2914
Canvas: 152.5 × 204.5 cm
Inscribed: *STANHOPE A. FORBES / 1881*[1]

By Order of the Court was painted at Newlyn in 1889–90;[2] on 12 March 1890 Frank Wright Bourdillon wrote to his sister Emily that Forbes was then painting an auction in a farmhouse;[3] Bourdillon gave General Pearl Yates as the name of one of the models for the bidders; others of the models were friends of the artist; some were Newlyn village people.[4] The artist was familiar with events of this type as he frequented local auctions when buying 'old things' for his home and studio at Newlyn;[5] the auctioneers used as models were Messrs. Lane of Penzance.[6]

Contemporaries were uncertain about the social status of the family whose possessions are being sold; Bourdillon referred to a farmhouse, and the artist himself[7] described his sources for the painting as his own visits to auction sales at 'farms and country houses'. Critics referred to 'a middle-class farmer', a 'little middle-class country villa', a 'lower middle-class country household',[8] an 'old-fashioned humble home of genteel poverty in the country',[9] 'the humble dwelling of some broken village-dweller'[10] or 'some humble Newlyn home'.[11] There may be a general reference to the agricultural depression of the 1880s, but more specifically the artist deplored – for aesthetic not social reasons – the incursion of modern 'luxury' into the traditional way of life in west Cornwall[12] and the objects on the table in this painting may well have been intended to represent this alien manufactured element – even possibly with a suggestion that their purchase by the farmer precipitated his bankruptcy. The critic of the *Athenaeum*[13] wrote:

There is character in such incidents as the teapot being of 'Britannia metal', the table ware of hideous patterns, and in company with uncouth figures of 'china' in shocking colours. The blue plates, the ancient coal-scuttle, the battered books, and the desk of old mahogany bound with brass – a relic of another generation it must have been hard to part with – are all capital if subordinate points which ought not to be overlooked by those who study the humour of a picture.

The same critic noted that the bidding for the clock seems to be being contested 'between a woman of the better class and her poorer, more demonstrative neighbour'.

The contre-jour lighting and the sharp, semi-humorous characterization were already established features of the artist's work by 1890 – as for example in the *Village Philharmonic* of 1888 (Birmingham City Art Gallery) and the *Health of the Bride* of 1889 (Tate Gallery),[14] but the emphatic pathos and anecdotic interest were new elements in the artist's work that were distinctly opposed to the dispassionate objectivity of the original Newlyn creed.[15] These compromises perhaps ensured the success of the painting with the critics. M.H. Spielmann,[16] for example, wrote:

In subject-pictures of a high order the exhibition of the Royal Academy is not wanting. As an example of what I have been saying, let me take Mr. Stanhope Forbes's 'By Order of the Court' as a justification of my contention. Here we have a picture which, if a little more literal and prosaic than the painter's work of last year, is entirely and artistically satisfying. The tones are just, the light and shade excellent, the composition good and original, the expressions lifelike, and it tells its own story. Is it any the worse for this? On the contrary, it at once appeals to us as a work of remarkable excellence. We realise the meaning of the scene at a glance, its truthfulness and its pathos, and we admire the consummate skill with which the painter has placed in the attitude, and on the face of each of the characters, the thoughts that are passing through the mind. Had the picture been badly painted we should, or ought to, have passed it by; but as our sympathies are touched, besides our eye being gratified, we are forced to recognise that, but for the story the picture tells us, the variety of expressions which are so subtly conveyed could not have been called into requisition, and would not have been painted.

Claude Phillips in the *Art Journal*[17] was no less enthusiastic about the characterization:

The best piece of modern genre produced this year is, in our opinion, Mr. Stanhope Forbes's 'By Order of the Court'. The sad scene represented is a forced auction in the humble dwelling of some broken village-dweller. In the grey-tempered light of a bare chamber are ranged in business-like attitudes the bidders – fellow townsmen, and no doubt gossips, of the unfortunate bankrupt; in front of them the auctioneer officiates, holding up for examination one of the prizes of the scanty store of miserable furniture and ornaments. The most delicate power of observation is revealed in the fashion in which physiognomy is discreetly individualized; its business-like eager character being just veiled with a shadow of genuine pity and regret. Mr. Stanhope Forbes is thus making good use of his solid foreign technique, using it as a weapon in the expression of English scenes and English types. No fault can be found with the execution of the picture, save that its general tonality is unduly and unnecessarily sombre, and wanting, too, in the kind of strength, which it might have achieved without departing from its quakerlike reticence of colour. The glimpse of out-door sunlight obtained through the small window is however charming.

For *The Times* and for George Bernard Shaw writing in *Truth*,[18] *By Order of the Court* was one of the best two or three pictures of the year and the critic of the *Saturday Review* felt that Forbes had 'narrowly escaped producing a great work'.[19] Shaw wrote:

Here at last the mastery of indoor light, at which the painter has aimed so diligently, is consummate. If Mr. Forbes had failed by a hair's breadth in characterization, in drama, in human interest, the impossibility of combining truth with aesthetic beauty in representing a group of commonplace heads round an auctioneer would have spoiled the picture. But he has not failed: the human interest steps in to the rescue where the beauty ceases . . .

It is said that the success of the picture contributed towards the artist's election as an associate of the Royal Academy in 1891.[20]

REPR: Pall Mall Gazette, *Pictures of 1890*, p. 13; *Magazine of Art*, 1890, p. 253; H. Blackburn, *Academy Notes*, 1890, p. 132; *Royal Academy Pictures*, 1890, p. 73; *Art Journal*, 1890, p. 171.

PROV: Bought by Sharpley Bainbridge (£500).[21] Anon sale, Christie's 19 May 1922, lot 102, bought Mitchell (£5.5s.). Presented by George Audley 1927.[22]

EXH: The Newlyn Private View March 1890;[23] Royal Academy 1890 (1146); Liverpool Autumn Exhibition 1890 (199); Berlin International Exhibition 1891.

1 All the evidence indicates that WAG 2914 was painted in 1889–90; indeed a date in 1881 is inconceivable for WAG 2914 in terms of the documentary sources and the evidence from style and from the costumes worn by the sitters; Anne Buck, letter to the Curator of the Walker Art Gallery, 20 September 1960 discusses the costume in WAG 2914 – the long handled umbrella or parasol of the woman on the right, the shoulder-line of her cloak and the 'postboy' or 'postilion' style hat just visible to the left of the window all indicate a date late in the 1880s or early in the 1890s. No explanation can at present be advanced for the inaccurate date on WAG 2914; the signature on WAG 2914 as it appears in the reproduction in *Royal Academy Pictures*, 1890 (p. 73) does seem slightly different from the signature now visible on WAG 2914 – the date on the reproduction is cut off by the edge of the illustration; possibly, therefore, the present signature and date are a later interpolation.

2 These dates are given in a notebook which apparently lists all the artist's paintings and is among the artist's papers now in the Tate Gallery. The artist wrote to the Curator of the Walker Art Gallery on 8 January 1928 (MS Walker Art Gallery): 'I painted it in my studio in Newlyn in 1890' – referring to WAG 2914.

3 Typescripts of these letters are now on loan to the Bristol City Art Gallery. Mrs. Lionel Birch, *Stanhope A. Forbes and Elizabeth Stanhope Forbes*, 1906, p. 39 suggests that most of the work on WAG 2914 was done in the autumn of 1889.

4 F. Dolman, 'Mr. Stanhope A. Forbes', *Strand Magazine*, November 1901, p. 488; George Audley wrote to Alderman Lea on 2 January 1924 (MS Walker Art Gallery): 'He [Forbes] thinks a lot of this picture, knowing all the models so intimately. The older ones are dead, the middle aged now old, and the children grown up.'

5 Dolman, *op. cit.*, p. 488

6 Plymouth City Art Gallery, *Stanhope Forbes*, 1964, p. 7, no. 9.

7 Dolman, *op. cit.*, p. 488.

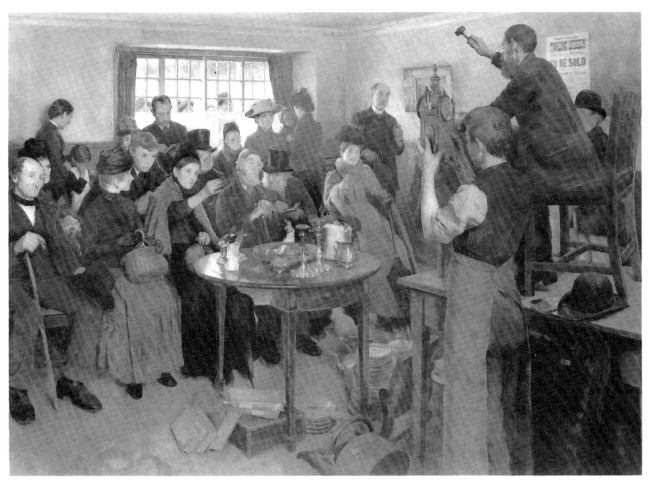

By Order of the Court WAG 2914

8 Reviews of WAG 2914 pasted into a press-cutting book among the artist's papers now in the Tate Gallery.

9 *The Portfolio*, 1890, p. xi.

10 Claude Phillips in *Art Journal*, 1890, pp. 169–70.

11 C. Lewis Hind, 'Stanhope Forbes', *Art Annual*, 1911, p. 20.

12 See particularly Stanhope Forbes, 'A Newlyn Retrospect', *Cornish Magazine*, 1898, vol. 1, pp. 80 ff. and Stanhope Forbes, 'Cornwall from a Painter's Point of View', Royal Cornwall Polytechnic Society, *Annual Report*, 1900, pp. 50 ff.

13 *Athenaeum*, 3 May 1890, p. 574. The review of WAG 2914 in the *Observer* (press-cutting book, see note 8) emphasized the social conflict in the painting: 'It is a microcosm of village life. The smug complacency of the women in town bonnets, the negligent superiority of broadcloth and the conscious importance of monied fustian are all indicated . . .'

14 The expressive faces in WAG 2914 ('the need of absolute fidelity to the realisation of his types – the homely, intent faces and the rugged hands') were noted by Birch, *op. cit.*, p. 39.

15 There is, however, some social realism in Forbes's *Their Ever Shifting Home* of 1887 (National Gallery of New South Wales, Sydney). It is

noteworthy too that the artist stated categorically that WAG 2914 was painted in his studio, presumably from sketches made on location – another departure from early Newlyn practice. Hind, *op. cit.*, p. 20, noted that WAG 2914 had 'superb craftsmanship' but 'small emotional or aesthetic appeal to the connoisseur'.

16 *Magazine of Art*, 1890, p. 254.

17 *Art Journal*, 1890, pp. 169–70; Phillips contributed a very similar review to the *Academy*, 24 May 1890, p. 360, again concentrating on the artist's delineation of character and type. Similarly the *Athenaeum*, 3 May 1890, p. 574, wrote: 'All the spectators are capitally conceived figures, admirably thought out, and executed with spirit. They are full of movement, highly dramatic and humorous, each man being cleverly connected with his neighbour by means of his looks and actions, while the expressions are extremely various.'

18 *The Times*, 20 June 1890, p. 13; S. Weintraub, *Bernard Shaw on the London Art Scene*, 1989, p. 322.

19 *Saturday Review*, 17 May 1890, p. 594.

20 Hind, *op. cit.*, p. 20. The painting won a gold medal at the 1891 Berlin International Exhibition (W. Meynell, 'Mr. Stanhope A. Forbes', *Art Journal*, 1892, p. 69; M.H. Dixon, 'Stanhope A. Forbes', *Magazine of Art*, 1892, p. 184; Birch, *op. cit.*, p. 39; *Magazine of Art*, 1891, p. xliv: 'it was to be expected that at Berlin the younger school would find favour rather than the more Academic of our painters').

21 'The Collection of Sharpley Bainbridge', *Art Journal*, 1898, p. 273; the artist's notebook (see note 2) gives the price as £500 and implies that Bainbridge bought WAG 2914 directly from the Royal Academy – but there was a price against it at the 1890 Liverpool Autumn Exhibition (no. 199, priced at £750); he certainly owned it by 1892 (see Meynell, *op. cit.*, p. 69) and he certainly bought it directly from the artist (the artist's letter to the Curator of the Walker Art Gallery of 8 January 1928 – MS Walker Art Gallery).

22 George Audley, *Collection of Pictures*, 1923, p. 19, no. 53.

23 *The Cornish Evening Tidings*, 27 March 1890; the private view in 1890 was held in the studio near the Newlyn Wesleyan Schools; for these Newlyn private views see Newlyn Art Gallery, *Artists of the Newlyn School 1880–1900*, 1979, pp. 26–7.

William Pascoe WAG 6002

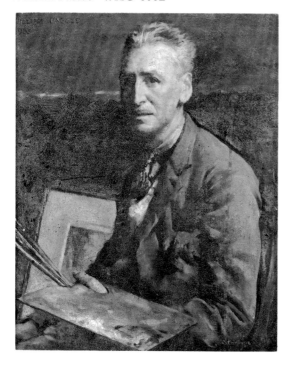

William Pascoe
WAG 6002
Canvas: 61.3 × 51.5 cm
Signed: *Stanhope Forbes*
Inscribed: *WILLIAM PASCOE / 1933*

This portrait does not seem to be listed in the notebook containing lists of pictures painted by Forbes,[1] but the signature and style seem reasonably compatible with the artist's later work. William Pascoe was a landscape painter exhibiting from 6 Wellington Terrace, Penzance between 1905 and 1912;[2] he may have been a friend of the artist, and this might explain the absence of any record of the portrait in the artist's notebook.

PROV: WAG 6002 is stated to have been deposited with Frank Lambert, Director of the Walker Art

Gallery 1931–1952, as security for a loan;[3] it was inventoried by the Gallery in 1961.[3]

1 The notebook is among the artist's papers now in the Tate Gallery.

2 *The Dictionary of British Artists 1880–1940*, ed. J. Johnson and A. Greutzner, 1976, p. 391. See also Walker's Galleries, London, *Exhibition of Pastels and Bronzes by Miss F. Midwood and Mr. William Pascoe*, 1912, nos. 1–44.

3 A printed label: *lot 235* was stuck on to the front of the canvas when WAG 6002 was inventoried.

FRASER, John (1857–after 1919)
On the Moray Firth[1]
WAG 1761
Canvas: 66.5 × 127.5 cm
Signed: *J Fraser 1881*

The fishing boat in the foreground can be identified as a Scaffie, the craft generally used in the Moray Firth until the Zulu became more popular.[2] Fraser's *With the Trawlers, Squally Weather* of 1880,[3] has a composition very similar to that of *On the Moray Firth*.

PROV: Bought from the artist 1882 (£60).

EXH: Royal Society of British Artists 1881–2 (454); Liverpool Autumn Exhibition 1882 (665)

1 The painting was exhibited in 1881 and in 1882 as *In the Murray Firth*.

2 J.K. Lindsay, letter to the compiler, 22 June 1881. The registration number on this boat's sails seems to be fictitious; in the Moray Firth it should have been INS (Inverness), BCK (Buckie) or BF (Banff). The more distant ship is probably a brig rather than another fishing boat.

3 Omell Gallery, *Marine Paintings*, 1974 (28).

FRIPP, George Arthur (1813–1896)
Mont Blanc from near Courmayeur, Val d'Aosta
WAG 750
Canvas: 169 × 246.5 cm

The artist visited the Alps during his honeymoon in 1846 and made sketches around Courmayeur for this painting.[1] Mont Blanc is the highest mountain at the left of the painting; just beneath it and slightly further to the left is the Aiguille Noire de Pétéret; still further to the left and more in the foreground is the Col Checouri; Mont Chétif is the large central mountain; beyond it and to the right of it is the Col du Géant leading up to the Dent du Géant; Mont Mallet is at the far distant right of the painting; the deep foreground valley is the Val Ferret.[2] The viewpoint is presumably a point just above Courmayeur.

J.M.W. Turner is stated to have praised Fripp's painting,[3] and the critics of the *Literary Gazette* and the *Art Union*[4] also admired it at the 1848 Royal Academy, although the *Art Union* found the painting 'deficient in freshness

On the Moray Firth
WAG 1761

155

Mont Blanc from near Courmayeur, Val d'Aosta WAG 750

of colour', and noted that this was the first large, important oil painting by an artist better known as a watercolourist. The review in the *Athenaeum*[5] was, however, more critical:

The large landscape of Mont Blanc from near Courmayeur, Val d'Aosta, *by Mr. G.A. Fripp is as a locality one of high interest; but here it is resolved into such distinct masses of hot and cold colour, and so wanting in intermediate tints to reconcile them to each other, as to raise the imputation of want of fidelity. Yet there is in the picture much clever and dexterous painting taken simply in the sense of brush handling.*

The Ashmolean Museum, Oxford, has a large watercolour by Fripp, *Mont Blanc from the Allée Blanche*, probably dating from 1849, and there is a large oil painting by Fripp of Mont Blanc signed and dated 1849 in a Welsh private collection.[6]

PROV: Presented by James Robinson 1852[7]

EXH: Royal Academy 1848 (12); Liverpool Academy 1848 (229).

1 H. Stuart Thompson, 'George A. Fripp and Alfred D. Fripp', *Walker's Quarterly*, 1928, p. 21.

2 Mr. C. Douglas Milner, conversation with the compiler, 6 April 1977.

3 *Athenaeum*, 24 October 1896, pp. 569–70.

4 *Literary Gazette*, 3 June 1848, p. 370; *Art Union*, 1848, p. 165.

5 *Athenaeum*, 13 May 1848, p. 690.

6 Charles Nugent, conversation with the compiler, 1993.

7 WAG 750 was one of the first paintings to enter the art collections of the Liverpool City Council – later to be designated to the Walker Art Gallery Collection.

FRITH, William Powell (1819–1909)
The Duel Scene from Twelfth Night
WAG 1736
Canvas: 72 × 92 cm
Signed: *W.P. Frith 1842*

The subject is taken from Shakespeare's *Twelfth Night*,[1] Act 3 Scene 4; the duel is between Viola (dressed as a man) and Sir Andrew Aguecheek; Fabian and Sir Toby Belch are also present. The *Art Union*[2] praised Frith's painting: 'A new work by this admirable artist and one that will at least sustain his fame. It is a capital reading of the subject, painted with matured skill; the characters have been happily rendered and it is well drawn and coloured with ability.' The *Athenaeum*[3] was less enthusiastic describing it as 'with all its clever points of "favour and prettiness" not Shakespearian, else would not Viola wear a look which reminded us involuntarily of Master Slender'.

A sketch or smaller version was in the collection of Matthew Uzielli,[4] while a preliminary study was in a scrapbook owned by Gilbert Davis.[5] The influence of Daniel Maclise, from whom Frith was then emancipating himself, seems still perceptible.[6]

PROV: George Briscoe[7] sale, Christie's 12–14 May 1860, lot 38, bought Gambart (£441). Presented by George Audley 1925.

EXH: Birmingham Society of Artists 1842 (95); British Institution 1843 (69).

1 Frith painted a number of other scenes from *Twelfth Night* – apparently his favourite play. For a list of other paintings representing the duel scene, see R.D. Altick, *Paintings from Books*, 1985, p. 276.

The Duel Scene from Twelfth Night WAG 1736

2 *Art Union*, 1842, p. 235. The same periodical was less enthusiastic when it reviewed WAG 1736 at the 1843 British Institution exhibition (*Art Union*, 1843, p. 66), noting that the characters seemed too cowardly; but the picture was still 'worthy of the most rising artist of the day'.

3 *Athenaeum*, 18 February 1843, p. 165.

4 His sale, Christie's 12 April 1861, lot 224, bought Mason (£87.3s.); Anon sale, Christie's 3 May 1862, lot 74, bought Bigge (£77.14s.); F.T. Turner sale, Christie's 4 May 1878, lot 23, bought Gurney (£63.15s.); this sketch or version measured 8½ × 11½ in.

5 Harrogate Art Gallery, *Frith*, 1951, no. 57.

6 W.P. Frith, *My Autobiography*, 1887–8, vol. 1, pp. 90 ff. Compare particularly Maclise's *Malvolio and the Countess* of 1840 (Tate Gallery).

7 Briscoe was an important early buyer of Frith's paintings of the 1840s; he lent Frith's *The Squire describing some Passages in his Town Life* to the 1844 Birmingham Society of Artists Exhibition (115).

The Village Pastor

WAG 227
Mill-board[1]: 23 × 31.5 cm
Signed: *W.P. Frith 1845*

A sketch for the painting of 1845[2] which illustrated Goldsmith's *Deserted Village*.

PROV: Francis Scaife, but then returned by him to the artist 27 August 1851 or 1857;[3] bought by George Holt from Agnew's (£70);[4] bequeathed by Emma Holt 1944.

The Village Pastor WAG 227

1 Stamped: Dimes and Elam, Manufacturers, 91 Great Russell Street, Bloomsbury.

2 Commissioned by John Gibbons in 1843 (W.P. Frith, *My Autobiography*, 1887–8, vol. 1, pp. 113–14, and vol. 3, pp. 197–214; some MS letters about the commission not quoted by Frith are still in the possession of the patron's family) and exhibited at the Royal Academy 1845 (498). The execution of the painting was carefully supervised by Gibbons; for his taste, see particularly Frith, *op. cit.*, vol. 3, pp. 196 ff. The version in the Anon sale, Christie's 19 May 1978, lot 171 (56.2 × 81 cm) was probably the Royal Academy picture as it corresponds exactly with the engraving (impression in the Witt Library); the painting at Christie's is reproduced in A. Noakes, *William Frith*, 1978, p. 12, and is now in a British private collection. A *Village Pastor* of the same size, but apparently dated 1903, was in the James Gresham sale, Christie's 12 July 1917, lot 210. A chalk drawing for the painting also survives – it last appeared in the Anon sale, Christie's 16 February 1984, lot 75 (63.5 × 86.5 cm). The 1845 painting illustrated these lines from Oliver Goldsmith's *Deserted Village* of 1770:

> *The service past, around the pious man,*
> *With steady zeal, each honest rustic ran;*
> *E'en children followed with endearing wile,*
> *And plucked his gown to share the good man's*
> *smile.*

It was reviewed by Thackeray in Fraser's Magazine for June 1845 – see W.M. Thackeray, *Miscellaneous Essays, Sketches and Reviews*, 1885, pp. 269–70. For the subject see also Thomas Brooks's *The Village Schoolmaster*, WAG 1778, p. **53** and R.D. Altick, *Paintings from Books*, 1985, pp. 408–10.

3 Label on the back of WAG 227. Francis Scaife was the artist's uncle; the artist went to live in his hotel on his arrival in London in 1835; he remained a close friend of Frith (Frith, *op. cit.*, vol. 1, pp. 21–3).

4 There is no record of the date of acquisition.

Prayer
WAG 1726
Canvas: 59 × 41.9 cm
Signed: *W.P. Frith 1878*

This is apparently a reduced and later version of the painting with the same title exhibited at the Royal Academy in 1874 (1331).[1]

PROV: Presented by George Audley[2] 1925.

1 The Royal Academy picture had a quotation from James Montgomery's *What is Prayer*, second stanza, as its sub-title. The *Examiner*, 23 May 1874, p. 548, referred to 'the devotional expression of the lady's face, which we see in profile, and which is most carefully modelled throughout'. The *Saturday Review*, 9 May 1874, p. 593, noted that 'the lady here chosen to personify "Prayer" might adorn a balcony at a carnival or a window at a boat race'. The *Illustrated London News*, 2 May 1874, p. 411, described it as a 'life size single female figure subject'; the artist, in *My Autobiography*, 1887–8,

Prayer WAG 1726

159

vol. 2, p. 53, described it as 'another life size work: a girl at her devotions, which I christened *Prayer*'; it was probably lot 157 in the Edward Brook sale, Christie's 4 March 1882, bought Bates (£162.15s.) There is, however, an MS label on the back of WAG 1726 describing it as the 1874 Royal Academy picture. Frith's untitled painting no. 74 at the 1852 Royal Academy, often described as *Bedtime* or *Prayer*, had a quite different composition; it showed a mother hearing her child say its prayers before going to bed – see *Art Journal*, 1852, p. 166. Many versions of the 1852 composition are recorded, including one of 1855 bought by W.H. Lever from Gooden and Fox on 5 June 1916 and sold by his executors, the Bungalow and Rivington Hall, Knight, Frank and Rutley, 9–17 November 1925, lot 1087.

2 WAG 1726 does not appear in George Audley, *Collection of Pictures*, 1923, and so was presumably acquired by him between 1923 and 1925.

'The Sweetest Beggar that e'er asked for Alms'

WAG 1326
Canvas: 86 × 65 cm
Signed: *W.P. Frith 1892*

This is a later version of the painting with the same title exhibited by Frith at the 1891 Royal Academy (257); it is identical to the Royal Academy painting.[1] The title is derived from Act 1 Scene 3 of Longfellow's play *The Spanish Student*;[2] Victorian, one of the students, is describing Preciosa, a gypsy girl.

PROV: Presented by William Hall Walker (first Baron Wavertree) 1928.

1 The Royal Academy picture is reproduced in Henry Blackburn, *Academy Notes*, 1891, p. 62, and in *Royal Academy Pictures*, 1891, p. 86;

'The Sweetest Beggar that e'er asked for Alms' WAG 1326

probably the 1891 version was used for the mezzotint reproduction by Gertrude Dale, published in 1895; it was also presumably this 1891 picture that appeared at the James Gresham sale, Christie's 12 July 1917, lot 225, bought Paris (£16.16s.).

2 Paul Barlow, conversation with the compiler, December 1988.

FRITH, William Powell, after
The Marriage of the Prince of Wales with Princess Alexandra of Denmark
WAG 117
Canvas: 154.9 × 215.9 cm
Signed: *W.P. Frith 1866* (bottom right corner)

This is a copy[1] after Frith's painting of 1863–5, now in the Royal Collection.[2] The ceremony took place in St. George's Chapel, Windsor, on 10 March 1863.

A replica of Frith's painting was painted for Louis Victor Flatow, who was to publish the engraving after it by W.H. Simmons; this replica was already being painted by the 'gentleman' commissioned by Flatow when the 1865 Royal Academy closed, and it was ultimately used by Simmons for his engraving published in 1870.[3] The Walker Art Gallery painting may be identifiable with this replica, but it seems very large for an engraver's copy.

PROV: (?) Louis Victor Flatow;[4] (?) Henry Graves and Co.;[5] (?) Mrs. Tanton, formerly the wife of L.V. Flatow,[6] sale Christie's 14 March 1874, lot 54, bought Gilbert (£740.5s.). William Harding, a brewer.[7] The Rydal House Collection;[8] for sale at Edward Howell's bookshop, 83 Church Street, Liverpool, priced 700 guineas;[9] Jane (Lilly) and Maria Lowndes, who lent WAG 117 to the Walker Art Gallery in 1914 and presented it to the Gallery in 1923 in memory of their parents, Thomas John and Maria Lowndes.

The Marriage of the Prince of Wales with Princess Alexandra of Denmark WAG 117

EXH: (?) Waring's;[10] (?) Messrs. Marcus Ward, Belfast, 1868.[11]

1 Oliver Millar, *The Victorian Pictures in the Collection of Her Majesty the Queen*, 1992, pp. 68–73, and J. Maas, *The Prince of Wales's Wedding*, 1977, p. 94, describe WAG 117 as a copy or replica, so does A. Noakes, *William Frith*, 1978, p. 99.

2 For the original painting, see particularly, Millar, *op. cit.* and Maas, *op.cit.* See also R. Ormond, 'Ceremonial Royal Groups', *Connoisseur*, 1977, vol. 195, p. 90, fig. 8.

3 See Millar, *op. cit.* This 'gentleman' might have been Marcus Stone, who copied Frith's *The Railway Station* for Flatow in 1862; Frith signed that copy just as he seems to have signed WAG 117; see Christie's sale, 11 June 1993, lot 133, where the whole problem is analysed in depth on the occasion of the sale of the *Railway Station* copy.

4 If, indeed, WAG 117 was the copy commissioned by Flatow, see above.

5 The copy made for Flatow (and for the engraving) had been acquired by Graves from Flatow by 1870 (*Art Journal*, 1870, p. 259); it was Graves not Flatow who ultimately published the engraving.

6 How and why this copy could have passed back from Graves to Flatow's widow is unclear – Flatow died in late 1867. A sketch (?) was apparently in the sale of (?) W.H. Duignan, Christie's 7 June 1879, lot 143, bought in (£325.10s.).

7 Barely legible note in Gallery files. There was a Liverpool brewing firm called Harding and Parrington in the 1880s. See John Gilbert's *The Army on the March: The Rearguard with the Baggage Waggons*, WAG 2923, which was presented by John Parrington (p. **168**).

8 Undated leaflet advertising WAG 117 for sale at Edward Howell's bookshop. Rydal Hall, Cumbria was owned by the Fleming or Le Fleming family in the 19th century (Christine Strickland, letter to the compiler, 26 March 1984).

9 Undated leaflet, *op. cit.*

10 Barely legible note, *op. cit.*

11 Eileen Black, letter to the compiler, 1 June 1994, relying on Belfast newspapers.

FULLEYLOVE, John (1845–1908)
The Temple of Jupiter and the Acropolis, Athens
WAG 3068
Canvas: 134.5 × 188.5 cm
Signed: *J. Fulleylove*

The artist visited Greece in 1895 and exhibited some ninety drawings and watercolours of Greece at the Fine Art Society in April 1896, including nearly twenty views of the Acropolis.[1] This painting is probably related to the large watercolour, *The Temple of Olympian Zeus*, exhibited by Fulleylove at the Royal Institute of Painters in Water Colours, 1899 (297).[2]

The Temple of Olympian Zeus is in the foreground; behind and to the right is the Arch of Hadrian, while the Acropolis is in the distance.[3] Fulleylove seems to have provided a reasonably accurate record of the scene, but he has carefully selected a viewpoint to conceal the excavations around the Temple and (so far as possible) the houses of modern Athens.[4]

PROV: Presented by T.W. Oakshott 1901.

EXH: Liverpool Autumn Exhibition 1901 (343).[5]

1 The exhibition was entitled *Greek Landscape and Architecture*; see the *Studio*, 1896, vol. 7, pp. 78 ff., 'Mr Fulleylove's Water Colour drawings of Greek Architecture and Landscape'. A painting now in the Leicestershire Museums can probably be identified with his *Acropolis from the Lower Slope of the Pynx Hill*, exhibited at the 1898 Royal Academy (1043) and at the Society of Oil Painters 1898 (132) – see the *Athenaeum*, 12 November 1898, p. 683. H.W. Nevinson's *Pictures of Classic Greek Landscape and Architecture*, with illustrations by Fulleylove, appeared in 1897, and 1906 saw the publication of *Greece* painted by J. Fulleylove and described by J.A. M'Clymont; an article by Alfred Higgins, 'Sketches of Greek Landscape and Ancient Greek Architecture', with illustrations by Fulleylove, was published in the *Magazine of Art*, 1898, pp. 33–9.

The Temple of Jupiter and the Acropolis, Athens WAG 3068

2 See the *Athenaeum*, 25 March 1899, p. 377, for a
 review. It was presumably the same watercolour
 that re-appeared at the Fine Art Society *Centenary
 Exhibition: 1876–1976*, 1976, no. 7 (66 × 88 cm,
 signed and dated 1899).

3 Photographs of this part of Athens, taken at
 approximately the same time that Fulleylove was
 there, are reproduced in Jane E. Harrison's
 Mythology and Monuments of Ancient Athens of
 1890, pp. 191, 194 and in E.A. Gardner's *Ancient
 Athens* of 1902, pp. 67, 117, 486.

4 For more details about Athens in the 1890s, see
 Athens, the Benaki Museum, *Athens 1839–1900:
 A Photographic Record*, 1985 (in English).

5 Where is was briefly reviewed in the *Artist*, 1901,
 vol. 31, p. 15.

GAVIN, Robert (1827–1883)
Rebekah at the Well
WAG 2956
Canvas: 122 × 97.8 cm
Signed: *R. Gavin R.S.A.*[1]

This is possibly Gavin's *Rebekah giving Water
to Abraham's Camels* of 1879, although here
Rebekah is giving water to Abraham's servant,
whose thirst she satisfied before moving on to
his camels.[2]

PROV: (?) D.W. Greenlees.[3] Presented by Walter
C. Clarke 1904.

EXH: (?) Royal Scottish Academy 1879 (268); (?)
Royal Glasgow Institute of the Fine Arts 1880 (337);
(?) Edinburgh International Exhibition 1886 (1541).

1 Gavin became an academician of the Royal
 Scottish Academy in 1879.

2 The story is in Genesis 24: 10–60. Abraham had sent his servant to seek a wife for his son Isaac, and Rebekah's conduct at the well was the sign to the servant that she was the right woman for Isaac. The identification of WAG 2956 with the 1879 painting is not supported by the review of the 1879 composition at the Royal Scottish Academy exhibition of that year in G.R. Halkett, *The Royal Scottish Academy Notes*, 1879, p. 35: 'On the line is one of Mr. Gavin's Moorish scenes noticeable for the realistic painting of the camels' shaggy coats.' Gavin specialized in Moorish scenes after his visit to Tangiers in 1874; see J.L. Caw, *Scottish Painting*, 1908, p. 166.

3 Greenlees lent *Rebekah at the Well* to the 1886 Edinburgh International Exhibition.

GILBERT, John (1817–1897)
Her Majesty the Queen holding a Drawing Room at St. James's Palace
WAG 2152
Panel: 26 × 43.8 cm
Signed: *John Gilbert 1851*

The title given by the artist indicates perhaps that no particular 'Drawing Room'[1] was represented in this painting. There was, however, an unusually splendid 'Drawing Room' at St. James's Palace on 31 May 1851, on the occasion of the Queen's birthday, at which Knights of the British Orders of Knighthood wore their Collars.[2] The Duke of Wellington, however, was not present at that 'Drawing Room',

Rebekah at the Well WAG 2956

164

Her Majesty the Queen holding a Drawing Room at St. James's Palace WAG 2152

whereas he did attend the 'Drawing Room' of 15 May.[3] Prince Albert is standing to the right of the Queen looking to the left, and just behind him is the Duke of Wellington. Gilbert's *St. James's Drawing Room*, a watercolour of 1848 now in the Guildhall Art Gallery, London (inv. 573), appears to show the arrival of the Queen at St. James's Palace for a 'Drawing Room'. A later watercolour of 1884, also at the Guildhall Art Gallery (inv. 543), shows the Prince and Princess of Wales on their way to a 'Drawing Room' at Buckingham Palace. The *Illustrated London News* of 31 March 1860 contained an illustration by Gilbert entitled *The Queen's Drawing Room – Ceremony of Presentation* and the Gilbert Sketchbooks at the Royal Academy (no. 14, not paginated) contain an engraving entitled *Le Drawing Room*; neither is close in composition to the Walker Art Gallery painting. A *Drawing Room* by Gilbert is also reproduced in Anne Somerset, *Ladies-in-Waiting*, 1984, plate 38. Henry Barraud's *Drawing Room held by Queen Victoria and the Prince Consort* of May 1847 is now in the Brinsley Ford Collection.

The critic of the *Athenaeum*[4] noted how similar this painting was to Gilbert's contem-porary illustrations in the *Illustrated London News*:

Her Majesty the Queen holding a Drawing-Room at St. James's Palace is another picture by Mr. Gilbert resembling in its design those ingenious illustrations by this artist which appear weekly in the columns of a contemporary – and both these pictures [Charge of Prince Rupert's Cavalry at the Battle of Naseby as well] demonstrate that, with discrimi-nating study, the artist may apply himself successfully to the illustration of the pages of our history. The study of the old masters and of Nature will not injure his thinking powers.

The *Art Journal*[5] described Gilbert's painting as a 'small picture of much elegant feeling', but in a later article on the artist[6] gave a more detailed account:

As if for the purpose of showing his versatility of thought, he sent to the British Institution, in 1852, two paintings which might not unaptly pass, relatively to each other, as emblematic of 'Peace' and 'War'; one, the 'Charge of Prince Rupert's Cavalry at the Battle of Naseby', so full of spirit and movement that we fancy we hear the trampling of the host of iron-

165

heeled chargers as they rush up the high ground; the other, a small picture, graceful in arrangement and brilliant in display, of 'Her Majesty the Queen holding a Drawing-room at St. James's Palace'. By the way, if recent account of these august ceremonies be true, pictorial representations of them must be classed among 'war-pictures' rather than 'peace-pictures'; this, however, is not the case with Mr. Gilbert's; it is elegant, decorous, and court-like, in the true definition of the term; the artist, when he sketched it, must have had the Lord Chamberlain at his elbow to point out how these matters ought to be managed, and not how they are.

PROV: Presented by George Audley 1925.[7]

EXH: British Institution 1852 (330).

1 'Drawing Rooms' were principally devoted to the presentation of women to the Sovereign; distinguished men were usually presented at a Levée. See Anne Somerset, *Ladies-in-Waiting*, 1984, pp. 288–9; Queen Victoria tightened discipline in the arrangements for 'Drawing Rooms'; for the chaos usual in earlier 'Drawing Rooms', see particularly George Cruikshank's hand-coloured etching of 6 May 1818, *Inconveniences of a Crowded Drawing Room* (A.M. Cohn, *George Cruikshank: A Catalogue Raisonné*, 1924, no. 1229).

2 During the 1851 Season 'Drawing Rooms' seem to have been held on 3 April, 6 May, 15 May and 31 May, see *Illustrated London News*, 5 April 1851, p. 268; 12 April 1851, p. 292; 10 May 1851, p. 381; 17 May 1851, p. 412; 7 June 1851, p. 505.

3 *The Times*, 2 June 1851 and 16 May 1851; these accounts include a complete list of those present – at least 100 people on each occasion.

4 *Athenaeum*, 21 February 1852, p. 231.

5 *Art Journal*, 1852, p. 73.

6 *Art Journal*, 1857, p. 242.

7 George Audley, *Collection of Pictures*, 1923, p. 22, no. 57; Audley stated that WAG 2152 came from the collection of the Earl of Crawford and Balcarres, but in a letter of June 1970 the 28th Earl denied that WAG 2152 had ever been in his family's collection.

The Army on the March: The Rearguard with the Baggage Waggons
WAG 2923
Canvas: 123.2 × 153.7 cm
Signed: *John Gilbert / 1863 / retouched 1873*[1]

The artist wrote in his diary[2] for 30 March 1863:

Set to work on my large oil picture 'An Army on the March; the Rear Guard with the Baggage Waggons' and toned down the hill in the background, took out the light from the water hatch and the white on some [of] the drapery in the principal waggon to give more force and prominence to the white horse. All this by David Roberts's advice.

This painting was the subject of a perceptive review in the *Reader*:[3]

Mr. Gilbert's clever picture of the 'Rearguard of an Army on the March' is full of spirit, fine action, good colour, and daylight. The qualities combined in this painter's work, are rarely found in the same picture; and the only drawback to our gratification in looking at it is the reflection that his power has not been, and probably now never will be, fully developed. Drawing for the Illustrated London News *and other periodicals has shown us his extraordinary versatility; but it has also been the cause of his incurable mannerisms and sketchiness. We never look at his work without thinking that he might have been and ought to have been, one of our most complete painters; and yet we know he has stopped short of this, and given occasion for the cavillings of those who can only see the defects, without the power of appreciating the really great qualities in his art.*

The critic of the *Art Journal*[4] was more conventional:

'An Army on the March – the Rear-Guard with the Baggage Waggons' is strong in the artist's well-known characteristics. His forms – horsemen, for example, crossing the stream – are noble. His handling has a vigour which cannot be surpassed. The present composition, however, labours under the disadvantage of being scattered, and therefore confused.

The dress is clearly mid-17th century and a reference to the English Civil Wars might be intended.[5] The debt to Rubens is clear.
A related sketch was no. 5 (ii) at the Winter 1863 exhibition of the Royal Society of Painters in Water Colour. The Gilbert sketchbooks

The Army on the March: The Rearguard with the Baggage Waggons WAG 2923

at the Royal Academy (pp. 12–14, no. 20) contain three further sketches; the first is a watercolour sketch for the entire composition signed and dated 1862; the second is a drawing for the foreground cavalier, also signed and dated 1862 and inscribed *Fredk sat for this*; the third contains drawings for various details and is signed and dated *July 21st 1862*.

Gilbert's *Rearguard of an Army* of 1870 was in the Edward Sutton sale, Christie's 8 March 1884, lot 67, bought Vokins (£110.5s.); this was presumably the watercolour *The Rearguard with the Baggage*, which was shown at the Winter 1870 exhibition of the Royal Society of Painters in Water Colour (382); it may be the watercolour now in the Birmingham City Art Gallery entitled *The Baggage Wagon* (inv. 6'93), which is not directly related to the Walker Art Gallery painting.

REPR: *Illustrated London News*, 23 May 1863, p. 573 (engraved by W. Thomas).

PROV: Mr. McLean;[6] Mr. Hooper;[7] presented by John Parrington 1876.[8]

EXH: Royal Academy 1863 (480).

1 The artist wrote in his notebook on 8 September 1873 (now Manchester City Art Galleries, inv. 1979.627):

Mr. Hooper, a dealer, 26 Bedford Square came down to see what I had done to a picture of mine which he had bought . . . It had been intensely varnished and be-deviled and the original date 1863 altered to 1869. For what I had done to it, repainting the water etc. I charged £50 which Mr. Hooper today paid.

167

2 Notes on the diaries made by Richard Ormond and now in the National Portrait Gallery archives; some of the original diaries were sold at the Bloomsbury Book Auctions, 28 February 1985, lot 172 and are now in a New York private collection.

3 *Reader*, 30 May 1863, p. 533. Similarly W.M. Rossetti in *Fraser's Magazine*, 1863, vol. 67, p. 791 described WAG 2923 as a 'very clever, stirring scene' and the *Spectator*, 16 May 1863, p. 2008 commented:

Mr. J. Gilbert extorts our admiration by his vigour in spite of carelessness and excessive mannerism in his workmanship. His picture, The Rearguard with Baggage Wagons *is full of life and action; the devil-may-care troopers attired in such coats, with lace and facings so faded and soiled as only Mr. Gilbert can paint; and the toiling waggon horses noisily with whip and voice urged up the rough ground beyond.*

4 *Art Journal*, 1863, p. 113. The author of a long description of WAG 2923 in the *Illustrated London News*, 23 May 1863, p. 574 (the artist himself perhaps) denounced this review on the grounds that the event would, in fact, have been confused.

5 See *Illustrated London News, op. cit.*, where the army is described as the Cavalier force in the Civil Wars.

6 In the 8 September 1873 entry in his notebook (see note 1), the artist stated that WAG 2923 had been 'purchased by Mr. McLean'. This was presumably the dealer Thomas McLean, who had a gallery in the Haymarket.

7 See note 1.

8 John Parrington of Harding and Parrington, St. James's Street, Liverpool, brewers, bought WAG 2923 in 1873 (*Liverpool Mercury* and *Liverpool Daily Post*, 2 August 1877).

Richard II resigning the Crown to Bolingbroke[1]
WAG 2925
Canvas: 123 × 161.3 cm
Signed: *John Gilbert / 1875.6*

Gilbert painted a large watercolour of the same subject in 1852;[2] it seems to have had many more figures than this version and considerably more dramatic emphasis. However, according to Spielmann,[3] the Walker Art Gallery painting 'justified Gilbert's election as an R.A. in July 1876'. At the Royal Academy, critics[4] noted its symmetry and its deep rich golden colour; the *Athenaeum*'s conclusions[5] were more hostile than those of the other critics:

Although there is much dramatic, or rather theatrical, spirit shown in Sir J. Gilbert's Richard the Second resigning the Crown to Bolingbroke . . . *and there is not a gleam of insight shown in it beyond that of the stage, it is an attractive example on account of the pathos of the figure of the lean, wan king and the showiness of the colour, the audacious contrasts of tone and light and shade which it exhibits. It is, even for the painter, unusually spotty, and harsh in colour, and with less chiaroscuro than ever. The melodramatic element, always distinct enough in the works of Sir J. Gilbert, is dominant here.*

REPR: H. Blackburn, *Academy Notes*, 1876, p. 21; H. Blackburn, *Exposition Universelle, Paris, Catalogue Illustré de la section des Beaux Arts, École Anglaise*, 1878, p. 28, no. 82; C. Tardieu, 'Le peinture à l'Exposition Universelle de 1878', *L'Art*, vol. 16, 1879, p. 162.

PROV: Purchased from the artist 1879 (£700).[6]

EXH: Royal Academy 1876 (165); Liverpool Autumn Exhibition 1876 (333); Paris, *Exposition Universelle*, 1878 (82).

1 The 1876 Royal Academy catalogue contained a long quotation from Shakespeare's *Richard II*, Act 4 Scene 1.

2 It was exhibited at the Society of Painters in Water Colours 1853 (77) and was favourably reviewed in the *Art Journal*, 1853, p. 153 and in the *Athenaeum* (for which see Randall Davies, 'Sir John Gilbert', *Old Water-Colour Society's Club*, 1932–3, vol. 10, p. 32); it was almost certainly the watercolour (50 × 40 in.) subsequently owned by

Mr. W.Y. Baker and reproduced in Alfred T. Story, 'Mr. W.Y. Baker's Collection at Streatham Hill', *Magazine of Art*, 1893, p. 232. Earlier it seems to have been at the Mrs. Mayhew sale, Christie's 31 March 1882, lot 43, at the William Carver sale, Christie's 22 March 1890, lot 116, and at an Anon sale, Christie's 27 February 1892, lot 153. Gilbert's later works seem to have been not infrequently simplified versions of earlier paintings; see also WAG 912, p. **170** and WAG 2924, p. **176**. There are also a number of illustrations of *Richard II*, Act 4 Scene 1, in the edition of Shakespeare's plays illustrated by Gilbert – *Works of Shakespeare*, ed. Staunton, 1862, vol. 1, pp. 477 ff.; moreover, the Gilbert sketchbooks at the Royal Academy (no. 12, not paginated) contain an engraving of this same scene.

3 M.H. Spielmann, 'Sir John Gilbert', *Magazine of Art*, 1898, pp. 56 and 64.

4 *Saturday Review*, 6 May 1876, p. 585; *Architect*, 13 May 1876, p. 305; *Spectator*, 13 May 1876, p. 625; *Art Journal*, 1876, p. 229.

5 *Athenaeum*, 13 May 1876, p. 671. W.M. Rossetti's review in the *Academy* (6 May 1876, p. 442) was on very similar lines praising the rich colours and tonal contrasts but criticizing the picture as 'too demonstrative in a sermonising way'.

6 The artist wrote in his notebook on 22 December 1876 (now Manchester City Art Galleries, inv. 1979.627) that he had received a draft from Liverpool Corporation amounting to only £665 – five per cent had been deducted.

Horse Pond at Tarring, Sussex WAG 707

Horse Pond at Tarring, Sussex

WAG 707
Canvas: 38.3 cm × 91.5 cm
Signed: *JG (in monogram) 1882*

The horse pond at Tarring, near Worthing, is shown on contemporary maps as adjacent to Tarring church on the north side; it had close to it buildings and a coppice as in this painting; the buildings were probably part of Church Farm, the farmhouse of which was just south east of the church; the pond had gone by the Ordnance Survey revision of 1933.[1]

There are a considerable number of other Sussex views and landscapes by Gilbert at the Guildhall Art Gallery.

PROV: Presented by the artist 1893.[2]

1 Hywel Griffiths, letter to the compiler, 29 November 1986.

2 WAG 707, together with WAG 912, WAG 2919, WAG 708, WAG 2918, WAG 2917 and WAG 2924, were presented to the Walker Art Gallery in 1893 as part of a general distribution by the artist to galleries controlled by city councils or corporations – notably London (Guildhall Art Gallery), Birmingham, Manchester, Blackburn and Liverpool. In 1884 or 1885 he decided to stop selling his paintings and instead to accumulate them for an eventual gift to the nation; at that time he also intended to build a gallery for their display. In 1893, however, he abandoned this plan in favour of a simple gift to selected municipal galleries, and the chairmen and curators of these galleries were invited to make their own selection from Gilbert's accumulated paintings. A.G. Temple of the Guildhall Art Gallery seems to have had the first choice and the Walker Art Gallery the second, although William Forwood, then the Chairman of the Liverpool City Council Libraries, Museums and Arts Committee, believed that he was given the first choice. See A.G. Temple, *Guildhall Memories*, 1918, p. 117; W.B. Forwood, *Recollections of a Busy Life*, 1910, p. 122; *Magazine of Art*, 1893, p. xxix; *Art Journal*, 1893, p. 190; Arts Council of Great Britain, *Great Victorian Pictures*, 1978, p. 39; *Dictionary of National Biography*.

Don Quixote and Sancho at the Castle of the Duke

WAG 912
Canvas: 91.5 × 61.2 cm
Signed: *JG (in monogram)*

This is probably the painting exhibited by the artist at the 1883 Royal Academy (20), *Don Quixote and Sancho at the Castle of the Duke*.[1]

The artist showed a painting with the same subject at the 1875 Royal Academy (540), *Don Quixote and Sancho at the Castle of the Duke and Duchess*, but the 1875 version seems to have included the Duchess's ladies carrying the perfumed water with which Don Quixote was to wash himself.[2]

Gilbert painted a very large number of scenes from *Don Quixote* throughout his career and seems to have been particularly fond of the episodes involving the Duke and Duchess.[3] As early as 1842 he sent *The First Interview of the Duke and Duchess with Don Quixote and Sancho* to the Royal Academy (1070).

The *Athenaeum*[4] found Gilbert's 1883 *Don Quixote and Sancho at the Castle of the Duke* lacking in dignity:

Sr John Gilbert's 'Don Quixote and Sancho at the Castle of the Duke' (20) is, of course spirited, but it lacks something of the dignity of Cervantes's hero; this figure looks more like Malvolio's than Quixote's as he marches in the gallery in a red cloak, attended by the grinning lout who serves as Sancho. In the grouping of light and shade and colour the picture is a credit to the painter.

The *Art Journal*,[5] on the other hand, described it as 'a very dignified quiet rendering of the Don, vigorously painted and simply treated'.

PROV: Presented by the artist 1893.[6]

EXH: (?) Royal Academy 1883 (20).

Don Quixote and Sancho at the Castle of the Duke WAG 912

1 *Don Quixote at the Duke's Castle* is inscribed in black print on the top left corner of the canvas.

2 See Miguel de Cervantes Saavedra, *The Adventures of Don Quixote*, 1604–14, part 2, chapter 31: 'Don Quixote then dressed himself, girt on his sword, threw the scarlet mantle over his shoulders, put on a green satin montera which the damsels had given him and thus equipped marched out into the great saloon . . .' The quotation in the 1875 Royal Academy catalogue contains this section – which refers to both paintings – but then goes on with the description of the Duchess's ladies, who are not to be seen in WAG 912 – but presumably were included in the 1875 painting. The 1847 *Don Quixote at the Castle of the Duke experiences in Person the Honours which he had read were paid to his Predecessors, the great Knight-errants of Antiquity* was formerly in the Lady Lever Art Gallery and seems to have had exactly the same subject as the 1875 painting. Towards the end of his career Gilbert appears to have sometimes painted simplified versions of earlier compositions – see also WAG 2925, p. **168** and WAG 2924, p. **176**.

3 For further details about other 19th-century artists specializing in scenes from *Don Quixote*, see Johannes Hartau, *Don Quijote in der Kunst*, 1986, pp. 115–241.

4 *Athenaeum*, 12 May 1883, p. 607. The *Saturday Review*, 5 and 26 May 1883, pp. 566 and 665, also complained that the figure of Don Quixote lacked distinction and nobility.

5 *Art Journal*, 1883, p. 201.

6 See WAG 707, above.

The Standard Bearer

WAG 2919
Canvas: 123.2 × 92 cm
Signed: *JG* (in monogram)

This painting does not exactly correspond with the published reproductions of *The Standard Bearer* exhibited by Gilbert at the 1885 Royal Academy, but the similarities are sufficiently striking for it to be identified with this 1885 *Standard Bearer*.[1]

In fact, the artist painted a large number of *Standard Bearers* – Royal Society of British Artists 1874 (74) and 1876–7 (65), Society of Painters in Water Colours 1852 (228), 1856 (37), 1857 (37), Winter 1863 (43), Winter 1866 (36), 1872 (2), Winter 1873 (40), 1881 (106), 1892 (101), 1897 (119), and Institute of Painters in Water Colours 1871 (64). An oil painting with this title is in the Leeds City Art Gallery (inv. 255/14) and there are watercolours in the Guildhall Art Gallery (inv. 792) and Manchester City Art Galleries (inv. 1893.12). The Guildhall Art Gallery watercolour is very close to the Walker Art Gallery painting. A study for a *Standard Bearer* (inv. 782) – oil on panel – was formerly in the Guildhall Art Gallery, and a pen and ink sketch for a *Standard Bearer* is still there (inv. 1075a).

There were also *Standard Bearers* in the following sales: R.H. Grundy, Christie's 20 November 1865, lot 119 (watercolour 18½ × 12½ in.); E. Heritage, Christie's 4 March 1882, lot 99; G.R. Burnett, Christie's 18 March 1882, lot 59; Mrs. Sara Austen, Christie's 10 April 1889, lot 103 (drawing 17¼ × 11 in.); R.E. Tatham, Christie's 29 February 1908, lot 60 (drawing 23 × 17¾ in.); T.H. Ismay, Christie's 4 April 1908, lot 11 (drawing 17½ × 11¼ in.); Anon sale, Morrison McChlery and Co. (Glasgow) 7 April 1971, lot 6 (24 × 16 in.), 1872; Anon sales, Christie's and Edmiston's (Glasgow) as lot 98, 20 May 1982 and as lot 105 (11¾ × 9 in.), 21 April 1983, formerly in the Northwick Collection. Furthermore, Colonel Seely lent a *Standard Bearer* to Nottingham in 1878 (127) and A.D. Halford lent a drawing with this title (17½ × 12¼ in.) to the Royal Academy *Winter Exhibition*, 1907 (205).

REPR: Pall Mall Gazette, *Pictures of 1885*, p. 38; H. Blackburn, *Academy Notes*, 1885, p. 41.

PROV: Presented by the artist 1893.[2]

EXH: Royal Academy 1885 (269); Whitechapel Art Gallery 1909 (31).

1 See above under Reproduced.

2 See WAG 707, p. **170**.

The Standard Bearer · WAG 2919

On the Road to the Horse Fair

WAG 708
Canvas: 38.1 × 91.5 cm.
Signed: *JG* (in monogram) *1885*

The critic of the *Athenaeum*[1] wrote:

If Sir J. Gilbert had never done anything more ambitious or finer than On the Road to the Horse Fair, *that comparatively small example would have proved him to be an artist of high rank, so grateful to painter's eyes is the landscape background, rich in aerial qualities, colour, tone, and well-studied lines and masses. Not less fine are the troop of horse-dealers*

bestriding their brown steeds in the foreground, and the grand sky loaded with dense grey clouds that tower over and close in the scene. The work is dated 1885.[2]

REPR: *Royal Academy Pictures*, 1893, p. 22; H. Blackburn, *Academy Notes*, 1893, p. 54; Pall Mall Gazette, *Pictures of 1893*, p. 33.

PROV: Presented by the artist 1893.[3]

EXH: Royal Academy 1893 (141); Liverpool Autumn Exhibition 1893 (953).

1 *Athenaeum*, 13 May 1893, p. 611. Few other critics seem to have noticed WAG 708 at the 1893 Royal Academy, but there was a generous comment from Paul Leroi in *L'Art*, 1893, p. 119.

2 In 1885 the artist decided to sell no more of his paintings 'with a view to presenting a collection of them to the nation' (*Dictionary of National Biography*); in 1893 he in fact presented a large number to the Guildhall Art Gallery, London, and to a number of provincial galleries. This may in part explain his decision to exhibit at the 1893 Royal Academy a picture painted in 1885. See also WAG 707, p. **170**.

3 See WAG 707, p. **170**.

The Slain Dragon

WAG 2918
Canvas[1]: 214.7 × 152.5 cm
Signed: *JG* (in monogram) *1885*

The subject is taken from book 1, canto 11 of Spenser's *Faerie Queene*:

> *But when they came where that dead dragon lay,*
> *Stretcht on the ground in monstrous large extent,*
> *The sight with ydle feare did them dismay.*

The Red Cross Knight has killed the dragon and Una has dared to come to inspect the corpse.[2]

Critics at the 1886 Royal Academy commented on the old-fashioned complexity of the composition. Thus the *Saturday Review*[3] observed: 'Sir J. Gilbert's "Slain Dragon", though rugged and lumpy in workmanship, and dark and dirty in colour, is not without a certain classic dignity of composition very rare in these days of realistic cleverness.'

The *Athenaeum*[4] similarly observed:

Sir John has chosen to depict cloudy and gloomy weather and a landscape full of those black shadows he affects. The enormously lengthy beast is stretched in a ravine near the mouth of a cavern from which he imprudently ventured. A mail-clad hero with shaggy hair seems to be expatiating on his conquest. Of course, the details of the design are dramatic, its effect is telling, the tones are effective, and the colour,

On the Road to the Horse Fair WAG 708

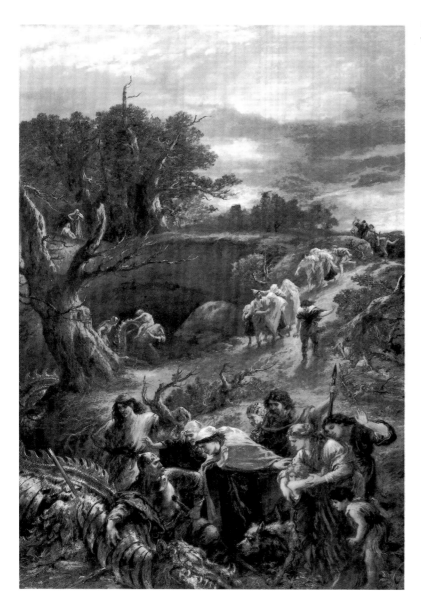

although it is marred by a certain smokiness we cannot account for, is vigorous. Notwithstanding these elements of good art, the work does not appeal to us by spontaneity of conception or the simplicity of its composition. A confused conception, founded on one of the most laboured passages in 'The Faerie Queen', is embodied in a weak design. In Sir John's mannered way the landscape is the best part.

REPR: H. Blackburn, *Academy Notes*, 1886, p. 33; Pall Mall Gazette, *Pictures of 1886*, p. 17; Royal Academy, *Official Illustrated Catalogue*, 1886, plate 27.

PROV: Presented by the artist 1893.[5]

EXH: Royal Academy 1886 (179).

1 Charles Roberson label, with the artist's address (now illegible).

2 For the subject see R.D. Altick, *Paintings from Books*, 1985, p. 350. Altick points out that most artists took their subjects from book 1 of the *Faerie Queene* rather than from subsequent books and that Una was the main attraction for them.

3 *Saturday Review*, 22 May 1886, p. 705.

4 *Athenaeum*, 8 May 1886, p. 621. Other reviews appeared in the *Illustrated London News*, 15 May 1886, p. 508 – identifying Gilbert's source as Tintoretto's *St. George and the Dragon* in the National Gallery; in the *Art Journal*, 1886, p. 221; in the *World*, 5 May 1886, p. 523 (by George Bernard Shaw) – describing Gilbert as 'incurably shaggy as to his forms, incurably brave as to his colour and incurably romantic as to his subjects'.

5 See WAG 707, p. **170**.

Landscape with Gypsy Encampment

WAG 2917
Canvas[1]: 122.5 × 92 cm
Signed: *J. Gilbert* (initials in monogram) *1888*[2]

This is one of Gilbert's 'long gipsy series which afforded him opportunities for rendering the more rugged side of picturesque humanity, and that rougher and raggeder side of nature in which he so delighted'.[3] It can almost certainly be identified with the *Landscape: Evening* exhibited by Gilbert at the Royal Society of British Artists in 1888–9 and described thus in the *Magazine of Art*:[4] 'Sir John Gilbert's "Landscape: Evening", a rapid sketch of a gipsy encampment, is painted with

Landscape with Gypsy Encampment WAG 2917

force and energy; but the colour is not good, the textures are badly rendered, and the whole seems somewhat "woolly".'

The critic of *The Times*[5] found the same painting 'conventional in design but excellent in colour'.

PROV: Presented by the artist 1893.[6]

EXH: (?) Royal Society of British Artists 1888–9 (268) as *Landscape: Evening.*

1 Charles Roberson, Long Acre, label.

2 The date is not now clearly visible but is recorded in the Gallery's archives.

3 M.H. Spielmann, 'Sir John Gilbert', *Magazine of Art*, 1898, p. 55; Gilbert's *Breaking up the Encampment*, now Manchester City Art Galleries, reproduced on p. 57 of this article is of the same date and type as WAG 2917.

4 *Magazine of Art*, 1889, p. 127.

5 *The Times*, 27 November 1888. Despite its title, WAG 2917 was certainly not the *Gipsy Encampment*, no. 869 at the 1885 Royal Academy – see *Athenaeum*, 13 June 1885, p. 766.

6 See WAG 707, p. **170**.

Don Quixote discourses on Arms and Letters to the Company at the Inn

WAG 2924
Canvas: 122 × 153 cm
Signed: *JG* (initials in monogram) *1890*

The subject is taken from Miguel de Cervantes Saavedra, *The Adventures of Don Quixote*, 1604–14, part 1, chapters 37–8; Don Quixote is arguing that a soldier's profession is superior to that of a student. This is a later version of a watercolour of 1863 now in the Victoria & Albert Museum (1215–1886); there are minor differences between the two compositions – for example, the 1863 watercolour lacks the lower figure on the stairs in the background – but in general the two pictures are nearly identical. The artist had contributed a water-colour with the same subject to the 1863 exhibition of the Society of Painters in Water Colours (18) and reviews indicate that it was

Don Quixote discourses on Arms and Letters to the Company at the Inn WAG 2924

the watercolour now in the Victoria & Albert Museum.[1]

The critics at the 1891 Royal Academy were unenthusiastic. Claude Phillips[2] could 'trace no spark of latent fire, while the execution of the large canvas is feeble in the extreme, and the colour toneless'. The *Athenaeum*[3] wrote:

Sir J. Gilbert's illustration on Don Quixote *shows the hero discoursing of chivalry to the company at the inn, is full of spirit, and attracts us by its variety and picturesque characters. The touch is rather loose, and the drawing wants firmness. In other respects it is worthy of the renowned illustrator of books and admirable painter.*

The *Saturday Review*[4] saw the painting (rightly) as an enlarged drawing:

Very curious and difficult to criticize is the art of Sir John Gilbert, produced, as we may put it, in absolute defiance of nature and in accordance with technical rules known only to himself – yet is such a large composition as 'Don Quixote discourses to the company at the Inn' amusing and interesting. It is indeed, a spirited black-and-white improvisation magnified and tinted.

REPR: H. Blackburn, *Academy Notes*, 1891, p. 53; *Royal Academy Pictures*, 1891, p. 11; Pall Mall Gazette, *Pictures of 1891*, p. 14.

PROV: Presented by the artist 1893.[5]

EXH: Royal Academy 1891 (225).

1 *Art Journal*, 1863, pp. 117–8; *Athenaeum*, 2 May
 1863, p. 591. Technically, therefore, WAG 2924
 should not have been shown at the 1891 Royal
 Academy as it was substantially a copy. The
 watercolour seems to have been in the Julius
 Sichel sale, Christie's 6 May 1865, lot 107 (19¼ ×
 26 in.). A number of Gilbert's later paintings
 seem to have been re-workings of earlier pictures,
 see also WAG 2925, p. **168** and WAG 912, p. **170**.

2 *Art Journal*, 1891, p. 194. In the *Academy*, 16 May
 1891, p. 471, Phillips was even more devastating,
 describing WAG 2924 as 'a complete failure,
 lacking from a technical point of view both
 certainty of execution, colour and relief, and
 making up for these defects by no genuine
 humour'.

3 *Athenaeum*, 16 May 1891, p. 643.

4 *Saturday Review*, 23 May 1891, p. 621.

5 See WAG 707, p. **170**.

GODDARD, George Bouverie
(1832–1886)

The Struggle for Existence
WAG 1137
Canvas: 153.7 × 307.3 cm
Signed: *Bouverie Goddard 1879*

The 1879 Royal Academy catalogue quotes
some lines from James Thomson's *Winter* of
1726[1] as the source for this painting, but the
artist's real inspiration must have come from
Charles Darwin's *Origin of Species* of 1859.[2]
Thomson's poem describes wolves attacking
other animals but not each other, and J. Wolf's
illustration to the 1859 edition of the poem
(published by James Nisbet, p. 197), shows
them attacking a horse – as related by Thomson. The critic of the *Magazine of Art*,[3] however, referred to Malthus rather than to
Darwin:

*A grim and a great animal picture is Mr. Bouverie
Goddard's Struggle for Existence. It illustrates a
law of the community of wolves, who, it seems,
engage every year in a deadly civil war whereby all
the weaker members are slaughtered, while the 'fittest
survive'. Malthus would recognise in the social economy of these hungry tribes the ideal of his system. Mr.
Goddard's work is full of the spirit and vigour of the
scheme.*

The Struggle for Existence WAG 1137

REPR: G.R. Halkett, *Walker Art Gallery Notes*, 1880, p. 96.

PROV: Bequeathed by James Carlyle 1879.

EXH: Royal Academy 1879 (639); Liverpool Autumn Exhibition 1879 (1315).[4]

1 These are the lines quoted:

> *By wintry famine roused, from all the tract*
> *Of horrid mountains . . .*
> *Cruel as death, and hungry as the grave!*
> *Burning for blood! bony, and gaunt, and grim!*
> *Assembling wolves in raging troops descend,*
> *And, pouring o'er the country, bear along,*
> *Keen as the north wind sweeps the glossy snow.*
> *All is their prize.*

2 See Edward Morris, 'The Struggle for Existence', *Annual Report and Bulletin of the Walker Art Gallery*, Liverpool, 1975–6, vol. 6, pp. 55 ff. Darwin was fond of the expression 'The Struggle for Existence' and often quoted the example of dogs and wolves in support of his theory that natural selection operates through the survival of the fittest; see in particular, the *Origin of Species*, 1859, pp. 9, 62, and *The Expression of the Emotions in Man and Animals*, 1872, pp. 9, 50–1, 117–18, 122, 125.

3 *Magazine of Art*, 1879, p. 217; see also *Art Journal*, 1879, p. 174. Malthus was of course Darwin's principal philosophical source; thus WAG 1137 is an illustration of the principal pessimistic strand in British 19th-century social philosophy. Goddard had considerable intellectual pretensions – in, for example, his *Fall of Man*, Sotheby's London, 18 June 1985, lot 117. *Famine* by J.C. Dollmann of 1904 (Salford Art Gallery) has a tall gaunt figure, representing famine, followed by hungry wolves. Dollmann's message is wider than Goddard's but he was another animal painter interested in the survival (or extinction) of species.

4 Where the *Porcupine*, 20 September 1879, p. 394, noted: 'There are not a few repulsive pictures, some of which have been wisely relegated to the staircase. Bouverie Goddard's big enormity of wolves in the *Struggle for Existence* is balanced on the opposite side by Mr. R.B. Browning's *Antwerp Fish Stall*.'

GOODALL, Edward Angelo (1820–1908)
The Pescheria in the Ghetto, Rome
WAG 2950
Canvas: 91.5 × 122.5 cm
Signed: *E.A. Goodall / 1873*

The Pescheria (or fishmarket) was held in and around the Portico of Octavia until the 1880s, when the market was removed and the Portico excavated.[1] The Portico, situated at the west end of the ghetto, dated originally from the period of the Emperor Augustus. Goodall exhibited *Fish Market at Rome* at the 1857 Liverpool Academy exhibition (No. 298)

PROV: Bought from the artist 1873 (£153.10*s*.).

EXH: Liverpool Autumn Exhibition 1873 (36).

1 Murray's *Handbook to Rome and its Environs*, 1875, p. 101, noted: 'The ruins [of the Portico] which now remain are situated in the Pescheria, the modern fishmarket, one of the filthiest quarters in Rome.' Plainly Goodall intended to contrast the splendour of ancient Rome with the squalor of its modern inhabitants. This subject was also popular with Samuel Prout, no doubt for the same reasons.

GOODALL, Frederick (1822–1904)
Market People of Brittany in a Boat[1]
WAG 232
Panel[2]: 20.3 × 35.5 cm
Signed: *F. Goodall 1842*

The artist was in Brittany in 1841 and 1842 and a number of paintings were based on these visits (see also *Fair at Fougères*, WAG 233 below).[3]

PROV: John Pye;[4] his sale, Christie's 20–21 May 1874, lot 32, bought Polak (£75.12*s*.); bought from W.G. Herbert by George Holt December 1874 (£130); bequeathed by Emma Holt 1944.

1 Pye called WAG 232 *Scene in France / Figures in a Boat* (old label on the back of WAG 232).

2 Winsor and Newton prepared panel (old label).

3 Frederick Goodall, *Reminiscences*, 1902, pp. 22–5; *Art Journal*, 1850, p. 213; he was also in

The Pescheria in the Ghetto, Rome WAG 2950

Market People of Brittany in a Boat WAG 232

179

Normandy in 1838, 1839 and 1840, see Goodall, *op. cit.*, pp. 16 ff., 379 ff. and *Art Journal, op. cit.*, p. 213.

4 John Pye, the engraver, was a close friend of the artist, see Goodall, *op. cit.*, pp. 313–5.

Fair at Fougères
WAG 233
Canvas: 27.6 × 40.5 cm
Signed: *F. Goodall 1842*

This is presumably a sketch for Goodall's *Fair at Fougères, Brittany* of 1842.[1] The artist witnessed this 'great fair' on his 1841 visit to Brittany.[2] The castle at Fougères can be seen on the hill at the left.

PROV: Bought by George Holt from W. Joy 25 June 1885 (£90); bequeathed by Emma Holt 1944.

Woman and Child WAG 442

1 According to George Holt's MS Catalogue, WAG 233 was submitted to the artist and authenticated by him. The large final painting was exhibited at the British Institution 1842 (17) where it was reviewed by the *Art Union*, pp. 57–8; it measured 46 × 62 in., including the frame, and was purchased by Alexander Glendinning for 200 guineas; it was then exhibited at Leeds 1868 (1384) and was apparently in the 1870 Glendinning sale (Christie's 9 May, lot 128, bought Hall £630) and in the 1873 Pilgeram sale (Frederick Goodall, *Reminscences*, 1902, pp. 24, 380; G. Redford, *Art Sales*, 1888, vol. 2, p. 46).

2 Goodall, *op. cit.*, p. 24.

Woman and Child
WAG 442
Composition board: 47 × 35.8 cm

Goodall was in Ireland on a sketching tour with Topham and Alfred Fripp in 1844 and this may be an Irish subject dating from that year.[1]

PROV: F.W. Topham sale, Christie's 30 March 1878, lot 162, bought for the Walker Art Gallery (£90.6s.).

1 Frederick Goodall, *Reminiscences*, 1902, pp. 27 ff.

A New Light in the Hareem
WAG 146
Canvas: 122.7 × 215.3 cm

The title may have been suggested by Frederic Leighton's *Light of the Hareem* (1880).[1] Another possible source is J.F. Lewis's *The Reception* of 1873 (Yale Center for British Art, New Haven). This is an Oriental interior (perhaps a harem) with elaborate lattice work and a gazelle. Goodall's *Pets of the Hareem* (1889) showed an odalisque lounging on an eastern sofa feeding an ibis and a monkey.[2] Presumably these paintings were derived from the sketches made by the artist during his Egyptian tours of 1858–9 and 1870. *A New Light in the Hareem* was described by the artist himself thus:[3]

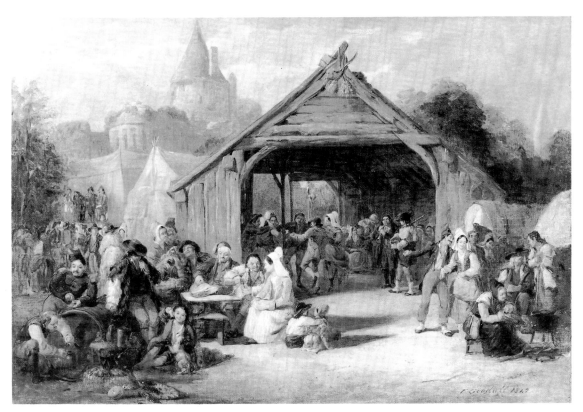

Fair at Fougères WAG 233

A New Light in the Hareem WAG 146

The New Light in the Hareem, *the new light being an infant lying on a rug on his back, and amused by his negro nurse with a live pigeon which she is holding in her hand, the lady of the harem lying on a couch embedded with the softest pillows covered with beautiful Persian embroideries. In this picture there is the gazelle that Sir William Flower so kindly procured for me from the Zoological Gardens to paint from, which I had in my studio for several days. The lattice of the* Musharabea *was an elaborate piece of work. The whole picture is full of detail. It was purchased by the Walker Art Gallery of Liverpool.*

Most reviewers were content merely to describe Goodall's painting when it was exhibited at the 1884 Royal Academy.[4] The *Athenaeum*[5] was, however, more analytical:

Smoothness and dexterity which, when unsympathetically applied, fail in the painter's hands, are not wholly unfortunate under other circumstances. No one paints so smoothly, and few owe so much to dexterity as Mr. F. Goodall, who, however, in A New Light in the Hareem *has made a hit, because his work has an animated motive, a certain kind of grace, and cheerful tone and colour. The new 'light' is a stout baby, whose long-limbed mother reclines on a couch, while a highly polished negress plays with the child kicking on a very neat carpet. Everything in the room is neat, clean, and elegant, but except the furniture and* bric-à-brac, *which might have been bought in Oxford Street, there is nothing especially Oriental in the character and motive of the design of this the most respectable picture in the exhibition, which is so thoroughly suggestive of the lamp that we soon tire of it.*

The *Magazine of Art*[6] was more hostile, noting that the selection of the painting for the permanent collection of the Walker Art Gallery was 'none of the happiest'.

A sketch was at Sotheby's (Belgravia) 20 May 1975, lot 86 (repr.). A version or copy signed *Lewis* and dated 1884 was sold at Sotheby's (New York) 12 October 1994, lot 64.

PROV: Purchased from the artist 1884 (£1000).

EXH: Royal Academy 1884 (235); Liverpool Autumn Exhibition 1884 (112).

1 Reproduced in Mrs. Russell Barrington, *Life, Letters and Work of Frederic Leighton*, 1906, vol. 2, opp. p. 256. The painting was formerly owned by the Fine Art Society. Goodall was a great admirer of Leighton's work, see Frederick Goodall, *Reminscences*, 1902, pp. 204 ff. The artist's sister, Eliza Goodall, however, exhibited a *Light of the Harem* at the 1848 Society of British Artists (149) and J.W. Chapman showed a *Light of the Harem* at the 1871 London International Exhibition (454). The original 'Light of the Harem' was Nourmahal in Thomas Moore's poem *Lallah Rookh* of 1816.

2 *Saturday Review*, 4 May 1889, p. 530. Goodall's *Gilded Cage* of 1898 was yet another harem scene; see Goodall, *op. cit.*, p. 392, for a description; a version was in the Sotheby's London sale, 26 November 1985, lot 27.

3 Goodall, *op. cit.*, 1902, p. 386 and N.G. Slarke, *Frederick Goodall*, 1981, p. 64. The artist had an example of Musharabea lattice work at the head of his stairs overlooking his studio in Avenue Road (Goodall, *op. cit.*, p. 293). He noted that WAG 146 and *Flight into Egypt* of the same date were his favourite pictures up to that time (Goodall, *op. cit.*, p. 180). See also Anne Crosthwait, 'Goodall and the Cult of Egypt', *Country Life*, 17 July 1969, p. 182 and G.M. Ackerman, *Les Orientalistes de l'École Britannique*, 1991, pp. 90 ff.

4 *Art Journal*, 1884, p. 209, which, however, also noted its popularity; *Portfolio*, 1884, p. 122; *Illustrated London News*, 3 May 1884, p. 419.

5 *Athenaeum*, 31 May 1884, p. 701. Graham Reynolds, *Victorian Paintings*, 1966, p. 144, also observed that the light in WAG 146 was that of an 'English drawing-room'.

6 *Magazine of Art*, 1884, p. vi.

On the Fringe of the Desert

WAG 231
Canvas: 66.9 × 153.6 cm

The artist visited Egypt in 1858–9 and in 1870; he subsequently painted many biblical and contemporary scenes based on his studies there.[1]

On the Fringe of the Desert WAG 231

REPR: Institute of Painters in Oil Colours, catalogue 1884–5 (828), plate 73.

PROV: Bought by Agnew's from the artist 17 November 1884; sold to George Holt 27 February 1888 (£200) with an exchange; bequeathed by Emma Holt 1944.

EXH: Institute of Painters in Oil Colours 1884–5 (828) as *By the Borders of the Desert*.

1 See particularly Anne Crosthwait, 'Goodall and the Cult of Egypt', *Country Life*, 17 July 1969, pp. 180–2 and G.M. Ackerman, *Les Orientalistes de l'École Britannique*, 1991, pp. 90 ff.

Puritan and Cavalier
WAG 2926
Canvas: 113 × 184.8 cm
Signed: *F G 1886* (initials in monogram)

The boy dressed as a Cavalier is trying to find the girl dressed as a Puritan, in order to kiss her under the mistletoe which he is carrying; but only the King Charles II spaniel can find her.[1] The incident seems almost a parody of the 16th/17th-century historical genre subjects

generally selected by the St. John's Wood School.[2] The models for the two children were Frederick William and Alice Frederica (or Rica), son and daughter of the artist.[3] The screen contains crewel work with a tree of life pattern; it is probably 19th century in date imitating 17th-century work.[4]

WAG 2926 was not well received by the critics. *The Times*[5] wrote:

In the second Room we come first upon a picture which shows Mr. Frederick Goodall in a new light – which shows him, indeed, as pictorially practising 'L'art d'être grand-père'. He has abandoned the Sphinx and the Pyramids, and has this year produced a Susanna and, by way of strictly observing the fitness of things, ever so many pictures of children in the most approved fashion of the British nursery; Puritan and Cavalier (87) is the first and the largest of these – a little girl hiding behind a painted screen, while a still smaller boy in a Vandyck dress is coming in search of her. On the whole we prefer Mr. Goodall among the Pyramids.

The critic of the *Athenaeum*[6] was no kinder:

Mr. F. Goodall's Puritan and Cavalier *(87) has for its scene the hall of a mansion where two children are at play. A little boy, mistletoe in hand, is seeking for a taller child who has concealed herself from him*

Puritan and Cavalier WAG 2926

between two leaves of a screen which extends across the picture, and is its least happy feature, because the painter (with characteristic conscientiousness and lack of true pictorial power) has spared us not a single detail of its bad decorations. He has made the screen as hard as it is flat and shiny, and given to it no varieties of tone, colour, or light and shade. The girl's figure is very good indeed; but even this figure, in spite of its fresh and true design and neat draughtsmanship, is cold in colour, hard, and almost metallic in tone, and the whole picture is distinguished by that vapid smoothness which we hoped was peculiar to Mr. Goodall's treatment of Scriptural stories. These stories Mr. Goodall has, we trust, finally abandoned.

REPR: Pall Mall Gazette, *Pictures of 1886*, p. 13; Royal Academy, *Official Illustrated Catalogue*, 1886, plate 13.

PROV: (?) Samuel J. Blackwell Sale,[7] Christie's 21 July 1922, lot 158, bought Sampson (£15.15*s.*); presented by George Audley 1925.

EXH: Royal Academy 1886 (87); Liverpool Autumn Exhibition 1886 (909); Munich International Jubilee Exhibition 1888; Liverpool Autumn Exhibition 1925 (1046).

1 Frederick Goodall, *Reminiscences*, 1902, p. 387.

2 Goodall lived in St. John's Wood but was not a member of the School. See also Walker Art Gallery, *And when did you last see your father*, 1992, p. 50. Goodall may also have intended a reference to William Burton's melodramatic *Wounded Cavalier*, which caused a sensation at the 1856 Royal Academy; see *Art Journal*, 1856, p. 170, for a description; it is now in the Guildhall Art Gallery.

3 Goodall, *op. cit.*, p. 298; a study of Rica for WAG 2926 hung in the billiard room of the artist's house, Avenue Road, Regent's Park; Pall Mall Gazette, *Pictures of 1886*, 3 May 1886, p. 2.

4 Xanthe Brooke, conversation with the compiler, 1992.

5 *The Times*, 1 May 1886.

6 *Athenaeum*, 8 May 1886, p. 621. The *Art Journal*, 1886, p. 187, found the children spindle-shanked and weak-kneed. P.H. Rathbone in 'The Autumn Exhibition of Pictures', *University College Magazine*, Liverpool, 1886, p. 289, wrote: 'An

arch, yet withal demure, little damsel is hiding in the corner of a folding screen from a still more diminutive cavalier, who is sure to detect her in a minute, and as certain to rob a kiss.'

7 Thomas Blackwell of Brookshill, Harrow Weald, together with his two sons Samuel J. Blackwell and Thomas F. Blackwell, were Goodall's principal patrons (Goodall, *op. cit.*, pp. 178 ff. and 384 ff.); strangely, however, Goodall (*op.cit.*, p. 387) does not record that any of them bought WAG 2926; it may have been acquired by Samuel J. Blackwell after 1902.

GOODALL, Thomas F. (1856/7–1944)
The Bow Net
WAG 2957
Canvas: 83.8 × 127 cm
Signed: *T.F. GOODALL 1886*

Goodall had been painting subjects in Norfolk since at least 1880, and in the summer of 1885 he and the artist H.H. La Thangue met the photographer P.H. Emerson there; Emerson had hired a yacht, the *Emily*, and was taking photographs on the Norfolk Broads. Goodall joined him for another cruise, this time on the yacht *Lucy*; they started from South Walsham, apparently in the autumn of 1885, and jointly took some of the photographs published in 1887 as *Life and Landscape on the Norfolk Broads* by P.H. Emerson and T.F. Goodall.[1] One of these photographs (plate II in the 1887 book) was *Setting the Bow Net*[2] and it is extremely close to this painting in composition and in details; Goodall wrote this description which was published in the book alongside the photograph:

Here we have an old Broadman and his daughter out in their flat-bottomed boat on a hot July afternoon, about to drop a bow-net into a likely corner of the Broad to catch some tench, that most edible of fish, firm and glutinous – the sole of the fresh waters.

The net, deftly braided by the girl's skilled fingers, has been bent by the old man to hoops of split hazel, and set taut by sticks of the same, notched at either end to fit the outer hoops, thus holding them wide apart, and forming a firm cylindrical cage. From each end springs a cone-shaped inner net which, tapering to the centre of the cage, has an opening at its apex; these openings are the entrances to the trap; a string fastened

to the hoop at the opposite end holds each one in position. A very large fish can easily push its way into these openings, but a small one would have much difficulty in getting out again, even if it managed to find the hole. The old man is putting a stone in the net to keep it on the bottom.

The bow-net is practically the only means of taking tench, as, though caught occasionally by the angler in quest of other fish, they bite at a bait so rarely that one can never depend on getting any with rod and line. We have been told by old Broadmen that in July tench may be taken on a hook baited with the small white flower of an aquatic plant which grows in tangled masses from the muddy bottom of the Broads, and also with white daisy buds just about to open; they say that good sport is to be obtained at times with these baits, but we have never tried the plan. Bunches of the former are often put inside the bow-net to attract the tench, which are said to be very fond of it. Tench lie up in the mud in winter, and are often transfixed by the eel-spears when the men are picking. In hot summer weather they swim along under the banks or in among the weeds and water-lilies. They seem to like to rub against things, and this taste accounts for the ease with which they find their way into the bow-net; rubbing their backs against the meshes of the narrowing entrance appears an irresistible pleasure. A net dropped in a lucky spot may be lifted next day with a score of fine fish in it and we have heard of even larger catches.

There is a remarkable consensus of testimony among the old fishermen of the Broads to the fact that if a bow-net with fish in it be lifted above the surface for inspection, and then put back into the water, the fish will at once find the way out, though they would remain safe for any length of time if undisturbed. Looking at the complicated structure of the net, and the nature of the exit, this seems incredible, but those who ought to know are quite positive as to the fact. Pressing an old Broadman one day on the point, he said: 'I ha' proved it; one time I was a-comin' through the weirs, and a chap as I was kinder chums along – we used ter fish tergether like sometimes – had got two or three nets down there. Well, I happened ter row right again one on 'em, and I jest lifted it up ter look, and there was three in; that's what there was, and I never meddled with 'em no more'n ter look, and dropped the net in agin. Few minits arter he come, and looks at the same net; I was stoppin' close by, and I see him stoop ter look, and then go on, so I calls out, 'Ther's some fish in that net'; 'No there aint', says he; 'Well, I know there is', I says, 'cos I see 'em'; so I goes back, and we lifted the net up agin, and sure enough there warn't no fish in then. 'Well, that's a rum un', says I; 'there was three tench in there not

five minits ago, cos I pulled the net up ter look, and I see 'em'. 'There, 'bor', says he, 'never you lift another net of mine up, ner yet yer own, without yer be a-going ter take the fish out; do, they'll all go out – I ha' been taken in like that afore'.

Bream and perch occasionally find their way into the bow-net, and more frequently pike, while sometimes an otter, arch enemy of the pike, will be found in the same net with his prey. An instance of this came under our notice not long ago: A man going to lift a net, which he had not looked at for two or three days, dropped it in a hurry when he saw in the water a ghastly brown head, with an ugly row of teeth, peeping through the meshes of the net close to his fingers. Reflection, and a certain odour of decay, convincing him that the animal, whatever it might be, was now past malice, he again cautiously lifted the net, and discovered a large pike and an otter lying dead side by side. The details of the tragedy were easy to conjecture; marks of violence at the junction of the head and neck of the pike showed where the otter had seized him with one fatal bite, before turning to carry him to the surface, he found his way barred by the meshes of the net, and himself also a prisoner. As the otter can only live a short time under water, the agony would be brief; but what a death struggle there must have been in that net among the roots of the lilies! while above, hiding the fierce despair of these two evil-looking predatory creatures, the broad leaves and white flowers floated placidly, and around, perhaps, the startled but exultant bream and roach gazed gleefully at this overthrow of their two most remorseless foes.

Although the book was not published until 1887, it has an 1886 imprint on the title page and nearly all the material for it was ready before the end of 1885;[3] Goodall would therefore have had available a print of the photograph as he was painting *The Bow Net*, but presumably he also relied on his own sketches, particularly one now owned by Mr. O. Stirling Lee. This sketch, 79 × 99 cm, is extremely close to the final painting and is signed: *T.F. Goodall unfinished study*.[4]

In painting *The Bow Net*, Goodall has chosen a slightly higher viewpoint than that selected by Emerson and himself for the photograph[5] – possibly for practical reasons they could not have taken the photograph

The Bow Net WAG 2957 (colour plate 6)

186

from a more elevated situation – but in other respects photograph and painting are very close, particularly in the figures, boat and bow net. The higher viewpoint, together with the flatter image and the more sharply tilted background resulting from it, are characteristic of Jules Bastien-Lepage and of his English admirers – a group to which Goodall and Emerson seem to have belonged.[6]

The painting attracted little attention from reviewers at the 1887 New English Art Club exhibition, but the *Bohemian*[7] described it as 'the best landscape and figure painting in the exhibition', noting that it was not 'scamped', nor did it 'partake of the nature of an impression'; the same periodical also described it as a 'River Scene early in the year'.

PROV: Purchased from the artist 1887 (£80).

EXH: New English Art Club 1887 (40); Liverpool Autumn Exhibition 1887 (247).

1 P.H. Emerson, *The English Emersons*, 1898, pp. 126–7: 'From South Walsham he and Goodall roamed about taking photographs and making notes all day, returning at night to the yacht to develop the negatives.' The photographs taken jointly by Emerson and Goodall were 'the result of an ideal partnership' (P.H. Emerson and T.F. Goodall, *Life and Landscape on the Norfolk Broads*, 1887, Preface). La Thangue had a house at South Walsham in this period and the cruise may have started from there. See also University of East Anglia, Sainsbury Centre for Visual Arts, *P.H. Emerson*, 1986, pp. 34, 60; Nancy Newall, *P.H. Emerson*, 1975, pp. 33 ff., 260–1; and Ellen Handy, 'Art and Science in P.H. Emerson's Vision', p. 187 and Fiona Pearson, 'P.H. Emerson and J. Havard Thomas, pp. 199–200, both in *British Photography in the Nineteenth Century*, ed. M. Weaver, 1989. In fact, a few of the photographs in *Life and Landscape on the Norfolk Broads* were taken by Emerson without any co-operation from Goodall; some were presumably taken by Emerson on his July–August 1885 cruise before he met Goodall, for which see P.H. Emerson, 'A Cruise on the Norfolk Broads', *Amateur Photographer*, 20 November 1885, pp. 545–8. Emerson and Goodall were back in Norfolk in the summer of 1887, with Goodall painting and both artists taking photographs jointly; Goodall seems to have been principally involved in selecting the subject while Emerson took the photograph; the result was *Wild Life on a Tidal Water*, 1890, containing various photo-etchings made from these photographs and one photo-etching (plate xxx) after Goodall's *The Last of the Ebb; Great Yarmouth from Breydon*, which was painted at Breydon during that summer and exhibited at the 1888 Royal Academy. The Norfolk Broads seem to have been popular with artists in the 1880s; in 1886 Miss E.M. Osborn exhibited a group of her paintings and watercolours at the Goupil Gallery under the title: *The Norfolk and Suffolk Rivers and Broads*; no. 12 was *An Eel Boat*.

2 Prints of this photograph were also apparently sold independently of the book and there is an example in the Walker Art Gallery, (inv. 9728); it differs slightly from those in the book in that clouds have been added.

3 University of East Anglia, *op. cit.*, p. 34. It seems that at least one of the photographs for *Life and Landscape on the Norfolk Broads* – 'Gathering Water-Lilies' – was taken by Emerson on a later visit to the Norfolk Broads in the spring of 1886 (for this later visit, at which Goodall was present, see P.H. Emerson, 'The Log of the Lucy', *Amateur Photographer*, 10 December 1886, Winter Number, pp. 1–3); Arthur Hacker met Goodall at or near Yarmouth on 24 April 1886 (Hacker's diaries, still in the family collection); completing the literary material for the book and the printing and reproducing of the photographs for it also occupied the early part of 1886 (Emerson 1898, *op. cit.*, p. 127).

4 A label on the back, presumably written by Thomas Stirling Lee reads: '. . . the first picture for the Bownet by T.F. Goodall. The later one is in the Walker Art Gallery, Liverpool. Given to me by T.F. Goodall.' (Elizabeth Stirling Lee, letter to the compiler, 9 October 1986)

5 The *Amateur Photographer*, however, in its review of *Life and Landscape on the Norfolk Broads* (25 March 1887, p. 145) wrote: 'In the joint productions Mr. Emerson has generally been persuaded to avoid an horizon line high above the principal objects in the composition.'

6 For a discussion of the relationship between photograph and painting, see K. McConkey in University of East Anglia, *op. cit.*, p. 49; McConkey sees WAG 2957 largely as a 'transcription on canvas' of the photograph, and thus as less atmospheric than most naturalist

paintings of the period; he sees the alterations introduced by the artist as intended mainly to clarify the action and background details. Goodall's *Appendix* to the *Life and Landscape on the Norfolk Broads*, 1887 (pp. 71 ff.) contains his principles of landscape painting: he emphasizes the special beauties of the lowland Norfolk Broads; paintings should be an exact transcript of nature but the particular slice of nature chosen should be carefully selected, particularly for its decorative arrangement; this is the method of the modern French school, especially Bastien-Lepage, 'greatest master of all'; photography, therefore, has an obvious function, but the photographer must select his lens, exposure, materials, focus, etc., with care, so that the final print is 'a true representation of nature as impressed on the mind by human vision'; there must be 'no biting sharpness of detail'; an artistic photograph of this type can be used by the painter; 'the proper function of the artist is to observe, not to imagine'. P.H. Emerson in his *Naturalistic Photography* of 1889, pp. 18, 26, 279–88 quoted extensively from Goodall's defence of photography as an art and as an aid to the artist; but, writing to the publishers on 18 August 1890 Frederic Leighton denounced Goodall's extreme views as expressed in this *Appendix*; he was repelled by Goodall's 'narrow dogmatism' and 'lop sided exaggeration' (University of East Anglia, *op. cit.*, p. 8). By 1891 Goodall seems to have retreated from this rather simplistic position; in their *Notes on Perspective Drawing and Vision* (1891) Emerson and Goodall argue that in practice we do not see in front of the landscape or building what would appear in a photograph or in a scientifically accurate perspective drawing of the landscape or building; our eyes distort – distant objects look larger than they would appear in a photograph and all objects look higher and narrower than they actually are; the naturalistic painter will not therefore rely too much on photographs.

7 *Bohemian*, 23 April 1887; a book of press-cuttings containing reviews of the 1887 New English Art Club exhibition is in the Tate Gallery archives.

GOTCH, Thomas Cooper (1854–1931)
A Pageant of Childhood
WAG 122
Canvas[1]: 142.7 × 244.3 cm
Signed: *T.C. Gotch*

This is one of Gotch's symbolist paintings of the period 1890–1920, reflecting his cult of childhood and motherhood – with particular emphasis on adolescent girls; the allegorical purpose is particularly evident from the figure of Time on the fresco (or tapestry) behind the children. The varied expressions and postures of the children demonstrate the effect of Time which, despite their present gaiety, will eventually carry them all away. *A Pageant of Childhood* is perhaps closely related to Gotch's *Golden Youth* (1907),[2] which shows a similar procession of dancing children, all rather older than in the Walker Art Gallery painting, and with a much larger proportion of girls.[3]

The other sources behind *A Pageant of Childhood* and similar works have been extensively analysed and include feminism,[4] a philanthropic concern for children,[5] the late 19th-century British interest in pageants,[6] 15th-century Florentine art,[7] poetic Pre-Raphaelitism,[8] French symbolism of the 1880s and 1890s[9] and the European emphasis on a decorative and formalist approach to art associated with Art Nouveau.[10]

Gotch's painting received rather conventional praise at the 1899 Royal Academy, the *Art Journal* criticizing its lack of animation, over-elaborate effect and even its composition.[11]

The artist's daughter, Phyllis, may have been the model for the girl behind the drummer; she would have been about sixteen when Goodall painted *A Pageant of Childhood*, and she was certainly the model for *The Child Enthroned* of 1894;[12] other models included Crosbie Garstin (son of Norman Garstin), Mary Ladner (later Mrs. Harry Waters) and Jinnie de Rouffignac, later Mrs. R.R. Bath (for the girl with the cymbals).[13]

REPR: *Royal Academy Pictures*, 1899, p. 150.

PROV: Purchased from the artist 1899 (£500).

EXH: Royal Academy 1899 (635); Liverpool Autumn Exhibition 1899 (177); Laing Art Gallery, Newcastle upon Tyne, *Children's Portraits and Child Pictures by T.C. Gotch*, 1910 (29).

A Pageant of Childhood WAG 122 (colour plate 7)

1 *James Lanham, artist's colourman, St. Ives Cornwall*, is inscribed on a metal label on the stretcher. *Studio*, 1899, vol. 16, p. 202, confirms that WAG 122 was painted in Cornwall.

2 With the Fine Art Society in 1978 (repr. Fine Art Society, *The Rustic Image*, 1979, no. 19).

3 C.H. Caffin, 'A Painter of Childhood and Girlhood', *Harper's Monthly Magazine*, 1910, p. 930, offers this interpretation of WAG 122: 'They do not represent a realistic scene of children playing, but embody in a scheme of rhythmic formality the idea of light-heartedness that is veiled beneath the child's engrossment in the importance of its games of make-believe.' The Laing Art Gallery, Newcastle upon Tyne, exhibition catalogue, *Children's Portraits and Child Pictures by T.C. Gotch*, 1910 (29) dates Gotch's symbolist period more precisely to 1892–1906 and simply describes WAG 122 as 'childhood in its various phases'.

4 Caffin, *op. cit.*, pp. 925–6.

5 Caffin, *op. cit.*, pp. 926–8; A.L. Baldry, 'The Work of T.C. Gotch', *Studio*, 1898, vol. 13,

pp. 73 ff., writes of 'the worship of child life, the pretty symbolism which he builds up round his studies of the dainty freshness of childhood, the poetic refinement of the domestic instinct'; *Art Journal, Supplement*, 1902, p. 9.

6 Caffin, *op. cit.*, p. 930.

7 Baldry, *op. cit.*, Caffin, *op. cit.*, p. 924, mentioning Benozzo Gozzoli, Luca della Robbia and Donatello.

8 Often largely discounted; see Fine Art Society, *Victorian Painting*, 1977, no. 70, and Arts Council of Great Britain, *Great Victorian Pictures*, 1978, pp. 40–1, no. 18, which both contain an account of Gotch's various styles.

9 French influence was not much mentioned by contemporary critics, except in connection with Gotch's earlier Newlyn style.

10 Baldry, *op. cit.*, and *Art Journal*, 1902, *op.cit.*

11 *Magazine of Art*, 1899, p. 391; *Art Journal*, 1899, p. 176; *Athenaeum*, 27 May 1899, p. 664; *Studio*,

1899, vol. 16, pp. 202 and 222, describing WAG 122 as an 'Italian' picture.

12 Newlyn Art Gallery, *Artists of the Newlyn School*, 1979, p. 177; Fine Art Society, *op. cit.*, no. 70 (colour plate).

13 Emily R. Bath, letters to the compiler, 16 and 27 January and 28 February 1985.

GRAHAM, Peter (1836–1912)
The Seabirds' Home
WAG 234
Canvas[1]: 60.8 × 91.5 cm
Signed: *Peter Graham 1879*

This is a smaller and slightly simplified version of the *Sea-Bird's Resting Place*, exhibited at the 1879 Royal Academy exhibition (447) and last recorded in Christie's London sale of 14 June 1991, lot 249.[2] It may be a sketch for the Royal

Academy, *Sea-Bird's Resting Place*, 'finished' subsequently.[3]

The source of the composition was 'a bit of coast in Cornwall, a few miles from Boscastle';[4] most of Graham's other paintings of seabirds on cliffs represent Scottish locations; he began to paint these subjects in 1872.[5]

PROV: (?) Sam Mendel sale, Christie's 26 April 1984, lot 110, bought Agnew (£393.15s.); E. Atkinson. Bought from J. Hopwood by Agnew's 4 July 1890 and sold to George Holt October 1891 (£682.10s.); bequeathed by Emma Holt 1944.

EXH: (?) Agnew's Exchange Gallery, Liverpool 1879 (89) as *The Seabird's Resting Place*.

1 Canvas stamps: *W. BENHAM / artist colourman / Whitehall* and *Prepared by Winsor and Newton*.

2 At the Royal Academy it was reviewed in *The Times*, 26 May 1879; *Athenaeum*, 7 June 1879, p. 734; *Portfolio*, 1879, p. 128; *Spectator*, 5 July 1879, p. 853; some of these reviews are quoted in the 1991 Christie's catalogue. Only the *Athenaeum* was hostile.

The Seabirds' Home WAG 234

3 Graham was noted for his preparatory oil and pencil studies (see W. Matthews Gilbert, 'The Life and Work of Peter Graham', *Art Annual*, 1899, p. 14) but WAG 234 seems too close to the final exhibited version to be in any sense a sketch for it. The most evocative description of Graham's cliff and seabird pictures is in J.L. Caw, *Scottish Painting*, 1908, p. 256.

4 According to a 5 September 1900 letter from the artist quoted in the 1991 Christie's catalogue.

5 Gilbert, *op.cit.*, pp. 14 ff.

On the Dunes

WAG 3067
Canvas: 174 × 129.5 cm
Signed: *Peter Graham / 1899*

Graham's paintings of Highland cattle had become so familiar by 1899 that *On the Dunes* attracted little attention at the Royal Academy exhibition. The critic of the *Athenaeum* commented: 'The customary cattle seem to be better painted than usual, but the landscape is decidedly trivial and thin.'[1] Writing in the same year, Gilbert[2] described the cattle as 'rough Highland kyloes' and the painting as 'a masterly rendering of Highland cattle feeding on a benty piece of sandy links . . . the animals stand out in grand relief against a great cloud which, by them, is kept well in its place'.

REPR: Photo-engraving by Bishop Pratt for Thomas Agnew and Sons 1899.

PROV: C.D. Rudd;[3] Agnew's sale, Christie's 29 April 1911, lot 62, bought Sampson (£493.10*s*.). Bequeathed by R.H. Welsford[4] 1918.

EXH: Royal Academy 1899 (231).

1 *Athenaeum*, 17 June 1899, p. 761. At least until 1891 Graham kept his Highland cattle in a paddock attached to his Buckinghamshire home (W. Matthews Gilbert, 'The Life and Work of Peter Graham', *Art Annual*, 1899, p. 31). *The Times* in its obituary on Graham of 20 October 1921 commented:

 A painter must live; to live he must sell his pictures; and such is the stupidity of purchasers that they will only buy 'characteristic' works, that is, works in the

On the Dunes WAG 3067

style by which a man has made his reputation. The wealthy manufacturer who wished to buy a Peter Graham must buy one that other wealthy manufacturers will recognize as a Peter Graham – that is, either a moorland scene or a scene of rocks and seagulls. It is the same with nearly every painter and his clients, but it must be owned that Graham yielded more than most to this tyranny, so destructive of artistic growth and freedom.

Graham's Highland cattle pictures started with his *The Way to the Cattle Tryst* of 1869 (Gilbert, *op. cit.*, p. 23).

2 Gilbert, *op.cit.*, p. 23.

3 The copy of Christie's catalogue in Agnew's archives has Rudd's name written in; the acquisition of WAG 3067 has not been traced in the Agnew Stock Books (Magdalen Evans, letter to the compiler, 7 November 1991).

4 He was managing director of J.H. Welsford and Co. (Limited), a Liverpool firm of shipowners.

Weal and Woe WAG 2927

GREGORY, Charles (1847–1920)

Weal and Woe

WAG 2927
Canvas[1]: 160.3 × 117.2 cm
Signed: *C. Gregory 1880*

This painting, understandably, did not attract much comment at the 1880 Royal Academy exhibition – except from the critic of the *Illustrated London News*[2] and from Henry Blackburn,[3] who observed that it would be more successful as an engraving; it did appear in that form in the *Art Journal*[4] of 1882 (engraved by Thomas Brown) with this explanation:

The vicissitudes of human life with all their intense and dramatic realism, are finely typified in this very able picture. The little child starting on her first voyage, with the emblem of hope and promise in her dimpled hand, has a fine antithesis in the aged labourer, worn with toil and the long burden of his many years, who will in so short a time take the last

journey of all. The pretty young mother and her babes well express happiness and content, as they look with bright-eyed hope across the placid river to the paths beyond. The mother, happy in the possession of her treasures, has a touch of sympathetic tenderness in her face, as not unconscious of the stricken one near her, who, like Rachel mourning for her children, will not be comforted. There is a fine touch of character in the stalwart boatman, whose youth and strength contrast so effectively with age and feebleness. In this work the artist has manifested with no uncertain hand his inventive faculty. The position of the boat enables him to bring his figures into excellent arrangement; the landscape is happily rendered, and the massing of the trees most successfully aids the general balance of the picture.

This is plainly a 'River of Life' picture, but unfortunately the *Art Journal* commentator did not explain the role of the two figures, well-dressed in late 18th-century costume, who seem to be seeing off or just observing the boat.

REPR: Henry Blackburn, *Academy Notes*, 1880, p. 56; G.R. Halkett, *Walker Art Gallery Notes*, 1880, p. 35; *Art Journal*, 1882, p. 80 (engraving by Thomas Brown).

PROV: Bought from the artist 1880 (£150).[5]

EXH: Royal Academy 1880 (599); Liverpool Autumn Exhibition 1880 (254).

1 Framer's label: Charles Roberson, Long Acre.

2 *Illustrated London News*, 29 May 1880, p. 531.

3 Henry Blackburn, *Academy Notes*, 1880, p. 56.

4 *Art Journal*, 1882, p. 80.

5 The money was provided by J.A. Picton – see *Saturday Review*, 20 August 1887, p. 256.

GRIMSHAW, Atkinson (1836–1893)

The Harbour at Whitby by Moonlight

WAG 10501
Board: 26.5 × 42.3 cm
Signed: *Atkinson Grimshaw 1879*

The artist began his series of views of the smaller east coast fishing ports by moonlight

in 1867 with his *Whitby Harbour by Moonlight* (private collection) and between about 1875 and 1880 he was living in Scarborough, which was then the principal seaside resort for Leeds, where he had his main residence; later in his career he concentrated on larger ports for his moonlight and twilight paintings.[1]

This painting shows the upper harbour of Whitby – or more specifically Spital Bridge; the large warehouse on the left still remains and the buildings on the right used to lead down to the old shipyard. The painting is very close indeed in composition – although rather less so in style – to Grimshaw's *Whitby Harbour* of 1878.[2] This was a favourite subject for the artist.

PROV: Joseph Utley Hodgson;[3] Arthur John Hodgson;[4] Margaret Josephine Hodgson;[5] presented by Surgeon Captain J.T. Morgan R.N.[6] 1984.

1 In Leeds City Art Gallery, *Atkinson Grimshaw*, 1979, David Bromfield notes that the inception of these moonlight scenes marked the end of Grimshaw's Pre-Raphaelite period – the generalizations of moonlight being contrary to the Pre-Raphaelite love of detail, but instead conveying mystery and intensity through the absence of precision and fact.

2 Reproduced in Alexander Robertson, *Atkinson Grimshaw*, 1988, plate 106. It measures 20.3 × 43.2 cm and was then owned by the Bury Street Gallery. It is apparently earlier in date than WAG 10501 but seems cruder – or more primitive and naive, as argued by Robertson, *op.cit.*, p. 114. Jacqueline Price, letter to the compiler, 12 October 1994, kindly provided the topographical details.

3 A partner in Hodgson Brothers, provision merchants, of 27–29 Stanley Street, Liverpool. Born in 1847 and died in 1926.

4 A Liverpool barrister, who ultimately became a judge at the Wandsworth County Court. Born in 1887 and died in 1971.

5 Also a barrister, but worked in broadcasting. Born in 1919–20, she was the daughter of Arthur John Hodgson.

6 A cousin of Margaret Josephine Hodgson.

The Harbour at Whitby by Moonlight WAG 10501

Fisherman's Wife WAG 2832

HACKER, Arthur (1857–1919)
Fisherman's Wife[1]
WAG 2832
Canvas: 130.2 × 174.6 cm
Signed: *Arthur Hacker 1885*

The subject-matter, fall of light and closely observed accessories of peasant life suggest the influence of the Newlyn School, although the smooth handling of paint is alien to the style of that School; soon after 1885, however, Hacker abandoned peasant realism (see WAG 2831 below) for history painting.[2]

The subject may be anecdotal: the wife anxiously awaits the return of her husband from fishing; the clock points to 7.50 p.m. The painting was praised as a 'quiet subject' by the *Illustrated London News*.[3]

The first reference to the *Fisherman's Wife* in the artist's diaries (still in the family's collection) seems to occur on 12 January 1885, when Hacker altered the pose of the woman in the picture. There are many notes on his work in late January and February; for example, the woman's arms were in progress on 13 January, her head on 14 January, her apron on 16 January and the background on 17 January.

REPR: Pall Mall Gazette, *Pictures of 1885*, p. 56; H. Blackburn, *Academy Notes*, 1885, p. 78.

PROV: Bought by Mr. Wignell in March 1885 for £210;[4] Anon sale, Christie's 21 April 1922, lot 161, bought Sampson (£11.11*s*.) (as *Fisherman's Wife*); presented by George Audley[5] 1927.

EXH: Royal Academy 1885 (1026); Liverpool Autumn Exhibition 1927 (112).

1 WAG 2832 was entitled *The Mother* on accession to the Walker Art Gallery. This was probably due to confusion with Hacker's *The Mother* of 1883,

194

reproduced in *Magazine of Art*, 1884, p. 160, and exhibited at the Institute of Painters in Oil Colours 1883–4 (91), to which, in conception and in composition, WAG 2832 is fairly close. The *Magazine of Art*, 1884, p. 162, praised *The Mother* in a long review, commending in particular the absence of any social realism; this may have encouraged Hacker to paint WAG 2832.

2 A.L. Baldry, 'The Paintings of Arthur Hacker', *Studio*, 1912, vol. 56, p. 176, describes Hacker's period as a genre painter and reproduces WAG 2832 (p. 179). W.H. Ward in 'Arthur Hacker', *Artist*, 1898, p. 67, described WAG 2832 as 'in the style of Israels'. Another of Hacker's early genre paintings is *Washing Dishes* of 1883 (Fine Art Society, *The Rustic Image*, 1979, no. 22, repr.), while *Cat and Mouse* of 1883, very similar in composition to WAG 2832, was sold at Christie's 9–10 June 1988, lot 42.

3 *Illustrated London News*, 30 May 1885, vol. 186, p. 564.

4 On 29 March 1885 a Mr. Wignell offered Hacker £210 for the *Fisherman's Wife*, but £300 if the picture was sold from the Royal Academy; since the painting is recorded as having been sold in

1885 for £210, the artist presumably accepted Mr. Wignell's first offer (the artist's diaries, still in the family collection).

5 George Audley, *Collection of Pictures*, 1923, p. 26, no. 68, as *The Mother*.

Pelagia and Philammon
WAG 2831
Canvas: 113 × 184.2 cm
Signed: *ARTHUR HACKER 1887*

The subject is taken from chapter 30 of Charles Kingsley's historical novel, *Hypatia*,[1] first published in 1853:

For in the open grave lay the body of Philammon the abbot: and by his side, wrapt in his cloak, the corpse of a woman of exceeding beauty, such as the Moors had described. Whom embracing straightly, as a brother a sister, and joining his lips to hers, he had rendered up his soul to God; not without bestowing on her, as it seemed, the most holy sacrament; for by the grave-side, stood the paten and the chalice emptied of their divine contents.

Pelagia and Philammon WAG 2831

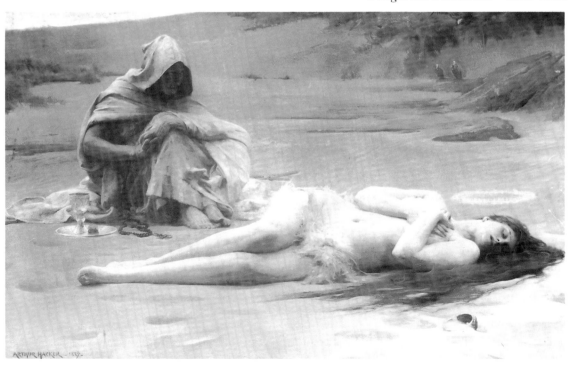

Pelagia, Philammon's sister, representing the old pagan beliefs, had lived a life of sin and luxury in 5th-century Alexandria before leaving the city for the desert; there she became a hermit and was eventually found by Philammon just as she was dying. In Kingsley's novel Pelagia was around forty years old and veiled to her feet in her black hair at the time of her death. In the foreground appears Pelagia's gold bracelet, which later worked miracles; in the background are waiting vultures. Two years earlier C.W. Mitchell's *Hypatia*, now in the Laing Art Gallery, Newcastle upon Tyne, had been exhibited at the Grosvenor Gallery; it depicted the naked Hypatia seeking refuge at the altar just before she is torn to pieces by the mob – an event taken from chapter 29 of the same book – and this painting had been extensively reviewed and discussed. Kingsley's unflattering – and highly controversial – account of the early Church in *Hypatia* is more clearly emphasized by Mitchell's painting than by *Pelagia and Philammon*, but Hacker's highly artificial combination of apparent sanctity and evident sensuality was very much in the spirit of the novel. Kingsley's novel was frequently reprinted in the late 19th century and his interpretation of the last years of the Roman Empire obtained further renown following his period as Professor of Modern History at Cambridge in the 1860s.

Pelagia and Philammon was one of Hacker's first history paintings[2] – his earlier work having consisted mainly of domestic genre and portraits – and it was well received by the critics (apart from R.A.M. Stevenson, who did not mention it in his *Art Journal* review). Its poetry, expression and drama were commended by the *Saturday Review*,[3] by the *Magazine of Art*[4] and by the *Athenaeum*,[5] but Hacker's command of the nude was criticized in the *Saturday Review*[6] and received barely a mention in the *Athenaeum*.

The progress of the work on Hacker's painting can be traced in some detail from the artist's diaries (still in the family's collection). The figure of Pelagia was drawn onto the canvas on 30 November 1886 from 'Alice', presumably a professional model, but on 6 December the same figure was sketched onto a 'clean canvas'. Two other models, 'Lane' and 'Collier', seem to have been used as models for Philammon. Alice sat frequently in early January, but work was then interrupted by the need to complete a portrait of Mr. E.

Seale-Hayne, M.P. Nevertheless, on 29 January 1887 Hacker started to finish the head of Pelagia from Alice, while work on her legs followed on 15 February, with some alterations; on 24 March C.E. Hallé and Comyns Carr called at Hacker's studio and invited him to exhibit the painting at the 1887 Grosvenor Gallery exhibition 'on the line'. 'Show Sunday' at Hacker's studio took place on 27 March, and many visitors admired *Pelagia and Philammon* there. On 4 April the artist went to the zoo in order to work on the vultures, and on 5 April the figure of Pelagia was finished; the picture went to the Grosvenor Gallery on 12 April;[7] there it was 'splendidly' hung in the centre of the big room.

A watercolour identical to this painting and signed and dated 1887 was sold at Christie's (New York) 1 March 1984, lot 500.

REPR: Henry Blackburn, *Grosvenor Notes*, 1887, p. 6; Pall Mall Gazette, *Pictures of 1887*, p. 74; *Die Kunst für Alle*, 1892–3, vol. 8, p. 15.

PROV: Purchased from the artist 1887 (£315).

EXH: Grosvenor Gallery 1887 (9); Liverpool Autumn Exhibition 1887 (242); Paris International Exhibition 1889 (58); Munich International Exhibition 1892 (3723).

1 For the controversy over Kingsley's *Hypatia*, see particularly Andrew Sanders, *The Victorian Historical Novel, 1840–1880*, 1978, pp. 122–33. Sanders notes (p. 127) that Kingsley's descriptions of the young Pelagia might have inspired the more erotic female figures of Leighton and Alma-Tadema later in the century. The novel is concerned with Philammon's journey from the desert to the city, and then back to the desert where he and Pelagia end as hermits.

2 A.L. Baldry, 'The Paintings of Arthur Hacker', *Studio*, 1912, vol. 56, p. 176. The luminous, bright tonality of WAG 2831 may owe something to Hacker's visits to North Africa in 1883 and subsequent years; the events in WAG 2831 took place there. W.H. Ward, 'Arthur Hacker', *Artist*, 1898, pp. 65 ff., also noted that WAG 2831 represented a new style for the artist.

3 *Art Journal*, 1887, p. 283; *Spectator*, 18 June 1887, p. 832, was also critical – condemning in particular the halo over Pelagia's head and the artist's error in depicting her as a young woman;

but it conceded that WAG 2831 was at least technically competent; *Saturday Review*, 14 May 1887, p. 689.

4 *Magazine of Art*, 1887, p. 343.

5 *Athenaeum*, 7 May 1887, p. 613.

6 *Saturday Review*, *op. cit.* George Bernard Shaw, in the *World*, 11 May 1887, p. 603, also commented unfavourably on Hacker's 'variation in dust colour of Delaroche's Christian Martyr theme'. WAG 2831 seems to contain Hacker's first female nude, a subject in which he was later to specialize – see Baldry, *op. cit.*, and Ward, *op. cit.*, who noted that the drawing of the nude in WAG 2831 was much discussed at the time.

7 Alma-Tadema was apparently 'riled' that WAG 2831 went to the Grosvenor Gallery rather than to the Royal Academy (artist's diaries still in the family's collection).

Christ and the Magdalen
WAG 2951
Canvas: 202.5 × 115.5 cm
Signed: *Arthur Hacker 1890*

No meeting between Christ and Mary Magdalen in his carpenter's workshop is recorded in the Bible, nor is there any well-known visual source for this subject.[1] Hacker's modernity, both in his use of apparently ethnic and so historically plausible costumes and in his realism – the emaciated figure of Christ and the wood shavings on the floor – was noticed by contemporary critics. Claude Phillips[2] observed:

Mr. Arthur Hacker has evidently been disquieted by the modern Munich School of naturalistic sacred art invented and led by Herr Fritz von Uhde. He has not, however, in his 'Christ and the Magdalen' (Royal Academy) adopted the kind of modernité *in vogue in the Bavarian capital, but has rather sought to strike out a new path of his own midway between idealism and realism. This group, showing the Magdalen prostrate at the feet of the Saviour, into whose face she gazes with an expression rather of ardent love than of devout adoration, is certainly one of the best composed things of the year. The painter has, however, made a capital mistake, into which Herr von*

Uhde and his school never fall – that of showing Christ himself as a mortal among mortals, mean in physique, weak and suffering in body, and himself pitiable as he is pitying. The true ring of sincerity does not, indeed, make its presence felt in this clever piece, which remains therefore without sufficient excuse, if we adopt the highest standpoint in estimating its worth.

The *Saturday Review*[3] also noticed Hacker's use of modern dress and accessories.

In the dearth of religious art at the Academy, Mr. Arthur Hacker's 'Christ and the Magdalene' will attract an amount of attention somewhat in excess of its positive merits. It is careful and refined, avoids the customary tricks of an easy symbolism, and is delicately drawn, but lacks tone. Mary comes to the Christ in the carpenter's shop, and falls at his feet – the costumes – except the semi-nudity of the Christ – and the general air are quite modern. The tones are pale, and kept below what is called 'exhibition-pitch'. This is a creditable, but scarcely an interesting, picture.

The *Magazine of Art*,[4] too, described Hacker's painting as 'touching and cleverly modernised' and only the *Athenaeum*[5] was distinctly hostile: 'It is a pity Mr. A. Hacker has not a more robust conception of Christ and the Magdalen than is embodied in his life size whole length figures which were designed without sympathy and painted in a flat and conventional way.'

The artist's diaries (still in the family's possession) seem to record work on the picture between November 1890 and March 1891; the female model seems to have been Miss or Mrs. Lee; the *Magdalen* is noted as begun in 1890 and finished in 1891; it was not sold.

REPR: *Royal Academy Pictures*, 1891, p. 77; Pall Mall Gazette, *Pictures of 1891*, p. 12.

PROV: Deposited by the artist 1910 and presented by his executors in accordance with his wishes 1919.

EXH: Royal Academy 1891 (1086); Liverpool Autumn Exhibition 1892 (1104); Chicago, *World's Columbian Exposition*, 1892; Earls Court, *Victorian Era Exhibition*, 1897 (551).

1 In his diaries (still in the family's possession) Hacker recorded that on 3 November 1890 he did a 'good sketch: "Who is he that condemneth"',

Christic and the
Magdalen WAG 2951

198

presumably referring to the woman taken in adultery (John 8: 1–11); this may have given him the idea for WAG 2951. W.H. Ward in 'Arthur Hacker', *Artist*, 1898, p. 70, noted that in WAG 2951 Christ was depicted as the Man of Sorrows; this may have been the artist's intention, but it seems to confuse the iconography still further. More plausibly, WAG 2951 could be seen to be related to the *Noli me tangere* theme; the poignancy of expression in WAG 2951 and the way Christ touches the forehead of Mary Magdalen suggest this subject, but there seems to be no precedent for locating this event in Christ's carpenter's workshop; it generally occurs outside the tomb. For further details of the iconography of this scene after 1600, see Emile Mâle, *L'Art religieux de la fin du XVI^e siècle, du XVII^e siècle et du XVIII^e siècle*, 1951, pp. 294–6. The most important source for 19th-century Magdalen iconography was the decoration of *La Madeleine* in Paris by various artists between 1833 and 1838; see N.D. Ziff, *Paul Delaroche*, 1977, pp. 135–44. The emotional *Magdalens* of Delaroche and Ary Scheffer may have been known to Hacker.

2 *Art Journal*, 1891, p. 186; Claude Phillips's review of WAG 2951 in the *Academy*, 9 May 1891, p. 447, is very similar; von Uhde used contemporary European peasant dress and figures in his religious pictures; Hacker's costumes seem in fact to be a compromise between 19th-century Palestinian fashions and the dress used in, for example, Dutch 17th-century religious paintings. Albert Edelfelt exhibited his *Christ and the Magdalen* (now in the Ateneumin Taidemuseo, Helsinki) at the 1890 Munich Künstlergenossenschaft exhibition; it is in the style of von Uhde, with a contemporary Mary Magdalen kneeling before Christ in a vaguely north European landscape setting. Hacker may have read Edward Armitage's *Lectures*, 1883, pp. 17–21, in which he discusses at length the appropriate costume for representations of New Testament figures – concluding that dull colours and a 'loose cloth bound round the head with a cord' were appropriate; compare the remarkable costume given to Christ in G.P. Jacomb-Hood's *Raising of the Daughter of Jairus*, 1885, now Guildhall Art Gallery, London.

3 *Saturday Review*, 9 May 1891, p. 559; the 'customary tricks of an easy symbolism' are perhaps to be seen in Hacker's 1892 *Annunciation* (Tate Gallery), which entirely lacks the realism of WAG 2951.

4 *Magazine of Art*, 1891, p. 258.

5 *Athenaeum*, 30 May 1891, p. 706.

HAGUE, Joshua Anderson (1850–1916)
Late Autumn
WAG 2929
Canvas: 131 × 98 cm
Signed: *Anderson Hague*

REPR: Liverpool Autumn Exhibition catalogue, 1890, p. 116.

PROV: Bought from the artist 1890 (£200).

EXH: Liverpool Autumn Exhibition 1890 (1164).

Late Autumn WAG 2929

Primrose Gatherers

WAG 510
Canvas: 71 × 101.9 cm

PROV: Bequeathed by George Audley[1] 1932.

1 George Audley, *Collection of Pictures*, 1923, p. 27, no. 69.

Primrose Gatherers WAG 510

HALSWELLE, Keeley (1832–1891)
Fish Auction at Newhaven

WAG 235
Canvas[1]: 33 × 46 cm
Signed: *K.H. 1867*

Many of Halswelle's paintings of the 1860s represented the Newhaven fishing community[2] and this painting is probably related to the *Fish Auction, Newhaven*, no. 2 at the 1868 Royal Academy and no. 8 at the 1869 Royal Scottish Academy.

The lower edge of this painting was seri-ously damaged by rain in 1954 with a considerable loss of paint in this area.

PROV: Bought from Nickisson (?) by Agnew's 8 December 1871; sold to George Holt 13 December 1871 (£150); bequeathed by Emma Holt 1944.

EXH: Glasgow Scottish National Exhibition 1911.

1 Canvas stamp: *JOHN D. SMITH / Carver and Gilder / Edinburgh*.

2 James Dafforne, 'The Works of Keeley Halswelle', *Art Journal*, 1879, p. 49. Many of

Fish Auction at Newhaven
WAG 235

200

these Newhaven scenes were exhibited at the Royal Scottish Academy between 1863 and 1869; Newhaven's picturesque fishermen and women were attracting tourists and artists as early as the 1820s – see particularly Scottish National Portrait Gallery, *Hill and Adamson's The Fishermen and Women of the Firth of Forth*, 1991, pp. 17–22.

Contadine in St. Peter's, Rome

WAG 3075
Canvas: 158 × 254 cm
Signed: *Keeley Halswelle / ROME 1871*

This painting was first exhibited in 1871 with the following quotation from Byron's *Childe Harold's Pilgrimage*, canto 4, stanzas 154 and 158 against it in the catalogue:

Majesty,
Power, glory, strength, and beauty, all are aisled
In this eternal ark of worship undefiled.
. . . Our outward sense
Is but of gradual grasp – and as it is
That what we have of feeling most intense
Outstrips our faint expression; even so this

Outshining and o'erwhelming edifice
Fools our fond gaze, and greatest of the great
Defies at first our nature's littleness,
Till, growing with its growth, we thus dilate
Our spirits to the size of that they contemplate.

The artist first went to Rome in 1868 and seems to have spent much of his life up to about 1874 in Italy.[1] Michelangelo's *Pietà* can be seen in the Capella della Pietà at the extreme right, and on the left, in the nave, is one of the two holy water-stoups by Giuseppe Lironi, Francesco Moderati, Giovanni Battista de Rossi and Agostino Cornacchini.[2] The view has been taken from the west end of the nave looking south.

The critics at the 1871 Royal Academy exhibition found the figures too theatrical and not sufficiently elevated in type, but they could not deny the power and vigour of the design.[3] The *Saturday Review* was typical:

The work has genius but no diffidence. Michael Angelo's Pietà and the famous flaunting cherubs of Bernini type are forced into a composition which though placed in St. Peter's could be got up by any shop costumier skilled in private theatricals. We have

Contadine in St. Peter's, Rome WAG 3075

often with a feeling of respect watched the peasant of the Roman Campagna enter a church and reverently throw himself on his knees. But Mr. Halswelle has wholly missed the sentiment; he quotes Byron wholesale, and his figures, instead of standing on the line of the Academy, should be transferred to the stage; they are inflated in sentiment and loudly declamatory.

Catalogued below is a small version of this composition.

PROV: Bought from Thomas Brassey by Agnew's 30 November 1871; sold to E. Hoette (?) 12 March 1872 (£1050). Philip Jacob Blessig; presented by E.W. Blessig 1909.

EXH: Royal Academy 1871 (359); Agnew's Liverpool 1871 (53).[4]

1 James Dafforne, 'The Works of Keeley Halswelle', *Art Journal*, 1879, p. 49.

2 See R. Engass, *Early Eighteenth Century Sculpture in Rome*, 1976, vol. 1, p. 172 and Carlo Galassi Paluzzo, *Le Chiese di Roma Illustrate: San Pietro in Vaticano*, 1963, vol. 2, pp. 181, 187, fig. 90; these sculptors were responsible for the putti but it is not possible to attribute particular putti to any one sculptor. J.J. Lefebvre's *Pilgrims in St Peter's Basilica, Rome* Sotheby's (New York) 16 February 1995, lot 112) shows pilgrims, rather more decorous than those in WAG 3075, before the same holy water-stoup.

3 *Saturday Review*, 20 May 1871, p. 635; *Art Journal*, 1871, p. 175; Dafforne, *op. cit.*, p. 50; *Art Pictorial and Industrial*, 1871, p. 195; *Architect*, 13 May 1871, p. 247; these two last periodicals were very enthusiastic about the painting. Many of the critics commented on Halswelle's debt to John Phillip.

4 The review in the *Porcupine*, 23 September 1871, p. 411, indicated that this was the large version.

Contadine in St. Peter's, Rome

WAG 236
Canvas: 39.4 × 61.2 cm
Signed: *Keeley Halswelle / ROME 1871*

This is a small version of – or possibly a sketch for – the large painting catalogued above; it is more or less identical to it, but perhaps slightly less finished.

PROV: James Brand sale, Christie's 10 March 1894, lot 90, bought Agnew's (£99.15s.); sold to George Holt August 1895 (£150); bequeathed by Emma Holt 1944.

Valley of the Thames

WAG 237
Canvas: 36.3 × 62.3 cm
Signed: *Keeley Halswelle / 1882*

Sonning Weir

WAG 238
Canvas: 36.4 × 62.3 cm
Signed: *Keeley Halswelle 1882/1878*

These two paintings were part of a group of eighty-two pictures of the Upper Thames done by the artist between 1877 and 1883 and eventually exhibited at Agnew's in 1883 under the title *Six Years on a House Boat*.[1] They were all painted from the artist's luxurious houseboat, *The Kelpie*, or from its attendant punt. The *Valley of the Thames* was described in Agnew's exhibition catalogue as *The Valley of the Thames from above Day's Lock, looking towards Oxford* and shows the stretch of the Thames running north between Dorchester (in the extreme distance on the right) and Little Wittenham; Day's Lock is prominent in the middle distance; the artist must have painted the view from Wittenham Clumps.[2] The artist put against it in the catalogue a quotation from the opening line of the well-known *Cuckoo Song* of *c.*1250: 'Sumer is icumen in'.

Sonning Weir was given a quotation from Coleridge's *Ancient Mariner* in the same catalogue (part 4, stanza 17):

> *That to the sleeping woods all night*
> *Singeth a quiet tune.*

*Contadine in St. Peter's,
Rome* WAG 236

Valley of the Thames
WAG 237

Sonning Weir
WAG 238

Although the *Valley of the Thames* and *Sonning Weir* are dated 1882 and 1882/1878, they appear on the list of Halswelle's works – which he painted on the walls of his studio[3] – under 1882–3 when, presumably, most of the work on them was done.

PROV: Bought by Agnew's from the artist 1 December 1883 (with the other eighty pictures); (WAG 238) sold to George Holt December 1884 (£130); (WAG 237) sold to George Holt February 1885 (£120) and a picture in exchange; bequeathed by Emma Holt 1944.

EXH: Agnew's, *Six Years on a House Boat*, 1883 (38 and 69).

1 Keeley Halswelle, *Six Years on a House Boat*, published by Agnew's, London, November 1883, pp. 5–10.

2 David Wilson, letter to the compiler, 5 January 1993; Halswelle's *Wittenham Clumps* was exhibited at the 1882 Royal Scottish Academy exhibition (no. 53) and the hill was favoured by Paul Nash for his mystic landscapes forty years later.

3 The studio, with the list still on its walls, is in Hampshire. I am grateful to Linda Homshaw for details of it. The list is entitled: 'Works painted or finished in this studio'. According to the list there were eighty-five, not eighty-two, paintings in the series.

'Flying Scud'

WAG 2835
Canvas[1]: 106 × 181.3 cm
Signed: *Keeley Halswelle 1884*

At the 1885 Grosvenor Gallery exhibition the *Art Journal*[2] critic preferred 'Flying Scud' to the artist's other work at that exhibition, *Kilchurn Castle*: 'We like better his 'Flying Scud' where the rushes beside the river seem to whistle and shiver beneath the gale.' The *Athenaeum* critic,[3] however, discussed *Kilchurn Castle* but not 'Flying Scud'. The influence of J.E. Millais's late landscapes is clear.

'Flying Scud' appears under 1884–5 on the list of works which Halswelle painted on the walls of his studio.[4]

The title of the painting may be derived from Dion Boucicault's play, *Flying Scud*, first performed in London in 1866.

PROV: Bought by J. Randles Withers of Lowlands, West Derby, 1886;[5] presented by his son Hugh Withers, together with the brothers and sisters of Hugh Withers, in memory of their parents 1930.

EXH: Grosvenor Gallery 1885 (199); Liverpool Autumn Exhibition 1885 (986) priced at £600; Royal Scottish Academy 1886 (197).

1 Frame maker's label: *[– – –] Smith Mortimer Street, Regent Street.*

'Flying Scud'
WAG 2835

The Fallen Monarch WAG 2834

2 *Art Journal*, 1885, p. 227. Henry Blackburn in his *Grosvenor Notes*, 1885, p. 44, simply described WAG 2835 as 'a powerful study of flat land and brown rushes in the wind'.

3 *Athenaeum*, 25 April 1885, p. 540.

4 See WAG 237 above (note 3).

5 Letter from Hugh Withers of 21 November 1930.

1 WAG 2834 was originally entitled *Kings of the Forest*; the description of *Kings of the Forest* in H. Blackburn, *New Gallery Notes*, 1891, p. 5, makes it plain that WAG 2834 is that picture.

2 *Athenaeum*, 9 May 1891, p. 611.

3 See WAG 237 above (note 3). *Kings of the Forest, Sketch* is listed under 1889–90.

The Fallen Monarch[1]
WAG 2834
Canvas: 104.8 × 174 cm
Signed: *Keeley Halswelle 1891*

The *Athenaeum*[2] critic commented: 'A confused sketch, not a picture, on a needlessly large scale, of felled trees on the bank of a river; the rainy sky is better than usual, but the standing oak is the best part'.

This painting appeared under its original title (*Kings of the Forest*) on the list of works painted on the walls of Halswelle's studio.[3]

PROV: Bequeathed by Dr. Edmund K. Muspratt 1924.

EXH: New Gallery 1891 (4) as *Kings of the Forest*.

HAMILTON, James Whitelaw
(1860–1932)
Bolton Castle
WAG 167
Canvas: 107.4 × 127.7 cm
Signed: *J. WHITELAW, HAMILTON*

The view is taken from the east or village side of the castle, which is situated in North Yorkshire.

PROV: Presented by Mrs. James Whitelaw Hamilton 1934.

EXH: (?) Royal Scottish Academy 1930 (142); (?) Royal Glasgow Institute of the Fine Arts 1931 (332).

Bolton Castle WAG 167

HAVERS, Alice Mary (1850–1890)

Blanchisseuses: 'What, no Soap?'[1]

WAG 2931
Canvas[2]: 110.2 × 183.8 cm
Signed: *A. Havers*

Henry Blackburn identified the area as Normandy.[3] The London critics scarcely noticed this painting,[4] but the Liverpool reviewers praised the brilliant sunny atmosphere and the happy graceful figures.[5] The title indicates that the artist may have intended to parody the well-known theme of picturesque rural washerwomen. She returned to this subject in 1885 with her *The Belle of the Village* (Atkinson Art Gallery, Southport), which shows women returning home by a wood with their washing and being gazed at by some men, but here there is an overtly sexual theme.[6]

REPR: H. Blackburn, *Academy Notes*, 1880, p. 76.

PROV: Purchased from the artist 1880 (£157.10*s*.).

EXH: Royal Academy 1880 (1465); Liverpool Autumn Exhibition 1880 (547).

1 This phrase is found in Samuel Foote's paragraph of nonsense intended to test the memory of Charles Macklin (*Quarterly Review*, September 1854, vol. 95, p. 516); the artist would have found it in a dictionary of quotations.

2 Canvas stamp: Winsor and Newton.

3 *Academy Notes*, 1880, p. 76. Blackburn knew Normandy but may have just been relying on the apple trees and the French title.

4 See *Art Journal*, 1880, p. 221.

5 *Porcupine*, 16 October 1880, p. 458; *Argus*, 2 October 1880, p. 812. In fact the artist was better known for her social realist paintings of the 1870s and 1880s; see Charlotte Yeldham, *Women Artists in 19th-Century France and England*, 1984, vol. 1, pp. 170–1.

6 See Deborah Cherry's remarks in *Painting Women*, Rochdale Art Gallery, 1987, p. 23.

HAWKSLEY, Arthur (1842–1915)

Landscape

WAG 713
Canvas[1]: 50.8 × 40.5 cm
Signed: *Arthur Hawksley 1882*

According to the artist's widow[2] this painting was 'a good many times taken for a Corot'. She also asserted that it was exhibited at the Royal Academy under the title 'The day is done', but this does not seem to have been correct.

PROV: Presented by Mrs. Arthur Hawksley, the artist's widow, 1926.

1 Canvas stamp: *W.A. SMITH 4 VICTORIA STREET NOTTINGHAM.*

2 Letter to the Curator of the Walker Art Gallery, 11 October 1926.

Landscape WAG 713

Blanchisseuses: 'What, no Soap?' WAG 2931

Under the Walls of Maastricht: Arrival of a Canal Boat WAG 473

HEMY, Charles Napier (1841–1917)
Under the Walls of Maastricht: Arrival of a Canal Boat

WAG 473
Canvas: 84.7 × 105.1 cm
Signed: *C. Napier Hemy 1869*

The artist[1] stated that this picture was 'painted in 1869 when I was still at school in Antwerp and is another imitation of Baron Leys. I got £80 for it.' The stiff parallel poses and apparently archaic dress of the two right-hand figures in the boat, together with the fixed distracted expressions and the abrupt perspectives, certainly suggest the influence of Henri Leys, with whom Hemy studied from 1867 until 1869, but Pre-Raphaelite influence still seems apparent, particularly in the background.[2] The critic of the *Athenaeum*[3] observed

that the painting 'disappoints our knowledge of and hopes in the artist. He ought to know better than to imitate M. Leys or any other painter. There is much richness of local colouring, also good lighting here.'

There is a watercolour study in a private collection; it is very close to the Walker Art Gallery painting but lacks the boat and figures.[4] Hemy's *God's House, Maastricht* of 1870 is in the Manchester City Art Galleries.

The canal is the former 'canal de Liège' and is seen here at the south-east corner of Maastricht; above the walls at the left is the paper mill, 'Het Anker', of 1775 and the tower of the Porte de l'Enfer; moving to the right, the west front of Notre Dame de Maastricht rises above houses of the 16th and 17th centuries.[5]

PROV: Presented by the executors of the late Robert and Mary Jones King 1900.[6]

EXH: Royal Academy 1869 (4).

1 MS letter to the Curator of the Walker Art
 Gallery of 24 November 1912; in the same letter
 he said that WAG 473 was not worthy of a place
 in the Walker Art Gallery, although in a letter to
 the Curator of 24 July 1878 he had listed WAG
 473 as one of his 'principal pictures'. *Pour la fête de
 Notre Dame* (Christie's 25 October 1991, lot 40)
 was also painted by Hemy while he was studying
 under Leys in Antwerp between 1867 and 1869;
 Leys actually worked on this picture.

2 A different analysis of WAG 473 appears in Laing
 Art Gallery, Newcastle upon Tyne, *Charles
 Napier Hemy*, 1984, p. 27.

3 *Athenaeum*, 15 May 1869, p. 674.

4 Laing Art Gallery, *op. cit.*, p. 26, no. 16.

5 Leo Ewals, letter to the compiler, 2 April 1985;
 the canal was filled in around 1960, but this
 stretch survives as a lake; the rest of the scene in
 WAG 473 survives to the present day, although a
 few houses and the central part of the wall have
 been demolished.

6 An MS label on the back of WAG 473 gives its
 original (?) price as £120.

A German Birthday Party in 1575[1]

WAG 715
Canvas: 91.5 × 136.5 cm
Signed: *C. Napier Hemy 1872–3–5*

This painting, like WAG 473 (see above),
demonstrates the influence of Henri Leys over
Hemy, in this case most notably through the
gravity of the figures and the picturesque
antiquarian details of dress, furniture and
architecture; the *Athenaeum*[2] observed that it
'with much good characterization recalls
Baron Leys and not unfortunately'.

PROV: Presented by T. Arthur Hope 1882.[3]

EXH: Royal Academy 1872 (1143).[4]

A German Birthday Party in 1575 WAG 715

1 At the 1872 Royal Academy WAG 715 was
simply entitled *The Birthday*, but the artist gave it
this fuller title in an MS letter to the Curator of
the Walker Art Gallery dated 24 November 1912
and WAG 715 was acquired with the long title in
1882.

2 *Athenaeum*, 25 May 1872, p. 661. Laing Art
Gallery, Newcastle upon Tyne, *Charles Napier
Hemy*, 1984, p. 27, also sees the influence of Leys
in WAG 715.

3 According to the artist's letter of 24 November
1912, Hope paid £80 for WAG 715, but 'regretted
ever having bought it and wrote many letters
complaining that it was a lifeless and worthless
sort of a picture'; Hope's criticisms may have
caused the artist to do further work on the
picture, as recorded by the dates against the
signature. Perhaps the female figure seated at the
end of the table, animated in a manner
uncharacteristic of Leys, was a later re-working.

4 The artist's letter of 24 November 1912 stated that
WAG 715 was at first rejected at the 1872 Royal
Academy. However, when an architect offered to
hang it in the architecture room, the painters on
the hanging committee agreed to place it among
the paintings; it hung in the lecture room.

A Nautical Argument

WAG 472
Canvas: 62.4 × 99.1 cm
Signed: *C. Napier Hemy 1877*
Inscribed: *Bristol Channel* (on chart)

This is one of a series of paintings representing
scenes on the lower reaches of the Thames
done in the period 1871–82;[1] in 1912[2] the artist
described it as 'a nice picture of its class painted
under the influence of Tissot; I never repeated
the experiment'. The narrative interest and
maritime setting reflect the example of Tissot,
but Tissot's irony and humour are absent and
the social class represented by Hemy is lower
than that usually adopted by Tissot.[3] *A Nauti-
cal Argument* may have been extensively
repainted and begun before 1877.[4] The critics
at the 1877 Royal Academy were favourable;

A Nautical Argument WAG 472

the picture was 'painted with much solidity and verve';[5] it was 'a fully toned and powerfully characteristic work with considerable humour';[6] the artist was never 'brighter or better'.[7]

The Walker Art Gallery painting was apparently preceded by a watercolour (or a drawing) of the same subject and composition.[8]

REPR: H. Blackburn, *Academy Notes*, 1877, p. 47.

PROV: Purchased from the artist 1877 (£250).

EXH: Royal Academy 1877 (517); Liverpool Autumn Exhibition 1877 (770).

1 A. Fish, 'C. Napier Hemy', *Magazine of Art*, 1900, p. 4: there is a list of some of these Thames paintings in *Art Journal*, 1881, pp. 226–7, and *Good Bye* is reproduced on p. 225. *Old River Barge, Limehouse* is in the Bolton Museums and Art Gallery.

2 MS letter to the Curator of the Walker Art Gallery of 24 November 1912; in an earlier letter to the Curator (24 July 1878) Hemy described WAG 472 as one of his 'principal pictures'.

3 Laing Art Gallery, Newcastle upon Tyne, *Charles Napier Hemy*, 1984, pp. 32–3; Hemy was a friend of Tissot during the 1870s – see M. Wentworth, *James Tissot*, 1984, p. 128; Tissot's *Interesting Story* of 1872 (National Gallery of Victoria, Melbourne) comes closest to WAG 472, but it has 18th-century costumes; among contemporary reviewers the critic of the *Illustrated London News*, 16 June 1877, p. 563, pointed out that WAG 472 was 'in the style of Mr. Tissot's waterside comedies'.

4 According to Laing Art Gallery, *op. cit.*, p. 33.

5 H. Blackburn, *Academy Notes*, 1877, p. 47.

6 *Athenaeum*, 26 May 1877, p. 677.

7 *Art Journal*, 1877, p. 270.

8 This work was exhibited at the Dudley Gallery watercolours and drawings exhibition of early 1876, (240) and there is a description of it in the *Pall Mall Gazette*, 3 February 1876: 'a group of sea captains assembled in the parlour of an inn with a chart spread out before them'; it is now lost. *The Chart*, no. 13 in the *Institute of Painters in Oil*

Colours exhibition of 1885–6, reproduced in the catalogue, has a similar subject – two men are looking at a chart on a table in a ship's cabin and a woman looks on.

Grey Venice

WAG 1239
Canvas: 91.5 × 138.1 cm
Signed: *C. Napier Hemy 1885*

Hemy went to Venice in April 1881, having apparently been commissioned to do paintings of the city for the Fine Art Society, which is said to have offered him £500 for each painting;[1] he seems to have stayed with Henry Woods,[2] the leader (with Luke Fildes) of the British Neo-Venetian school, but his Venetian style was quite distinct from that of Woods and Fildes; this is the only painting that can now be traced to this visit[3] and it did not pass through the Fine Art Society's hands. The artist[4] described it as 'another experiment painted when I was in Venice with Harry Woods and is also a picture with no personality in it'. Reviewers at the Grosvenor Gallery in 1885 pointed out that the colours and tonality were English, not Italian; Cosmo Monkhouse wrote: 'Mr. Hemy who has so often delighted us with his bold green English seas and animated shipping has in going to Venice changed neither his spirit nor his sky. His *Grey Venice* might be in England but for its buildings and crafts and is certainly not marked by poetry or refinement.'[5]

In the background appear the Dogana da Mar and the Basilica della Salute; the view seems to have been taken from the opposite side of the Grand Canal near the Calle Vallaresso.

REPR: Pall Mall Gazette, *Pictures of 1885*, p. 72; H. Blackburn, *Grosvenor Notes*, 1885, p. 9.

PROV: Purchased from the artist 1885 (£175).

EXH: Grosvenor Gallery 1885 (20); Liverpool Autumn Exhibition 1885 (1056).

1 Laing Art Gallery, Newcastle upon Tyne, *Charles Napier Hemy*, 1984, p. 38. However, the Fine Art Society held an exhibition *Venice: Paintings and Drawings* in 1882 at which Hemy did not exhibit, and there is no record of any commission to

Grey Venice WAG 1239

Hemy in the Fine Art Society's Minutes of Board Meetings, January 1879–December 1881 (Simon Edsor, letter to the compiler, 12 February 1985).

2 Woods spent much of his life in Venice after 1877.

3 Laing Art Gallery, *op. cit.*

4 MS letter to the Curator of the Walker Art Gallery of 24 November 1912.

5 *Academy*, 23 May 1885, p. 371. The Pall Mall Gazette, *Pictures of the Year*, 1885, p. 62, wrote: 'It is amusing to see Mr. Napier Hemy exchange Cornwall for Italy and still look at Venice with his Cornish eyes.' The Magazine of Art, 1885, p. 466, praised the naturalism and atmospheric effects of WAG 1239.

HERKOMER, Hubert von (1849–1914)

Eventide: A Scene in the Westminster Union

WAG 751
Canvas: 110.5 × 198.7 cm
Signed: *Hubert Herkomer 1878*

This painting was begun by September 1876 and was apparently intended to be 10 feet long and to have nearly life-size figures; it was conceived as a companion picture to the *Last Muster*.[1] Herkomer's 1876 illustration for the *Graphic*, *Christmas in a Workhouse*[2] has as its principal figure an old woman similar to the seated woman facing the spectator at the far side of the table in the Walker Art Gallery painting. This 1876 engraving, however, emphasizes philanthropy and charity in a festive setting; much closer to *Eventide* is his 1877 wood engraving in the *Graphic*, *Old Age – A Study at the Westminster Union*.[3] The three figures seated at the left of the table in *Eventide* also appear in this engraving and the compositions are very similar; the atmosphere and

expressions are, however, less bleak and more contented in *Eventide* – note, for example, the young nurse, who is not present in the wood engraving.[4] There is a watercolour sketch for *Eventide* in the Walker Art Gallery (WAG 1449); it shows the whole composition and is very close to *Eventide*. A black chalk drawing of the heads of two old women – now in the Egerton Collection on loan to the Watford Museum – may have been used as a preliminary study for *Eventide* or for one of the *Graphic* illustrations; the Egerton Collection drawing is inscribed *Mrs. Inwood*, apparently an inhabitant of Bushey. The artist intended to make a large elaborate and highly finished etching after *Eventide*, but this does not seem to have ever been done.[5]

The subject is presumably the St. James's Workhouse,[6] which lay between Poland Street and Marshall Street; it was taken over by the guardians of the newly formed Westminster Union in 1868 and eventually converted into a garage in 1925. Around 1870 the Poor Law Inspectors were encouraging boards of guard-ians to compel old people seeking relief to enter workhouses.[7] The artist wrote about the 1877 *Graphic* wood engraving: 'These poor old bodies formed a most touching picture. Work they would for industry was still in them; but it was most often childish work – still it was work. The agony of threading their needles was affecting indeed.'[8] James Charles's *Our Poor* (now Warrington Museum and Art Gallery) was also a workhouse scene and it, too, appeared at the 1878 Royal Academy (1026). Charles's approach was more sentimental than that of Herkomer.

At the Royal Academy exhibition most critics pointed to the similarity between *Eventide* and the *Last Muster*; the critic of the *Athenaeum*[9] went on:

That is a narrow view of Art which seeks only to amuse and Mr. Herkomer, Mr. Fildes and other painters of the same class appear to desire to give expression to some of the sadder truths of life existing in our midst but of which the ordinary world knows little . . . Mr. Herkomer has not forgotten in this

Eventide: A Scene in the Westminster Union WAG 751 (colour plate 8)

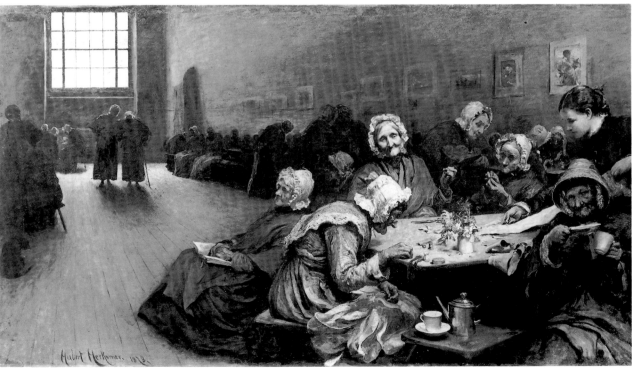

group the opportunity for giving various types of character in old age . . . But sadly simple as is Mr. Herkomer's theme, the sentiment of his work, peacefully felt and touchingly expressed, is one to reach all hearts.

The *Magazine of Art*[10] review was similar:

Every figure has been studied from the life with a rare truthfulness and appreciation, the general type and individual character being equally well represented; and if in one instance the character is horribly disagreeable the conscientious skill of the artist is no less evident there than in the old faces that are perfectly sympathetic.

The *Art Journal*[11] was, however, more critical:

One of the leading features here is Hubert Herkomer's 'Eventide', a long room in the Westminster Union, with the female inmates 'cosy and comfortable apparently' at their tea. If the perspective of the room is right – to us it looks as if the point of sight were too high – all the rest of the picture is most masterly, whether we regard its modelling, grouping, or chiaroscuro, although the subject is of a kind with which we have not much sympathy.

The *Saturday Review*[12] also criticized the composition: 'The faces of the old women who are extracting comfort from their tea are indeed rendered with singular penetration and exactitude but the composition of the picture is odd and can hardly be thought to be happy.' None of these critics seems to have felt the expressive force of the violent perspective in Herkomer's painting.

However, the most enthusiastic review came from Huysmans,[13] when *Eventide* was exhibited at the 1879 Paris Salon:

Il n'y a plus d'encouragements à adresser à M. Herkomer, ni de réussite à lui souhaiter. Celui-là est, Dieu merci! arrivé et connu. Les Invalides exposés à la section anglaise du Champ de Mars l'ont rendu célèbre – en France – du jour au lendemain. Sa toile de cette année, Un Asile pour la vieillesse, écrase ce qui l'entoure. La partie gauche du tableau comprenant le coin de la salle éclairé par la fenêtre et les deux vieilles qui s'avancent, appuyées l'une sur l'autre, tandis qu'apparaissent de maigres silhouettes de femmes accroupies commes ces vieilles de Villon, qui regrettent le temps passé devant un feu de chènevottes, est tout bonnement admirable. J'aime moins, en revanche, tout le côté droit, celui òu, assises autour d'une table, d'autres femmes boivent leur café et cousent. Certes, la malheureuse qui dort, un livre sur ses genoux, est superbe encore, mais parmi ce pensionnat de pauvresses, ratatinées, ridées comme des reinettes et briquetées aux joues par les chaleurs bienfaisantes du café et de l'ale, la femme qui gratte la table et celle qui s'évertue à enfiler son aiguille, me gâtent, avec leurs grimaces et leur cocasserie d'allure, le très bel ensemble de l'oeuvre.

Un fait curieux à noter, c'est que l'impression donnée par cette vue d'asile, n'est douloureuse, ni sinistre, comme celle que dégagerait le repaire où gisent les misères des vieillesses féminines, en France. L'asile anglais, tel que le représente M. Herkomer, est d'une tristesse résignée et souriante. Il y a même une certaine joyeuseté éparse dans ce lieu de souffrance. Les pauvresses sirotent doucettement, et paraissent accepter volontiers l'ouvrage que leur distribue une jeune sous-maîtresse. Faîtes la différence: représentez, dans un tableau vrai, l'une des salles de la Salpêtrière, à Paris: ce serait poignant et lugubre. On y sentirait d'avantage l'humanité hurlant après ses pauvres os, au milieu d'un spasme de rier causé par les médisances échangées sur les voisines. Je douterais même un peu, à ce point de vue, de la véracité de M. Herkomer si, dans ses notes sur l'Angleterre, M. Taine n'affirmait qu'au Workhouse 'toutes les vieillesses semblent bien portantes et n'ont pas l'air triste'.

Quoi qu'il en soit, embelli ou strictement exact, ce tableau est merveilleusement peint et l'on y sent la patte d'un fier artiste!

Two of the pictures on the walls in *Eventide* can be identified;[14] one shows the dead pensioner and his companion from the reduced version of the *Last Muster*;[15] the other is apparently a reproduction of Luke Fildes's *Betty*, first exhibited at the 1875 Royal Academy (and published in the *Illustrated London News* Christmas Supplement of that year).

REPR: H. Blackburn, *Academy Notes*, 1878, p. 67; G.R. Halkett, *Notes to the Walker Art Gallery*, 1878, p. 28; A. Bellenger, *Magazine of Art*, 1880, p. 261.

PROV: Purchased from the artist 1878 (£750).

EXH: The German Athenaeum, 41 Mortimer Street, 1878;[16] Royal Academy 1878 (1002); Liverpool Autumn Exhibition 1878 (110); Paris Salon 1879 (1547); Whitechapel Art Gallery, *Winter Exhibition*, 1903 (24).

1 J. Saxon Mills, *Life and Letters of Sir Hubert Herkomer*, 1923, p. 97. The artist had witnessed

the scene while roaming around London looking for interesting subjects – see *Graphic*, 7 April 1877, p. 326; he wrote: 'I was struck by the scene in Nature. I felt that every one of these old crones had fought hard battles in their lives – harder battles by far than those old warriors I painted – for they had to fight single-handed and not in the battalions as the men did.' (J.W. Comyns Carr, *Hubert von Herkomer: Modern Artists*, ed. Dumas, 1882–4, pp. 67–8). The *Last Muster* is in the Lady Lever Art Gallery, see Edward Morris, *Victorian and Edwardian Paintings in the Lady Lever Art Gallery*, 1994, pp. 50–6.

2 *Graphic*, Christmas Number, 1876, p. 30.

3 *Graphic*, 7 April 1877, pp. 324–5.

4 A watercolour and oil study identical to the *Graphic* illustration of 7 April 1877 and signed and dated 1877 was in the Christie's sale 10 July 1970, lot 23 (now in a private collection, London, and probably exhibited at the Dudley Gallery 1877 (353)). Similarly, there is a gouache study for the 1876 *Christmas in a Workhouse* illustration in the York City Art Gallery. A drawing formerly in the C.J. Galloway collection entitled *Eventide Westminster Union* (20 × 34 in.) may have been related to the *Graphic* engravings or to WAG 751 (*Catalogue of Paintings and Drawings collected by C.J. Galloway*, 1892, no. 278). It was the *Graphic* wood engravings, not WAG 751, that so deeply impressed Vincent van Gogh; see Arts Council of Great Britain, *English Influences on Vincent Van Gogh*, 1974–5, pp. 37, 43 and Watford Museum, *Sir Hubert von Herkomer*, 1982, p. 41. For these wood engravings see also H.D. Rodee, *Scenes of Rural and Urban Poverty in Victorian Painting 1850–1900*, 1975, pp. 194 ff.; Rodee also discusses other paintings of workhouses in this period.

5 Letter from the artist read to the Liverpool Corporation Libraries, Museums and Art Galleries Committee on 18 April 1878.

6 See London County Council, *Survey of London, Parish of St. James's, Piccadilly*, 1963, vol. 2, pp. 210 ff. James Dafforne, 'The Works of Hubert Herkomer', *Art Journal*, 1880, p. 111, confirmed that the subject of WAG 751 was the St. James's Workhouse.

7 Pauline Gregg, *A Social and Economic History of Britain*, 1971, p. 489. There is a brief account of the development of workhouses in the description

of the *Graphic* wood engraving of 7 April 1877 (*Graphic*, 1877, pp. 326–7); this account noted that by 1877 workhouses were mainly inhabited by the old and the infirm, and that women were usually there through no fault of their own; it deplored the plight of such women but also pointed to some alleviations in the workhouse routine. See also L.M. Edwards, *Hubert von Herkomer and the Modern Life Subject*, 1984, pp. 229 ff. and Manchester City Art Galleries, *Hard Times*, 1987, pp. 93–5.

8 *Graphic*, 7 April 1877, pp. 326–7.

9 *Athenaeum*, 4 May 1878, p. 577. Similarly, W.M. Rossetti (in the *Academy*, 25 May 1878, p. 470) noted that Herkomer 'neither embellishes nor degrades but shows us old age feeble, suffering, not wholly sunk into the blankness of non-employment, nor quite without separate and individual relish for the scanty comforts which remain to it'; he also noted that 'the perspective of the room is powerful in recession and in light and shade'.

10 *Magazine of Art*, 1878, p. 104.

11 *Art Journal*, 1878, p. 179. The *Spectator*, 22 June 1878, p. 795, found the technique 'rough and coarse'. Some critics thought that the old women were well cared for and fortunate; some thought – the *Athenaeum* critic in particular – that they were most unfortunate; for more reviews see Watford Museum, *op. cit.*, p. 40, Edwards, *op. cit.*, pp. 240 ff. and Rodee, *op. cit.* The artist himself wrote that 'the world hates to be reminded of the sorrowful side of humanity' (Carr, *op. cit.*, p. 68).

12 *Saturday Review*, 1 June 1878, p. 692.

13 J.K. Huysmans, 'Le Salon de 1879', *L'Art Moderne*, 1883, pp. 46–8. Charles Tardieu was much briefer in describing WAG 751 ('La peinture au Salon de Paris', *L'Art*, 1879, vol. 18, p. 81): 'un Daumier anglais, avons-nous dit, à propos de son *Asile pour la vieillesse*, nous pourrions ajouter un Hogarth plus peintre'. E. Chesneau in his *Artistes anglais contemporains*, n.d., however, described WAG 751 as 'composition sinistre, véritable danse macabre, dessin superbe, peinture médiocre'.

14 Edwards, *op. cit.*, pp. 235–6.

15 *Graphic*, 15 May 1875, pp. 474–5.

16 *Academy*, 6 April 1878, p. 310.

Watching the Invaders WAG 2932

Watching the Invaders

WAG 2932
Canvas: 112.7 × 143.5 cm
Signed: *H.H. 1902*

This painting was described by the artist's widow as a Welsh landscape and is in the tradition of *Found*, 1884, a bleak Welsh landscape with figures from Roman Britain.[1] Presumably in *Watching the Invaders*, the British inhabitants of North or Mid-Wales are watching Danish invaders advancing up the river around the 9th century (or (?) Saxon invaders in the 6th or 7th century) – Herkomer was fond of the writings of the early Welsh bards.[2] Herkomer's painting aroused little critical reaction at the 1902 Royal Academy, but the *Magazine of Art* described it as 'robust and largely stated'.[3]

REPR: The artist (etching?);[4] Art Journal, *Academy Pictures*, 1902; Liverpool Autumn Exhibition catalogue, 1902, p. 115; Pall Mall Magazine, *Pictures of 1902*, p. 14; *Royal Academy Pictures*, 1902, p. 126.

PROV: Presented by Lady Herkomer, the widow of the artist, 1920.

EXH: Royal Academy 1902 (470); Liverpool Autumn Exhibition 1902 (972); Whitechapel Art Gallery, *Winter Exhibition*, 1907 (103).

1 J. Saxon Mills, *Life and Letters of Sir Hubert Herkomer*, 1923, p. 284. *Found* is now in the Tate Gallery, London.

2 Mills, *op. cit.*, p. 112. Herkomer may have known *Les garde-côtes gaulois* (1888–9) by Jean Lecomte du Nouy (now Musée d'Orsay, Paris).

216

3 *Magazine of Art*, 1902, p. 399; see also Pall Mall Gazette, *Pictures of 1902*, p. 14, and *Royal Academy Pictures*, 1902, p. 126.

4 Liverpool Autumn Exhibition 1910 (1475).

2 C.R. Grundy, *A Catalogue of the Pictures and Drawings in the Collection of F.J. Nettlefold*, 1933, vol. 2, pp. 184–5.

3 Stanbridge, *op. cit.*

4 Grundy, *op. cit.*, pp. 180–1.

HILDER, Richard (1813–1852)
A View near Sevenoaks, Kent
WAG 1299
Panel: 37.5 × 49.7 cm

Hilder's wife, Emma Guest, whom he married in 1841, lived in Sevenoaks[1] and another *View Near Sevenoaks* was formerly in the Nettlefold Collection.[2] It is stated that the figures in Hilder's landscapes painted after 1839 were usually done by an artist called Duveen.[3]

PROV: Anon sale, Christie's 16 March 1912, lot 133, bought Leggatt (£29.8s.); Frederick John Nettlefold;[4] presented by the National Art Collections Fund 1948.

EXH: (?) Royal Academy 1851 (515) as *Near Sevenoaks, Kent*.

1 Mr. Stanbridge, great-grandson of the artist, letter to the compiler, July 1986.

HILL, Lady Caroline Emily Gray (1843–1924)
Sunrise from over the Mountains of Moab[1]
WAG 2409
Panel: 10 × 40.7 cm

This painting is probably to be identified with the artist's *Sunrise on the Dead Sea from over the Mountains of Moab* exhibited at the 1899 Liverpool Autumn Exhibition.[2] She used to spend about six months every year in her house in Jerusalem.[3]

PROV: Bequeathed by John Elliot 1917.

EXH: (?) Liverpool Autumn Exhibition 1899 (894).

1 The title inscribed in the Gallery's records omits the word 'from'.

A View near Sevenoaks, Kent WAG 1299

Sunrise from over the Mountains of Moab WAG 2409

2 The Autumn Exhibition painting was certainly purchased from that exhibition, but the Gallery's records do not identify the name of the buyer.

3 *Liverpool Daily Post*, Obituary, 24 March 1924.

Mother and Child WAG 243

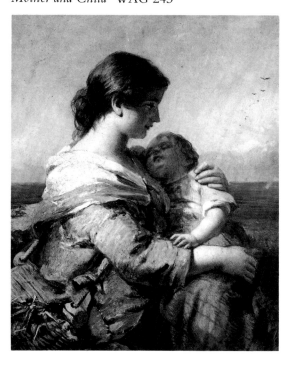

HILL, James John (1811–1882)
Mother and Child
WAG 243
Board[1]: 17.5 × 15.2 cm

PROV: Acquired by George Holt from an unknown source (£14).

EXH: (?) Liverpool Academy 1848 (32).

1 There is an indecipherable inscription on the front, and on the back is inscribed: *Half a day's work* . . .

HOLIDAY, Henry (1839–1927)
Dante and Beatrice
WAG 3125
Canvas[1]: 142.2 × 203.2 cm

Dante relates in his autobiographical *Vita Nuova*[2] how he concealed his love for Beatrice by pretending to be attracted by other women. Beatrice heard some gossip and a misunderstanding between Dante and Beatrice resulted; she refused him her usual greeting when they met. Dante then describes at length the anguish which this caused in him. The central figure in the group of three women is Beatrice and on her right is Monna Vanna (or Giovanna);[3] the woman on Beatrice's left is presumably a maidservant. The *Vita Nuova*, however, suggests that Beatrice was alone when she refused Dante her greeting. The artist seems to have intended to achieve a dramatic contrast between the demure,

reserved, other-worldly Beatrice and the more flamboyant, extrovert, demonstrative Monna Vanna with her remarkable and quite unhistorical dress.

Subjects from the *Vita Nuova* attracted many British 19th-century artists, but Holiday must have known the many paintings from this source by D.G. Rossetti, whose art Holiday much admired;[4] closest in subject to Holiday's picture is Rossetti's watercolour of 1851, *Beatrice meeting Dante at a Marriage Feast denies him her Salutation*,[5] although Rossetti's highly charged and emotional approach is quite alien to Holiday's more anecdotal emphasis.

The history of this painting can be traced in detail.[6] In 1875 Holiday painted a *Head of Dante* from a cast taken by Woolner from 'a life mask' of Dante;[7] at some time before this

he had made a sketch for *Dante and Beatrice* as well as a few studies but had not taken the composition further.[8] In July or early September 1881 he made his first drawings for the heads of Beatrice and Monna Vanna from Eleanor Butcher and Milly Hughes respectively;[9] in late September he went to Florence to make studies for the background and did a sketch from one end of the Ponte Santa Trinità looking towards the Ponte Vecchio along the Lungarno; he had decided quite arbitrarily that the famous encounter took place there and this is the part of Florence that appears in *Dante and Beatrice*. He also did research on the appearance of late 13th-century Florence in the city's libraries and archives; he concluded that Florence was paved with bricks at that time and he found in Siena an example of herring-

Dante and Beatrice WAG 3125

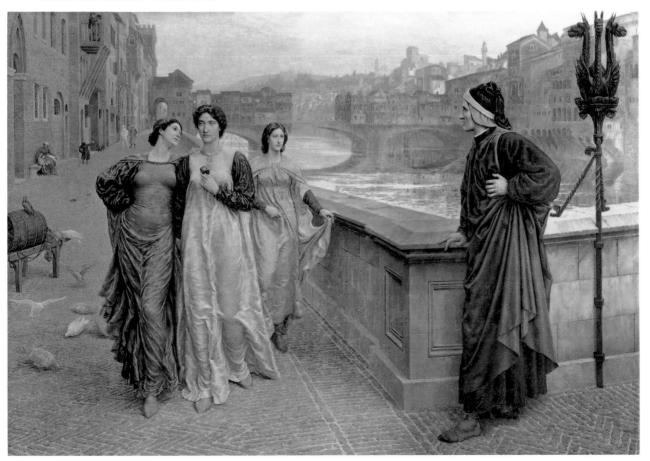

bone style brick paving as in his painting. He was in Florence and Siena between 30 September and 7 October and described his activities there to Dean Kitchin thus:

The scene lies on the Lung' Arno. Dante is crossing the Ponte Santa Trinità and sees Beatrice and three ladies coming along the Lung' Arno from the Ponte Vecchio. Beatrice, having heard some gossiping tales against Dante, cuts him and he is sadly distressed. You remember the passage doubtless. The place where they met is not mentioned but I assume it to be as I have described. I wanted to get on the spot the general lie of the lines – the perspective, in fact, of the buildings and still more the sense of colour, and as far as possible to collect such fragments as remain of buildings of Dante's time, so as to be able to alter the details to the character of the period. This I have done partly from the buildings themselves, partly from bits of background in the frescoes of Giotto and Co., and partly by looking up the subject in the Biblioteca Nazionale. I got there an interesting monograph by Nanni on the Ponte Vecchio which gave me some valuable points. It mentions, for instance, that the bridge (which is conspicuous in my picture) was destroyed by an inundation in 1235 and could not have been completed again in 1294 because that year the municipal authorities were discussing whether to pave the bridge with bricks as the other roads in Florence were paved – and again that all the shops were burnt down in 1323.

This gives me three points: first to pave my Lung' Arno with brick, second to put the shops in (which I had been led to believe did not exist then), and third, the date of my subject being 1285–90, to assume the bridge to be unfinished and to show the scaffolding.

On his return to England in October 1881 he made a plaster statuette[10] of the two principal female figures nude; it was begun on 14 November and completed on 19 November; he then draped them in plaster after studying models wearing dresses[11] (as in the final painting) walking up and down in his studio; the draped statuette was completed on 6 December. He had also made on 18 October a clay model of the houses on the far side of the River Arno to assist with perspective and chiaroscuro[12] and between 8 and 12 December he modelled a bust of Dante, relying both on the fresco in the Bargello Museum attributed to Giotto[13] and on the Torrigiani Mask. Kitty Lushington[14] was the model for the girl in blue (perhaps a maidservant) and the Italian artist

Gaetano Meo modelled for Dante, although Holiday used Alfred Schultz-Curtius[15] for Dante's hands, and also of course employed the bust based on historical sources. Ellen Scott[16] modelled for the woman leaning over a balcony in the left background. In addition to the sculptures Holiday made a large number of drawings for *Dante and Beatrice*: (1) sketchbooks of 1881 now in a private collection;[17] (2) a study for the whole composition now in the Victoria & Albert Museum (inv. E. 1376–1927); (3) two drapery studies for Dante also in the Victoria & Albert Museum (inv. E 1377, 1378–1927); (4) a watercolour drawing exhibited at the Paris, *Exposition Universelle*, 1878, (72) and possibly related to the Walker Art Gallery painting; (5) a study for the whole composition, now in the Walker Art Gallery (inv. 8965); (6) a watercolour study for the whole composition, also in the Walker Art Gallery (inv. 8964); (7) a study for the maidservant (?) to the right of Beatrice (inscribed on frame Miss Katherine Lushington, Mrs. L.J. Maxse), also in the Walker Art Gallery (inv. 10366); (8) two studies on a single sheet for the figure of Dante, also in the Walker Art Gallery (inv. 8966); (9) a study for Beatrice, sold at Christie's 25 October 1988, lot 270; (10) a study for Monna Vanna, reproduced by A.L. Baldry;[18] (11) a study for the figures of Beatrice and Monna Vanna, also reproduced by A.L. Baldry.[19]

The painting itself was begun in October 1882, but due to the artist's other commitments was still unfinished in April 1883 when it was exhibited at the Grosvenor Gallery. After its return from that exhibition the artist completed it and the pigeons were added by the artist J.T. Nettleship (1847–1902); it was finished in time for the Liverpool Autumn Exhibition which opened in September 1884.

The critics at the 1883 Grosvenor Gallery exhibition were, in view of the picture's later fame, rather unenthusiastic. The *Art Journal*[20] was the kindest:

Mr Henry Holiday has always used his art for decorative purposes, and if we remember right, has painted fewer incidents than allegorical or monumental groups. In 'Dante and Beatrice' he has the loveliest city scenery in Europe in which to place his figures, and the noble profile and austere draperies of the young Dante to set before a background of Arno and the Ponte Vecchio. And in the incident he has chosen appears in all its exquisiteness that mystical simplicity

which so utterly differentiates the life of medieval Florence from the life of modern London.

Cosmo Monkhouse of the *Academy*[21] was more severe:

Pure and sweet in colour and sentiment is Mr. H. Holiday's 'Dante and Beatrice' with the poet standing by the Ponte S. Trinità while his lady-love and her friends in gay raiment saunter – with careless grace – along the Lung' Arno. The streets are perhaps too empty, the raiment is perhaps too gay, the whole scene too set, its poetry and its realism are scarcely harmonised but it is charming, nevertheless, and enables us to feel vividly how grievous a thing it was to be denied 'her sweet salutation'.

The *Athenaeum*[22] found the painting dull:

Despite the highly artistic painting and modelling of the dresses of the three ladies who meet the poet, and the skill employed in all the figures of the design, which is of a noble kind, this elaborate picture is one of Mr. Holiday's mistakes. It would be difficult to say where the error lies, although it is evidently radical. The red pavement rises against our faces, as artists say, it is so defective in perspective. The very refined technique is peculiarly uninteresting; it is perfectly respectable, but undeniably weak.

A *tableau vivant*, or living picture, based on *Dante and Beatrice* was created for public display at St. George's Hall (presumably in Liverpool) during May 1896 as part of a presentation illustrating past, present and future dress organized by the Healthy and Artistic Dress Union, of which the artist was president.[23] Another *tableau vivant* based on the principal figures of the painting was displayed in Cardiff during June 1916 in aid of a Red Cross Fund; Holiday was very much impressed by the 'spiritual beauty' of the woman, Mrs. (Ada) Charles Forestier-Walker, who took the part of Beatrice in the *tableau* and soon afterwards he painted a half-length portrait of her as Beatrice – that is he painted a replica of *Dante and Beatrice* but only including the upper part of the figure of Beatrice and the area immediately around her and substituted the face of Mrs. Forestier-Walker for that of Eleanor Butcher.[24] In 1918 the artist allowed the Carl Rosa Opera Company to reproduce the Walker Art Gallery painting in connection with one of their productions.[25] A parody of the picture by A. Bertiglia is reproduced by Gladys Storey in her *All Sorts of People*.[26]

Dante and Beatrice was severely damaged when in transit by air to Italy in 1965. Large areas of paint within about 28 cm from the left-hand edge of the canvas and within about 27 cm from the bottom edge became totally detached. During restoration at the Istituto Centrale del Restauro in Rome in 1965–7, some of this paint was recovered and resecured to the canvas; eventual losses from these two areas totalled about 15 per cent in all.

REPR: Henry Blackburn, *Grosvenor Notes*, 1883, p. 40;[27] C.O. Murray (engraving), *Art Journal*, 1884, opp. p. 4; Berlin Photographic Company.

PROV: Bought from the artist 1884 (£500).

EXH: Grosvenor Gallery 1883 (165); Liverpool Autumn Exhibition 1884 (212).

1 Frame maker's label: Charles Roberson; another label gives the price of WAG 3125 with its frame as 700 guineas.

2 See Dante's *Vita Nuova with Rossetti's Version*, ed. Oelsner, 1908, section 9, pp. 34–5; the artist inserted a quotation from this passage into the 1883 Grosvenor Gallery catalogue (165), but he did not use Rossetti's translation. In 1859–60 Holiday had painted *Dante's First Meeting with Beatrice*, an earlier episode in the *Vita Nuova* – C.E. Norton's translation of Dante's text having appeared in 1859 and D.G. Rossetti's rendering in 1861; however, around 1875 Holiday began studying Italian so that he could read the *Vita Nuova* in its original language (Henry Holiday, *Reminiscences of my Life*, 1914, pp. 67, 243).

3 Beatrice wears the white dress recorded in Dante's earlier (and more successful) meeting with her as an adult, see Dante's *Vita Nuova, op. cit.*, section 2, p. 9. Monna Vanna appears in the *Vita Nuova*, and in Dante's sonnets, as a companion of Beatrice. She was the mistress of Dante's friend, Guido Cavalcanti, whose poems celebrate her virtues.

4 See R.T. Holbrook, *Portraits of Dante from Giotto to Raphael*, 1911, pp. 219 ff., for a list of 19th-century (and earlier) *Vita Nuova* paintings and sculptures, including details of Rossetti's other *Vita Nuova* paintings; Holbrook, however,

3 *Athenaeum*, 19 May 1866, p. 675.

4 *The Times*, 5 May 1866.

5 *Spectator*, 19 May 1866, p. 550.

Athenaeum, 20 May 1871, p. 627; *Architect*, 13 May 1871, p. 248.

2 George Audley, *Collection of Pictures*, 1923, p. 29, states that WAG 717 was also sold at Christie's in 1889 for £367.

3 Audley, *op. cit.*

A Thorn

WAG 717
Canvas: 78.7 × 139.8 cm
Signed: *JCH* (in monogram) *1871*

Hook exhibited *A Thorn* at the 1871 Royal Academy exhibition alongside some Norwegian scenes, and it was the former – identified by *The Times* as a Surrey landscape – that the critics liked.[1]

PROV: Henry Jenkins sale,[2] Christie's 27 March 1897, lot 73, bought Agnew (£451); (?) C. Cazarnikow. Presented by George Audley 1925.[3]

EXH: Royal Academy 1871 (153).

1 F.G. Stephens, 'James Clarke Hook', *Art Annual*, 1888, p. 30; A.J. Hook, *Life of James Clarke Hook*, 1929–32, vol. 2, p. 181; *The Times*, 29 April 1871;

Hard Lines

WAG 511
Canvas: 75.8 × 130.5 cm
Signed: *JCH* (in monogram) *1876*

Hard Lines was painted at Hallsands, a small picturesque fishing hamlet near Start Point in Devon only accessible by boat or by a walk along cliffs and beach.[1] The artist spent the summer of 1875 working there and at Hope Cove (Bigbury Bay), also in Devon.[2]

The critic of the *Athenaeum*[3] wrote a long account of *Hard Lines*, describing it as 'charming' and 'delightful' and as possibly the artist's masterpiece. The *Spectator*[4] was briefer:

A Thorn WAG 717

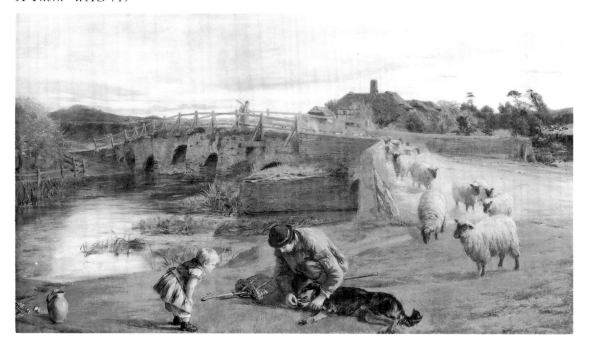

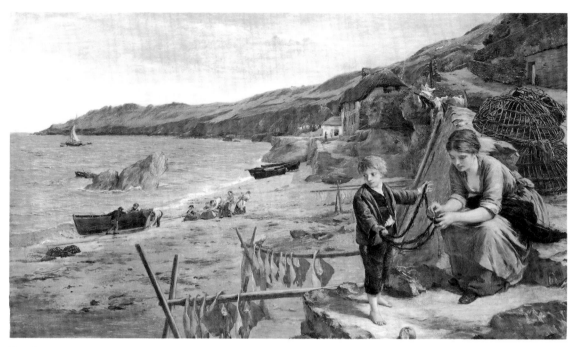

Hard Lines WAG 511

From this we range with great pleasure to 'Hard Lines', by J.C. Hook, R.A. – one of Mr. Hook's most pleasant fisher-girls, winding a skein of worsted, which her little brother holds, while he turns wistful eyes to the shore, on which the blue waves are dancing merrily. The great beauty of these pictures of Mr. Hook's seems to us that, whatever may be their faults, they have always in them the sun and the breeze. They might be illustrations to one of Charles Kingsley's novels, so full are they of fresh manliness and honest delight in the beauty of nature.

A sketch for the background was reproduced in 1888 by A.H. Palmer[5] and a very early photograph of the whole painting is in a private collection.[6] Hook's fishing accessories used in paintings of this type appear in a photograph in Mary Hook Pickersgill's Sketch Album (now Barber Institute, Birmingham).

PROV: John Mallinson.[7] Mrs. John Fielden sale, Christie's 27 May 1910, lot 135, bought Vaile (£210).[8] Anon sale, Christie's 2 February 1923, lot 119, bought Sampson (£99.15s.); presented by George Audley 1925.[9]

EXH: Royal Academy 1876 (498).

1 MS letter from the artist to John Mallinson of 3 June 1886.

2 A.J. Hook, *Life of James Clarke Hook*, 1929–32, vol. 2, pp. 211 ff.

3 *Athenaeum*, 29 April 1876, p. 201.

4 *Spectator*, 10 June 1876, p. 739.

5 A.H. Palmer, 'James Clarke Hook', *Portfolio*, 1888, p. 79.

6 Copy print in the Witt Library.

7 George Audley, *Collection of Pictures*, 1923, p. 60; see also note 1.

8 The catalogue gives the wrong dimensions for WAG 511, but this was probably a misprint.

9 WAG 511 is listed in an addendum to the catalogue (Audley, *op. cit.*), indicating that Audley bought it in 1923.

A Fisherman's Home WAG 2933

2 Reynolds, *op. cit.*, p. 191. It seems reasonable to suppose that WAG 2933 is the *Fisherman's Home* described by Reynolds, but it should be noted that there exist many autograph replicas of Holl's Welsh cottage pictures (Reynolds, *op. cit.*, p. 185).

3 *Art Journal*, 1881, p. 190. The *Magazine of Art*, 1881, p. xxvi, also found WAG 2933 to be the 'lion of the gallery', with a descriptive review similar to that in the *Art Journal*.

4 H.D. Rodee, *Scenes of Rural and Urban Poverty in Victorian Painting 1850–1900*, 1975, p. 87.

5 Reynolds, *op. cit.*, p. 191.

6 Brown lent *A Fisherman's Home*, presumably WAG 2933, to Bradford in 1882.

7 George Audley, *Collection of Pictures*, 1923, p. 29, no. 80.

HOOK, James Clarke (1819–1907)
Give us this Day our Daily Bread[1]
WAG 245
Canvas: 69.3 × 108.3 cm
Signed: *JCH* (in monogram) *1866* or *1865*

Hook began this picture at St. Abb's Head, Berwickshire, in the early autumn of 1864 while he was staying at Coldingham, whose inn was already popular with artists; this was the first of his many trips to the north. The crew of a herring boat are hoisting their sails on their way out to the fishing grounds where they will remain all night; the boy on the left is pushing the boat away from the shore with an oar.[2]

The critic of the *Athenaeum*[3] praised the colour, lighting and rendering of motion in the water, but *The Times*[4] was more poetic:

J.C. Hook's 'Give us this day our daily bread' gives us a Scotch fishing-boat; just pushing off, with the men hauling on the halyards of the red-tanned lug-sail. Like all Hook's boat pictures, this smacks of the sea, is instinct throughout with the movement, manliness, and hardihood of sea-life. We rise with the boat,

and push with the boys, and clasp on to the rope with the men, as we look. We have 'realization of a subject' in the truest sense.

The *Spectator*[5] was distinctly hostile, however, complaining that Hook's work had become coarse and was 'painted by the yard'.

PROV: Bought from the artist by Charles P. Matthews; his sale, Christie's 6 June 1891, lot 47, bought Agnew (£1,785); George Holt; bequeathed by Emma Holt 1944.

EXH: Royal Academy 1866 (239); Vienna International Exhibition 1873; Cork 1902; Whitechapel Gallery, *Spring Exhibition*, 1908 (219).

1 The title was changed to *Hoisting the Sail*, probably by C.P. Matthews (see Provenance and F.G. Stephens, 'James Clarke Hook', *Art Annual*, 1888, pp. 21 and 28).

2 A.J. Hook, *Life of James Clarke Hook*, 1929–32, vol. 2, pp. 157–8. F.G. Stephens, *op. cit.* states that WAG 245 was painted in 1866 and that the herring boats were Scottish (pp. 21, 28).

Give us this Day our Daily Bread WAG 245

completely misunderstands the subject of WAG 3125 (p. 231). J.W. Waterhouse's sketch for his unpainted *Dante and Beatrice* is presumably much later than WAG 3125; see A. Hobson, *J.W. Waterhouse*, 1980, p. 231, plate 144.

5 See V. Surtees, *The Paintings and Drawings of Dante Gabriel Rossetti*, 1971, no. 50 (owned by Mrs. David Sells); the subject of this watercolour is taken from a slightly later episode in the *Vita Nuova* (Oelsner, *op. cit.*, section 13, pp. 54–5). Rossetti's *Monna Vanna* of 1866 (Tate Gallery) may have encouraged Holiday to see this figure as a sensual and erotic counterpart to the more demure and restrained Beatrice.

6 The following is taken from Holiday, *op. cit.*, pp. 27 ff., from an MS letter from the artist to Dean Kitchin of 6 October 1881, from a copy of an MS letter from the artist to the Curator of the Walker Art Gallery of 14 March 1912 and from what appears to be a transcript from the artist's diary of 1881. The original Dean Kitchin letter and the transcript are in the Walker Art Gallery.

7 The *Head* was exhibited at the Royal Academy in 1875 (639) and was still in the artist's collection in 1918 (MS letter from the artist to E.R. Dibdin of 19 November 1918 in the Dibdin Library sale, Eldon Worrall and Co. (Liverpool) 13–14 May 1987, lot 347); it is reproduced in A.L. Baldry, 'Henry Holiday', *Walker's Quarterly*, 1930, opp. p. 25. The life mask was presumably the famous Torrigiani Mask now in the Bargello Museum, Florence – see Holbrook, *op. cit.*, pp. 36 ff.

8 The sketch might be the one now in the Victoria & Albert Museum, (E 1376–1927) as asserted in Waltham Forest, William Morris Gallery, *Henry Holiday*, 1989, p. 14, no. 75, but it could also have been inv. 8965 or inv. 8964, both now in the Walker Art Gallery. All these sketches differ considerably from the final composition with, in particular, four female figures in the main group.

9 The artist had been introduced to both women through personal friends, see Holiday, *op. cit.*, pp. 280–1 for further details about them. The first drawing for Beatrice from Eleanor Butcher was probably the drawing sold at Christie's 25 October 1988, lot 270, and the first drawing for Monna Vanna from Milly Hughes may have been the one reproduced in Baldry, *op. cit.*, opp. p. 75.

10 This plaster statuette with added draperies is now in the Walker Art Gallery (inv. 8982); it is reproduced in Holiday, *op. cit.*, opp. p. 278, both in its completed state and with the two figures still nude.

11 There is a photograph in the Walker Art Gallery which is said to represent two models – not those used by the artist for WAG 3125 – one wearing the dress used by one of the female figures in WAG 3125 and the other wearing Dante's costume in that painting. A different photograph of the artist and of two models – one wearing Dante's costume in WAG 3125 and the other wearing Beatrice's costume in that painting – is reproduced in J. Maas, *The Victorian Art World in Photographs*, 1984, p. 189; the female model in that photograph is stated to be Ada Forestier-Walker – see note 24.

12 Reproduced in Holiday, *op. cit.*, opp. p. 278.

13 See Holbrook, *op. cit.*, pp. 73 ff.

14 She was the daughter of Vernon Lushington, a well-known judge. Waltham Forest, *op. cit.*, p. 14 (no. 77) describes her as Laura Lushington.

15 A director of music and Wagnerian enthusiast.

16 Waltham Forest, *op. cit.*, p. 14, no. 77. She was the wife of the architect George Gilbert Scott Junior. A portrait study of her by Holiday was sold at Christie's 25 October 1988, lot 271.

17 See Waltham Forest, *op. cit.*, nos. 76 and 78.

18 Baldry, *op. cit.*, p. 75.

19 Baldry, *op. cit.*, p. 24.

20 *Art Journal*, 1884, p. 7.

21 *Academy*, 5 May 1883, p. 316.

22 *Athenaeum*, 12 May 1883, p. 609.

23 Holiday, *op. cit.*, pp. 404 ff.; a photograph of the *tableau vivant* is owned by Anthony Crane, see Waltham Forest, *op. cit.*, no. 110. The display was intended to improve contemporary dress by contrasting it unfavourably with fashions of the past. The costume in WAG 3125 seems plausibly 13th-century, except for Monna Vanna's

remarkable dress which may have been inspired by antique examples.

24 MS letters of 13 August 1916 and 19 November 1918 from the artist to E.R. Dibdin, Curator of the Walker Art Gallery; the 1916 letter is in the Walker Art Gallery; for the 1918 letter see note 7; see also Sotheby's sale of 19 July 1990, lot 412 for the artist's letters to Mrs. Forestier-Walker; a drawing of Mrs Forestier-Walker as Beatrice, presumably dating from about 1916, is in the Walker Art Gallery (inv. 8656); she was the daughter of Colonel Robert Henry Mansel and married Charles Evelyn Forestier-Walker in 1905; further details about her in in Burke's *Peerage*. The painting of Mrs. Forestier-Walker as Beatrice is presumably the *Beatrice on the Lung' Arno* dated by Baldry to 1921 (*op. cit.*, p. 76); it is not clear why Baldry gives the painting such a late date.

25 MS letter of 19 November 1918 from the artist to E.R. Dibdin (see note 7).

26 *All Sorts of People*, 1929, opp. p. 212.

27 For the artist's drawing used by Blackburn, see Christie's and Edmiston's sale (Glasgow) 25 April 1985, lot 3. Blackburn records WAG 3125 in its uncompleted state.

HOLL, Frank Montague (1845–1888)
A Fisherman's Home
WAG 2933
Canvas: 101.6 × 128.3 cm
Signed: *Frank Holl 1881*

This is one of the last of Holl's Welsh cottage interiors and is based on a fisherman's cottage which he found on the sand dunes at Criccieth in 1876; the cottage was then tenanted by a widow with two young children; she had a 'magnificent build and presence' and 'was of a massive and almost savage type living quite alone with her children and seeing no-one for weeks together'.[1] Holl was in Criccieth in 1876, 1877 and 1879; this painting relied on sketches he made in 1879.[2] The massive tenant of the Criccieth cottage seems to appear in the painting together with one of her children; the male model must have been imported.

The critic of the *Art Journal*[3] noted *A Fisherman's Home* as the most important painting at the 1981 McLean Gallery exhibition. He described it as:

a wife holding a loaf of bread in her hand, regarding her stalwart husband, who has returned from his labours, and, tired and weary, has just seated himself by the table. At the end of it stands their little girl, whose figure catches the beams of light which find their way through the little window. The tone of the picture is necessarily low; but the chiaroscuro is so skilfully managed that not a single detail of the interior is lost, and the whole scene is presented with a force which only belongs to a painting of high quality.

H.D. Rodee[4] notes the influence of Israels on Holl's painting.

PROV: Bought from the artist by Thomas McLean (£350);[5] Thomas Brown.[6] Anon sale, Christie's 28 May 1920, lot 88, bought Sampson (£136.10s.); George Audley[7] who presented it 1925.

EXH: Thomas McLean's Gallery, *Annual Exhibition of Cabinet Pictures*, 1881 (32); Bradford Technical School, *Fine Art and Industrial Exhibition* 1882 (171).

1 A.M. Reynolds, *Life and Work of Frank Holl*, 1912, pp. 133–191. In the 1880s Holl concentrated mainly on portraiture.

Opposite:
*The Morning
of St. Valentine*
WAG 943

HOPWOOD, Henry Silkstone
(1860–1914)

Morning

WAG 942
Canvas: 55.7 × 42.2 cm

This is an oil version of Hopwood's 1906 watercolour also entitled *Morning*.[1] The *Art Journal*[2] described it as 'a variation on the theme of sunlight, less experimental in effect than is often the case with this type of picture'. Around 1906–9 the artist was spending his winters in North Africa and his summers at Montreuil, Pas de Calais.[3] *Morning* and the related watercolour are presumably Montreuil scenes.

PROV: Purchased from the artist 1909 (£30).

EXH: New Gallery Summer 1909 (40); Liverpool Autumn Exhibition 1909 (964).

1 The watercolour was reproduced in C.H. Hartmann, 'Henry Silkstone Hopwood', *Old Water-Colour Society's Club Annual Volumes*, 1924–5, vol. 2, p. 56, plate XVI, when it was owned by Fred C. Johnson; it was presumably no. 72 at the 1906 Royal Society of Painters in Water Colours summer exhibition and no. 165 at the 1907 Manchester Academy of Fine Arts – see Hartmann, *op. cit.*, p. 61. Hartmann noted that Hopwood's oils were more 'impressionistic' than his watercolours (*op. cit.*, p. 55); this certainly seems to be true of WAG 942.

2 *Art Journal*, 1909, p. 176.

3 Hartmann, *op. cit.*, p. 55. P.W. Steer also liked Montreuil and was there in 1907.

HORSLEY, John Callcott (1817–1903)
The Morning of St. Valentine
WAG 943
Canvas[1]: 38.3 × 45.8 cm
Signed: *J.C. HORSLEY 1865* (?)

This is a version of the painting exhibited by
Horsley at the 1863 Royal Academy as *The
Morning of St. Valentine* (157).[2] Many versions
exist; the one in the Wolverhampton Art
Gallery (59.7 × 71.4 cm) is signed and dated
1863 and so is probably the Royal Academy
picture.[3] Other versions include: (1) Rochdale
Art Gallery (43 × 51 cm); (2) formerly in the
J. Paul Getty Museum, Malibu, sold Sotheby's
21 November 1989, lot 25 (61 × 75 cm); (3)
sold Christie's 18 November 1960, lot 178
(40.5 × 47 cm) signed and dated 1865; (4) sold
Sotheby's (Belgravia) 25 January 1977, lot 200
(58.5 × 69 cm).

PROV: Presented by George Audley 1925.[4]

1 Canvas stamp: *MULLER and Co. / 36 LONG
 ACRE / LONDON.*

2 See the review in the *Art Journal*, 1863, p. 111,
 and in the *Athenaeum*, 9 May 1863, p. 623.

3 See Central Art Gallery, Wolverhampton, *The
 Cranbrook Colony*, 1977, no. 34, which notes the
 artist's reliance on 17th-century Dutch genre
 painting in style and in the use of period settings
 and dress. It should be noted, however, that the
 letter in WAG 943 and in the Wolverhampton
 version is addressed to Celia, a generic name for
 English lovers. This catalogue quotes another
 review of the 1863 Royal Academy painting in
 London Society, June 1863, p. 544.

4 George Audley, *Collection of Pictures*, 1923, p. 30,
 no. 83.

4 Jacomb-Hood, *op. cit.*, implies that the portrait of his sister in question was exhibited at the Royal Society of British Artists while Whistler was president of that society – that is, 1886–8. The *Art Journal*, 1887, p. 30, reviewing the Royal Society of British Artists exhibition wrote: '"A Portrait", by Mr. Jacomb-Hood, of a young lady in black, is the strongest and most serious piece of workmanship he has ever executed.' George Bernard Shaw, writing in the *World*, 8 December 1886, p. 683, described the same portrait as 'capital'; the *Saturday Review*, 11 December 1886, p. 782, described it as 'one of the best pictures in the room', but complained that the black of the dress was 'not enough lost either in shadow or in light'.

5 Mrs. Jacomb-Hood, letter to the Curator of the Walker Art Gallery, 25 September 1935, asserted that WAG 2955 was exhibited at the Paris Salon and Jacomb-Hood, *op. cit.*, states that the portrait of his sister under discussion was exhibited there in 1887, gaining him an Honourable Mention; according to Mrs. Jacomb-Hood, *op. cit.*, WAG 2955 was favourably reviewed at the Salon by the *Journal de Paris*.

JOHNSTON, Alexander (1815–1891)
A Thought of Love
WAG 4137
Canvas: 61 × 49 cm
Signed: *A Johnston*

PROV: Liverpool Academy; presented by the Liverpool Academy to the Liverpool Town Council 1851;[1] transferred to the Walker Art Gallery 1948.

EXH: Liverpool Academy 1843 (182).

1 Liverpool Academy, *Minutes of Proceedings*, 14 April 1851; for further details see p. **76** (under Cobbett).

A Thought of Love WAG 4137

The Introduction of Flora Macdonald to Prince Charles Edward Stuart after the Battle of Culloden WAG 587

The Introduction of Flora Macdonald to Prince Charles Edward Stuart after the Battle of Culloden

WAG 587
Canvas: 66 × 91.5 cm
Signed: *Alex Johnston*

This is a reduced version of the 1846 painting which last appeared at Christie's 5 February 1965, lot 59.[1] It is virtually identical to the painting at Christie's, but it lacks the notice offering a reward for the capture of the Prince which appears at the Prince's feet in the larger picture.

PROV: Walter Thompson sale, J.F. Griffiths (Liverpool) 28 March 1860, lot 32, bought Walker (£189); presented by Colonel W. Hall Walker (later Lord Wavertree) 1913.

1 The large painting (162 × 225 cm) was exhibited at the Royal Academy 1846 (374), at the Liverpool Academy 1846 (163), where it nearly won the £50 prize for the best picture – see *Art Union*, 1846, p. 311; *Spectator*, 16 May 1846, p. 475 and *Literary Gazette*, 30 May 1846, p. 500 – and, apparently, at the Paris, *Exposition Universelle*, 1855 (845); see also *Art Journal*, 1857, p. 58 and *Connoisseur*, April 1956, p. 201. It was engraved in mezzotint by J.G. Murray in 1851. Another small version of this composition is in the Mappin Art Gallery, Sheffield (112 × 157 cm) and in 1957 a Mr. Hunter of Keswick believed that his father had owned the original version, which was subsequently destroyed – this seems improbable. The large painting probably first appeared on the market at the S. Hammond sale, Christie's 17 June 1854, lot 30, bought in £336. Johnston's *Flora Macdonald* is in the Royal Collections at Osborne House. Flora Macdonald first met Prince Charles in Angus Macdonald's hut on the island of Benbecula in the Hebrides during late June 1746. Johnston's source may have been the *Memoirs of the Jacobites* by Mrs. Thomson (1846, vol. 3, p. 322).

'Tatties and Herrin!' WAG 2938

then lived in Musselburgh, where the artist had his studio.[3]

Caw[4] noted that around 1905 Hutchison became much influenced by the later work of Josef Israels, resulting in the artist's use of 'a rather inexpressive rotten and crumbly impasto of disagreeable quality'.

Another version of *'Tatties and Herrin!'* was sold at Sotheby's (Gleneagles Hotel) 30 August 1983, lot 1023 and then at Christie's and Edmiston's (Glasgow) 25 April 1985, lot 128.

PROV: Presented by Alderman T.W. Oakshott 1906.

EXH: Royal Scottish Academy 1905 (550); Liverpool Autumn Exhibition 1905 (310).

1 There seems to be considerable confusion over Hutchison's date of birth. Most dictionaries of artists have 1855, but Frank Rinder, *The Royal Scottish Academy*, 1917, p. 186, says 1860. The artist himself, in MS biographical particulars sent to the Curator of the Walker Art Gallery, gives 1861.

2 Jorien Jas, letter to the compiler, 19 August 1993.

3 Mrs. Ann Naysmith, letter to the compiler, 28 February 1978; her mother was then 88 years old.

4 J.L. Caw, *Scottish Painting*, 1908, p. 428.

JACOMB-HOOD, George Percy
(1857–1929)

My Sister
WAG 2955
Canvas[1]: 153.7 × 123.2 cm
Signed: *G.P. Jacomb Hood / 1886*

This is presumably the portrait of his sister noted by the artist as inspired by Whistler and responsible for his friendship with Humphrey Ward, art critic of *The Times*.[2] She may be wearing dress intended for fencing.[3]

PROV: Presented by Mrs. G.P. Jacomb-Hood, the artist's widow, in 1935.

EXH: (?) Royal Society of British Artists 1886–7 (250) as *A Portrait*;[4] (?) Paris, *Société des Artistes français*, 1887 (1259) as *Portrait*;[5] (?) Paris, *Exposition Universelle*, 1889 (71); Walker's Galleries, *Memorial Exhibition of Works by the late G.P. Jacomb-Hood*, 1934 (20).

1 Canvas stamp: *LECHERTIER BARBE & CO / . . . REGENT ST W.*

2 G.P. Jacomb-Hood, *With Brush and Pencil*, 1925, pp. 35–6. According to R.B. Cunninghame Graham in the Walker's Galleries exhibition catalogue (see Exhibited above) Whistler 'thought well' of WAG 2955; Cunninghame Graham himself liked it better than any other of the artist's works.

3 The *Exposition Decennale des Beaux Arts*, 1889–1900 (Paris, *Exposition Universelle*, 1900) contained, as no. 135, *Ma soeur en costume d'escrime* by Jacomb-Hood.

My Sister WAG 2955

A Secret Message

WAG 913
Canvas: 84.2 cm × 61 cm
Inscribed: *J.C. Horsley*

The attribution of this painting to Horsley must be regarded as doubtful.

PROV: Anon sale, Christie's 27 April 1923, lot 33, bought Sampson (£31.10s.); presented by George Audley 1925.[1]

1 George Audley, *Collection of Pictures*, 1923, p. 31, no. 85, where it is wrongly stated that WAG 913 was exhibited at the New Gallery in 1890.

HUNTER, Colin (1841–1904)

The Pool in the Wood, Helmsdale

WAG 2837
Canvas: 108 × 183.5 cm
Signed: *Colin Hunter 1897*

The Helmsdale is a river flowing to the sea at a small port of the same name in Sutherland. Hunter painted the port in 1898 and the picture is now in the Victoria Art Gallery, Bath. R.C. Trafford[1] noted that Hunter rarely painted inland waters and that it was probably only the importance of this river for fishing which induced him to do so on this occasion.

The critics at the 1897 Royal Academy exhibition liked the painting.[2] The *Art Journal* wrote:

A Secret Message WAG 913

Mr. Colin Hunter still shows abundant evidence of his perfect knowledge of the art of reproducing scenes whose charm relies on sea or water of any kind. The famous salmon river flowing through Helmsdale, in Sutherlandshire, has afforded him a congenial subject

The Pool in the Wood, Helmsdale WAG 2837

230

for his largest canvas, The Pool in the Wood. *The view is taken from just below a small spate, and the rich yellow scheme of the picture, further enriched by the patches of purple heather, is wholly suggestive of the season of autumn.*

REPR: Pall Mall Gazette, *Pictures of 1897,* p. 6; *Art Journal,* 1897, p. 168; Studio, *Art of 1897,* p. 20; H. Blackburn, *Academy Notes,* 1897, p. 62; *Royal Academy Pictures,* 1897, p. 136.

PROV: Purchased from the artist 1897 (£400).

EXH: Royal Academy 1897 (253); Liverpool Autumn Exhibition 1897 (1063); Glasgow Institute of the Fine Arts 1898 (470).

1 R.C. Trafford, 'The Art of Colin Hunter', *Windsor Magazine,* 1912, vol. 36, p. 504. Most of Hunter's paintings are related to fishing. For the importance of the River Helmsdale to fishermen, see W.L. Calderwood, *The Salmon Rivers and Lochs of Scotland,* 1909, *passim.*

2 See *Art Journal,* 1897, p. 174; *The Times,* 25 May 1897; *Magazine of Art,* 1897, p. 156.

HURT, Louis Bosworth (1856–1929)
Highland Cattle
WAG 1348
Canvas: 102 × 81 cm
Signed: *Louis B. Hurt*

Another version of this painting was exhibited at Vicars, London, in 1936;[1] it differed slightly from the Walker Art Gallery painting, having more cattle in the background but no trees.

PROV: Presented by James Monro Walker 1921.[2]

1 There is a photograph in the Witt Library; Hurt specialized in Highland cattle seen among mountains during inclement weather.

2 Hurt sold many of his pictures through Frost and Reed Ltd. (Ambrosine B. Hurt, letter to the compiler, 9 March 1985) but, unfortunately, their records do not survive (Tim Swain, letter to the compiler, 26 March 1985); the artist ceased exhibiting his pictures around 1900 'having as many commissions as I can execute without exhibiting' (letter to the Curator of the Walker Art Gallery of 5 February 1923).

HUTCHISON, Robert Gemmell
(1860–1936)[1]
'Tatties and Herrin!'
WAG 2938
Canvas: 102.2 × 128 cm
Signed: *R. Gemmell Hutchison*

Potatoes and herrings were the usual working-class diet in 19th- and early 20th-century Britain. The costume in this painting, however, is clearly Dutch – the women's bonnets in particular resemble those generally worn in Scheveningen around 1900.[2] The artist's point is presumably that potatoes and herring were the diet of the poor throughout northern Europe, particularly in maritime areas. Hutchison exhibited two scenes from North Brabant and one from Volendam in 1906–7.

'Tatties and Herrin!' was, however, painted in Scotland from Scottish models. The mother and aunt of Mrs. Ann Naysmith served as the models for the girl at the extreme right of the painting and for the younger girl sitting with her back to the spectator (respectively). They

Highland Cattle WAG 1348

Hornet, Touchstone and Mystery WAG 2671

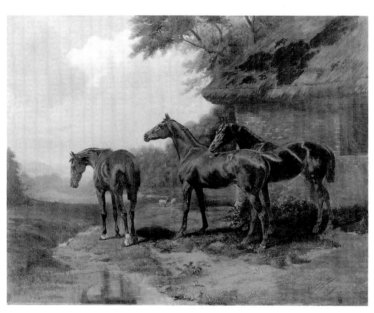

Coronet, Merryman and Dewdrop WAG 2672

JONES, Adrian (1845–1938)
Hornet, Touchstone and Mystery
WAG 2671
Canvas: 71 × 91.7 cm
Signed: *Adrian Jones / 1895*

Coronet, Merryman and Dewdrop
WAG 2672
Canvas: 71 × 91.5 cm
Signed: *Adrian Jones / 1895*

The Soarer
WAG 2673
Canvas: 71.5 × 91.7 cm
Signed: *Adrian Jones 1896*

Hurlingham: Nimble, Cicely, Dynamite and Lady Jane
WAG 2608
Canvas: 107.7 × 153.7 cm
Signed: *Adrian Jones* (and in monogram)

236

Merry Gal

WAG 2609
Canvas[1]: 71.8 × 92.7 cm
Signed: *ADRIAN JONES / 1900*
Inscribed: *Merry Gal*

Colonel William Hall Walker, later the first Baron Wavertree (1856–1933) was the third son of Andrew Barclay Walker, the founder of the Walker Art Gallery, and was a major breeder, trainer and owner of racehorses (as well as being a substantial benefactor of the Gallery). In breeding he relied not only on science but also on astrology and was well known for his unshakeable opinions and convictions on the matter. In 1916 he presented his stud to the nation as the nucleus of the National Stud. He was himself a considerable horseman and competed extensively in amateur races.[2] He was the Unionist Member of Parliament for Widnes 1900–19.[3]

Hornet, Touchstone, Mystery, Coronet, Merryman and Dewdrop were all owned by Lord Wavertree and the two paintings were commissioned by him in 1895.[4] The Soarer was born in 1889 by Skylark out of Idalia. He was bred by Mr. Doyle and bought in Ireland as a four-year-old by David Campbell (later Sir David Campbell, 1869–1936), who sent him to be trained at Weyhill by Willie Moore and John Collins. He won seven races as a five-year-old but then lost his form until 1896 when he won both the Great Sandown Chase and the Grand National. Campbell sold him to Lord Wavertree just before this Grand National on the understanding that Campbell should ride him in the race; he fell in both his subsequent attempts to win this race.[5] In fact Lord Wavertree commissioned from Jones three identical versions of The Soarer. One is the painting here catalogued. One passed to the jockey, David Campbell, and is still in his family collection. The third was probably presented to the 9th Lancers, the regiment in which Campbell served; it is now unlocated.[6] The Aintree racecourse appears in the background of the painting with the finishing post as the most prominent object.[7] In 1896 Lord Wavertree commissioned Jones to do a model of The Soarer; this was made in silver by Lucius Movio.[8] The head of The Soarer from this model was again used to decorate an ink stand in the same year.[9]

Hurlingham: Nimble, Cicely, Dynamite and Lady Jane shows Lord Wavertree changing ponies during a game of polo; it has been dated to 1896; all the ponies were owned by Lord Wavertree, who commissioned the painting.[10]

Merry Gal was born in 1897 by Galopin out of Mary Seaton. She won £13,017 in prize money with notable successes in the Princess of Wales's Stakes, the Nassau Stakes, the Epsom Cup, the Hardwicke Stakes, etc.[11] Like all the other horses painted by Jones and now in the Walker Art Gallery, she was owned by Lord Wavertree, and it is reasonable to suppose that this painting was also commissioned by Lord Wavertree.

Hurlingham: Nimble, Cicely, Dynamite and Lady Jane WAG 2608

PROV: Bequeathed by Lord Wavertree 1933.

1 Canvas stamp: KFAS, 26 Alfred Place,
 S. Kensington.

2 See Jocelyn de Moubray, *Horse-racing and Racing Society*, 1985, pp. 14–16; S.G. Galtrey, *Memoirs of a Racing Correspondent*, 1934, p. 138; George A. Fothergill, *A Gift for the State: The National Stud*, 1916; in fact Lord Wavertree gave all his horses, valued at £48,040, but the government had to pay £65,625 for his stables and land at County Kildare and in Wiltshire; *Complete Peerage*, ed. Doubleday and Howard de Walden, 1940, vol. 13, p. 322. See also pp. **346–7** (under Paton) for further paintings of Lord Wavertree's horses.

3 *Who's Who of British Members of Parliament*, ed. M. Stenton and S. Lees, 1979, vol. 3, p. 363.

4 Sladmore Gallery, *Adrian Jones*, 1984, under *Biography*. None of these horses can be traced with any certainty in the *Racing Calendar*.

Merry Gal WAG 2609

The Soarer WAG 2673

5 Patricia Smyly, *Encyclopaedia of Steeplechasing*, 1979, p. 258. Reg Green, *A Race Apart*, 1988, pp. 132–3, gives a full account of the 1896 Grand National.

6 David M. Courage, letter to the compiler, 23 September 1987.

7 Loraine Knowles, conversation with the compiler, 19 August 1994.

8 There is a silver version in the Walker Art Gallery (inv. 3324); it was bequeathed by Lord Wavertree.

9 David M. Courage, letter to the compiler, 23 September 1987.

10 Sladmore Gallery, *op. cit.*, no. 37.

11 Fothergill, *op. cit.*, p. 113, with further details about her pedigree.

Storm in the Pass of Leny, Perthshire
WAG 2940

KAY, Archibald (1860–1935)
Storm in the Pass of Leny, Perthshire
WAG 2940
Canvas: 152.4 × 123.2 cm
Signed: *Archibald Kay*

In the foreground is the River Leny, which runs down the Pass of Leny. The artist exhibited a considerable number of paintings of this subject.

PROV: Bought from the artist 1916 (£315).

EXH: Royal Academy 1914 (597); Royal Glasgow Institute of the Fine Arts 1914 (277); Royal Scottish Academy 1915 (74); Liverpool Autumn Exhibition 1915 (1110).

KENNEDY, Charles Napier (1852–1898)
Neptune
WAG 752
Canvas[1]: 168.2 × 244.5 cm
Signed: *C.N. KENNEDY 1889*

Neptune was first exhibited at the New Gallery with a quotation from Keats's *Hyperion*.

*Have ye beheld the young god of the seas
My dispossessor? . . .*

*. . . foam'd along –
By noble winged creatures he hath made?*

In Keats's poem Oceanus, one of the Titans, is speaking about their fall at the hands of the new gods, notably Jupiter and Neptune. In effect therefore this is a triumph of Neptune, who has dispossessed the old god of the sea, Oceanus. The female figure is presumably Amphitrite, daughter of Oceanus; Neptune seduced her with the aid of a dolphin and here she is seated on a dolphin; in front of her is her son Triton who is generally represented as half human and half dolphin.

The critics generally admired the vigour, vitality and movement in *Neptune*. The account in the *Saturday Review*[2] was typical.

Among subject-pictures at the New Gallery none is likely to be a greater favourite than Mr. C.N. Kennedy's Neptune *which has the place of honour in*

239

the North Room. The young sea-god, astride on one monster, and his goddess and a boy-god, riding another by his side, plunge with infinite zest and fire through a raging deep blue ocean. The foam flies over them, their sea-beasts cleave the currents with their snouts, while that which Neptune has made his courser neighs or shrieks aloud in its ecstasy, showing a formidable range of tusks. The god waves his trident in the air, while the wind draws back his harsh black tresses. This is a very remarkable piece of work, masculine and sturdy, and yet full of poetical feeling, which will advance Mr. Kennedy's reputation. But why are painters so careless about their tags from the poets? Keats's god of the seas was 'foam'd along / By noble winged creatures, he hath made', while Mr. Kennedy's monsters are a kind of hippopotamus, and would not know where to pack away a pair of wings.

The review by P.H. Rathbone,[3] the Chairman of the Walker Art Gallery was, however, the most engaging:

In the same rooms as these two pictures is one which is sure to attract attention, Neptune, by C.N. Kennedy. There is a go and a dash in this work which is quite invigorating. Neptune seated on a shark, is using his trident as a harpoon, while Amphitrite upon another is looking on with mingled admiration for her husband and keen anxiety as to the result of his sport. The roll of the waves is full of life, though there is a question whether that might not be increased by continuing the second wave right out of the picture. A great discussion has arisen as to how far the sharks are correctly portrayed, and this leads to the question to what degree in a mythological or imaginary subject it is requisite to be scientifically accurate in the details. The answer is that even in these subjects it is desirable to preserve as much veri-similitude as possible, and for this purpose to represent both men and animals under the forms which it may be supposed they would have borne if they had existed. Mr. Kennedy is therefore quite right in having actually copied certain existing forms of sharks.[4] But there is another quality in this picture which takes it out of the ordinary level. Both the attitude and facial expression of Amphitrite embody a whole-souled self-forgetting sympathy with the aims and objects of Neptune, which is the true note of a noble affection between man and woman.

Neptune WAG 752

When this painting was exhibited at the New Gallery and at the Liverpool Autumn Exhibition in 1889, seaweed concealed Amphitrite's genitals. This was subsequently removed and indeed is not visible in an early but undated Gallery photograph nor in the illustration reproduced in the Walker Art Gallery Permanent Collection catalogue of 1927. The seaweed was probably inserted by the artist at the request of the New Gallery organizers, who may have been particularly sensitive to public criticism in only their second annual exhibition, and then subsequently removed by the artist, although it is still present in the P.A. Massé etching of 1890.[5]

Herbert Draper's *The Foam Sprite* of 1897[6] is so close to *Neptune* that it seems to be almost a case of plagiarism.

REPR: H. Blackburn, *New Gallery Notes*, 1889, p. 32; Pall Mall Gazette, *Pictures of 1889*, p. 69; Liverpool Autumn Exhibition, *Illustrated Catalogue*, 1889, p. 105; *Art Journal*, 1890, frontispiece (etching by P.A. Massé).

PROV: Presented by Albert Wood[7] 1912.

EXH: New Gallery 1889 (114); Liverpool Autumn Exhibition 1889 (1187).

1 Canvas stamp: Newman, Soho Square.

2 *Saturday Review*, 4 May 1889, p. 535. Similar reviews appeared in the *Art Journal*, 1890, p. 30; *Spectator*, 18 May 1889, p. 681; *Illustrated London News*, 18 May 1889, p. 627; *Scottish Art Review*, 1889–90, p. 7. The *Academy*, 18 May 1889, p. 348, regarded WAG 752 as the most remarkable of the works of younger artists at the 1889 New Gallery exhibition; only the *Athenaeum*, 25 May 1889, p. 670, was distinctly hostile, describing the painting as a 'turgid commonplace' with 'three nudities of the Life School'. Many of the critics, however, complained that Kennedy's sea animals lacked the wings specified by Keats.

3 P.H. Rathbone, 'The Autumn Exhibition of 1889', *University College Magazine*, Liverpool, 1889, vol. 4, p. 115.

4 In fact neither of the sea monsters in WAG 752 are accurate representations of any real creature; Amphitrite's mount is somewhere between a porpoise and a dolphin (Ian Wallace, conversation

with the compiler, April 1991). A very similar sea monster appears in Kennedy's *Perseus and Andromeda* of 1890 (Sotheby's (New York) 13 October 1993, lot 85).

5 For details of reproductions of WAG 752 at the exhibitions and in 1890, see Reproduction above.

6 Reproduced in A.L. Baldry, 'Our Rising Artists: Mr. Herbert J. Draper', *Magazine of Art*, 1899, p. 48.

7 He owned it as early as 1890 (*Art Journal*, 1890, p. 30).

KENNINGTON, Thomas Benjamin
(1856–1916)

Daily Bread
WAG 2941
Canvas[1]: 101.5 × 76.2 cm
Signed: *T.B. KENNINGTON 83*

Daily Bread is one of a number of rather sentimental social realist paintings – often representing children – done by Kennington in the 1880s; *Orphans* of 1885 (now Tate Gallery) and *One of the Masses* (exhibited at the New English Art Club 1888, no. 86)[2] are two further examples.

A watercolour also entitled *Daily Bread* was shown by the artist at the Royal Society of British Artists in 1883–4 (718) 'by permission of Liverpool Corporation'; it was presumably closed related to the Walker Art Gallery painting.

PROV: Purchased from the artist 1883 (£80).[3]

EXH: Liverpool Autumn Exhibition 1883 (80).

1 Canvas stamp: *G.H. Bowden*; George and William Bowden, artists' colourmen, are listed in the 1882 Post Office London Directory at 47 Brompton Road; by 1885 the firm was listed as Bowden Brothers. The artist seems, however, to have spent most of 1883 in Paris (Biographical Particulars, MS Walker Art Gallery).

2 Reproduced in Pall Mall Gazette, *Pictures of 1888*, p. 85. Compare also the *Battle of Life*, New English Art Club 1887 (92) reproduced in Pall Mall Gazette, *Pictures of 1887*, p. 86; *Widowed and*

Fatherless, Royal Academy 1888 (1126)
reproduced in *Royal Academy Pictures*, 1888, p. 38
and *The Pinch of Poverty*, Royal Academy 1889
(734) reproduced in *Royal Academy Pictures*, 1889,
p. 26. Kennington's pathetic scenes with children
and mothers are discussed by H.D. Rodee in
*Scenes of Rural and Urban Poverty in Victorian
Painting 1850–1890*, 1975, p. 222, in the context
of late social realism. Tate Gallery, *The Modern
British Paintings, Drawings and Sculpture*, 1964, vol.
1, p. 357, suggests the influence of Murillo in
these paintings.

3 During the 1880s the Walker Art Gallery
 purchased a number of paintings by young and
largely unknown artists trained in Paris; the most
famous of these paintings were *Hard Times* by
Frederick Brown (see p. **54**) and *A Street in
Brittany* by Stanhope Forbes (see p. **144**), but
WAG 2941 is also a notable example. The *Art
Journal*, 1883, p. 342, commented on the
considerable number of paintings at the 1883
Liverpool Autumn Exhibition contributed by
British artists then living in Paris, where
Kennington spent most of 1882 and 1883
(Biographical Particulars, MS Walker Art
Gallery). Kennington was trained in Liverpool
and lived there from 1870–7; this may have
influenced the acquisition of WAG 2941.

Poor Relations WAG 916

KILBURNE, George Goodwin
(1839–1924)

Poor Relations

WAG 916
Canvas: 76.7 × 106.9 cm
Signed: *G.G. Kilburne 1875*

A watercolour version of this composition
(25 × 35.5 cm) signed and dated 1877, was
sold at Sotheby's (Billingshurst) 26 November
1990, lot 99. Another watercolour entitled *The
Poor Relation* was sold at Sotheby's (Chester)
26 April 1990, but its composition was entirely
different from that of the Walker Art Gallery
painting.

H.D. Rodee[1] notes Kilburne's painting as a
narrative work extolling domestic charity
more characteristic of the 1850s than of the
1870s.

PROV: Bequeathed by Miss Agnes S. Steele 1903.

EXH: Royal Academy 1875 (493);[2] Liverpool
Autumn Exhibition 1875 (119).

1 H.D. Rodee, *Scenes of Rural and Urban Poverty in
 Victorian Painting 1850–1900*, 1975, p. 163.

2 In a letter of 19 November 1912 the artist
 confirmed that WAG 916 was the 1875 Royal
 Academy painting.

KING, Yeend (1855–1924)

From Green to Gold

WAG 123
Canvas[1]: 157.5 × 213.5 cm
Signed: *YEEND KING*

The critics at the 1889 Royal Academy were
divided over the merits of this landscape. *The
Times*[2] wrote:

*The large picture by Mr. Yeend King which has been
honoured with a central position on the line is by far
the most considerable work that this artist has
attempted till now, and though it is not altogether
satisfactory it must be taken as an honest attempt to
paint a very difficult subject, and a subject that comes
quite lawfully within the scope of the landscape
painter. It is simply a bit of English scenery, a thicket
by the brookside; but how complex may be the
elements therein implied, how multitudinous the lines
of branch and stem, the tints of bark and blade and
leaf, few know but those who have tried to render
them. Mr. King is somewhat of an impressionist and
his sense of colour, though there is, perhaps, too much
blue in the green that he most prefers, is on the whole
true. One might say of him, although he is not yet
quite a Constable, there were very few of Constable's
contemporaries who could have painted such a good
picture as this; the danger is that he should become
slovenly in his execution, the common danger of our
younger school of artists and one that is only to be
avoided by the old method of incessant studies from
nature.*

243

From Green to Gold WAG 123

The critic of the more progressive *Academy*[3] was much less enthusiastic:

Powerful of its kind and self assertive is Mr. Yeend King's large landscape From Green to Gold in which he displays a certain unity of motive and power of selection such as must be the result of foreign training. The artistic fibre revealed is, however, a somewhat coarse one whether we consider the heaviness and want of charm in the execution, or the failure to present more than nature's most obvious and least touching aspects.

REPR: Liverpool Autumn Exhibition catalogue, 1889, p. 69.

PROV: Bought from the artist 1889 (£400).

EXH: Royal Academy 1889 (739); Liverpool Autumn Exhibition 1889 (217).

1 Canvas stamp: *Newman, Soho Square, London.*

2 *The Times*, 1 June 1889.

3 *Academy*, 22 June 1889, p. 436. There are also brief reviews in the *Art Journal*, 1889, p. 220, and in the *Illustrated London News*, 18 May 1889, p. 654. P.H. Rathbone wrote in the *University College Magazine, Liverpool*, 1889, vol. 4, p. 118: 'Perhaps the best landscape is that of Yeend King [at the Liverpool Autumn Exhibition] of which the subject is inclined to verge on the commonplace, but of which the details are wrought out with a cheerful sympathy with nature that has much charm.'

Showery Weather WAG 2942

KNIGHT, Joseph (1837–1909)
Showery Weather
WAG 2942
Canvas: 87.6 × 128.2 cm
Signed: *J. Knight 76*

This Welsh[1] landscape received a rather pedantic review from the Liverpool press[2] when it was acquired for the Walker Art Gallery:

We have occasion to rejoice that one good, if not great, picture has become the property of the town. 'Showery Weather', though abounding in all the evils of French landscape art, has in it much of its vital power, and no small allowance of English freshness and vigour. The sand and porous stones in the foreground would, no doubt, readily absorb the water deposited by a passing shower; but surely with a sky such as is so ably represented, some residue, at least, of the last downfall should be apparent. However, this is of quite minor importance to the very careless or imbecile manipulation of the distant peak, which is quite inadmissible in a finished picture, and shows the total inability of the painter to appreciate the higher qualities of landscape art. The faithful representation of distant rocks is evidently beyond his powers.

PROV: Purchased from the artist 1876 (£150).

EXH: Liverpool Autumn Exhibition 1876 (44).

1 In 1875–6 Knight moved to a house near Llanrwst and WAG 2942 is noted as Welsh in the Gallery files. It has Knight's Llanrwst address on an inscription on the back of the canvas.

2 *Porcupine*, 9 September 1876, p. 377.

LANGLEY, Walter (1852–1922)
A Cornish Idyll
WAG 408
Canvas: 128.2 × 122.2 cm
Signed: *WALTER LANGLEY 1902*

A Cornish Idyll shows the old harbour wall at Newlyn, with part of the village beyond rising up to the area known as the Cliff.[1] Red earthenware pitchers occur very frequently in Langley's paintings and represent the simple peasant life of the figures he depicted.[2]

A watercolour copy after *A Cornish Idyll*

was painted by the artist in 1902 for his second wife, Ethel;[3] a further watercolour was begun as a sketch for *A Cornish Idyll* and was then completed from it.[4]

A Cornish Idyll was scarcely noticed by reviewers at the 1902 Royal Academy;[5] Newlyn School pictures of this type were no doubt regarded as long out of date.

REPR: Black and White, *Handbook to the Royal Academy*, 1902, p. 79; Art Journal, *Academy Pictures*, 1902, p. 39; *Royal Academy Pictures*, 1902, p. 51; Liverpool Autumn Exhibition catalogue, 1902, p. 53.

PROV: Presented by Alderman J.W. Oakshott J.P. 1902.[6]

EXH: Royal Academy 1902 (99); Liverpool Autumn Exhibition 1902 (8).

1 Tessa Sidey, letter to the compiler, 18 October 1984; compare the photographs of Newlyn in the 1880s and 1890s reproduced in Newlyn Art Gallery, *Artists of the Newlyn School*, 1979, pp. 41–2, and Langley's own *Departure of the Fishing Fleet for the North* (reproduced in A. Meynell, 'Newlyn', *Art Journal*, 1889, p. 137).

2 Exeter, Royal Albert Memorial Museum, *Walter Langley*, 1984, p. 5; the artist had pitchers from Lake's Pottery, Truro, as studio props.

3 Exeter, Royal Albert Memorial Museum, *op. cit.*, no. 34; it is still in the family collection.

4 According to the artist in a letter of 2 January 1913 to the Curator of the Walker Art Gallery; it was owned in 1912 by Mr. F.D. Docker of The Gables, Kenilworth, who bought it in June 1902 from Mr. I. Lloyd of 3 New Street, Birmingham; the artist had sold it to a Birmingham dealer called Luton in May 1902 for £50 (R.C. Langley, letter to the compiler, 6 September 1986). It was presumably this watercolour that was sold at Sotheby's (Billingshurst, Sussex) 23 September 1986, lot 3176 and then subsequently at Sotheby's

(London) 11 May 1988, lot 9; the Sotheby's watercolour (58 × 54.5 cm) is more or less identical to WAG 408.

5 There was, however, a very favourable review of WAG 408 in the *Cornishman*, 27 March 1902: 'In a *Cornish Idyll*, Mr. Walter Langley is at his best and rarely do we remember seeing anything from his talented brush which pleased us more.' The reviewer had evidently seen WAG 408 before it left Cornwall for London.

6 The Walker Art Gallery purchased WAG 408 from the artist for £300 and then Alderman Oakshott contributed that amount to the Gallery.

LA THANGUE, Herbert Henry
(1859–1929)

Selling Chickens in Liguria
WAG 946
Canvas: 106.7 × 88 cm
Signed: *H.H. LA THANGUE*

The artist's first Ligurian paintings seem to date from about 1904;[1] R. Dircks,[2] referring to all of La Thangue's pictures at the 1906 Royal Academy, praised 'the golden sunshine of Mr. La Thangue's rural scenes' and around 1900 the artist had begun to specialize in picturesque peasant scenes with brilliant sunlight effects.[3]

Also at the 1906 Royal Academy was La Thangue's *Winter in Liguria*, which was the same size as *Selling Chickens in Liguria*, represented the same peasant woman and may have been intended as a pendant to it.[4]

Selling Chickens in Liguria
WAG 946

REPR: *Royal Academy Pictures*, 1906, p. 86; Liverpool Autumn Exhibition catalogue, 1906, p. 127.

PROV: Bought from the artist 1907 (£315).

EXH: Royal Academy 1906 (751); Liverpool Autumn Exhibition 1906 (941); Oldham Art Gallery, *H.H. La Thangue*, 1978 (26).

1 Oldham Art Gallery, *H.H. La Thangue*, 1978, p. 12.

2 *Art Journal*, 1906, p. 162.

3 For further discussion of this stylistic change, see Oldham Art Gallery, *op. cit.*, p. 12. George Clausen wrote: 'for La Thangue, it was, primarily, the beauty of things in sunlight that excited him' (Brighton Art Gallery, *H.H. La Thangue*, 1930, p. 6).

4 Susan P. Casteras, *The Edmund J. and Suzanne McCormick Collection*, 1984, p. 54, no. 20. La

Thangue's *Selling Oranges in Liguria* of 1905 was also the same size as WAG 946; it is reproduced in *Royal Academy Pictures*, 1905, p. 89.

Goats at a Fountain
WAG 1718
Canvas: 81.3 × 73 cm
Signed: *H.H. LA THANGUE*

The fountain and goatherd also seem to appear in the artist's *Provencal Workers* of 1929,[1] and so, presumably, *Goats at a Fountain* depicts a scene in Provence.[2]

REPR: *Royal Academy Illustrated*, 1926, p. 34.

PROV: Bequeathed by Mrs. Katherine La Thangue (widow of the artist) 1941.

EXH: Royal Academy 1926 (159); Brighton Art Gallery, *H.H. La Thangue*, 1930 (62); Fine Art

Goats at a Fountain WAG 1718

Society, *H.H. La Thangue*, 1931 (7); Oldham Art Gallery, *H.H. La Thangue*, 1978 (36).

1 *Royal Academy Illustrated*, 1929, p. 2; Oldham Art Gallery, *H.H. La Thangue*, 1978, no. 36.

2 La Thangue seems to have started painting Provence in about 1901; see Oldham Art Gallery, *op. cit.*, p. 12.

An Old Italian Garden

WAG 667
Canvas: 68.5 × 75.5 cm
Signed: *H.H. LA THANGUE*

REPR: *Royal Academy Illustrated*, 1927, p. 20.

PROV: Bequeathed by Mrs. Katherine La Thangue (widow of the artist) 1941.

EXH: Royal Academy 1927 (178); Brighton Art Gallery, *H.H. La Thangue*, 1930 (74); Fine Art Society, *H.H. La Thangue*, 1931 (36); Oldham Art Gallery, *H.H. La Thangue*, 1978 (37).

An Old Italian Garden WAG 667

Parable of Forgiveness WAG 3077

LAUDER, James Eckford (1811–1869)
Parable of Forgiveness
WAG 3077
Canvas: 198 × 313.5 cm
Signed: *J. Eckford Lauder / Pinx 1847*

This was first exhibited at, and presumably painted for, the 1847 exhibition of oil paintings at Westminster Hall, which was organized by the Royal Commission on the Fine Arts in order to allocate commissions for oil paintings in the new Palace of Westminster; together with Lauder's *Wisdom*, it won a third class premium (£200) at the exhibition.[1] The painting represents the parable of the unmerciful servant told in Matthew 18:23–35; the king is in the act of pardoning the unmerciful servant as the servant is just about to be dragged away to be sold into slavery together with his wife and children, who are presumably the three figures in the centre foreground and the two figures to the right of the soldiers with spears. The subject is very uncommon in art, although Rembrandt's so-called *Centurion Cor-*

nelius in the Wallace Collection may in fact represent this parable.

The verdict of the judges at the Westminster Hall exhibition seems to have received general approval[2] and Lauder's painting was well reviewed by both the *Art Union* and by the *Athenaeum*; the critic of the *Athenaeum*[3] wrote:

The conduct of the first exhibits an attention to the true philosophy of Art and its highest and noblest direction in the expression of a great moral principle. The parable is explained with all the perspicuity of which the painter's art is susceptible. He has made his own plot out of the ideas suggested by the lines, and his dramatis personae *eloquently elucidate the theme. Great disposition is shown for colour and harmony, as well as for perception of character. The drawing is not of equal vigour.*

The *Art Union*[4] also had much praise:

It is distinguished by much that is beautiful. The King – who is too young a man, and not sufficiently signalized as a royal personage – is seated on the left,

and before him has been led the servant whose debt to him is ten thousand talents. Himself, his wife, children – all that he possesses – have been condemned to be sold in justification of the debt, and he is now about to be dragged from the presence by two muscular figures who are finely developed in the action. Hence the picture could never be regarded as an illustration of forgiveness, but of condemnation, inasmuch as the latter is the point dwelt upon; and there is nothing to speak of forgiveness. The centre group, consisting of the servant, his family, and the royal officials, is beautifully made out; and many of the supplementary figures are highly characteristic. The background is a flat, open, airy monotony which, had it been toned down a little, the external figures had been better supported.

The style presumably reflects the artist's stay in Italy (1834–8), where he is said to have made many copies from the works of the old masters; in later years his work became much less Italianate.[5]

REPR: *Illustrated London News*, 28 August 1847, p. 141.

PROV: Presented by Mrs. George Arkle 1878.

EXH: Westminster Hall, Exhibition of Oil Paintings, 1847 (93); Royal Scottish Academy 1848 (206); Liverpool Academy 1848 (108).

1 For the background to these exhibitions, see particularly T.S.R. Boase, 'The Decoration of the New Palace of Westminster', *Journal of the Warburg and Courtauld Institutes*, 1954, vol. 17, pp. 342–3 and David Robertson, *Sir Charles Eastlake*, 1978, pp. 325 ff. The Royal Commission announced the exhibition on 7 August 1845; subject matter was not specified, except for the statement that 'the subjects are required to come under the general classes of religion, history, or poetry'; the figures had generally to be life size; the paintings had to be sent to Westminster Hall in June 1847; the judges were Lord Lansdowne, Robert Peel, Samuel Rogers, Richard Westmacott, Richard Cook and William Etty. An earlier announcement had been made in 1844 for a similar exhibition to be held in 1846, but the exhibition was eventually postponed until 1847. The Royal Commission acquired four paintings from the exhibition for the decoration of Committee Rooms in the Palace of Westminster, but WAG 3077 was not among them (Irish University Press, *Series of British Parliamentary*

Papers: Education: Fine Arts, vol. 2: *Sessions 1841–1847*, 1971, pp. 444, 537–8, 565, 584–7). These exhibitions were largely ignored by members of the Royal Academy and by established artists generally; even most of the prizes went to younger artists such as J.E. Lauder. W.D. McKay, *The Scottish School of Painting*, 1906, p. 257, states positively that WAG 3077 was painted for the 1847 Westminster Hall Exhibition, announced in 1845, but the *Art Journal*, 1869, p. 157, recorded that it was begun as early as 1842. *Wisdom* is described in *Art Union*, 1847, p. 271; it consisted of three female figures of which the central one represented Wisdom.

2 *Illustrated London News*, 3 and 17 July 1847, pp. 11 and 39; *Art Union*, 1847, p. 265; Lindsay Errington in National Gallery of Scotland, *Master Class*, 1983, p. 25, states, however, that many reviewers of the exhibition (presumably Scottish) were surprised that J.E. Lauder had received a prize while his elder and more famous brother, R.S. Lauder, had not. R.S. Lauder's contribution to the exhibition was *Christ teacheth Humility* now in the National Gallery of Scotland.

3 *Athenaeum*, 3 July 1847, p. 705. The *Literary Gazette*, 10 July 1847, p. 507 described WAG 3077 as 'handled in a masterly manner' and its subject as 'Christ forgiving the indebted servant'.

4 *Art Union*, 1847, p. 271. This reviewer seems to suggest that Lauder was seeking to represent the second appearance of the unmerciful servant before the king, not his first appearance, but this seems implausible. Indeed Matthew 18: 23–27 are quoted in the Liverpool Academy catalogue of 1848 (see under Exibitions above).

5 See McKay, *op. cit.*, J.L. Caw, *Scottish Painting*, 1908, p. 118, and D. and F. Irwin, *Scottish Painters at Home and Abroad*, 1975, p. 298.

The Duenna

WAG 2513
Canvas: 120 × 143 cm

PROV: Purchased 1878 from an unknown source.

The Duenna WAG 2513

LAVERY, John (1856–1941)
Hazel in Rose and Gold
WAG 2879
Canvas: 201.3 × 100.3 cm
Signed: *J. Lavery*

This portrait, painted in 1918, is closely related to Lavery's *Hazel in Black and Gold* of 1916,[1] another of his 'fair women' paintings,[2] again with his wife[3] as the model; the colours are, however, brighter and more strident than the artist had used in earlier paintings of this type.[4] In the 1920s Lavery concentrated on painting formal 'arrangements' in various shades of red, possibly prompted by his wife's similar taste in evening dress; this portrait may be seen as the first of this series.[5]

There is a sketch in the National Gallery of Ireland, Dublin.[6] At the 1918 International Society exhibition, *The Times*[7] critic wrote that the artist was 'becoming more and more a British Boldini though still careful not to commit himself or his sitter as completely as Boldini does'.

REPR: *Les Arts*, 1919, p. 4, no. 179 (showing slight differences from the present state of WAG 2879, particularly in highlights on the dress); Liverpool Autumn Exhibition catalogue, 1921, fig. 16.

PROV: Purchased from the artist 1921 (£500).

EXH: International Society of Sculptors, Painters and Gravers, *Summer Exhibition*, 1918 (32); Paris, *Salon d'Automne*, 1919; Belfast Art Society 1920 (199); The Hague, *Pulchri Studio*, 1921;[8] Liverpool Autumn Exhibition 1921 (964).

1 Now in the Laing Art Gallery, Newcastle upon Tyne; see Ulster Museum, Belfast, *Sir John Lavery*, 1984, p. 78, no. 75. The name of the

Hazel in Rose and Gold WAG 2879

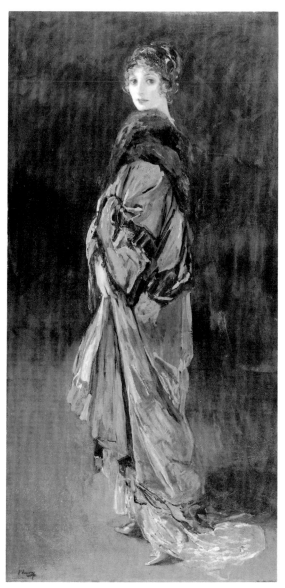

artist, title and date of WAG 2879 are inscribed on the back of the canvas.

2 Lavery became best known for these portraits or studies of elegant and fashionable women based on the work of Sargent and Whistler; the earliest of them date from the 1890s; J.L. Caw, *Scottish Painting*, 1908, pp. 378–9, analyses the early examples unfavourably. Ulster Museum, Belfast, *op. cit.*, p. 47, presents a more balanced judgment with further references and suggesting 18th-century sources.

3 The artist married Hazel Trudeau, daughter of a Chicago industrialist and widow of a French Canadian doctor, in 1910. She was herself an artist and was an important influence on his career. There exist innumerable paintings of her by her husband and by other artists, notably Sargent, Birley and McEvoy, and dramatic portrayals of her face and clothes – like WAG 2879 – transformed her from a well-known society personality into almost an icon (see K. McConkey, *Sir John Lavery*, 1993, p. 146). She seems to have become rather less devoted to him than he was to her – see Martin Stannard, *Evelyn Waugh: The Early Years*, 1986, pp. 306–7.

4 Ulster Museum, Belfast, *op. cit.*, p. 87.

5 McConkey, *op. cit.*, pp. 145–6.

6 Ulster Museum, Belfast, *op. cit.*, p. 87, no. 92.

7 *The Times*, 11 May 1918; other reviews of WAG 2879 are quoted in Ulster Museum, Belfast, *op. cit.*, p. 87.

8 Ulster Museum, Belfast, *op. cit.*, p. 87, no. 91.

LAWSON, Francis Wilfred (1842–1935)
Home Again: France 1870[1]
WAG 2976
Canvas: 90.8 × 70.5 cm
Signed: *F.W. Lawson*

This is a painted version of one of Lawson's illustrations of the Franco-Prussian war which appeared in the 1870 *Graphic*;[2] there are minor differences in the foreground between engraving and painting. The accompanying text in the *Graphic* (possibly by Lawson himself)

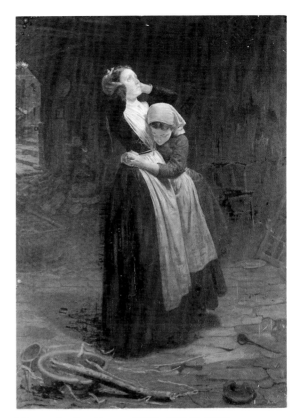

Home Again: France 1870 WAG 2976

explained that peasants in France were fleeing before the invading German soldiers, but then had to return, only to find their homes in ruins once the Germans had left; the author also pointed out that war is a greater burden for the poor than for the rich.

PROV: Presented by James Allanson Picton[3] 1880.

EXH: Royal Academy 1872 (1089).

1 WAG 2976 was entitled *Footprints of War* when it was acquired in 1880.

2 The *Graphic*, 10 December 1870, p. 569. Another of Lawson's illustrations of the war appeared in the *Graphic* on 27 August 1870 and was entitled *Peasant Girls tending the Wounded*. His painting, *News from the War* of 1871, was exhibited at the International Exhibition, London 1871 (404).

3 The Walker Art Gallery's record card says: 'purchased out of the Picton Fund'.

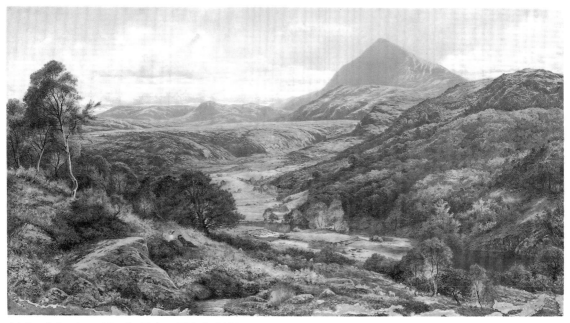

A Fine Morning, North Wales WAG 2977

LEADER, Benjamin Williams (1831–1923)
A Fine Morning, North Wales
WAG 2977
Canvas: 93 × 168 cm

This landscape was signed and dated 1864,[1] but damage to the lower edge resulted in the loss of the signature and date in the 1950s. It is very similar to Leader's *A Quiet Valley among the Welsh Hills*, signed and dated 1860 and now in the Worcester Museum and Art Gallery (74 × 107 cm);[2] it differs in many details, however, from the Worcester picture and seems rather more simplified and perhaps inferior in quality. The Curator of the Walker Art Gallery wrote to the artist about it, enclosing a sketch, and received this reply written on 15 August 1909;[3] 'I find that in 1864 I painted two pictures in which Moel Siabod was introduced. I have no doubt the picture you have is one of them, especially as it is signed and dated.' Autograph repetitions are, however, relatively uncommon in Leader's early work and in Pre-Raphaelite painting generally;[4] the Walker Art Gallery landscape is not listed in Frank Lewis, *Benjamin Williams Leader*, 1971. The view in it seems to have been taken from an area two or three hundred

yards behind the present Tyn y Coed Hotel, Capel Curig; in the foreground is the River Llugwy; the two small buildings left of centre in the middle distance are Cae Gwegi farmhouse and outbuilding.[5]

There are two pencil sketches for this landscape in an early sketch-book now in the Victoria & Albert Museum (E489 and E496–1969).

PROV: (?) B. Hall of Liverpool.[6] Presented by Ellis E. Edwards 1907.

1 MS letter from the Curator of the Walker Art Gallery to the artist of 12 August 1909.

2 According to Lewis Lusk, 'B.W. Leader', *Art Annual*, 1901, p. 18, the Worcester picture was no. 467 at the 1860 Royal Academy; it is reproduced in Worcester City Museum and Art Gallery, *Benjamin Williams Leader: A Rural Vision*, n.d., cat. no. 2.

3 MS letters; it is plain that Leader did not see WAG 2977 in 1909 but gave his opinion simply from the Curator's sketch.

4 For Leader's Pre-Raphaelite period, see A. Staley, *The Pre-Raphaelite Landscape*, 1973, pp. 57, 175–6;

according to Lusk, *op. cit.*, p. 23, Leader reached his 'rather reticent middle style' by 1870.

5 Alan Jones, letter to the compiler, 22 May 1985. The same view, but observed from a lower viewpoint, seems to be represented in John Finnie's *Moel Siabod from Capel Curig* at the Victoria & Albert Museum (9098–1863).

6 The artist's Account Books, now with Frost and Reed, London, list under 1864 *Moel Siabod from below Capel Curig*, B. Hall Esq., Liverpool, £170; there is no mention that this 1864 painting was a version of an earlier composition. The compiler is indebted to Ruth Wood for assistance with this and other B.W. Leader entries.

Near Capel Curig, North Wales
WAG 803
Canvas: 51.7 × 77.1 cm
Signed: *B.W. Leader 1872*

As well as this landcape, Lewis[1] lists a *Near Capel Curig* of 1873, another *Near Capel Curig* of 1874, a *Fine Morning near Capel Curig* (1873) and a *Quiet Nook near Capel Curig* (1875).

PROV: (?) Mr. Wallis.[2] (?) George Philip. (?) Anon sale, Christie's 28 May 1904, lot 148 (*Near Capel Curig*, 19½ × 30 in.), bought Arthur Tooth (£136. 10*s*.). Bequeathed by James Monro Walker 1921.

EXH: (?) New British Institution, 39 Old Bond Street, 1872–3 (46).[3] (?) Walker Art Gallery, Liverpool, *Grand Loan Exhibition*, 1886 (1191) as *Near Capel Curig* (1872), lent by George Philip.

1 Frank Lewis, *Benjamin Williams Leader*, 1971, pp. 34 ff., nos. 85, 94, 95, 107, 119 and fig. 14.

2 The artist's Account Books, now with Frost and Reed, London, list under March 1872 *Morning near Capel Curig*, Mr. Wallis, £25; the price, however, indicates a picture smaller than WAG 803; Mr. Wallis was presumably Henry Wallis, proprietor of the French Gallery.

Near Capel Curig, North Wales WAG 803

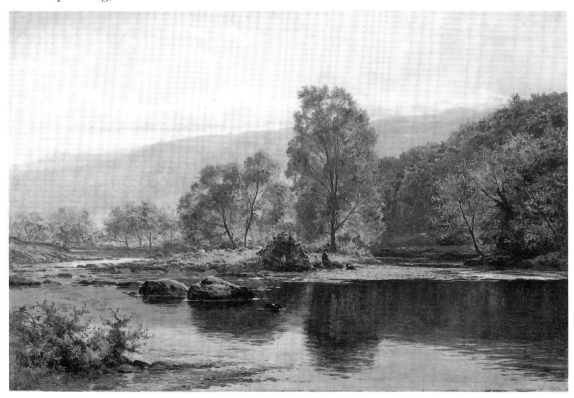

3 See the review of this exhibition in *Art Journal*, 1873, p. 7, in which no. 46 was described as 'light, atmospheric and altogether a landscape of refined taste'; WAG 803 was certainly not *Passing Clouds near Capel Curig, North Wales*, no. 139 at the 1872 Royal Academy – see *Art Journal*, 1872, p. 152, and Lewis, *op. cit.*, p. 34, no. 84.

Evening at Norton, Worcestershire

WAG 254
Canvas: 61.2 × 91.6 cm
Signed: *B.W. LEADER 1886*

This landscape is listed twice by Lewis[1] – under no. 245, *Evening at Norton, Worcester*, and no. 250, *Worcester Landscape*. Norton or Norton–juxta–Kempsey is very close to Whittington, where Leader lived for some years, often painting views in the area.[2]

The artist wrote in his diary on 7 January 1887:[3] 'I had a successful year last year; my pictures were very popular, much praised by the country press but scarcely criticized by the London critics, at least by many of them. They do not treat me justly but my works were never more popular.'

PROV: Bought by Agnew's from the artist 22 July 1886;[4] sold to George Holt 10 December (£300); bequeathed by Emma Holt 1944.

1 Frank Lewis, *Benjamin Williams Leader*, 1971, p. 41, fig. 48.

2 Brian Morris, letter to the compiler, 18 June 1985, confirmed that WAG 254 does represent the area around Norton-juxta-Kempsey; the hills in the left background are probably the Suckley Hills and the view has been taken looking west.

3 The diary is now with Frost and Reed, London.

4 The artist's Account Books, now with Frost and Reed, London, list under July 1886: *Near Norton, Worcestershire*, Messrs. Agnew and Son, £200.

Evening at Norton, Worcestershire WAG 254

Evening in a Surrey Pine Wood WAG 1533

Evening in a Surrey Pine Wood

WAG 1533
Canvas: 61.2 × 51.2 cm
Signed: *B.W. LEADER 1898*

Autumn in a Surrey Wood

WAG 1338
Canvas: 51.3 × 76.8 cm
Signed: *B.W. LEADER 1902*

A large number of Surrey woodland scenes date from 1890–1923, when the artist was living at Gomshall in Surrey.[1] *A Quiet Evening (Surrey Pines)* in the collection of Robert Fleming and Co., Ltd. (inv. 253) is very close to the 1898 landscape, which seems to be unfinished in places, particularly on the tree trunks.

PROV: Bequeathed by James Monro Walker 1921.[2]

1 Frank Lewis, *Benjamin Williams Leader*, 1971, pp. 47 and 51, nos. 424 and 541, fig. 50. WAG 1533 was not, however, as Lewis suggests, the *Evening in a Surrey Pine Wood* owned by Agnew's in 1904. The Agnew's picture measured 12 × 18 in.; see their Picture Stock Book, no. 1246 for 20 April 1904.

2 WAG 1533 was presumably the *Evening in a Surrey Pine Wood* listed in the artist's Account Books (now with Frost and Reed, London) under 11 May 1898, priced at £45 but with no purchaser marked in; alternatively it might have been the *Surrey Pines* sold to a Mr. Richardson for £38 on 9 May 1898. WAG 1338 was probably the *A Surrey Wood, Autumn* listed in the Account Books under June 1902 and apparently sold to a Mr. Richardson for £95.

Autumn in a Surrey Wood
WAG 1338

Shere Church WAG 1475

Shere Church

WAG 1475
Canvas: 61.2 × 50.8 cm
Signed: *B.W. LEADER*

Other paintings of this church by Leader are recorded;[1] Shere is very close to Gomshall, where the artist lived from 1889 until his death.

PROV: B.W. Leader sale, Christie's 25 May 1923, Lot 124, bought Sampson (£25. 4*s*.); presented by George Audley 1925.[2]

1 Manchester City Art Galleries (inv. 1934, 415) signed and dated 1892; Lewis Lusk, 'B.W. Leader', *Art Annual*, 1901, pp. 17 and 25; Leader sale, Christie's 25 May 1923, lots 58, 65, 67, 73 and 116. WAG 1475 is closely related to Leader's *The Village Church* of 1894 (reproduced in *Royal Academy Pictures*, 1894, p. 70). There are numerous pictures of Shere Church recorded in the artist's Account Books (now with Frost and Reed, London) from 1890 onwards. WAG 1475 is listed by Frank Lewis, *Benjamin Williams Leader*, 1971, p. 57, no. 732, but he does not suggest a date.

2 George Audley, *Collection of Pictures*, 1923, p. 32, no. 92, with inaccurate dimensions.

LEAR, Charles Hutton (1818–1903)
Beech Trees
WAG 1371
Canvas: 59 × 49 cm

Lear[1] is best known for his drawings of artists made in the Royal Academy Schools between 1845 and 1846, but he also exhibited subject pictures at the Royal Academy and elsewhere between 1842 and 1852 and – on the evidence of *Beech Trees* – painted landscapes rather later, when he had already given up 'his profession except as a pastime'.

PROV: Presented by John Elliot.[2]

EXH: Walker Art Gallery, *Liverpool Historical Exhibition*, 1908 (736).

1 R. Ormond, 'Victorian Student's Secret Portraits', *Country Life*, 9 February 1967, vol. 141, pp. 228–9 and National Portrait Gallery,

Beech Trees WAG 1371

Early Victorian Portraits, 1973, pp. 561–2. An unpublished article on Lear by John Hawke-Genn is in the Walker Art Gallery; he suggests a date 'late in the ninteenth century' for WAG 1371 (p. 11).

2 Elliot was a close friend and executor of the artist. He had a considerable collection of paintings by Liverpool artists, many of which he bequeathed to the Walker Art Gallery.

LEAR, Edward (1812–1888)

Bethlehem

WAG 1534
Canvas[1]: 70.5 × 115.2 cm
Signed: *EL* (in monogram) *1861*

Lear made the drawings for this painting during his stay at Bethlehem in early April 1858.[2] He wrote to Lady Waldegrave on 27 May 1858:[3] 'My stay at Bethlehem delighted me greatly . . . All the country near it is lovely, and you see Ruth in the fields all day below those dark olives.'

The diagonal composition, detailed foreground and small scattered figures recall Pre-Raphaelite principles, in particular the work of Holman Hunt, but in fact Lear chose a viewpoint for his *Bethlehem* similar to that selected by David Roberts for his *Bethlehem looking towards the Dead Sea* of 1853 – a painting which Lear probably saw at the 1853 Royal Academy.[4] Lear and Roberts were painting the town from the west with the Dead Sea and Moabite hills beyond.

Bethlehem is noted as no. 180, 1861, in the artist's 1877 list of pictures painted between 1840 and 1877.[5] It was done between November 1860 and early February 1861 while Lear was staying at the Oatlands Park Hotel, Walton on Thames,[6] and its progress can be charted from his diaries;[7] he worked on it on 19 November 1860 until 3.30 p.m.; he returned to the painting during the period 21–30 January 1861 and devoted most of his time to it. He was also working on *Interlaken* and on *Cedars of Lebanon*; although the completion of these paintings, the necessity to frame them and the payment for them caused him much concern, he recorded the completion of *Bethlehem* on 14 February 1861.

Bethlehem WAG 1534

There are a number of related sketches, drawings and versions by Lear:

1 A watercolour, 15.3 × 23.2 cm, sold at Christie's 14 June 1977, lot 32.

2 A watercolour dated *June 1871*, 9.9 × 20.3 cm, sold at Christie's 8 July 1986, lot 156; it had been given by the artist to his servant Giorgio Kokali.

3 An oil painting, 45.5 × 73.7 cm, dated *1859* and inscribed: *painted for Bernard Hussey Hunt Esqr 1858/9*; it was at the Leger Galleries in 1971.

4 An oil painting, 23 × 46 cm, dated 1873 and inscribed: *1873 – painted for Charles Allanson Knight*; it was last sold at Sotheby's 22 November 1983, lot 24.

5 An oil painting, very similar to (4) above, 22.8 × 45.8 cm, formerly owned by Mrs. Valpy and exhibited at the Fine Art Society, *Travellers beyond the Grand Tour*, 1980 (6) and again at the Fine Art Society, *Spring Exhibition*, 1992 (17).

6 Two watercolours in the Houghton Library, Harvard University, 19.5 × 30.5 cm and 19.6 × 30.5 cm, catalogue nos. 851 and 852; both are dated *3 April 1858* and inscribed *Bethlehem*, but neither is closely related in composition to the Walker Art Gallery painting.

7 A drawing in a New Zealand private collection, dated *April 2 and 3 1858* and representing Bethlehem.[8]

PROV: Painted for S. Price Edwards. Presented by the executors of Mrs. Hugh Perkins[9] 1914.

1 Canvas stamp: Prepared by Charles Roberson, 99 Long Acre, London.

2 There is a partly destroyed MS label on the stretcher of WAG 1534: 'Bethlehem [painted in] 1861 [by] Edward Lear / from drawings made there by him in 1858 / Painted for S. Price Edwards Esq / Edward Lear'.

3 *Letters of Edward Lear to Chichester Fortescue and Frances Countess Waldegrave*, ed. Lady Strachey, 1907, p. 108. Lear left Jerusalem for Bethlehem on 1 April 1858 (*Letters of Edward Lear, op. cit.*, p. 97).

4 See Barbican Art Gallery, *David Roberts*, 1986, no. 157, plate 76.

5 Lear gives the first purchaser as S. Price Edwards; this list was published in *Letters of Edward Lear, op. cit.*, pp. 311–8.

6 Edward Lear, *Selected Letters*, ed. Vivien Noakes, 1988, pp. 165–7.

7 Edward Lear's unpublished diaries are in the Houghton Library, Harvard University.

8 Nancy Finlay, letter to the compiler, 4 October 1991; neither she nor the compiler has seen this drawing.

9 She was the daughter of Sir Hardman Earle Bart.

LEECH, John (1817–1864)
A Capital Finish
WAG 2306
Canvas: 44.5 × 63.5 cm
Signed: *John Leech*
Inscribed: *A Capital Finish / Fox-hunter (a little behind) 'Seen the Hounds?' / Old man 'All right, Sir – Fox and hounds have just run into the Infant School!'*

Very Attentive
WAG 2360
Canvas: 47.2 × 65 cm
Signed: *John Leech*
Inscribed: *Very Attentive – / Hard riding Cornet (to old Party, who is rather bothered by a brook) 'Don't move Sir! Pray don't move! and I'll take you over with me'*

These are two of Leech's sixty-seven 'Sketches in Oil' which were first exhibited in the Egyptian Hall in 1862; work on them began in about 1860; they were enlargements from some of his earlier illustrations and were made partly mechanically, partly by hand; the outlines were printed on to the canvases lithographically and Leech then painted over these outlines to create the finished work of art.[1] *A*

Capital Finish is based on a cartoon which first appeared in *Punch* on 18 February 1860 (vol. 38, p. 74); *Very Attentive* on a cartoon which first appeared in *Punch* on 13 February 1858 (vol. 34, p. 64).[2] A few of the other 'Sketches in Oil' are known to survive, notably *A Brilliant Idea*, now in the Victorian & Albert Museum.

REPR: (WAG 2306 only) Thomas Agnew and sons, *Celebrated Hunting Subjects*, 1865–1866, no. 10 as a chromolithograph.[3]

PROV: (WAG 2360): John Pender sale, Christie's 27 January 1873, lot 685, bought Agnew (£52.10s.);[4] sold to W. Collie 20 February 1873. Anon sale, Christie's 18 July 1879, lot 50, bought Agnew (£12.1s.6d.); sold to H. Dewhurst 7 February 1880; Henry Dewhurst sale, Christie's 19 April 1890, lot 35, bought Agnew (£30.9s.);[5] sold to Clement Royds 22 September 1890; Walter Stone;[6] bequeathed by Miss Mary Stone 1944.

(WAG 2306): John Fleming sale, Christie's 22 March 1879, lot 86, bought Williamson (£50.8s.);[7] Agnew; sold to H. Dewhurst 7 February

A Capital Finish WAG 2306

Very Attentive WAG 2360

1880; Henry Dewhurst sale, Christie's 19 April 1890, lot 36, bought Agnew (£30.9*s.*);[8] sold to Clement Royds 22 September 1890; Walter Stone;[9] bequeathed by Miss Mary Stone 1944.

EXH: Egyptian Hall, London 1862 (56);[10] Agnew's Liverpool 1863.

1 W.P. Frith, *John Leech: His Life and Work*, 1891, vol. 2, pp. 247 ff.; T. Bodkin, *The Noble Science: John Leech in the Hunting Field*, 1948, pp. 12 ff.; Arts Council of Great Britain, *Great Victorian Pictures*, 1978, p. 50; S. Houfe, *John Leech and the Victorian Scene*, 1984, pp. 156–71. Leech's own description of the process, published in *Mr. John Leech's Gallery of Sketches in Oil: Egyptian Hall, 1862* and in Thomas Agnew and Sons, *The Originals of Mr. John Leech's Sketches in Oil now exhibiting at Thomas Agnew and Sons, Liverpool*, 1863, p. iii, is as follows:

For some years past, I have been frequently asked by collectors of works of Art what drawings I had by me, what subjects there were in my portfolio suitable to the walls of country houses, and like questions; my unavoidable answer has been, that I had nothing by me but my own rough memoranda and jottings, inasmuch as the greater part of my life was passed in drawing upon wood, and the engravers cut my work away as fast as I produced it.

But the invention of a new process patented by the Electro-Block Printing Company, Burleigh Street, Strand, for producing enlarged transcripts of drawings and engravings, suggested to me that, by combining that process with the use of oil colours, I might produce on canvas repetitions of my engraved and published drawings, capable of preservation for as long a time as any pictures, and susceptible of such modifications and painstaking as I might deem to be improvements. These Sketches in Oil are the result. As I have used the word 'repetitions', I desire to add here, that it is not my intention to copy or reproduce any subject that I once sketch in oil. Whosoever may do me the honour to place one of these little works in a collection, will possess what is so far a speciality that it will never exist in duplicate.

These Sketches have no claim to be regarded, or tested, as finished pictures. It is impossible for any one to know the fact better than I do. They have no pretensions to a higher name than the name I give them – SKETCHES IN OIL. But they perpetuate (I trust with some new appearance of freshness and cheerfulness) subjects which have been received by many thousands of persons with great favour; and so I am tempted to hope that in this brighter and more

durable form than the Steam-Press could impart to them, they may not be unwelcome.

2 The *Punch* cartoons were reprinted in John Leech, *Pictures of Life and Character*, 1887, vol. 2, p. 156 and vol. 3, p. 219; they were also reprinted in *The Originals from Punch of Mr. John Leech's Sketches in Oil Exhibited at the Egyptian Hall*, 1862, pp. 25 and 16, and in Agnew, *op. cit.*, pp. 61 and 25; there are slight differences between the original cartoons and the final paintings (WAG 2306 and 2360); the inscription in WAG 2306 has been changed from the original caption in the *Punch* cartoon.

3 The chromolithograph is reproduced in Bodkin, *op. cit.*, p. 27, together with the original *Punch* drawing; the chromolithograph is identical to WAG 2306; see also Dudley Snelgrove, *British Sporting and Animal Prints, Paul Mellon Collection*, 1981, pp. 114–5. According to Arts Council, 1978, *op. cit.*, the chromolithographs were from the same edition as the lithographs overpainted by Leech to make the 'Sketches in Oil'.

4 The dimensions in the sale catalogue do not quite correspond with those of WAG 2360 but there is an Agnew label on the back of WAG 2360.

5 See note 4.

6 *The Walter Stone Collection*, 1938, p. 22, no. 27a.

7 The dimensions in the sale catalogue do not quite correspond with those of WAG 2306, but there is an Agnew label on the back of WAG 2306.

8 See note 7.

9 *The Walter Stone Collection*, 1938, p. 22, no. 27b.

10 *The Originals from Punch, op. cit.*, pp. 25 and 61, stated that WAG 2306 was on view; WAG 2360 was not then hanging but was expected very soon.

LEIGHTON, Frederic (1830–1896)
An Italian Cross-bow Man
WAG 2881
Canvas[1]; 105.4 × 64 cm

The subject was explained in the *Athenaeum*[2] just before the painting was first exhibited:

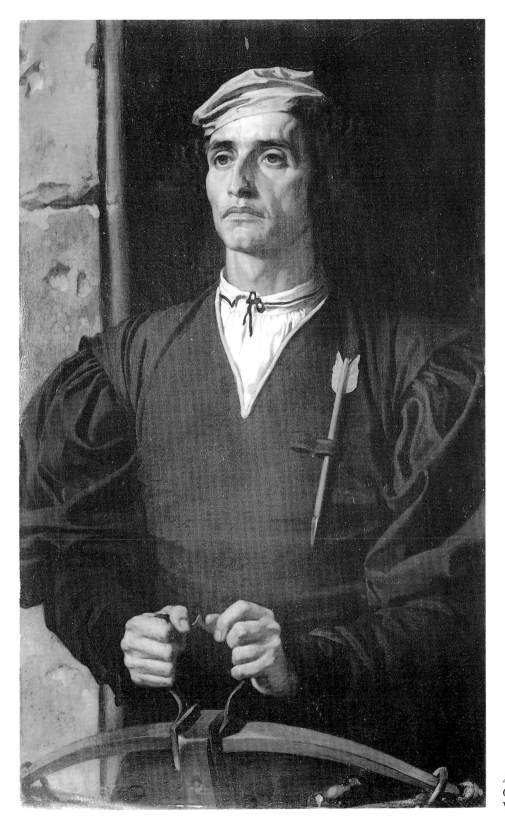

*An Italian
Cross-bow Man*
WAG 2881

263

Mr. Leighton will probably contribute to the Royal Academy the following pictures . . . 2. A Cross-bow Man, standing with his hands upon the arc of his weapon; his costume is that of Italy in the fourteenth century; he may be imagined one of the defenders of the city who has the death of one he loved to revenge; this is suggested by a perished human hand nailed to the wall behind him, and his stern countenance.

The same periodical[3] advanced an alternative explanation of the meaning of the picture a month later:

An Italian Cross-bow Man is the title of a half-length, life-size figure of a soldier, with a cross-bow upon which his hands rest; he wears a black dress and cap of the same; behind him hangs upon the wall a perished hand of some destroyed enemy or some dead friend he has sworn to avenge. The face is stern, and may be read either way. The whole of this work is remarkable for solid painting.

The perished human hand is no longer visible; it can, however, be seen on X-rays just to the left of the crossbowman's head, and was presumably painted out because it was considered too gruesome and grisly.

This was one of the last of Leighton's Italian Renaissance subjects;[4] more graceful but less expressive classical themes preoccupied him later in his career. Its dramatic character was emphasized by the 1863 reviews. The *Saturday Review*[5] commented:

Here the gloomy colour corresponds with the sentiment of the scene, although the force of purpose is so strongly marked on the archer's face that the artist might have given glow and richness of tone to the whole work without compromising its dramatic effect.

PROV: The artist's sale, Christie's 11 July 1896, lot 104, bought White (£44.2s.); F.A. White.[6] Presented by George Audley[7] 1928.

EXH: Royal Academy 1863 (528); Worcester Society of Arts 1863 (151), priced at £210.

1 Canvas stamp (barely legible): *W. EATWELL/ 49 DORSET STREET* (William Eatwell, artist's colourman, is listed in the 1869 Kelly's Directory at 49 Dorset Street). At the artist's sale of 1896, WAG 2881 measured 130 cm high (see Provenance), but in George Audley, *Collection of Pictures*, 1923, p. 33, it is listed as 104 cm high.

There is no technical evidence that the canvas of WAG 2881 was cut at the top or bottom after completion, but it does seem that the stretcher was extended at the top and at the bottom (Jim France, conversation with the compiler, 28 February 1986).

2 *Athenaeum*, 28 March 1863, p. 432.

3 *Athenaeum*, 9 May 1863, p. 622. W.M. Rossetti in *Fraser's Magazine*, 1863, vol. 67, p. 790, described WAG 2881 as the best of Leighton's pictures at the 1863 Royal Academy: 'a man of iron mould, bronzed like a bronze statue, in a jerkin of intensest black'. The *Spectactor*, 16 May 1863, p. 2007, noted that 'the somewhat theatrical crossbowman is chiefly remarkable for its black shadows'.

4 *A Condottiere* of 1872, now in the Birmingham City Art Gallery, is a rare example of a later subject of this type. L. and R. Ormond, *Lord Leighton*, 1975, p. 59, link WAG 2881 with the artist's contemporary illustrations to George Eliot's *Romola*, a novel set in 15th-century Florence.

5 *Saturday Review*, 16 May 1863, p. 628. The *Illustrated London News*, 9 May 1863, p. 518, contained a very similar review.

6 Edgcumbe Staley, *Lord Leighton*, 1906, p. 234.

7 Audley, *op. cit.*

A Sunny Corner

WAG 257
Canvas[1]: 20.4 × 14.6 cm

The Ormonds date *A Sunny Corner* to about 1872.[2]

PROV: Bought by George Holt from W.G. Herbert 4 September 1872 (£52.10s.); bequeathed by Emma Holt 1944.

1 *W. MORRILL Liner* is stamped on the stretcher and there is a frame maker's label of W.A. Smith, 14 Charles Street, late J. Green; Smith is recorded at Charles Street 1872–80.

2 L. and R. Ormond, *Lord Leighton*, 1975, p. 161, no. 206.

Weaving the Wreath

WAG 256
Canvas[1]: 63.7 × 59.9 cm

Weaving the Wreath was well received by the critics when first exhibited at Liverpool in 1872 and then at the Royal Academy in 1873. The *Saturday Review*[2] provided perhaps the most interesting review:

We have spoken of the growing naturalism of the English school; we have also shown how the study of nature has of late been brought under the spell of imagination and the power of emotion, so that many popular pictures of the day are to be read, not as the prose of nature, but as the poetry of nature. A small figure, 'Weaving the Wreath' by Mr. Leighton, R.A., may be quoted as a case in point.

The relief in the background, apparently representing satyrs and maenads, does not seem to be based on any classical prototype; its relationship to the figure is unclear, perhaps deliberately so.

There is a study for *Weaving the Wreath* in the Royal Academy (tracings 16) and another is reproduced by C. Tardieu.[3] A study in Leighton House (Royal Borough of Kensington and Chelsea), LH 821, might have been used for this painting.

PROV: Bought by George Holt October 1872 (£525);[4] bequeathed by Emma Holt 1944.

EXH: Liverpool Autumn Exhibition 1872 (256);[5] Royal Academy 1873 (261); Glasgow International Exhibition 1888 (25); Guildhall Art Gallery, *Loan*

A Sunny Corner WAG 257

Exhibition, 1894 (31); Royal Academy, *Winter Exhibition*, 1897 (6).

1 Frame maker's label of Foord and Dickenson, 90 Wardour Street.

2 *Saturday Review*, 7 June 1873, p. 748; see also *Art Journal*, 1872, p. 276 and 1873, p. 170; *Athenaeum*, 3 May 1873, p. 570.

3 'La peinture à l'Exposition Universelle de 1878', *L'Art*, 1879, vol. 16, p. 44.

4 Surely an enormous sum for a relatively insubstantial work, but see WAG 258 (p. **267**). The price was recorded in the *Art Journal*, 1873, p. 87.

5 It was very unusual for artists to exhibit at the Liverpool Autumn Exhibitions before the Royal Academy; Leighton may have been trying to lend prestige to the Liverpool Autumn Exhibitions, which had begun in 1871 – for this see L. and R. Ormond, *Lord Leighton*, 1975, pp. 108, 119; Leighton's *Antique Juggling Girl* of 1873 was also exhibited in Liverpool before it was shown in London.

Study: At a Reading Desk
WAG 258
Canvas[1]: 63.1 × 72.7 cm

The model for the small girl is stated to have been Connie Gilchrist.[2] The desk may have been one which appears in photographs of the Arab Hall in the artist's house.[3] Favourable reviews of this painting appeared in the

Athenaeum[4] and the *Saturday Review*;[5] the *Athenaeum* wrote:

A girl reading is the subject of Study, *a little child of Oriental character, richly clad in Eastern costume of delicate tissues and hues, seated and diligently reading music. It is placed on a sort of stool-desk of dark rich wood, inlaid with mother-o' pearl, which is before her as she rests on a cushion on a splendid pavement. The graceful simplicity of this picture has a great charm, the treatment is truly refined, the face is lovely, the colouring throughout delicate and beautiful, especially in the leading elements – the pale rose and golden hue costume of the figure.*

There are studies in the Royal Academy (notebook IX) and in the Walker Art Gallery (WAG 6303).[6] The artist described the painting as 'recently taken in hand' and 'commenced' in November and December 1876.[7]

REPR: T.L. Atkinson (mezzotint) 1878 for Pilgeram and Lefèvre.

PROV: Bought from the artist by Miss Mary Augusta Smith January 1877[8] (£525);[9] bought from her by George Holt 1892 (£500); bequeathed by Emma Holt 1944.

EXH: Royal Academy 1877 (268) as *Study*; Royal Academy, *Winter Exhibition*, 1897 (8); Blackburn 1907 (38); Wolverhampton 1911; Liverpool Autumn Exhibition 1922 (439).

Study: At a Reading Desk WAG 258 (colour plate 9)

1 The frame appears to have been made by Agnew's in 1895 to match WAG 256 (above).

2 Mrs. Russell Barrington, *Frederic Leighton*, 1906, vol. 2, p. 197; E. Rhys, *Frederic Lord Leighton*, 1900, p. 37; Connie Gilchrist enjoyed seeing WAG 258 and other paintings of herself by Leighton at the 1877 Royal Academy; see L. and R. Ormond, *Lord Leighton*, 1975, p. 133.

3 See Rhys, *op. cit.*, p. 96. It is based on the usual type of Koran Stand of which there are examples from the 16th to the 19th centuries in the Museum of Turkish and Islamic Art at Istanbul. L. and R. Ormond, *op. cit.*, p. 98, argue that WAG 258 was one of a group of paintings inspired by the artist's journey to Damascus in 1873.

4 *Athenaeum*, 5 May 1877, p. 581. W.M. Rossetti in the *Academy*, 19 May 1877, p. 444, saw WAG 258, rather prosaically, as a scene from colonial life; 'perhaps a British girl in her Indian home'.

5 *Saturday Review*, 2 June 1877, p. 671.

6 Reproduced in C. Tardieu, 'La peinture à l'Exposition Universelle de 1878', *L'Art*, 1879, vol. 16, p. 45.

7 MS letters from the artist to Miss Mary Augusta Smith of 23 November (1876?) and 18 December 1876; the former letter is in the Walker Art Gallery; the latter is stated by R. Ormond (letter to the compiler, 24 October 1972) to be in the Royal Borough of Kensington and Chelsea Libraries and Arts Service, but it does not seem to be listed in B. Curle, *Lord Leighton: A Catalogue of Letters*, Royal Borough of Kensington and Chelsea Libraries and Arts Service, 1983. Leighton ordered a 'reversed canvas on best stretcher' from Roberson on 8 July 1876; it measured $28\frac{1}{2} \times 25$ ins (Roberson Archive, by permission of the Syndics of the Fitzwilliam Museum, Cambridge, kindly communicated by Sally Woodcock.)

8 MS letter from the artist to Miss Smith, 6 January 1877 (Walker Art Gallery).

9 MS letter from Miss Smith to George Holt, 17 December 1892 (Walker Art Gallery).

Elijah in the Wilderness

WAG 147
Canvas[1]: 234.3 × 210.4 cm

Elijah – fleeing from Jezebel, who had vowed to kill him – fell asleep under a juniper tree in the wilderness, having first asked for death; the angel, however, then brings him bread and water.[2] The painting dates from 1877–8 and Leighton apparently said that 'he put more of himself' into it than into any other picture that he had painted up to that time.[3]

A large number of drawings survive. The National Gallery of Victoria, Melbourne, has a drawing (acc. 38/2)[4] of the entire composition very similar to the final painting, but some other (and presumably earlier) drawings show both figures in poses very different from those ultimately adopted; located drawings include: (1) three in the Walker Art Gallery, Liverpool (WAG 6267, WAG 6647 and WAG 6266); (2) eight in Leighton House, Royal Borough of Kensington and Chelsea (LH 517, 585–591);[5] (3) one in the Royal Academy (tracings 21). Two drawings were formerly owned by Agnew's, and another drawing very similar to LH 588 is reproduced by C. Tardieu.[6] Further studies were exhibited at the Royal Society of British Artists, 1890 (340) and at the Grosvenor Gallery, *Winter Exhibition*, 1880 (406). According to Spielmann,[7] Leighton also made a model (or models) for WAG 147 to study the fall of light on the figures. An oil sketch for WAG 147 is in the collection of Brinsley Ford; like the Melbourne drawing it is very close to the final composition.

The most interesting review of *Elijah* appeared in the *Magazine of Art*:[8]

This magnum-opus of Sir Frederic Leighton's genius is painted in one of his lightest and brightest moods as a colourist; the soft tints are relieved from insipidity by their perfect harmony; and the most striking characteristic of the scheme of colour is its curious originality – misty gold and rose predominate. The prophet sleeps in an attitude rather more suggestive of the schools than of the abandonment of nature; this is nevertheless, an heroic figure. The angel, who has a slightly feminine character (proved by the persistent way in which careless spectators speak of this figure with a feminine pronoun) has just alighted, the magnificently coloured plumed wings are still open, the drapery floats upwards from the descending feet with a pleasant mixture of naturalism and there is the

Elijah in the Wilderness WAG 147 (colour plate 10)

familiar Old Master treatment of angel's robes. A strong contrast is probably intended between the heavy repose of the man and the buoyant movement of his heavenly visitant. The fine sky is also half realistic, half decorative; it has an epic splendour and meaning, and is strangely suggestive of a misty heat and drought. Sir Frederic Leighton seems, in deference to the now prevailing opinions as to the aims of art, to have banished emotion and passion from his pictures; he paints year by year beauty in negative repose, and even here, where his pencil has aimed at a nobler and more significant theme, expression has been studiously avoided, the man is asleep and the angel is serene.

The *Athenaeum*[9] contradicted the opinion expressed by some French critics that this and the other works by Leighton at the 1878 Paris *Exposition Universelle* reflected the influence of

Cabanel, but conceded that these works were 'cosmopolitan': 'They compel our admiration, but they do not sway our hearts, as they would do if the artist deigned to look down on this poor, workaday England of ours.'

The *Art Journal*[10] admired everything except the drapery:

There are many passages, also, of great beauty in Sir Frederic's large canvas representing a radiant angel ministering to 'Elijah in the Wilderness'. The muscular sympathy arising from utter exhaustion, as the prophet lies with his head pillowed on the hard rock, is as perfect in its rendering as the cumuli are beautiful, rolling in their silver whiteness beyond the level reaches of the stratus-banked clouds. To get like brilliancy and truth we must go to Peter Graham's 'Cloudland and Moor', also in the next gallery. Yet the drapery at the feet of the angel is allowed to fall into what we think impossible convolutions – a fault which will become by-and-by a habit of his pencil, if Sir Frederic is not careful. The design altogether is a very impressive one, and in its presence one feels almost ashamed of even appearing hypercritical.

Henry James,[11] however, was less impressed:

This picture was one of the ornaments of the English department at the Paris Exhibition of last year; but in spite of this fact, of its ambitious intention, and of an execution as brilliant in many ways as Sir Frederic Leighton has accustomed us to look for, it cannot be called a success or commended as an example of the author's best skill.

Some French critics were no more enthusiastic than James; Charles Tardieu[12] wrote:

M. Leighton – aujourd'hui Sir Frederic Leighton, P.R.A. – pousse à la même roue. Les Prophètes de Michel-Ange excitent son émulation. Il peint Élie au désert, travail considérable, qui atteste de nobles efforts, et témoigne des plus hautes préoccupations de style. Le nu est consciencieusement étudié dans la figure d'Élie, et les croquis de l'artiste que nous publions montrent avec quelle persévérance il a poursuivi la forme et le modelé. A-t-il rendu clairement intelligible la situation dont il s'est inspiré? Nous n'oserions pas l'affirmer . . . Ainsi parle le Livre des Rois. Mais nous ne savons pas au juste si l'Élie de Sir Frederic Leighton se lamente, se réveille ou se rendort. En dépit de la bigarrure de son plumage l'ange a la gravité qui convient à sa mission céleste, mais le type n'est-il un peu fortement empreint du cachet local pour un messager de Dieu? Cet ange est trop foncière-

ment anglais pour un tableau biblique. C'est là un des écueils du classicisme britannique. Le génie de la race emporte tout, et brise, malgré la volonté de l'artiste, le moule des types conventionnels. Mais le malheur veut que ces types s'imposent, et que faute de les subir l'oeuvre la plus originale n'a plus que les apparences d'une traduction en langue étrangère.

REPR: H. Blackburn, *Exposition Universelle, Paris, 1878: Catalogue Illustré*, 1878, p. 51, no. 135; H. Blackburn, *Academy Notes*, 1879, p. 25; G.R. Halkett, *Notes to the Walker Art Gallery*, 1879, p. 22.

PROV: Presented by Andrew G. Kurtz[13] 1879.

EXH: Paris, *Exposition Universelle*, 1878 (135);[14] Royal Academy 1879 (188); Liverpool Autumn Exhibition 1879 (83); Royal Academy, *Winter Exhibition*, 1897 (135).

1 Canvas stamp of Charles Roberson, 99 Long Acre. WAG 147 was painted on a double canvas. Leighton described his working methods for WAG 147 in detail as part of a general survey of Academicians' methods conducted on the occasion of the 1879 Royal Academy exhibition; he used a primed semi-absorbent canvas with a white ground; he underpainted in brown and white monochrome then applied a semi-opaque coat of grey over the whole canvas; he then used the appropriate colours followed by a black glaze applied to all areas except the sky (comprising Lake, Vandyke brown, cobalt and Roberson's medium); the varnish was Roberson's medium. I am indebted to Helen Valentine for this information; Leighton's account is in the Royal Academy Library; for the background see the Royal Academy, *Annual Report*, 1875, p. 15.

2 I Kings, 19: 4–7. Leighton's *Jezebel and Ahab* (about the same size as WAG 147) is now in Scarborough Art Gallery. Leighton was anxious to secure for himself subjects from the lives of Elijah and Jezebel when contributing to Dalziel's *Bible Gallery* in 1863–4 (The Brothers Dalziel, *A Record of Work*, 1901, p. 238) and WAG 147 has some of the sculptural simplicity and monumental grandeur of his earlier Bible illustrations – although C. Newall, *The Art of Lord Leighton*, 1990, p. 92, notes an element of baroque drama characteristic of Leighton's religious paintings. T.S.R. Boase in 'Biblical Illustration in Nineteenth Century English Art', *Journal of the Warburg and Courtauld Institutes*, 1966, vol. 29, pp. 362–6 compares Leighton's *Elijah* with other

artists' treatment of this theme, in particular, Burne-Jones's painting in the Birmingham City Art Gallery, Frederick Walker's illustration in the Dalziel Bible Gallery of 1880 and Gustave Doré's engraving in the Doré Bible of 1866; he notes that WAG 147 has the 'boldness that characterizes Leighton's woodcuts'.

3 Leighton's account of his working method in WAG 147 (see note 1) dates it to 1877–8; the *Academy*, 18 August 1877, p. 178, reported that the artist was painting WAG 147; see Mrs. Russell Barrington, *Life, Letters and Work of Frederic Leighton*, 1906, vol. 2, p. 256. Leighton ordered a 'double canvas on best stretcher' 92 × 82½ ins on 10 May 1877 from Roberson (Roberson Archive, by permission of the Syndics of the Fitzwilliam Museum, Cambridge, kindly communicated by Sally Woodcock.)

4 Reproduced in E. Rhys, *Frederic, Lord Leighton*, 1900, p. 38.

5 WAG 6266 is reproduced in C. Tardieu, 'La peinture à l'Exposition Universelle de 1878', *L'Art*, 1879, vol. 16, p. 42, and WAG 6267 is reproduced in A.L. Baldry, 'Lord Leighton's Sketches', *Magazine of Art*, 1897, p. 71; LH 588 is reproduced in Barrington, *op. cit.*, p. 255, and in Tardieu, *op. cit.*, p. 4.

6 See Thomas Agnew and Sons Ltd., *From the Pre-Raphaelites to Picasso*, 1969 (172); the other Agnew drawing is recorded in a Witt Library photograph of about 1971 – it measured 9 × 11¾ in. See Tardieu, *op. cit.*, p. 5.

7 M.H. Spielmann, 'The Late Lord Leighton', *Magazine of Art*, 1896, p. 214. A.G. Kurtz saw a model of each figure when he visited the artist's studio on 17 May 1877 – see note 13.

8 *Magazine of Art*, 1879, pp. 125–6.

9 *Athenaeum*, 11 May 1878, p. 609.

10 *Art Journal*, 1879, p. 127.

11 Henry James, *The Painter's Eye* (ed. Sweeney), 1956, p. 178.

12 Tardieu, *op. cit.*, p. 8.

13 The *Athenaeum*, 16 March 1878, p. 357, and the *Academy*, *op. cit.* reported that WAG 147 was already 'destined for the Liverpool Gallery'; the official catalogue of the 1878 Paris *Exposition*

Universelle said 'destined to be presented to the Museum of Liverpool'; H. Blackburn in *Exposition Universelle, Paris, 1878: Catalogue Illustré*, 1878, p. 51, stated that WAG 147 was 'painted for the Walker Art Gallery'. Kurtz was a chemical manufacturer of Liverpool and St. Helens; for details of his industrial career, see T.C. Barker and J.R. Harris, *A Merseyside Town in the Industrial Revolution: St. Helens*, 1954, *passim*; he owned a considerable number of paintings by Leighton, including *Winding the Skein* (1878), *Nausicaa* (1878) and *Ariadne* (1868) ('The Private Collections of England: Mr. Kurtz's, Wavertree, Liverpool', *Athenaeum*, 12 September 1885, pp. 341–2). Kurtz had actually wanted from Leighton a 'subject dealing with female beauty' (D.S. Macleod, 'Mid-Victorian Patronage of the Arts', *Burlington Magazine*, 1986, vol. 128, p. 602), but he left the subject and treatment entirely to the artist and therefore had only himself to blame if he did not like the final result. The history of this commission can be traced in some detail from Kurtz's MS Diaries (Liverpool City Libraries). On 19 April 1877 Kurtz received a letter from Leighton stating that Leighton was ready to begin the painting which Kurtz had commissioned from him for the Walker Art Gallery; the letter stated that the subject was to be the Angel feeding Elijah, the figures to be life-size and the picture to measure 7 feet by 8 feet. On the same day Kurtz wrote back saying that he would leave everything relating to the picture entirely to Leighton 'as his fame was so nearly concerned in it'. On 17 May Kurtz went to see Leighton at the artist's studio and saw the studies and sketches for WAG 147, together with models about 14 in. high, both of the prophet and of the angel; at this same meeting Kurtz also agreed to buy Leighton's *Winding the Skein* (now in the Art Gallery of New South Wales, Sydney) for 1500 guineas and his *Nausicaa* (now owned by Sebastian de Ferranti) for 700 guineas, having seen both these pictures in the artist's studio; WAG 147 was priced at 1,000 guineas; all these prices excluded the frames. The relatively low price of WAG 147 is perhaps to be explained by the fact that it was effectively a public commission and the artist was able to choose the subject. On 21 December 1877 Kurtz had a further letter from the artist enquiring if Kurtz wished to order his own frames for the three pictures – if not Leighton would be pleased to design them for him; Kurtz wrote back leaving the frames entirely to Leighton. Finally on 16 October 1879 Kurtz went to see WAG 147,

now on view in the Walker Art Gallery; he noted that it 'gained with familiarity but it was not a picture I should have bought myself either for public or private purposes'. See also Edward Morris and Christopher Fifield, 'A.G. Kurtz: A Patron of Classical Art and Music in Victorian Liverpool', *Journal of the History of Collections*, 1995, Vol. 7, pp 103–114.

14 According to the *Magazine of Art*, 1878, p. 43, WAG 147 was originally to be exhibited at the 1878 Royal Academy but was at the last moment diverted to the 1878 Paris *Exposition Universelle* where the artist was a juror; see also *Athenaeum*, 16 March 1878, p. 357, for the proposed exhibition of WAG 147 at the 1878 Royal Academy. Lady Dilke in the *Academy*, 6 July 1878, p. 21, noted that WAG 147 looked very unlike the other British paintings at the 1878 Paris *Exposition Universelle*.

Elegy
WAG 897
Canvas[1]: 61.5 × 51.3 cm

The *Athenaeum*[2] described *Elegy* as one of a number of new pictures[3] planned by Leighton in July 1888: ' "Elegy" is the suggestive title of a bust of a lady of great beauty, in a wide hat and modern dress, the mournful pathos of whose expression and the pose of her head explain the pathos of the picture'. The same periodical[4] reviewed the painting favourably at the 1889 Royal Academy:

A bust of a beautiful damsel wearing a wreath, and with a sad expression on her drawn-looking face, excels most of the President's numerous pictures of this class. Its carnations are less smooth than he generally makes them, while the expression is as tender as the

Elegy WAG 897

272

face is refined and natural. Its title, Elegy, *is perfectly suitable.*

The *Saturday Review*[5] compared *Elegy* with similar works by Poynter, Perugini and Alma-Tadema:

Another of Mr. Poynter's pictures, 'On the Terrace' hangs beside the 'Elegy' of Sir F. Leighton and the 'Corona' of Mr. Perugini, both to some extent examples of the same smooth, elaborate, neo-Greek style of art. The President's is the broadest, the most decorative, and the most imaginative of the little collection. The elegant way in which the wreath is intertwined with the hair calls for special attention. Moreover, the general idea and its arrangement suit the formal convention of the President's art better than any of his pictures this year. There is less poetry in Mr. Perugini's stiffer and more laborious work, and while we admire all these little pictures, we feel that Mr. Alma-Tadema's [At the Shrine of Venus] is the most powerfully realized, and Sir F. Leighton's the most gracefully conceived.

PROV: Lord Cheylesmore sale, Christie's 7 May 1892, lot 62, bought Koekkoek (£346.10s.). Lord Mount-Stephen sale, Christie's 19 May 1922, lot 48, bought Sampson (£29.8s.); presented by George Audley 1924.

EXH: Royal Academy 1889 (187); Liverpool Autumn Exhibition 1923 (1000).

1 There is a Charles Roberson, 99 Long Acre, London, label on the back of WAG 897.

2 *Athenaeum*, 21 July 1888, p. 105. Leighton's expressive studies of semi-ideal female heads – starting with the very successful *Pavonia, Sunny Hours* and *La Nanna* of 1859 – were a well-established genre by 1889; L. and R. Ormond, *Lord Leighton*, 1975, p. 128, describe the type at some length; they also (p. 124) classify WAG 897 as one of a series of 'sibyl-like' pictures; the compiler finds this less convincing.

3 Copyright in WAG 897 was registered by the artist on 11 February 1889.

4 *Athenaeum*, 4 May 1889, p. 573.

5 *Saturday Review*, 18 May 1889, p. 605. Poynter's *On the Terrace* is also in the Walker Art Gallery, see p. **369**.

Perseus and Andromeda
WAG 129
Canvas[1]: 235 × 129.2 cm

Cassiope, Queen of Ethiopia, boasted that she was more beautiful than Juno and the Nereids; in revenge the Nereids persuaded Neptune to flood Ethiopia and to send a sea monster to ravage the coasts; Andromeda, the daughter of Cassiope, was tied naked to the rocks as a propitiatory victim for the monster; she was rescued by Perseus, who eventually married her.[2]

The artist made studies, perhaps in the 1870s, for the rocks at Malin Head, Donegal, and a notebook of the early 1870s (Royal Academy Notebooks III) may contain an early idea for the pose of Andromeda.[3] An oil sketch for the whole composition is at the Russell-Cotes Art Gallery and Museum, Bournemouth.[4] At the Royal Academy there are plaster and bronze models for the two principal groups (Andromeda with the monster and Perseus on Pegasus)[5] and a plaster model for the figure of Andromeda alone. There are drawings for *Perseus and Andromeda*: (1) in the British Museum (1897–5–12–20); (2) in the National Gallery of Canada, Ottawa (inv. 4462); (3) in the Royal Academy (tracings 39–40); (4) in Leighton House, Royal Borough of Kensington and Chelsea (LH 693);[6] LH 773 and 669 in the same collection may also relate to *Perseus and Andromeda*. (5) in the Walker Art Gallery (inv. 8588);[7] (6) with J.S. Maas in 1993; (7) reproduced in Pall Mall Gazette, *Pictures of 1891*, 1891, pp. 3–4; (8) exhibited at the Royal Academy, *Winter Exhibition*, 1897 (250); (9) exhibited at the Royal Society of British Artists 1892 (16).

Generally speaking, the contorted pose of Andromeda enclosed within the repeated twisted coils of the monster reflects the sophisticated linear rhythms of the artist's late style, and critics in 1891 generally praised the striking originality and intricate formal design of the painting, elements of particular importance in such a familiar subject. The *Athenaeum*[8] contented itself with a long description of the painting, noting its superiority to the artist's *Return of Persephone* 'in virility of conception, fulness of tone and wealth of colour'. M.H. Spielmann[9] wrote:

His 'Perseus and Andromeda' is actually an original rendering of one of the most hackneyed subjects in the

Perseus and Andromeda
WAG 129

range of pictorial art; the equestrian figure of the flying Perseus, fair Andromeda in the very toils of the monster, the insistence on the horror of the scene, so to say, is its most beautiful aspect – this is all original in its treatment, so far as my knowledge goes. And yet it is hardly this rare and valuable quality which constitutes the true merit of this work; it is the oft repeated beauty of composition which gives it distinction among all the productions of the year.

On very similar lines, Claude Phillips[10] observed:

In his 'Perseus and Andromeda' Sir Frederic Leighton has evidently been haunted by the idea that his new version of a dangerously familiar subject must not in any particular resemble any 'Perseus and Andromeda' which had preceded it; for he has not a little twisted and distorted the elements of his picture in his effort to attain originality.

The Saturday Review,[11] however, was more critical:

Honour is always due to the learned and accomplished President. He knows what there is to know, and he may be trusted to have given mature thought to any large composition. We are therefore bound to believe in his treatment of the story of 'Perseus and Andromeda'; there is a propriety which is not easily perceived. Andromeda is chained erect upon an islet, or rock, in a strait between red sandstone cliffs. The dragon so shrouds her with its body and one outstretched wing as positively to form a canopy over her, a sort of fantastic metallic shrine. The monster has risen out of the sea at her left hand, and was apparently preparing to coil round her laterally – in a mode impossible to a reptile – when Perseus shot it with a golden arrow that quivers in its mail. Perseus, who might be confounded with Bellerophon, is seen in the sky, on a white horse with great yellow wings, a coil of sage-green drapery flying behind him. Andromeda, in her mane of bright red hair, bends forward, bowed with the positive weight of the dragon on her neck. The architectonics of the picture are ingenious and novel; the colour soft and glowing. But Sir Frederic Leighton has not succeeded in devising a dragon; this one is a Japanese contrivance of broiled paper, with fireworks inside, and Perseus, with his arrow, has let them off; they come up through the dragon's mouth in a monstrous pother of flame and by an unhappy twist of the creature we see that his body is absolutely empty and collapsible.

For modern critics, however, the monster was all too real. L. and R. Ormond[12] refer to

Leighton's sexual or even obscene allusions in the way the dragon encloses Andromeda, but Adrienne Munich[13] provides the details. For her 'the crazed monster with its gleaming red eye ravages the maiden in a symbolic representation of a fantasy of sexual activity that is violent, hideous and frightening combining scatological and scopophilic elements' – while Perseus remains aloof and uninvolved.

Leighton extensively repainted (but did not alter) the painting in 1894;[14] in its present state it does not seem to differ substantially from its appearance in 1891.[15] According to the Ormonds, Dorothy Dene was the model for Andromeda.[16]

REPR: Royal Academy Pictures, 1891 (frontispiece); H. Blackburn, Academy Notes, 1891, p. 42; Pall Mall Gazette, Pictures of 1891, p. 5; Berlin Photographic Company, photogravure, 1891.[17]

PROV: The artist's sale, Christie's 11 July 1896, lot 117, bought Tooth (£651). Bought by Sir William P. Hartley from Grindley and Palmer (Liverpool) 21 August 1909 (£1,000); presented by him 1909.

EXH: Royal Academy 1891 (147); Liverpool Autumn Exhibition 1891 (799); Munich, Internationale Kunstausstellung, 1892; Chicago, World's Columbian Exhibition, 1893; Oldham, Loan Exhibition of Pictures, 1894 (135); Venice, Esposizione Internationale d'Arte, 1895 (183); Liège, Salon des Beaux Arts, 1896; Brussels, Exposition Internationale et Triennale, 1897; Royal Academy, Winter Exhibition, 1897 (32); St. Louis, Louisiana Purchase International Exhibition, 1904 (77) lent by Arthur Tooth and Sons.

1 Label: Charles Roberson, 99 Long Acre, artist's colourman.

2 There are many versions of the myth. The principal source is Ovid's Metamorphoses, IV, 670 ff. Some versions ascribe the boasting to Andromeda's mother, some to Andromeda, and Perseus is often said to have changed the monster into a rock merely by displaying the head of Medusa. Claude Phillips in the Art Journal, 1891, p. 186, and the critic of the Saturday Review, 2 May 1891, p. 532, both observed that the Perseus in WAG 129 has the winged horse and arrows more generally associated with Bellerophon, victor over the Chimaera. Leighton's Perseus and Pegasus with the Head of Medusa coming to the Rescue of Andromeda of 1895–6 is now in the Leicestershire Museums and Art Gallery. E.J.

Poynter's *Perseus and Andromeda* was exhibited at the 1872 Royal Academy. For the subject generally see Musée du Louvre, *Les Dossiers du Département des Peintures: L'Andromède de Pierre Mignard*, 1989.

3 Lot 87 at the artist's sale, Christie's 11 July 1896 was a study of rocks at Malin Head used in WAG 129 and first exhibited in 1882. L. and R. Ormond, *Lord Leighton*, 1975, p. 120, state that the artist first visited Donegal in 1874. R. Ormond, letter to the compiler, 29 June 1973, mentioned the Royal Academy Notebook. WAG 129 was not actually begun until June 1890; on 9 June Leighton ordered from Roberson 'a best stretcher 92 × 49 ins covered reversed SP canvas etc' and on 30 June he ordered 'an extra fine linen canvas prepared SP 96 × 54 ins on stretcher' (Roberson Archive, by permission of the Fitzwilliam Museum, Cambridge, kindly communicated by Sally Woodcock.)

4 Merton Russell-Cotes bought this study from the artist – see his *Home and Abroad*, 1921, vol. 2, p. 729.

5 Reproduced in E. Rhys, *Frederic Lord Leighton*, 1900, pp. 68 ff., and in Mrs. Russell Barrington, *Life, Letters and Work of Frederic Leighton*, 1906, p. 256. The model for Perseus on Pegasus seems to have been re-used for Leighton's *Perseus and Pegasus with the Head of Medusa coming to the Rescue of Andromeda* of 1895–6 (Leicestershire Museums and Art Gallery).

6 Reproduced in Barrington, *op. cit.*, vol. 2, p. 256.

7 Reproduced in Rhys, *op. cit.*, p. 58.

8 *Athenaeum*, 2 May 1891, p. 573.

9 *Magazine of Art*, 1891, p. 218. Similarly, Shaw writing in the *Observer* praised the 'beauty of form and grace of composition' of WAG 129 (S. Weintraub, *Bernard Shaw on the London Art Scene*, 1989, p. 345).

10 *Art Journal*, 1891, p. 186. In his review in the *Academy*, 9 May 1891, p. 447, Phillips discussed the iconography of WAG 129 at greater length likening the dragon to the 'cumbrous Fafner of the Nibelungen trilogy' and noting that Perseus had the winged horse and arrows of Bellerophon.

11 *Saturday Review*, 2 May 1891, p. 532. WAG 129 reminded George Moore of Mantegna (*Speaker*, 2 May 1891, p. 519).

12 L. and R. Ormond, *op. cit.*, p. 127; Minneapolis Institute of Arts, *Victorian High Renaissance*, 1978, p. 38.

13 A.A. Munich, *Andromeda's Chains*, 1989, pp. 171–6.

14 He wrote to Mrs. G.F. Watts on 25 August 1894: 'I have been largely repainting, tho' not altering my Perseus and Andromeda' (MS Royal Borough of Kensington and Chelsea Libraries and Arts Service), see B. Curle, *Lord Leighton: A Catalogue of Letters*, Royal Borough of Kensington and Chelsea Libraries and Arts Service, 1983, cat. no. 334, inv. 12796.

15 See, for example, the reproduction in *Royal Academy Pictures*, 1891 (frontispiece).

16 L. and R. Ormond, *op cit.*, p. 127.

17 Reproduced in *Magazine of Art*, 1896, opp. p. 200.

LE JEUNE, Henry (1819–1904)
Cherubim
WAG 1122
Canvas: 30.5 × 25.7 cm

The *Art Union*[1] commented: 'Exquisitely drawn and coloured, a very simple composition, but full of power.'

PROV: Bought from the artist by the Liverpool Academy of Arts December 1842; presented to Liverpool Town Council 1851;[2] transferred to the Walker Art Gallery 1948.

EXH: Liverpool Academy 1842 (129).

1 *Art Union*, 1842, p. 232.

2 Liverpool Academy, *Minutes of Proceedings*, 14 April 1851; for further details see p. **76** (under Cobbett).

Contemplation
WAG 259
Panel[1]: 30.4 × 25.2 cm

Another *Contemplation* by Le Jeune was lot 73 in the H. Wallis sale, Walker and Ackerley's

Cherubim WAG 1122

Contemplation WAG 259

Gallery (Liverpool) 15 October 1863. The Roberson panel stamp indicates a date before 1853.

PROV: Agnew's (Manchester); George Holt Senior (1790–1861); George Holt; bequeathed by Emma Holt 1944.

1 Panel stamp: *ROBERSON & CO / 51 Long Acre London.*

Rush Gatherers

WAG 260
Panel[1]: 43 × 53.3 cm

The critic of the *Art Journal*[2] at the 1852 British Institution exhibition wrote:

Rush Gatherers, H. LE JEUNE. A group of children have been collecting bullrushes; two are stooping to bind up their sheath, while another stands looking upwards and holding one of the bullrushes: we may say that this exquisite figure is the picture; if the others

were not there, the effect and deep sentiment of this figure would be enhanced ten-fold.

PROV: Alfred Brooks[3] sale, Christie's 17 May 1879, lot 106, bought Agnew (£168); sold to George Holt October 1879 (£241.10s.) with *Market Day* by G.B. O'Neill (WAG 282) and another picture in exchange; bequeathed by Emma Holt 1944.

EXH: British Institution 1852 (91);[4] Agnew's Exchange Art Gallery Liverpool 1879 (114).

1 Panel stamp: Ch. Roberson & Co, Long Acre.

2 *Art Journal*, 1852, p. 71. The *Literary Gazette*, 21 February 1852, p. 187, was more enthusiastic: 'The Rush Gatherers is only a group of three children but, so far as the subject goes, perfect, and of admirable colouring.'

3 Alfred Brooks already owned WAG 260 in 1858; see 'Henry Le Jeune', *Art Journal*, 1858, p. 267.

4 The measurements given in the catalogue were 25 × 29 in.

Rush Gatherers WAG 260

Innocence

WAG 1156
Canvas: 30.5 × 25 cm
Signed: *HLJ* (in monogram)

This might have been Le Jeune's *Infant Prayer* at the 1853 Royal Academy,[1] or his *Innocence* at the 1874 Royal Academy.[2]

PROV: Presented by George Audley 1925.

EXH: (?) Royal Academy 1853 (342) as *Infant Prayer*.

1 There is a review of this painting in the *Art Journal*, 1853, p. 147: 'A small study of a child repeating its prayers on rising from bed. In sentiment and colour this little study is extremely attractive. We cannot too highly praise the graceful innocence with which this artist invests his infantine figures.' A painting identified as Le Jeune's *Infant Prayer* of 1853 was sold at Christie's 7 May 1982, lot 118, 28 × 22.8 cm; it does not correspond with the composition of WAG 1156 and shows a young girl rather than an infant at prayer.

2 *Innocence* by Le Jeune was in the T.O. Potter sale, Christie's 25 March 1876, lot 50, bought France (£325.10*s*.); a painting as small in size and as modest in scope as WAG 1156 would not have reached this price.

Right: *Innocence* WAG 1156

The Convent Garden WAG 261

LESLIE, George Dunlop (1835–1921)
The Convent Garden
WAG 261
Canvas: 46.2 × 61.8 cm
Signed: *GDL*

This seems to be a relatively early work done when the artist was still under some Pre-Raphaelite influence.[1] The meaning of the painting – if there is one – is not clear. The fashionably dressed young woman in the foreground looks up at the nun representing chastity; however down on the ground in front of her but concealed from the nun, is a lute symbolizing, perhaps, love.

PROV: H.E. Green sale, Christie's 6 February 1886, lot 85, bought Agnew (£73.10s.); bought by George Holt 27 July 1886 (£150); bequeathed by Emma Holt 1944.

1 For Leslie and Pre-Raphaelitism, see Percy Bate, *The English Pre-Raphaelite Painters*, 1899, p. 90. It is just possible that WAG 261 might be Leslie's *Eloisa* exhibited at the 1857 Royal Academy (439). Heloise spent much of her life in a convent and the lute (?) in the foreground might symbolize her love for Abelard; neither the architecture nor the costume seems, however, to be 12th century. WAG 261 is not related to the *In the Convent Garden* by Leslie, lot 220 at Sotheby's sale of 13 June 1984.

Fortunes

WAG 393
Canvas: 42.1 × 93 cm
Signed: *GDL / 1870*

This painting was entitled *Trout Stream and Ladies Fishing* when it entered the Walker Art Gallery in 1932, but the reviews in the *Athenaeum* and *Art Journal* of the artist's *Fortunes*, exhibited at the 1870 Royal Academy, enable it to be identified with reasonable certainty as that painting or as a version of it. G.P. Boyce[1] stated that Leslie was working on a picture of 'girls watching roses floating down a stream' in February 1870.

The critic of the *Athenaeum*[2] wrote:

Groups of damsels are gathered in a garden, and on a rustic bridge over a watercourse. Four girls sit by the low wall of the pleasaunce at the side of the swift brooklet, a fifth and a child stand on the bridge: a basket of flowers is at the feet of the latter: from this they have cast full-blown blooms into the water, and in that mode of divination which is so ancient, and is still almost universal, essay to learn their nuptial fortunes; as the flowers sink, stay or swiftly swim, so is presumed to be their ladies' luck. The water has already prophesied ill of one questioner, for her rose has gone to a little cascade; another quickly floats along, its fate as yet undecided. Two damsels of the larger group sit on the wall: one wearing a white hat is gazing rather nervously at the roses in her lap; another, with a puppy on her knees, has yet not attained a desire for second-sight of matrimonial fortunes. A gold brunette, with amorous eyes, gazes over the shoulder of the last and peers in lazy luxury at the trial. Another, demure and earnest, sits on the grass with a damask rose in her lap, holding it steadily and anxiously. This is a charming picture – the faces are exquisite, richly varied in beauty and expressions; the attitudes are finely varied and always graceful; the colour is deliciously tender and warm. It is Mr. Leslie's best picture.

The review in the *Art Journal*[3] was very similar:

'Fortunes', by G.D. Leslie, is a composition most fortunate and fascinating. A bevy of charming young maidens amuse themselves by tossing flowers into a running stream, to try their fortunes in love. It is a summer day, the air is balmy, the light silvery, and the hearts of these pretty girls, though touched possibly by tender passion, are happy as the day is long. The scene is well suited to the painter's style; he casts a soft silvery haze, as of sentimental reverie, over the landscape; figures, and grass, and trees, are brought into tender tones, and reduced to a certain placidate of pictorial effect. Quietude is in the painter's pictures uniformly maintained; silence is seldom broken; even here, among these girls, there is no chattering. The sentiment is that of love in idleness; the subject is treated with dreamy dalliance; gracefully and agreeably, even the colours have a sentimental hue which shuns positive intensity, and abhors decisive contrast.

Fortunes WAG 393

A much larger version of Leslie's *Fortunes* (110.5 × 244 cm) was in the collection of William Waring, exhibited at the *Royal Jubilee Exhibition*, Manchester 1887, no. 291[4] and sold at Christie's 22 February 1902, lot 45, bought Wallis (£94.10s.); this was probably the version exhibited at the 1870 Royal Academy exhibition.

PROV: William Leech sale, Christie's 21 May 1887, lot 118, bought Cookson (£304.10s.) (as 16 × 36 in.); bequeathed by George Audley 1932.

1 *Diaries of George Price Boyce*, ed. Surtees, 1980, p. 51 (entry for 27 February 1870).

2 *Athenaeum*, 30 April 1870, p. 585.

3 *Art Journal*, 1870, p. 163.

4 These verses were quoted in the Manchester 1887 catalogue and in the William Leech sale catalogue against Leslie's *Fortunes*:

> For maiden tongues of love will talk,
> And all their fancies turn on love;
> And when we pulled the tender stalk,
> And the fair flowers about it wove,
>
> And flung it in the tiny torrent,
> 'This he, and this is I', we cried,
> 'As fare her flowers by wind and current,
> To each shall weal or woe betide'.

The Novel

WAG 394
Canvas: 39.3 × 39.3 cm (circular)
Inscribed: *G.D. Leslie*

George Audley catalogued this painting as Leslie's *Willow, Willow*[1] of 1867, but the review of this painting in the *Athenaeum*[2] indicates that this identification cannot be right. The present title is also scarcely appropriate, as the painting presumably represents a woman who has received a (love?) letter from a man, a miniature of whom she holds in her left hand. Nor, despite the inscription, can the attribution to Leslie be regarded as secure.

PROV: Presented by George Audley 1932.

1 George Audley, *Collection of Pictures*, 1923, p. 35.

2 *Athenaeum*, 11 May 1867, p. 629.

The Novel WAG 394

LINDNER, Moffat Peter (1854–1949)
Holland

WAG 2882
Canvas[1]: 115.5 × 148 cm
Signed: *Moffat Lindner*

Lindner's *Dutch Waters* (or *Breezy Holland*), exhibited at the 1898 International Society of Sculptors, Painters and Gravers exhibition, seems to show the same view as *Holland* and contains a similar range of boats.[2]

PROV: Bought from the artist 1902.

EXH: Royal Academy 1902 (290); Liverpool Autumn Exhibition 1902 (907).

1 Metal plaque on stretcher: *James Lanham, artist's colourman, St. Ives, Cornwall.*

2 *Dutch Waters* is reproduced in the exhibition catalogue as no. 319. There are other very similar compositions by Lindner but they in fact represent different places – see *The Times*, Obituary, 22 September 1949:

The Heights of the Abruzzi
WAG 265

Holland WAG 2882

Lindner had a limited range of nominal subjects being content for the most part to explore the possibilities of coastal waters in Holland and Venice . . . but he was so sensitive to differences in light and atmosphere that monotony was in the titles rather than in the treatment of his pictures. Broad sails against the sky, generally a ragged if not a stormy sky, were his favourite material . . .

282

LINNELL, William (1826–1906)

The Heights of the Abruzzi

WAG 265

Canvas: 92.4 × 164.5 cm

Signed: *William Linnell 1868*

The artist was in Italy between October 1861 and June 1862 and then again from January 1863 to September 1865;[1] he may well have returned there later in the 1860s.[2] However, he did not start exhibiting Italian scenes at the Royal Academy until 1868. The mountains of the Abruzzi, due east of Rome, were among the wildest and least accessible parts of Italy, but they were valued by artists for the picturesque costume and the primitive life-style of the inhabitants. Edward Lear was there in 1842 and 1843,[3] Lowes Dickinson toured the villages in 1851[4] and Ernest Hébert, with other French artists, visited the area in 1853–4.[5]

The *Art Journal*[6] critic admired this 'scene of considerable grandeur'. An oil sketch of the landscape without the figures belongs to the Ivimy Linnell family. Another version of it, differing only in a few foreground details, is in a Northumberland private collection. This version is signed and dated 1869.

PROV: Bought by George Holt from Agnew's October 1868 (£650); bequeathed by Emma Holt 1944.

EXH: Royal Academy 1868 (555); Agnew's Liverpool, Liverpool and London Chambers 1868;[7] Southport Centenary Exhibition 1892.

1 A.T. Story, *Life of John Linnell*, 1892, vol. 2, pp. 111 ff. and 142 ff., quoting letters from the artist's father giving him advice on his work in Italy. See also David Linnell, *Blake, Palmer, Linnell and Co.*, 1994, pp. 289, 296, which suggests that the second visit to Italy only lasted from 1864–5.

2 The Royal Academy catalogues give the artist an Italian address in this period.

3 Edward Lear, *Illustrated Excursions in Italy*, 1846.

4 Lowes Dickinson, *Letters from Italy 1850–1853*, n.d., pp. 120–55. His unhappy experiences with the local police indicate reasons for the unpopularity of the area with visitors at that time.

5 R.P. d'Uckerman, *Ernest Hébert*, 1982, pp. 73–84.

6 *Art Journal*, 1868, p. 109.

7 *Porcupine*, 29 August 1868, p. 203 (with a brief review).

LLEWELLYN, Samuel Henry William (1858–1941)

Queen Mary

WAG 7028

Canvas: 280 × 184 cm

Signed: *Wm. Llewellyn 1912*

This portrait is a replica of the state portrait commissioned on the accession of George V in 1911 and completed in 1912.[1]

Queen Mary WAG 7028

PROV: Commissioned by Liverpool City Council August 1911;[2] transferred from the Liverpool Corporation Estates Committee to the Walker Art Gallery 1968.

1 It was exhibited at the 1912 Royal Academy (150). The only difference between the two portraits is that the state portrait, now in the Royal Collections, has a crown on the table on Queen Mary's right. Llewellyn painted an entirely different portrait of Queen Mary in 1913 for the United Services Club (see *Royal Academy Pictures*, 1913, p. 5).

2 A portrait of George V by or after Luke Fildes was commissioned at the same time; it too is now in the Walker Art Gallery, see WAG 7027, p. **139**.

LOGSDAIL, William (1859–1944)
Eve of the Regatta
WAG 2884
Canvas[1]: 130.5 × 193 cm
Signed: *W. Logsdail 1882*

This is one of the first paintings done by the artist during his long Venetian residence (1880–1902) and represents 'a Venetian fisherman and a gondolier in earnest discussion over plans for the fête'.[2] The artist noted in his Memoirs:[3] 'In my Venetian picture, The Eve of the Regatta, I painted two life size figures of my gondoliers. It was done in a care free mood almost as a joke as they sat over their jug of wine. It was begun and finished in ten days.' Venetian regattas, large and small, took place throughout the year and were effectively gondola races combined with popular festivities.[4]

Most of the critics[5] at the 1883 Royal Academy exhibition concentrated on Logsdail's more ambitious *The Piazza* (now Birmingham City Art Gallery), but the *Athenaeum*[6] remarked: 'We recommend his "Eve of the Regatta" to the attention of those who recognize the merits of two boldly painted figures as displayed on high in Gallery IV.'

PROV: Presented by James Harrison 1883.[7]

Eve of the Regatta WAG 2884

EXH: Royal Academy 1883 (372); Liverpool Autumn Exhibition 1883 (274).

1 Label: *Smith, Mortimer Street, London, framemaker.*

2 See Usher Art Gallery, Lincoln, *William Logsdail*, 1952, pp. 6–7 and 19. Another gondolier picture by Logsdail, *A Venetian al Fresco*, of 1885, was sold at Christie's 5 March 1993, lot 91.

3 Unpublished MS now owned by the Lisson Gallery and kindly transcribed by Rosalyn Thomas.

4 A contemporary account in English is Horatio F. Brown, *Life on the Lagoons*, first published in 1884 with many subsequent editions. There is a chapter on regattas.

5 See particularly Lady Dilke in the *Academy*, 19 May 1883, pp. 353–4.

6 *Athenaeum*, 16 June 1883, p. 769.

7 In his unpublished Memoirs (see note 3) Logsdail stated that he sold WAG 2884 for £250.

LOMAX, John Arthur (1857–1923)

Over the Border
WAG 725
Panel: 29.7 × 45.7 cm
Signed: *JOHN A. LOMAX*

Sketches
WAG 947
Panel: 42 × 31.5 cm
Signed: *JOHN A. LOMAX*

Trophies
WAG 948
Panel: 40.6 × 30.4 cm
Signed: *JOHN A. LOMAX*

Dawn
WAG 1157
Panel: 40.6 × 30.4 cm
Signed: *JOHN A. LOMAX*

The Parson brewed the Punch
WAG 1334
Panel: 29.8 × 46.3 cm
Signed: *JOHN A. LOMAX*

Sketches WAG 947

Trophies WAG 948

Over the Border WAG 725

The Parson brewed the Punch
WAG 1334

Enough WAG 1477

Dawn WAG 1157

Enough
WAG 1477
Panel: 31.3 × 48.2 cm
Signed: *JOHN A. LOMAX*

These six paintings are characteristic examples of the imitations of the work of J.L.E. Meissonier which Lomax exhibited towards the end of the 19th century (and later).[1] Like Meissonier, he was particularly fond of duel scenes and scenes in which an artist displays his paintings (usually female nudes) to a group of friends; again, like Meissonier, he favoured 18th-century dress and settings.

Over the Border (or a version of it) was reproduced in 1903 by Bromhead,[2] who wrote a long description of the Gretna Green smithy where eloping couples took advantage of the liberal Scottish marriage laws after 1754, when clandestine marriage in England became illegal; Lomax has in fact anachronistically used early 18th-century costume for this painting.

PROV: T. Richardson, Fine Art Galleries, 43 Piccadilly, London;[3] bequeathed by James Munro Walker.

1 See H.W. Bromhead, 'The Romantic Pictures of Mr. John A. Lomax', *Art Journal*, 1903, pp. 27–30.

2 Bromhead, *op. cit.*, pp. 29–30.

3 Richardson's labels are still on the backs of WAG 1157, 1334 and 1477. This group of six panels comes in only two standard sizes; they were probably acquired as a group from T. Richardson and may have been painted as a group.

LUCAS, Henry Frederick Lucas
(born *c.* 1858, died 1943)[1]
Bendigo, The Bard, Galore, Minting
WAG 2329, 2330, 2331, 2332
Panel, each: 23 × 30.5 cm
Signed: *H.F. LUCAS LUCAS* and with name of horse[2]

Bendigo,[3] born in 1880 by Ben Battle out of Hasty Girl, was owned by Major H.T. Barclay; he was a very successful racehorse, winning over £20,000 in stakes. He won the first race for the Eclipse Stakes at Sandown Park in 1886 and the 1887 Champion Stakes at Newmarket. He also won the Cambridgeshire, the Kempton Jubilee, the Lincolnshire Handicap and the Hardwicke Stakes at Ascot. He sired the important mare Black Cherry.

The Bard,[4] born in 1883 by Petrarch out of Magdalene, was owned in partnership by General Owen Williams and Robert Peck. As a two-year-old he won all his races but was eventually beaten by Ormonde in the Derby. Subsequently, however, he won the Doncaster and Goodwood Cups. He was bought by Henri Sai for 10,000 guineas, the highest price then paid for a stallion in France. His name appears in the pedigree of many famous French racehorses.

Galore,[5] born in 1885 by Galopin out of Lady Maud, was unlike the other three horses represented in this set of paintings in that he was not a successful horse. He was owned by Mr. N. Fenwick and came fourth in the 1888 Derby.

Bendigo WAG 2329

The Bard WAG 2330

Minting,[6] born in 1883 by Lord Lyon out of Mint Sauce, was owned by Robert Vyner. As a two-year-old he won the Champagne and Middle Park Stakes. He was beaten by Ormonde in the Two Thousand Guineas, but won the Grand Prix in a canter. Subsequently he was successful in the Kempton Park Great Jubilee Handicap.

PROV: Walter Stone;[7] bequeathed by Miss Mary Stone 1944.

1 See G.M. Waters, *Dictionary of British Artists*, 1975, p. 210. Lucas established his studio in Rugby in 1878, thus indicating a date of birth around 1858.

Galore WAG 2331

Minting WAG 2332

2 WAG 2332 is signed: *sketch by H.F. LUCAS LUCAS.*

3 Roger Mortimer, Richard Onslow and Peter Willett, *Biographical Encyclopaedia of British Flat Racing*, 1978, p. 54.

4 Mortimer, Onslow and Willett, *op. cit.*, p. 607.

5 Roger Mortimer, *The History of the Derby Stakes*, 1973, p. 301; Racing Information Bureau, letter to the compiler, 16 April 1970; J.G. Ellis, *The Walter Stone Collection*, 1938, p. 22.

6 Mortimer, Onslow and Willett, *op. cit.*, p. 389.

7 Ellis, *op. cit.*, p. 22, no. 28.

LUCAS, John Seymour (1849–1923)
Unbreathed Memories
WAG 726
Canvas: 82 × 66.3 cm
Signed: *Seymour Lucas 1876*

This painting was identified as Seymour Lucas's *Unbreathed Memories* in the 1922 Christie's sale catalogue,[1] but if this identification is correct, Lucas painted the picture in 1876 and did not exhibit it until 1879[2] – which is improbable. The black cuffs and lace around the bodice and collar probably indicate that the woman is wearing half-mourning – characteristically adopted by widows some two years after the death of their husbands.[3]

PROV: Anon sale, Christie's 10 July 1922, lot 122, bought Wilson and Co. (£19.19s.); Henry J. Mullen

sale, Christie's 21 March 1924, lot 128,[4] bought Newman (£65.2s.); presented by George Audley 1925.[5]

EXH: (?) Royal Academy 1879 (944) as *Unbreathed Memories*.

1 See Provenance above.

2 See Exhibited above. *Unbreathed Memories* is listed in Allan Fea, 'Seymour Lucas', *Art Journal*, Christmas Number, 1908, p. 32, as painted in 1879.

3 See L. Taylor, *Mourning Dress, a Costume and Social History*, 1983, pp. 146–9. Pauline Rushton kindly assisted with this reference.

4 The dimensions given in this sale catalogue (26½ × 19½ in.) do not correspond with those of WAG

726; the painting sold may therefore not have been WAG 726.

5 George Audley, *Collection of Pictures*, 1923, pp. 37–8, no. 107.

MACBETH, Robert Walker (1848–1910)
Our First Tiff
WAG 919
Canvas: 70.5 × 106.2 cm
Signed: *RM 1878*

Macbeth's early work was generally rustic or pastoral in tone. Chesneau[1] rightly listed *Our First Tiff*, with its upper-middle-class social anecdote reminiscent of Orchardson, as the 'première infidélité du peintre à ses amours rustiques'.

REPR: H. Blackburn, *Grosvenor Notes*, 1879, p. 27.

PROV: E. Allday sale, Christie's 16 March 1895, lot 51, bought Marshall (£110.5s.);[2] Anon sale, Christie's 10 July 1922, lot 121, bought Wilson and Co. (£17.17s.); presented by George Audley 1927.[3]

EXH: Grosvenor Gallery 1879 (68).

1 E. Chesneau, *Artistes anglais contemporains*, n.d., p. 50. The best description of Macbeth's early work is in J.L. Caw, *Scottish Painting*, 1908, which notes the influence of G.H. Mason, G.J. Pinwell and Frederick Walker on much of it; see also A.L. Baldry, 'R.W. Macbeth', *Art Journal*, 1900, pp. 289–92.

2 There are labels on the back of WAG 919 stating that it was owned by Sir Henry Layard and by George McCulloch; it was not, however, in the McCulloch sale at Christie's 23–30 May 1913, nor in the exhibition of the McCulloch Collection at the Royal Academy *Winter Exhibition* of 1909. Layard died in 1894 and was interested in Renaissance rather than contemporary art; WAG 919 was not at his executor's sale, Christie's 15 May 1913.

3 George Audley, *Collection of Pictures*, 1923, p. 38.

Our First Tiff WAG 919

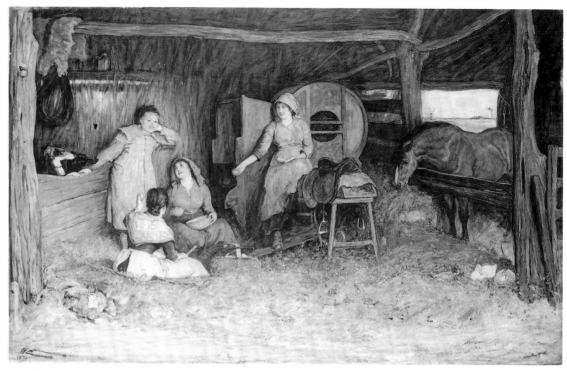

In Clover WAG 1329

In Clover

WAG 1329
Canvas: 54.2 × 87.2 cm
Signed: *RM 1879*

The critics at the 1880 Royal Academy exhibition contented themselves with merely describing *In Clover* – 'some peasants at their repast in an outhouse while a horse looks in and nibbles at the clover',[1] or 'girls and a horse; stable floor covered with clover',[2] or 'there is less that we can see of paintable matter in Mr. Macbeth's *In Clover* (149), girls and a horse in a clover-strewed stable'.[3]

PROV: Presented by John Temple 1894.

EXH: Royal Academy 1880 (149).

1 *Art Journal*, 1880, p. 187.

2 H. Blackburn, *Academy Notes*, 1880, p. 18.
 Blackburn adds that the artist's principal works were exhibited at the Grosvenor Gallery in 1880.

3 *The Times*, 19 May 1880.

Fishing Boats off Yarmouth

WAG 346
Panel: 19.5 × 29.2 cm

Caw noted that Macbeth 'now and then' painted fishing scenes, but there seems no way to date this sketch.[1]

PROV: Given by the artist to Miss Katherine C. Maclennan; presented by her 1912.

1 J.L. Caw, *Scottish Painting*, 1908, p. 279.

MACGREGOR, Jessie (c.1850–1919)

Jepthah

WAG 2902
Canvas: 87.6 × 158 cm
Signed: *Jessie Macgregor*

Jepthah, having overcome the Ammonites, vowed that he would sacrifice the first person to come out to meet him on his return from battle. That person was his virgin daughter,

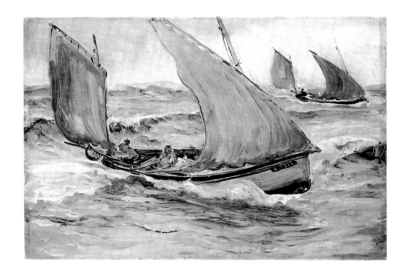

Fishing Boats off Yarmouth
WAG 346

his only child, who 'came out to meet him with timbrels and with dances'. Jepthah kept his vow – with his daughter's full consent.[1]

Religious subjects, particularly those involving female characters, acquired a new popularity with women artists in the 1880s,[2] although the story of Jepthah and his daughter was not among the most popular – possibly because it so clearly exemplifies the principle of female submission to paternal authority?

Edwin Long's enormous *Jepthah's Return* of 1886 shows father and daughter embracing rather than the moment when he first saw her on his return.[3]

REPR: H. Blackburn, *Academy Notes*, 1889, p. 34; Liverpool Autumn Exhibition catalogue, 1889, p. 68.

Jepthah WAG 2902

PROV: Painted for the Walker Art Gallery and presented by subscribers 1889.

EXH: Royal Academy 1889 (315); Liverpool Autumn Exhibition 1889 (204).

1 Judges 8: 30–40.

2 Charlotte Yeldham, *Women Artists in 19th-Century France and England*, 1984, vol. 1, p. 131; vol. 2, p. 34.

3 The painting is now in the Russell-Cotes Art Gallery and Museum, Bournemouth, and is reproduced in their *Illustrated Souvenir*, 1924, p. 44.

In the Reign of Terror
WAG 2826
Canvas: 92 × 72 cm
Signed: *Jessie Macgregor / 1891*

A royalist mother guards her baby during the 'reign of terror' following the French Revolution.[1] The effect of war on the lives of women was a very popular subject for female artists from the 1880s onwards.[2]

REPR: H. Blackburn, *Academy Notes*, 1891, p. 132; Pall Mall Gazette, *Pictures of 1891*, p. 78.

PROV: Bought from the artist 1891 (£100).

EXH: Royal Academy 1891 (1109); Liverpool Autumn Exhibition 1891 (822).

1 Deborah Cherry in *Painting Women*, Rochdale Art Gallery, 1987, p. 27, notes: 'The setting is the years immediately following the French Revolution of 1789, a period of history regarded with considerable apprehension by the middle class whose sympathy was often elicited for the deposed monarchy.'

2 Charlotte Yeldham, *Women Artists in 19th-Century France and England*, 1984, vol. 1, p. 133.

MANN, Alexander (1853–1908)
Burning Couch Grass
WAG 654
Canvas[1]: 51 × 60.8 cm
Signed: *Alexr. Mann*

This was painted from the hills around Blewbury, Oxfordshire,[2] where the artist settled in 1901. First exhibited in 1902, it can therefore probably be dated to 1901–2. There seem to be no related drawings in the surviving sketchbooks although many were taken from the area.[3] Caw[4] wrote of pictures of this type: 'But in virtue of a refined sense of tone and a real, though unimpassioned, feeling for the hush of dusk, and the brooding quiet of night, he touched, now and again, in pictures of . . . a stretch of level country under the star-strewn heavens, a true and affecting note.'

PROV: Purchased from the artist 1906 (£20).

EXH: The Continental Gallery (157 New Bond Street) *Surrey Art Circle*, June 1902 (73) priced at £30;[5] Royal Glasgow Institute of Fine Arts 1903 (5) priced at £30; Walker Art Gallery, Liverpool Autumn Exhibition 1906 (92).

In the Reign of Terror WAG 2826

Burning Couch Grass WAG 654

1 Framer's label: *W TAYLOR and Co. LONDON.*

2 Martin Hopkinson, letter to the compiler,
 24 September 1984.

3 Martin Hopkinson, *op. cit.*

4 J.L. Caw, *Scottish Painting*, 1908, p. 385.

5 MS letter from the artist to his wife, 27 May 1902
 (private collection; see Martin Hopkinson, *op.
 cit.*).

MARKS, Barnett Samuel (1827–1916)

***A Reminiscence of a Court of Quarter
Session: 'What are the shepherds doing,
that the lambs go astray?'***

WAG 7141
Canvas: 35 × 31 cm
Signed: *BS Marks* (in monogram)

The first version of this composition was
exhibited at the 1868 Royal Academy (370).
The artist, while acting as a juror, 'was
shocked and distressed that twelve comfort-
able and well fed gentlemen were sitting in
judgment on this little child'; he made a sketch
on his cuff and later did the Royal Academy

A Reminiscence of a Court of Quarter Session:
'What are the shepherds doing, that the lambs go
astray?' WAG 7141

painting from it. A Dr. Forrest[1] bought this
version and F. W. Farrar[2] purchased a copy
made for him by the artist. Through these two
men and through the seventh Earl of Shaftes-
bury, the artist was drawn into philanthropic
work for destitute children – in particular
providing free tuition in art for them.[3] He also
painted more subjects similar to the boy in the
dock – notably pairs of portraits of the same
boy before and after rescue by Dr. Barnardo's
Homes – which were exhibited at the 1873
Royal Academy exhibition. His *Portraits of the*
same boys before and after training on board the
good ship Chichester were sold at Phillips
(London) 21 June 1994, lot 111.

PROV: Transferred from the Liverpool Magis-
trates Courts 1969.

1 Probably Robert William Forrest, Dean of
 Worcester from 1891, died 1908.

2 Frederic William Farrar (1831–1903), headmaster
 of Marlborough College 1871–6 and Dean of
 Canterbury 1895–1903.

3 Mrs. Gladys Davies in a letter to *Country Life*,
 8 January 1970, p. 78. A second copy of the
 composition was retained by the artist and passed
 to Mrs. Davies, who was his granddaughter. Mr.
 H.L. Palmer in a letter to *Country Life*,
 27 November 1969, p. 1382, stated that he too
 then owned a version (14 × 12 in.), which was
 reproduced with his letter; this may have been the
 version previously owned by F.W. Farrar; neither
 it nor WAG 7141 was the original 1868 Royal
 Academy version which went to Dr. Forrest; a
 photograph survives of that 1868 version and
 Mrs. Davies kindly sent a print of it to the Walker
 Art Gallery on 6 March 1970. There was certainly
 a version painted in 1871 and exhibited by the
 artist as a 'replica' at the 1871 London
 International Exhibition (374) and presumably it
 was yet another version that was shown by the
 artist at the 1873 Liverpool Autumn Exhibition
 (95) with the same title but abbreviated to *The*
 Dock: 'What are the shepherds doing, that the lambs go
 astray?' – very possibly to be identified with WAG
 7141.

MARKS, Henry Stacy (1829–1898)
What is it?
WAG 268
Canvas: 67.5 × 104.5 cm
Signed: *H.S. MARKS 1872*

Marks was fond of titles containing an inter-
rogation. His *Where is it?* of 1882 (now Bir-
mingham City Art Gallery) shows an old man
rummaging in a drawer; Alma-Tadema's *Who*
is it? dates from 1884. Marks's intention seems
to have been to paint a picture without a
subject in the sense that both the incident being
watched and the response of the watching
spectators are concealed. He wrote to George
Holt,[1] the second owner of the painting, about
its subject: 'I cannot pretend to solve the query
which forms the title of the work in question
– but you may be assured it is nothing exciting
or sensational or we would have more action
in the spectators.' Indeed, *What is it?* may have
been intended to parody the typical 'sensa-
tional' Victorian subject painting. Similarly
Marks's *Waiting for the Procession* exhibited at
the 1872 Royal Academy simply showed a
crowd on a raised path by the wall of a town
waiting to watch Richard II and Bolingbroke

on their way to London – without the principal figures in the picture at all.

The critics barely understood the artist's humorous intention and felt that the subject was too trivial. The reviewer for the *Examiner*[2] at the 1873 Royal Academy wrote: 'The curiosity of these folks is quite contagious, and we should really like to know what is going on in the stream below. Whether this is a sufficient motive for a picture on which great skill and a great deal of labour have been expended may be doubted . . .'

The *Athenaeum* critic[3] produced a more sophisticated response, but was also concerned about the lack of action and passion:

'What is it?' will attract much popular attention, and secure no little technical praise. The answer to the questioning title is to be found in the scene and composition, a bridge and a group of figures of people, who, with their backs towards us, look into the river, where something occurs or is to be seen which we cannot see, and, unless Mr. Marks takes us into the secret we shall never be able to discover. There is no want of variety in the design here; but the figures –

we can hardly speak of the faces – lack something, at least some of them do, of action and spirit; vivid rendering of something like vital emotion would, of course, move us more powerfully than any composition, however carefully considered or carefully painted can do, if there is no action. The tale Mr. Marks intended to tell is perfectly well told; nothing could be clearer and plainer than the fact that he has not aimed at producing a greater effect than is apparent here. It is a question, however, whether it would not have been better for us if he had expended the care and skill this work has received on a subject involving action, if not passion. The attitudes, without the expressions of the faces, would suffice for this, quite as finely as they do for the sober theme of this picture as it is.

There are various pentimenti in this painting – in particular the legs of the figure second from the left were changed repeatedly by the artist.

What is it? Cartoon for the Picture was at the 1880 Grosvenor Gallery Winter Exhibition (286)[4] and a watercolour entitled *What is it?* was exhibited at the Liverpool Society of Water Colour Painters in 1874 (7);[5] probably it was the same watercolour that was lent to

What is it? WAG 268

the Liverpool Art Club 1878 (15) and to the Grosvenor Gallery Winter Exhibition 1878–9 (950) by W.S. Caine and then appeared at Christie's 5 November 1993, lot 104 (42.2 × 67.3 cm); it is now in the collection of the artist's family. *A Study for Two Figures in What is it?* was exhibited at the Winter Exhibition of the Society of Painters in Water Colours 1873 (392).[6] A large drawing including a study for the female figure at the extreme right is in the collection of the artist's family.

The Walker Art Gallery painting was listed by the *Athenaeum* as in progress on 4 January 1873.[7]

PROV: Bought from the artist by Agnew's 21 December 1872 (before its completion); sold to H. Gaskell (presumably Holbrook Gaskell) 28 January 1873 (£672.10s.); bought back by Agnew's 8 December 1873[8] and sold to George Holt 25 October 1873 (£430) with an exchange painting; bequeathed by Emma Holt 1944.

EXH: Royal Academy 1873 (195); Paris, *Exposition Universelle*, 1878 (163);[9] Liverpool, *Grand Loan Exhibition*, 1886 (1209).

1 MS, 26 February 1874.

2 *Examiner*, 17 May 1873, p. 526.

3 *Athenaeum*, 3 May 1873, p. 571. Other reviews appeared in *Art Journal*, 1873, p. 169 and in the *Saturday Review*, 31 May 1873, p. 716.

4 Presumably this cartoon was the one reproduced in J. Oldcastle, 'Sketches and Studies by Old and Modern Masters', *Magazine of Art*, 1881, p. 84; this cartoon differs considerably from WAG 268.

5 *Art Journal*, 1874, p. 147.

6 See *Athenaeum*, 6 December 1873, p. 737.

7 *Athenaeum*, 4 January 1873, p. 23.

8 This is the date in Agnew's Stock Books; it may be the date of delivery of the picture rather than the date of sale.

9 Henry Blackburn, *Exposition Universelle: Catalogue Illustré de la Section des Beaux Arts, École Anglaise*, Paris, 1878, p. 16.

A Treatise on Parrots[1]

WAG 267
Canvas: 108.2 × 76.5 cm
Signed: *H.S. Marks 1885*

By 1885 Marks had become well known for his bird paintings[2] and for his figures of old scholarly men; for this reason the critics were brief or rather unenthusiastic over this painting.[3]

The reviewer for the *Spectator* was an exception:[4]

the small, one figure composition, entitled 'A Treatise on Parrots', which besides its graphic humour, is one of the most exquisitely painted pictures which we have ever seen in the Academy. Let us not be misunderstood, Mr. Marks's painting is of the very reverse kind to what the French artists would like; it belongs rather to the old Dutch school and its peculiarity lies rather in concealing its method than revealing it frankly. But if we accept its aim, it would be hard to find a better example than 'The Treatise on Parrots'.

Marks's '*Of making books there is no end: and much study is a weariness of the flesh*' of 1893 had the same figure as in *A Treatise on Parrots* seated at a desk studying the skulls of animals.

REPR: Henry Blackburn, *Academy Notes*, 1885, p. 40.

PROV: Bought from the artist by Agnew's 24 March 1885, sold by them to George Holt 9 November 1885 (£525); bequeathed by Emma Holt 1944.

EXH: Royal Academy 1885 (248); Manchester, *Royal Jubilee Exhibition*, 1887 (130); Royal Academy, *Winter Exhibition*, 1901 (92); Hulme Hall, Port Sunlight, *An Exhibition to Celebrate the Coronation*, 1902 (60); Whitechapel Gallery, *Animals in Art*, 1907 (127); Liverpool Autumn Exhibition 1922 (476).

1 When it was first exhibited at the Royal Academy in 1885, the catalogue contained the following quotation against WAG 267:

Splendid in hue, and delicate in form,
God's feathered fairies, birds whose very effigies
In which but sound and movement lack to life,
Plumage, shape, colour, all remaining, still
Enchant the eye, and stir the dreaming heart:
And so the life-long lover of sweet fowls,

Old, calm, and solitary, feels the glow,
The love of science and the love of art,
Which stir the tender soul, yet strongly drawn
To worship the Creator in His works.

2 See Amanda Kavanagh, 'Parrots with a Smile',
 Country Life, 13 February 1986, pp. 412–5.

3 *Athenaeum*, 2 May 1885, p. 572; *Magazine of Art*,
 1885, p. 350; *Saturday Review*, 9 May 1885,
 p. 612; *Art Journal*, 1885, p. 258.

4 *Spectator*, 13 June 1885, p. 784. Marks was the art
 critic of the *Spectator* in the 1860s.

Red and Blue Macaw

WAG 266
Canvas: 92 × 46 cm
Signed: *H.S.M.*

Marks exhibited other studies of macaws in
his Fine Art Society exhibition of 1889, *Draw-
ings and Paintings of Birds*, and in the Royal
Society of Painters in Water Colours exhibi-
tions of 1891 and 1894.

PROV: Bought by Agnew's from the artist
11 August 1886;[1] sold to George Holt 9 August
1886 (£105); bequeathed by Emma Holt 1944.

1 This may be the date of delivery to Agnew's rather than the date of the sale.

Red and Blue Macaw WAG 266

A Select Committee

WAG 2827
Canvas: 111.7 × 86.7 cm
Signed: *H.S.M.*

The *Athenaeum*[1] critic analysed this painting at the 1891 Royal Academy exhibition:

It was long ago admitted on all hands that the forte of this artist is humour; accordingly everyone comes to a picture of his prepared to smile if not to laugh outright. Such anticipations may sometimes be rather unfair to one who, if he is not in good spirits, often conceals comical intentions so effectually that his less reasonable admirers are baffled. Of late he has frequently proved a master of bird character, and satirized men after the fashion of Aesop. This year's picture is no exception to the rule, for in A Select Committee *he ridicules many a council, board, and congress by a group of blue, white, and black parrots and cockatoos perched in an aviary and gravely discussing the affairs of birdland. There is an abundance of character in the dictatorial black bird in front; in his stupid, hectoring brother in blue, who is as dogmatic and insolent as a biped can be; and in the cautelous old president on the highest bar, who lifts his foot solemnly and lays down the law. One councillor has gone to sleep, one is fussy, and another is a type of artfulness in feathers. A little flat and hard, as Mr. Marks's birds are apt to be, these figures are drawn well, deftly modelled, and even better painted than usual. Apart from this the group does not give an impression that the birds are making a noise, as we should expect them to do.*

Although Marks claimed that 'he had never caricatured or humanised a bird', this painting plainly does treat the parrots in an anthropomorphic manner.[2]

REPR: Pall Mall Gazette, *Pictures of 1891*, p. 51; *Royal Academy Pictures*, 1891, p. 21; Henry Blackburn, *Academy Notes*, 1891, p. 63; G.D. Leslie, 'Henry Stacy Marks', *Magazine of Art*, 1898, p. 243 as *Chairman of Committee*.

PROV: Purchased from the artist 1891 (£300).

EXH: Royal Academy 1891 (259); Liverpool Autumn Exhibition 1891 (53).[3]

1 *Athenaeum*, 2 May 1891, p. 577. There is another brief review in the *Saturday Review*, 23 May 1891, p. 621.

300

2 Amanda Kavanagh, 'Parrots with a Smile',
 Country Life, 13 February 1986, p. 414. Similarly
 the artist's close friend G.D. Leslie wrote: 'He
 never dishonours his Creator by giving human
 eyes and human expressions to the birds that he
 portrays in order to gain a cheap popularity for
 humour.' ('Henry Stacy Marks', *Magazine of Art*,
 1898, p. 238)

3 E.J. Gregory in his review of the Liverpool
 Autumn Exhibition published in the *Artist*,
 February 1892, remarked: 'The Council has
 redeemed its credit with the Philistines by the
 purchase of Stacy Marks's *The Select Committee*
 which is so much admired by lovers of colours
 and politics.' The compiler is indebted to Martin
 Hopkinson for this reference.

MASON, George Heming (1818–1872)
Ploughing in the Campagna
WAG 269
Canvas: 38.3 × 75.2 cm

Ploughing in the Campagna was perhaps painted
when the artist and Giovanni Costa were
guests of the Tittoni family, farmers in the
Roman Campagna and strong republicans.[1] It
has been dated to about 1857[2] and the influence
of French academic painting, which the artist
would have seen in Paris in 1855, has been
suggested.[3] It was probably exhibited at the
1857 Royal Academy (314);[4] *The Times*[5]
described it as 'a spirited reminiscence of
country life and scenery near Rome' and notes

Ploughing in the Campagna WAG 269

its small scale; the *Art Journal*[6] decided that 'the interest of the composition centres on the yoke of the oxen that are working in the plough; they are fine long-horned animals of the Spanish breed'. The distant aqueduct is probably the Aqua Claudia, then the most prominent feature of the Campagna.

PROV: Probably commissioned by the second Baron Lurgan in about 1856;[7] his sale, Christie's 13 June 1874, lot 45, bought Agnew (£84);[8] sold to George Holt 29 September 1874 (£157.10s.); bequeathed by Emma Holt 1944.

EXH: (?) Royal Academy 1857 (314).

1 Simon Reynolds, 'George Heming Mason', *Apollo*, 1981, vol. 113, p. 107. Reynolds was presumably merely relying on the statement in O.R. Agresti, *Giovanni Costa*, 1904, p. 70, that Mason and Costa spent some time on Tittoni's farm in the Campagna during the period 1852–6.

2 Stoke-on-Trent City Museum and Art Gallery, *George Heming Mason*, 1982, no. 27.

3 Stoke-on-Trent, *op. cit.*, Introduction. The influence of Costa on WAG 269 seems, however, more obvious.

4 Reynolds, *op. cit.*; Stoke-on-Trent, *op. cit.*, no. 27. A. Staley, *The Pre-Raphaelite Landscape*, 1973, p. 177 implies that WAG 269 was not the Royal Academy picture.

5 *The Times*, 18 May 1857.

6 *Art Journal*, 1857, p. 171. This was the first picture exhibited by Mason at the Royal Academy and these favourable reviews may have encouraged Mason to marry and return to England in 1858. A photograph of about 1870 showing some of these long-horned oxen in Rome is reproduced in Thorvaldsens Museum, Copenhagen, *Rome in Early Photographs 1846–1878*, 1977, plate 131.

7 Unpublished letter of 25 February 1857 from the artist to an unidentified nobleman; it is quoted in R. Billingham, 'George Mason', University of Leicester M.Phil. thesis, 1975, Appendix 2; the

artist asked the nobleman to allow him to exhibit *Ploughing in the Campagna* at the Royal Academy; Lurgan, if he was the nobleman in question, commissioned a number of other paintings from Mason at the same time, including an *Evening Scene with the Castle of Ostia*.

8 Agnew's Stock Books confirm that WAG 269 was indeed lot 45 at this sale. Lurgan also sold at the same sale and all were by Mason: lot 46, *A Bullock Waggon in the Campagna* dated 1855 (bought White £44.2s.); lot 47, *In the Campagna with a Shepherd and Sheep* (bought Agnew £57.15s.); lot 48, *Near Rome: Evening* (bought Agnew £52.10s.); the commission of about 1855 presumably comprised these paintings with WAG 269. Lurgan's sale catalogue confirms that all four paintings were bought by him from the artist; his name does not appear in the printed catalogue but Christie's records indicate that he was the vendor. Lurgan was certainly in Rome in early 1853 when he may have met the artist – see *Letters of the Hon. Mrs. Edward Twisleton*, ed. Vaughan, 1928, pp. 68, 78. Agnew's in an MS letter of 27 July 1875 stated that WAG 269 was in the artist's executors' sale at Christie's 15 February 1873; this seems improbable, although lot 139 at that sale was *Ploughing, Roman Campagna* (bought Brandling £110.4s.).

Evening, Matlock

WAG 10767
Canvas: 44.5 × 70.5 cm

Evening, Matlock was probably the major work done by the artist between his three paintings exhibited at the 1865 Royal Academy and his *Evening Hymn* of 1868; it was very well received by the critics at the 1867 Royal Academy. The *Athenaeum*[1] wrote:

Mr. G. Mason's 'Evening, Matlock' might be called a landscape if the figures were not so rich in feeling, and delicately expressed. It represents the mixture of sunlight and moonlight on a newly-reaped upland; a broad stretch of shadow widens on the sloping side of a field, down which a gleaner, a very graceful figure, drives some sheep; beyond, shocks of corn stand in the sun-lighted space of the land; the full moon rises in all the glow of her summer perfectness. Notice the subtle harmonies of this picture in colour and tone; the admirable manner in which all its elements have been studied, and, be they of lines, tones or tints, with perfect taste combined. Similar, if not equal, craft and poetic feeling appear in 'The Unwilling Playmate'.

The review in *The Times*[2] was on similar lines:

Evening, Matlock WAG 10767

Mr. MASON's 'Unwilling Playmate', a stubborn donkey, which a girl is vainly trying to tug by the halter . . . is as a whole inferior to his other picture this year called 'Evening, Matlock', which is made up of upland cornfields, in which the late harvesters and reapers are still working under the harvest moon, while in the foreground a gleaner descends a rough hill path driving a few sheep before her. The colour and sentiment of this picture are extremely delightful, and we are not sure that Mr. Mason has painted anything sweeter than the three far-off cornfields sleeping under the broad low moon which is still white in the warm sky, where the flush of evening sunset still lingers. The picture is full of the ineffable poetry which belongs to this painter's work, in a way we are neither able nor anxious if we were able to explain, for those to whom it appeals feel it, and those to whom it is caviare cannot be made to feel it, by any amount of writing.

Sir John Forbes White[3] noted that *Evening, Matlock* is closely related in theme and in feeling with Mason's later *Harvest Moon* of 1872 (Tate Gallery).

PROV: Bought from the artist by Hugh Lupus Grosvenor, later Marquis of Westminster;[4] Sotheby's (Belgravia) 27 June 1978, lot 116; Fine Art Society; Duncan MacLaren; Christie's 27 June 1988, lot 702, bought Agnew for the Walker Art Gallery (£9,500).

EXH: Royal Academy 1867 (202); Burlington Fine Arts Club, *The Late George Mason's Pictures*, 1873 (14); London International Exhibition 1873 (765); Manchester, *Royal Jubilee Exhibition*, 1887 (661); Earls Court, *Victorian Era Exhibition*, 1897 (12); Royal Academy, *Winter Exhibition*, 1901 (103); Stoke-on-Trent City Museum and Art Gallery, *George Heming Mason*, 1982 (43).

1 *Athenaeum*, 18 May 1867, p. 667.

2 *The Times*, 14 May 1867. Reviews on similar lines also appeared in the *Illustrated London News*, 1 June 1867, p. 554 and in the *Art Journal*, 1867, p. 145.

3 'The Late George Mason's Pictures', *Contemporary Review*, 1873, vol. 21, p. 730.

4 There is an unpublished letter from Grosvenor to Mason in Leighton House in which Grosvenor asks if Mason will sell his 'picture of the Harvest with the sheep in the foreground' (Stoke-on-

Trent City Museum and Art Gallery, *George Heming Mason*, 1982, no. 43). Grosvenor was to be an important friend and patron of the artist during his last years – he also owned one of Jules Breton's *Reapers*, which he exhibited at Wrexham in 1876.

MAY, Arthur Dampier (active 1873–1914)
Portrait of a Boy
WAG 3169
Canvas: 61.3 × 51 cm
Signed: *A. DAMPIER. MAY 1899*

PROV: (?) Bequeathed by Mrs. A. M. Roscoe 1950.

Portrait of a Boy WAG 3169

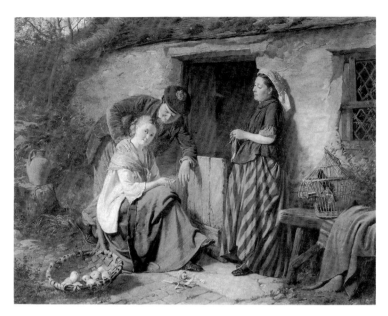

MIDWOOD, William H. (born 1833/34)
The Proposal
WAG 1626
Canvas[1]: 71.7 × 92 cm
Inscribed: *Thomas Faed 1860*

The Proposal was acquired as a work by Thomas Faed,[2] presumably on the strength of the inscription, but two variants signed by Midwood exist[3] and both differ from it only in accessories, dress and other details. *The Proposal* is not close to Faed's known style, nor can it be identified with any of the paintings recorded by Faed as painted by him in 1860;[4] McKerrow, however, retains the old attribution to Faed.[5]

PROV: Alice Mary, Lady O'Hagan (1846–1921);[6] her sale, Christie's 24 November 1922, lot 116, bought Sampson (£14.14*s*.); presented by George Audley 1925.

EXH: Towneley Hall, Burnley 1903 (207) as *Courtship in the Highlands*.

1 Stamped: *Winsor and Newton 38 Rathbone Place, London.*

2 George Audley, *Collection of Pictures*, 1923, p. 17, no. 47.

3 One was owned by M. Newman Ltd. in 1965 and was signed and dated 1872 (71 × 91.5 cm); the other was sold at Sotheby's 29 March 1983, lot 118, signed and dated 1876 (71 × 91.5 cm). The second – and probably also the first – were signed *Midwood*; the artist was presumably the W.H. Midwood who exhibited genre paintings at the Royal Society of British Artists 1867–71; auction sale catalogues often give his Christian names as William Henry; the 1871 Census gives William as his first name, his place of birth as Huddersfield and his date of birth 1833/4 (R.A. Bowden, letter to the compiler, 9 May 1984). Three signed paintings by him are reproduced in the Sotheby's (Belgravia) sale catalogue of 17 June 1980, lots 133, 151 and 160.

4 List of Pictures Painted by T. Faed from the Year 1845 or 1846, MS National Gallery of Scotland, Edinburgh.

5 Mary McKerrow, *The Faeds*, 1982, p. 157. In a letter to the compiler of 25 June 1981 she felt, on balance, that WAG 1626 was probably by Faed despite the uncharacteristic signature and the use of a Winsor and Newton canvas – unusual for Faed, who preferred Roberson's canvases.

6 Audley, *op. cit.*

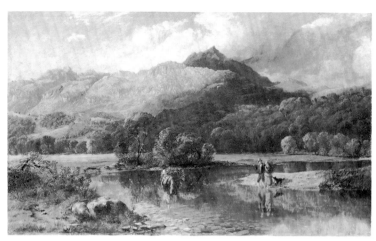

MOGFORD, John (1821–1885)

The Ford near Pont Aberglaslyn, North Wales

WAG 5604
Canvas: 46 × 77 cm
Signed *John Mogford 1859* (?)

The date on the painting is hard to read and
by 1859 Mogford was specializing in cliffs and
rocks in the style of John Brett.

PROV: Artist's Sale, Christie's 25 February 1886,
lot 526, *The Ford, North Wales,* bought E.C. Smith
(£4.4s.) Found in the Gallery 1956.

MOON, Henry George (1857–1905)

Corfe Castle

WAG 951
Canvas: 40.8 × 51 cm

Two paintings of Corfe Castle, both dating
from 1903, were at the 1908 Leicester Galleries
exhibition.[1]
 Corfe village is in the foreground; the castle
ruins are on the hill to the left. The view seems
to have been taken from the south.[2]

EXH: (?) Leicester Galleries, *Henry G. Moon,* 1908
(32 or 65).

Corfe Castle WAG 951

PROV: Bequeathed by J.B. Davis 1943.

1 See Exhibitions above. Moon rarely exhibited his paintings except with selected dealers; see T.S. Lee's introduction to the Leicester Galleries 1908 exhibition catalogue, pp. 5–9.

2 See Sidney Toy, 'Corfe Castle', *Archaeologia*, 1929, vol. 79, pp. 85–102, which reproduces views from three angles.

MOORE, Albert (1841–1893)
The Shulamite
WAG 2904
Canvas: 97 × 214 cm

The subject is ostensibly the dialogue between the Shulamite and the daughters of Jerusalem about her beloved:[1]

> I charge you, O daughters of Jerusalem, if ye find my beloved, that ye tell him, that I am sick with love,
>
> What is thy beloved more than another beloved, O thou fairest among women? what is thy beloved more than another beloved, that thou dost so charge us?
>
> My beloved is white and ruddy, the chiefest among ten thousand.

Baldry was the first to note that *The Shulamite*, painted in 1864–6, was a transitional work; it still has an Old Testament subject and some emotion, but lacks the emphatic action and dramatic composition of Moore's *Elijah's Sacrifice* of 1863; of it Baldry wrote:

He finally abandoned the methods of his earlier years, with their sombre colour and tentative modes of expression, and, instead, set himself to work out the first of those problems of colour arrangement and line composition to which the remaining twenty-seven years of his life were to be devoted.

Furthermore and more specifically, *The Shulamite* was probably the first major work by Moore to have the row of carefully posed, aesthetically spaced and classically draped female figures with the self-conscious, subtle colour arrangement that were all to characterize his mature work.[2]

Contemporary reviewers generally noted the originality of the painting and its dependence on classical art,[3] but there was little praise except from the *Athenaeum*,[4] which having condemned the 'too obvious disproportions' went on:

The last-named is The Shulamite – *here placed above the door to the North Room – a subject from 'the Song of Solomon' – painted with great ability in the disposition of drapery, colour, and tone; withal in so novel a style that the artist must expect some time to pass before it is popularly mastered.*

The *Art Journal*[5] critic wrote:

Mr. A. MOORE last year, even by his eccentricities, excited curiosity, and raised expectations not wholly unfavourable. 'Elijah's Sacrifice', however, scarcely prepared us to expect anything quite so exceptional as the artist's latest manifesto, 'The Shulamite'. We frankly admit that we do not know what the hangers could do, save what they have done – place the picture out of the way over the door. The work has no beauty or charm to recommend its singularity. The heads are without variety; the drapery repeats itself; and there is not the slightest approach to composition or concentration, either in forms, colours, light or shade.

Lastly, J. Beavington Atkinson in the *Fine Arts Quarterly Review*[6] saw only promise:

We are at a loss to know what Mr. A. Moore means by 'The Shulamite'. He would seem to have aimed at a revival of Greek or rather Roman style, displayed in such works as the Aldobrandini Marriage, and the mural paintings of Pompeii. Hence it can scarcely be tested by modern standards. We cannot admit, however, that the picture is good of its kind. Panoramic composition, evenly diffused light, and a certain chalkiness of colour, might indeed be sanctioned in Pompeian decorations. Examination, however, shows that the mannerism rather than the merit of the originals has been caught. The composition is not well managed; it is loose and out of balance, the forms suffer from repetition, and the drapery is unfortunately not cast like the best Grecian style, but after the manner of the corrupt Roman. Mr. Moore, however, need not be discouraged, even by the treatment of the hangers. The newly opened mine he attempts to work is rich: the sphere in which he labours is scarcely preoccupied; and the success which may be attained has been already proved in pictures by Gérôme and other French artists.

The Shulamite WAG 2904 (colour plate 11)

There are four studies for figures in *The Shulamite* at the Victoria & Albert Museum (D 1661–1664–1904) and a watercolour study for the whole composition is in an English private collection.[7]

PROV: Philip H. Rathbone[8] (by 1876); bequeathed by him 1895.

EXH: Royal Academy 1866 (354); Wrexham 1876 (44); Walker Art Gallery, Liverpool, *Grand Loan Exhibition*, 1886 (1244); Grafton Gallery 1894 (162).

1 Song of Solomon 5: 8–10. The Song of Solomon was a popular source for Rossetti and Burne-Jones; Rossetti's *The Beloved* (or *The Bride*), Tate Gallery, dates from 1863–5 and in the 1870s Burne-Jones made some designs for embroideries from the Song of Solomon, some of which were later developed into paintings. They are described at length in Malcolm Bell, *Sir Edward Burne-Jones*, 1901, pp. 54 ff. Henry Holiday in his very early *Song of Solomon* of 1861–2 adhered to the Christian interpretation of the dialogue according to which the Bride (or the Church) is persuading the Daughters of Jerusalem (or the World) to join her in seeking Christ – see his *Reminicences of my Life*, 1914, pp. 74–5, repr. p. 96. Spencer

Stanhope was another Pre-Raphaelite artist fond of *The Shulamite* as a subject. Perhaps the most interesting comparisons for WAG 2904 are with two French paintings: Gustave Moreau's *Song of Songs* of 1853 (Musée des Beaux Arts, Dijon) and Alexandre Cabanel's *The Shulamite* of 1876 (formerly in the Metropolitan Museum, New York and reproduced in R. Muther, *History of Modern Painting*, 1907, vol. 1, p. 280). The former is extravagant, violent and emotional; the latter is an exotic oriental harem scene.

2 A.L. Baldry, *Albert Moore*, 1894, pp. 20, 32. This analysis is endorsed in Minneapolis Institute of Arts, *Victorian High Renaissance*, 1978, pp. 140–1. Baldry continued: 'The effect of the whole work is refined and subtle without any suggestion of feebleness or lack of variety.' The *Magazine of Art*, 1894, p. xvii, wrote, confirming the early date for WAG 2904:

In the Shulamite Woman, painted in 1864, there is already ample evidence of the artist's power in giving grace and refinement of pose to the figures, and of his wonderful skill in arrangement of draperies, but it may be said to be in harmonious monochrome, and the colour scheme which so distinguished his later work is as yet absent.

Allen Staley in Minneapolis Institute of Arts, *op. cit.*, pp. 25–6, argues that Moore's paintings of the mid-1860s depend on Rossetti's watercolours of the late 1850s; Laing Art Gallery, Newcastle upon Tyne, *Albert Moore and his Contemporaries*, 1972, pp. 5–6, suggests that Moore's principal source was Greek sculpture; Sidney Colvin, however, in 'Albert Moore', *Portfolio*, 1870, p. 5, noted more plausibly the importance of Moore's decorative work in the early 1860s, particularly the *Four Seasons* fresco of 1864 – an opinion confirmed by Gregory Hedberg in Minneapolis Institute of Arts, *op. cit.*, p. 131.

3 *Illustrated London News*, 19 May 1866, p. 498; WAG 2904 was badly hung at the Royal Academy and the *Saturday Review*, 30 June 1866, pp. 782–3, as well as the *Illustrated London News*, 26 May 1866, p. 508, commented on this.

4 *Athenaeum*, 2 June 1866, p. 742. The *Spectator*, 26 May 1866, p. 579, detected in WAG 2904 the 'queenly forms and flowing draperies of the later Greek art', and asked why the Song of Solomon should be illustrated with 'ladies barely clad in the Coa Vestis', but went on to note 'a rare power of composition and sense of beauty which the artist will probably some day cultivate at the fountain head'. Similarly, *The Times*, 22 May 1866, found 'uncommon qualities of style and refinement' in WAG 2904; four years later Colvin, *op. cit.*, described WAG 2904 as 'a lovely listening group of women in faint silver and rose-colour' and even earlier in 1867 he remarked: 'His chief exhibited picture, *The Shulamite*, was hung, with academic discretion where its exquisite draperies, clothing exquisite form, were wholly out of sight' ('English Painters and Painting in 1867', *Fortnightly Review*, 1867, vol. 8, p. 474). Similarly, Whistler particularly admired WAG 2904 when he stayed with Philip Rathbone in 1891, describing it as 'very sweet and really most beautiful' (letter to his wife of 3 August 1891 now in the Glasgow University Library, GUL W588).

5 *Art Journal*, 1866, p. 164.

6 *Fine Arts Quarterly Review*, 1866, New Series, vol. 1, p. 347.

7 It is signed both in monogram and with a Greek anthemion (photograph in Walker Art Gallery).

8 Rathbone also owned Moore's other notable transitional painting, the *Marble Seat* (now lost)

exhibited at the Royal Academy in 1865, see Edward Morris, 'Philip Henry Rathbone and the Purchase of Contemporary Foreign Paintings for the Walker Art Gallery, Liverpool', *Annual Report and Bulletin, Walker Art Gallery, Liverpool*, 1975–6, vol. 6, pp. 59 ff.; Rathbone's comment on Moore is therefore of some interest: 'In Albert Moore we shall have cramped into domestic decoration a genius whose grace of line remains upon private canvases instead of upon public walls, but whose nobility of idea and conception has had absolutely no field for expansion.' ('The Encouragement of Monumental Forms of Art', *Transactions of the National Association for the Advancement of Art, Edinburgh Meeting*, 1889, p. 349)

Shells

WAG 2286
Canvas: 157.5 × 70 cm
Signed with anthemion

Shells was painted as a pendant to Moore's *Sea Gulls*[1] exhibited at the 1871 Royal Academy (520); both were apparently commissioned by F.R. Leyland around 1870.[2] There is a certain general similarity between *Shells* and Leighton's *Greek Girls picking up Pebbles by the Sea* (now lost) of 1871[3] and between *Shells* and Whistler's *Symphony in Blue and Pink*;[4] in 1870, having seen sketches for *Shells* and for *Sea Gulls*, Whistler felt that both his reputation and that of Moore might suffer from this last similarity, but William Eden Nesfield reassured him that this was unlikely.[5] A pastel sketch of 1873 for *Shells* had a rather different and somewhat brighter colour scheme,[6] while a later 1875 version of it, although very close to it, incorporated some ideas from the sketch;[7] in the mid-1870s Moore painted a number of versions of various compositions each with a different colour scheme – illustrating the importance to him of colour.[8]

For *Shells* and for *Sea Gulls* Moore used a powerful fan to create an air current strong enough to lift the draperies and make them flutter in order to make studies for the painting.[9] Traces of the outline drawing made from the cartoon for *Shells* onto the canvas are visible around the figure and drapery.[10] Reviews of *Shells* at the Royal Academy, where it hung as a pendant to Thomas Armstrong's *A Girl Watching a Tortoise*, were

reasonably sympathetic. The *Saturday Review*[11] wrote:

Among other signs of the times are a couple of large single figures hung as companions, the one 'Shells', by Mr. Albert Moore, the other 'A Girl Watching a Tortoise', by Mr. Armstrong. The style and the technique partake of the character of wall decorations as practised in former times. The handling is sketchy as a fresco; the chalky colour is pitched in a light key, the lines are studious of concords, the draperies are diaphanous, revealing the figure as in classic sculpture. We thank these painters for adding to the clever curiosities of the Exhibition; we can ill afford to lose works painted for the sake of an idea.

While the *Athenaeum*[12] recorded:

In the Lecture-Room is Mr. A. Moore's fine piece of decorative art, styled Shells, a noble study of colour – a full-length upright figure of a nymph of a stream – a study of a high kind which should have been better drawn if the artist cared for his own reputation or respected the spectator.

The most appreciative and extensive reviews, however, appeared in the *Art Journal*[13] and the *Pall Mall Gazette*;[14] both critics saw Moore as one of the few contemporary British artists exclusively concerned with beauty of form and colour and the *Art Journal* compared him to Raphael in this respect; both critics also related the formal structure of *Shells* to real life; the *Pall Mall Gazette* critic wrote:

The beauty of the work lies in the new suggestion of grace Mr. Moore has taken from the simple physical movement made to resist the breeze. At the moment chosen the body is turned slightly towards the right, giving a varied and curving line upon the other side. The arms pass one another in almost parallel lines across the figure, the right hand resting on the left shoulder, the left inclining downwards to the right hip, and both employed in keeping the drapery in its place. The drapery itself is carefully studied, but not grandly disposed. One end of the white scarf that is uppermost has been set free by the breeze and flutters loosely behind the head; that upon the body is blown closely so as to follow and cling to the line of the figure. Where the left elbow is thrust a little outwards the lines take a new direction forced into faltering curves by the breeze that comes from below. What first strikes us about the grace of this figure is its certain and simple relation to actual fact. The naive and instructive movement to resist the breeze has been taken by Mr.

Moore as the basis of his composition, and has been treated with such profound artistic consideration that we recognize, as it were, a new attitude that seems to have been chosen only for its grace, and is, nevertheless, made credible and natural by its subtle physical truth. It is this union of the qualities of cultivated form with the elementary and instinctive movements of actual life that gives to Mr. Moore's work its power and distinction. Other painters among us rightly appreciate formal beauty, and carry the recollection of great achievements in art easily and successfully into their own drawing; but Mr. Moore stands almost alone in the power of finding out for himself and in common nature the sources of this ideal loveliness and of thus forging a new and stronger link between art and truth.

The two critics bestowed measured praise on the artist's use of colour; the *Pall Mall Gazette* found Moore's colour harmonies too contrived; the *Art Journal* saw them as technically correct but as lacking imaginative power.

As a contrast to these critics, the *Spectator*[15] in discussing WAG 2286, attacked the very basis of Moore's art:

We wholly decline to accept the theory laid down by some critics, that this action of resistance to the effect of wind and light drapery is by itself a sufficient motive for a large oil picture . . . But the works of the little clique to which these two artists belong would not be what they are without a refined sensibility to certain kinds of beauty which might be exercised in a larger field. What tends to narrow their school and place it in opposition to other departments of Art, is the virtual denial by its supporters that refinement and sensibility may exist in many other matters wherein a painter is called upon to exercise his taste besides those of purely sensuous beauty.

The 'classicism' of Moore's frame for *Shells* is noted by Lynn Roberts.[16]

REPR: *Art Journal*, 1881, p. 163 (showing some variations from WAG 2286 in its present form).

PROV: F.R. Leyland sale, Christie's 28 May 1892, lot 38, bought Gooden (£409); E.M. Denny sale, Christie's 8 May 1925, lot 148, bought Sampson (£68.5s.); presented by George Audley 1926.

EXH: Royal Academy 1874 (936); Grafton Gallery 1894 (157).

Shells WAG 2286

1 Now in the Williamson Art Gallery, Birkenhead (155 × 69 cm).

2 Minneapolis Institute of Arts, *Victorian High Renaissance*, 1978, p. 146; Andrew McLaren Young and others, *The Paintings of James McNeill Whistler*, 1980, p. 49; Leyland certainly showed Whistler Moore's sketches for WAG 2286 and for *Sea Gulls* in 1870 (undated letter from Whistler to Moore, MS Glasgow University Library GUL BP II M/97 (M436); the letter can be dated to about September 1870; see note 5 for the full text).

3 L. and R. Ormond, *Lord Leighton*, 1975, p. 90.

4 Young, *op. cit.*, p. 49, no. 86 (Freer Gallery of Art, Washington, D.C.). M. Wentworth, *James Tissot*, 1984, also sees a similarity between WAG 2286 and Tissot's *October* of 1877 (Montreal Museum of Fine Arts).

5 The letters from Whistler to Moore and from Nesfield to Whistler are in the Glasgow University Library GUL BP II M97/8 (M436 and N20); the former is published in Robin Spencer, *Whistler Retrospective*, 1989, pp. 85–6. The compiler is most grateful to Dr. Nigel Thorp for help with these letters; Whistler was perhaps worried by the sketch for *Sea Gulls* rather than by the sketch for WAG 2286; his letter (1) and that of Nesfield, dated 19 September 1870 (2), follow:

(1) My dear Moore
I have something to say to you which in itself difficult enough to say, is doubly so to write – Indeed for the last few days I have several times sat down to the matter and losing courage given it up – however it must be done at once or set aside forever as your precious time may not be lost – This is an awful opening rather and the affair is scarcely worthy of such solemnity – The way of it is this – First tho' I would like you to feel thoroughly that my esteem for you and admiration for your work are such that nothing could alter my regard and in return I would beg that if I am making an egregious mistake you will be indulgent – and forgive – believe that I do so with great timidity wishing for nothing more than to be put right – and would rather anything than that a strangeness should come about in our friendship through any stupid blundering letter I might write. Well then your two beautiful sketches were shown to me by Leyland, – and while admiring them as you know I must do everything of yours – more than the production of any living man – it struck me dimly – perhaps – and with great hesitation that one of

my sketches of girls on the sea shore, was in motive not unlike your yellow one – of course I don't mean in scheme of color but in general sentiment of movement and in the place of the sea – sky and shore – & c. – Now I would stop here and tear this letter up as I have done others if I were not sure that you could not impute to me self-sufficiency enough to suppose that I could suggest for a moment that any incomplete little note of mine could even unconsciously have remained upon the impression of a man of such boundless imagination and endless power of arrangement as yourself – Also I am encouraged a little to go on and send this to you by my remembering that one day you came to me and told me that it was your intention to paint a certain bathing subject and that you were uncertain whether a former sketch of mine did not treat of the same subject – and thereupon told me that it would annoy you greatly to find yourself at work upon anything that might be in the same strain as that of another – Now what I would propose is that you should go with Billy Nesfield down to my place and together look at the sketch in question (it is hanging up on the wall in the studio) where you will be at once admitted without the necessity of mentioning your purpose – The one I mean is one in blue, green and flesh color of four girls careering along the sea shore, one with a parasol the whole very unfinished and incomplete – But [what] I want you two to see is whether it may be dodged by any suggestion of yours that we may each paint our picture without harming each other in the opinion of those who do not understand us and might be our natural enemies – Or more clearly if after you have painted yours I may still paint mine without suffering from any of the arrangement either of the sea and shore or the mouvement of the figures – If however Nesfield and you find that I am unnecessarily anxious and that I am altogether mistaken I will be more than satisfied and acknowledging my error still hope that you will consider all that I have written unsaid –

Again in every case begging you to excuse anything that may appear to you 'inconvenant' in this letter believe me my dear Moore ever yours affectionately.

(2) My dear Whistler
Albert Moore called here today & we went to Chelsea to examine conscientiously the causes which led to your note to him, which I have read – I must preamble my opinion by stating that as you & Albert have asked me to be arbitrator in this matter I of course take it for granted that my decision is valuable & to be accepted, also that we are all 'in the family' – Thus I strongly feel that you have seen & felt Moore's specialité in his female figures, method of clothing them & use of colored muslin also his hard study of Greek work. Then Moore has thoroughly appreciated & felt your mastery of

painting in a light key – I have such a sincere admiration for you both that this slight awkwardness has considerably worried me – so much so that I have not done a stroke of work today, having considered the matter chez vous, with Moores figure's with me, & I conscientiously think thus – In answer to your question 'could each paint the two pictures without harming each in the opinion of those who do not understand you both' I am quite certain you both may – The effect & treatment are so very wide apart, that there can be no danger from the vulgar fact of there being, shore, sea, & sky & a young woman walking on the foreground – The bare facts that there are in both pictures sea shore & sky might certainly suggest that there was a similarity in the circumstances & sentiment of the two designs.

For the background to this dispute see M.T. Benedetti, 'Whistler e Moore', *Paragone*, 1981, vol. 32, pp. 21–39, no. 375; Benedetti discusses the contribution of Whistler and Moore to the classical revival in England during the 1860s and 1870s.

6 A.L. Baldry, *Albert Moore*, 1894, pp. 42, 46. The sketch is probably the one now in the Fogg Art Museum Cambridge.

7 Baldry, *op. cit.*, pp. 42, 46; the 1875 version was at Christie's (New York) 18 February 1993, lot 135; see Minneapolis Institute of Arts, *op. cit.*, no. 75, and Laing Art Gallery, Newcastle upon Tyne, *Albert Moore and his Contemporaries*, 1972, no. 46, for further details and an exact explanation of the differences in colour between the two versions. The 1875 version was presumably the *Sea Shells* on sale at Agnew's Exchange Art Gallery, Liverpool, 1878 (12) priced at £241.10s.

8 Baldry, *op. cit.*, p. 46; Minneapolis Institute of Arts, *op. cit.*, no. 75. Baldry, *op. cit.*, pp. 73 ff., contains a long account of Moore's working methods; he seems to have worked simultaneously on a number of separate canvases for each composition; this may account for the existence of versions and variants of his paintings; a rather different description of Moore's methods is in W. Graham Robertson, *Time Was*, 1931, p. 61; both Baldry and Robertson were pupils of Moore.

9 Baldry, *op cit.*, pp. 83–4.

10 See Baldry, *op. cit.*, p. 74, for this technique.

11 *Saturday Review*, 9 May 1874, p. 593.

12 *Athenaeum*, 2 May 1874, p. 600.

13 *Art Journal*, 1874, pp. 197–8.

14 *Pall Mall Gazette*, 18 May 1874. The critic was probably Sidney Colvin.

15 *Spectator*, 30 May 1874, p. 691. F.T. Palgrave in the *Academy*, 30 May 1874, p. 615 was also hostile: 'Mr. A. Moore, after promising much manlier and more varied art, has for the present settled into a style of his own.' Palgrave then went on to criticize the narrow range and possibilities in Moore's new style.

16 See Van Gogh Museum, Amsterdam, *In Perfect Harmony, Picture and Frame, 1850–1920*, 1995, p. 70.

A Summer Night

WAG 2125
Canvas: 132 × 228.5 cm
Signed with anthemion

A Summer Night, finished early in 1890[1] but begun much earlier, is generally regarded as the last work by Moore in which formal qualities and the decorative use of colour are paramount; from 1890 onwards he was more concerned with emotion, with drama and with allegory and symbolism.[2] Baldry's analysis of *A Summer Night* as pure form and colour should be quoted:[3]

If not so exquisite in its refinement as Reading Aloud, *nor so amazing in its power as* Midsummer, *it goes further than either of them in its invention, its successful conquest over difficulties of composition and lighting, and in its variety of technical motive. If it has a fault, it is that in arrangement and grouping it is somewhat too formal and deliberate; and betrays to a slight extent the care and ingenuity that he always lavished upon his productions, but which in other pictures are better concealed. In the drawing of both figures and draperies, in brushwork, and in the combination and harmonizing of the different colours, it is admirable, and worthily represents the best phase of his art . . .*

In colour it is mainly an arrangement in flesh colour, yellow, and grey, the yellow running through the paler primrose and buttercup shades up to a definite orange, and the greys ranging from black to the palest silver. The flesh tones are warm and full, creamy rather than silvery, and are juxtaposed with the pale primrose yellow of the draperies wrapped round the legs of the seated figures and thrown over the cushions upon which the centre girl reclines. The brocade of which the covering and valances of the seats are made is of a strong buttercup yellow with orange patterns, and the flowers festooned above are yellow pansies. The lights of the town beyond the lagoon are strong orange red, and, small as they are, serve a valuable purpose in the ordering of the colour. The two extremes of the grey scale are the black fur rug in the centre of the picture, and warm silver, almost white, of the moonlight on the surface of the water. Between the two come the tones of ashy grey in the sky, and in the clouds and distant hills, as well as the dark and light inlaying of the balcony front, of the chest upon which one of the girls is seated, and of the black and silver vase in the right-hand corner of the picture. A slight contrast is made by the dark grey-blue floor inlaid with patterns in yellow-brown; by the green jar filled with silvery seed pods, which stands against the end of the seat; and by a tuft of ivy leaves almost in the centre, breaking the line made by the edge of the fur rug against the floor.

The artist apparently used one of the preliminary drawings for *A Summer Night* as a study for the figure in his *Silver* of 1885–6 and, indeed, that figure is very similar to the figure second from the left in *A Summer Night*.[4]

A Summer Night was reviewed at length when displayed at the 1890 Royal Academy. There was praise for the colour harmonies[5] and for the poses of the figures,[6] but the general composition was criticized[7] as was also the lack of naturalism in the lighting[8] and the quality of the flesh painting.[9]

A squared-up sketch for the whole composition is in the Walker Art Gallery (WAG 8295);[10] the setting broadly follows that in the large painting and the two central figures are similar (but transposed) in sketch and final painting; however, considerable changes were made by the artist to the two figures at either end.

REPR: Liverpool Autumn Exhibition catalogue, 1890, p. 85; photo-engraving made by Franz Hanfstaengl for Thomas McLean 1894;[11] A.L. Baldry, 'Albert Moore', *Studio*, 1894, vol. 3, p. 11.

PROV: Purchased from the artist 1890 (£800).[12]

EXH: Royal Academy 1890 (487); Liverpool Autumn Exhibition 1890 (790); Paris, *Exposition Decennale des Beaux Arts 1889–1900* (*Exposition Universelle*), 1900 (181).

A Summer Night WAG 2125

1 A.L. Baldry, *Albert Moore*, 1894, p. 17. Winslow Homer's *Nuit d'Été* (now Musée d'Orsay, Paris) was also painted in 1890. Baldry, *op. cit.*, p. 59, seems to state that the first preliminary studies for WAG 2125 dated from late 1885.

2 Laing Art Gallery, Newcastle upon Tyne, *Albert Moore and his Contemporaries*, 1972, p. 10; Minneapolis Institute of Arts, *Victorian High Renaissance*, 1978, p. 155; Baldry, *op. cit.*, p. 21. Baldry, *op. cit.*, p. 20, associated this new interest after 1890 in emotion and meaning with a decline in the artist's health and noted that an earlier illness around 1884 had precipitated a similar but more gradual concern in Moore's work with incident and expression; the paintings of 1884–90, wrote Baldry, 'illustrated occurrences, as in *Midsummer* or *Waiting to Cross* or most of all in *A Summer Night*', while the early 1880s was 'a period of absolute repose' in Moore's work. However, the *Art Journal* critic in 1894 (p. 89) saw WAG 2125 as the first of Moore's symbolist and emotional works of the 1890s:

The large canvas, A Summer Night, *was at the Academy in 1890, and marks the commencement of the final stage of his career. For some months previously to the completion of this picture his health had been affected, and the first symptoms of the illness which ultimately caused his death had made themselves perceptible. Strangely enough, with the increase of physical suffering came a modifying of the definiteness of his artistic belief, and a partial reversion to the emotional motives of his earlier works. The* Summer Night *was an awakening from the sublime unconsciousness of the dozen years immediately preceding.*

Baldry evidently disliked Moore's symbolist phase (Baldry, *op. cit.*, pp. 21–2 and, more clearly, in 'Albert Moore', *Art Journal*, 1903, p. 36) and may have been trying to rescue WAG 2125 for an earlier period of Moore's art; his statement that WAG 2125 'illustrated' an 'occurrence' is strange. More 'realistic' interpretations of WAG 2125 are available; Richard Jenkyns in the *Victorians and Ancient*

314

Greece, 1980, p. 325, has tried to localize
A Summer Night in time and place – a hot
Mediterranean evening; in another study of
Victorian classicism, *Dignity and Decadence*, 1991,
p. 277, he argues that 'despite vague intimations
of the Orient . . . Moore invites us into a
glamorous idyll, and bids us to escape with him
to Mediterranean joys'. J.A. Kestner (*Mythology
and Misogyny*, 1989, p. 183) has described the four
figures in WAG 2125 as being in 'various attitudes
of erotic awareness'.

3 Baldry, 1894, *op. cit.*, pp. 63–4. Baldry might
have compared WAG 2125 with Moore's
Lightning and Light of 1892 (Forbes Magazine
Collection); both paintings have a group of
women by a placid sea but also a highly charged
enigmatic atmosphere. Baldry did not indicate
any specific Japanese influence in WAG 2125, but
D.J. Bromfield in 'The Art of Japan in later 19th
Century Europe: Problems of Art Criticism and
Theory', University of Leeds, Ph.D. thesis, 1977,
vol. 2, p. 695, has related the central recumbent
figure in WAG 2125 to Hokusai. The compiler is
indebted to Martin Hopkinson for this reference.

4 Baldry, 1894, *op. cit.*, p. 59; Laing Art Gallery,
op. cit., p. 27, no. 68; *Silver* was at Christie's
25 March 1988, lot 125.

5 Claude Phillips in *Art Journal*, 1890, p. 162, and in
the *Academy*, 10 May 1890, p. 326; *Athenaeum*,
3 May 1890, p. 575; the *Saturday Review*, 10 May
1890, pp. 568–9, however, found the colours 'a
little garish'.

6 *The Times*, 13 June 1890; *Athenaeum*, *op. cit.*; *Art
Journal*, *op. cit.*; M.H. Spielmann in the *Magazine
of Art*, 1890, p. 258.

7 *Athenaeum*, *op. cit.*: 'His notions of composition
seldom rise above the principles of design
inevitable in bas-relief.'

8 *Saturday Review*, *op. cit.*; *Athenaeum*, *op. cit.*; *The
Times*, *op. cit.*; *The Times* also suggested that few
women would wear so little in the open air at
night.

9 *Athenaeum*, *op. cit.*; *Saturday Review*, *op. cit.*; the
critic of the *Magazine of Art* at the 1894 Grafton
Gallery exhibition (1894, p. xvii) remarked that in
WAG 2125: 'The artist has in some measure
departed from his usual decorative and flat
treatment of the figures; and beautiful though the
picture be, the more realistic painting of the flesh
cannot be said to be altogether a gain.' Baldry, *op
cit.*, p. 64, observed that WAG 2125 has 'the
characteristics that make for popular success' and
may have felt that the colours were stronger and
the nudes less statuesque than was usual in
Moore's work.

10 WAG 8295 has been described as having a
photographic base or as being developed from a
photograph, but Baldry, *op. cit.*, p. 74, states that
Moore only used photography for drapery
studies; W. Graham Robertson, *Time Was*, 1931,
p. 61, also refers to photography only in
connection with Moore's drapery studies.

11 The version of WAG 2125 used to make this
engraving was severely damaged by the heat of
the lights employed to photograph it (Mr. Don
Pavey, letter to the compiler, December 1993).

12 Merton Russell-Cotes, the founder of the Russell-
Cotes Art Gallery and Museum in Bournemouth
offered £1000 for WAG 2125 on 17 October 1890.
He intended to hang it in the Royal Bath Hotel,
Bournemouth, which he owned and used for the
display of his collections; however, his wife
believed that the painting would not be liked by
hotel guests and the offer was withdrawn. The
Walker Art Gallery had already offered £800 for
WAG 2125 and the artist eventually accepted this
offer. Russell-Cotes must have been sorry to lose
the picture; he was a personal friend and fervent
admirer of Moore – see his *Home and Abroad*,
1921, vol. 2, pp. 711–20. P.H. Rathbone then
dominated the affairs of the Walker Art Gallery
and his description of WAG 2125 is in his
Impressionism in Art, 1890, p. 9.

Launching the Lifeboat, Coast of Cumberland WAG 2905

MOORE, Henry (1831–1895)
Launching the Lifeboat, Coast of Cumberland

WAG 2905
Canvas: 122 × 213.3 cm
Signed: *H. Moore 1876*

This is one of the artist's early seascapes,
which were notable for their stormy weather;
it is unusual for Moore in that it portrays a
dramatic incident.[1] Critical opinion at the 1876
Royal Academy was mixed; the *Art Journal*[2]
found Moore's painting too large and the
waves rather woolly but conceded that the sea
was very 'true to nature'; the *Spectator*[3]
doubted whether any lifeboat could have been
launched in the manner shown; the *Athen-
aeum*,[4] however, in a long review, praised the
artist's 'amazing vigour', 'characteristic learn-
ing', 'vigour of execution', 'energy of
expression' and 'bold treatment of sea sands
and cloudy air'. Similarly, H.H. Statham[5] in
the *Fortnightly Review* noted that the artist had
subordinated detail to the 'main feeling' and
went on:

*It is this inner consciousness of the artist, this realisa-
tion by him of the pervading feeling of the scene which*
*gives the highest intellectual interest to landscape art,
and constitutes the real excellence of the contemporary
school of French landscape painting in its best form,
which is so little understood in England, although it is
really an amplification and extension of the art of
Constable.*

There seems to have been another, later, ver-
sion of *Launching the Lifeboat* with many differ-
ences in details.[6]
 The locality seems to have been first identi-
fied as Cumberland in 1879.[7]

REPR: H. Blackburn, *Academy Notes*, 1876, p. 41;
G.R. Halkett, *Notes to the Royal Manchester Institu-
tion*, 1878, p. 59; *Art Journal*, 1881, p. 162.

PROV: Presented by Sir Henry Tate[8] 1893.

EXH: Royal Academy 1876 (455) as *A Lifeboat*;
Royal Manchester Institution, *Works of Modern Art-
ists*, 1878 (720) as *A Lifeboat*, price £800; York City
Art Gallery, *Yorkshire Fine Art and Industrial Exhibi-
tion*, 1879 (311) as *Launching the Life Boat, Coast of
Cumberland*, lent by the artist.

1 See York City Art Gallery, *The Moore Family
 Pictures*, 1980, p. 16, for the artist's stormy

316

seascapes of the 1870s; they were invariably based on drawings made by the artist on the spot, and there is a drawing by Moore in the Victoria & Albert Museum (E 3968–1920) inscribed *H. Moore 12 noon Oct. 26th 1875* showing a large group of men pulling a lifeboat ashore; its composition is, however, very different from that of WAG 2905. WAG 2905 seems to have fallen into the category of 'grey sea pictures', according to the classification in F. Maclean, *Henry Moore*, 1906, pp. 65–6. M.H. Spielmann wrote of WAG 2905: '*The Launch of the Lifeboat* was one of the few successes with which he delighted the public otherwise than by his painter's art alone.' (*Magazine of Art*, 1895, p. 379) Moore may have seen Thomas Brooks's *Launching the Lifeboat* (now Ferens Art Gallery, Hull) at the 1868 Royal Academy; it was also reproduced in J. Dafforne, 'Thomas Brooks', *Art Journal*, 1872, p. 197.

2 *Art Journal*, 1876, p. 262.

3 *Spectator*, 1876, p. 680.

4 *Athenaeum*, 29 April 1876, p. 603. W.M. Rossetti, writing in the *Academy*, 27 May 1876, p. 519, also liked WAG 2905: 'painted with all that fullness of knowledge and direct sufficiency of power which characterise the artist'. According to Maclean, *op. cit.*, WAG 2905 was also much praised by the *Daily Telegraph*.

5 H.H. Statham, 'Reflections at the Royal Academy', *Fortnightly Review*, July 1876, vol. 26, pp. 60 ff.

6 E. Rimbault Dibdin, *The Art Gallery of H.H. Maharaja Gaekwar of Baroda*, 1920, p. 26 (photograph in the Witt Library); this version seems to have been signed and dated 1887 and is in the Baroda Museum and Art Gallery, India; it has the subtitle: *Give Way, Men*; Maclean, *op. cit.*, p. 204, lists a *Give Way, Men*, 7 × 4 ft., exhibited at Adelaide 1887, a rough sea piece with a lifeboat being launched through the surf; it was owned in 1905 by Mrs. Luker the artist's daughter; no records survive at Adelaide giving further details of the picture exhibited there in 1887 (Barbara Fargher, letter to the compiler, 5 March 1986). *Lifeboat going out to a Wreck* was exhibited at York Corporation Art Gallery, *The Moore Family Pictures*, 1912 (201) owned by W. Rodman and Co., Ltd. and priced at £31.10s.

7 York City Art Gallery, *Yorkshire Fine Art and Industrial Exhibition*, 1879 (311).

8 Tate owned WAG 2905 by 1881 (*Art Journal*, 1881, p. 164), but at the Manchester and York exhibitions of 1878 and 1879 it was still owned by the artist. The *Architect*, 19 August 1876, p. 104, stated that Henry Moore's *Lifeboat* had been sold from the Royal Academy exhibition for £1050; this seems to have been inaccurate – unless the picture exhibited at Manchester and York in 1878 and 1879 was not WAG 2905 but another version of it. The *Art Journal*, 1893, pp. 68–9, published a list of those paintings offered by Sir Henry Tate to the new Tate Gallery (some of which were declined); WAG 2905 does not appear on that list; see Walter Armstrong, *The Henry Tate Collection*, 1893, pp. 65 ff.

Nearing the Needles: Return of Fine Weather after a Gale

WAG 2906
Canvas: 91.5 × 183.5 cm
Signed: *H. Moore 1888*

This is a larger version of the painting with the same title exhibited at the 1888 Royal Academy (62).[1]

A study of waves (15 × 44.5 cm) by Moore – possibly related to the Walker Art Gallery painting – entitled *Nearing the Needles from the Westward* and inscribed 4 August 1883, was sold at Sotheby's (Belgravia) 16 December 1980, lot 142; another small study (19 × 44 cm) by Moore seems to depict more or less the same view of the Needles from the sea; entitled *Looking towards Cliffs* and dated 2 July 1883, it was sold at Sotheby's (Belgravia) 14 February 1978, lot 23.[2]

At the 1888 Royal Academy the *Athenaeum*[3] had unreserved praise for the Royal Academy version of this composition:

Nearing the Needles *is vigorously and solidly painted so as to secure the utmost breadth and luminosity and, with extreme force and brilliancy, perfect homogeneity . . . Fronting us in the mid-distance, and capped with verdure which is rather low in colour, stretches a long range of white cliffs, gilded by the sun and culminating in a conspicuous pyramidal mass. The sea, generally of the darkest sapphire, rolls in great hollows and foams where the crests turn and fall under the continuing impulse of yesterday's gales. The nearer portion of the sea is darkened by the shadow of a great cloud. This, the sea, the golden cliffs, and the*

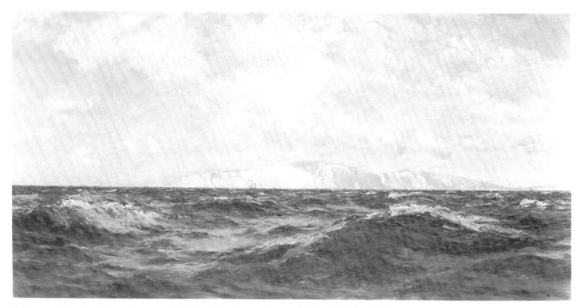

Nearing the Needles: Return of Fine Weather after a Gale WAG 2906

blue sky constitute so many bands of colour, each of which is a treasury of broken tints, but otherwise as massive as it can be. By these means that great breadth which is one of the best qualities of this picture has been secured.

According to Maclean[4] the vaporous clouds suggest past bad weather as the title of the painting indicates. The distant cliffs are those of the Isle of Wight.[5]

PROV: Bought by George Holt from the 1888 Liverpool Autumn Exhibition; presented by him 1889.

EXH: Liverpool Autumn Exhibition 1888 (993) priced at £840.[6]

1 The Royal Academy version is reproduced in H. Blackburn, *Academy Notes*, 1888, p. 25; it measured 61 × 101.5 cm and seems to have differed slightly from WAG 2906, particularly in the waves; it was also dated 1888; reviewing the Royal Academy version, the *Illustrated London News* (5 May 1888, p. 473) wrote: 'Mr. Henry Moore's *Nearing the Needles* is made up of very much the same materials as his great picture of last year but, rich and true as the colouring is, we fail to see in what, except in size, it differs from the original work'; neither, however, of Moore's exhibits at the 1887 Royal Academy (both

reproduced in H. Blackburn, *Academy Notes*, 1887) resembled WAG 2906 or the 1888 Royal Academy version of it. The reproduction of WAG 2906, in F. Maclean, *Henry Moore*, 1905, p. 88, seems to differ slightly from the painting in its present state, particularly in the sky.

2 From 1873 onwards the artist painted extensively from two yachts: *Dawn*, owned by George Burnett, and *Gladys*, owned by a Mr. Gossage; see York City Art Gallery, *The Moore Family Pictures*, 1980, p. 17. According to Maclean, *op. cit.*, p. 88, studies for WAG 2906 were made from George Burnett's yacht while sailing from Cherbourg to the Isle of Wight; these studies passed into the collections of Mrs. Luker (the artist's daughter) and Charles Winn.

3 *Athenaeum*, 5 May 1888, p. 574; other reviews, all praising Moore's picture, are in *Academy*, 9 June 1888, p. 401; *Spectator*, 7 July 1888, p. 933; *Art Journal*, 1888, p. 181 and *Magazine of Art*, 1888, p. 271.

4 Maclean, *op cit.*, p. 88.

5 Maclean, *op. cit.*, p. 88.

6 Holt actually paid £500.

MORGAN, Frederick (1847–1927)

The Pedlar

WAG 45
Canvas: 70.8 × 103.3 cm
Signed: *Fred Morgan 1883*

The artist provided a long description of this painting:[1]

The pedlar is one of those itinerant hawkers of cheap drapery who call at farm houses and display their tempting wares. In this case the farmer, wife and her two daughters are carefully examining a piece of cotton print with a view to a smart dress. The old mother expostulates somewhat earnestly upon the high price charged while the pedlar in his turn protests with equal earnestness that the price is ridiculously low in comparison with the quality of the material. A young farmer looks on with silent wonderment.

David Wilkie's *The Pedlar* of 1814[2] and John Burr's *The Pedlar* of around 1855[3] also show an itinerant pedlar demonstrating his wares to family groups.

PROV: Bought from Arthur Tooth and Sons 1883 (£210).[4]

1 Letter to the Curator, 5 April 1883. The artist seems to have forgotten that he did not include the farmer or his wife in the painting – or possibly these two figures were painted out.

2 Reproduced in J. Dafforne, 'John Burr', *Art Journal*, 1869, p. 337.

3 For full details, see North Carolina Museum of Art, Raleigh, *Sir David Wilkie of Scotland*, 1987, pp. 162–4. Wilkie shows the pedlar in an interior, but, like Morgan, he concentrates on the different expressions and poses of the various participants in the scene.

4 But not shown at either of Tooth's exhibitions in 1883.

MORGAN, John (1823–1885)

Don't 'ee tipty toe

WAG 922
Canvas': 91.5 × 61 cm
Signed: *John Morgan*

The critics at the 1885 Royal Academy exhibition were, understandably perhaps, not very interested in Morgan's painting, but the *Illustrated London News*[2] saw it as one of the most attractive of the minor pictures.

Mr. R. Ropner[3] bought a version of this painting from the artist on 11 August 1885.

PROV: Purchased from the artist 1885 (£120).[4]

EXH: Royal Academy 1885 (433); Liverpool Autumn Exhibition 1885 (311).

The Pedlar WAG 45

1 The canvas was accidentally torn between the Royal Academy and the Liverpool Autumn Exhibition of 1885; it was repaired by the artist.

2 *Illustrated London News*, 23 May 1885, p. 533.

3 Letter to the Curator, 30 November 1936 from Mr. L. Ropner.

4 For the comments of the Curator at the time, Charles Dyall, on this type of painting, see. p. **6**.

Don't 'ee tipty toe WAG 922

MORLAND, James Smith (1846–1921)
The Old Soldier
WAG 2907
Canvas: 91.7 × 138 cm
Signed: *J.S. MORLAND 84*

Between about 1884 and 1887, Morland was living in an artist's colony at Trefriw near Llanwrst in North Wales.[1] This or another village in the area may be the place represented in *The Old Soldier*. The *Magazine of Art*[2] described the painting as 'a good twilight effect with figures'.

PROV: Bought from the artist 1884 (£100).

EXH: Liverpool Autumn Exhibition 1884 (866) with the quotation: 'With martial strains he wins the rustic ear'.

1 Cape Town, South African National Gallery, *J.S. Morland*, 1977, n.p.

2 *Magazine of Art*, 1884, p. xlvii.

The Old Soldier WAG 2907

320

MORRIS, Philip Richard (1836–1902)

The Shepherd of Jerusalem

WAG 2908
Canvas: 246.4 × 108 cm
Signed: *Phil R. Morris*

The Shepherd of Jerusalem is one of a number of genre scenes connected with the Crucifixion which the artist painted early in his career;[1] another example is *Where they Crucified Him* (or *Whereon He died*).[2] The doves flying down on to the cross, the blasted tree, together with the sheep and lambs heedless of the snake in the foreground, were all presumably intended to have symbolic purpose.[3]

The *Art Journal*[4] reviewed the painting kindly in 1871:

Of still nobler purpose is a well-conceived composition, 'The Summit of Calvary', by P.R. MORRIS. A shepherd with his flock, walking on the hill of the Crucifixion, comes to the Cross; he pauses in dismay. The scene is novel and striking: the picture as a sacred drama is most impressive.

The same journal[5] was even more enthusiastic in 1872:

To 'The Summit of Calvary', by P.R. Morris, we referred in our notice last year of the Royal Academy Exhibition; it has since been touched upon, and is here better seen. The Cross is still standing, from which the body of our Lord has been but recently removed. A shepherd has approached the spot, and is looking intently at the writing which was placed over the head of the Saviour. The composition is severe in its exaltation; there is nothing in it that does not help the sacred theme. The shepherd seems to read and think aloud; he and his flock prefigure many shepherds and many flocks. The picture is professedly simple, but it is a result of profound and felicitous thought, and sets forth to the mind a vision of the early history of the Christian Church.

Edward Samuelson owned the 'first study' for the painting.[6]

REPR; *Art Journal*, 1872, p. 163 (engraving by Butterworth and Heath, after a drawing by W.J. Allen, showing considerable differences from WAG 2908);[7] W.H. Simmons (line engraving) for H. Graves and Co., 1873.[8]

The Shepherd of Jerusalem WAG 2908

PROV: Presented by Henry Branston[9] 1881.

EXH: Royal Academy 1871 (1177) as *The Summit of Calvary*; Mr. Hutton's Gallery (168 New Bond Street) 1872.[10]

1 For the popularity of this type in the 19th century, see Maria Poprzecka, 'Le Sacré au Salon', in *Saloni, Gallerie, Musei, etc.*, *Atti del XXIV Congresso Internazionale di Storia dell'Arte*, ed. F. Haskell, 1979, pp. 49–55. James Dafforne, 'Philip Richard Morris', *Art Journal*, 1872, pp. 162–3, described the type as 'semi-religious'. Morris may have known Edwin Landseer's *Shepherd's Prayer* (1845) in which a Belgian shepherd with his flock stands before a Crucifix on the field of Waterloo; Landseer's *Baptismal Font* (1872), another of his religious allegories involving sheep, was originally commissioned by Baroness Burdett-Coutts who also owned Morris's *Shadow of the Cross*; both paintings by Landseer are now in the Royal Collection; see R. Ormond, *Sir Edwin Landseer*, 1981, pp. 187, 218. *Consummatum est* (or *Golgotha*) by J.L. Gérôme of 1867 (Christie's (New York) 1 March 1990, lot 84) was probably the most influential prototype. It is now in the Musée d'Orsay (Paris).

2 Reproduced in *Art Journal*, 1868, p. 200, an 1873 version is in the Sunderland Art Gallery. John Ruskin much admired the picture; see his *Works*, ed. Cook and Wedderburn, 1904–12, vol. 19, pp. 51–2 (*The Cestus of Aglaia* of 1865–6).

3 See Dafforne, *op. cit.*, pp. 162–3, and the review of WAG 2908 in *Art Pictorial and Industrial*, January 1872.

4 *Art Journal*, 1871, p. 178.

5 *Art Journal*, 1872, p. 27.

6 It was exhibited at the Walker Art Gallery, Liverpool, *Grand Loan Exhibition*, 1886 (1482). The artist wrote to Samuelson on 28 November 1881 about WAG 2908:

And with regard to the number of pictures of the same subject, the reason is that at that time I used to make many studies, large and small for my pictures. The one you possess was the first. And the large one now in the Walker Gallery was the Exhibited work in the R.A. of 1871. The Engraved picture was also a study afterwards finished for the Publisher, M. Greaves [sic]. I even made a model in clay but that is in its

native state now. I always liked the thought of the picture but never pleased myself with the technique and for that reason I am sorry it is accepted by the Committee.

7 The engraving in the *Art Journal* of 1872 was presumably made from the study for (or version of) WAG 2908 which appeared as 'lot 130, *The Shepherd of Jerusalem* by P.R. Morris, the engraved picture' in the James S. Virtue sale, Christie's 1 March 1879, bought Fine Art Society (£94.10*s*.)

8 This engraving was made from a 'study afterwards finished for the publisher', see note 6.

9 A maltster in business at Newark-on-Trent.

10 *Art Pictorial and Industrial*, January 1872; *Art Journal*, 1872, p. 27.

The Return from Communion

WAG 669
Canvas: 50.7 × 76.8 cm
Signed: *Phil Morris*

This is a variant of the *Return from Confirmation* exhibited at the Grosvenor Gallery 1883 (127); it differs quite considerably from the Grosvenor Gallery picture – in particular, the third figure in the foreground group of the Walker Art Gallery painting is dressed as a nun in the Grosvenor Gallery version.[1]

PROV; (?) John H. Merchant of 15 London Street, Southport;[2] presented by George Audley 1924.

1 The Grosvenor Gallery picture was reproduced in H. Blackburn, *Grosvenor Notes*, 1883, p. 30, and was engraved by Thomas Brown in the *Art Journal*, 1884, opp. p. 368. These two compositions are entirely different from Morris's *The première Communion, Dieppe*, exhibited at the 1878 Royal Academy (506) and reproduced in the *Magazine of Art*, 1878, p. 44; it was also engraved by Lalauze for *L'Art*, 1878, vol. 14, p. 212, and seems to have been in the collections of A. Hicklin and of Captain Hill of Brighton.

2 Label on back of WAG 669.

Princess Victoria WAG 347

MORRIS, William Bright (1844–1915)
Princess Victoria
WAG 347
Canvas: 32.9 × 25.5 cm

This is a faithful, if slightly generalized, copy after the portrait of Princess, later Queen, Victoria, aged four, painted by S.P. Denning (*c*.1787–1864) and now in the Dulwich Art Gallery. The original was presumably painted in 1823 and this copy in 1904.[1]

PROV: Presented by Henry Yates Thompson 1904.

1 Label on the back of WAG 347. The original entered Dulwich Art Gallery in 1890.

MULLER, Edmund Gustavus (1816–1888)
East Lyn, Lynmouth, North Devon[1]
WAG 3994
Canvas[2]: 43.1 × 84.5 cm
Signed: *E.G. Muller*

Muller exhibited *On the East Lyn, Lymouth, North Devon* at the Liverpool Academy in 1849 (398) and at the Royal Hibernian Academy, Dublin, in 1850 (157), but his address as given on an MS label on the back of the Walker Art Gallery painting ('Redland, Bristol') corresponds with his Bristol address of 1853 onwards (Woodfield Villa, Redland Road or Lower Redland).[3]

The Return from Communion
WAG 669

323

East Lyn, Lynmouth,
North Devon
WAG 3994

PROV: Found in the Gallery about 1960.

1 The title is taken from an old MS label on the
 back of WAG 3994.

2 Label: W.M. Walters, Bold Street, Liverpool,
 frame makers.

3 Francis Greenacre, letter to the compiler,
 22 November 1993, relying on Bristol street
 directories.

Landscape with Old Cottages: Winter WAG 3106

1 James Charles, *Spring Blossom at Ambersham* WAG 855

2 John William Waterhouse, *Echo and Narcissus* WAG 2967

3 George Clausen, *The Golden Barn* WAG 1808

4 Evelyn De Morgan, *Life and Thought emerging from the Tomb* WAG 3074

5 Stanhope Alexander Forbes, *Off to the Fishing Ground* WAG 1638

6 Thomas F. Goodall, *The Bow Net* WAG 2957

7 Thomas Cooper Gotch, *A Pageant of Childhood* WAG 122

8 Hubert von Herkomer, *Eventide: A Scene in the Westminster Union* WAG 751

9 Frederic Leighton, *Study: At a Reading Desk* WAG 258

10 Frederic Leighton, *Elijah in the Wilderness* WAG 147

11 Albert Moore, *The Shulamite* WAG 2904

12 Briton Riviere, *Daniel in the Lions' Den* WAG 2700

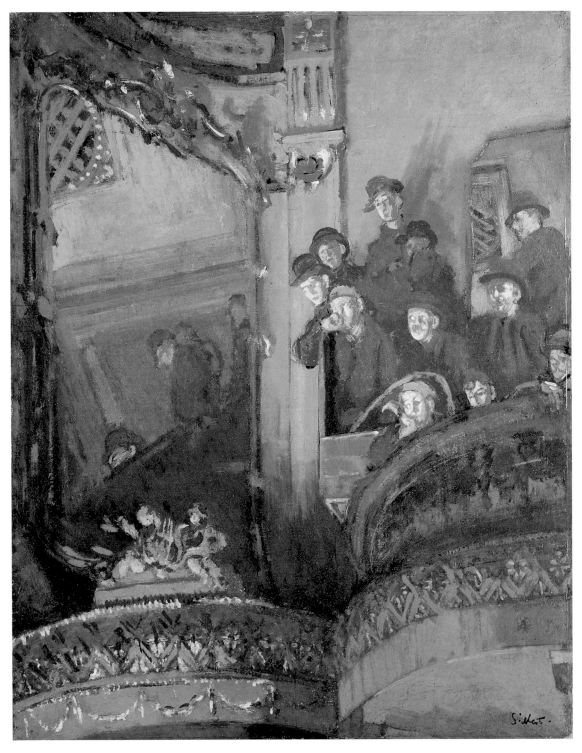

13　Walter Richard Sickert, *The Old Bedford*　WAG 2264

14 Henry Scott Tuke, *The Promise* WAG 675

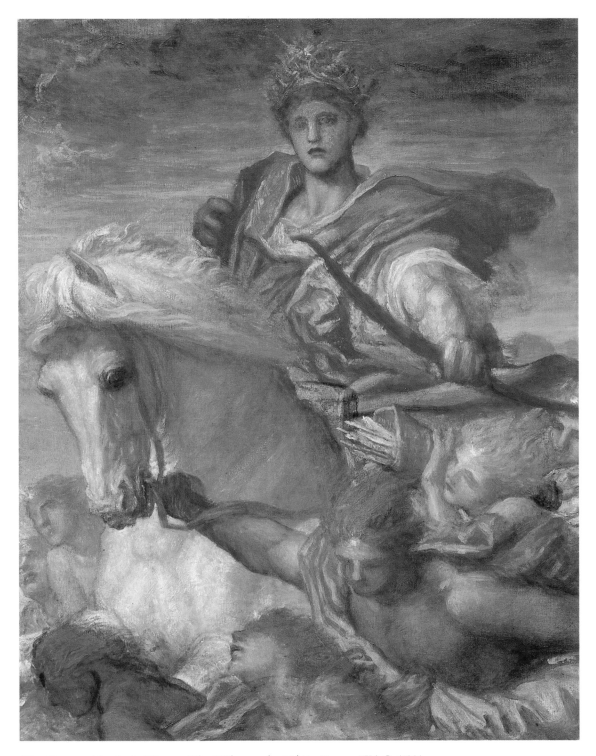

15 George Frederic Watts, *The Rider on the White Horse* WAG 1741

16 Richard Caton Woodville, *Maiwand 1880: Saving the Guns* WAG 140

MULLER, William James (1812–1845)
Landscape with Old Cottages: Winter
WAG 3106
Panel: 26 × 37.2 cm
Signed: *W. Muller 33*

This may be one of the 'snow and hoar-frost pictures with frozen water' which were based on sketches made by Muller among the Norfolk Dykes early in 1831.[1] It seems to be the earliest of his snow scenes and is perhaps the finest; the later winter scenes depend to a large extent on Dutch 17th-century examples rather than on the artist's experience.[2]

PROV: (?) D.W. Acraman;[3] A.T. Hollingsworth sale, Christie's 19 April 1929, lot 164, bought Leggatt (£31.10s.); presented by the executors of F.J. Nettlefold 1948.

EXH: (?) Bristol Institution, *Bristol Society of Artists*, 1834 (146) as *Frost Scene* lent by D.W. Acraman.

1 C.R. Grundy and F.G. Roe, *Catalogue of the Pictures and Drawings in the Collection of F.J. Nettlefold*, 1937, vol. 3, p. 110; N. Neal Solly, *Memoirs of the life of William James Muller*, 1875, pp. 12–13. Other paintings of this type and period include three of 1836, *Winter Scene* (Sotheby's 23 August 1970, lot 198), *Hoar Frost* (Parke Bernet (New York) 7 December 1963, lot 34) and *Norfolk Dyke in Winter* (formerly Mrs. Mander), together with two of 1838, a *Frozen River* (Sotheby's (London) 19 July 1972, lot 118) and *An Extensive Winter Landscape* (Christie's 12 July 1990, lot 20). There is a further list of Muller winter scenes in Bristol Museums and Art Gallery, *W.J. Muller*, 1991, no. 25, pp. 68–9. For Muller's period in Norfolk in 1831 and the supposed influence on him at that time from the Norwich School, see D. Thomas, 'William James Muller and the Norwich Connection', *Connoisseur*, 1978, vol. 197, pp. 78 ff.

2 Bristol Museums and Art Gallery, *op. cit.*, discusses the extent to which Muller's Norfolk and Somerset winter scenes relate to actual landscapes and winters.

3 Bristol Museums and Art Gallery, *op. cit.*

Tivoli
WAG 2124
Canvas: 183.2 × 127.6 cm
Signed: *W. Muller Pinxt / Novbr. 1839*

Muller and G.A. Fripp spent three weeks sketching at Tivoli in December 1834 and January 1835.[1] On his return to England later in 1835 Muller painted from these sketches a considerable number of views of Tivoli, rather in the style of Claude and at considerable speed.[2] This landscape includes in the background the Villa of Maecenas, now known as the Santuario di Ercole Vincitore, and it seems to have been painted from the north-east, perhaps from the Cascatelle Grandi. Various drawings and watercolours by Muller show the villa from the same angle but have different foregrounds: (1) Sotheby's 7 July 1977, lot 157, signed and dated 1835; (2) Sotheby's 26 March 1975, lot 256; (3) Christie's 9 November 1976, lot 97 (watercolour); (4) Fine Art Society 1970; (5) Tate Gallery NO2341. There is also a drawing in the Tate Gallery, *Tivoli: Villa of Maecenas from the North West* (NO2342), related to a painting by Muller which last appeared at Christie's 13 February 1981, lot 193. Muller may have known Richard Wilson's *Tivoli: Villa of Maecenas*, which exists in many versions.[3]

PROV: (?) Mr. Walker sale, Christie's 22 February 1851, lot 97 as *View of Tivoli: Looking to Maecenas's Villa with a noble group of trees in the foreground, upright, one of his finest works*, bought Atherstene (£162.15s.); (?) George Briscoe sale, Christie's 12 May 1860, lot 36 as *Maecenas's Villa, Tivoli*, bought Grundy (£199.10s.); (?) P. Proudfoot sale, Christie's 3 June 1882, lot 114 as *Tivoli 1839*, bought McLean (£357). Purchased from James King, 1 Brown's Building, Liverpool.

1 N. Neal Solly, *Memoirs of the Life of William James Muller*, 1875, pp. 41 ff.

2 Solly, *op. cit.*, pp. 50 ff.; Solly dates most of these paintings to 1835–8; he describes a number of the Tivoli views but none can be identified for certain with WAG 2124; they were mostly upright in format. There is also a list of Muller's Tivoli views in C.G.E. Bunt, *The Life and Works of W.J. Muller*, 1948, p. 108. For Muller's views of the Villa of Maecenas from the north, see Bristol Museums and Art Gallery, *W.J. Muller*, 1991

p. 95, no. 67, which also discusses his work at Tivoli generally.

3 W.G. Constable, *Richard Wilson*, 1953, pp. 225 ff., plates 117–9.

MULLER, William James
(1812–1845) **after**

Alpine Landscape
WAG 276
Canvas: 56.7 × 83.8 cm
Inscribed: *W. Muller 1838*

This is apparently a copy of a painting by Muller entitled *On the Via Mala, Switzerland*, signed and dated 1838.[1] It also represents the same view as a painting in the Bristol City Art Gallery, *An Alpine Scene* (K812),[2] although it differs from it in almost all details.

326

PROV: Colonel Robert Trimble;[3] bought by George Holt from W.G. Herbert; bequeathed by Miss Emma Holt 1944.

1 Sotheby's 26 March 1975, lot 83, and 9 November 1994, lot 109, 53.5 × 85 cm. This may have been the *Via Mala* lent to the 1901 Glasgow Exhibition by Sir J.C. Holder. For Muller's tour in Switzerland in 1834 and the paintings resulting from it, see N. Neal Solly, *Memoirs of the Life of William James Muller*, 1875, pp. 30, 50, and C.G.E. Bunt, *The Life and Works of William James Muller*, 1948, p. 31. The Via Mala leads from Thusis to Splugen along the Rhine; see *John Murray's Handbook for Travellers in Switzerland*, 1838, pp. 206–9.

2 The Bristol painting was entitled *Pic du Midi* at Christie's sale 15 June 1925, lot 129, but simply *An Alpine Scene* at the Birmingham City Art Gallery, *W.J. Muller* exhibition of 1876 (26). The Pic du Midi is near Mont Blanc at the opposite end of Switzerland from the Via Mala. The Bristol painting and its derivatives (including WAG 276) are probably imaginary views; see in particular Bristol Museums and Art Gallery, *W.J. Muller*, 1991, p. 96, no. 69, for a discussion of the topography and of Muller's Continental tour of 1834–5.

3 There were no paintings by Muller at the Colonel Trimble sale, Christie's 25 May 1869.

Young Anglers

WAG 277
Canvas: 58.3 × 46 cm
Signed: *W. Muller 1843*[1]

This is a version of a well-known composition by Muller; other versions include the *Young Anglers* of 1843 formerly in the F.J. Nettlefold Collection;[2] the *Gillingham* of 1845 owned by the Mitchell Galleries in 1947;[3] the *Young Anglers* in the Lady Lever Art Gallery, Port Sunlight (LL 3687);[4] the *Young Anglers* formerly in the Lady Lever Art Gallery (WHL 2800)[5] and the *Gillingham on the Medway* of 1841 now in the Guildhall Art Gallery, London.[6] The Walker Art Gallery painting does not appear to be by Muller himself, but it is very close to the Nettlefold one. The church appears in other Gillingham views of this period by Muller; it may be identifiable with St. Mary Magdalene, Gillingham, but that church, even before its restoration in 1868, differed considerably from the church in *Young Anglers*.[7] Copies and forgeries of Muller's works were circulating as early as 1848.[8]

PROV: Bought by George Holt from Polak probably on 5 August 1882 (£80, plus a picture valued at £200 in exchange); bequeathed by Emma Holt 1944.

1 A 5 appeared beneath the 3 when the painting was cleaned in 1957.

Alpine Landscape WAG 276

2 22 × 16 in.; C.R. Grundy and F.G. Roe, *Catalogue of the Pictures and Drawings in the Collection of F.J. Nettlefold*, 1937, vol. 3, p. 114; this was presumably the *Gillingham: two children fishing in the foreground*, lot 321 in the Sam Mendel sale, Christie's 15 March 1875, bought Agnew (£630) for Sir William Armstrong; his sale, Christie's 24 June 1910, lot 81, bought Gooden and Fox (£210).

3 42 × 36 in.; reproduced in 'Souvenir of the Antique Dealer's Fair', *Connoisseur*, 1947, p. 48, and there stated to have been lot 181 in the John Heugh sale, Christie's 24 April 1874, lot 181, bought Agnew (£2,152.10s.). The Heugh picture, however, was 33 × 54 in. according to the sale catalogue. The Mitchell picture was sold at Christie's 15 April 1988, lot 56.

4 36 × 27¾ in.; see Edward Morris, *Victorian and Edwardian Paintings in the Lady Lever Art Gallery*, 1994, pp. 88–9 (LL 3687).

5 41½ × 33½ in.; see R.R. Tatlock, *A Record of the Collection in the Lady Lever Art Gallery, Port Sunlight*, 1928, vol. 1, p. 107 (there stated to have come from the collection of Lord Northwick and J.H. Standen) and C.G.E. Bunt, *The Life and Works of William James Muller*, 1948, p. 87; it was no. 76 (repr.) in the 1896 Birmingham City Art Gallery, *W.J. Muller* exhibition (there stated to have been formerly owned by Lord Northwick and George Wyatt) and lot 131 in the Joseph Standen sale, Christie's 26 May 1916, bought Gooden and Fox (£252) for W.H. Lever; then it was sold at Christie's 17 March 1961, lot 77, bought Davidge (£115.10s.).

6 42 × 34 in.; Charles Gassiot Bequest. This was probably the version exhibited at the British Institution 1842 (112), 57 × 49 in. including the frame, as *Gillingham on the Medway*. Other *Young Anglers* and *Gillingham* paintings are listed by Bunt, *op. cit.*, and by N. Neal Solly, *Memoirs of the Life of William James Muller*, 1875, but may refer to quite different compositions. The *View at Gillingham with Cottages* of 1841 in the Birmingham City Art Gallery (79'21) is related to WAG 277 but lacks the church and the anglers, while a copy after the composition without the

Young Anglers WAG 277

Cornish Trawlers at Rest WAG 279

anglers was made by Alfred Vickers (*Apollo*, 1934, p. iii – then owned by Vicars Brothers, 23 × 18 in.).

7 Russell Thomson, letter to the compiler, 8 May 1885; W.N. Yates, letter to the compiler, 25 June 1985.

8 See Bristol Museums and Art Gallery, *W.J. Muller*, 1991, p. 126, which argues that the composition reflects the demands of Muller's patrons, public and dealers, rather than his own ambitions.

MUNN, George Frederick (1852–1907)
Cornish Trawlers at Rest
WAG 279
Canvas[1]: 61.5 × 51 cm
Signed: *Geo. F. Munn 1879* (?)

The critics of both the *Athenaeum*[2] and the *Magazine of Art*[3] noted the powerful tones and strong colour effects in this painting. The *Athenaeum*[4] identified the harbour as Whitby despite the title of the painting.

PROV: Bought from the artist by Agnew 1879; sold to George Holt June 1880 (£45); bequeathed by Emma Holt 1944.

EXH: Dudley Gallery 1879 (114) priced at £31.10*s*.

1 Canvas stamp: *LECHERTIER BARBE & CO / 50 REGENT ST / LONDON W.*

2 *Athenaeum*, 29 November 1879, p. 700.

3 *Magazine of Art*, 1879, p. 119.

4 Athenaeum, *op. cit.*

MURRAY, Charles Fairfax (1849–1919)
The Violin Player
WAG 2911
Canvas: 219.7 × 157.5 cm

The artist copied old master paintings for John Ruskin in Italy after his early career with Morris and Co.; the influence of these paintings (particularly those of the early 16th-century Venetian School) is clear in *The Violin Player*.[1] The Aesthetic Movement especially admired Venetian art of this period for its apparent disregard of defined subject and distinct narrative; in his essay, *The School of Giorgione* of 1877,[2] Walter Pater insists on the role of music in Giorgione's art (and indeed in all great art), and *The Violin Player* might have been intended as one of Pater's 'painted idylls' with 'people with intent faces, as if listening, like those described by Plato in an ingenious passage, to detect the smallest interval of musical sound'.[3]

There are two drawings at the Art Museum, Princeton University (New Jersey), each for one of the two figures in *The Violin Player* (accession numbers 48–1474 and 14–1495).

PROV: Presented by R.A. Murray, the artist's son 1926.[4]

EXH: Grosvenor Gallery 1888 (138).

1 J.A. Crowe and G.B. Cavalcaselle, *A History of Painting in North Italy*, 1871, vol. 2, pp. 157–69, contains details of paintings of this period representing music being played or heard. George Bernard Shaw wrote of WAG 2911: 'Mr. Fairfax Murray's *Violin Player* reminds me of Bonifazio but I cannot think of any work of Bonifazio's that reminds me of Mr. Fairfax Murray' (S. Weintraub, *Bernard Shaw on the London Art Scene*, 1989, p. 221). The artist's son, R.A. Murray, wrote to the Curator of the Walker Art Gallery on 24 September 1926 that WAG 2911 'was the only picture of original composition' painted by his father, suggesting that all the others were literal copies; however, the artist exhibited extensively at the Grosvenor Gallery between 1879 and 1888.

2 Published in Walter Pater, *The Renaissance: Studies in Art and Poetry* 1904 edn., pp. 130–54; it contains the famous sentence: 'All art constantly aspires towards the condition of music.'

3 Pater, *op. cit.*, pp. 149, 151.

4 D'Oyly Carte apparently offered the artist £300 for WAG 2911, but the artist refused the offer; earlier D'Oyly Carte had bought Murray's *Concert* for the Palace Theatre (W.S. Spanton, *An Art Student and his Teachers in the Sixties*, 1927, p. 101). D'Oyly Carte insisted on an 'aesthetic' decorative scheme for the Savoy Theatre (opened in 1881) and refused to accept the traditional gold stucco treatment of walls and other surfaces – see François Cellier and Cunningham Bridgeman, *Gilbert, Sullivan and D'Oyly Carte*, 1927, pp. 98–9.

MURRAY, David (1849–1933)
The River Road
WAG 174
Canvas: 126.5 × 182.8 cm
Signed: *DAVID MURRAY / 92*

The critics of the *Saturday Review*,[1] the *Art Journal*[2] and the *Academy*[3] all detected the impact of Corot in the *River Road*. Claude Phillips in the *Academy* thought that Corot's influence 'might have been advantageously carried further in the direction of unity and subordination of non-essential detail', while

the *Art Journal* critic similarly detected 'a certain influence of Corot which we should have been glad to see asserting itself even more strongly'. Both of these critics admired *The River Road*, but the *Saturday Review* wrote: 'Mr. David Murray may be improving, but he improves slowly. If he had advanced somewhat in the *River Road* it must be confessed that his treatment scarcely deserves the magnificent collaboration of nature in providing him with a "motif" fit for Corot.'

REPR: Marion Hepworth Dixon, 'David Murray' *Art Journal*, 1892, p. 144; Pall Mall Gazette, *Pictures of 1892*, p. 82; H. Blackburn, *Academy Notes*, 1892, p. 52; *Royal Academy Pictures*, 1892, p. 45; A. Boulard (etching) for Arthur Tooth and Sons, 3 July 1893.

PROV: George McCulloch[4] sale, Christie's 23 May 1913, lot 80, bought George (£294). Bequeathed by George Audley 1932.[5]

EXH: Royal Academy 1892 (179); Chicago 1893; Royal Academy, *Winter Exhibition*, 1909 (143).

1 *Saturday Review*, 21 May 1892, p. 597.

2 *Art Journal*, 1892, p. 242.

3 *Academy*, 4 June 1892, p. 549. There is also quite a long analysis of WAG 174 in Marion Hepworth Dixon, 'David Murray', *Art Journal*, 1892, p. 148. J.L. Caw in *Scottish Painting*, 1908, p. 305, shrewdly analyses the impact on Murray of French art in the late 1880s.

4 WAG 174 appears in a view of the interior of McCulloch's house (184 Queens Gate, London) reproduced in 'The McCulloch Collection of Modern Art', *Art Journal*, 1909, p. 123.

5 George Audley, *Collection of Pictures*, 1923, p. 41.

The River Road WAG 174

Meadow-sweets WAG 631

Meadow-sweets

WAG 631
Canvas: 122 × 187.5 cm
Signed: *DAVID MURRAY 1893*

Meadow-sweets was hung at the 1893 Royal Academy as a pendant to Murray's *Fir Faggots: A Hampshire Landscape* (now Glasgow Art Gallery and Museum), which is almost exactly the same size.[1]

The critic of the *Athenaeum*[2] commented:

Fiends' Weather: The Clyde
WAG 2910

The Meadow Sweets *of Mr. D. Murray charms us by its silvery greys and greens, the hugeness of its grand bulk of summer clouds, the skill with which the atmosphere is treated, and the well-concealed art of its composition. There is nothing but a slight excess of paint and a few signs of the artist's growing reliance upon his rare gift of felicitous dexterity to impair our pleasure in so fresh and delightful a picture.*

REPR: *Royal Academy Pictures*, 1893, p. 150; Black and White, *Handbook to the Royal Academy*, 1893, p. 66; Liverpool Autumn Exhibition catalogue, 1893, p. 94.

PROV: Purchased from the artist 1893 (£420).

EXH: Royal Academy 1893 (11); Liverpool Autumn Exhibition 1893 (889).

1 A.G. Temple, *The Art of Painting in the Queen's Reign*, 1897, pp. 225–6. H. Blackburn, *Academy Notes*, 1893, p. 1. Leighton's *Farewell* seems to have been in the middle.

2 *Athenaeum*, 10 June 1893, p. 738. J.L. Caw in *Scottish Painting*, 1908, p. 308, noted Murray's 'delight in . . . flowery foreground growths'.

Fiends' Weather: The Clyde

WAG 2910
Canvas: 101.5 × 153 cm
Signed: *DAVID MURRAY 1908*

The critic of the *Athenaeum*[1] observed:

Of the official landscape painters of the Academy Mr. David Murray is the most capable, and his Fiends' Weather, the Clyde, *is a powerful and dramatic painting. It would have been better, perhaps, for a closer parallel between nature's methods and the painter's. The murky veil which gives a lurid intensity to the passage of green and brown in the sky might well have been rendered by some painter's method analogous to that of nature. By building up these strangely poignant hues in two brusquely separate tones of solid paint Mr. Murray has obtained an effect more surprising, but hardly so impressive. No living landscape painter can approach Mr. Murray for cleverness in the difficult task of reconciling the claims of expressive paint and the obvious realism demanded by the public.*

REPR: *Royal Academy Pictures*, 1908, p. 78; Black and White, *Handbook to the Royal Academy*, 1908, p. 73.

PROV: Bequeathed by the artist 1934.

EXH: Royal Academy 1908 (189); Royal Glasgow Institute of the Fine Arts 1913 (461).

1 *Athenaeum*, 9 May 1908, p. 581.

The Heart of the Trossachs

WAG 630
Canvas: 140 × 167.7 cm
Signed: *DAVID MURRAY 1912*

REPR: *Royal Academy Pictures*, 1912, p. 28; Black and White, *Handbook to the Royal Academy*, 1912, p. 44.

PROV: Presented by John William Hughes 1912.

EXH: Royal Academy 1912 (768); Liverpool Autumn Exhibition 1912 (968).

The Heart of the Trossachs WAG 630

Rio Pinelli, Venice

WAG 632
Canvas: 140.3 × 167.8 cm
Signed: *DAVID MURRAY 1913*

The critic of the *Connoisseur*[1] contributed a long review of this painting, comparing Murray to Turner and analysing Murray's use of colour in *Rio Pinelli* in some depth – noting that Murray achieved an effect of intense light without resorting to the use of contrasting dark tones.

The Rio Pinelli is not listed in the principal guides to Venice and the *Connoisseur* critic noted that it was little known to tourists.[2]

REPR: *Royal Academy Pictures*, 1913, p. 147; Pall Mall Magazine, *Pictures of 1913*, 1913, p. 15; Black and White, *Handbook to the Royal Academy*, 1913, p. 68; Liverpool Autumn Exhibition catalogue, 1913, p. 53.

PROV: Presented by John Rankin 1922.

EXH: Royal Academy 1913 (171); Liverpool Autumn Exhibition 1913 (902); Bristol 1921.

1 *Connoisseur*, 1913, vol. 36, p. 57.

2 *Connoisseur, op. cit.*

NAISH, John George (1824–1905)
Boulders at Rest

WAG 2703
Canvas: 106.7 × 153.7 cm
Signed: *J.G. NAISH*

The reviewers of both the *Magazine of Art*[1] and the *Athenaeum*[2] insisted that Naish was providing the geological history of the rocks as well as simply describing them. The *Magazine of Art* wrote:

In his admirably real and forcible rendering of rocks and stones he [Mr. Brett] has a strong rival in Mr. Naish, whose 'Boulders at Rest' may take a place among the truest pieces of painting of the year. The artist has done his work with a fine intelligence and knowledge of the forms of his boulders, of the forces they have endured, and of their history when they were 'at rest'. There is a suggestion about them of the long subsidence of stormy powers which is full of nobility. In his manner of execution Mr. Naish works with an intensity of brilliant detail which is no doubt apparent in nature to any exceptionally strong and long eyesight, but which to ordinary vision seems somewhat more insistent than the natural fact.

The cliffs, rocks and boulders are certainly granite and in general resemble those to be

Rio Pinelli, Venice WAG 632

Boulders at Rest WAG 2703

found in the Land's End area of Cornwall – among other locations.[3]

PROV: Presented by Philip Henry Rathbone 1881.

EXH: Royal Academy 1881 (1352); Liverpool Autumn Exhibition 1881 (111).

1 *Magazine of Art*, 1881, p. 398.

2 *Athenaeum*, 4 June 1881, p. 755, which refers to 'an ancient cliff and the huge granite and slate boulders which the sea left at its foot long ago before it retreated almost out of sight, so that they lie here with lumps of quartz, serpentine and other debris'.

3 Geoffrey Tresise, conversation with the compiler, 2 December 1993.

NIEMANN, Edmund John (1813–1876)
View on the Thames near Maidenhead
WAG 2514
Canvas: 113 × 211.5 cm

The house visible among the distant trees seems to be Sir George Warrender's Cliveden, built in 1824 and burnt down in 1849;[1] Niemann lived in Buckinghamshire from 1839 until 1848 so this is the house with which he would have been familiar.

Two other versions exist; one shows only the left hand half of the composition and differs in a few other details;[2] the other entitled *Cliveden, Maidenhead* shows the same view as in the Walker Art Gallery painting and from the same viewpoint, but has quite different trees in the right foreground as well as other variations in details.[3]

The first version of this composition was probably *The Thames at Maidenhead* which was shown at the Free Exhibition, Hyde Park

Corner, 1848,[4] but the Walker Art Gallery painting was almost certainly no. 1 at the 1858 Liverpool Academy exhibition, and the *Liverpool Mercury*[5] published this review of it:

From its size and position, this landscape challenges attention, conspicuous as it is amongst so many more less pretentious and imposing. It includes equal proportions of land, water, and foliage, and a broad expanse of blue and white sky. A deep, still river, shaded and darkened by the impenetrable foliage of dense forest the entire length of its further bank, is obstructed by a dam, which stretches across from the forest to an island in the centre of the stream, which constitutes the foreground of the picture. Upon this and the dam the artist has expended most care; and his success diminishes as the picture radiates from this centre. In the distance there is an uncertain and unsatisfactory vagueness about the sky and forest, which is not in keeping with the pains evinced by the distinctness and accuracy of the foreground; the mansion commanding the forest and looking down upon the scene reminds one of a ruin; and the limestone side of a hill looks almost like a smudge of white paint amongst the green foliage. There are a compensating placidity, smoothness, and variation of shade in the course of the stream; a redeeming industry in the drawing of the rough woodwork of the dam, and the frothy oozing of the water through its crevices; and, on the whole, careful and judicious treatment about the island foreground, *in the expanded leaves of the water lily and the rustics on the left, the boat aground wherein the three fishermen recline, the wickerwork poultry cage, the drooping, decayed oak, the ledges of stone and rock, and the wild luxuriance of ferns and rushes. It will thus be seen that it is in the broader generalization of distance that the artist displays inequality with his more successful rendering of nearer subjects. Even with the defects named, the work is one above mediocrity, a cheerful landscape, gaining much by the forcible yet harmonious contrast of light and shade; and it gives the artist a* status *as a painter of English scenery.*

PROV: Bought from the 1858 Liverpool Academy by H. Chapple (£30 with another picture);[6] presented by Alexander Baillie Arkle[7] 1878.

EXH: Liverpool Academy 1858 (1) as *View on the Thames near Maidenhead.*

1 William Burn's drawings for the 1824 Cliveden are now at the Royal Institute of British Architects (arc. III, 65–8, wrongly identified as Clifden, Co. Galway; see Royal Institute of British Architects, *Catalogue of the Drawings Collection,* B volume, 1972, pp. 124–5); the scene in WAG 2514 also resembles that in an undated lithograph inscribed *Clifden, Bucks. The seat of the Right Honble. Sir G. Warrender Bart. Drawn on*

View on the Thames near Maidenhead WAG 2514

Stone by *J.D. Harding from a picture by A. Lee. Printed by C. Hullmandel*; this lithograph in particular has the eel traps visible in WAG 2514; Cliveden is about four miles north of Maidenhead and on the east bank of the Thames, which at that point flows south; the compiler is indebted to Christopher Wall for help with these details. A much earlier view of the same stretch of the Thames by Hendrik Frans de Cort (a drawing of 1797) was lot 61 in the Sir John and Lady Witt sale, Sotheby's 19 February 1987.

2 Christie's London 26 April 1974, lot 154.

3 Reproduced in *Country Life*, 10 February 1966, and then owned by Richard Green.

4 See the *Critical Catalogue of some of the principal Pictures painted by the late Edmund J. Niemann*, 1890, n.p. and *Art Union*, 1848, p. 143.

5 *Liverpool Mercury*, 17 September 1858; Niemann's early reputation was established at Liverpool and Manchester exhibitions of around 1844–50 (J. Dafforne, 'The Works of Edmund J. Niemann', *Art Journal*, 1877, pp. 201–4).

6 Liverpool Academy Records, MS Walker Art Gallery.

7 George Arkle lent *Cowley Springs near High Wycombe, Buckinghamshire – Gathering Water Cresses for the London Market* by Niemann to the 1860 Liverpool Society of Fine Arts Exhibition, Supplementary Catalogue, no. 72.

NOBLE, James Campbell (1846–1913)
Sunday Morning
WAG 409
Canvas: 77.1 × 122.5 cm
Signed: *J. Campbell Noble ARSA 1879*

The critic of the *Magazine of Art*[1] mentioned at the 1880 Royal Scottish Academy: 'some striking shipping scenes by Mr. J.C. Noble A.R.S.A., a young artist who has attained great dexterity in rendering the atmospheric buoyancy and lightness of sky effects and who, besides, ranks high as a colourist'. Similarly, G.R. Halkett[2] noted: 'vigorous and effective touches of colour and, as in other works from the same hand, the sky is a specially praiseworthy feature'.

REPR: G.R. Halkett, *Royal Scottish Academy Notes*, 1880, p. 16; G.R. Halkett, *Notes to the Walker Art Gallery*, 1880, p. 45.

PROV: Purchased from the artist 1880 (£105).

EXH: Royal Scottish Academy 1880 (89); Liverpool Autumn Exhibition 1880 (381).

1 *Magazine of Art*, 1880, p. 435.

2 G.R. Halkett, *Royal Scottish Academy Notes*, 1880, p. 16. J.L. Caw, *Scottish Painting*, 1908, p. 309, also describes these shipping and harbour scenes by Noble of the 1880s in some detail. WAG 409 must have been one of the earliest.

A Dutch Scene

WAG 348
Cardboard[1]: 30.2 × 40.7 cm
Signed: *J.C. Noble*

Noble visited Holland for the second time in 1900[2] and most of his Dutch scenes date from 1900 until his death.

PROV: Presented by Mrs. James Campbell Noble 1914.

1 There is a pencil inscription on the back of WAG 348: *Painted by James Campbell Noble RSA. Vouched for by Robert Noble RSA.*

2 J.L. Caw, *Scottish Painting*, 1908, p. 310.

NORTH, John William (1842–1924)
The Morning Moon

WAG 1524
Canvas: 132.7 × 184 cm
Signed: *JWN ARA 1898–1899*[1]

The *Athenaeum* was unable to understand North's poetic evocation of the rural camper's simple life[2] and published a hostile review of this painting:[3]

Mr. J.W. North's quite inexplicable Morning Moon *which suggests, if it does not represent, a very blue stream rushing between rocky and wooded banks and amid impossible mists, the whole being without form, atmosphere or solidity. Ordinary eyes see nothing like this in nature, nor is the picture a beautiful invention.*

North's representation of the campers may reflect his passionate concern for free public access to the countryside.[4]

PROV: Purchased from the artist 1899 (£300).

EXH: Royal Academy 1898 (571); Liverpool Autumn Exhibition 1899 (40).

1 There seems no reason to doubt that WAG 1524 was the *Morning Moon* exhibited at the 1898 Royal Academy, particularly because it has on the back a manuscript label giving this title. The painting must therefore have been re-worked after this exhibition – North's working methods were often laborious and protracted.

2 See particularly, Herbert Alexander, 'John William North', *Old Water-Colour Society's Club Annual Volume*, 1927–8, vol. 5, pp. 48–9. North 'waited until an entrancing moment in the passage of light or some human episode happily related to its surroundings awoke in his heart the ecstasy which is the poetic state'.

The Morning Moon WAG 1524

3 *Athenaeum*, 18 June 1898, p. 797. Alexander, *op. cit.*, p. 48, puts the same point rather differently: 'multitudinous form is conjured by finding and losing it in endless hide and seek till the eye accepts infinity'.

4 Alexander, *op. cit.*, p. 36.

O'NEILL, George Bernard (1828–1917)
Market Day
WAG 282
Panel[1]: 22.5 × 35.6 cm
Signed: *G B O'NEILL*

This is a sketch for, or possibly a version of, the artist's *Market Day*, exhibited at the 1856 Royal Academy and sold first in the John Noott sale (Broadway, Worcestershire), of 1977 (84 × 137 cm)[2] and then at Sotheby's 5 June 1991, lot 142. There are considerable differences between the sketch and the final version.

PROV: Alfred Brooks sale, Christie's 17 May 1879, lot 127, bought Agnew (£105.10*s.*); sold to George Holt October 1879 (£241.10*s.*) (with *Rush Gatherers* by Le Jeune (WAG 260) and another picture in exchange); bequeathed by Emma Holt 1944.

Market Day WAG 282

1 Panel stamp: Dimes and Elam, 91 Great Russell Street, London.

2 *Market Day by G.B. O'Neill 1856* is inscribed on the back of the panel. John Ruskin reviewed the Royal Academy painting as 'a map of a market-day instead of a picture of one' (*Works*, ed. Cook and Wedderburn, 1904–12, vol. 14, p. 60) and Andrew Greg in Central Art Gallery, Wolverhampton, *The Cranbrook Colony*, 1977, n.p., compared it with Frith's panoramas of modern life of the 1850s and 1860s. The Royal Academy picture was engraved by Henry Linton for the *Illustrated London News*, 17 May 1856, p. 529 and reproduced in *Apollo*, 1977, vol. 105, p. 91, as *Market Day: The Arrival of the Hippodrome*.

Mending Dolly

WAG 17
Canvas: 41.6 × 36.4 cm
Signed: *G B O'N / 68*

The background is probably taken, with some alterations, from one of the rooms at Old Willesley, the large 15th to 16th-century timber-framed house in Cranbrook, Kent, which the artist rented between about 1860 and 1890.[1] These quite grand surroundings may have encouraged O'Neill to move away from the direct and naive naturalism of his early work towards period themes and settings and more pretentious subject-matter – although the figures in *Mending Dolly* largely retain his usual simple charm and contempor-

Mending Dolly
WAG 17

ary dress – and there may be a deliberate contrast between an historic interior and child-ish pursuits.[2]

The models for the girls were probably the artist's daughters;[3] the dark-haired one, Constance O'Neill, is believed to have been used by Burne-Jones as a model in his *Golden Stairs* (Tate Gallery).[4]

Over the fireplace is a copy or version of Titian's *The Three Ages of Man* of about 1510–15 (Ellesmere Collection, now on loan to the National Gallery of Scotland) and a portrait similar to work by Holbein is on the adjacent wall.

A version of, or sketch for, *Mending Dolly* (panel, 21.5 × 16.5 cm) was sold as lot 231 by James Thompson at their salerooms in Kirkby Lonsdale on 3 June 1981 as *The Toy Doctor*.

PROV: Sold by the artist to Arthur Tooth on 1 February 1870 (£65);[5] Baroness Burdett-Coutts;[6] presented by George Audley[7] 1925.

1 C. Hussey, 'Old Wilsley', *Country Life*, 2 and 9 July 1948, pp. 26–9, 79–81. Andrew Greg in Central Art Gallery, Wolverhampton, *The Cranbrook Colony*, 1977, n.p., says that the Painted Room at Old Willesley was used, but this does not seem certain. The dates of O'Neill's tenancy of Old Willesley seem to be unclear, but he was undoubtedly there by 1862.

2 See Central Art Gallery, Wolverhampton, *op cit.*

3 Central Art Gallery, Wolverhampton, *op cit.*, nos. 53 and 56. Possibly the model for the boy was one of the artist's three sons, Harry, Frank or Norman, who were born in that order after the three daughters, Constance, Kathleen and Alice (see Derek Hudson, *Norman O'Neill*, 1945, p. 13).

4 Hudson, *op cit.*, p. 15. She is not, however, listed as a model for this painting by John Christian in Arts Council of Great Britain, *Burne-Jones*, 1975, p. 54. She married Cecil Benson.

5 The artist's MS Account Book now in the Victoria & Albert Museum Library (86 HH 19); the purchaser is simply listed as Tooth but must be the dealer Arthur Tooth who bought much of O'Neill's output at this time.

6 George Audley, *Collection of Pictures*, 1923, p. 60; WAG 17 was not, however, at the Baroness Burdett-Coutts sale, Christie's 4–5 May 1922 nor

at the W. Burdett-Coutts sale, Prickett, Ellis, which took place at his house Holly Lodge, West Hill, Highgate on 12–14 December 1921 – unless it was lot 932, *The Umbrella Mender* by O'Neill, at the 1921 sale.

7 Audley, *op cit.*

ORCHARDSON, William Quiller
(1835–1910)
The Chinese Cabinet
WAG 47
Canvas: 65.8 × 53 cm
Signed: *W.O. Orchardson A.R.A. 68*[1]

The Chinese Cabinet is not included in the list of the artist's works drawn up by his daughter in 1930,[2] but she does reproduce it in her book.[3] The model for the figure may have been Ellen Moxon, whom Orchardson married in 1873.[4] Various Oriental cabinets were included in the artist's sale, Gillow's 24–27 May 1910 – for example lots 22 and 60; either might have been used by Orchardson for *The Chinese Cabinet*.

PROV: Purchased from the French Gallery (Wallis and Son) 1925 (£250).

EXH: Liverpool Autumn Exhibition 1925 (936).

1 Orchardson became an Associate of the Royal Academy in 1868.

2 H.O. Gray, *Life of Sir William Quiller Orchardson*, 1930, pp. 11–14; in the late 1860s, Orchardson was exhibiting principally at the Royal Academy and at the winter exhibitions of the French Gallery; WAG 47 does not seem to have been shown at either of these locations.

3 Gray, *op cit.*, opp. p. 120. WAG 47 was no. 16 in Scottish Arts Council, *Sir William Quiller Orchardson*, 1972.

4 Scottish Arts Council, *op. cit.*, no. 18; the same model seems to have been used for the artist's *Her Idol* of about 1868–70 (Manchester City Art Galleries).

OULESS, Walter William (1848–1933)
Henry Stacy Marks
WAG 2574
Canvas: 87.5 × 113 cm

Henry Stacy Marks (1829–1898) studied art under J.M. Leigh and at the Royal Academy Schools. He was a member of the St. John's Wood School (or Clique) but became best known later in his career for his bird paintings. The most famous of these was *Saint Francis Preaches to the Birds* of 1870 (now in the collection of the artist's descendants) and a drawing for this painting – or a version of it – seems to be stuck to the wall behind Marks in this portrait.

Ouless had a studio at 43 Bloomsbury Square in the early 1870s and knew Marks there;[1] it was at this time that Ouless was abandoning subject paintings for portraiture.

The critic of the *Pall Mall Gazette*[2] wrote a long review of the portrait:

Mr. Ouless's execution is not troubled by any technical pecularities. His method is broad and simple, and the scope of his work always clearly defined. He is not, like Mr. Orchardson, specially attracted to his subject by the perception of some happy arrangement of colour, or by a characteristic correspondence between the figure and its surroundings. His aims are more entirely those of an accomplished workman, intent rather upon presenting a vigorous image of his subject as a whole than upon giving special emphasis to a particular aspect of it. Thus, although his painting may miss something of the pictorial unity of Mr. Orchardson's work, it wants nothing in strength and fidelity of portraiture. He possesses so sure a mastery over the means of expression that his portraits always approach very nearly to the force of reality; and we

doubt whether he has ever exhibited a better example of his art than this likeness of a brother artist. It is strong in every quality of sound workmanship. The skilful drawing of every part, the solid modelling of the features, and the effective but unexaggerated disposition of light and shade, render the work altogether remarkable, and in its particular style it will bear comparison with any painting in the exhibition; and, although the painter does not deliberately devise a scheme of colour, there is no want of harmony in the result, while it may be added that his use of colour in imitating the appearances of reality is altogether admirable.

The book held by Marks probably reflects the literary bias of his paintings.[3]

REPR: A.L. Damman (etching, *Portfolio*, 1880, p. 77).

PROV: Bequeathed by Mrs. Henry Stacy Marks 1911.

EXH: Royal Academy 1875 (29); Liverpool Autumn Exhibition 1875 (73); Manchester, *Royal Jubilee Exhibition*, 1887, (346); Liverpool Autumn Exhibition 1894 (1192); Fine Art Society, *Exhibition of Sketches and Drawings of Birds by H.S. Marks*, 1890 (125).

1 B. Webber, *James Orrock*, 1903, vol. 1, p. 44.

2 *Pall Mall Gazette*, 2 June 1875, p. 11. Less interesting reviews were published in the *Saturday Review*, 25 October 1890, p. 481, which noted that even by then 'the pigments have visibly darkened' and in the *Art Journal*, 1875, p. 216. Henry Blackburn in his *Academy Notes*, 1875, p. 7, described WAG 2574 as 'a real portrait of this artist, reclining on a sofa; nearly life size, accurate and full of character'.

3 *Portfolio*, 1880, pp. 78–9, with a long analysis of the portrait.

Henry Stacy Marks WAG 2574

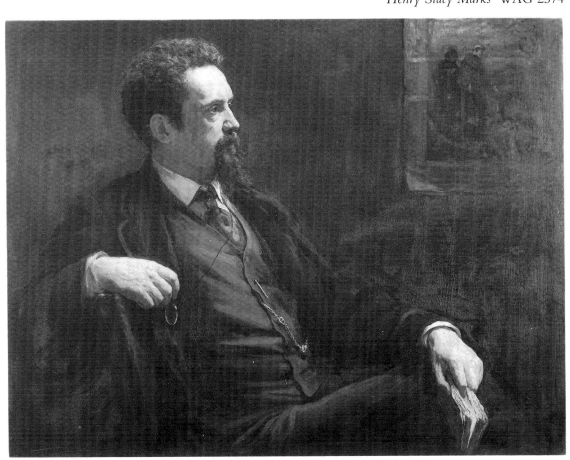

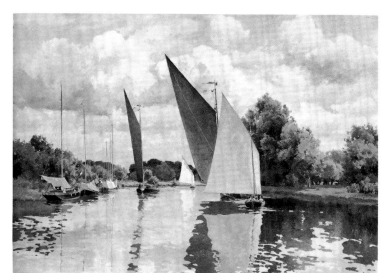

On the Bure at Wroxham
WAG 1535

River Scene with Shepherd and Sheep by a Ferry WAG 6004

PARSONS, Alfred (1847–1920)
On the Bure at Wroxham
WAG 1535
Canvas: 82 × 112.5 cm
Signed: *ALFRED PARSONS*

REPR: Liverpool Autumn Exhibition catalogue, 1910, p. 104.

PROV: Purchased from the artist 1910 (£150).

EXH: Royal Academy 1910 (64); Liverpool Autumn Exhibition 1910 (996).

River Scene with Shepherd and Sheep by a Ferry
WAG 6004
Canvas[1]: 71.8 × 122 cm
Signed: *ALFRED PARSONS*

PROV: Found in the Gallery 1958.[2]

1 There are two illegible canvas stamps on WAG 6004.

2 WAG 6004 may have been in the collection of Colonel W. Pilkington.

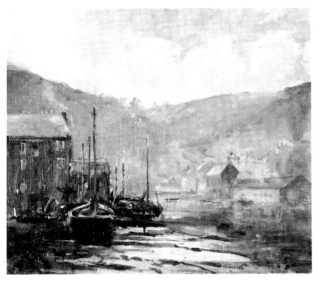

PATERSON, Emily (1855–1934)

Polperro

WAG 476
Canvas: 37.7 × 44.7 cm
Signed: *Emily N. Paterson*

The artist exhibited a Polperro view at the 1931 Royal Scottish Academy – *Outer Harbour, Polperro* (360); this too may therefore be a late work, done when Emily Paterson was mainly preoccupied with flower painting.[1]

PROV: Presented by the artist's family 1935.

EXH: (?) Walker's Galleries, *Works by the late Emily Paterson*, 1935, (1) as *Fishing Boats, Polperro* or (39) as *Polperro* or (42) as *Polperro* or (88) as *Evening Light, Polperro*.

1　There are biographies of the artist in *Walker's Monthly*, February 1935, pp. 1–2, by D.P. Bliss and by Harold Steevens.

PATERSON, James (1854–1932)

The Dean, Edinburgh, Summer Morning

WAG 2708
Canvas: 122.5 × 191.7 cm
Signed: *JAMES PATERSON*

The Dean lies north-west of Edinburgh city centre and is rich in 19th-century warehouses. In the distance can be seen the towers of the Dean orphanage in Belford Road, along which the artist himself resided.

The artist exhibited a watercolour entitled *The Dean, Edinburgh – Early Morning* at the Royal Society of Painters in Water Colours 1920 (no. 150).

PROV: Purchased from the artist 1920 (£200).

EXH: Royal Glasgow Institute of the Fine Arts 1919 (320); Liverpool Autumn Exhibition 1920 (104).

The Dean, Edinburgh, Summer Morning
WAG 2708

345

The Flirt WAG 2675

Dorothy WAG 2626

PATON, Frank (1856–1909)
The Flirt
WAG 2675
Canvas: 50.8 × 61 cm
Signed: *F. Paton / 1880*

Dorothy
WAG 2626
Paper: 28.6 × 36.5 cm

Dorothy
WAG 2619
Canvas: 51.2 × 61.3 cm
Signed: *FRANK PATON 1888*

The Flirt and Dorothy were horses owned and ridden by Lord Wavertree at various amateur races in the late 1870s and 1880s.[1] The smaller version of Dorothy seems to be painted over an engraving.

346

Dorothy WAG 2619

Jewel WAG 10235

PROV: Bequeathed by Lord Wavertree 1933.

1　The names and achievements of these horses are
　engraved on the silver cups, beakers, tankards and
　vases bequeathed by Lord Wavertree to the Walker
　Art Gallery (inv. nos. 3316–3416). H.J.B.
　Dickinson's *Lord Wavertree on Flirt* is also in the
　collection (WAG 2666). For further details about
　Lord Wavertree and his horses, see pp. **236–9**
　(under Jones).

Jewel
WAG 10235
Canvas[1]: 53.3 × 61 cm
Signed: *FRANK PATON 1886*

PROV: Presented by H.M. Government from the
estate of the seventh Countess of Sefton 1982.

1　Canvas stamp: Reeves, 113 Cheapside.

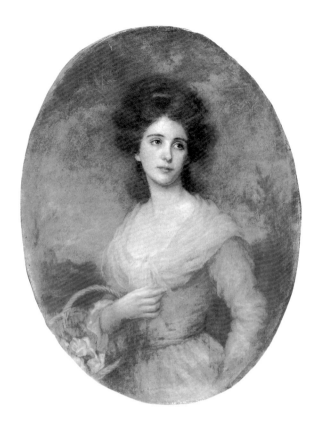

Olivia WAG 2425

PATRY, Edward (1856–1940)
Olivia
WAG 2425
Canvas: 94.7 × 73 cm

REPR: Liverpool Autumn Exhibition catalogue, 1896, p. 103.

PROV: Found in the Gallery 1958.

EXH: Liverpool Autumn Exhibition 1896 (919).

PERUGINI, Charles Edward (1839–1918)
Playing at Work
WAG 284
Canvas: 82.5 × 154.6 cm
Signed: *CEP* (in monogram)

The *Art Journal*[1] critic described Perugini's painting prosaically but accurately:

'Playing at Work' by C.E. PERUGINI, is really very harmonious in colour, and soft and broad in execution. It is remarkable for the entire absence of any disturbing element. The canvas is perhaps too large for the subject, as giving undue importance to incident which had been more agreeably represented on a smaller scale. The scene is a garden, wherein ladies appear to be amusing themselves as supplementary

Playing at Work WAG 284

gardeners. *It is worthy of attention, as alone in the entire collection representing a style of art long gone by, and conveying the impression that the manner of the painter is based on the practice of fresco.*

There is a drawing in the Birmingham City Art Gallery (inv. 68'35) with studies for the figure at the extreme left and for the figure to the right of the one with the wheelbarrow.

PROV; Bought by George Holt from Agnew's October 1872 (£400); bequeathed by Emma Holt 1944.

EXH: Royal Academy 1872 (480); Hulme Hall, Port Sunlight, *An Exhibition to Celebrate the Coronation*, 1902 (12).

1 *Art Journal*, 1872, p. 181; M.H. Spielmann, 'C.E. Perugini', *Magazine of Art*, 1898, p. 462, describes

Playing at Work as a notable work. Thomas Armstrong's *Hay Time* of 1869 (Victoria & Albert Museum) also has fashionable young women ostensibly engaged in manual labour, but Perugini has neither Armstrong's poetry nor his 'artistic' costume.

Faithful

WAG 2710
Canvas: 126.4 × 100.3 cm
Signed: *CP* (in monogram)

The subject was explained by G.R. Halkett:[1] 'An old woman sitting sadly by the grave of her husband, upon which she has strewn fresh flowers.'

PROV: Purchased 1880 (£200).[2]

Faithful WAG 2710

EXH: Liverpool Autumn Exhibition 1879 (577).

1 G.R. Halkett, *Notes to the Walker Art Gallery*, 1879, p. 76. This subject was very unusual for Perugini.

2 Probably from the artist.

Dolce far niente

WAG 2982
Canvas: 119.4 × 138.5 cm
Signed: *CEP* (in monogram)

The *Art Journal*[1] critic at the 1882 Royal Academy commented on *Dolce far niente* thus (with reference presumably to Leighton's *Day Dreams* hanging in the same room):

Hung in the neighbourhood of Sir Frederic's canvases, this picture provokes comparisons which, instead of damaging it, only help to call attention to its beauties. These are, briefly, a clearness of atmosphere and illumination which are not always to be found in decorative work, and an exquisite piece of design in the drapery of the taller figure.

M.H. Spielmann[2] described the painting as 'two Florentine girls in pleasing draperies standing beside a bowl of carnations indolently whiling away their time playing with a snail' – although the sea suggests Perugini's native Naples rather than Florence. Beatrix Potter[3] was more succinct: 'Dolce far niente, C.E. Perugini. Sky rather violent blue, carnations very queer, dresses, particularly red silk, beautifully painted.'

There is a drawing in the Birmingham City Art Gallery for the left-hand figure (inv. 64'35).

REPR: H. Blackburn, *Academy Notes*, 1882, p. 12; Photogravure (Goupil and Co.) 1884 for the Fine Art Society Ltd; M.H. Spielmann, 'C.E. Perugini', *Magazine of Art*, 1898, p. 460.

PROV: Bequeathed by Mrs. Allan of Rosemount, Elmswood Road, Aigburth 1928.

EXH: Royal Academy 1882 (78).

1 *Art Journal*, 1882, p. 179.

2 M.H. Spielmann, 'C.E. Perugini', *Magazine of Art*, 1898, p. 462. Spielmann's general characterization of Perugini's art fits WAG 2982 very well: 'Mr. Perugini is in fact the painter par excellence of the siesta, the recorder in delicate colour and harmonious line of the delights of

Dolce far niente WAG 2982

sweet idleness . . . and is for ever celebrating, with respectful admiration and decorous affection, the veiled charm of modest vestals, the innocent grace and pretty indolence of lovable womanhood.'

3 *The Journal of Beatrix Potter*, ed. Linder, 1966, p. 16.

Peonies

WAG 1622
Canvas: 77.4 × 59 cm
Signed: *CEP* (in monogram)

The critics at the 1887 Royal Academy exhibition noted Perugini's closeness to Leighton in works of this type. Bernard Shaw[1] observed:

'Pretty ladies who wish to be portrayed with waxen cheeks and jellied ear tips may now transfer their patronage [from Leighton] to Mr. C.E. Perugini (see for a dainty sample his *Peonies*).'

Similarly, the *Illustrated London News*[2] wrote:

Mr. Perugini is perhaps the most successful of those who follow the President. His Peonies, *the study of a girl, has all the refinement of his leader's work; it is as even in surface, as delicate in colour and, though wanting in vigour and originality, it often has a poetry of its own.*

Robin Spencer[3] noted Perugini's general adherence to the aesthetic movement and in particular, his use in *Peonies* of a flower's name

to set the mood and establish the key of a painting – with the flower actually in the picture.

REPR: *Art Journal*, 1887, p. 279, fig. 3; H. Blackburn, *Academy Notes*, 1887, p. 38.

PROV: Bought from the artist 1887 (£200).

EXH: Royal Academy 1887 (138); Liverpool Autumn Exhibition 1887 (1117).

1 Stanley Weintraub, *Bernard Shaw on the London Art Scene*, 1989, p. 164 (*The World*, 4 May 1887, p. 562).

2 *Illustrated London News*, 30 April 1887, p. 481.

3 Robin Spencer, *The Aesthetic Movement*, 1972, p. 142. The figure in WAG 1622 plainly wears 'aesthetic dress'.

PETTIE, John (1839–1893)
Scene in the Temple Garden
WAG 2712
Canvas: 124.5 × 185.5 cm
Signed: *J. Pettie*

The subject is taken from Shakespeare's *Henry VI*, Part One, Act Two Scene Four.[1] Richard, Duke of York, in the left foreground, picks a white rose; the Duke of Somerset, at the right, plucks a red rose; the Earl of Warwick, just to the right of the Duke of York, predicts the ensuing Wars of the Roses; the Earl of Suffolk is presumably the figure next to the Duke of Somerset. The other two figures are Vernon and a lawyer. Much later Henry Arthur Payne painted the same subject for the Commons' East Corridor in the Palace of Westminster under the supervision of E.A. Abbey – this commission dated from 1908.[2]

The critics at the 1871 Royal Academy exhibition were sharply divided. The *Art Journal* review was typical of those favourable to Pettie:[3]

Scene in the Temple Garden WAG 2712

J. PETTIE, A.R.A., gives, after his self-reliant manner, verisimilitude to a fictitious 'Scene in the Temple Gardens'. Shakespeare invented this rise of the quarrel of the Roses for the purpose of his drama and Mr. Pettie sees in the imagined scene a subject for a striking picture. Plantaganet, Somerset, Suffolk, Warwick and others are grouped round the red and white rose-trees, supposed to grow in the Temple Gardens. The composition is compact, the situation dramatic, the colour and shade are of sombre depth, which seems to forebode tragedy.

The *Pall Mall Gazette*,[4] however, found the painting 'quite bad with its melodramatic gesture and greasy, green colour', and the *Architect*[5] saw it as 'barely saving Mr. Pettie from mediocrity'. On the other hand, John Ruskin, surprisingly, admired Pettie's picture – it was 'graceful and powerful though too slightly painted'; he would have bought it if he could have afforded it.[6]

Martin Hardie[7] dates the *Scene in the Temple Garden* to 1870. A sketch for it (or possibly a small version of it) seems to have been in the Christie's sales of 24 July 1875 (lot 96) and 2 May 1885 (lot 113); this version (28 × 40 in.) was subsequently owned by J.G. Fenwick and was reproduced by A.G. Temple in 1897[8] – it differs slightly from the Walker Art Gallery version.

REPR: *Graphic*, 6 May 1871, p. 417; *Art Journal*, 1874, p. 132 (engraving by F.A. Heath).

PROV: (?) Humphrey Roberts. (?) Maple and Co. Presented by George Audley[9] 1924.

EXH: Royal Academy 1871 (501); Glasgow Institute of the Fine Arts 1872 (33), priced at £630; (?) Wrexham 1876 (518); (?) Whitechapel Art Gallery, *Winter Exhibition*, 1910 (114); Liverpool Autumn Exhibition 1923 (854).

1 There is a long quotation from Scene Four in the 1871 Royal Academy catalogue.

2 See R.D. Altick, *Paintings from Books*, 1985, pp. 280–1, for other representations of the three parts of *Henry VI*.

3 *Art Journal*, 1871, p. 177. *The Times*, 29 April 1871, praised the grouping and the expressions of the figures. The *Saturday Review*, 20 May 1871, p. 635, compared WAG 2712 favourably with Yeames's *Dr. Harvey and the Children of Charles I.*

Subsequent analysis of the painting was also broadly sympathetic, see *Art Journal*, 1874, p. 132 and A.G, Temple, *The Art of Painting in the Queen's Reign*, 1897, p. 281.

4 *Pall Mall Gazette*, 17 May 1871, p. 12.

5 *Architect*, 20 May 1871, p. 259.

6 John Ruskin, *Works*, ed. Cook and Wedderburn, 1904–12, vol. 20, p. 195 and vol. 37, p. 30 (*Aratra Pentelici* of 1872 and letter to Mrs. Arthur Severn of 29 April 1871).

7 Martin Hardie, *John Pettie*, 1908, pp. 90–1, 224.

8 A.G. Temple, *England's History as pictured by Famous Painters*, 1897, p. 91.

9 George Audley, *Collection of Pictures*, 1923, p. 42.

The Jester's Merry Thought

WAG 2711
Canvas[1]: 153.7 × 118 cm
Signed: *J. Pettie*

Caw[2] listed this costume painting as a product of Pettie's 'whimsical humour'. A monk and a soldier in 16th-century dress are pulling the merry thought (or wishbone) of a fowl; whichever of the two is left with the longer bone, will have his wish granted.[3]

The *Athenaeum*[4] critic liked the painting:

'The Jester's Merry Thought' has a Rabelaisian subject rendered with exceptional 'elan' by Mr. Pettie. The immortal jester, monk, and soldier are taking their repast in the shade of a sandpit. The abundance of life and almost passionate merriment are most aptly expressed by their actions and expressions. The colour is brilliant and very attractive, but might be improved, without loss of the brightness of the picture as a whole, if some of the now isolated parts were massed in tone. At present the bright contrasts confuse the observer and mar the homogeneity of the work. The citron and black of the jester's dress are too strongly contrasted. The crimson velvet and armour of the soldier and the monk's brown frock are capitally painted. The riant faces are characteristic of the accepted types of the personages. This is one of the best costume pictures of the year.

The Jester's Merry Thought WAG 2711

On the other hand, the *Illustrated London News* published a very hostile review:[5]

Mr. Pettie is drifting towards wreck fast, with his bravura of handling, his neglect of gradation, sobriety, repose, drawing and modelling. Is that a worthy theme in No. 471, where we see in the hollow of a blinding bare mess of sandpit, a scarlet clad warrior and a bloated old Franciscan breaking a fowl's breast-bone between them, while a jester sprawls grinning on the ground near the black puddings and other comestibles – hence called 'The Jester's Merrythought'?

A sketch for (or version of) the painting was owned by Fairfax Rhodes in 1908; it measured 31 × 24 in.[6]

REPR: Art Journal, *The McCulloch Collection of Modern Art*, 1909, p. 60.

PROV: J.M. Keiller sale, Christie's 25 May 1895, lot l92, bought Guillem (£409.10*s.*). George McCulloch sale, Christie's 23 May 1913, lot 182, bought Connell (£577.10*s.*).[7] Presented by George Audley 1927.

EXH: Royal Academy 1883 (471); Manchester, *Royal Jubilee Exhibition*, 1887 (100); Royal Academy, *Winter Exhibition*, 1894 (191); Royal Academy, *Winter Exhibition*, 1909 (253); Liverpool Autumn Exhibition 1927 (66).

1 Label: H. Hunt, picture restorers, Southport.

2 J.L. Caw, *Scottish Painting*, 1908, p. 241.

3 Martin Hardie, *John Pettie*, 1908, p. 120.

4 *Athenaeum*, 26 May 1883, p. 674.

5 *Illustrated London News*, 5 May 1883, p. 490.

6 Hardie, *op. cit.*, p. 242; this version was in the Robert Dawber sale, Christie's 25 May 1895, lot 105, bought Gribble (£126).

7 *Buchanan Collection* is inscribed on a Witt Library photograph of WAG 2711.

PHILLIP, John (1817–1867)
The Barefooted Friar
WAG 2713
Canvas: 91.5 × 71 cm
Signed: *J. Phillip 1842*

The artist quoted these lines from Scott's *Ivanhoe* of 1820 in the 1842 Liverpool Academy catalogue:

*The Friar has walked out, and where'er he has
 gone,
The land and its fatness is mark'd for his own;
He can roam where he lists, he can stop where he
 tires,
For every man's house is the barefooted Friar's.*

These lines are in fact one of the stanzas of the ballad sung by the hermit to the knight in chapter 17; the ballad describes the opulent, carefree life of the barefooted friar in the reign of Richard I.

PROV: Bought by the Liverpool Academy of Arts December 1842;[1] presented by the Liverpool Academy to the Liverpool Town Council 1851;[2] transferred to the Walker Art Gallery 1948.

EXH: Liverpool Academy 1842 (331).

The Barefooted Friar WAG 2713

1 Liverpool Academy, *Minutes of Proceedings*, 20 December 1842; the Academy seems to have used an Art Union prize of £30 for the acquisition.

2 Liverpool Academy, *Minutes of Proceedings*, 14 April 1851; for further details see p. **76** (under Cobbett).

Gypsy Sisters of Seville

WAG 285
Canvas,[1] painted oval: 71 × 56.7 cm
Signed: *18 JP 54* (initials in monogram)

This is one of Phillip's many paintings of Spanish gypsies.[2] Dora Yates[3] noted that the girl on the left has a shawl of red silk edged with black lace, together with a scarf patterned in yellow, and that red, black and yellow are gypsy colours; furthermore, the shawl worn by the girl on the right reminded her of the striped blankets worn by gypsies in 15th to 16th-century Europe.

An identical composition is engraved in the *Illustrated London News* for 27 January 1855, and there described as in the Royal Collection, but no records referring to this picture have been traced in the Windsor Archives and it would in fact seem to represent *Gypsy Sisters of Seville*.

REPR: J. Orrin Smith (engraving) in *Illustrated London News*, 27 January 1855, p. 88 (with a description of the painting).

PROV: Commissioned by George Holt Senior 1854 (150 guineas);[4] Miss Anne Holt, after whose death in 1885, given by Robert Durning Holt to George Holt;[5] bequeathed by Miss Emma Holt 1944.

EXH: International Exhibition 1873 (1217).

1 Label: *LINED (?) Roberson & Co / 51 Long Acre.*

2 J. Dafforne, *Pictures by John Phillip*, n.d., p. 67 – see pp. 21 ff. for Phillip's Spanish gypsy pictures generally; T.O. Barlow, *Catalogue of the Works of John Phillip*, 1873, p. 31, no. 62.

3 Dora E. Yates, 'John Phillip's The Gypsy Sisters', *Journal of the Gypsy Lore Society*, 1968, vol. 47, pp. 1–2.

4 Phillip noted the despatch of this picture in a letter to George Holt Senior, postmarked Liverpool 21 July 1854: 'I forwarded this morning the picture I have had the pleasure of painting for you and hope it will meet with your approval. The subject is "Gypsy Sisters of Seville" and the price is 150 guineas.' (Holt Papers, Walker Art Gallery)

5 On presenting the picture to George Holt in 1885, his brother Robert Durning Holt wrote to him:

It is the particular desire of Lallie and myself that you accept from us the picture of The Gypsy Sisters. We believe there is no picture in the old family collection more intimately associated with the brighter memories of Father and Mother and Anne than this picture and for these associations we hope it will be both valuable and acceptable to you. We hope it will be the right size and colouring for the vacant space over the fireplace in the Garden Vestibule . . .

(Letter dated 1 May 1885, Robert Durning Holt papers deposited in Liverpool Record Office, Liverpool City Libraries)

Students of Salamanca Serenading

WAG 2715
Canvas: 153 × 120 cm
Inscribed: *HAMB* (on one of the students'
hat-bands)

The mule (or donkey) is supposed to have
been painted by Richard Ansdell,[1] indicating a
date of about 1857 for this painting – Ansdell
and Phillip were in Spain together in 1856–7.

Students at Salamanca University were
allowed to sing and make music in the streets
in order to raise money for their studies; they
often wore oilskin cocked hats in which a
wooden spoon was placed.[2] In the hat-band of
one of Phillip's students, appears the Spanish
word 'hambre' (or hunger) to signify the pur-
pose of their 'rag' day. The University of
Salamanca was well known, but Phillip may

have read Washington Irving's story 'The Stu-
dent of Salamanca' in his *Bracebridge Hall* of
1822.

The painting appears to be unfinished; it is
unsigned and does not seem to have been
exhibited while the artist was alive.

PROV: (?) Artist's sale, Christie's 31 May 1867, lot
369, bought G. Earl (£157.10s.).[3] (?) Sewal W.
Barker sale, Christie's 31 May 1875, lot 105,
bought Anerley (£892.10s.) as *Row of Spanish Stu-
dents*. Presented by Benson Rathbone 1880.

1 E. Rimbault Dibdin, 'The Walker Art Gallery',
 Magazine of Art, 1889, p. 16.

2 See Richard Ford, *A Handbook for Travellers in
 Spain*, third edn, 1855, part 2, pp. 517–18. This is
 the guide probably used by Phillip and Ansdell in

1856–7. Ford implies that the custom had fallen into disuse in the 19th century and WAG 2715 may be a 'period picture' rather than a record of a contemporary event seen by Phillip and Ansdell.

3 See J. Dafforne, *Pictures by John Phillip*, n.d., p. 64.

Resting after the Dance
WAG 2714
Canvas: 81.3 × 61cm
Signed: *JP* (in monogram) *1865*

This is one of Phillip's many sketches and paintings of Spanish dancers.[1]

Resting after the Dance WAG 2714

PROV: Alexander Collie sale, Christie's 26 February 1876, lot 148, bought Agnew (£672); David Duncan M.P.; presented in memory of David Duncan by his daughter Mrs. F. Woodsend 1916.

EXH: Leeds National Exhibition 1868 (1185); International Exhibition 1873 (1295).

1 J. Dafforne, *Pictures by John Phillip*, n.d., p. 68; T.O. Barlow, *Catalogue of the Works of John Phillip*, 1873, p. 99, no. 194.

PICKERING, James Langsdale
(1845–1912)
Pan's Sanctuary
WAG 3085
Canvas: 167.8 × 219.8 cm
Signed: *J.L. Pickering*

REPR: *Royal Academy Pictures*, 1908, p. 70; Liverpool Autumn Exhibition catalogue, 1908, p. 86; Pall Mall Magazine, *Pictures of 1908*, p. 80.

Students of Salamanca Serenading WAG 2715

Pan's Sanctuary WAG 3085

Prospero and Miranda WAG 731

358

PROV: Presented by the artist's daughters, Miss Pauline V. Pickering and Mrs. Edna J. Blumberger 1925.

EXH: Royal Academy 1908 (416); Liverpool Autumn Exhibition 1908 (218); Royal Glasgow Institute of the Fine Arts 1909 (89) priced at £500; Crystal Palace, *Festival of Empire Exhibition*, 1911.

A Circassian Girl WAG 2726

PICKERSGILL, Frederick Richard
(1820–1900)

Prospero and Miranda
WAG 731
Canvas[1]: 64.2 × 50.7 cm

Pickersgill exhibited *Miranda, Ferdinand and Prospero* at the 1861 Royal Academy Exhibition (77) and *Ferdinand and Miranda* at the 1863 Exhibition (37),[2] but this painting from *The Tempest* (presumably Act 1 Scene 2, with Prospero relating to his daughter the story of their life) does not seem to have been exhibited;[3] it probably dates, however, from the same period.[4] Severe criticism in periodicals and newspapers discouraged Pickersgill from exhibiting in public after the early 1860s.[5] One of Prospero's books, the source of his power, lies on the ground behind Miranda. Altick[6] notes the popularity of subjects from Act 1 Scene 2 of *The Tempest* among painters of the 19th century.

PROV: Presented by George Audley 1925.[7]

1 Label: Charles Roberson, colourman.

2 This painting was sold at Sotheby's (Belgravia) 24 October 1978, lot 173. The artist seems to have used the same model for Miranda in this painting as in WAG 731.

3 Jean Vialla, *Les Pickersgill-Arundale*, 1983, p. 172.

4 R.D. Altick, *Paintings from Books*, 1985, p. 328.

5 Vialla, *op. cit.*, pp. 81–102.

6 Altick, *op. cit.*, p. 329.

7 George Audley, *Collection of Pictures*, 1923, p. 43.

PICKERSGILL, Henry Hall (1812–1861)
A Circassian Girl
WAG 2726
Canvas: 76 × 63.5 cm

The artist went to Russia in 1843 and remained there for rather more than two years.[1] *A Circassian Girl* probably dates from that period or shortly afterwards. In subject and composition it relates fairly closely to a painting by the artist's father, H.W. Pickersgill – the *Syrian Maid* of 1837 (Tate Gallery).[2]

PROV: Bequeathed by Miss Agnes S. Steele 1903.

1 *Art Journal*, 1861, p. 76 (Obituary); Jean Vialla, *Les Pickersgill-Arundale*, 1983, p. 68.

2 Vialla, *op. cit.*

POINGDESTRE, Charles H.
(active by 1849, died 1905)

Still Life with Boar's Head

WAG 4603
Canvas: 75.5 × 117 cm
Signed: *C.H. Poingdestre / Roma 1869*

The artist was best known for his Italian landscapes around Rome of the 1870s and 1880s, but he did exhibit two still lifes earlier in his career at the British Institution – *Game* in 1849 and *The Sportsman's Spoil* in 1850.

Wild boar, the *cinghiale maremmano*, were fairly common in the 19th century in the marshes of central Italy.

PROV: Found in the Gallery about 1960.

POTTER, Frank Huddlestone (1845–1887)

Embers

WAG 2716
Panel[1]: 51.5 × 33.5 cm

This enigmatic painting was described thus by H.W. Wheeler:[2] 'A girl of about fifteen seated on the edge of an upholstered stool near a fire, her head bent pensively gazing at the embers. It is a charming study full of poetic inspiration.' The artist's MS label on the back notes his address as 205 or 208 Stanhope Street, where he seems to have lived between 1875 and 1882;[3] *Embers* should therefore be dated to those years.

PROV: Purchased from Percy Thomas[4] 1888 (£20).

EXH: Royal Society of British Artists, *Memorial Exhibition*, 1887 (43).

1 Label: Charles Roberson, 99 Long Acre. There is also an MS label signed by the artist stating: 'If this picture is cleaned great care must be taken as the colours are mixed with varnish. Embers. 205 (or 208) Stanhope St N.W.'

2 H.W. Wheeler, 'Frank Huddlestone Potter', *Studio*, 1917–18, vol. 72, p. 152. Most of the artist's work consisted of single figure studies of young girls.

3 See the addresses given by the artist in the Liverpool Autumn Exhibitions and in the Royal Society of British Artists exhibitions.

4 Percy Thomas was an etcher and pupil of Whistler; his father and brother acted as dealers – particularly in Whistler's works; he was also a friend and patron of Potter; see Allen Memorial Art Museum, Oberlin College, *The Stamp of Whistler*, 1977, p. 137 and Wheeler, *op. cit.*, p. 151; ten of the thirty paintings at the artist's 1887 memorial exhibition (see under Exhibited) were then owned by Percy Thomas – including WAG 2716. The Liverpool City Council strongly objected to the purchase of one of Potter's paintings for the Walker Art Gallery (see note 3 under the entry relating to Potter's *Girl with Fan*, below) – the picture objected to may have been *Embers*.

Girl with Fan
WAG 2717
Canvas: 51.5 × 25.7 cm
Signed: *FH Potter* (initials in monogram)

This is one of the many single-figure studies of young girls painted by the artist. Dating is difficult, but the rather similar *Wandering Thoughts*[1] was exhibited at the 1876 Liverpool Autumn Exhibition, while the *Young Girl Reading*, now in York City Art Gallery, also has a similar composition and has been dated to about 1880.[2]

PROV: Philip H. Rathbone;[3] Mrs. Philip H. Rathbone. Presented by Charles E. Ashworth 1924.

EXH: Liverpool Domestic Mission, *Aesthetic Fair Loan Art Collection*, 1896 (24).

1 Sold at Bonham's (London) 3 May 1979, lot 202 and reproduced in the catalogue.

2 York City Art Gallery, *Catalogue of Paintings*, 1974, vol. 3, p. 69.

3 Edmund Rathbone, Philip Rathbone's son and partner in the architectural practice Ware and Rathbone, wrote in the *Aesthetic Fair Loan Art Collection* catalogue (see under Exhibited):

The Liverpool Council strongly objected to the purchasing of one of Mr. Potter's pictures for the

Walker Art Gallery yet nothing could be more beautiful than the quality of tone in this picture; and the way in which the light falls upon the figure, and the way in which the face in shadow is expressed, are very wonderful and artistic.

Girl with Fan WAG 2717

POYNTER, Edward John (1836–1919)
Mercury stealing the Cattle of the Gods
WAG 2718
Canvas: 83.8 × 51.5 cm
Signed: *EJP 1860* (in monogram)

This is presumably the *Mercury with the Cattle of Apollo* begun in Paris in the summer of 1859 and refused at the British Institution in 1860.[1] It is one of the earliest surviving paintings by Poynter and seems to reflect the styles of Charles Gleyre and Frederic Leighton with whom Poynter had studied.

The infant Mercury meets an old man while driving away Apollo's cattle; Mercury warns him not to reveal what he has seen.[2]

PROV: T. King, Baillie Gallery; presented by George Audley 1926.[3]

EXH: Liverpool Domestic Mission, *Aesthetic Fair Loan Art Collection*, 1896 (69), catalogue by Edmund Rathbone; Baillie Gallery, *Simeon Solomon etc.*, 1905–1906 (124); Baillie Gallery, *Liverpool School etc.*, 1906 (not numbered).

1 P.G. Hamerton, 'Edward J. Poynter', *Portfolio*, 1877, p. 12; Malcolm Bell, *The Drawings of Sir E.J. Poynter*, n.d., p. 9; Cosmo Monkhouse, 'Sir Edward J. Poynter', *Easter Art Annual*, 1897, p. 7. The *Art Journal*, 1881, p. 28, however, states that the *Mercury with the Cattle of Apollo* was projected in Paris (presumably in 1859) but painted in London (presumably in 1860).

2 According to Hamerton, *op. cit.*, Poynter's source was Shelley's translation of the Homeric *Hymn to Mercury* (first published 1824); stanza 15 relates how Mercury met the old man. The subject seems to be very uncommon; Claude and other artists illustrated the version of the story related in Ovid's *Metamorphoses* (see A. Pigler, *Barockthemen*, 1974, vol. 2, p. 34).

3 George Audley, *Collection of Pictures*, 1923, p. 43, no. 128.

Mercury stealing the Cattle of the Gods
WAG 2718

Faithful unto Death

WAG 2118
Canvas: 115 × 75.5 cm
Signed: *EJP / 1865* (in monogram)

The 1865 Royal Academy catalogue had this explanation of *Faithful unto Death*:

> In carrying out the excavations near the Herculaneum gate of Pompeii, the skeleton of a soldier in full armour was discovered. Forgotten in the terror and confusion that reigned during the destruction of the city, the sentinel had received no order to quit his post, and while all sought their safety in flight, he remained faithful to his duty, notwithstanding the certain doom which awaited him.[1]

Another possible literary source for *Faithful unto Death* is Edward Bulwer-Lytton's *The Last Days of Pompeii*, 1834, book 5, chapter 6 (describing the flight of Clodius and Diomed from Pompeii by way of the Herculaneum gate):

> The air was still for a few minutes. The lamp from the gate streamed out far and clear: the fugitives hurried on – they passed the Roman sentry; the lightning flashed over his livid face and polished helmet, but his stern features were composed even in their awe! He remained erect and motionless at his post – the hour itself had not animated the machine of the ruthless majesty of Rome into the reasoning and self-acting man! There he stood amidst the clashing elements, he had not received the permission to desert his station and escape!

The artist may have known K.P. Bruloff's large and famous *Destruction of Pompeii* painted in Italy in 1833 and engraved by A.F. Girard; P.F. Poole contributed to the 1865 Royal Academy (162) *A Suburb of the Roman City of Pompeii during the eruption (of 79 A.D.) when the city was buried under showers of ashes from Vesuvius*; to the 1860 Royal Academy he had sent *The Escape of Glaucus and Ione, with the blind girl Nydia from Pompeii* (40).[2] Harriet Hosmer's marble *Pompeian Sentinel*, exactly the same subject as Poynter's painting, seems to have dated from 1866–7 and may have been inspired by it.[3]

Most of the critics at the 1865 Royal Academy were principally concerned with explaining the subject of *Faithful unto Death*. The *Art Journal*,[4] however, described it as the artist's best picture so far and went on: 'Mr. Poynter's

drawing is certain, the articulation of the limbs is sure, the eye and the mouth, firm in form, speak calm resolve. The picture is considerably injured by the unmitigated ardour of the red.'

The Times[5] commented: 'There is only one suggestion we would venture to make to the painter of this very striking picture – that his veteran would have been more impressive if he had given his face more character and less academic regularity.' Holman Hunt[6] was impressed by *Faithful unto Death*, tried to persuade several friends to buy it and eventually attempted to purchase it himself, but was too late.

A reduced version was at Sotheby's 9 June 1994, lot 185,[7] while there is a watercolour version in the Southampton Art Gallery (37.5 × 24.2 cm). The 'original drawing' for *Faithful unto Death* was lot 900 in the Colnaghi sale, Christie's 16 March 1867, bought Haywood or Hayward (£35.14s.) and there were studies for it at the artist's sale, Christie's 19 January 1920, lot 6 (chalk on brown paper), bought Rowell (£4.4s.). A study in black chalk for the painting is now in the Courtauld Institute, Witt Collection (inv. 1112).

REPR: F. Joubert (engraving).[8]

PROV: Purchased by 'an amateur' at the 1865 Royal Academy;[9] presented by Charles Langton 1874.

EXH: Royal Academy 1865 (542); Royal Manchester Institution, *Works of Modern Artists*, 1865 (66).[10]

1 The skeleton had been discovered during the excavations at Pompeii of the late 18th century. Excavations there, however, received a new impetus after the expulsion of the Bourbons from Naples and its incorporation into the new Kingdom of Italy in 1861; this may have drawn Poynter's attention to the subject. *Les fouilles à Pompeii* by Edouard Sain (now Museé d'Orsay, Paris) dates from 1865–6. R.D. Altick, *Paintings from Books*, 1985, p. 462, ignores the archaeological sources for WAG 2118 and concentrates on Bulwer-Lytton's novel, but most paintings taken from the novel emphasize the roles of Nydia, Glaucus and Ione. In 1864 Poynter had exhibited another sentinel picture – *On Guard in the Time of the Pharoahs* (Royal Academy, 277). Joseph Kestner, 'The Representation of Armour and the Construction of Masculinity in Victorian

Painting', *Nineteenth Century Studies*, 1993, vol. 7, p. 2, relates WAG 2118 to the masculine ideal and even to Baden-Powell's *Scouting for Boys*.

2 Nydia, the heroine of Edward Bulwer-Lytton's *The Last Days of Pompeii*, 1834, was the subject of a statue by Randolph Rogers, completed in Rome in 1853 and now in the Art Institute of Chicago; Poynter was in Rome in 1853.

3 Harriet Hosmer, *Letters and Memories*, ed. Carr, 1912, pp. 246 ff. There is an analysis of the significance of the Pompeii theme and a list of pictures representing it in Altick, *op. cit.*, pp. 461 ff. In 1888 Herbert Schmalz exhibited his *Faithful unto Death* at the Royal Academy; it depicted naked Christian girls tied to columns in a Roman arena; they are about to be eaten by lions.

4 *Art Journal*, 1865, p. 166.

5 *The Times*, 8 May 1865. There was also a review in the *Athenaeum*, 13 May 1865, p. 658. The *Reader*, 10 June 1865, p. 663, praised the execution of WAG 2118 but found its treatment too theatrical and the sentinel too similar to 'an English model'.

6 W. Holman Hunt, *Pre-Raphaelitism and the Pre-Raphaelite Brotherhood*, 1905, vol. 2, pp. 218–19. W.M. Rossetti in *Fraser's Magazine*, 1865, pp. 745–6, however, quoted Ruskin's remark on a painting by Tintoretto: 'like all mere firelights that I have ever seen, totally devoid of interest'.

7 This version is signed and dated 1865 and measures 33.7 × 21.6 cm; it was also at Christie's 4 November 1988 lot 163A; Sotheby's (New York) 21 May 1987, lot 409; Christie's 1 June 1984, lot 174 and at Sotheby's (Belgravia) 9 April 1980, lot 50; formerly it was in the Forbes Magazine Collection. Perhaps it was this version that was exhibited at Thomas Agnew and Sons (Liverpool) in 1869, see *Porcupine*, 4 September 1869, p. 218.

8 *Art Journal*, 1886, opp. p. 225. Between 1889 and 1937 the Walker Art Gallery received about ninety applications to reproduce WAG 2118 and it became one of the best-known Victorian paintings; as such its composition and structure were condemned by Roger Fry in a lecture of 1933 (Roger Fry, 'The Double Nature of

Faithful unto Death WAG 2118

Painting', *Apollo*, 1969, vol. 89, pp. 366–7). A poem by Joseph Malins (see J.S. Bratton, *The Victorian Popular Ballad*, 1975, p. 64) was probably inspired by WAG 2118 rather than by Bulwer-Lytton's novel or the discovery of the skeleton; it runs:

> *What of the faithful sentinel?*
> *Undaunted still is he!*
> *There, lava pours, 'midst thunderous roars,*
> *Into the boiling sea;*
> *Here, clouds of burning ashes fall,*
> *And all in terror flee –*
> *Save one, whose grave doth round him rise;*
> *He stands unmoved; and standing – dies!*

The theme of absolute devotion to duty and of total obedience to orders by a military elite had a special appeal to late-Victorian imperialist Britain.

9 Holman Hunt, *op. cit.*; WAG 2118 was no longer for sale when it was exhibited at the Royal Manchester Institution in the autumn of 1865. According to G. Redford, *Art Sales*, 1888, vol. 2, p. 99, WAG 2118 or a version of it was in the Elwyn sale of 1869, bought Worrall (£99.15s.); this sale has not been traced.

10 At this exhibition WAG 2118 won the £50 prize.

Psyche in the Temple of Love
WAG 673

Psyche in the Temple of Love

WAG 673
Canvas: 66.3 × 50.7 cm
Signed: *EJP 1882* (in monogram)

This was apparently painted in the summer of 1882 but not completed until November of that year.[1]

Cupid, having fallen in love with Psyche, brought her to a beautiful palace where he visited her every night but never during the day; here she is shown amusing herself during the day with her emblem, a butterfly.[2]

Psyche in the Temple of Love was not reviewed by the critics of the *Art Journal* or the *Magazine of Art*, but the *Athenaeum*[3] was appreciative:

The visitor will be delighted with the skill and correctness shown in 'Psyche' idling in the palace of Cupid – a figure standing in the full light of a window recess, holding a branch of honeysuckle, and with girlish gravity, watching her own emblem, a butterfly, hovering near the blossoms. Her carnations are unusually warm and clear for Mr. Poynter, and very sweet and girl-like, rounded, and elegantly full like those of fine sculpture. The carnations owe something of their clearness and sweetness of tint to the bright walls of African alabaster, which, enriched with carvings in white marble and classic mouldings, form a vista to a sunlit garden, many stately trees, and a summer sky.

A watercolour *Psyche* was exhibited at the Royal Society of Painters in Water Colours 1884 (170) and a study for the Walker Art Gallery painting – head only – was at Sotheby's (Belgravia) 8 April 1975, lot 47, black chalk, 21.5 × 18 cm.[4]

Cosmo Monkhouse[5] was no doubt thinking of *Psyche in the Temple of Love* (and of *On the Terrace*, see below) when he spoke of Poynter's small, classical highly finished cabinet pictures in the style of Frederic Leighton or of Lawrence Alma-Tadema with 'slightly draped figures of women and children engaged in some simple or playful occupation' and set in 'interiors mostly of Greek or Roman temples, houses and baths, or scenes on marble terraces and steps with sparkling glimpses of sea or landscapes in the distance'.

PROV: This painting was apparently commissioned on behalf of the Liverpool Committee of the Social Science Congress by William Crosfield, P.H.

Rathbone and A. Hornby Lewis in 1876 (£360);[6] in 1882 it was 'presented on behalf of the Local Committee of the Social Science Congress (Meeting in Liverpool, 1876) by William Crosfield Esq., Treasurer, P.H. Rathbone Esq. and A. Hornby Lewis Esq., Hon. Sec'.[7]

EXH: Royal Academy 1883 (191).

1 Letters from Poynter to William Crosfield of 6 and 8 November and of 3 December 1882 (MS Walker Art Gallery).

2 Letter from Poynter to William Crosfield of 20 November 1882 (MS Walker Art Gallery): 'She is supposed to be idling away the time in the Palace of Love – where if you remember she is left alone all day. She is playing with a butterfly, which is the well-known emblem of Psyche.' In 1878 Poynter designed a flagon and basin, both decorated with scenes from the life of Psyche, see Malcolm Bell, *Drawings of Sir E.J. Poynter*, n.d., plates 24 and 26.

3 *Athenaeum*, 5 May 1883, p. 576; there is a less favourable review in the *Illustrated London News*, 5 May 1883, p. 490.

4 Poynter seems to have used the same model in his *A Greek Girl* of 1884 (*Art Journal Easter Annual*, 1897, p. 13 (repr.)) and in his *Diadumene* of 1883 (with Newman Ltd. 1969).

5 Cosmo Monkhouse, *British Contemporary Artists*, 1899, p. 258.

6 Crosfield was one of the Treasurers and Rathbone and Lewis two of the Secretaries of the Local Executive Committee of the Twentieth Annual Congress of the National Association for the Promotion of Social Science; this Congress met in Liverpool in October 1876; one of its five departments was devoted to art and Poynter acted as President of this department (see National Association for the Promotion of Social Science, Twentieth Annual Congress, Liverpool 1876, *Programme of Arrangements*, p. 10); for Poynter's speech at the Congress, see P.G. Hamerton, 'Edward J. Poynter', *Portfolio*, 1877, p. 14. The special subjects for discussion included the improvement of street architecture, the encouragement of mural decorations, the influence of academies and the importance of decorative art and art workmanship in 'all household details'; WAG 673 was presumably

commissioned to commemorate this occasion; in a letter of 6 November 1882 to Crosfield, Poynter referred to WAG 673 as 'the picture which I am commissioned to do for the Liverpool Gallery' (MS Walker Art Gallery); it is not clear whether or not the subject of WAG 673 was specified by Crosfield, Rathbone and Lewis; it seems an odd choice to commemorate a Social Science Congress.

7 *Thirtieth Annual Report of the Committee of the Free Public Library, Museum and Walker Art Gallery*, Liverpool, 1883, p. 31. On 14 November 1882 Poynter wrote to Crosfield: 'Having had no

answer from P.H. Rathbone I was uncertain as to whether after so long a lapse of time the commission was still considered valid' (MS Walker Art Gallery). Poynter's duties as Director of the Art Department at South Kensington between 1875 and 1881 left him little time for painting – see *Dictionary of National Biography*.

On the Terrace
WAG 9097
Canvas: 59.5 × 42.2 cm

The Times[1] and the *Art Journal*[2] praised *On the Terrace* for its 'charm' and 'exquisite detail'; the *Athenaeum*[3] described the figure thus:

Here she enjoys the dolce far niente *of a seat on a marble terrace overlooking a great prospect, while, with a splendidly coloured feather, she is playing with a beetle alighted on her palm-leaf fan. She is very graceful, fair, and ingenuous, and her face is pretty. The marble about her challenges dangerous comparisons with that of Mr. Alma-Tadema, but it is otherwise very good indeed.*

Cosmo Monkhouse[4] also noted a superficial similarity between *On the Terrace* and the work of Alma-Tadema; for the category – established by Monkhouse – to which it belongs, see *Psyche in the Temple of Love*, above. Poynter's *Roman Boat Race* also of 1889 (Sotheby's 10 November 1981, lot 52) has a composition very similar to that of *On the Terrace* and contains the same fan.

REPR: Pall Mall Gazette, *Pictures of 1889*, p. 6; *Royal Academy Pictures*, 1889, p. 45; H. Blackburn, *Academy Notes*, 1889, p. 16.[5] In 1892 a photogravure was published by P. & D. Colnaghi in London and by Stephen Gooden in Washington.[6]

PROV: Max Waechter;[7] bequeathed by Frederic Barnes Waldron 1976.

EXH: Royal Academy 1889 (188); Chicago, *World's Columbian Exposition*, 1893 (British Section: 398).

1 *The Times*, 4 May 1889.

2 *Art Journal*, 1889, p. 188.

3 *Athenaeum*, 18 May 1889, p. 637.

4 Cosmo Monkhouse, 'Sir Edward J. Poynter', *Easter Art Annual*, 1897, p. 22 – WAG 9097 is reproduced on p. 13 as *A Greek Girl*.

5 The 1889 reproductions include a classical frame which WAG 9097 now lacks.

6 Art Gallery of Ontario, Toronto, *Pictures for the Parlour*, 1983, p. 74, no. 70.

7 There is a label on the back of WAG 9097 from the dealer N. Mitchell of 2 and 3 Duke Street, London; he may also have owned WAG 9097 at some time.

PRICE, Julius Mendes (1856/7–1924)
Missed: An Episode of the Rocket Brigade, Scilly Isles
WAG 131
Canvas: 149 × 242.6 cm
Signed: *Julius M. Price 1883*

The artist recalled[1] that in about 1883 he wished to paint an important picture for the Royal Academy; he did a careful sketch, noted the intended dimensions of the final painting and showed it to Frederic Leighton, who suggested that the Royal Academy would hang it if the frame was narrow; accordingly, Price went to the Scilly Isles in the summer of 1883 and painted the Walker Art Gallery picture on the rocks at the edge of the sea at some risk to his own life;[2] despite Leighton's support,[3] the completed picture was not hung at the 1884 Royal Academy through lack of space; Leighton advised Price to submit it again in 1885 as it had not actually been rejected, but the Walker Art Gallery purchased it in the autumn of 1884.[4]

The officer in the foreground is presumably Ambrose White, Chief Officer of the Coastguard Service in the Scilly Isles in 1883;[5] the rocket is of the Boxer type introduced in about 1865.[6] John Dawson Watson had popularized the Coastguard Service as a subject with his *Northumbrian Life Brigade, Man Throwing the Hand Rocket to a Wreck* of 1870[7] and his *Saved* of 1871.[8]

PROV: Purchased from the artist 1884 (£50).

REPR: Undated wood engraving entitled *Did that reach her?* (Witt Library).

EXH: Liverpool Autumn Exhibition 1884 (1165) as *Missed*.

1 J.M. Price, *My Bohemian Days in London* [1914], pp. 96–7. Price exhibited *Un moment d'angoisse* at the 1883 Paris Salon (no. 1980); possibly this was the sketch shown to Leighton – or another ship rescue painting. Slightly earlier he had painted

Missed: An Episode of the Rocket Brigade, Scilly Isles WAG 131

another sea rescue scene at Gorleston, near Great Yarmouth, showing a man on a pier about to throw a rope into a stormy sea – Price, *op. cit.*, p. 60. Price's *All Hands to the Life Boat* was reproduced in the *Illustrated London News*, 26 November 1887, p. 619.

2 This seems barely credible considering the size of WAG 131; it is also strange that the figures in WAG 131 are not wearing oilskins or other protective clothing; the background of WAG 131 shows Peninnis Head, St. Mary's, Isles of Scilly, where the *Criccieth Castle* sank on 9 February 1883 (Enid Malec, letter to the compiler, 19 March 1985).

3 Price, *op. cit.*, pp. 125 ff.; WAG 131 is reproduced opposite p. 128.

4 A remarkable purchase as Price was then little known except to those artists he had met in Paris around 1878–82; Price had been introduced to Leighton by J.L. Gérôme, his Parisian master (J.M. Price, *My Bohemian Days in Paris*, 1913, p. 263).

5 *Navy List*, July 1883, p. 264. He has the stripes of a Royal Navy Lieutenant. The Royal Navy had taken over the Coastguard Service in 1856.

6 For further details, see W. Webb, *Coastguard*, 1976, pp. 62–3, and B. Scarlett, *Shipminder*, 1971, p. 91. A Boxer rocket is illustrated in the Department of Transport leaflet *History of H.M. Coastguard* (T.D. Coppin, letter to the compiler, 23 January 1985).

7 Royal Academy 1870 (174).

8 Royal Academy 1871 (281), now apparently owned by the South Shields Volunteer Life Brigade and reproduced in Webb, *op. cit.*, p. 38, and in Scarlett, *op. cit.*, p. 32; it depicted the rescue of the *Tenterden* at Tynemouth on 2 April 1866, according to Scarlett, *op. cit.*, pp. 86–7.

PRINSEP, Valentine Cameron
(1836–1904)
A Venetian Water Carrier
WAG 1339
Canvas[1]: 87.6 × 49.5 cm
Signed: *VENICE Oct 63 / VCP* (in monogram)

A Venetian Water Carrier WAG 1339

The artist was in Venice in 1860 with Burne-Jones[2] and, to judge from the signature of this painting, returned there in 1863. Indeed, he exhibited a considerable number of Venetian subjects during the 1860s.

PROV: Bequeathed by George Audley 1932.[3]

1 MS label giving the title as *A Venetian Water Girl* and another MS label with title and artist and *FG No 27538.*

2 V.C. Prinsep, 'An Artist's Life in Italy in 1860', *Magazine of Art*, 1904, p. 417.

3 George Audley, *Collection of Pictures*, 1923, p. 44.

Leonora di Mantua
WAG 2723
Canvas: 167.7 × 124 cm

A considerable number of Mantuan duchesses and princesses were called Leonora (or Eleonora). The most celebrated was probably the daughter (1598–1655) of Vincenzo I Gonzaga, Duke of Mantua, who married the Emperor Ferdinand II and was crowned with great pomp and ceremony in Prague in 1627–8.[1] It has been suggested that this painting 'may be a portrait'[2] rather than a historical reconstruction, but there is a distinct similarity between it and the portrait of this Eleonora of 1623 by Justus Sustermans in the Palazzo Pitti.[3]
The *Art Journal* critic[4] remarked:

The figure is of heroic proportions and the yellow robe, in which it is attired, with the green bodice could only produce the effect they do in the hands of a perfect master of his art. That the picture is in character most voluptuous none can dispute but that it is a splendid picture most desirable for a large gallery or town collection few will deny.

PROV: Presented by Philip H. Rathbone and George Holt 1873.[5]

EXH: Liverpool Autumn Exhibition 1873 (188) priced at £315.

1 See C.V. Wedgwood, *The Thirty Years War*, 1957, p. 200. Monteverdi dedicated music to her; her husband sacked her native Mantua in 1630.

2 Leicester Museums and Art Gallery, *The Victorian Vision of Italy*, 1968, p. 13. The author of the Leicester catalogue was presumably seeing WAG 2723 in the tradition of D.G. Rossetti's female figures of this period.

3 Art. Iahn-Rusconi, *La R. Galleria Pitti in Firenze*, 1937, p. 287, no. 203. The portrait was already in the Palazzo Pitti by 1842, when it was reproduced as plate 99 in Luigi Bardi, *L'Imperiale e Reale Galleria Pitti*, 1837–42, vol, 1, plate 99. The portrait of the same sitter by Sustermans at the Kunsthistorisches Museum, Vienna, is also fairly similar to WAG 2723.

4 *Art Journal*, 1873, p. 339.

5 They probably bought it from the Liverpool Autumn Exhibition for the Gallery because it had been painted for the Autumn Exhibition rather than sent on from the London summer exhibitions (see p. **21**).

The Goose Girl

WAG 2722
Canvas: 113 × 143.5 cm

In the fairy tale of the brothers Grimm, the goose girl was in reality a princess; her maid had represented her as only capable of servile jobs, while she herself posed as the princess. The castle of the prince, whom the princess will eventually marry once her maid's deception has been uncovered, is shown in the distance of this painting.

The mother of Wing Commander C.F. Price was the model for the goose girl.[1]

The critic of the *Magazine of Art* at the 1900 Royal Academy exhibition[2] liked the picture, but Frank Rinder, writing for the *Art Journal*,[3] was unenthusiastic.

REPR: *Royal Academy Pictures*, 1900, p. 101.

PROV: Purchased from the artist 1900 (£250).

EXH: Royal Academy 1900 (148); Liverpool Autumn Exhibition 1900 (93).

1 Wing Commander Price, letter to the compiler, 27 November 1966; his mother died in 1965.

2 'Royal Academy', *Magazine of Art*, 1900, p. 388.

3 Frank Rinder, 'Royal Academy of 1900', *Art Journal*, 1900, pp. 161–83.

The Goose Girl WAG 2722

Ophelia WAG 3081

RAE, Henrietta (Mrs. Ernest Normand)
(1859–1928)

Ophelia

WAG 3081
Canvas: 161 × 230 cm
Signed: *H. Rae 1890* (now barely visible)

The subject is taken from Act 4 Scene 5 of
Shakespeare's *Hamlet*; Ophelia is offering rue
to the king and queen; Laertes and the Danes
are in the background.[1]

Ophelia, apparently painted in 1889–90,
caused the artist much trouble – particularly in
the positioning of the heads of the seated king
and queen.[2] It was eventually badly hung at
the 1890 Royal Academy and, as her husband's
Vashti Deposed[3] was also placed in an incon-
spicuous position at that exhibition, both hus-
band and wife, feeling that their ability was
being questioned, went for further instruction

to the Académie Julian in Paris; they remained
there for a few months as students.[4]

The reviews of *Ophelia* at the Royal Acad-
emy were indeed unenthusiastic; the
Athenaeum[5] observed: '*Ophelia*, by Mrs. H.
Rae, and *Vashti Deposed*, by Mr. E. Normand,
hang as pendants to each other, and are far
from being unlike; the former has the more
fibre; each is a melodrama loosely painted, and
not quite worthy of the artist. *Ophelia* is in
this respect the worse of the pair.' The *Maga-
zine of Art*[6] commented that *Ophelia* was a
'fairly novel version of the oft-painted heroine'
and that although 'clever', it was 'distinctly
conventional in character, academic to a
degree, and coldly worked out'.

REPR: *Royal Academy Pictures*, 1890, p. 19; Pall
Mall Gazette, *Pictures of 1890*, p. 50; H. Blackburn,
Academy Notes, 1890, p. 122; Leily Bingen, 'About
Henrietta Rae', *Cassell's Magazine*, 1903, p. 688.

374

PROV: Purchased from the artist 1890 (£300).

EXH: Royal Academy 1890 (1041) as *Ophelia: 'There's rue for you'*; Liverpool Autumn Exhibition 1890 (925).

1 Arthur Fish, *Henrietta Rae*, 1905, p. 56. Charlotte Yeldham, *Women Artists in 19th-Century France and England*, 1984, vol. 3, pp. 118 ff. lists pictures by women artists with Shakespearian subjects of 1880–1900.

2 Fish, *op. cit.*, pp. 56 ff.; she received much contradictory advice from her artist friends over this and kept changing these two heads. A candid account of these arguments is contained in an MS letter from the artist's husband (Ernest Normand) to the Curator of the Walker Art Gallery dated 12 April 1917:

These passages recall to me vividly the heated arguments that ensued during the progress of the picture between Sir W. Richmond and Val Prinsep, our neighbours, who at that date used our studio as a battlefield in which to contest their theories. Richmond contended (and rightly) that the exterior light should dominate, and Prinsep thought it had no business there at all. The limit was reached when a week before sending in day, Richmond, in my absence, mixed a saucerful of black mess, and proceeded to 'make an old master of the picture' by passing this all over the surface. It took me 2 days to remove it and even now I do not doubt there remains traces of this application in the inderstices of the paint. Leighton, who at that date dominated my wife's work, disagreed with the subject and method of execution entirely. Alluding to alterations in the design of the left hand group, he one day sarcastically observed, 'There is still one place where you have not tried the King's head, why not put it on the floor?'

To escape these disagreements husband and wife moved away from Kensington to Upper Norwood in 1893; see F. Rinder, 'Henrietta Rae', *Art Journal*, 1901, p. 305. The artist also had problems with the model for the queen, who objected to posing so close to the (male) model for the king on grounds of propriety; eventually Henrietta Rae had to use male models for both figures but painted the face of the queen later from a female model posing on her own ('Artists' Models', *Strand Magazine*, 1906, vol. 31, p. 623).

3 He was Ernest Normand; *Vashti Deposed* is now in the Oldham Art Gallery.

4 Fish, *op. cit.*, pp. 59 ff.; Fish describes the change in the artist's style occasioned by her French studies.

5 *Athenaeum*, 24 May 1890, p. 678.

6 *Magazine of Art*, 1890, p. 255. R.D. Altick, *Paintings from Books*, 1985, p. 302, notes that WAG 3081 was unusual in showing Ophelia in 'a clear dramatic context' and in portraying Ophelia realistically as an actress of the 1890s.

REID, Flora Macdonald
(active about 1879–1929)

The Last Sacrament: 'Lo we bend the adoring knee'
WAG 2688
Canvas: 96.5 × 151.8 cm
Signed: *Flora M. Reid 95*

This painting is perhaps related to the artist's *The First Communion* of 1894 (Birmingham City Art Gallery). Both pictures show religious themes set amidst everyday street scenes[1] in Bruges,[2] but the Birmingham painting is rather larger. The Liverpool painting does not contain an accurate representation of any part of Bruges, but it does include in the manner of a capriccio the St. John Nepomuc bridge and the Dyver Canal, as well as the famous belfry.'[3]

P.H. Rathbone[4] reviewed *The Last Sacrament* in Liverpool and noted the influence on the artist of Rembrandt's chiaroscuro.

REPR: *Royal Academy Pictures*, 1895, p. 70; H. Blackburn, *Academy Notes*, 1895, p. 52.

PROV: Bought from the artist 1895 (£105).

EXH: Royal Academy 1895 (179); Liverpool Autumn Exhibition 1895 (1058).

1 J.L. Caw in *Scottish Painting*, 1908, p. 283, commented on the artist's liking for 'Continental market places' and for 'bargaining or gossiping groups'.

2 Bruges's famous belfry seems to appear in both paintings.

The Last Sacrament: 'Lo we bend the adoring knee' WAG 2688

3 D. Marechal, letter to the compiler, 25 May 1994.

4 'The Liverpool Autumn Exhibition', *The Sphinx*, 1895–6, vol. 3, p. 34.

REID, John Robertson (1851–1926)
Rival Grandfathers
WAG 413
Canvas: 158.4 × 122.5 cm
Signed: *John R. Reid 84*

Rival Grandfathers was probably painted from the bridge connecting East and West Looe; the fishing boats on the right operated from West Looe, while the schooners on the left are moored off East Looe; the church of St. Nicholas is just visible in the top right-hand corner.[1] The artist seems to have used the same setting for *Jack's Yarn* of 1883[2] and for *The Mate of the Mermaid's Wedding* of 1892.[3] The artist's sister is believed to have been the model for the woman in the painting, while the model for the little girl is stated to have been Mary Ann Rostock, born in April 1874.[4]

Henry Detmold's *A Glimpse of Future Seas*[5] of 1889 has a similar child and telescope theme.

The critics noted Reid's reliance on contemporary French art and the anecdotal quality in the painting. Claude Phillips[6] wrote:

Very successful in its way is The Rival Grandfathers *by Mr. J.R. Reid, who, without losing his English individuality, has, in some respects, profited by the example of the modern French school as regards technique. Two old fishermen compete for the notice of a little girl, their grandchild, to whom they are exhibiting the wonders of a telescope, while her mother stands looking on. The background is one of calm sea and coast upon which the figures have hardly sufficient relief. The quaint simplicity of the subject and the skill and truth of the rendering are alike to be commended; but exception must be taken to the general scheme of colour – almost entirely a combination of blue and green, which on so large a scale is anything but agreeable.*

The critic of the *Athenaeum*[7] was also worried by the blue tonality: 'In *Rival Grandfathers* Mr. J.R. Reid has depicted, with a coarse sort of energy and effective handling a little girl

waited on by two old fishermen. It may be called a heavy exercise of the Impressionist School in unclear blues.'

The *Spectator*[8] disliked the subject:

Mr. J.R. Reid's Rival Grandfathers *is much the same as was his last year's picture, with the same faults, and the same merits – we might almost say the same subject. The work is good and strong, though a little defective in delicacy, and the motive of the picture is feeble. There is a sort of over-domesticity about Mr. Reid's work which is very apt to tire the spectator – like literature of the Band of Hope style, one seems to smell a moral in everything.*

The handling of paint and use of colour in this painting now seems very free and arbitrary, reminiscent more of William McTaggart than of the pupils of Bastien-Lepage. Reid had studied under McTaggart, but if one compares *Rival Grandfathers* in its present state with the reproductions of it made in 1884,[9] it is clear that it has suffered severe damage – probably during re-lining in 1914 – and that it was originally more carefully harmonized and less raw in appearance.

REPR: *Magazine of Art*, 1884, p. 445; H. Blackburn, *Grosvenor Notes*, 1884, p. 9.

PROV: Bought from the artist 1884 (£500).

EXH: Grosvenor Gallery 1884 (35); Liverpool Autumn Exhibition 1884 (665); Berlin International Exhibition 1886; Paris, *Exposition Universelle*, 1889 (134).

Rival Grandfathers WAG 413

1 H.L. Douch, letter to the compiler, 15 November 1985. The branch railway line between Looe and Liskeard opened to passengers in 1879. Looe's narrow vertiginous streets were seen by contemporaries as romantic and picturesque – but as well behind Newlyn in this respect; see for example, *Murray's Handbook for Devon and Cornwall*, 1859 edn., pp. 189, 263.

2 Reproduced in G.R. Halkett, 'John R. Reid', *Art Journal*, 1884, p. 266.

3 Reproduced in *Royal Academy Pictures*, 1892, p. 157.

4 Mrs. A. Evans, letter to the compiler, 11 August 1972; she confirms that Reid painted a number of other inhabitants of Looe at this time. Mrs. Lynn Simpson, letter to the compiler, 1 November 1994, gave further details.

5 Reproduced in the *Graphic*, 19 October 1889, p. 469.

6 *Academy*, 17 May 1884, pp. 354–5.

7 *Athenaeum*, 10 May 1884, p. 603.

8 *Spectator*, 17 May 1884, p. 649. For other reviews, see Halkett, *op. cit.*, p. 267; *Magazine of Art*, 1884, pp. xxix and 443 ff.

9 See Reproduced.

RICHMOND, William Blake (1842–1921)
Venus and Anchises
WAG 3082
Canvas: 148.6 × 296.5 cm

Instigated by Jupiter, Venus fell in love with Anchises; here she visits him while he is tending his flocks on Mount Ida; their son will be Aeneas. This painting is not, however, merely an illustration of this legend; the artist put into the 1890 New Gallery catalogue a quotation from Shelley's[1] platonic love poem, *Epipsychidion*, against the catalogue number for the picture:

Athwart that wintry wilderness of thorns
Flashed from her motion splendour like the morn's
And from her presence life was radiated
Through the grey earth and branches bare and
 dead;
So that her way was paved and roofed above
With flowers as soft as thoughts of budding love.

Richmond seems to have seen a parallel between the myth of Venus and Anchises and Shelley's vision of his beloved Emily, as described in the lines quoted from *Epipsychidion*. The subject of the painting was apparently suggested to him by William Watkiss Lloyd,[2] the author of numerous books on British and classical literature and on the history of art; possibly therefore Lloyd, who had written an unpublished and now lost work on the Neo-Platonists, may have led Richmond to conceive a painting symbolizing the coming of spring by embracing both classical myth and modern romantic love poetry; certainly Helen Lascelles[3] saw the Venus of Richmond's painting as the goddess of spring bringing back budding flowers and singing birds to the wintry earth and this interpretation was endorsed by A.M.W. Stirling[4] – who apparently had access to letters about the picture which passed between the artist and his father, George Richmond. Clearly Richmond's *Venus and Anchises* is in no sense a literal rendering of the story of Venus and Anchises; traditionally Venus appeared to him in disguise so that he should not suffer the inhibitions natural to a mortal loved by a goddess. Similarly the lion and lioness have no obvious relevance to the story of Venus and Anchises,[5] except perhaps as symbols of summer. The doves, however, are the traditional attributes of Venus. The artist clarified the philosophical meaning of the painting when he exhibited it at the Royal Birmingham Society of Artists *Autumn Exhibition* of 1890; in this catalogue (412) he dropped the quotation from Shelley and substituted some lines from the famous invocation to Venus as the great creative force of nature in the first book of the *De Natura Rerum* of Lucretius:

Venus . . . glory of the blest abode . . .
At thy approach, the author of their joy,
Each beast forgets his rage and entertains
A softer fury; through the flowery plains,
Through rapid streams, through woods and silent
 groves,

Whole nature yields into your charms; the way
You lead, she follows, and eagerly obeys.

Not only did Richmond have the assistance of Lloyd in drawing up the programme for *Venus and Anchises*, but he was himself an avid reader of the classics and his painting seems to be of particular importance in assessing the influence of Greek mythology on Victorian Art.[6] The symbolic and allegorical use of classical myth is often claimed for Victorian artists – particularly for Richmond's friend, Frederic Leighton – but here it can be documented.

The critics at the 1890 New Gallery exhibition were understandably bewildered by the iconography of the picture; the *Saturday Review*[7] thought that the female figure must be Venus and the male figure Shelley; the *Magazine of Art*[8] felt that the subject was Venus and Anchises and that therefore Shelley's poem simply did not fit; the *Speaker*[9] on the other hand saw the painting as an illustration of the poem except that Shelley's Emily was 'beautiful as Aphrodite'. The reviewers in the *Art Journal*[10] and in the *Athenaeum*[11] were probably closer to the artist's intentions in seeing

the painting primarily as an allegory of spring and love; in the former Alfred Higgins wrote:

We have, however, in this picture, no merely illustrative or literary work, but one dealing with a theme as old as human nature and as fresh as a newly-opened leaf – the association of love with the renewed life of nature in spring-time. Nowhere perhaps is the sudden outburst of spring more lovely than in this England of ours. No wonder then that when an English artist sees the goddess of Love, robed in the tints of yellow roses, descend upon the earth, driving before her all things that wear the dull colours of winter, the verdure that spreads itself beneath her feet has a northern greenness, and the flowers that break so profusely into blossom about her are the apple blossoms of an English orchard, though the deep sapphire of the distant mountains and the gloomy background of pine forest tell of a land of southern passion and romance.

The *Athenaeum* critic was more detached:

Mr. W.B. Richmond sends a sort of allegory of Spring, in the form of a beautiful young maiden clad in quasi-Greek garments. She is walking through a

Venus and Anchises WAG 3082

cloudy landscape, where, as she passes, crocuses start from the sward, the thorns of other trees burst into blossom, and a gleam of light, cleaving the mist-laden air, attends her footsteps, while a score of doves in sheeny plumage hover near her. We hesitate to say if it is the moon we see amid the distant vapours. We do not care for the allegory or the sentiment of the design. It does not seem to be quite fresh; indeed, we think we have met with something of the kind before. But the damsel's spontaneous grace and vigorous movement, and the beauty of the colour centring in her draperies, are most acceptable.

Generally speaking the landscape received more praise than the figures, and Frederic Leighton's influence was widely noted.

Venus and Anchises was begun in 1889[12] and finished by April 1890 for the New Gallery exhibition. Some repainting at the extreme left was undertaken after the painting was engraved for reproduction in 1890.

Several drawings for the painting were owned in 1970 by Alister Matthews, Bournemouth, including a *Head of a Lion* inscribed and dated *1887 Berlin Zoo for Venus and Anchises* (black chalk on white paper, 23 × 14 cm) and a *Study of a Leg* inscribed *Study for right leg of Venus in Venus and Anchises* (black chalk on white paper, 23 × 14.5 cm) – (both probably from a sketch-book).

REPR: Henry Blackburn, *New Gallery Notes*, 1890, p. 39; Pall Mall Gazette, *Pictures of 1890*, p. 96; *Magazine of Art*, 1890, p. 304; *Art Journal*, 1890, p. 237; a print was published by the Fine Arts Publishing Company Limited.

PROV: Purchased from the artist 1892 (£800).

EXH: New Gallery 1890 (72);[13] Royal Birmingham Society of Artists, *Autumn Exhibition*, 1890 (412); Berlin, Verein Berliner Künstler, *Internationale Kunstausstellung*, 1891 (2618);[14] Liverpool Autumn Exhibition, 1892 (1064); New Gallery, *William Blake Richmond*, 1900–1 (59); St. Louis International Exhibition 1904 (65).

1 Shelley's poetry was not widely used by 19th-century artists but Walter Crane's *Death of the Year* of 1872 (owned by Peter Nahum Ltd. in 1989) was inspired by Shelley's *Dirge for the Year* and the Shelley Society was founded in 1886. Richmond's *Near Via Reggio where Shelley's body was found* is now in the Manchester City Art Galleries.

2 A. Higgins, 'Mr. W.B. Richmond's Work and his Life as an Artist', *Art Journal*, 1890, p. 237; Helen Lascelles, 'Sir William B. Richmond', *Art Journal*, 1902, p. 17. For Lloyd, see the memoir of his life by Sophia Beale in William Watkiss Lloyd, *Elijah Fenton*, 1894, pp. 125–43.

3 Lascelles, *op. cit.*, p. 18.

4 *The Richmond Papers*, ed. A.M.W. Stirling, 1926, p. 370. Richmond's *Amor Omnia Vincit* of 1891 also has vegetation springing into life at the appearance of Venus; see *The New Gallery: An Illustrated Catalogue with Notes by Henry Blackburn*, 1891, pp. 17 and 60; the painting is now in Aberdeen Art Gallery, where it is described as *The Bath of Venus*.

5 Exceptionally, the lion can be a symbol of love, see Jochen Becker, 'Amor Vincit Omnia' *Simiolus*, 1988, vol. 18, pp. 134–54, but it is doubtful that either Richmond or even Watkiss Lloyd can have known this, and in this context the lion is generally associated with Cupid not with Venus.

6 For this subject, see particularly Richard Jenkyns, *The Victorians and Ancient Greece*, 1980, pp. 298 ff. G.P. Jacomb-Hood in his *With Brush and Pencil*, 1925, p. 54, testified to Richmond's knowledge of ancient literature and philosophy.

7 *Saturday Review*, 3 May 1890, p. 537.

8 M.H. Spielmann, 'The New Gallery', *Magazine of Art*, 1890, p. 306.

9 *Speaker*, 17 May 1890, p. 537.

10 Higgins, *op. cit.*, p. 238.

11 *Athenaeum*, 3 May 1890, p. 577. On the other hand, Shaw was contemptuous of the painterly qualities of WAG 3082: 'An outline drawing of it in the manner of Duchesne or Retzch would create a high opinion of its merit, but one cannot face its light and colour and pronounce it a success.' (S. Weintraub, *Bernard Shaw on the London Art Scene*, 1989, p. 330)

12 The Richmond Papers, *op. cit.*, p. 370.

13 WAG 3082 had the central position in the large room at the New Gallery.

14 Thanks to this exhibition, WAG 3082 became
 well known in Germany – see Richard Muther,
 The History of Modern Painting, 1907, vol. 3,
 p. 197.

RIVIERE, Briton (1840–1920)
Daniel in the Lions' Den

WAG 2700
Canvas: 98.5 × 152.5 cm
Signed: *Briton Riviere 1872*

The subject is taken from Daniel 6. King
Darius of Babylon had ordered Daniel to be
thrown into a den of lions for praying to God
rather than to him. However, God closed the
lions' mouths and Daniel emerged unharmed.
The artist painted a later incident in the same
story with his *Daniel's Answer to the King* of
1890, now in the Manchester City Art Galler-
ies.

This is the first of Briton Riviere's Assyrian
subjects; later came *The King's Libation* (etched
by E.G. Murray) and *A Mighty Hunter before*
the Lord of 1891. An Assyrian relief carved on
the wall of the lions' den in *Daniel in the Lions'*
Den, shows a king pouring a libation over the
bodies of dead lions. The artist obtained the
design from an actual Assyrian relief deposited
in the British Museum during the early 1850s.[1]
The subject of the relief seems to relate
remotely to the subject of the painting.

Daniel in the Lions' Den was widely praised
at the 1872 Royal Academy exhibition and
became generally regarded as the artist's mas-
terpiece.[2] Henry Morley's remarks[3] were typ-
ical:

There is a like freedom from conventionality in the
Daniel of Mr. Briton Riviere. Daniel in the Lions'
Den has been painted and sketched many thousands of
times, yet here is the old theme made new, and, so to
speak, realised into poetry. Mr. Riviere has often
before, in unassuming pictures, given human interest
to his experiences of brute life. He now suggests the
grandeur of man's spiritual power by showing it
reflected from the lions and their young, who crouch
before the erect form of Daniel. The grey-haired
prophet stands with his hands bound behind him. We

Daniel in the Lions' Den WAG 2700 (colour plate 12)

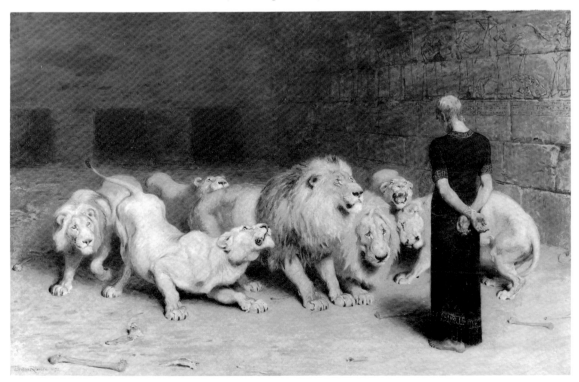

also stand behind, see the bound hands and the erect spare form before the beasts. They press their claws upon the ground, and crouch in forms suggestive of a cruel strength restrained in spite of nature, with their eyes fixed on the prophet. The calm of faith, the power that came of a perfect trust in God, we are left to imagine in the unseen face. The square stone walls with their Assyrian chisellings, the just sufficient traces on the floor of the use made of this dread chamber in the palace help to tell the story, while the force and variety of expression in the group of lions simply impress upon the mind the divine light in the face that awes them. Thus the study is a study of lions, and yet the whole interest of the picture centres upon Daniel.

Drawings for the painting were exhibited at the Grosvenor Gallery *Winter Exhibition*, 1880 (126) and (probably) at the Fine Art Society *Exhibition of Studies and Designs by Briton Riviere*, 1902 (4). A watercolour version was exhibited at the Manchester *Art Treasures Exhibition*, 1878 (210) and at the Manchester *Royal Jubilee Exhibition*, 1887 (1304); it was owned by Edward Cross.

REPR: Engraving by Charles G. Lewis, published by Agnew's 1874.

PROV: Bought from the artist by Agnew February 1872; sold to John Heugh in the same month (£1000);[4] sold through Agnew's to Edmund C. Potter May 1874 (£1732.10s.); his sale, Christie's 22 March 1884, lot 51, bought Agnew (£2625) for T.H. Ismay;[5] bequeathed by T.H. Ismay 1900.

EXH: Royal Academy 1872 (539); Paris, *Exposition Universelle* 1878 (232); Walker Art Gallery, Liverpool, *Grand Loan Exhibition*, 1886 (29); Manchester, *Royal Jubilee Exhibition*, 1887 (364); Guildhall Art Gallery 1890 (121).

1 The British Museum relief is reproduced in Eva Strommenger, *The Art of Mesopotomia*, 1964, plate 260. The compiler is indebted to Frederick Bohrer for help with the Assyrian reliefs. For the artist's interest in Assyrian art in later life, see Michael Riviere, *Notes on the Huguenot Family of Rivière in England*, 1965, p. 87.

2 See particularly Arts Council of Great Britain, *Great Victorian Pictures*, 1978, p. 72.

3 *Fortnightly Review*, June 1872, vol. 17, pp. 692–704. Other reviews appeared in the *Architect*, 18 May 1872, p. 252, the *Examiner*,

4 May 1872, p. 456, *The Times*, 4 May 1872, the *Athenaeum*, 4 May 1872, p. 565, *Art Journal*, 1872, p. 183. Some of these are quoted in Arts Council, *op. cit.* Only the *Art Journal* seems to have had serious reservations about WAG 2700. F.G. Stephens in 'Briton Riviere', *Portfolio*, 1892, p. 81, particularly insisted on the originality of the composition in WAG 2700 – with the principal figure displaying his back to the spectator. Stephens also insisted on the artist's command of animal psychology in the depiction of the lions in WAG 2700.

4 The price (£1000) is recorded in Arts Council, *op. cit.*, but apparently not in the Agnew Stock Books (no. 6785).

5 He was the founder and principal partner in the shipowning firm Ismay, Imrie and Co. (the White Star Line).

Watching Dog

WAG 292
Canvas: 21 × 30.4 cm
Signed: *Briton Riviere 1875*

A sheet of drawings of a long-haired terrier (none closely related to this painting) were reproduced by F.G. Stephens in 1892.[1]

PROV: Anon. Branch and Leete sale, Liverpool 18 November 1891, lot 357, bought Agnew

Watching Dog WAG 292

Sketch for 'A Legend of St. Patrick' WAG 293

(£45.3*s.*) for George Holt (£49.13*s*.6*d.*); bequeathed by Emma Holt 1944.

1 F.G. Stephens, 'Briton Riviere', *Portfolio*, 1892, p. 78.

Sketch for 'A Legend of St. Patrick'

WAG 293
Canvas: 43.6 × 51 cm
Signed: *B. Riviere / 77*

This is a sketch for or possibly a small version of *A Legend of St. Patrick*, exhibited at the Royal Academy in 1877, with a description in the catalogue from the *Acta Sanctorum*:

When St. Patrick had ascended the hill whereon he afterwards built Ard-machae, he found a roe with her little fawn beside her. He would not suffer his companions to kill them, but taking up the fawn in his arms, he carried it to a place of safety, while the roe followed him like a pet lamb.[1]

PROV: Charles Skipper sale, Christie's 24 May 1884, lot 92, bought Agnew (£147); sold by Agnew's to George Holt 26 June 1888 (£100 with an exchange picture); bequeathed by Emma Holt 1944.

1 The large picture (142 × 123 cm) seems to have been last recorded in the Edmund C. Potter sale, Christie's, 26 March 1884, lot 54, bought Agnew (£976.10*s.*). It is reproduced in H. Blackburn, *Academy Notes*, 1877, p. 14.

Playfellows WAG 602

Playfellows

WAG 602
Canvas: 74.3 × 50 cm
Signed: *BR* (in monogram)[1] *1900*

This painting is not related to the artist's *Playfellows* engraved by F. Stacpoole in 1886 and presumably exhibited at the Royal Academy 1883 (392)[2] as *Old Playfellows*.

PROV: Presented by George Audley[3] 1925.

1 As recorded in P. Nahum, *Monograms of Victorian and Edwardian Artists*, 1976, p. 225.

2 Reproduced in H. Blackburn, *Academy Notes*, 1883, p. 40. It was lent by Jesse Haworth to the Manchester *Royal Jubilee Exhibition*, 1887 (370).

3 George Audley, *Collection of Pictures*, 1923, p. 44.

ROBERTSON, Charles (1844–1891)
Hic Jacet: 'The Waste and Lumber of the Shore'

WAG 2515
Canvas[1]: 123.8 × 184.8 cm

REPR: H. Blackburn, *Academy Notes*, 1885, p. 32.

PROV: Presented by the artist 1885.

EXH: Royal Academy 1885 (191); Liverpool Autumn Exhibition 1885 (202).

1 According to the Gallery's records there is a signature, but it is no longer visible.

SADLER, Walter Dendy (1854–1923)
Friday

WAG 3126
Canvas[1]: 108 × 217 cm
Signed: *W. Dendy Sadler 1882*

This is one of a group of mildly satirical paintings by Sadler showing the domestic life of monks and friars;[2] they date from about 1865–90; in particular, *Friday* is closely related to Sadler's *Thursday* of 1880 (now Tate Gallery, London) in which a group of Franciscan friars are catching fish – presumably for consumption on Friday, the day of fasting, on which meat was traditionally forbidden. *Habet* of 1886 depicted a monk with a newly caught large fish. Satire of this nature was usually directed at the Franciscans – an order particularly devoted to poverty[3] – but *Friday* depicts a Dominican refectory to which two Franciscans have been invited.[4]

Friday attracted little attention at the 1882 Royal Academy because it was hung so high as to be nearly invisible;[5] the *Art Journal*[6] criticized the modern appearance of the furniture but praised 'the genuine humour' and 'the careful solidity of the execution'.

The artist painted at least two repetitions, each showing selected sections of the original. *A Tasty Dish* (33½ × 25 in.) signed and dated 1882, contains the two seated figures third and fourth from the left talking to each other, together with the man standing just behind

Hic Jacet: 'The Waste and Lumber of the Shore'
WAG 2515

Friday WAG 3126

them; it was with Frost and Reed in 1929. *Dominican Fare* was exhibited at the Institute of Painters in Oil Colours 1886–7 (251)[7] and was later sold at Sotheby's 2 October 1985, lot 133 as *Fish for Supper*, signed and dated 1886 (26¾ × 35½ in.); it shows the Dominican about to carve, with the two Franciscans on either side of him and the standing figure carrying a plate behind them.

REPR: F. Slocombe (etching), reproduced in *Art Journal*, 1885, opp. p. 72.

PROV: Presented by James Pegram[8] 1883.

EXH: Royal Academy 1882 (784); Liverpool Autumn Exhibition 1882 (669) priced at £1000.

1 James Bourlet label, Nassau Street, frame maker.

2 WAG 3126 is in fact – for Sadler – unusually hostile to its subject matter; see *Art Journal*, 1885, p. 72. WAG 3126 was apparently reproduced around 1902 or 1903 in the *Primitive Methodist Magazine* as well as in numerous other periodicals and books up until the 1930s.

3 *Art Journal*, *op. cit.*; W.L. Woodroffe, 'W. Dendy Sadler', *Magazine of Art*, 1896, pp. 267–8.

4 Father Justin McLoughlin, letter to the compiler 28 March 1968, suggests that in WAG 3126 Sadler is alluding to the Feast of St. Dominic; on this day Franciscans are traditionally the guests of the Dominicans, who do the serving. The artist had this to say about WAG 3126:

'Friday' shows an abbot and monks at dinner on Friday enjoying their meal of fish in lieu of the prohibited meat. The figures to the right and left of the abbot are priests from another monastery . . . I can recall no reason why I tried to paint monks, but I do remember that I never had a real monk as a model. I have studied them on the Continent, also at a small monastery at Crawley, in Sussex. The figures to the right and left of the abbot are monks of the order of St. Francis, their habits are brown; the other monks are of the order of St. Dominic; and their habits are black and white' (undated printed description of WAG 3126 in Gallery files).

The subject matter of the two paintings hanging in the refectory of WAG 3126 is not clear; they are, however, plainly baroque in style whereas Woodroffe (*op. cit.*) believed that Sadler was painting a medieval subject. G.D. Leslie's *Fast-day in the Convent* of 1861, showing a nun fishing in the convent moat, might have inspired WAG 3126 and *Thursday* (see *Art Journal*, 1861, p. 140, for a description of Leslie's picture).

5 H. Blackburn, *Academy Notes*, 1882, p. 67; *Art Journal*, 1882, p. 238; *Builder*, 6 May 1882, p. 539.

6 *Art Journal*, 1882, p. 238.

7 Reproduced in the catalogue, p. 2.

8 A prosperous Liverpool dealer in tea who eventually owned shops all over the city.

Darby and Joan
WAG 296
Canvas: 61.2 × 86.7 cm
Signed: *W. Dendy Sadler*

This is a replica of the original painting first exhibited at the Grosvenor Gallery in 1889

Darby and Joan WAG 296

(121);[1] it differs from the original in lacking the swags around the fireplace.[2]

PROV: Bought Agnew from the artist 7 May 1889; bought George Holt 31 July 1889 (£210); bequeathed by Emma Holt 1944.

EXH: Glasgow International Exhibition 1901 (553); Ferens Art Gallery Hull 1901–2.

1 F.G. Stephens, 'Walter Dendy Sadler', *Art Journal*, 1895, p. 199, dates the original to 1889; it is reproduced on p. 194, while the illustration on p. 193 shows the artist painting it; it is also reproduced in *Magazine of Art*, 1890, opp. p. 268, as an engraving by Jonnard (with a description), and in Pall Mall Gazette, *Pictures of 1889*, p. 85, while an etching after it by W.J. Boucher was published by L.H. Lefevre in 1890 (see Arts Council of Great Britain, *Great Victorian Pictures*, 1978, p. 73); for the subject matter, see Edward Morris, *Victorian and Edwardian Paintings in the Lady Lever Art Gallery*, 1994, p. 106; the original painting was owned by John Ashby of Staines in 1901 (artist's letter to Miss Holt, 19 November 1901, MS Walker Art Gallery), and may be the version now in the Towneley Hall Art Gallery, Burnley (84 × 120.5 cm).

2 The artist wrote to Miss Holt on 19 November 1901 (MS Walker Art Gallery): 'Your picture [WAG 296] was painted entirely de novo without reference to Mr. Ashby's picture, so there must be some considerable difference between the two. It is of a different shape, being a little broader in proportion. It is a mistake to paint a replica, and I am thankful to say I have painted but very few . . .'

In fact the difference in proportions between WAG 296 and the original is extremely small and it is inconceivable that WAG 296 was painted without reference at least to one of the reproductions of the original picture – or possibly to a photograph of it – all the more so as it seems that both WAG 296 and the original were painted more or less simultaneously; WAG 296 was bought by Agnew's in May 1889 and in the same month, the original went on exhibition at the Grosvenor Gallery (see Provenance above).

SALMON, John Cuthbert (1844–1917)
Landscape: Lake Scene with Church
WAG 2631
Canvas: 25.7 × 46 cm
Signed: *J.C. Salmon 1872*

Landscape: Lake Scene
WAG 2632
Canvas: 25.7 × 46 cm
Signed: *J.C. Salmon 1872*

The artist moved to Liverpool in 1871–2 and is best known for his North Wales landscapes.[1]

PROV: Found in the Gallery 1958.

1 For the identity of the artist, see J.B. Penfold, 'John Francis Salmon', *Connoisseur*, 1975, vol. 188, p. 28 and the Liverpool Autumn Exhibition catalogues of 1871 and 1872; there are obituaries in the *Liverpool Courier*, and in the *Liverpool Post*, both 16 October 1917.

Landscape: Lake Scene with Church WAG 2631

Landscape: Lake Scene WAG 2632

SANDYS, Emma (1834–1877)

Viola

WAG 674

Canvas: 53 × 40.2 cm

Inscribed on the frame[1] are the famous lines from Act 2 Scene 4 of Shakespeare's *Twelfth Night* in which Viola, pretending that she is referring to an imaginary sister, avows her unrequited love for the Duke. In this scene (and throughout most of the play) Viola was dressed as a man and was accepted as such.[2] The artist may have been intending to represent Viola's imaginary sister suffering from her undeclared love, or she may have thought it appropriate in painting this crucial episode of the play in which Viola speaks with such emotion of woman's love – and obliquely of her own love – to transpose Viola back into a woman. The mirror and the window were usual symbols of unfulfilled love. Roddam Spencer Stanhope's *Patience on a Monument smiling at Grief*[3] was another highly imaginative composition based on the same speech by Viola.

Emma Sandys painted a considerable number of enigmatic but emotionally charged female heads rather in the style of D.G. Rossetti (and of her brother, Frederick[4]).

PROV: Bequeathed by Mrs. Constance Emily Warr on behalf of her husband Professor George Warr 1908.

1 The actual lines inscribed on the frame are:

> DUKE: *And what's her history*
> VIOLA: *A blank, my lord.*
> *She never told her love.*
> TWELFTH NIGHT ACT II SCENE IV

2 And indeed most 19th-century paintings of Viola showed her as a man – for example, G.A. Storey's *Viola* sold at Sotheby's 15 December 1976, lot 291.

3 Reproduced in A.M.W. Stirling, *A Painter of Dreams*, 1916, p. 336.

4 Frederick's wife was a Shakespearian actress and she may have suggested the subject of WAG 674 to Emma.

Viola WAG 674

SANT, James (1820–1916)

The Fairy Tale[1]

WAG 1160

Canvas[2]: 61 × 76.2 cm

Signed: *JS* (in monogram)

Another slightly larger version of this composition entitled *Learning from Nature* and attributed to Thomas Brooks, was sold at Sotheby's (Belgravia) 30 March 1982, lot 124. The monogram on the Walker Art Gallery version is, however, typical of Sant,[3] and there is no reason to doubt the attribution to him.

PROV: Presented by George Audley[4] 1925.

1 There is no reason to think that this was the title chosen by the artist. The subject of WAG 1160 seems to be a comparison between nature, to which the older figure points, and art, represented by the book (or sketch book) held by that figure. The flowers in the basket and the boy's ball and bow may also refer to the outside world rather than to the world of books.

2　Canvas stamp: Winsor and Newton, 38 Rathbone Place, London.

3　See Peter Nahum, *Monograms of Victorian and Edwardian Artists*, 1976, pp. 167, 241.

4　WAG 1160 is not included in George Audley's *Collection of Pictures* of 1923, so he presumably acquired it between 1923 and 1925.

Sterne's Maria

WAG 297
Canvas[1]: 60.9 × 50.7 cm
Signed: *JS* (in monogram)

Towards the end of Sterne's *Sentimental Journey*[2] he meets Maria, whose misfortunes in love have made her mad; she sits by the road near Moulins all day playing tunes to the Virgin. Sant quoted the final lines from this passage in Sterne's account as the sub-title for this painting:

'And is your heart still so warm Maria?' said I. I touched upon the string on which hung all her sorrows. She look'd with wistful disorder for some time in my face; and then, without saying anything, took her pipe, and play'd her service to the Virgin.

Sterne's Maria was a very popular sentimental subject for British 19th-century artists;[3] Frith's painting of 1868 represented the same incident selected by Sant and had the same title.

PROV: Bought by George Holt from the artist 1890 (£120); bequeathed by Emma Holt 1944.

The Fairy Tale WAG 1160

EXH: Liverpool Autumn Exhibition 1889 (77); Atkinson Art Gallery Southport, *Annual Exhibition of Modern Pictures*, 1890 (432).

1 Canvas stamp: Prepared by Winsor and Newton, Rathbone Place, London.

2 Laurence Sterne, *A Sentimental Journey*, 1768, Everyman Edition, 1927, pp. 120–5.

3 See the lists in Catherine M. Gordon, *British Paintings of Subjects from the English Novel*, 1988, pp. 59 and 263 ff.

Sterne's Maria WAG 297

SEVERN, Arthur (1842–1931)
Waves breaking at Cannes
WAG 299
Canvas: 69.1 × 87 cm
Signed: *Arthur Severn R.I.*

Severn was fond of this subject. As early as 1867 his drawing *Waves breaking by Moonlight* was well received at the Dudley Gallery exhibition of that year and a replica of it was purchased by the Duchess of Sutherland.[1]

PROV: Bought by Mrs. George Holt from the artist;[2] by descent to Emma Holt who bequeathed it 1944.

EXH: Society of Oil Painters 1902 (342) priced at £50.[3]

1 Sheila Birkenhead, *Illustrious Friends*, 1965, pp. 169–70.

Waves breaking at Cannes
WAG 299

2 If indeed WAG 299 was acquired by the Holt family from the 1902 Society of Oil Painters exhibition (see note 3) it must have been bought by George Holt's widow as he died in 1896.

3 There is an undated Society of Oil Painters label on the back of WAG 299 giving the title as *Waves breaking at Cannes*.

SHALDERS, George (1825–1873)
Canterbury Meadows
WAG 2635
Canvas: 62.2 × 108 cm
Signed: *G. Shalders 1855*

The river is presumably the Stour.

PROV: Presented by James Smith of Blundellsands 1892.

SICKERT, Walter Richard (1860–1942)
The Old Bedford[1]
WAG 2264
Canvas: 76.3 × 60.5 cm
Signed: *Sickert*

The Bedford Music Hall in Camden Town (and other music halls) were painted by Sickert several times in the period 1888–90,[2] but this painting, with its related compositions, was, with the exception of *Miss Minnie Cunningham* of 1892 (Tate Gallery), the only major new music hall subject done by the artist in the period 1890–5, when he was principally engaged on portraiture.[3] Baron sees it as the culmination of a number of related drawings and paintings made by Sickert around 1894–5;[4] she also sees the composition as possessing a new sophistication for Sickert and the colour scheme as having a new and more muted subtlety; it is the first of his music hall scenes to represent the audience alone with no view of the stage.[5]

The Old Bedford was favourably reviewed (twice) by Frederick Wedmore, who used its original title:

The voice of the scoffer is raised very frequently over the work of Mr. Walter Sickert, an artist who – though a full measure of success may often be lacking to his interesting efforts, declines to be commonplace – does really see that, whatever be the subject, the individuality of the artist must assert itself. It may be given to him sometimes to paint things uglily – it is vouchsafed to him, at any rate upon occasion, to see things finely. Why, at the Goupil Gallery lately, there was a vision of St. Mark's, of his St. Mark's, no merely architectural monument, but a Venetian dream. Now it is again a music-hall, and The Boy I Love is in the Gallery. The boy that every music-hall singer loves is obliged to be in the gallery; lack of pence takes him there; his admiration of the artiste *keeps him there; and from the gallery comes the keen appreciation by which the* artiste *has to be sustained. It is the enthusiasm of the gallery that begets the*

The Old Bedford WAG 2264 (colour plate 13)

renewed effort. Is it the old Standard Music Hall in Pimlico, I wonder, that Mr. Sickert has painted? I wandered into it aimlessly, myself, one idle night.

The learned in these matters tell me it has the reputation of being the oldest existing music-hall in London. Anyhow, whatever may be the precise scene

of Mr. Walter Sickert's picture, the painter has known how to make it pictorial – pictorial and dramatic to boot. 'Composition' has not been disregarded in the intricacy of the lines and in their sweeping balance. Light and shade has not been disregarded. Light and shade, indeed, and the interesting problems of foreshortening count for much in such a scene.[6]

Quite one of the best of Mr. Walter Sickert's music-hall theatrical subjects is to be found here. It bears the title of 'The Boy I Love is in the Gallery' – a reference, possibly to the fact that in the goodwill of the gallery is the true support of the comedian, of whichever sex, and whether of the dramatic or the music-hall stage. But the sweeping and fine lines of the composition – the large picturesqueness of the scene – interest the intelligent spectator more than the actual story.[7]

The review identifying the Walker Art Gallery painting as the painting at the 1895–6 New English Art Club exhibition was written by George Moore:[8]

For its very rare beauty of tone I admire Mr. Walter Sickert's picture representing the gallery of a music-hall. I like it because of its beauty; it has beauty of tone, colour, and composition. I admire it for the fine battle the painter has fought against the stubborn difficulty of the subject. For to have discovered that architecture and to have fitted it into his canvas was no little feat – that grey space of ceiling with its coloured panel, and that space of grey-blue beneath the gallery with just sufficient pillar to explain, are they not admirably balanced? That pilaster, too, about which the boys crowd and cling keeps its place in the composition – the red paint with which it is decorated is low in tone and harmonious; the shadow, too, that floats over the gold ornaments is in its right place; it is as transparent as a real shadow, and therefore redeems the vulgar painting and gilding. That which was hideous in reality is beautiful in the picture. The great mirror in which vague shadows are reflected, is it not a triumph? For to be vague without suspicion of weakness or incoherency is no easy matter; to draw the obscure and impalpable is as difficult in painting as in literature – more difficult. There are so many merits that I wonder why there is not sufficient room between the pilaster and the wall for the gallery boys; moreover, the boys are not indicated – they are blurred. The painter has striven to hide his weakness; and in place of faces we have but a beautiful brown tone. But the picture is a good one; for the deficiencies have been slurred over in a way that says much for Mr. Sickert's knowledge of his limitations.

REPR: An etching by Sickert in the 1915 Carfax Series reproduces WAG 2264 fairly exactly, but the etching extends upwards and includes the ceiling of the theatre.

PROV: Hotel Drouot sale (Paris) 20 June 1909, lot 8 as *Au Poulailler* (64 × 76 cm);[9] Adolphe Tavernier;[10] Comtesse Solcedo de Rios;[11] a French dealer;[12] Adams Gallery; purchased from the Mayor Galleries 1947 (£1000).

EXH: New English Art Club Winter 1895–6 (73) as *The Boy I Love is up in the Gallery*; Paris, Bernheim-Jeune, 1907 (22) as *Le Poulailler de Bedford, Camden Town*;[13] Glasgow 1937.

1 The original title of WAG 2264 was *The Boy I Love is up in the Gallery*, a song sung at the Old Bedford and elsewhere by Marie Lloyd, Little Dot Hetherington and Nellie Power; the song continued: 'The boy I love is looking down at me / There he is – can't you see him, waving of his hankeyche? / As merry as a robin that sings on a tree'; see Geoffrey Fletcher, 'Cupid in the Gallery', *Camden Journal*, 1970–1, vol. 6, p. 4, and R. Pickvance, 'The magic of the Halls and Sickert', *Apollo*, 1962, vol. 76, pp. 107 ff. Little Dot Hetherington is singing this same song in Sickert's *Little Dot Hetherington at the Bedford Music Hall* of 1888–9 (private collection) and WAG 2264 may have been conceived as a pendant to this earlier painting. Copyright in the song was acquired by Nellie Power who was able to prevent other singers from using it – see R.A. Baker, *Marie Lloyd*, 1990, p. 16. WAG 2264 is also known as *Cupid in the Gallery*. The gallery contained the cheapest seats in the theatre and was largely occupied by working-class men – the most vital and important section of the audience in the eyes of many middle-class observers (and apparently of the performers).

2 The Bedford Music Hall was built in Grove Street, off Camden High Street, in 1861, largely re-built on a more substantial scale in 1867–8 and then re-erected in a grander fashion in 1896–8 as the New Bedford Theatre, which was also painted by Sickert; see D. Howard, *London Theatres and Music Halls, 1850–1950*, 1970, p. 21 and particularly Marian Kamlish, 'The Alhambra of Camden Town', *Camden History Review*, 1995, vol. 19, pp. 30–33. For Sickert's enthusiasm for this and other music halls, see Fletcher, *op. cit.*, pp. 4–7, and R. Emmons, *The Life and Opinions of Walter Richard Sickert*, 1941, p. 48. William

Rothenstein in *Men and Memories 1872–1900*, 1931, p. 169, wrote: 'Night after night Sickert would go to the Bedford or Sadler's Wells, to watch the light effects on stage and boxes, on pit and gallery, making tiny studies on scraps of paper.' For the sources used by Sickert in his music hall scenes, see Pickvance, *op. cit.*, and W. Baron, *Sickert*, 1973, pp. 24 ff., p. 42. The sexual and social implications of Sickert's music hall scenes have recently been extensively explored; see particularly Anna Gruetzner Robins, 'Sickert Painter-in-Ordinary to the Music-Hall' in Royal Academy, *Sickert: Paintings*, 1992, pp. 13–24, and Andrew Stephenson, 'Buttressing Bohemian Mystiques and bandaging Masculine Anxieties', *Art History*, 1994, vol. 17, pp. 269–78.

3 Baron, *op. cit.*, pp. 39 ff.

4 She suggests this order of composition: (1) black chalk drawing, 33 × 43.2 cm, Baron, *op. cit.*, p. 310, no. 1; (2) pencil, chalk, pen and blue ink drawing, 44.5 × 32.4 cm, Baron, *op. cit.*, p. 310, no. 4; (3) pencil drawing, 30.9 × 19.4 cm, Baron, *op. cit.*, p. 310, no. 5; (4) pencil, pen and ink drawing, 33 × 22.9 cm, Islington Public Libraries; Baron *op. cit.*, p. 310, no. 2; (5) pencil drawing, 35.6 × 24.8 cm, British Museum; Baron, *op. cit.*, p. 310, no. 3; (6) pencil drawing, 15.6 × 10.2 cm, Walker Art Gallery, Liverpool; Baron, *op. cit.*, p. 310, no. 6 – WAG 5311; (7) pencil drawing, 31.7 × 19.6 cm, Baron, *op. cit.*, p. 310, no. 7; (8) chalk, watercolour and gouache drawing, 36.2 × 26.7 cm, Baron, *op. cit.*, p. 310, no. 8; subsequently sold at Christie's 13 June 1980, lot 44; (9) charcoal drawing, 54.6 × 38.1 cm, Baron, *op. cit.*, p. 311, no. 74; (10) pencil drawing, 40.6 × 25.4 cm, British Museum; Baron, *op. cit.*, p. 310, no. 9; (11) oil on panel, 24.8 × 16.5 cm, Baron, *op. cit.*, p. 311, no. 1; (12) oil on canvas, 54.9 × 38.1 cm, Fitzwilliam Museum, Cambridge; Baron, *op. cit.*, p. 311, no. 2; (13) drawing published in the *Idler*, March 1895, p. 169; (14) pen and ink, red chalk heightened with white drawings, 50.2 × 31.8 cm, South African National Gallery, Capetown; Baron, *op. cit.*, p. 310, no. 10; (15) WAG 2264, Baron, *op. cit.*, p. 310, no. 73; (16) oil on panel, 38.1 × 38.1 cm, Baron, *op. cit.*, p. 311, no. 75, dated by her to about 1898; (17) oil on panel, 37.5 × 30.5 cm, Baron, *op. cit.*, p. 311, no. 76, dated by her to about 1898; (18) oil on canvas, 127 × 77.5 cm, National Gallery of Canada, Ottawa; Baron, *op. cit.*, p. 312, no. 78, dated by her to about 1898; (19) oil on canvas, 86.4 × 54.6 cm, Baron, *op. cit.*, p. 312, no. 78, version, dated by her to about 1915–20. The order given in Fitzwilliam Museum, Cambridge, *Catalogue of Paintings, British School*, 1977, pp. 222–3 substantially follows Baron's ideas.

5 Baron, *op. cit.*, pp. 41–4; see also W. Baron, *The Camden Town Group*, 1979, p. 7, where she argues that in this composition Sickert goes decisively beyond what he had learnt from Degas and Whistler; she discusses possible German and British sources for Sickert's new concentration on the audience rather than on the stage in Royal Academy, *op. cit.*, 1992, p. 96, no. 16. Sickert had used the mirrors of the Old Bedford Music Hall before – most notably in *Little Dot Hetherington at the Bedford Music Hall* of 1888–9 (private collection).

6 F. Wedmore, 'The New English Art Club', *Studio*, 1895–6, vol. 6, p. 219.

7 *Academy*, 16 November 1895, p. 417.

8 The *Speaker*, 23 November 1895, pp. 548–9, partly quoted in Baron, 1973, *op. cit.*, p. 40, but see W. Baron, *Miss Ethel Sands and her Circle*, 1977, p. 103 for Moore's much less favourable opinion of WAG 2264 written in 1912. For the generally unfavourable critical reaction to Sickert's music hall paintings, see Pickvance, *op. cit.*, pp. 107–10.

9 See Baron, 1973, *op. cit.*, p. 311, no. 74; the sale was sponsored by the dealers Bernheim-Jeune, but WAG 2264 was probably still then owned by the artist.

10 Tavernier was an important early French collector of Sickert's work and wrote the preface to the 1909 sale; he was also a personal friend of the artist around 1888–1910, see Emmons, *op. cit.*, pp. 75, 142 and W. Baron, 'Sickert's Links with French Painting', *Apollo*, 1970, vol. 91, p. 186. He was also a close friend of Sisley; see L. Venturi, *Les Archives de l'Impressionisme*, 1939, vol. 1, pp. 98–9, 201.

11 Tavernier's daughter.

12 Cyril Adams, letter to the compiler, 17 January 1968.

13 See Baron, 1973, *op. cit.*, p. 311, no. 74.

Bathers, Dieppe WAG 2262

Bathers, Dieppe

WAG 2262
Canvas: 131.4 × 104.5 cm
Signed: *Sickert*

This and three (or five) other paintings of Dieppe scenes were commissioned by a Dieppe hotel proprietor in 1902 to decorate his restaurant; the hotelier did not like them and

they were acquired by Frederick Fairbanks.[1] These paintings were considerably larger than Sickert's other works of this period – no doubt at the request of the patron; for this reason the paint is smoother and flatter, the brushwork less obtrusive than usual and the forms and colours bolder and brighter; in the Walker Art Gallery painting in particular, the absence of any point of reference in form of shore, beach or horizon and the sharply tilted viewpoint give the composition the appearance of an abstract colour harmony or pattern.[2] The bathing costumes were of the type hired out by the Dieppe Casino.[3]

PROV: A Dieppe hotel proprietor;[4] Frederick Fairbanks;[5] purchased from Alex Reid and Lefèvre 1935.

EXH: Paris, *Salon des Indépendants*, 1903 (2235) as *Bain de Mer*; Liverpool Autumn Exhibition, 1935 (92).

1 W. Baron, *Sickert*, 1973, pp. 68, 71, 329–30; Simona Pakenham, *Sixty Miles from England*, 1967, p. 202. The hotelier's name seems to have been Mantren and the price he offered was 40 francs for each picture – although Pakenham says 100 francs for each picture – but the prices are very low; in 1899 Sickert was hoping to receive £10 or £15 each for small panels about eight or nine inches square; see Baron, *op. cit.*, p. 59; Sickert was at this time short of money after his divorce from his wealthy first wife in 1899. Fairbanks was an American musician, then resident in Dieppe; his wife was a close friend of the artist – see Pakenham, *op. cit.*, pp. 189 ff. The other paintings from this commission are *La Rue Notre Dame and the Quai Duquesne*, National Gallery of Canada, Ottawa (Baron, *op. cit.*, p. 329, no. 148), *The Statue of Duquesne*, Manchester City Art Galleries (Baron, *op. cit.*, p. 330, no. 156), *St. Jacques* (Baron, *op. cit.*, p. 330, no. 157), together with, possibly, *La Darse*, Glasgow City Art Gallery (Baron, *op. cit.*, p. 329, no. 150) and another painting of the same subject now unlocated (see Baron, *op. cit.*, p. 329, no. 150, for further details). In 1914 Ethel Sands commissioned Sickert to paint a series of large music hall paintings to cover the walls of her dining room at 15 Vale Avenue, Chelsea; the results, however, were as unhappy as this earlier decorative commission; see W. Baron, *Miss Ethel Sands and her Circle*. 1977, pp. 119-23.

2 Baron, *op. cit.*, p. 69. Most of the other paintings from this commission derived from earlier paintings, but WAG 2262 was an entirely new composition and no related works (or drawings) survive. In Royal Academy, *Sickert: Paintings*, 1992, p. 128, no. 32, Baron points to the influence of Impressionism and of Manet's later works, in particular, on the treatment of the water in WAG 2262. She also states that *Bathers, Dieppe* must have been 'inspired by a photograph', and provides a detailed analysis of the composition.

3 Pakenham, *op. cit.*, p. 202.

4 See note 1.

5 See note 1. Frederick Fairbanks sold WAG 2262 to Alex Reid and Lefèvre on 23 February 1935 (Janey Cookman, letter to the compiler, 29 August 1985).

Fancy Dress, Miss Beerbohm
WAG 2263
Canvas: 50.8 × 40.4 cm
Signed: *Sickert*

This can be dated from a sketch related to it sent on a postcard by the artist to Mrs. George Swinton at Easter 1906; the sketch is inscribed *Good Friday's canvas*.[1] There is another version which, although in fact rather closer to the 1906 sketch, is dated by Baron to about 1916.[2] Baron accepts the identification of the model as Miss Beerbohm, presumably Agnes Mary Beerbohm, a close friend of the artist and sister of Max Beerbohm.[3]

PROV: Walter Taylor;[4] Mark Oliver;[5] presented through the National Art Collections Fund by Mrs. D.M. Fulford 1945.

EXH: (?) Allied Artists Association, London Salon 1908 (885) as *Fancy Dress*; National Gallery, London, *Sickert*, 1941 (67).

1 W. Baron, *Sickert*, 1973, pp. 87, 338, no. 215; the sketch was sold at Sotheby's 2 November 1983, lot 36. Another of these postcard sketches, lot 36d in the same sale and inscribed *Saturday's picture: Débardeur No. 2*, shows the same sitter in the same dress and hat.

Fancy Dress, Miss Beerbohm
WAG 2263

2 Baron, *op. cit.*, p. 339.

3 WAG 2263 was exhibited at the National Gallery, London, *Sickert*, 1941 (67) as *Marie*. Sickert had also painted her in about 1894 – see Baron, *op. cit.*, p. 308, no. 62. She was born in 1865, married Ralph Neville in about 1885 but had separated from him by 1890; on his death she married Vesey Knox (1917); she died in 1947; see David Cecil, *Max: A Biography*, 1964, pp. 56, 346, 466.

4 Baron, *op. cit.*, p. 338, no. 215. A friend of the artist (see Baron, *op. cit.*, p. 157); he was a watercolour painter, a member of Sickert's Fitzroy Street Group and a considerable collector of contemporary British art, see W. Baron, *Miss Ethel Sands and her Circle*, 1977, pp. 68, 70–1.

5 He lent WAG 2263 to the National Gallery in 1941; he was a pupil of Sickert and a partner in

the Savile Gallery, which was among the principal dealers in Sickert's work around 1927–30 – see Baron, 1973, *op. cit.*, p. 167 and R. Emmons, *The Life and Opinions of Walter Richard Sickert*, 1941, p. 255.

Summer Lightning

WAG 2261
Canvas[1]: 62.7 × 72.3 cm
Signed: *Sickert*

This is one of Sickert's so-called *English Echoes*, a series of paintings mainly loosely based on mid-Victorian English illustrations by John Gilbert and other artists; the first of this series date from about 1927 and they continued into the mid-1930s.[2] *Summer Lightning* is taken from an engraving by Gilbert,

The Unexpected Rencontre.[3] The reference to the weather and to the time of the year was added by Sickert, but in other respects the painting closely follows Gilbert's engraving. The *English Echoes* at the 1932 Beaux Arts Gallery seem to have been well received by the critics thanks to the decorative character and to the Victorian revival of the period.[4]

REPR: Helen Brook, 'Richard Sickert: Originals and Echoes', *Studio*, 1932, vol. 103, p. 272; Beaux Arts Gallery *Paintings by Richard Sickert*, 1932 (8).

PROV: Purchased from the Beaux Arts Gallery 1932 (£175).

EXH: Beaux Arts Gallery, *Paintings by Richard Sickert*, 1932 (8); Walker Art Gallery, Liverpool, *Lancashire and Cheshire Artists' Exhibition* 1932 (501); Arts Council of Great Britain, *Late Sickert*, 1982 (73).

1 The artist's squaring-up is still visible.

2 R. Emmons, *The Life and Opinions of Walter Richard Sickert*, 1941, p. 211; W. Baron, *Sickert*, 1973, pp. 172–3; Arts Council of Great Britain, *Late Sickert*, 1982, pp. 17, 102 ff. At the first exhibition devoted to the *English Echoes*, Sickert wrote an appendix on his sources for the catalogue and had this to say about Gilbert (Leicester Galleries, May 1931, *English Echoes*, Appendix; these comments were reprinted in Beaux Arts Gallery, *Paintings by Richard Sickert*, 1932, where WAG 2261 was first exhibited):

Summer Lightning WAG 2261

John Gilbert, born at Blackheath in 1817, draughtsman on wood, Illustrated London News, London Journal, *etc. He was best known for his illustrations of Shakespeare. It is probable that he will be ultimately remembered by his smaller cuts in the* London Journal *and other periodicals, where he was master of romantic and melodramatic subjects, and could move more freely in ground that had not been stereotyped by the theatre. His pencil shone with equal facility in low-life, colonial subjects, and in dazzling saloons of the aristocracy.*

Sickert knew Gilbert in the 1890s and drew his portrait for the *Pall Mall Gazette* (Baron, *op. cit.*, pp. 385, 306).

3 Baron, *op. cit.*, p. 387, no. 440; WAG 2261 and the engraving by Gilbert were reproduced together in *Illustrated London News*, 9 April 1932, p. 556; WAG 2261 differs only in minor details from the engraving. In a letter of 12 December 1932 Sickert wrote: 'Liverpool has bought the summer lightning picture (the G.O.M.'s rendez-vous with Mrs. Langtry) for several hundreds I forget how many' (Tate Gallery, Liverpool, *W.R. Sickert*, 1989, p. 43) but Richard Shone (Tate Gallery, *op. cit.*, p. 14) thought that WAG 2261 was 'a painting of impending molestation or rape'.

4 Baron, *op. cit.*, p. 172; Arts Council, *op. cit.*, pp. 16 ff. See the reviews in *The Times*, 13 April 1932, and in *Studio* (Helen Brook, 'Richard Sickert: Originals and Echoes', 1932, vol. 103, pp. 266–72). *The Times* wrote: 'In comparison with the earlier paintings these later inventions are a sort of commentary upon an artistic method, in a good sense a sort of caricature of it with wider intervals between the tones and a more summary style of drawing.' The more 'advanced' critics of the period were less enthusiastic. D.S. MacColl wrote of the *English Echoes*: 'the refuge of a tired old age in reproductions of other men's designs with bright arbitrary colours' (D.S. MacColl, *Philip Wilson Steer*, 1945, p. 32). Emmons, *op. cit.*, pp. 211, 255, stated that the *English Echoes* were never popular. Richard Shone in Royal Academy, *Sickert: Paintings*, 1992, p. 308, no. 113, relates the *English Echoes* both to the artist's growing conservatism in old age and to the Victorian revival of those years.

SKILLETT, S.D. (active 1845–1856)
The Sailing Ship Lord Elgin
WAG 2972
Canvas: 50.8 × 76.2 cm
Inscribed: *LORD ELGIN* (on pennant and on bows)

The *Lord Elgin* was a fully rigged sailing ship of 859 tons, 141.9 feet in length, built in Quebec, where she was registered under the ownership of John James Nesbitt. She entered Liverpool from Quebec on 2 August 1847 and was registered there on 19 August with this description: ship rigged with standing bow-sprit, square sterned, carvel built, no gallery and a man figurehead. Her owner now was

The Sailing Ship Lord Elgin
WAG 2972

399

the well-known Liverpool merchant Samuel Robert Graves, but he sold her on the day of registration to John and Barcroft Carroll of Cork, where she was again registered in December 1847. The Carrolls sold the *Lord Elgin* in 1860 and she passed successively to Matthew Isaac Wilson of Liverpool, to Hugh Watson and finally to Henry Salt of Liverpool before being sold to a foreigner in late 1865. The ship traded between Liverpool, Quebec and London and this painting can presumably be dated to the period 1847–65.[1]

The artist has been identified from a trade card[2] attached to the stretcher. The small brown boat at the left may be a Deal Lugger; these boats provisioned ships at anchor in the Downs.

PROV: Found in the Gallery 1958.

1 Mary Bennett, 'The Sailing Ship *Lord Elgin*', *Liverpool Bulletin*, 1959–60, vol. 8, pp. 34–6.

2 The card reads: *S.D. Skillett, Marine and Landscape Painter, 11 Jamaica Terrace, Commercial Road, Limehouse.*

SMART, John (1838–1899)
The Pass of the Cateran
WAG 2651
Canvas: 106.7 × 183 cm
Signed: *J. Smart 1874* (?) (initials in monogram)

Caterans were lawless Scottish Highlanders notable for plunder and violence. Here they are presumably stealing the cattle which they are driving along. The critics of the *Examiner*[1] and the *Saturday Review*[2] liked *The Pass of the Cateran*. The former referred to:

a well considered landscape by J. Smart, which he calls 'The Pass of the Cateran', in which we see a herd of cattle being driven by armed caterans through a dark, misty mountain gorge. The gloom and mystery of the scene are well caught, and this episode of a bygone time is fairly realised . . .

The *Athenaeum*,[3] however, denounced the painting as derivative and worthless:

We have already noticed the larger works of Mr. Millais, and may take those which now come to view in their order on the walls. By no other rule should we notice before others the 'clever', but fallacious picture, by Mr. J. Smart, The Pass of the Cateran, a motive so commonly dealt in by painters of the artist's calibre, e.g. Messrs. MacTaggart, MacWhirter, P. Graham, and others, that we wonder they are not as weary of painting it as we are of seeing what year after year they are content to give us. There must be a receipt for the manufacture of pictures of mountains, with heathery sides, and with clouds rushing over and between them, and casting dark shadows in the sunlit view. A pool here and there a rock are added, here a cow and there a sheep, sometimes a rushing stream, sometimes a fall of rain, sometimes a shepherd or two; while, if the 'artist' is in a pathetic mood, he touches our hearts with the wreck of what, in Scotch novels, is called 'a shieling'; or, if cruel enough, he throws in his foreground the ragged and scurfy enclosure where, 'The rude forefathers of the hamlet sleep'; and, if a genius of superior power, he brings down a gleam of light between the

The Pass of the Cateran
WAG 2651

dark clouds of his painted sky, to show what he would be at. The humbler, it may be the duller, producers of this kind of 'art-manufacture', do not aspire beyond the cows, as Mr. J. Smart has done in the picture before us. It may be all very well that the hackneyed elements of the picturesque which supply materials for the inferior specimens of what are called 'Scotch' landscape paintings, i.e., rocks, heather, sun-gleams, and the like, of which the artists we have named are the most industrious producers, should continue to be employed to manifest trivial and worn-out ideas; but, on the other hand, we should, in that case, have good, sound, and solid execution, but that we never find in this class of works . . .

PROV: Bequeathed by Samuel Stitt 1898.

EXH: Royal Academy 1874 (2).

1 *Examiner*, 9 May 1874, p. 493.

2 *Saturday Review*, 13 June 1874, p. 748.

3 *Athenaeum*, 16 May 1874, p. 671.

SMETHAM, James (1821–1889)
Counting the Cost
WAG 2652
Canvas[1]: 107 × 91.4 cm
Signed: *J. Smetham*

Counting the Cost[2] illustrates Luke 14: 28: 'For which of you, intending to build a tower, sitteth not down first, and counteth the cost.' The figure on the right holding the drawing of the tower is no doubt intended to be the architect or builder (or quantity surveyor?). He has a hammer and plumb-line at his feet. Smetham was trained as an architect and so would have been naturally attracted by this verse in St. Luke's Gospel. The distant figures are presumably Christ and two of his disciples. One of Smetham's biblical 'squarings' is a detailed drawing for this composition.[3]

PROV: Alfred Smetham[4] bequeathed by Mrs. Jessie Alexandra Blair Smetham.

Counting the Cost WAG 2652

EXH: Royal Academy 1855 (491).

1 Canvas stamp: Charles Roberson, 31 Long Acre.

2 WAG 2652 is listed by E. Malins and M. Bishop, *James Smetham and Francis Danby*, 1974, p. 40, and in the *Letters of James Smetham*, ed. S. Smetham and W. Davies, 1902, p. 18.

3 See S.P. Casteras, *James Smetham*, 1995, pp. 34–8, fig. 11; 'squarings' were small drawings inspired by biblical or other texts. This squaring was drawn into a Bible with notes by the Reverend James Allen and now owned by Christopher Gibbs.

4 Label on the back of WAG 2652; he seems to have lived at Rock Ferry near Liverpool.

SMYTHE, Lionel Percy (1839–1918)
Kindred Spirits
WAG 6887
Canvas: 73 × 56 cm
Signed: *L.P. Smythe*

Kindred Spirits WAG 6887

This was acquired as *Playmates*, but the description of the 1879 *Kindred Spirits* by R.M. Whitlaw and W.L. Wyllie leaves no doubt that the Walker Art Gallery painting is indeed that picture or a version of it; *Kindred Spirits* was painted in the back garden of the house in Gloucester Crescent, London, owned by the artist's step-father, W.M. Wyllie, also an artist and the father of W.L. Wyllie, the artist's step-brother; the model was Norah, the artist's eldest daughter.[1]

PROV: Bought by Margaret, wife of Sir William Armstrong, first Baron Armstrong of Cragside, and hung at their house, Jesmond Dene, New-castle.[2] Presented to the Merseyside County Museums by Mrs. W. Brock 1960; transferred to the Walker Art Gallery 1969.

EXH: Royal Academy 1879 (368).

1 R.M. Whitlaw and W.L. Wyllie, *Lionel P. Smythe*, 1923, p. 90. WAG 6887 was described by H. Blackburn in *Academy Notes*, 1879, p. 39, as 'swing, cats scrambling up a tree trunk, a touch of nature'.

2 Whitlaw and Wyllie, *op. cit.*; WAG 6887 was not at the Armstrong sale, Christie's 24 June 1910; nor is it mentioned in any surviving Cragside inventories (R.J.H. Whitworth, letter to the compiler, 26 July 1985); Jesmond Dene was given by Lord Armstrong to the City of Newcastle upon Tyne in 1878 and 1884.

In the Cornfield
WAG 763
Canvas: 64.7 × 48.8 cm
Signed: *L.P. Smythe 1910*

This seems to be a variant of *The Rising Moon*, of which there was an oil version at the 1910 Royal Academy (565) and a watercolour version at the 1910 winter Royal Society of Painters in Water Colours (365); R.M. Whitlaw and W.L. Wyllie[1] described *The Rising Moon* as 'a picture of a girl with a rake and a bundle of gleanings in the early twilight glow with full moon beyond'.

PROV: Anon sale, Christie's 22 June 1923, lot 34, bought Sampson (£31.10s.); presented by George Audley 1925.

1 R.M. Whitlaw and W.L. Wyllie, *Lionel P. Smythe*, 1923, p. 182. For details of the exhibitions, see R.M. Whitlaw, 'Lionel Percy Smythe', *Old Water-Colour Society's Club Annual Volumes*, 1923–4, p. 76. A number of earlier cornfield paintings by Smythe are reproduced in 'E. Lionel Smythe's Place in the Cosmos', *Art Journal*, 1904, pp. 223 ff.; A.L. Baldry, 'Lionel P. Smythe', *Studio*, 1910, vol. 49, pp. 171 ff. reproduces yet more cornfield subjects similar in style to WAG 763.

SOLOMON, Solomon Joseph (1860–1927)
Job
WAG 2642
Canvas: 127.5 × 101.5 cm
Signed: *S.J. Solomon 81*

The subject is taken from Job 1: 13–22; in the background to the right are the four messengers who have brought to Job news of the loss of his children and livestock.

Job is apparently the first of the artist's exhibited works and therefore of particular importance, as most of his early paintings have been destroyed;[1] it may have been painted in Paris where, around 1881, he was studying at the École des Beaux Arts under Cabanel.[2]

In the Cornfield WAG 763

403

The artist's liking for Old Testament sub-jects may reflect his Jewish origins.

PROV: Presented by Eustace Harrison as a gift from the family of the late Edward H. Harrison[3] 1910.

EXH: Liverpool Autumn Exhibition 1882 (264).

1 Iris Montagu, the artist's daughter, letter to the compiler, 7 March 1970; see also WAG 3131 below.

2 Leon Bonnat's realistic *Job* attracted much attention at the 1880 Salon, but WAG 2642 owes no real debt to it. Rather imprecise chronologies of the artist's early career appear in A.L. Baldry, 'The Work of Solomon J. Solomon', *Studio*, 1896, vol. 8, pp. 1 ff., and in O.S. Phillips, *Solomon J. Solomon*, n.d., pp. 35 ff. He exhibited two paintings at the 1883 Paris Salon.

3 Presumably Edward Hodgson Harrison (1825–1907), a Liverpool foreign-produce broker and brother of James Harrison (see WAG 3131 below); for further details about James, see F.E. Hyde, *Shipping Enterprise and Management 1830–1939, Harrisons of Liverpool*, 1967, pp. 4 ff., and B.G. Orchard, *Liverpool's Legion of Honour*, 1893, p. 356.

Samson

WAG 3131
Canvas: 244 × 366 cm
Signed: *Solomon J. Solomon*

Samson was painted in the artist's studio at 18 Holland Park Road; the model for Samson was the artist's younger brother, Philip, and the models for Delilah were Therese Abdullah, the daughter of Sir Albert Sassoon's cook (head only), and Madeleine Fionda, an Italian model (body only).[1]

The subject is taken from Judges 16: 21, but strictly the artist has departed from the Bible; Samson was bound by the Philistines at Gaza, not when he awoke immediately after Delilah cut off his hair; and the binding did not take place in her presence. Solomon's sources prob- ably included Rubens's *Taking of Samson* at Munich.[2] The artist's liking for Old Testament subjects may reflect his Jewish origins.

At the Royal Academy there was some admiration among the reviewers for Solomon's dramatic power[3] and brushwork,[4] his ambition[5] and originality,[6] together with his depiction of human emotion;[7] his unflattering conception of Delilah,[8] obtrusive anatomy[9] and confused composition[10] received less praise, and there was a general feeling that the artist had attempted something rather beyond his powers.[11] The review in the *Athenaeum*[12] was atypically severe but most worth quoting:

From this chronicle of small beer let us turn to the mock tragedy Mr. Solomon J. Solomon calls Samson, *a pretentious and demonstrative illustration of the*

Samson WAG 3131

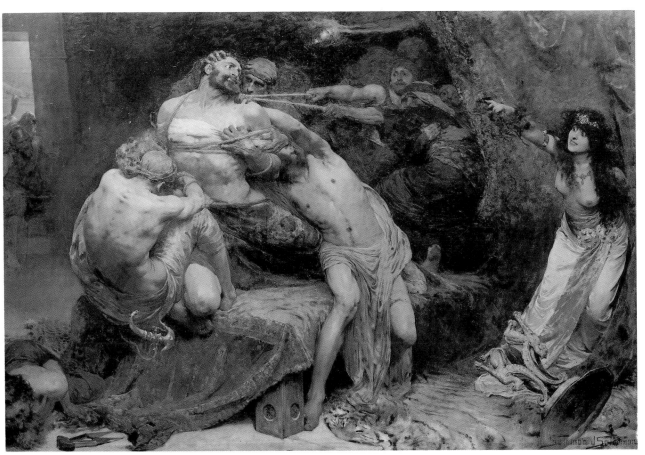

binding of the hero of Israel, well worthy of a fourth-rate, not thoroughly educated Frenchman with a future before him. The Philistines bind the tremendous man, who has the physical character of the Farnese Hercules, and suggests what that statue might look like in a fit of convulsions. There is a captor to each of his limbs, and they have enough to do, though he struggles in vain, and looks at his coarse, elf-like, black haired betrayer. The furious passion of the subject is overdone, and there is no real impressiveness or force of design. There is much demonstration of an ambition to draw the nude in a grand style, an ambition too easily satisfied and not content to labour in studies of a higher kind. Mr. S.J. Solomon must practise self-restraint and patience before he can hope to reach the solid ground of noble art. We do not say he should not be ambitious, and we respect even his blustering way of showing that he is so.

Subsequent comment on *Samson* became less favourable; Sickert[13] wrote of it with respect but without enthusiasm, while Rothenstein[14] saw it as the best example in England of the 'big Salon machine'; Baldry,[15] however, described *Samson* as 'an excellent realisation of violent action and frantic movement', and the *Artist*,[16] noting first the Parisian influence in *Samson*, observed that 'it was at once academic and naturalistic – the latter in its very remarkable rendering of racial types'.

A sketch after the figure of Delilah was made by the artist for reproduction in the *Pall Mall Gazette*, 1887, Extra Number 34, p. 25. A *Delilah* (not related to the Walker Art Gallery painting) was sold at Sotheby's (Belgravia) on 15 May 1979, lot 133 (signed and dated 1887). A copy (41 × 69 in.) was owned by Louis Tussaud's Waxworks (Blackpool) Ltd. in 1978. Another copy was sold at Christie's 6 March 1970, lot 53 (13½ × 19½ in., bought Stone Gallery). A version or sketch was with J.S. Maas and Co., Ltd. in 1982 (36 × 54 in.); this version was sold at Christie's 21 July 1989, lot 231 (bought in) and again on 3 November 1989, lot 116. Three studies for *Samson* are owned by Mrs. Gillian Eves; one of these was exhibited at the Ben Uri Art Gallery, *Solomon J. Solomon* exhibition in 1990 (catalogue no. 4, 102 × 152 cm). Madame Tussaud's exhibited a waxwork reconstruction of *Samson* in London in the 1950s and 1960s.

REPR: Pall Mall Gazette, *Pictures of 1887*, p. 24; H. Blackburn, *Academy Notes*, 1887, p. 80.

PROV: Presented by James Harrison [17] to celebrate Queen Victoria's Golden Jubilee, 1887.

EXH: Royal Academy 1887 (503); Paris, *Exposition Universelle*, 1889 (144); Guildhall Art Gallery 1895 (35); Royal Academy, *Winter Exhibition*, 1928 (305).

1 O.S. Phillips, *Solomon J. Solomon*, n.d., pp. 42–3; Millais visited Solomon in his studio while he was painting *Samson* and was surprised that such a large picture could be painted in so small a studio. The destruction of most of Solomon's work of the 1880s renders WAG 3131 and WAG 2642 (see above) of particular importance (Iris Montagu, the artist's daughter, letter to the compiler 7 March 1970). *Niobe* (1888) is, however, reproduced in A.L. Baldry, 'The Work of Solomon J. Solomon', *Studio*, 1896, vol. 8, p. 8.

2 Perhaps Solomon also knew F.R. Pickersgill's *Samson Betrayed* of 1850 (acquired by the Manchester City Art Gallery in 1882); he is unlikely, however, to have known Frederic Leighton's *Samson and Delilah* of about 1858 (now untraced and sold by the artist at auction in 1866). A. Pigler, *Barockthemen*, 1974, vol. 1, pp. 127 ff., has a list of 16th-, 17th- and 18th-century paintings of this subject. The subject of WAG 3131 was set for the Prix de Rome at the École des Beaux Arts, Paris, in 1821; see P. Grunchec, *Le Grand Prix de Peinture*, 1983, pp. 173 ff. The winning entry was by J.D. Court.

3 Claude Phillips in the *Academy*, 7 May 1887, p. 331; *Art Journal*, 1887, p. 277; *The Times*, 3 June 1887.

4 *Saturday Review*, 7 May 1887, p. 650.

5 *Saturday Review*, op. cit.; *Magazine of Art*, 1887, p. 271; *Spectator*, 11 June 1887, vol. 60, p. 798; Harry Quilter, *Preferences in Art*, 1892, p. 361.

6 *Academy*, op. cit.

7 *Academy*, op. cit.

8 *Saturday Review*, op. cit.; *Academy*, op. cit.; *Spectator*, op. cit.; Quilter, op. cit.

9 *Saturday Review*, op. cit.

10 *Academy*, op. cit.; *Saturday Review*, op. cit.; *The Times*, op. cit.

11 *Magazine of Art*, *op. cit.*; *Academy*, *op. cit.*

12 *Athenaeum*, 28 May 1887, p. 708. George Bernard Shaw in the *World*, 4 May 1887, p. 562, also found WAG 3131 too pretentious, but he was not as devastating as the *Athenaeum* critic:

As for Mr. Solomon, he bids boldly for high place as a nineteenth-century Rubens by a Samson in the old-fashioned magnificent style. Some stamp of modern Paris is upon Delilah, a little black-haired, raven-eyed witch, who, from a safe distance, shakes Samson's shorn locks in his face in frantic devilment. He, infuriated by her laughter, struggles in an immensely brawny fashion as the Philistines drag at him with ropes, like a team of bullocks. Altogether a brilliant and spirited achievement, and a severe abashing to the countenance in which the namby-pamby pictures used to keep each other whilst they had the field all to themselves.

The Times, *op. cit.*, also mentioned French influence, and French inspiration was emphasized in Harold Rathbone's review of WAG 3131 at the Liverpool Autumn Exhibition (*University College Magazine*, Liverpool, 1887, vol. 2, pp. 144–5); Rathbone saw the painting as 'typical of a certain restless energy of our times, a passionate longing to disenthrall oneself from the tyranny of many of our social conventionalities, the enslavement of machinery and the other distracting influences of our modern progress'.

13 W.R. Sickert, *A Free House*, ed. O. Sitwell, 1947, p. 300 (written in 1910).

14 W. Rothenstein, *Men and Memories*, 1931, vol. 1, p. 35.

15 Baldry, *op. cit.*, p. 4.

16 *Artist*, 1896, p. 100.

17 Presumably the Liverpool ship owner James Harrison (1812–1891) – see F.E. Hyde, *Shipping Enterprise and Management 1830–1939, Harrisons of Liverpool*, 1967, pp. 4–60, and B.G. Orchard, *Liverpool's Legion of Honour*, 1893, pp. 356–7, where he is described as a considerable collector of modern paintings; he was a brother of Edward Hodgson Harrison (see WAG 2642 above).

SOMERSCALES, Thomas Jacques (1842–1928)

A Man Overboard

WAG 2653
Canvas: 122.5 × 183.5 cm
Signed: *T. Somerscales 93*

A Man Overboard WAG 2653

The action in the painting is described thus by A.A. Hurst:[1] 'The [rescue] boat is out on the right of the picture and the barque, with all her way off her, is drifting down to leeward.'

REPR: *Magazine of Art*, 1894, p. 143.

PROV: Purchased from the artist 1893 (£262.10s.).

EXH: Liverpool Autumn Exhibition 1893 (230).

1 A.A. Hurst, *Thomas Somerscales*, 1988, p. 192, no. 129. The artist seems to have liked placid ship paintings with tragic subject matter and there are other paintings by Somerscales with this subject. P.F. Tupper, *Somerscales*, 1979, p. 149, no. 87, describes WAG 2653 as *Un hombre al agua*.

SPALDING, G.B.[1] (active *c.* 1840–1855)

A Huntsman with his Horse and a Group of Hounds

WAG 2311
Canvas: 20.3 × 26 cm
Signed: *G.B. Spalding 1855* (?)

PROV: Walter Stone;[2] bequeathed by Miss Mary Stone.

1 The Royal Academy catalogues of 1840–9 give him various different first initials, but WAG 2311 seems to be signed with an initial G.

2 *The Walter Stone Collection*, 1938, p. 25, no. 35.

STANHOPE, John Roddam Spencer (1829–1908)

The Expulsion from Eden

WAG 132
Canvas[1]: 136 × 176.8 cm

The critics at the 1900 New Gallery exhibition tended to regard *The Expulsion from Eden* as a curiosity or survival from a dying Pre-Raphaelite tradition;[2] the influence of Burne-Jones, particularly in the figure of Eve, was also widely noted,[3] as was the extreme archaism of composition and feeling.[4] The artist had painted this subject at Marlborough College Chapel much earlier (1875–9) and that composition is generally very similar to the Walker Art Gallery version – particularly in the figures of Adam and Eve and in the massive arch through which they are going – but with four angels rather than the one in the later painting.[5] Spencer Stanhope's *Eve Tempted*, exhibited at the 1877 Grosvenor Gallery exhibition, is now in the Manchester City Art Galleries.

A Huntsman with his Horse and a Group of Hounds WAG 2311

The Expulsion from Eden WAG 132

REPR: Liverpool Autumn Exhibition catalogue, 1900, p. 110.

PROV: Bought by Louis S. Cohen[6] from the 1900 Liverpool Autumn Exhibition; presented by his family in his memory 1925.

EXH: New Gallery 1900 (58); Liverpool Autumn Exhibition 1900 (1141).

1 WAG 132 seems to be painted largely in tempera; the artist played a considerable part in the revival of this technique; he started to use tempera around 1873 and thereafter gradually gave up oil in favour of egg yolk as his medium (R. Spencer Stanhope, 'Yolk of Egg Tempera', *Papers of the Society of Painters in Tempera*, 1901–7, vol. 1, second edn, 1928, pp. 38. 42).

2 *Speaker*, 28 April 1900, p. 92; *Builder*, 28 April 1900, p. 418. Inevitably, the final verdicts of the

Speaker, the *Magazine of Art* (1900, p. 391) and *The Times* (23 April 1900) on WAG 132 were not favourable – they saw it as 'over-laboured', 'unconvincing' and 'among the less interesting things in the exhibition'. None of the critics linked WAG 132 with European symbolism of around 1900.

3 *The Times*, *op. cit.*; *Builder*, *op. cit.*; the *Athenaeum*, 28 April 1900, p. 534, liked the figures of Adam and Eve.

4 *Speaker*, *op. cit.*: 'even more merciless than the medieval art that they claim to revive . . . the sentiment is as archaic as their treatment'.

5 *Athenaeum*, 30 October 1875, p. 582. The subjects were twelve recorded visits from angels starting with the expulsion from Eden. Much subsequent repainting has been done on these panels. David West, Honorary Archivist of Marlborough College, was most helpful over their paintings.

6 He was a nephew of David Lewis of Liverpool
 who founded Lewis's, the department store chain.
 Cohen inherited part of this chain and managed
 the Liverpool Lewis's store.

STANNUS, Hugh Hutton (1840–1908)

Eight Cartoons for the Dome of St. Paul's Cathedral

WAG 4416 A–H

Canvas: A (109 × 205 cm); B (216 × 145 cm
(at bottom) or 99 cm (at top));[1] C (124.5 ×
152.5 cm);[2] D (diameter 114.5 cm); E
(diameter 152.5 cm); F (diameter 183 cm);[3]
G (diameter 155 cm); H (diameter 152.5 cm)

In 1852 Francis Cranmer Penrose was
appointed Surveyor to St. Paul's Cathedral.[4]
He was a very old friend of Alfred Stevens and
was to play a large part in the 1858 decision to
select Stevens as the sculptor for the Welling-
ton Monument to be placed in the cathedral.
He recommended that the interior decoration
of the cathedral should be reconsidered, sug-
gesting in particular that mosaic should be
employed in the great central dome and in the
whole area of the crossing under it. In 1862 he

spoke unofficially to Stevens, who immedi-
ately started work on his own account on a
scheme for mosaics and sculpture to cover the
dome, the drum and the walls and the arches
beneath them. Stevens built a large model,
now in St. Paul's Cathedral, in order to dem-
onstrate his scheme for the mosaics and sculp-
ture. The model shows only half the dome,
drum and sub-structure, and there is no evi-
dence that he worked on any designs for the
other half.

The only part of this programme to be
actually executed in the cathedral were the
designs for the prophets in the spandrels below
the drum and dome – and three of these were
carried out by W.E. Britten long after Ste-
vens's death. However, the Dean and Chapter
did buy Stevens's model after he died, and in
1879 Frederic Leighton, E.J. Poynter and
Stannus[5] were asked to provide new cartoons
compatible with the overall structure and
organization of Stevens's design – that is eight
vertical ribs with small and large roundels
between them and within them, together with
eight seated colossal figures between the ribs
but beneath the roundels and with angels and
nude figures helping to support and fill the
spaces between the roundels within the ribs.
These new cartoons were, however, radically

Cartoon for the Dome of St. Paul's Cathedral
WAG 4416A

Cartoon for the Dome of St. Paul's Cathedral
WAG 4416B

410

Cartoon for the Dome of St. Paul's Cathedral
WAG 4416C

Cartoon for the Dome of St. Paul's Cathedral
WAG 4416D

Cartoon for the Dome of St. Paul's Cathedral
WAG 4416E

Cartoon for the Dome of St. Paul's Cathedral
WAG 4416F

different from Stevens's narrative roundels, both in style and subject. The Leighton/Poynter programme[6] involved a scheme of circular panels showing the visions of the Apocalypse, and Leighton's *And the sea gave up the dead which were in it* (Tate Gallery) is a reduced version of one of his roundels for this revised scheme. Stannus's alternative programme seems to be represented by his detailed small drawing of 1880 entitled, *St. Paul's Cathedral: Design for the decoration of the Cupola and Pendentives by Alfred Stevens as modified with additional design for the treatment of the peristyle, podium and quarter-galleries by Hugh Stannus A.R.I.B.A.*, now in the Walker Art Gallery.[7] However, after seeing some of his cartoons (perhaps WAG 4416 A–H) temporarily in place in St. Paul's Cathedral in 1884–5, Stan-

Cartoon for the Dome of St. Paul's Cathedral
WAG 4416G

Cartoon for the Dome of St. Paul's Cathedral
WAG 4416H

nus changed his mind in favour of a single (rather than a double) row of very large circular panels, one of which was to show the Resurrection.[8]

Stannus's 1880 drawing shows four of the vertical ribs within the dome and three of the intervening segmental spaces together with the drum and arches below – the organization into ribs, into roundels and into large-scale figures just above the drum and between the ribs follows Stevens's design but all the details and scenes are different. The style is flatter, simpler and more primitive than Stevens's vigorous baroque or High Renaissance approach based on Michelangelo. These eight paintings by Stannus are the full-size cartoons for eight small separate parts of this 1880 design:

A A small part of the 'cherub frieze' immediately above the windows in the drum and just below the dome.

B Two prophets (?) right at the top of the dome, just to the left of the central figure with raised arms.

C The central figure with raised arms right at the top of the dome.

D The small roundel showing a woman with a picture, top centre right in Stannus's 1880

drawing. The roundel is at the top of the second vertical rib from the right.

E The small roundel, showing an angel (?) with a staff, middle extreme right in Stannus's 1880 drawing. The roundel is in the middle of the extreme right-hand vertical rib.

F The large figure at the bottom of the dome just above the windows in the centre of Stannus's 1880 drawing. This corresponds with the figure of Moses in Stevens's original model.

G and H The heads and shoulders of only two of the six angels at either side of the three large figures just above the windows.

There are two further cartoons similar to D and E above for the same 1880 design in St Paul's Cathedral.[9]

However, even with the revisions of Leighton, Poynter and Stannus, Stevens's great scheme still proved unacceptable. Nothing was done and Thornhill's original frescoes still remain in the dome.

PROV: Presented by Miss J. Stannus Robertson and M.H.S. Stannus (date unknown).

1 Inscribed *WOR(T)* at top. All the cartoons except WAG 4416 A are squared up for transfer.

2 Inscribed *TOP* (?) at top.

3 Inscribed *SMYRNA*.

4 This account broadly follows Susan Beattie's analysis in Royal Institute of British Architects, *Catalogue of the Drawings Collection: Alfred Stevens*, 1975, pp. 51–2.

5 F.C. Penrose, 'Notes on St. Paul's Cathedral', *Transactions of the Royal Institute of British Architects*, 1879, first series, vol. 29, p. 99. Stannus's own analysis of Stevens's original scheme can be found in his *Alfred Stevens and his Work*, 1891, pp. 25–6; he insists that Stevens's decorative principles are sound but that modification of the pictorial elements is possible.

6 *Architect*, 6 January 1883, p. 11, and 28 April 1883, p. 291, where there are reproductions of the Leighton/Poynter scheme.

7 Inv. no. WAG 1861.

8 Cartoons showing the two rival schemes (those of Leighton and Poynter on the one hand and of Stannus on the other) were in place in St Paul's Cathedral by October 1884 (*Athenaeum*, 18 October 1884, pp. 502–3) and Stannus defended his proposals at two meetings of the Royal Institute of British Architects on 17 November and 1 December 1884. See the *Transactions of the Royal Institute of British Architects*, 1884–5, NS, vol. 1, pp. 13–28, where his lecture, 'The internal treatment of cupolas in general and that of St Paul's in particular' is published, and the *Architect*, 22 November 1884, pp. 337–8, 29 November 1884, pp. 345–6 and 6 December 1884, pp. 365–6 and 369–70. See also *Architect*, 13 June 1885, p. 351, which contains a reproduction of Stannus's revised design.

9 Dr. Judith Bronkhurst, letter to the compiler, 14 April 1995.

STARLING, Albert (1857–1947)
Strangers in a Strange Land
WAG 3069
Canvas: 122.5 × 186.7 cm
Signed: *Albert Starling / 1889*
Inscribed: *THE THREE MARINERS INN / MARINERS / F. TAPLEY*[1] *LONDON* (on fish box) / *FERRY* (and price list)

Two itinerant child musicians, probably Italian, are playing for a group of fishermen. P.H. Rathbone[2] commented:

The picture is well felt throughout, the pathos is unforced, and the separate component parts are in admirable proportion to each other. A sunny atmosphere breathes over the whole. Two little Italian musicians are playing in front of a seaside beerhouse, and the interest excited in the old sailors by these little foreign children is simply but graphically expressed.

Strangers in a Strange Land
WAG 3069

Strangers in a Strange Land is likely to have been painted on the east coast of England where Starling worked for many years in the late 19th century.[3]

REPR: H. Blackburn, *Academy Notes*, 1889, p. 87; Liverpool Autumn Exhibition catalogue, 1889, p. 67.

PROV: Purchased from the artist 1889 (£150).

EXH: Royal Academy 1889 (1203); Liverpool Autumn Exhibition 1889 (195).

1 Frank Tapley and Co. were fish salesmen and factors of Lower Thames Street in the late 19th century.

2 'The Liverpool Autumn Exhibition', *University College Magazine*, Liverpool, 1889, vol. 4, p. 116.

Rathbone was then Chairman of the Walker Art Gallery and probably played a considerable part in the purchase of WAG 3069 for the Gallery.

3 Letter to the compiler from Mrs. Nancy Woods, daughter of the artist, 3 October 1993.

STARR (CANZIANI), Louisa (1845–1909)
Sintram
WAG 2655
Canvas[1]: 153.7 × 123 cm
Signed: *L. Starr*

At the end of *Sintram and his Companions* by de la Motte Fouqué,[2] Sintram meets his mother for the first time since he was a child. She has become a nun, and he now offers to enter a

Sintram WAG 2655

monastery. She, however, persuades him to continue as a warrior, protecting the weak and restraining the powerful.[3] The critics do not seem to have been impressed. *The Times*,[4] referring to the fact that Louisa Starr was the first female gold medallist at the Royal Academy Schools, detected in *Sintram* 'a defect hardly to have been expected in the picture of an artist who was the first lady to carry off the highest academic honour before Miss Macgregor – that is the strange disproportion between the cloistered mother behind the grating and the warrior son who kneels for her blessing'. The *Architect*[5] contended that the artist had neither the power nor the imagination to rise above portraiture.

Sintram was painted in 1872.[6]

PROV: Purchased from the artist 1873 (£210).[7]

EXH: Royal Academy 1873 (311); Liverpool Autumn Exhibition 1873 (162).

1 Canvas stamp: Winsor and Newton.

2 The 1873 Royal Academy catalogue contained this long quotation from chapter 29:

Silently weeping, the son knelt down before his mother, kissed her garment that floated forward through the bars, and felt as it were in Paradise, where every wish and every tumult is hushed.

* 'Dear Mother', said he after a time, 'let me become a holy man, as thou art a holy woman! Then will I go into that cloister of monks on the other side yonder.'*

* 'That would be a beautiful, stilly, joyful existence, my good child', replied the Lady Verena. 'Such, however, is not thy destiny. A brave high and mighty knight must thou remain, and employ thy long life in protecting the weak and repressing the wanton.'*

3 The artist was particularly fond of *Sintram and his Companions* and of *Undine* and often recounted stories from them to her daughter, Estella Canziani; see Estella Canziani, *Round about Three Palace Green*, 1939, p. 31. Charlotte Yeldham, *Women Artists in 19th-Century France and England*, 1984, vol. 3, pp. 105 ff., lists paintings of 1870–9 by women artists with miscellaneous literary subject matter.

4 *The Times*, 26 June 1873. E.J. Sullivan's illustration of this scene in the edition of *Sintram and his Companions* published in 1908, p. 187, has the mother as the dominant figure.

5 *Architect*, 24 May 1873, p. 272.

6 Canziani, *op. cit.*, p. 31.

7 The artist was much encouraged by the acquisition of WAG 2655, see Canziani, *op.cit.*, p. 31.

STEER, Philip Wilson (1860–1942)
The Wye at Chepstow
WAG 2375
Canvas: 92.7 × 123 cm
Signed: *P W Steer 1905*

This is one of a number of views of the Wye and Chepstow Castle done in 1905, when Steer visited the area.[1] It was not exhibited until the 1909 New English Art Club exhibition,[2] where it seems to have failed to attract much attention.[3]

Chepstow Castle can be seen on the far bank of the river and the town appears to the left.

PROV: Purchased from the executors of Charles John Darling, first Baron Darling, with the aid of a contribution from the National Art Collections Fund 1936 (£650).

EXH: New English Art Club, Summer 1909 (29); White City, London, *Latin-British Exhibition*, 1912;[4] Liverpool Autumn Exhibition 1926 (934); Venice, Biennale, 1932 (119).

1 For Steer at Chepstow, see particularly D.S. MacColl, *Philip Wilson Steer*, 1945, pp. 81–5, and B. Laughton, *Philip Wilson Steer*, 1971, pp. 93–4. For MacColl, WAG 2375 was 'comparatively dull', while for Laughton it was 'overworked to the point of death'. Robin Ironside, *Wilson Steer*, 1943, p. 11, noted the influence of Constable on Steer's Chepstow paintings. Other Chepstow Castle paintings of 1905 are listed by Laughton, *op.cit.*, p. 144, nos. 349, 352, 366, 367.

2 The *Art Journal* critic at that exhibition (1909, p. 221) noted that it was a painting of 1905.

3 *The Times*, 22 May 1909, and the *Saturday Review*, 29 May 1909, in their reviews noted that Steer's paintings at the New English Art Club exhibition were less notable than those at his one-man exhibition of that year at the Goupil Gallery.

The Wye at Chepstow WAG 2375

The *Art Journal*, *op.cit.*, mentioned 'a shimmering, pearly River Wye' by Steer. T. Martin Wood, 'The New English Art Club's Summer Exhibition', *Studio*, 1909, vol. 47, p. 183, described Steer's two River Wye paintings at that exhibition as 'canvases full of mysterious effects of shifting lights, great light clouds hanging over the valley of dark trees and mirrored in the river'. The review of the New English Art Club exhibition in the *Athenaeum* of 29 May 1909, pp. 652–3, consisted largely of a comparison between the work of Steer and that of Augustus John with a distinct preference for the latter; Steer

was, however, praised for his manipulation of paint and colour, for his purely artistic qualities. There is a book of press-cuttings containing reviews of the 1909 New English Art Club exhibition in the Tate Gallery archives; there were further brief comments in the *Pall Mall Gazette*, 24 May 1909, and in the *Morning Post*, 31 May 1909.

4 Also called the Anglo-Latin Exhibition; no catalogue seems to survive.

Corfe Castle and the Isle of Purbeck
WAG 3146
Canvas: 45.7 × 61 cm
Signed: *P.W. Steer*

This is a small version of (or sketch for) the *Corfe Castle and the Isle of Purbeck* now in the Johannesburg Art Gallery;[1] the two compositions are very similar, but the Walker Art Gallery version lacks the small figures of the Johannesburg picture. The artist was at Corfe in the summer of 1908 and the Liverpool canvas was probably painted in that year.[2] There are studies for it (or for the Johannesburg picture) in a sketch-book by Steer now in the Victoria & Albert Museum (E274–1943); sketches for the whole composition and for details – notably the castle – are included.

PROV: Bought from Barbizon House 1935 (£315).

1 B. Laughton, *Philip Wilson Steer*, 1971, pp. 100, 147, no. 422, describes WAG 3146 as a version of the Johannesburg picture, but there seems no reason why it should not be described as a sketch for the larger picture. Of the relationship between the two versions, Laughton, *op.cit.*, p. 100, wrote as follows:

Also at Johannesburg is the even bigger Corfe Castle and the Isle of Purbeck *painted in the same year. This canvas looks an heroic effort, but without the same strength of design as* The Limekiln. *The rolling carpet of the Purbeck hills is an elusive form. The result is a very English theme: distant castle, dramatically lit; expanse of grass under lowering sky reminiscent of David Cox; nothing very new. But a smaller version at the Walker Art Gallery, Liverpool, suggests a different story. The colour of this slightly wonky study has a violence and acidity that gives a new dimension to Steer's experience. Away from the domestic setting of Cheyne Walk his feelings, at this moment, have been stirred.*

Corfe Castle and the Isle of Purbeck WAG 3146

Some influence from Cézanne on paintings of this type has been assumed; see particularly, Fitzwilliam Museum, Cambridge, *Philip Wilson Steer*, 1986, no. 50.

2 Laughton, *op.cit.*, dates WAG 3146 to about 1908 and the Johannesburg picture to 1908–9; D.S. MacColl, *Philip Wilson Steer*, 1945, p. 212, dates WAG 3146 to 1909, following *Barbizon House Record*, 1935, no. 29. The *Corfe Castle* (91) at the New English Art Club, Summer 1910, was a watercolour, see *Daily Telegraph*, 16 May 1910 and *Daily Mirror*, 31 May 1910; it therefore cannot be identified with WAG 3146 as is suggested in Fitzwilliam Museum, *op.cit.*

Thames from Cheyne Walk

WAG 7638
Canvas: 76.5 × 137.5 cm
Signed: *P W Steer 1925*

This was presumably painted from the artist's house at 109 Cheyne Walk;[1] visible from right to left on the far (south) bank of the Thames are St. Mary's Church, Mayhew's flour mill and the chimneys of the Battersea Chemical Works.[2] Steer's *Thames at Chelsea, Sunset*[3] of 1923 and his *Thames from Cheyne Walk*[4] of about 1923, are closely related to this composition and may have acted as sketches for it. The Walker Art Gallery painting is signed and dated 1925 but is dated by Laughton to 1923–5.[5]

At the 1925 New English Art Club exhibition, *The Times*[6] commented on the Liverpool painting:

With Mr. P. Wilson Steer we come to a painter whose interests are chiefly atmospheric and never has he indulged them with a more brooding tenderness than in The Thames at Chelsea *all in a rosy mist through which the buildings on the further bank take on a friendly character; the picture being framed with an elegance which seems to comment on its mood.*

The review in *Country Life*[7] was similar: 'All the magic of the river on a foggy day, through which the sun just penetrates, has been worked into a composition that, in elegance, well fits its beautiful French frame.'

REPR: *Country Life*, 1925, vol. 57, p. 719.

PROV: Bequeathed by Mrs. Clara Lister Gabbatt 1961.

EXH: New English Art Club, Summer 1925 (110).

1 For the house, see B. Laughton, *Philip Wilson Steer*, 1971, pp. 73–4, and D.S. MacColl, *Philip Wilson Steer*, 1945, pp. 54 ff. Later paintings of 1927–30, also apparently showing views from this house, may have been based on WAG 7638 or on its related canvases; see Laughton, *op.cit.*, p. 156, nos. 625–8.

2 Mireille Galinou, letter to the compiler, 6 September 1984.

3 Laughton, *op.cit.*, p. 155, no. 595, now in the National Gallery of Canada, Ottawa.

4 Laughton, *op.cit.*, p. 155, no. 596.

5 Laughton, *op.cit.*, p. 155, no. 597. MacColl, *op.cit.*, p. 221, dates it to 1925.

Thames from Cheyne Walk
WAG 7638

6 *The Times*, 25 April 1925.

7 M. Chamot, 'The Royal Academy and the New
 English Art Club', *Country Life*, 1925, vol. 57,
 p. 720. The frame, to which both reviews refer, is
 still attached to WAG 7638; the photograph of
 WAG 7638 reproduced in the 1925 *Country Life* is
 now among the Steer Papers deposited by D.S.
 MacColl in the Print Room of the British
 Museum, and it shows the same frame as that
 now attached to WAG 7638.

Ships in a Storm WAG 3421

A Village Inn in Winter WAG 2685

Horse and Lioness WAG 2394

STEVENS, Alfred (1818–1875)
A Village Inn in Winter
WAG 2685
Panel: 34.3 × 47.6 cm
Signed: *A. Stevens Decr 27th 1827*

Horse and Lioness
WAG 2394
Panel: 35 × 50.5 cm
Signed: *A. Stevens June 1829*

Ships in a Storm
WAG 3421
Panel: 38 × 46.8 cm

These three small panels were copied by Ste-
vens, presumably from prints,[1] during his
childhood in Blandford. The first was done in
1827, the second and the third in 1829.[2]

PROV: Alfred Pegler;[3] Edith Pegler; purchased
from Miss Pegler[4] 1943.

EXH: Tate Gallery, *Alfred Stevens*, 1911, WAG
2394 (1), WAG 2685 (2), WAG 3421 (9); Mappin
Art Gallery, Sheffield, *Alfred Stevens*, 1912, WAG
2394 (11), WAG 3421 (12), WAG 2685 (15).

1 WAG 2394 is copied in reverse from a 1774
 engraving by Benjamin Green, after George

419

Stubbs, entitled *The Horse and Lioness*; the original painting by Stubbs is lost (Judy Egerton, letter to the compiler, 27 February 1986).

2 Labels on the backs of the three panels; the dates for WAG 2394 and WAG 3421 are confirmed by a letter of 19 October 1911 to D.S. MacColl from C.H. Curtis (MacColl Papers, Victoria & Albert Museum); Hugh Stannus, *Alfred Stevens and his Work*, 1891, p. 2, confirms the dates for WAG 2394 and WAG 3421, but he states that WAG 2685 was painted in 1828; the Tate Gallery, *Alfred Stevens*, 1911 catalogue states that WAG 2394 was made in 1827.

3 Stannus, *op.cit.*; he was a close friend of the artist.

4 She seems to have been one of the daughters of Alfred Pegler.

Emma Pegler
WAG 1770
Canvas: 30 × 23.7 cm

Emma Pegler was the daughter of Samuel Pegler (see WAG 1771, below); she taught the artist as a child[1] and was the sister of his close friend Alfred Pegler. This portrait certainly dates from before the artist's departure for Italy in 1833;[2] there is another quite different portrait of Emma Pegler by Stevens at the Tate Gallery.[3]

PROV: Alfred Pegler Junior;[4] purchased from Miss Pegler[5] 1943.

EXH: Tate Gallery, *Alfred Stevens*, 1911 (7); Mappin Art Gallery, Sheffield, *Alfred Stevens*, 1912 (5).

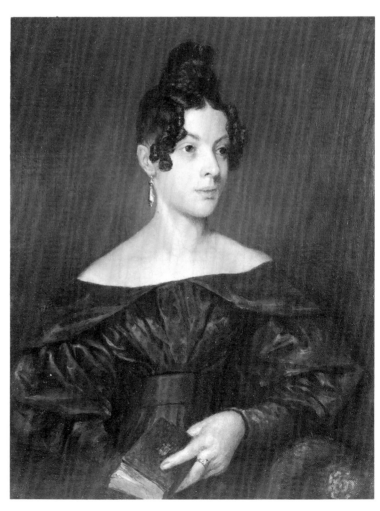

Emma Pegler WAG 1770

1 D.S. MacColl, 'The Stevens Memorial and Exhibition at the Tate Gallery', *Burlington Magazine*, 1911–12, vol. 20, p. 117; K.R. Towndrow, *Alfred Stevens*, 1939, p. 11.

2 Tate Gallery, *Alfred Stevens*, 1911, no. 7, as 'an early work'. K.R. Towndrow, *Alfred Stevens*, 1939, dates WAG 1770 to between 1831 and 1833.

3 Tate Gallery, *Works of Alfred Stevens*, 1950, p. 55, there dated to about 1832.

4 Nephew of Emma Pegler and son of Alfred Pegler, the friend of the artist.

5 She seems to have been one of the daughters of Alfred Pegler, the friend of the artist and thus a sister of Alfred Pegler Junior.

Samuel Pegler

WAG 1771
Canvas: 30.4 × 24.2 cm

Samuel Pegler was a radical Nonconformist watchmaker and gunsmith of Blandford; he was a friend of the artist's family and assisted Stevens in his training as an artist at Blandford; he may also have provided some money towards Stevens's expenses in Italy after 1833.[1] There is another version of this portrait in the Tate Gallery (but with very substantial differences);[2] the Walker Art Gallery version is dated by Towndrow to 1833.[3]

PROV: Alfred Pegler Junior;[4] purchased from Miss Pegler[5] 1943.

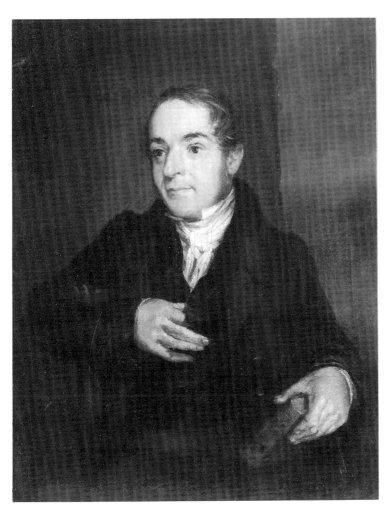

Samuel Pegler WAG 1771

EXH: Tate Gallery, *Alfred Stevens*, 1911 (3); Mappin Art Gallery, Sheffield, *Alfred Stevens, 1912 (7)*.

1 K.R. Towndrow, *Alfred Stevens*, 1939, pp. 53–5.

2 Tate Gallery, *Works of Alfred Stevens*, 1950, p. 55, there dated to 1832; apparently in the Tate Gallery portrait Pegler originally held a copy of *The Times*, but Stevens painted it out when the newspaper started supporting the Tory rather than the Liberal Party.

3 According to Tate Gallery, *op.cit.*, the date 1834 originally appeared on the back of WAG 1771 – and this is confirmed by a letter from Frank Lambert to K.R. Towndrow of 23 March 1943 – but the date cannot now be seen. Stevens left for Italy in 1833 and so Towndrow (in Tate Gallery, *op.cit.*) assumes that 1834 was an error for 1833.

Hugh Stannus, *Alfred Stevens and his Work*, 1891, p. 2, gave 1834 as the date for WAG 1771.

4 Grandson of Samuel Pegler and son of Alfred Pegler, the close friend of the artist.

5 She seems to have been one of the daughters of Alfred Pegler, the friend of the artist, and thus a sister of Alfred Pegler Junior.

James Barrett
WAG 1769
Canvas: 31.5 × 25.6 cm

James Barrett was a school-friend of the artist; the portrait was painted in 1833.[1]

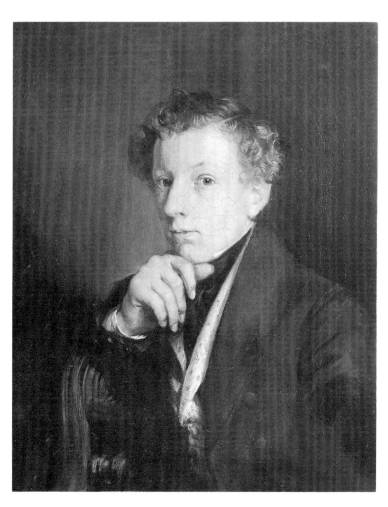

James Barrett WAG 1769

PROV: Mrs. King of The Lodge, Blindley Heath, South Godstone. Anon sale, Sotheby's 1 August 1928, lot 88, bought Barton (£26); Lt. Colonel R.L. Barton; presented by Miss L. Barton 1945.

EXH: Mappin Art Gallery, Sheffield, *Alfred Stevens*, 1912 (1).

1 Inscription on back of canvas – K.R. Towndrow, *Alfred Stevens*, 1939, p. 12.

Assumption of the Virgin
WAG 1901
Canvas: 101 × 56 cm

This is a copy after Titian's *Assumption of the Virgin* of 1518 over the High Altar of Santa Maria dei Frari, Venice.[1] The copy was made by Stevens in Venice late in 1839 or early in 1840[2] and he used it for his unfinished *Ascension of Christ* (c.1846), now in the Fitzwilliam Museum, Cambridge.[3]

PROV: The artist's sale, Robinson and Fisher 20 July 1877, lot 18, bought Fowler (£26.5s.); John Fisher sale, Sotheby's 4 July 1928, lot 150, bought Parsons (£65); S.J. Davis sale, Christie's 24 March 1937, lot 122, bought Bevan (£11.11s.). Purchased from W. Winkworth 1947.

EXH: Royal Academy, *Winter Exhibition*, 1890 (71); Mappin Art Gallery, Sheffield, *Alfred Stevens*, 1912 (20).

1 During the 19th century Titian's painting was in the Accademia, Venice.

2 Hugh Stannus, *Alfred Stevens and his Work*, 1891, p. 4. K.R. Towndrow, *Alfred Stevens*, 1939, p. 63. There are lists of other copies after Titian made by Stevens in 1839–40 in Royal Institute of British Architects, *Catalogue of the Drawings Collection: Alfred Stevens*, 1975, p. 14, and in the sale catalogue of Stevens's studio after his death, reprinted in Tate Gallery, *Works of Alfred Stevens*, 1950, p. 131; see also Graves Art Gallery, Sheffield, *Festival of Britain Art Exhibition*, 1951, nos. 291–3, P. Synge-Hutchinson, 'Alfred Stevens' Martyrdom – a discovery', *Connoisseur*, 1963, vol. 152, pp. 106–7, and Tate Gallery, *Landscape in Britain*, 1973, no. 16. Stevens made these copies for study purposes and for sale, see Miss Florence Morris-Moore's letter of 5 November 1890 to Alphonse Legros (Stannus Papers, Royal Institute of British Architects) and Royal Institute of British Architects, *op.cit.*, p. 14. At one time WAG 1901, together with some of Stevens's other Titian copies, were offered by the artist to Colnaghi's for £4 each (Towndrow, *op.cit.*, p. 63). Like many other British 19th-century artists Stevens was fascinated by 16th-century Venetian painting techniques, particularly in the rendering of flesh; for his research on this see D.S. MacColl, 'A portrait by Alfred Stevens', *Burlington Magazine*, 1911–12, vol. 20, p. 210.

3 Royal Institute of British Architects, *op.cit.*, p. 18.

Assumption of the Virgin WAG 1901

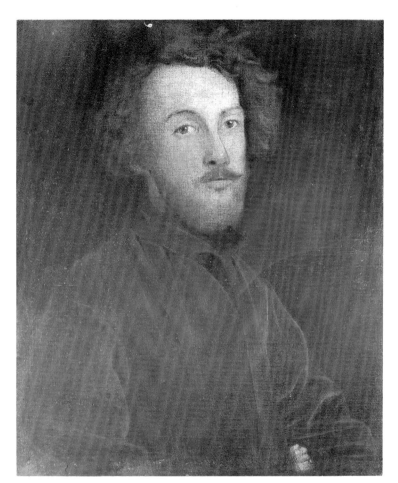

Mr. Tobin

WAG 1722
Canvas: 60.8 × 50.8 cm

This portrait seems to have been painted in Rome around 1840–2; nothing is known of the sitter except that he was a friend of the artist in Italy; the portrait hung in the artist's study and was carried about by him wherever he went.[1] Copies after it were made by Reuben Townroe and James Gamble.[2]

PROV: The artist's sale, Robinson and Fisher 20 July 1877, lot 20 (as a *Portrait of Mr. Tobbitt*) bought Eaton (£5.5*s.*); purchased from F.R. Eaton 1946.[3]

EXH: Tate Gallery, *Alfred Stevens*, 1911 (27); Mappin Art Gallery, Sheffield, *Alfred Stevens*, 1912 (6).

1 D.S. MacColl, 'A Portrait by Alfred Stevens', *Burlington Magazine*, 1911–12, vol. 20, pp. 208–10; K.R. Towndrow, *Alfred Stevens*, 1939, p. 46. WAG 1772 certainly seems to be inspired by Venetian 16th-century portraiture and the artist was in Venice in 1839–40. K.R. Towndrow, letter to the Director of the Walker Art Gallery, 15 May 1946, doubted the attribution of WAG 1772 to Stevens and wondered whether WAG 1772 might not have been a copy of the lost original (despite its provenance). Frank Lambert, letter to K.R. Towndrow, 9 May 1946, suggested, again despite the provenance, that WAG 1772 might have been one of the copies made by Townroe and Gamble.

2 MacColl, *op.cit.*

3 WAG 1772 has an MS label on its back stating that it was bought by George Clayton Eaton,

424

F.R. Eaton's father, from the Robinson and Fisher sale after Stevens's death and that it was the portrait described in MacColl, *op.cit.*, and exhibited at the Tate Gallery in 1911.

Study for Parmigianino painting 'The Vision of St. Jerome' during the Sack of Rome

WAG 1831
Panel[1]: 68 × 13.6 cm

Vasari[2] records how the Imperial soldiers surprised Parmigianino at work on his *Madonna and Child with Saints John the Baptist and Jerome*[3] during the Sack of Rome in 1527 but left him unmolested.[4] Stevens projected a large painting with this subject in about 1844 but it was never finished[5] and was eventually cut up and destroyed.[6] Many drawings for this composition survive; most date from around 1847–9[7] but Stevens seems to have still been working on this subject as late as 1854.[8]

PROV: James Gamble;[9] Alfred Drury; purchased from the Leicester Galleries 1946.

EXH: Tate Gallery, *Alfred Stevens*, 1911 (36); Leicester Galleries, *The Alfred Drury Collection of Drawings by Alfred Stevens*, 1946 (34).

1 Charles Roberson, 51 Long Acre, label on back.

2 Giorgio Vasari, *Le Vite*, ed. Milanesi, 1878, vol. 5, pp. 224 ff.

3 This painting, known in the 19th century as *The Vision of St. Jerome*, entered the National Gallery in 1826 (National Gallery Catalogues, *The Sixteenth Century Italian Schools*, 1962, pp. 131 ff.). Stevens seems to have made a watercolour copy of the altarpiece; the copy passed into the collection of Mrs. Gamble (Tate Gallery, *Alfred Stevens*, 1911, no. 95).

4 The subject of WAG 1831 reflects the exalted role that Romanticism ascribed to the arts – even soldiers sacking a city respected an artist at work. K.R. Towndrow, *Alfred Stevens*, 1939, p. 24, suggests that Stevens identified his own serenity in a hostile world with that of Parmigianino and that the figure of the artist in WAG 1831 was to some extent a self portrait.

Study for Parmigianino painting 'The Vision of St. Jerome' during the Sack of Rome
WAG 1831

5 Hugh Stannus, *Alfred Stevens and his Work*, 1891, p. 6.

6 Tate Gallery, *Works of Alfred Stevens*, 1950, pp. 62–3; Towndrow, *op.cit.*, pp. 24, 64; Towndrow states that F.W. Moody of the South Kensington Schools owned the original unfinished canvas (or part of it) around 1875. For this assertion he seems to have relied on a record of a conversation between D.S. MacColl and Reuben Townroe of 10 October 1907: 'Moody had beginning of Parmigianino picture' (MacColl Papers, Victoria & Albert Museum Library).

7 Royal Institute of British Architects, *Catalogue of the Drawings Collection: Alfred Stevens*, 1975, pp. 23–4; Tate Gallery, *op.cit.*, pp. 62–3; there are also drawings for this composition in the Fitzwilliam Museum, Cambridge (Sketch-book 2187, 68), the Ashmolean Museum, the Victoria & Albert Museum, the British Museum and the Walker Art Gallery, Liverpool (inv. 1826, 1887, 1945, 1949, 1958, 1960, 1966, 1967, 1968, 1985, 1994).

8 Royal Institute of British Architects, *op.cit.*, p. 24.

9 WAG 1831 was lent to the Tate Gallery 1911 *Alfred Stevens* exhibition by Mrs. Gamble and it has a label on its back: *Gamble Collection No. 21*. It is possible that F.W. Moody owned WAG 1831 rather than the unfinished final canvas (see note 6) or even that WAG 1831 was itself the unfinished final painting.

Deysbrook House Decorations

WAG 10359
Plaster: now stored in sections, crated

A new wing was added to Deysbrook House in the 1840s[1] and the owner, Richard Benson Blundell-Hollinshead-Blundell, a coal-mine proprietor and coal merchant, seems to have asked the firm Collmann and Davis, decorators and upholsterers of London, to decorate it for him.[2] Leonard William Collmann (1816–1881) was a friend of Stevens[3] and Stevens provided designs in 1847 for the walls and ceilings of the two drawing rooms and for the ceiling of the dining room; furthermore, he actually painted the figurative panels at Deysbrook in Parris' medium over a period of about a month in the same year.[4] The iconog-

raphy of the decorations in the two drawing rooms was elucidated by Stannus in 1904.[5] Briefly, the roundel in the centre of the cove at each side of the rooms represented a god or goddess; the wall panels under each roundel contained figures personifying the virtues normally associated with the deity in the roundel above; the ceiling panels over each roundel desplayed a genre scene or incident characteristic of the activities generally associated with the deity in the roundel below; the gods, virtues and activities opposite each other in the two rooms were seen as complementary – thus Mercury (representing Commerce) is opposite Ceres (representing Agriculture); Stannus argued that the careful and meaningful relationship between panels and roundels reflected Stevens's study of Raphael's similar practice in the Stanza della Segnatura. The programme on the dining-room ceiling seems to have been less intellectually rigorous; according to Stannus[6] the figures in the four corner panels represented the domestic virtues, *Friendship, Generosity, Cheerfulness* and *Contentment*. Stevens's decorations in their original state at Deysbrook can best be seen in the illustrations published by MacColl in 1911.[7] Stannus[8] described Stevens's work in the two drawing-rooms as done 'in a free variety of the Pompeian style' or as 'plotted-out in a severe manner which is an improvement on the Rafaellesco style, as that had been an improvement on the Roman "grottesco" treatment'; as for the dining-room ceiling, Stannus referred to its 'low rich Venetian scale of colour such as would have pleased the owner of the Palladian Villa at Castelfranco and his friends'.

The largest collections of preparatory drawings and studies for the Deysbrook paintings are in the Victoria & Albert Museum and the Walker Art Gallery.[9] There are further drawings in the Fitzwilliam Museum, Cambridge, and at Princeton University, New Jersey.

PROV: Richard Benson Blundell-Hollinshead-Blundell; his son, Henry Blundell-Hollinshead-Blundell;[10] removed from Deysbrook House in 1946.[11]

1 *Historic Houses, Churches and other Architectural Antiquities in County of Lancaster*, photographed by James A. Waite, 1888–1921, vol. 2, MS Liverpool City Libraries; the name of the architect does not seem to have been recorded.

Deysbrook House Decorations: Thankfulness
WAG 10359

Deysbrook House Decorations: Sculpture and Architecture
WAG 10359

Deysbrook House Decorations: Arithmetic
WAG 10359

Deysbrook House Decorations: History
WAG 10359

Deysbrook House Decorations: Small Drawing Room Cove
WAG 10359

Deysbrook House Decorations: Small Drawing Room Ceiling
WAG 10359

2 Royal Institute of British Architects, *Catalogue of the Drawings Collection: Alfred Stevens*, 1975, pp. 19–20, 34.

3 According to K.R. Towndrow, *Alfred Stevens*, 1939, pp. 81–2, and Tate Gallery, *Works of Alfred Stevens*, 1950, p. 73, Stevens first met Collmann around 1835–8 in Florence, where they were both students. Other work done by Stevens for Collmann and Davis is listed in Royal Institute of British Architects, *op.cit.*, p. 34.

4 Royal Institute of British Architects, *op.cit.*; Hugh Stannus, *Alfred Stevens and his Work*, 1891, p. 8.

5 Hugh Stannus, 'Some Designs in Applied Art by Alfred Stevens', *Art Workers Quarterly*, 1904, vol. 3, pp. 129–30. In detail the subjects are as follows: (1) Large drawing room, a) west, *Mercury* (cove), *Unloading a Boat* (ceiling), *Watchfulness* and *Righteousness* (wall panels); b) east, *Ceres* (cove), *Tilling the Ground* (ceiling), *Knowledge* and *Strength* (wall panels); c) north, *Bellona* (cove),

Deysbrook House Decorations: Dining Room Ceiling WAG 10359

Fame (ceiling); d) south, *Fortuna* (cove), *A Queen begging at the gate of Pavia (ceiling), Truthfulness* and *Temperance* (wall panels); (2)Small drawing room, a) west, *Venus* (cove), *Amusements* (ceiling); b) east, *Jupiter* (cove), *Diogenes* (ceiling), *Astronomy* and *Geometry* (wall panels); c) north, *Apollo* (cove), *Five Muses* (ceiling), *Architecture* and *Sculpture* (wall panels); d) south, *Minerva* (cove), *Four Muses* (ceiling), *Arithmetic* and *Writing* (wall panels).

6 Stannus, 1891, *op.cit.*, p. 8; the drawing for the ceiling in the Victoria & Albert Museum has inscribed on it at the four corners: *La Liberalità, La Contentezza, L'Allegrezza* and *L'Amicizia*, see W. Armstrong, *Alfred Stevens*, 1881, p. 32.

7 D.S. MacColl, 'The Decorations by Alfred Stevens at Deysbrook', *Architectural Review*, 1911, vol. 30, pp. 297 ff. See also Stannus, 1891, *op.cit.*, plates VII–XI.

8 Stannus, 1904, *op.cit.*, pp. 52, 129; Stannus, 1891, *op.cit.*, p. 8.

9 Many are reproduced in Stannus, *op.cit.*, 1904, pp. 49 ff., 129 ff.; see also Tate Gallery, *op.cit.*, pp. 65–6, and Royal Institute of British Architects, *op.cit.*; the studies in the Walker Art Gallery are inv. nos. 1832–1841, 1995, 2018; there are two very detailed watercolours in the Victoria & Albert Museum showing most of the decorative scheme (inv. 8586A and 8586B).

10 He was living at Deysbrook in 1893, see B.G. Orchard, *Liverpool's Legion of Honour*, 1893, p. 180.

11 In 1911 Deysbrook House had just become a children's hospital (see MacColl, *op.cit.*, p. 297); by 1946 it had become part of an army barracks.

Justice

WAG 1763
Board[1]: 48 × 48 cm

Poetry

WAG 1764
Board[1]: 45.7 × 45.7 cm

Original Sin

WAG 1765
Board[1]: 49.5 × 39 cm

Astronomy

WAG 1766
Board[1]: 49.5 × 39 cm

Judgment of Solomon

WAG 1767
Board[1]: 48.8 × 39 cm

Victory of Apollo over Marsyas

WAG 1768
Board[1]: 49.5 × 39 cm

Justice WAG 1763

The Crystal Palace was re-erected at Sydenham in 1852–4 and Stevens painted two ceilings for its Italian Court; one of these was a copy of the ceiling in the Stanza della Segnatura in the Vatican; it was about half the size of the original ceiling;[2] these panels are reduced copies of six of the eight principal panels[3] by Raphael in the Vatican ceiling and were presumably painted by Stevens to assist him in his work at the Crystal Palace; they are about one-third the size of the original frescoes; he did not work from Raphael's original frescoes in Rome but relied on copies of the ceiling presented to the Royal Academy by Lady Bassett.[4] There are further copies by Stevens after the Stanza della Segnatura frescoes in the Victoria & Albert Museum, E2759–1911, E2704–1911, E2974-2976–1911, E2955-2966–1911 (some apparently by Reuben Townroe after Stevens); there are studies for the architecture and decoration of the Italian Court in the Royal Institute of British Architects.[5]

Poetry WAG 1764

PROV: The artist's sale, Robinson and Fisher 20 July 1877, parts of lots 13–16, bought Fowler (£29.10s.); John Fowler sale, Sotheby's 4 July 1928, parts of lots 148–149, bought Parsons (£112). WAG 1764–1766 were purchased from Captain G. Fenwick-Owen in 1942. WAG 1763, 1767, and 1768 passed into the collection of James Gamble; the first was purchased from the Leicester Galleries in 1948; the other two from L. Crispin in 1950.

EXH: Mappin Art Gallery, Sheffield, *Alfred Stevens*, 1912 (16, 17, 19, 22, 23, 24).

Original Sin WAG 1765

Astronomy WAG 1766

Judgment of Solomon WAG 1767

Victory of Apollo over Marsyas WAG 1768

431

1 WAG 1763–1768 all have Charles Roberson, Long Acre, labels.

2 M. Digby Wyatt and J.B. Waring, *The Italian Court in the Crystal Palace*, 1854, pp. 6, 69, 73; Hugh Stannus, *Alfred Stevens and his Work*, 1891, p. 14; K.R. Towndrow, *Alfred Stevens*, 1939, pp. 114–15, 264; Royal Institute of British Architects, *Catalogue of the Drawings Collection: Alfred Stevens*, 1975, p. 31. For Stevens's attitude to copying after Raphael, see D.S. MacColl, 'A Portrait by Alfred Stevens', *Burlington Magazine*, 1912, vol. 20, p. 209; it should be done 'with spirit . . . and freedom as a work of fancy'.

3 The two missing panels, *Theology* and *Philosophy*, were in the artist's studio sale after his death (Robinson and Fisher, 20 July 1877, lots 13 and 16) but are now unlocated. They were lent to the 1912 Mappin Art Gallery, Sheffield, *Alfred Stevens* exhibition by John Fowler.

4 Wyatt and Waring, *op.cit.*, p. 73; a chromolithograph of the Stanza della Segnatura ceiling appeared as plate 80 in L. Gruner, *Ornamental Designs*, 1850. Stevens made a number of sketches in the Vatican in 1859 (Stannus, *op.cit.*, p. 24) but there seems to be no reason for any connection between WAG 1763–1768 and this visit; for further details about these 1859 sketches, see Royal Institute of British Architects, *op.cit.*, p. 49.

5 Royal Institute of British Architects, *op.cit.*, p. 31.

STOCKS, Arthur (1846–1889)
The Best of Husbands
WAG 2656
Canvas: 143 × 113 cm
Signed: *A Stocks 1877*

PROV: Presented by Alderman Bernard Hall 1877.[1]

EXH: Royal Academy 1877 (653); Liverpool Autumn Exhibition 1877 (859).

1 Hall had bought WAG 2656 from the 1877 Liverpool Autumn Exhibition.

The Best of Husbands WAG 2656

Motherless
WAG 2636
Canvas: 112.7 × 87.3 cm
Signed: *A Stocks / 1883*

Motherless was exhibited by Stocks at the 1883 Royal Academy as *In Memory* with this quotation from Elizabeth Barrett Browning:[1]

All are not taken! there are left behind
Living belovèds, tender looks to bring,
And make the daylight still a blessed thing.

For the Liverpool Autumn Exhibition later the same year, he changed the title to *Motherless* and reduced the supporting quotation to one unattributed line:

The image shall ever be loved and lost in memory.

The critics at the Royal Academy exhibition displayed little attention to this painting, but the *Illustrated London News*[2] explained the subject: 'In Memory, a rustic labourer, with his baby, tending his wife's grave.'

REPR: Engraving by W. Biscombe Gardner (Witt Library); H. Blackburn, *Academy Notes*, 1883, p. 67.

PROV: Purchased from the artist 1883 (£210).

EXH: Royal Academy 1883 (815); Liverpool Autumn Exhibition 1883 (47).

1 These are in fact the first three lines from her sonnet entitled *Consolation*.

2 *Illustrated London News*, 5 May 1883, p. 518.

STOKES, Adrian (1854–1935)

Villeneuve-les-Avignon and Ruins of the Bridge

WAG 805
Canvas: 63.2 × 81 cm
Signed: *Adrian Stokes*

Villeneuve-les-Avignon is on the opposite (west) side of the Rhône from Avignon itself. The 14th-century Fort St. André is conspicuous in the distance. The ruins of the Pont Saint-Bénézet are in the foreground.

 C. Reginald Grundy[1] noted that the painting 'must be chiefly regarded as a subtle and harmonic arrangement in russet, white and blue expressed with full regard for atmospheric truth, of which the components have

433

My Lady is a Widow and Childless
WAG 2637

been carefully selected to accord with the tonal scheme'; rhythm and decorative arrangement, he argued, were more important to Stokes than topographical accuracy.

REPR: *Royal Academy Illustrated*, 1922, p. 4.

PROV: Purchased from the artist 1922 (£140).

EXH: Royal Academy 1922 (30); Liverpool Autumn Exhibition 1922 (885).

1 'The Subject in Art: A Glance through the Royal Academy Pictures', *Connoisseur*, 1922, vol. 63, p. 116. The critic of the *Studio*, however, did not include WAG 805 in his list of commended landscapes at the 1922 Royal Academy (*Studio*, 1922, vol. 83, pp. 302–3).

Villeneuve-les-Avignon and Ruins of the Bridge
WAG 805

STONE, Marcus (1840–1921)
My Lady is a Widow and Childless
WAG 2637
Canvas: 110 × 73.6 cm
Signed: *MARCUS STONE*

This is a reduced version of the large painting first exhibited at the Royal Academy 1874 (106);[1] this large painting appeared at the Guildhall Art Gallery, *A Summer Show for the City*, 1983 (10) and was sold at Sotheby's 21 June 1989, lot 141; it is now in the Forbes Magazine Collection, which also owns a smaller version.

PROV: (?) Joshua Bower.[2] Presented by George Audley 1926.

1 For the large painting (185 × 124 cm) see particularly, A.L. Baldry, 'Marcus Stone', *Art Annual*, 1896, pp. 18–20, and L.G. Robinson, 'Marcus Stone', *Art Journal*, 1885, p. 71; Baldry noted that with it Stone was abandoning history painting in favour of pathetic scenes from modern life; it was engraved by George Every in 1874 as *Sunshine and Shadow*.

2 George Audley, *Collection of Pictures*, 1923, p. 51, no. 149; Audley, however, confused his picture (WAG 2637) with the large painting, which may have been the one owned by Joshua Bower. Audley also states that WAG 2637 was exhibited at the 1879 Industrial and Fine Art Exhibition held in Clayton Hospital, Wakefield; no catalogue for this exhibition seems to survive, but Joshua Bower of Hunslet (near Leeds) was a lender (Corinne Miller, letter to the compiler, 12 September 1985); James Virtue lent a version, presumably the large painting, to the Paris, *Exposition Universelle*, 1878 (245).

Waiting
WAG 765
Canvas: 39.8 × 50.7 cm
Signed: *MARCUS STONE*

This is one of those paintings – enigmatic subjects involving romantic love set in 'raised terraces of old gardens, alcoves and yew-sheltered walks' – which became the artist's

Waiting
WAG 765

435

speciality after about 1875.[1] The woman's costume dates from about 1810.

PROV: The artist's sale, Christie's 24 June 1921, lot 114, bought Sampson (£22. 10s.); presented by George Audley 1925.[2]

1 See A.L. Baldry, 'Marcus Stone', *Art Annual*, 1896, p. 21, and L.G. Robinson, 'Marcus Stone', *Art Journal*, 1885, p. 71. Presumably the principal influence behind these works was Tissot.

2 George Audley, *Collection of Pictures*, 1923, p. 51.

STOREY, George Adolphus (1834–1919)
The Duet
WAG 2638
Canvas: 106 × 89 cm
Signed: *G.A. Storey 1869*

The critics of the *Art Journal*, the *Athenaeum*, the *Saturday Review* and *The Times* all identified the work of Pieter de Hooch as the source for this painting with the light coming in from the open door, the two lovers singing, the distant courtyard, the mirror, the black framed landscape and the general interest both in the diffusion of light over an interior and in the mildly humorous depiction of sexual attraction.[1] In fact the story in the painting relates more closely to the work of Terborch than that of de Hooch – for example to Terborch's *A Woman making Music with Two Men* in the National Gallery. The costume and architecture are also clearly intended to relate to 17th-century Holland.

Despite appearances, however, this interior and those in some other of Storey's 'Dutch' paintings were derived from sketches made by the artist in the Casa Abad in Toledo, where he took lodgings from December 1862 until

The Duet WAG 2638

February 1863 during his Spanish excursion of 1862–3.[2]

The most perceptive comments came from the *Saturday Review*, which observed that Storey combined 'Dutch realism and chiaroscuro with a grace and fancy in keeping with the sentiment of modern times', and that 'Mr. Storey's humour, spiced occasionally by good tempered malice, imparts to the spectator just about as much emotion as is usually cared to be felt'.

There are numerous pentimenti, particularly in the area around the seated man; the doorway was originally further to the left and there was a ceiling with beams. There were several alterations by the artist to the position of the woman's hands, and the *Athenaeum* reviewer indicates that originally the standing man was pressing one of them to his breast.[3] The artist may have re-arranged the woman's hand and arm for reasons of morality and decorum; 19th-century imitators of Dutch 17th-century genre painting were careful to avoid the occasional coarse humour of their prototypes.

PROV: Anon sale, Christie's 26 April 1884, lot 144, bought in (£152.5s.). Presented by George Audley[4] 1925.

EXH: Royal Academy 1870 (11) as *A duet: 'If music be the food of love, play on'* – *Twelfth Night*.

1 *Athenaeum*, 21 May 1870, p. 681; *The Times*, 18 May 1870; *Art Journal*, 1870, p. 161; *Saturday Review*, 14 May 1870, p. 642; Storey painted his first 'De Hooghe', as he called this type of picture, at Hever Castle in 1866; this was his *Children at Breakfast* (G.A. Storey, *Sketches from Memory*, 1899, pp. 333–4). See also J. Dafforne, 'The Works of George Adolphus Storey', *Art Journal*, 1875, p. 176, where the links with de Hooch and Terborch are also emphasized. Other contemporary reviews of WAG 2638 appeared in the *Saturday Review*, 14 May 1870, p. 642 and the *Architect*, 7 May 1870, p. 220. J.C. Horsley was also doing imitations of de Hooch in the 1860s; see Wolverhampton Art Gallery, *The Cranbrook Colony*, 1977, nos. 33–7.

2 Storey, *op.cit.*, pp. 190–2.

3 *Athenaeum*, *op.cit.*: 'The gentleman presses the lady's hand to his breast in an exaggerated fashion which is capitally suggestive of the state of his heart.' This alteration cannot, however, be confirmed from an examination of the painting in its present state.

4 George Audley, *Collection of Pictures*, 1923, p. 51.

STOTT, William (1858–1900)
Alps by Night
WAG 2644
Canvas[1]: 95 × 146.7 cm
Signed: *WILLIAM STOTT OF OLDHAM*

The artist went to Switzerland in late 1888 or early 1889 and camped out on the Jungfrau to observe Alpine night effects; drawings, sketches and pastels based on this experience were exhibited at the Durand Ruel Galleries in Paris in 1889 and at the Second Pastel Exhibition in the Grosvenor Gallery, London, during the same year.[2] Subsequent Alpine paintings include *The Eiger* (Manchester City Art Galleries), *The White Mountain* (Oldham Art Gallery) and *Morning in the Alps* (first exhibited at the Salon Nationale des Beaux Arts, Paris 1894 (1100) and now unlocated).[3]

Alps by Night seems to have been first exhibited in Liverpool in 1892 and was therefore probably painted in that year. The artist was on the hanging committee for the 1892 Liverpool Autumn Exhibition and may therefore have felt obliged to contribute a new unexhibited painting.

PROV: Purchased from the artist 1892 (£300).[4]

EXH: Liverpool Autumn Exhibition 1892 (1157); Whitehall Rooms, London, *Alpine Club*, 1893; Royal Watercolour Society, *Works by William Stott of Oldham*, 1901.

1 Frame maker's label: R Dolman, 4 New Compton Street, Soho.

2 Alice Corkran, 'William Stott of Oldham', *Scottish Art Review*, 1889, pp. 319 ff. She describes these sketches as 'drenched in a sort of Pantheism'. One of them, *An Alpine Peak*, coloured chalks, was sold at Sotheby's (Belgravia) 6 June 1972, lot 30 (from the collection of Sir Thomas Hall Caine); others were exhibited at the Manchester City Art Gallery, *Exhibition of Paintings and Drawings by James Charles, George Sheffield, William Stott of Oldham and D.A.*

Alps by Night WAG 2644

Williamson, 1912, nos. 108, 117, 124, 125. The Grosvenor Gallery Second Pastel Exhibition of 1889 included these works by Stott: *Morning, Alps* (73); *Jungfrau* (113); *The Eiger* (120); *The White Mountain* (125).

3 The best analysis of Stott's Alpine paintings – and of his gradual descent into symbolism which culminated with these mountain pictures – is in R.A.M. Stevenson, 'William Stott of Oldham', *Studio*, 1894, vol. 4, p. 15:

I know few pictures more subtle in colour than Mr. Stott's large, soft, and luminous views of stony peaks and white visionary glaciers. Alpine drawings, sketches, hard studies and wonderful photographs we have seen in plenty; but scarce anything that showed one of the many kinds of beauty discoverable in the great mountains. That is a task especially calling for

the recent art of impressionism, and therefore Mr. Stott's canvases are probably the most successful of all attempts hitherto made. But these pictures are not for the Alpine climber who wishes to retrace his perilous route. Mr. Stott has chosen at any price to give us some of the beautiful qualities of the hills, and he steeps us in dreamy visions of delicate colour and exquisitely soft definition.

Similarly, the anonymous writer on Stott in the *Magazine of Art*, 1902, p. 82, particularly admired the artist's Alpine scenes for their 'elegance and refinement', but conceded that they were too large and would never be popular. Subsequently Richard Whiteing wrote an appreciation of Stott's work for the catalogue of the Leeds City Art Gallery, *Spring Exhibition*, 1903, which included a section devoted to Stott; he particularly admired WAG 2644.

4 There was considerable opposition to the purchase of WAG 2644 in the Liverpool City Council; see p. **12** and George Moore, 'The Alderman in Art', *Speaker*, 22 October 1892, pp. 497–8, reprinted in *Modern Painting*, 1893, p. 165; for fuller details, see E.A. Hornel, *Newscuttings Book 1890–1894*, Hornel Trust, Kirkcudbright.

STRUDWICK, John Melhuish (1849–1937)
Circe and Scylla
WAG 303
Canvas[1]: 99.7 × 69.8 cm

George Holt seems to have written to the artist in early May 1890 enquiring about the *Gentle Music of a Byegone Day*, then at the New Gallery.[2] Strudwick replied saying that this picture was sold; he then had only one unsold painting, his *Circe and Scylla* of 1886; his letter included[3] this long description of the subject:

Circe and Scylla WAG 303

Scylla was greatly loved by Glaucus, one of the deities of the sea. She scorned his addresses, and he, to render her more propitious, applied to Circe, whose knowledge of herbs and incantations was universally admitted. Circe no sooner saw him than she became enamoured of him, and instead of giving the required assistance, attempted to make him forget Scylla, but in vain. To revenge herself, Circe poisoned the stream where Scylla bathed; and no sooner had the nymph touched the water than she was changed into a frightful monster. This sudden metamorphosis so terrified her, that she threw herself into that part of the sea which separates the coast of Italy from Sicily, where she was changed into rocks which continue to bear her name.

The picture represents Circe squeezing the fatal juice into the stream and Scylla descending the rocks to bathe.

Few of the critics at the 1886 Grosvenor Gallery exhibition noticed *Circe and Scylla*; however, the *Athenaeum*[4] described it at length but did not take it very seriously:

Very poetical is Mr. J.M. Strudwick's 'Circe and Scylla', in which the painter continues to proclaim his allegiance to Mantegna (or Mocetto). The witch stands at the entrance of her cave and squeezes a spongeful of sirups red as wine into the headwaters of a fountain. In the distance is the nymph hastening to bathe. Syclla's bathing costume is more proper than Brighton beach demands, and she is descending a series of those rocks which are invariably at the service of Mantegnesque designers, who, contrary to the practice of other men, contrive their figures first and then adjust the ground for them to stand on. Consequently Scylla has a convenient flight of steps, while Circe's cave fits her figure very neatly. The slabs of rock resemble the wing-pieces and 'flies' of theatres. There is something childish in this, and it is unworthy of so careful a painter as Mr. Strudwick, who, his whims apart, draws and paints with taste and care. Scylla, although unbathed, is already very clean, while a god so jolly as Glaucus would not look twice on a Circe so burnt up as Mr. Strudwick's. An effective point, always to be found in Mantegnesque designs, is the circean snake, which seems to climb the red column of the poison falling from the witch's hand into the fountain. This is a telling idea in the mode of the Renaissance, which revelled in poetic extravagances of the sort. Circe's garments of bronze shot with gold and marone [sic], and her complexion – darkened as with smoke of necromancy – suggest the gloom and horror of her life. The chestnut trees near the cave are worthy of Styx's banks. There is good colour in the picture.

REPR: H. Blackburn, *Grosvenor Notes*, 1886, p. 6.

PROV: Bought by George Holt from the artist 1890 (receipt dated 10 June, £350); bequeathed by Emma Holt 1944.

EXH: Grosvenor Gallery 1886 (6); Paris, *Exposition Universelle*, 1889 (151); Wolverhampton 1902.

1 Label of Charles Roberson, 99 Long Acre, on stretcher, and frame maker's label of Smith and Uppard, 77 Mortimer Street.

2 Sold at Christie's 11 June 1993, lot 130. It is not clear why Holt contacted Strudwick in the first place, but William Imrie had been a friend and patron of the artist since about 1882 (MS letter from Strudwick to Holt of 4 September 1892); both Holt and Imrie lived in Mossley Hill, a suburb of south Liverpool, and presumably knew each other. Imrie's collection of works by Strudwick is discussed and reproduced by Bernard Shaw in 'J.M. Strudwick', *Art Journal*, 1891, pp. 97–103.

3 MS letter from Strudwick, 8 May 1890; repeated on MS label on back of picture in the artist's hand. This same description of WAG 303 was published in the 1886 Grosvenor Gallery catalogue (see Exhibited). S. Kolsteren, 'The Pre-Raphaelite Art of J.M. Strudwick', *Journal of Pre-Raphaelite and Aesthetic Studies*, 1988, vol. 1, p. 3, notes the interest of Burne-Jones, D.G. Rossetti and J.W. Waterhouse in the Circe story; Waterhouse's *Circe Invidiosa* of 1892 (Art Gallery of South Australia, Adelaide) represents the same scene selected by Strudwick but omits the figure of Scylla; see Anthony Hobson, *Art and Life of J.W. Waterhouse*, 1980, p. 73, plate 53.

4 *Athenaeum*, 15 May 1886, p. 651. The *Magazine of Art*, 1886, p. 347, found the painting too small for comment.

Love's Palace

WAG 304
Canvas[1]: 64.7 × 114.9 cm
Signed and dated: *JMS 1893*

Holt commissioned Strudwick to paint him another picture in 1890 – after his purchase of *Circe and Scylla* (see above). In a letter to Holt of 14 June,[2] the artist suggested the possible subject, which was agreed upon. It was, the artist stated: 'to represent "Love" seated on an ivory throne in as wonderful a Palace as I can produce – He will be surrounded by "Loves" and Lovers, by Girls playing musical instruments, by – but I have not even given this idea shape on paper yet . . .'

At this stage, the title of the picture was *The King's Palace*, but before its exhibition in 1893 this was changed by the artist to the quotation:[3] 'Let come what may, for that grim fate decides, Love rules the day, and Love, enthroned abides'.

Progress on the painting was slow. In October 1891,[4] Strudwick reported that he was copying his studies on to the canvas. In the same letter he suggested a price of £800 to represent at least one year's work, together with the cost of materials, frame, models, etc. In February 1892[5] he remarked to Holt that work was slow because he had no studio assistants to assist him with routine, mechanical work. In November 1892[6] he was making some alterations to the painting as originally he had characteristically 'thought too much of the literary and not enough of the artistic side'. In March 1893[7] he noted that the light on the picture should come from the spectator's left (or from above). Finally, *Love's Palace* went to the New Gallery exhibition in April 1893 still unfinished.[8]

On 4 May 1893, after it was paid for, Strudwick sent Holt a detailed description of it:[9]

In the centre Love sits enthroned – Around are a number of winged boys or Amorini, one of whom has fallen asleep at the foot of the throne.

At the base of the steps leading to the throne sit the three Fates – Around the feet of Clotho, flowers are

Love's Palace WAG 304

growing; while Atropos, who holds the shears, treads upon dead leaves, amongst which are a few ears of corn (unfinished).

On the left of the centre figure as we look at the picture, are three girls; two of whom are watching a bubble as it floats in the air, the bubble has burst for the third girl and she is in grief. A little winged love tries to comfort her, but in vain as yet.

On the other side a girl is listening to Love's music; another is learning from Love's book, and another, who is also learning, tries to prevent her winged teacher turning the page, for her lover is whispering to her, and the page is pleasant, too pleasant to be turned she thinks.

At the back Knights are riding by. Most of them look into Love's house as they pass; but one, who rides a white horse, keeps his eyes straight in front – Love's joys are not for him – the Knights on the other side are in grief; except the one who rides on the white horse, and keeps his eyes straight in front – Love's sorrows are not for him.

Low down in the front of the picture, winged boys are playing amongst brambles, amidst which lie the King's crown, knights' armour, and wise men's books. One of the winged boys sleeps, and his fellows wonder 'will he wake again, or is he dead?'

Some final retouching by the artist was done after the New Gallery exhibition closed and the picture was finally sent to Holt in Liverpool at the end of November 1893.[10]

Kolsteren[11] has provided an analysis of *Love's Palace* and of its Pre-Raphaelite sources, together with an account of its origin and progress between 1890 and 1893. A less polite account of the picture appeared in the 1893 *Athenaeum*:[12]

There is usually something confused and laboured about the work of Mr. J.M. Strudwick, who, in No. 19, has attempted an apotheosis of Love. The scene is a kind of hall of marble, richly sculptured and painted, while in an open arcade of the background a company of young knights and others are seen riding without. A number of pretty figures of damsels and 'amorini', which are left quite isolated and are not brought into any relation to one another, are delineated in a manner which reminds of a late 16th century illumination of a decaying school. The design cannot be said to be confused, because no composition is discoverable in it, there is no systemised scheme of coloration, tone, or chiaroscuro. Love, nondescript, splendidly attired and winged, is enthroned under a sort of alcove and upon a platform which is approached by steps in the foreground. Mr. Strudwick has toiled on this curious

anachronism in a neat and over laboured rather than prim and really finished style.

REPR: H. Blackburn, *New Gallery Notes*, 1893, p. 29.

PROV: Commissioned by George Holt 1890, begun 1891, finished 1893 (final receipt dated 5 May 1893, £850). Further work (receipt dated 5 December 1893, £100); bequeathed by Emma Holt 1944.

EXH: New Gallery 1893 (19); Brussels 1897; Shepherd's Bush, London, *Franco-British Exhibition*, 1908 (408).

1 Label: *Charles Roberson 99 Long Acre* on stretcher.

2 MS letter.

3 The quotation serving as the eventual title of the picture seems to have been written by G.F. Bodley, whose name appears against the lines in an inscription on the frame of WAG 304 and in the 1893 New Gallery catalogue (see Exhibited). These lines do not, however, appear anywhere in Bodley's one volume of verse, published six years later in 1899. Bodley was, however, a patron of the artist – he owned Strudwick's *Golden Strings* (MS letter from the artist to Holt of 9 August 1895) – and he may have suggested the lines privately to the artist. Many of his poems are concerned with the power of Love and one (pp. 150–2) describes Burne-Jones's *Chant d'Amour* and *Love among the Ruins*. Indeed, he lent two important works by Burne-Jones to the 1899 New Gallery retrospective exhibition of the artist's work and he lent a *Virgin and Child with Saints*, attributed to Memlinc, to the 1900 New Gallery exhibition of early Flemish art. He was also a close friend of J.R. Spencer Stanhope – see A.M.W. Stirling, *A Painter of Dreams*, 1916, pp. 338–9. Another possible literary source is P.B. Marston's sonnet, *Love's Lost Pleasure House*, published in his *A Last Harvest* of 1891, the year Strudwick started on WAG 304; see S. Kolsteren, 'The Pre-Raphaelite Art of J.M. Strudwick', *Journal of Pre-Raphaelite and Aesthetic Studies*, 1988, vol. 1, pp. 1–2. This new title was definitely agreed in an MS letter from the artist to Holt of 30 March 1893. Strudwick also suggested to Holt a painting based on Swinburne's poem, *The King's Daughter*, but this idea was not followed up; the poem is unknown to the compiler.

4 MS letter from the artist to Holt of 11 October 1891.

5 MS letter from the artist to Holt of 11 February 1892.

6 MS letter from the artist to Holt of 3 November 1892.

7 MS letter from the artist to Holt of 27 March 1893.

8 MS letter from the artist to Holt of 24 April 1893.

9 MS letter from the artist to Holt of 4 May 1893.

10 MS letter from the artist to Holt of 20 November 1893.

11 Kolsteren, *op.cit.*, pp. 1–3; he used the letters written by the artist cited above. The compiler is also indebted to Maia Murray for assistance with Strudwick.

12 *Athenaeum*, 6 May 1893, p. 576. As usual the *Athenaeum* seems to have been the only serious periodical even to mention Strudwick's work.

Oh Swallow, Swallow

WAG 305
Canvas[1]: 93 × 59 cm
Signed and dated; *JMS 1894*

George Holt apparently suggested to the artist that he might paint another picture after *Love's Palace* (see above) and on 27 March 1893, Strudwick replied, suggesting the subject of this painting – which he had indeed begun some three years earlier.[2] Holt was pleased with the idea[3] and the picture was completed and then sent off to Holt in Liverpool on 16 July 1894.[4] Holt, however, complained that it was too dark.[5] It was returned to Strudwick in March 1895 for exhibition at the New Gallery,[6] and early in 1896 the artist altered the dress and face of the girl and made the painting rather lighter in tone.[7]

The full title, under which the picture was exhibited, was:

Oh Swallow, flying from the golden woods
Fly to her, and pipe and woo her, and make her
* mine,*
And tell her, tell her, that I follow thee.

This is the eighth stanza of the prince's love song from part 4 of Tennyson's *The Princess* of 1846–7. Strudwick was not, however, deeply concerned with the poem or its subject, the higher education of women; he commented to George Holt that his painting had been suggested by Tennyson's poem but was not an exact rendering of the lines quoted; he did observe that in his picture the golden chain must have been given to the girl by her lover and that she has just ceased playing on her instrument, the memory of her music still in the air; thus she hears the swallow but does not turn her head. On 16 July he wrote to Holt:

The picture is quite simple and represents nothing more extraordinary than a girl sitting at a window, & a bird flying past. The girl holds in her hands a golden chain – perhaps it was given to her by her lover before he went to the land of the 'golden woods'. So it's a fortunate time for the swallow to come with his message; & although the girl does not even turn her head (the chirping of a bird among those orchard trees is too common an occurrence to make her do that) she hears the piping mixed with evening sounds & fading light & one can't doubt but the swallow is fulfilling his instructions in an exemplary manner . . . I don't imagine the picture can be accepted as a quite exact illustration of the verse, it is not English enough in character or realistic enough in treatment for that, but since the lines suggested the picture I think I am justified in using them as its title.[8]

Strudwick must have known Millais's rather prosaic 'Swallow! Swallow!' of 1864–5, which was taken from the same love song.[9]

The critic of the *Athenaeum*[10] was as contemptuous as usual with Strudwick's work:

Mr. Strudwick's laboured illustration of the late Laureate's 'O Swallow, flying from the golden woods. / Fly to her.' In an elaborately adorned chamber, crowded with all sorts of 'bric-a-brac', and what auctioneers call 'antiques', sits a rather weak-minded young lady with lightless eyes and an expression which has not the least animation, supposed to be the damsel for whom the lover's message was intended. Inane and passionless, she will never respond to his cry; her eyes will not attract him, nor will she trouble

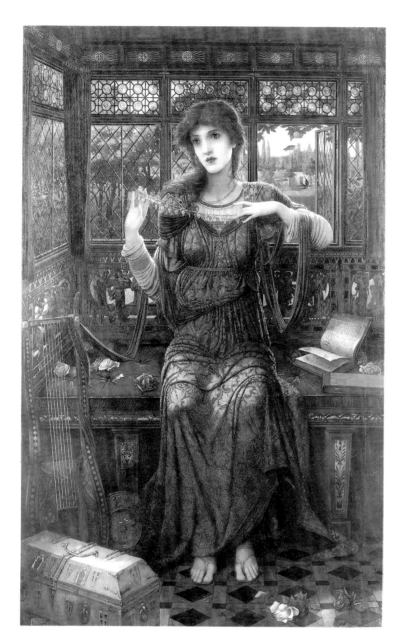

herself to rise to admit the swallow when that bird reaches this wonderful chamber; she is doing something with a necklace, but what that is does not appear, while in her figure and its surroundings we have the fruits of mechanical polishing which, not being researchful, is not true finish, and a technique which, not being organic, is not really artistic.

PROV: Commissioned by George Holt March 1893, finished 1894 (receipt dated July 1894, £500) retouched 1896; bequeathed by Emma Holt 1944.

EXH: New Gallery 1895 (64); Earls Court, *Victorian Era Exhibition*, 1897 (80); Liverpool Autumn Exhibition, 1928 (282).

1 The frame was made in Florence (MS letter from the artist to Mrs. George Holt of 29 June 1896). For the importance of Strudwick's 'Renaissance' frames made in Florence, see Lynn Roberts, 'Nineteenth Century English Picture Frames II', *International Journal of Museum Management and Curatorship*, 1986, vol. 5, pp. 286–8.

444

2 MS letter from the artist to Holt of 27 March 1893.

3 MS letter from the artist to Holt of 30 March 1893.

4 MS letters from the artist to Holt of 1 and 16 July 1894.

5 MS letter from the artist to Holt of 24 August 1894.

6 MS letter from the artist to Holt of 4 March 1895.

7 MS letters from the artist to Holt of 1 and 9 August 1895, of about January 1896 and of 19 February 1896. Strudwick was also trying to simplify WAG 305 and bring it together.

8 MS letters from the artist to George Holt of 16 July 1894 and of 11 March 1895. S. Kolsteren, 'The Pre-Raphaelite Art of J.M. Strudwick', *Journal of Pre-Raphaelite and Aesthetic Studies*, 1988, vol. 1, pp. 3–4, provides an analysis of subject and style.

9 See J.G.Millais, *Life and Letters of Sir John Everett Millais*, 1900, vol. 1, p. 369 (repr.) and Elaine Shefer, 'The Woman at the Window in Victorian Art', *Journal of Pre-Raphaelite Studies*, 1983, vol. 4, pp. 14–26. Strudwick's *Isabella and the Pot of Basil* (Sotheby's (New York) sale, 16 February 1994, lot 109) is another woman at the window composition very similar to WAG 305.

10 *Athenaeum*, 11 May 1895, p. 615. *The Times*, 11 May 1895, compared Strudwick's picture to that of a follower of Van Eyck.

Saint Cecilia

WAG 306
Panel[1]: 33.6 × 27.9 cm

Saint Cecilia was commissioned by George Holt in March 1895 as a companion picture to his *Two Mothers* by D.G. Rossetti.[2] It was not, however, completed until after Holt's death in 1896. The artist wrote to Mrs. George Holt in July 1896 explaining that St. Cecilia is looking down – rather than up as was usual with this subject – because she is playing earth's not heaven's music and that the angels have sad faces because earth's music is always sad.[3] The picture was sent to Mrs. Holt in July 1896.[4]

The *Artist*[5] commented on *Saint Cecilia*: 'The artist disdains to aim at realism but prefers to give us a well studied scheme of colour and decoration that in a room may serve as a spot of calm repose for the eye.'

Strudwick's very different *Saint Cecilia* of 1882 was sold at Sotheby's (Belgravia), 9 April 1974, lot 69 (repr.). It had been in the collection of Holt's neighbour, William Imrie.[6]

PROV: Commissioned by George Holt March 1895 and completed July 1896 (receipt dated 27 July 1896, (£200);[7] bequeathed by Emma Holt 1944.

EXH: Liverpool Autumn Exhibition 1896 (1009) and 1922 (23); New Gallery 1897 (78).

1 Label of Charles Roberson, 99 Long Acre, on stretcher, and frame maker's label of Smith and Uppard, 77 Mortimer Street (successor to W.A. Smith).

2 MS letter from the artist to George Holt of 4 March 1895 and from the artist to Mrs. George Holt of 28 April 1896.

3 MS letter from the artist to Mrs. Holt of 27 July 1896. Strudwick wrote:

St. Cecilia is generally represented looking up to convey the impression that her music is more of heaven than earth. I have made her looking down. I have done so because I think earth's sweetest music is not an echo of heaven's music at all but something quite different, with a sweetness all its own.
 I don't think angels would have left Heaven to hear St. Cecilia if she had only faintly echoed Heaven's songs. They came because she played earth's music as sweetly as it can be played. I have made my angel sad-faced because there's always a strain of sadness in our mortal songs, and most perhaps when they are played the best.

4 MS letter from the artist to Mrs. Holt of 23 July 1896; delay was caused by the slowness of the frame maker (MS letter from the artist to Mrs. Holt of 29 June 1896).

5 *Artist*, 1897, p. 275. The *Magazine of Art*, 1897, p. 140, also mentioned WAG 306.

6 See *Circe and Scylla* (WAG 303) p. **440**, note 2.

7 There was no prior agreement on the price of
St. Cecilia, so a figure was fixed by a small
committee of the artist's friends (MS letter from
the artist to Mrs. Holt of 23 July 1896).

SWYNNERTON, Annie Louisa
(1844–1933)

The Sense of Sight

WAG 2640
Canvas[1]: 87.3 × 101 cm
Signed: *Annie L Swynnerton / 1895*

The precise meaning of this painting remains
uncertain. The artist noted[2] that Charles Proc-
ter bought it as he was losing his sight and
that he was deeply impressed by it, although
he could scarcely see it; she gave him 'an
account of what I meant by it and the idea
which prompted it', but no record survives of
this.

 M. Phipps Jackson writing for the *Magazine
of Art*,[3] described *The Sense of Sight* as 'a
beautiful female study with rather obscure
title', but the critic of the *Athenaeum*[4] tried
rather harder to find a meaning:

*Mrs. A.L. Swynnerton is, artistically speaking, the
antithesis of Mr. Watts, and yet her flesh-painting
attests the strength of her efforts to render nature truly.
The Sense of Sight is, as we understand it, an
allegory treated with extreme realism, and expressing
itself by means of forms and colours, without the least
touch of the abstract. A winged woman, angel, or
spirit incorporate seems to have fallen from the zenith
because her wings are broken, and gazes upwards
again with intense emotion and a devout passion that
finds expression in her piercing eyes and parted lips.
The features of the face, the eyes especially, are drawn*

and modelled with admirable thoroughness and skill, and instinct with style at once large and fine. All the while the shoulders and torso are so badly drawn and proportioned as to be almost inexplicable, and the surface of the picture is so rough and crude that few casual observers would give the accomplished lady who has painted it half the credit which is due to her skill, vigour and knowledge.

George Moore[5] often praised Mrs. Swynnerton's work and he particularly liked this painting:

Mrs. Swynnerton's work I nearly always admire; although it is not the kind of art that I am naturally drawn towards, but I admire all who think clearly and forcibly. Mrs. Swynnerton's work is astonishingly vigorous, and as beautiful as a richly-coloured piece of stone carving might be. Her picture is of a woman with wings looking into the sky. Her arms are outspread in a fine gesture of wonderment, and the face tells the story of the vision that it has come to her to see. The beautiful face is distinctive; it is a portrait, no doubt, but Mrs. Swynnerton's fervid imagination has lifted it out of mere external portraiture. I admire the drawing of the face; the mouth is expecially well drawn; the wings are not possible wings, but that is a detail; the real and radical fault is the fault that I found in Mr. Alma-Tadema's pictures. The figure is not in the canvas; it is modelled to look as if it were falling out of the canvas. It seems strange that painters of such technical accomplishment should sin so fla-

The Sense of Sight WAG 2640

447

grantly against what the old masters considered to be one of the first principles of the art of painting.

Only the critic in *Punch*[6] was entirely dismissive, wondering if the figure in *The Sense of Sight* was preparing to catch a cricket ball, to cut an acquaintance or to recite something.

The painting was returned to the artist in January 1896 so that she could do more work on the drapery in the lower right area of the composition.[7] Another version of the painting (89 × 103 cm) signed by the artist and dated 1898, was sold from the R.E. Summerfield Collection.[8] It differed considerably from the Walker Art Gallery painting in the draperies.

The Sense of Sight was painted at Shepherd's Bush[9] where the artist and her husband then had their studio.

REPR: H. Blackburn, *New Gallery Notes*, 1895, p. 69; Pall Mall Gazette, *Pictures of 1895*, p. 106; Liverpool Autumn Exhibition catalogue, 1895, p. 114.

PROV: Presented by Charles J. Procter 1896.

EXH: New Gallery 1895 (259); Liverpool Autumn Exhibition 1895 (1137).

1 Label on stretcher: Francis Draper, Grosvenor Square, frame maker.

2 Letter to the Curator of the Walker Art Gallery, 18 July 1927.

3 *Magazine of Art*, 1895, p. 286.

4 *Athenaeum*, 27 July 1895, pp. 135–6.

5 *Speaker*, 4 May 1895, pp. 487–8. An eccentric review by P.H. Rathbone appeared in *Sphinx*, 1895–6, vol. 3, p. 34.

6 *Punch*, 11 May 1895, p. 227.

7 Compare the illustration in the 1895 Liverpool Autumn Exhibition catalogue (p. 114) with the painting in its present state.

8 Christie's (South Kensington) 2 November 1989, lot 142; the painting then passed to the J.S. Maas Gallery. It is now in a German private collection.

9 Manchester City Art Gallery, *Paintings by Mrs. Swynnerton*, 1923 (22).

TOMSON, Arthur (1859–1905)

'Piping down the Valleys Wild'[1]

WAG 2660
Canvas[2]: 51 × 76.5 cm
Signed: *A Tomson*

REPR: Pall Mall Magazine, *Pictures of 1892*, p. 126.

PROV: Presented by Mrs. Tomson, the artist's widow, 1907.

EXH: New English Art Club 1892 (58).

1 A quotation from the introduction to William Blake's *Songs of Innocence* of 1789.

2 Canvas stamp: Newman, London.

TOPHAM, Frank William Warwick (1838–1924)

The Fall of Rienzi, the Last Roman Tribune

WAG 135
Canvas: 152.4 × 107.3 cm
Signed: (?) *FWT 1872*

Cola di Rienzi (c.1313–1354) briefly revived the ancient Roman republic and expelled the nobles from the city. The artist placed this quotation from the *Vita di Cola di Rienzo*[1] against the title of this painting in the 1872 Royal Academy catalogue: 'Finding the people clamoured for his death he attempted to escape from the Capitol disguised, his face blackened and hidden under spoils from the palace.'

In 1849, under the influence of the 1848 revolutions and of the Italian republican political exiles in Rossetti's circle,[2] the young Holman Hunt had painted a very heroic episode from Rienzi's life: *Rienzi vowing to obtain justice for the death of his young brother.* Holman Hunt's source was Bulwer-Lytton's *Rienzi, the last of the Tribunes* of 1835 (republished in 1848),[3] but Topham used a much earlier and more reliable source emphasizing ignoble and pedestrian detail rather than heroic and grand ideals. The critic of the *Art Journal*[4] disapproved of this: 'The particular circumstance here illustrating the *Fall of Rienzi, the Last Roman Tribune* by F.W.W. Topham has not been judiciously selected, for it introduces

Rienzi in a very undignified situation, as the bearer of a mass of household material to assist him in escaping from his enemies.' *The Times*[5] was also unenthusiastic and after describing Topham's *A Fresh Excavation at Pompeii*, went on:

We cannot but regret that the painter had not thrown his full strength into this suggestive subject of real life, instead of treating it as secondary to his historical picture, really inferior in interest to ninety-nine out of a hundred spectators, of Rienzi seized by the mob in his attempt to escape down the stairs of the capitol, with blackened face, carrying a bundle of palace spoils upon his head. The group has much spirit, is well drawn, and the painter has evidently arrived at something dignified as well as daring. But putting in the foreground a screaming old woman strikes us as a mistake. A cry can no more be painted than a laugh. The one degenerates into a distortion, as the other into a grin; and both are painful when stereotyped and forced on the attention in the fixed record of a picture.

The Fall of Rienzi, the Last Roman Tribune
WAG 135

PROV: Purchased from the artist 1872 (£300).

EXH: Royal Academy 1872 (674); Liverpool Autumn Exhibition 1872 (188).

1 This anonymous contemporary (or near contemporary) biography, rich in picturesque detail and incident, was published in two Italian editions of 1828 and 1854. There were also earlier editions. Topham has provided an inexact translation from p. 164, book 2, chapter 24 of the 1854 edition (ed. Zefrino Re).

2 Walker Art Gallery, Liverpool, *William Holman Hunt*, 1969, p. 23, no. 12.

3 Rienzi's reputation as a medieval political reformer had been established by Byron's *Childe Harold's Pilgrimage* of 1812 (stanza 114) and then by Bulwer-Lytton's novel dedicated to Manzoni (see Lindsay Errington, *Social and Religious Themes in English Art*, 1984, pp. 210–43 and Leicester Museums and Art Gallery, *The Victorian Vision of Italy*, 1968, p. 17). Gibbon's account, closely based on Topham's source, was much more sceptical (*The Decline and Fall of the Roman Empire*, 1776–88, Everyman Edition, vol. 6, pp. 507–27). Bulwer-Lytton did describe the incident selected by Topham (book 10, chapter 9); he recounted that Rienzi put on 'coarse working garb' and 'placed upon his head some of the draperies and furniture of the palace as if escaping with them'.

4 *Art Journal*, 1872, p. 184.

5 *The Times*, 5 June 1872. *The Architect*, 18 May 1872, on the other hand, liked the picture: 'If time and space permitted we would gladly dwell upon its forcible delineation of character and other merits.'

TUKE, Henry Scott (1858–1929)
The Promise
WAG 675
Canvas: 56.8 × 67.5 cm
Signed: *H.S. TUKE 1888*

The artist wrote in his Registers[1] against *The Promise*: 'Painted in the orchard at Penmere.[2] Begun in the spring and resumed in the autumn. Jack Rolling[3] and his sweetheart's

sister, Jessie Nicholls from Flushing, near Falmouth, were the models.' Some years later the artist wrote (apparently) about the same picture:[4] 'There is one painting here, however, that interests me more than many I have done. I have called it "The Promise". It is a very simple little scene, and I have left the sea behind me, for a wonder, and gone inland.'

The Promise particularly attracted the attention of the *Portfolio*'s critic at the 1888 New English Art Club exhibition:[5]

But the bit of rustic life, The Promise, *a boy's and a girl's heads and hands, against a background of fruit-blossom, is deliciously fresh and well modelled, but an instance of the fad of placing the subject on the canvas as if it was a piece awkwardly cut out of a big picture, a fashion for which Mr. Tadema has something to answer.*

REPR: Pall Mall Gazette, *Pictures of 1888*, p. 84; Flora Klickmann, 'An Interview with Mr. H.S. Tuke', *Windsor Magazine*, 1895, vol. 1, p. 608 (in its original frame).

PROV: Bought from the 1888 New English Art Club exhibition by Percy Arden (£36.15*s.*);[6] his sale, Christie's 13 December 1909, lot 108, bought Sampson (£39.18*s.*);[7] bought from W.W. Sampson by Mr. Kennedy in April 1911.[8] Presented by George Audley 1925.

EXH: New English Art Club 1888 (39); McLean's Gallery 1910 (35);[9] Liverpool Autumn Exhibition 1924 (874); Newlyn Art Gallery, *Artists of the Newlyn School 1880–1900*, 1979 (43).

1 *The Registers of Henry Scott Tuke*, ed. Price, 1983, R. 92.

2 Penmere is about one-and-a-half miles from Falmouth, where the artist had his studio. According to David Wainwright and Catherine Dinn, *Henry Scott Tuke*, 1989, p. 41, the orchard was just above Tuke's cottage (Pennance Cottage) at Sunny Cove.

3 Jack Rolling or Rowling was used by the artist many times as a model from 1886 onwards; here he is wearing a fisherman's jersey and cap; he was 'a very loveable young barbarian, who could look like an angel and behave like a demon' (M.T. Sainsbury, *Henry Scott Tuke*, 1933, p. 81); he became a diver, married badly and died young; for further information about him, see *Tuke*

The Promise WAG 675 (colour plate 14)

Reminiscences, ed. Price, 1983, pp. 15, 44 etc. Wainwright and Dinn, *op.cit.*, p. 41, argue that WAG 675 'could signify Tuke's acceptance that Jack's affections were directed towards girls'; many of Tuke's friendships were homosexual in nature.

4 Flora Klickmann, 'An Interview with Mr. H.S. Tuke', *Windsor Magazine*, 1895, vol. 1, p. 609; the 'here' in this quotation refers to the artist's studio, but in 1895 WAG 675 seems to have been owned by Percy Arden, not by the artist (see Provenance); however, *The Promise* described in the *Windsor Magazine* article is reproduced in the article (p. 608) and this reproduction more or less corresponds with WAG 675.

5 *Portfolio*, 1888, p. 104. The *Globe* also felt that WAG 675 was a fragment of a larger composition and added that the artist had 'imitated the executive manner of the late Bastien-Lepage' (9 April 1888). Tuke's sketch reproduced in the Pall Mall Gazette, *Pictures of 1888*, p. 84 has a more conventional composition. The *Standard*, 16 April 1888, found WAG 675 'strenuous and grave, as such a scene might be if Tom and Maggie Tulliver took part in it'. There are other reviews in the *Artist*, May 1888, p. 151, and the *Saturday Review*, 14 April 1888. A book of press-cuttings containing reviews of the 1888 New English Art Club exhibition is in the Tate Gallery archives. More recently Kenneth McConkey sees the symbolism of love in the dense foliage and

blossom behind the figures – in the manner of Burne-Jones (Barbican Art Gallery, *Impressionism in Britain*, 1995, p. 205).

6 Registers, *op.cit.*

7 But it seems that the artist had WAG 675 or a version of it in his Falmouth studio in 1895, see Klickmann, *op.cit.*, p. 609.

8 Registers, *op.cit.* This Mr. Kennedy was possibly the artist's close friend and model, Colin Kennedy, who later lived with him – see Sainsbury, *op.cit.*, p. 163, Registers, *op.cit.*, R. 911, 931, 933–4, 950 and *Tuke Reminiscences*, *op.cit.*, pp. 20, 25, 32–4, etc., for Kennedy; the artist seems, however, to have first met Colin Kennedy rather later than 1911, and the purchaser of WAG 675 may have been another Mr. Kennedy; Colin Kennedy still seems to have been quite a young man in Tuke's *Facing South* of 1920; J.A. Hone stated that Colin Kennedy never bought any pictures by Tuke.

9 *Athenaeum*, 26 March 1910, p. 377. No catalogue of this exhibition seems to survive.

Old Letters WAG 350

WALKER, Frederick (1840–1875)
Old Letters
WAG 350
Canvas: 31.5 × 26.3 cm
Signed: *F.W.*

Although *Old Letters* was regarded as typical of Walker's work by Reynolds[1] and accepted as autograph by Hillier,[2] who dated it to the early 1860s, there is considerable doubt about its attribution.[3] Another version of it signed *J. Lewis* and dated 1863 was in 1968 owned by the Ferrers Gallery, London.[4] The woman's dress seems to date from the 1860s.

PROV: Bequeathed by Mrs. Constance Emily Warr on behalf of her husband George C.W. Warr 1908.

1 Graham Reynolds, *Victorian Painting*, 1966, pp. 112, 116, fig. 71.

2 B. Hillier, 'The St. John's Wood Clique', *Apollo*, 1964, vol. 74, p. 492.

3 Walker does not seem to have exhibited a painting with this title nor did it appear in his retrospective exhibition at the Deschamps Gallery, New Bond Street, in 1876 or at his studio sale, Christie's 17 July 1875.

4 Mappin Art Gallery, Sheffield, *Victorian Paintings*, 1968, p. 35, no. 112, where WAG 350 is listed as 'attributed to Frederick Walker'. Perhaps the other version was an early work by John Hardwicke Lewis.

WALTON, Frank (1840–1928)
'*Down in the Reeds by the River*'[1]
WAG 2966
Canvas: 183.8 × 138.5 cm
Signed: *Frank Walton*

The critics at the Royal Academy found this landscape too large. The *Athenaeum*[2] commented: 'In Mr. F. Walton's "Down in the Reeds by the River", which is much too large, the treatment of the brown herbage which covers a marshy field and the brook that runs through it is commendable. The handling is marked by rather pretentious "chic".'

'*Down in the Reeds by the River*' WAG 2966

The *Illustrated London News*[3] said much the same: 'Frank Walton's "Down by the River", with its deep tangle of weeds and chance-sown grain in the rank yellow of late autumn, is well and carefully done, but monotonous in colour and hardly of interest proportionate to its size.'

REPR: H. Blackburn, *Academy Notes*, 1880, p. 50; G.R. Halkett, *Notes to the Walker Art Gallery*, 1880, p. 13.

PROV: Bought from the artist 1880 (£262. 10*s*.).

EXH: Royal Academy 1880 (529); Liverpool Autumn Exhibition 1880 (38).

1 The quotation is from Elizabeth Barrett Browning's *A Musical Instrument*:

> *What was he doing, the great god Pan*
> *Down in the reeds by the river?*

2 *Athenaeum*, 29 May 1880, p. 702.

3 *Illustrated London News*, 5 June 1880, p. 547. The *Art Journal*, 1880, p. 220, however, described the painting as 'clever'. The Liverpool press was much more flattering – see the *Liverpool Albion*, 3 September 1880, the *Argus*, 11 September 1880 and the *Liverpool Mail*, 11 September 1880.

WARD, Edward Matthew (1816–1879)

Antechamber at Whitehall during the Dying Moments of Charles II

WAG 138
Canvas[1]: 160.3 × 229.2 cm
Signed: *E.M. Ward RA*

This is one of the few examples of a 19th-century British history painting with an avowed,[2] distinct and controversial interpretation[3] of the event depicted – in this case an attack on the immorality of the court of Charles II. Ostensibly Ward followed the account of the death of Charles II in Thomas Macaulay's *The History of England*, 1848 (chapter 4) and indeed quotations from this source were given in the 1861 Royal Academy catalogue.[4] In fact, however, Ward has painted the dissipated revelry described by Macaulay as occurring just before the King's final illness, whereas Macaulay makes it clear that the King's mistresses, prominent in Ward's painting, had to retire to their own rooms once the seriousness of the King's illness was apparent and that thereafter the Whitehall antechamber was occupied by officials (that is peers, privy councillors, ambassadors, bishops and doctors).[5] Ward's intention in outdoing even Macaulay's Whig prejudices was presumably to make a dramatic contrast between the solemn and fateful reception of Charles II into the Catholic Church – he is accepting absolution, communion and extreme unction from Father Huddlestone beyond the closed door in Ward's painting – and the callous and frivolous amusements of the court outside. The key to the meaning of the picture and the link between these two sharply contrasted scenes, one visible and the other imagined, is the glass of water being passed from the antechamber to the King's bedroom beyond; this was to enable him to swallow the consecrated bread of the communion service. In the second of the two quotations from Macaulay's *History of England*, reprinted by Ward in the 1861 Royal

453

Academy catalogue,[6] Macaulay described the gradual awareness among the courtiers in the antechamber about the King's first public profession of his Catholic faith, and Ward has attempted to depict various levels of anxiety and concern in the crowd concerning the events in the King's bedroom.

It is not easy to identify the various participants. The bishops must include William Sancroft of Canterbury, Thomas Ken of Bath and Wells and perhaps Henry Compton of London. Saint Evremond must be the seated figure with the skull-cap at the extreme left near the fire; the French ambassador, Paul Barrillon, is probably the standing figure taking snuff, half hiding his face behind his right hand and with his cane attached to his left wrist; the Duchess of Portsmouth, one of Charles II's mistresses, may be the distant female figure beyond the open door coming in from the stairs and preceded by a servant.[7] Other of the King's mistresses must be represented by the more prominent female figures in the foreground – Macaulay mentions the Duchess of Cleveland and Hortensia Mancini. The boy making a house of cards at the left no doubt has a symbolic purpose; the carvings on the door to the King's bedroom with their erotic subjects also reflect the immorality of the King and of the events in the painting. The Palace of Whitehall of the 1680s was not well documented in the 1860s (or now) and the architecture is likely to be imaginary, but Van Dyck's *The Five Eldest Children of Charles I* could formerly be seen in Ward's picture at the extreme left;[8] it is now virtually invisible.

Reviewers at the 1861 Royal Academy regarded the *Antechamber at Whitehall* as one of the most important paintings on display there,[9] and the artist's skill in conveying his moral message of courtly heartlessness was generally admired,[10] although the *Saturday Review* complained that the exact subject could not be understood without a key.[11] The rather diffuse composition[12] and the arbitrary scattering of light and shade over it[13] were criticized. The characterization was praised,[14] but the colour was seen as too gaudy.[15] The *Saturday Review* was uncharacteristically harsh but most worth quoting:

It is not surprising that Mr. E.M. Ward's 'Antechamber at Whitehall, during the dying moments of Charles II', should be one of the most popular pictures of the year. So large a canvas, gorgeously coloured, *and full of dramatic incident, is sure to be attractive. And deservedly enough, in a way; for there is infinite matter in the picture. The variety of action is almost Hogarthian, without his caricature, and the details are all expressed with vast skill and power. Mr. Ward paints, too, conscientiously. All is honest work; and the gay, busy scene is finished with something like Dutch minuteness. It is impossible not to admire this laborious work in its several parts. The solid sentry, the disconcerted group of bishops, the knots of shameless women and profligate men, the spaniels and pages and ushers, and all the costly paraphernalia of the court, claim notice in turn. But after all, would any one understand this picture without a key? We confess that, with every desire to be impressed by the jewelled sacerdotal hand stretched out of the almost closed door for the glass of water which the dying king requires, we cannot get up the proper emotion. We see indeed a masterly presentment of the heartless scene which Macaulay describes; but the moral of it – the contrast between the levity of this wicked, selfish court, and the awful crisis within – is not (as perhaps it could not be) effectually transferred to the canvas. So far, therefore, as regards the highest aim and scope of art, this great picture fails. What it really reaches is the praise of almost rivalling Veronese in the power of scenic effect – of excelling him, indeed, in significance of subject and in historical fidelity, while not equalling him in his unapproachable grace and freedom. But then Mr. Ward would not be content with this praise. For he aims higher, and might mount higher. We wish that he would choose for his next work some more concentrated effort, with more unity of purpose.*

A year later, however, Palgrave[16] saw the painting at the 1862 International Exhibition and found only 'a meretriciousness of colour and a vulgarity of sentiment and character besides the slovenliness of handling'. Ward's picture was also disliked by French critics at the 1867 Paris *Exposition Universelle*.[17]

The *Antechamber at Whitehall* was well advanced by April 1860[18] and was retouched by the artist in 1867.[19] John Doran, an antiquarian friend of the artist, was the model for the hand emerging to take the glass of water.[20]

REPR: Autotype (Swan's Patent Carbon Process), 1868.[21]

PROV: The artist's sale, Christie's 29 March 1879, lot 107, bought in (£945); bought from the artist's widow 1880 (£800).[22]

454

Antechamber at Whitehall during the Dying Moments of Charles II WAG 138

EXH: Royal Academy 1861 (169); Liverpool Society of the Fine Arts 1861 (389);[23] London International Exhibition 1862 (749); Birmingham, *Society of Artists*, 1863 (90); Paris, *Exposition Universelle*, 1867 (153); Liverpool Autumn Exhibition 1876 (156).

1 Label: Charles Roberson, artist's colourman, 99 Long Acre.

2 As well as the quotation from Macaulay's *History of England*, the 1861 Royal Academy catalogue contained a quotation from Psalm 37: 35–6: 'I have seen the wicked in great power, and spreading himself like a green bay tree. Yet he passed away, and, lo, he was not.'

3 The artist's wife wrote of Ward's paintings: 'He never began a work without being persuaded that it had the right elements to teach some truth.' (Mrs. E.M. Ward, *Memories of Ninety Years*, n.d., p. 53). In *Mrs. E.M. Ward's Reminiscences*, ed. E. O'Donnell, 1911, p. 31, she also emphasized that her husband's paintings had a moral message.

4 Ward often breakfasted with Macaulay in the 1840s and 1850s (Mrs. E.M. Ward, *op.cit.*, p. 49) and probably acquired from Macaulay both his interest in Stuart history and his Whig prejudices in painting it. Other paintings by Ward hostile to the later Stuarts include *Scene from the Memoirs of the Count de Grammont*, Society of British Artists 1841 (397), *Judge Jeffreys bullying Richard Baxter* (Sheffield City Art Galleries), *The Disgrace of Lord Clarendon* (Tate Gallery), *The Interview between Charles II and Nell Gwynn* (Victoria & Albert Museum) and *James II receiving News of the Landing of William of Orange* (Tate Gallery).

Macaulay was a member of the Fine Arts Commission while it was superintending the decoration of the new Palace of Westminster in 1841–65, and Ward did the eight 'paintings illustrative of that great contest which commenced with the meeting of the Long Parliament and terminated in 1689', but Ward and Macaulay had to be even-handed between Royalists and Parliamentarians in this public commission (David Robertson, *Sir Charles Eastlake*, 1978, pp. 332 ff., and T.S.R. Boase, 'The Decoration of the new Palace of Westminster', *Journal of the Warburg and Courtauld Institutes*, 1954, vol. 17, pp. 319 ff.).

5 W.P. Frith's *Charles II's Last Sunday* of 1867 (formerly Leger Galleries, sold at Sotheby Parke Bernet (New York) 28 October 1982, lot 47, and reproduced in A. Noakes, *William Frith, Extraordinary Victorian Painter*, 1978, p. 112) shows the light-hearted social amusements of the Court on the Sunday just before the King's last illness exactly as recounted by Macaulay, but Frith's source was in fact John Evelyn's *Diary* – not Macaulay – although he must surely have known WAG 138; for this picture and for the low reputation of Charles II in Victorian England, see R. Strong, *And when did you last see your Father?* 1978, pp. 94–5, and Hilarie Faberman, *Augustus Leopold Egg*, Yale University Ph.D. thesis, 1983, pp. 112–15.

6 These quotations were: (1) 'The King found so much difficulty in swallowing the bread that it was necessary to open the door and procure a glass of water.' (2) 'The whole ceremony had occupied about three quarters of an hour; and, during that time, the courtiers who filled the outer room had communicated their suspicions to each other by whispers and significant glances. The door was at length thrown open, and the crowd again filled the chamber of death.'

7 The *Athenaeum*, 23 February 1861, p. 226, identified the bishop on the left as the resolute young Compton, with the timid and cringing Sancroft in the middle and the mild and intelligent Ken behind. The other three identifications were also made by the *Athenaeum*, *op.cit.* However, J. Dafforne in *The Life and Works of E.M. Ward*, 1879, p. 48, hesitantly identified the woman with the fan at the extreme right of the painting as the Duchess of Portsmouth. The *Athenaeum*, *op.cit.*, identifies the hand reaching out for the glass of water as that of the Earl of Feversham, one of the

two Protestant witnesses of the ceremony in the King's bedroom; but attributing the hand to the Duke of York, the future James II, would have added dramatic power to the scene.

8 *Athenaeum*, *op.cit.*

9 *Literary Gazette*, 11 May 1861, p. 449; *The Times*, 4 May 1861; *Art Journal*, 1861, pp. 163–4; *Illustrated London News*, 11 May 1861, p. 440.

10 *Literary Gazette*, *op.cit.*; *The Times*, *op.cit.*; *Art Journal*, *op.cit.*, *Athenaeum*, 4 May 1861, p. 599; *Saturday Review*, 18 May 1861, p. 502.

11 *Saturday Review*, *op.cit.*

12 *Athenaeum*, *op.cit.*

13 *Literary Gazette*, *op.cit.*; *Art Journal*, *op.cit.*; *Athenaeum*, *op.cit.*

14 *Literary Gazette*, *op.cit.*; *Art Journal*, *op.cit.*; *Athenaeum*, *op.cit.*; *Saturday Review*, *op.cit.*; *Illustrated London News*, *op.cit.*

15 *Literary Gazette*, *op.cit.*

16 F.T. Palgrave, *Handbook to the Fine Art Collections in the International Exhibition 1862*, 1862, pp. 50–1.

17 M.B. Howkins, *The Victorian Example: French Critical Response to mid-Victorian Paintings in Paris 1850–1870*, University of Columbia Ph.D. thesis, 1985, p. 181.

18 *Athenaeum*, 14 April 1860, p. 515; Ward exhibited nothing at the 1860 Royal Academy, so WAG 138 may well have been begun in 1859.

19 Dafforne, *op.cit.*, p. 48.

20 O'Donnell, *op.cit.*, pp. 144, 169.

21 *Art Journal*, 1868, p. 57.

22 According to the *Argus*, 18 September 1880, the Walker Art Gallery Committee originally agreed to buy the picture without reference to the City Council. The artist had valued the picture at £3,000 and his widow had asked 800 guineas for it.

23 Ward was awarded a prize of £50 for WAG 138 by the Society at its 1861 exhibition (*Art Journal*,

1861, pp. 317, 374). The Society had been set up to oppose the Pre-Raphaelite tendencies of the Liverpool Academy and so no doubt welcomed a major work by an artist so totally hostile in his work to Pre-Raphaelitism.

Dr. Goldsmith and the Apothecary

WAG 1342
Canvas: 89 × 101.6 cm
Signed: *EM WARD RA/1871*

John Forster[1] in his biography of Goldsmith related that in 1765 Goldsmith practised briefly as a doctor; one of his patients, however, a Mrs. Sidebotham, preferred the opinion of her apothecary to that of Goldsmith, much to the annoyance of the latter. Here the apothecary is seated at the left; Mrs. Sidebotham supported by pillows, is seated next to him; her servant is behind her and Goldsmith is at the right about to leave in great annoyance.

An earlier and slightly larger version of this composition was apparently exhibited at the French Gallery in 1866 (217);[2] it is now unlocated.

The critics at the 1871 Royal Academy exhibition praised Ward's anecdotal powers, but the reviewer of the *Architect* questioned the likeness of Goldsmith by comparison with Reynolds's portrait.[3]

Dr. Goldsmith and the Apothecary WAG 1342

PROV: Bought from the artist by Thomas Taylor;[4] his sale (Aston Rowant Gallery), Christie's 28 April 1883, lot 65, bought in (£178. 10s.). Presented by George Audley 1925.

EXH: Royal Academy 1871 (260).

1 John Forster, *The Life and Times of Oliver Goldsmith*, 1871 edn, pp. 394–6. The 1871 Royal Academy catalogue contained a long quotation from these pages, describing in detail the events in WAG 1342. E.M. Ward's *John Forster in his Library* is now in the Victoria & Albert Museum. The picturesque and chequered career of Goldsmith made him a favourite subject of 19th-century genre painting, particularly after the publication of Forster's biography in 1848; as early as 1844 Ward himself had painted Goldsmith earning a night's lodging by playing the flute, and other artists selected similar amusing scenes from his career; for full details see R.D. Altick, *Paintings from Books*, 1985, pp. 158–9. See also WAG 315, below.

2 J. Dafforne, *The Life and Works of E.M. Ward*, 1879, p. 64; *Athenaeum*, 25 March 1871, p. 375, in which WAG 1342 is described as a 'new version or reproduction' of the 1866 picture. The descriptions of the 1866 version in Dafforne, *op.cit.*, p. 53, and in the *Art Journal*, 1866, p. 374, indicate that it was virtually identical to WAG

1342. The 1866 painting was probably lot 103 (38 × 43 in.) in the E. Dixon sale, Christie's 21 March 1873, bought Bourne (£336).

3 *Architect*, 6 May 1871, p. 231; *Athenaeum*, 20 May 1871, p. 628.

4 According to the Taylor sale catalogue of 1883.

WARD, Edward Matthew (1816–1879), **after**

Dr. Johnson perusing the Manuscript of the Vicar of Wakefield, as the Last Resource for rescuing Goldsmith from the Hands of the Bailiffs
WAG 315
Canvas: 35.5 × 45.3 cm
Signed: *E.M. Ward RA*

Oliver Goldsmith had asked Samuel Johnson for money to pay his rent; Johnson sent a guinea – which Goldsmith used to buy a bottle of Madeira – and came immediately; Goldsmith told him that he had completed the manuscript of his *Vicar of Wakefield*; Johnson read it and then promptly sold it to a bookseller for £60. Goldsmith and Johnson are

Dr. Johnson perusing the Manuscript of the Vicar of Wakefield, as the Last Resource for rescuing Goldsmith from the Hands of the Bailiffs WAG 315

seated at the table; Goldsmith's landlady stands behind him while behind her are the bailiffs; a servant girl stands at the door; Goldsmith's flute is on the floor; a painting of the Good Samaritan on the wall symbolizes Johnson's rescue of Goldsmith.[1] The room in the picture was painted from the artist's own room in Russell Place.[2]

This seems to be a later version or copy of the composition first exhibited at the Royal Academy in 1843. The signature or inscription has *RA* against it, indicating that it was painted after 1854, when the artist became a member of the Royal Academy, and its quality seems very much inferior to that of the larger version of this composition sold at Sotheby's in 1972.[3] In some respects, the Walker Art Gallery version is closer to the engraving by Bellin after the composition than to the Sotheby's 1972 version; for example, the carpet in the former and in the Bellin engraving are more or less identical, but both carpets differ to some extent from that in the Sotheby's 1972 version. The Liverpool version may therefore have been a version done for the engraver or a copy after the engraving; if, however, it was indeed owned by George Holt Senior (1790–1861) – see Provenance – it must have been painted before 1861. The *Literary Gazette*[4] reviewed the original version at the 1843 Royal Academy exhibition; it noted that imprisonment for debt was soon likely to be abolished and described the painting as 'a well conceived and well executed representation of the event, and therefore a production of public interest'.

REPR: J. and G. Nicholls, engraving (*Art Journal*, 1855, p. 48); S. Bellin.

PROV: George Holt Senior (1790–1861); George Holt; bequeathed by Emma Holt 1944.

1 See James Boswell, *The Life of Dr. Johnson*, 1791 (1949 Everyman Edition, vol. 1, p. 257); J.W. Croker published a controversial edition of Boswell's *Life* in 1831 and the appropriate passage is quoted in the 1843 Royal Academy catalogue. Eighteenth-century literary subjects became very popular in the 1840s and this composition was one of Ward's first successes; Ward subsequently painted other incidents from the careers of Johnson and Goldsmith, including WAG 1342 (see above); for further details see particularly J. Dafforne, *The Life and Works of E.M. Ward*, 1879, pp. 14–15; *Art Journal*, 1855, p. 46;

Magazine of Art, 1878, p. 16 and R.D. Altick, *Paintings from Books*, 1985, pp. 156–9. Ward was also attracted by subjects involving the hardships suffered by artists; for this see K. Bendiner, *An Introduction to Victorian Painting*, 1985, p. 51, fig. 19; Bendiner notes the dependence of WAG 315 on Hogarth's *The Distressed Poet*, and H. Faberman, 'Augustus Egg's Self-Portrait as a poor Author', *Burlington Magazine*, 1983, vol. 125, pp. 224 ff., discusses the same theme.

2 Mrs. E.M. Ward, *Memories of Ninety Years*, n.d., p. 45.

3 The 1843 Royal Academy version was selected in that year by G. Rutter, a prizeholder of the Art Union of London (*Art Union*, 1843, p. 140). Another version was apparently painted for John Montefiore and was lot 74 (25 × 30 in.) at his sale, Christie's 18 April 1874, bought in (£472.10s.); this same version was presumably that sold at Sotheby's (Belgravia) 20 June 1972, lot 32 (24 × 29 in.); the Sotheby's version is signed and perhaps dated 1850, but the date is indistinct; it cannot, however, be the 1843 Royal Academy version so it is just possible, but very unlikely, that WAG 315 is that 1843 version with a signature added later.

4 *Literary Gazette*, 27 May 1843, p. 354.

WARD, Henrietta Mary Ada (1832–1924)
The Queen's Lodge, Windsor, in 1786[1]
WAG 2960
Canvas: 118 × 133.3 cm

Mrs. Mary Delaney, at the extreme right, is talking to Queen Charlotte; George III, on the floor, is playing with Princess Amelia; the other four royal princesses, Charlotte Augusta, Elizabeth, Augusta Sophia and Mary are seated at the table with an elder woman, who is presumably a lady-in-waiting or a governess (possibly Miss Mary Hamilton, later Mrs. John Dickenson).[2] The four elder royal princesses at the table appear to be drawing from flowers; this may reflect Mrs. Delaney's own interests in making paper silhouettes, collages and other copies from flowers and in natural history in general.[3] Mrs. Delaney, noted for her intellectual, personal, artistic and social qualities, contributed nota-

The Queen's Lodge, Windsor, in 1786 WAG 2960

bly to the high moral tone and relaxed bourgeois manners of George III's court.

The *Art Journal*[4] praised Henrietta Ward's painting extravagantly, but the critic of the *Architect*[5] found 'nothing but the brightest and most gaudy combinations of colour' and went on: 'We regret to say the only merit we could perceive in the work was the face of Mrs. Delaney, which is certainly expressive and possesses considerable character.'

PROV: W. Lawson Peacock and Co. sale, Christie's 11–14 November 1921, lot 149, bought Sampson (£9.9s.). Presented by George Audley 1925.[6]

EXH: Royal Academy 1872 (510); West Ham.

1 WAG 2960 has been known as *George III and his Family at Windsor*.

2 The 1872 Royal Academy catalogue contained these quotations:

Mrs. Delaney at Court: 'The Queen', said Mrs. Delaney, 'was graceful and genteel. The dignity and sweetness of manner . . . soon made me perfectly at ease . . . The King's fondness for children is well known.' The Queen's affability did not prevent the aged lady from noticing that Her Majesty condescended to take snuff, in the admixture and scent of which she was curious and learned. – See Dr. Doran's 'Lives of the Queens of Hanover'.

460

The Queen had the goodness to make me sit down next to her . . . while the younger part of the family are drawing and working . . . the beautiful babe, Princess Amelia, bearing her part in the entertainment . . . sometimes playing with the King on the carpet . . . In the next room is the band of music playing. – See 'Letters and Correspondence of Mrs. Delaney', ed. Lady Llanover.

The second quotation is from *The Autobiography and Correspondence of Mary Granville, Mrs. Delaney*, ed. Lady Llanover, 1862, second series, vol. 3, pp. 308–9 (a letter from Mrs. Delaney to Mrs. Frances Hamilton of 9 November 1785); Mrs. Delaney went on to describe a family evening at Queen's Lodge: 'It was such a delightful scene as would require Addison's pen, or a Vandyke's pencil, to do justice to it.' The artist frequently visited the Royal Family at Windsor in the 1850s – she painted them and taught them art – and so knew the area well (see Mrs. E.M. Ward, *Memories of Ninety Years*, n.d., pp. 78 ff. and *Mrs. E.M. Ward's Reminiscences*, ed. E. O'Donnell, 1911, pp. 167, 208 ff.). She will have known the many paintings in the Royal collections by Zoffany (depicting the idyllic domestic life of George III) and was presumably inspired by them; she may also have known the works of Ingres and Bonington representing the intimate family life of Henry IV of France. The exemplary domestic life of George III was often contrasted with the less happy family life of the French kings, particularly by Conservative critics; Henrietta Ward may have been aware of this tradition as her husband painted a number of scenes showing the tribulations of the French royal family during the Revolution; one of these, *The Return from Flight* – depicting the ignominious return of Louis XVI and his family from Varennes – was at the same Royal Academy exhibition as WAG 2960. *The Times* critic commented (4 May 1872):

If Mrs. Ward and her husband had wished to paint the moral of Monarchy by contrast they could not have done it more pointedly – he by this scene of the return from Varennes, she by her pretty picture of one of the visits recorded in Mrs. Delaney's letters to the private apartments of George III.

By 1872 Henrietta Ward had largely abandoned specific domestic subjects in favour of history paintings, but the domestic content of her history paintings also, of course, reflected her sex and contemporary prejudice – for this see Pamela G.

Nunn, 'The Case History of a Woman Artist; Henrietta Ward', *Art History*, 1978, vol. 1, p. 303 and *Victorian Women Artists*, 1987, pp. 140–1, together with Charlotte Yeldham, *Women Artists in 19th-Century France and England*, 1984, vol. 1, pp. 308–9, who comments that the artist specialized 'in reducing the great to average domestic size whether by showing them as children or as adults in a domestic context while at the same time making them examples of good conduct'.

3 See Ruth Hayden, *Mrs. Delaney, her Life and her Flowers*, 1980, pp. 163–7.

4 *Art Journal*, 1872, p. 183.

5 *Architect*, 18 May 1872, p. 252. Henrietta Ward evidently relied on Opie's portrait of Mrs. Delaney for Mrs. Delaney's face; the portrait is reproduced in Lady Llanover, *op.cit.*, first series, vol. 1, frontispiece and in Peter Quennell, *Samuel Johnson, his Friends and Enemies*, 1972, p. 121.

6 George Audley, *Collection of Pictures*, 1923, p. 54, no. 159.

WATERHOUSE, John William
(1849–1917)

Echo and Narcissus
WAG 2967
Canvas: 109.2 × 189.2 cm
Signed: *J.W. Waterhouse 1903*

Echo, deprived by Juno of the power of independent speech, fell in love with the beautiful Narcissus, but he, seeing his own reflection in a fountain, became infatuated with it and consequently despised Echo; Echo pined away and died. The theme of unrequited love, emphasized by the physical isolation of the two very introspective figures, was often the subject of Waterhouse's paintings.[1] The daffodils (or narcissi) have an obvious connection with the subject of the painting; the iris may symbolize love. The artist's symbolic use of water in this and other late works is discussed by Sketchley.[2] A.L. Baldry[3] noted the decorative and formal character of the composition, which he saw as a new tendency in the artist's later work; the painting was 'remarkable for

Echo and Narcissus WAG 2967 (colour plate 2)

its largeness of manner and its virility of decorative treatment'.

Contemporary critics were less sure even of the formal qualities of the painting; the *Athenaeum*[4] wrote:

Mr. Waterhouse seems to be troubled by uncertainties of another kind. His Echo and Narcissus *is an entirely well-intentioned effort at making grand decorative design. The lines of the composition are well arranged and a rough sketch of the picture would suggest a fine and powerful work; yet the picture itself is not so fine and powerful. It would seem as if Mr. Waterhouse, after conceiving his design and to some extent working it out, was overtaken with the Ruskinian idea of truth to nature. In obedience to that idea he tried to make his tree-trunks and foliage and grass look exactly like nature, with the result that the masses lost all their breadth and cohesion from being broken up by detail, and the picture went to pieces.*

The hard, unrelated reds of the drapery simply emphasize their incoherence; and yet the problem is one that any pupil of Rubens could have solved without an effort.

The *Art Journal*,[5] on the other hand, had no doubts; *Echo and Narcissus* was 'one of the best examples of imaginative art which can be found in the Academy'.

A study probably used for the head of Echo was reproduced in the *Studio* of 1908[6] and there are various preliminary drawings for the painting in a sketch-book now in the Victoria & Albert Museum (E1111–1963), pp. 21, 50, 71.[7] An oil sketch for the entire composition is in an Oxford private collection. An oil study for the head of Echo was sold at Christie's 9 February 1990, lot 254 (40.7 × 33 cm), while a drawing for the same head appeared at Bonham's, 16 November 1994, lot 136.

PROV: Bought from the artist 1903 (£800).[8]

EXH: Royal Academy 1903 (16); Liverpool Autumn Exhibition 1903 (636).

1 See A. Hobson, *J.W. Waterhouse*, 1980, pp. 119 ff.; Hobson compares WAG 2967 to Solomon J. Solomon's *Echo and Narcissus* of 1895 (reproduced in *Royal Academy Pictures*, 1895, p. 37) in which Echo leans against Narcissus.

2 R.E.D. Sketchley, 'J.W. Waterhouse R.A.', *Art Annual*, 1909, p. 23.

3 A.L. Baldry in 'Some recent work by Mr. J.W. Waterhouse', *Studio*, 1911, vol. 53, p. 180.

4 *Athenaeum*, 9 May 1903, p. 600.

5 *Art Journal*, 1903, p. 166.

6 'Drawings by J.W. Waterhouse R.A.', *Studio*, 1908, vol. 44, p. 255.

7 Hobson, *op.cit.*, p. 200, no. 384.

8 This was one of the purchases denounced by Frank Rutter in *The Sport of Civic Life*, ed. C.W. Sharpe, 1909, p. 10.

WATERLOW, Ernest Albert (1850–1919)
A Summer Shower
WAG 474
Canvas: 60.8 × 91.5 cm
Signed: *E. Waterlow 74*

A Summer Shower was painted only a year after Waterlow left the Royal Academy Schools and was his first major success.[1]

PROV: Bought from the artist 1874 (£50).

A Summer Shower WAG 474

EXH: Liverpool Autumn Exhibition 1874 (66).

1 C. Collins Baker, 'Sir E.A. Waterlow', *Art Annual*, 1906, p. 6; Austin Chester, 'The Art of Sir Ernest Waterlow', *Windsor Magazine*, 1911, vol. 33, p. 578.

Forest Oaks, Fontainebleau

WAG 1623
Canvas: 137.2 × 121.3 cm
Signed: *E.A. Waterlow*

Waterlow was at Moret on the edge of the Forest of Fontainebleau in 1895[1] and a number of landscapes showing the forest resulted; these included *Forest Path, Barbizon* and *Forest Glade, Fontainebleau* (both of 1897)[2] and *Through the Wood* (1898).[3]

The critic of the *Athenaeum*[4] found a tragic grandeur in *Forest Oaks, Fontainebleau*:

Forest Oaks *conveys tragic sentiment in Hobbema's fashion, much as the* Côte d'Azur *repeats with greater brightness and more sparkle the serenity Claude loved to paint. It delineates a group of shattered and aged trees that stretch their rugged arms to the sky, while at their feet a woman stoops to gather flowers from among the heather and waste which, chequered with bands of light and shadow, extends towards the horizon. In the half-distance a storm is impending, and this adds to the impressiveness of a picture which is bolder, if not rougher, than the painter usually produces.*

REPR: *Royal Academy Pictures*, 1899, p. 164; Art Journal, *Academy Pictures*, 1899, p. 43; Liverpool Autumn Exhibition catalogue, 1902, p. 110.

PROV: Bought from the artist 1902 (£400).

EXH: Royal Academy 1899 (990) as *Forest Oaks*; Glasgow International Exhibition 1901 (549) as *Forest Oaks*; Liverpool Autumn Exhibition 1902 (924) as *Forest Oaks, Fontainebleau*.

Forest Oaks, Fontainebleau
WAG 1623

1 C. Collins Baker, 'Sir E.A. Waterlow', *Art Annual*, 1906, pp. 16–21. Waterlow saw Sisley at work there but was not impressed.

2 Both were shown at the *Landscape Exhibition* (171 Piccadilly) 1897 (8 and 11).

3 At the 1898 Royal Academy exhibition (576).

4 *Athenaeum*, 17 June 1899, p. 760. There was also praise for WAG 1623 in the *Art Journal*, 1899, p. 166, and in the *Magazine of Art*, 1899, p. 455.

WATTS, George Frederic (1817–1904)
Found Drowned[1]
WAG 2104
Canvas: 27.9 × 42.5 cm
Signed: *G.F. Watts*

This appears to be a study for the large picture of 1848–50 now in the Watts Gallery, Compton.[2] The subject is said to have been inspired by an incident seen by the artist,[3] but it may also have been suggested by Thomas Hood's poem, *The Bridge of Sighs*, of 1844. The large painting was one of four social realist works all painted around 1848–50, partly inspired by the Irish famine of those years and partly by the artist's sense of depression after his return from Italy.[4]

PROV: Charles H. Rickards (by 1880);[5] his sale, Christie's 2 April 1887, lot 8 as *Bridge of Sighs: 'Take her up tenderly/Lift her with care'*, bought Johnson £178.10*s*). Aleco Ionides;[6] bought from the artist by James Smith 1903, probably for 50 guineas;[7] bequeathed by James Smith 1923.

EXH: Liverpool Academy 1862 (377);[8] Dudley Gallery, *Winter Exhibition of Cabinet Pictures in Oil*, 1875 (211);[9] Royal Manchester Institution, *Exhibition of Works by G.F. Watts lent by Charles H. Rickards*, 1880 (35) as *The Bridge*; Grosvenor Gallery, *Winter Exhibition*, 1881–2 (18) as *Study for the Picture*.

1 Rickards entitled WAG 2104 *The Bridge of Sighs* from the title of Thomas Hood's poem, but the artist's wife in her MS Catalogue (Watts Gallery, Compton) noted that Watts liked his titles short

Found Drowned WAG 2104

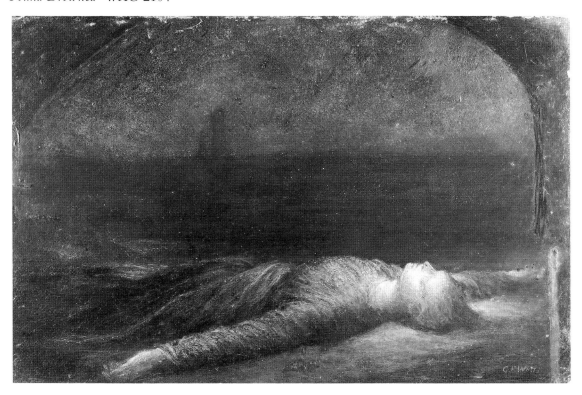

and simple. The short title was a legal expression often used in coroners' inquests (L. Errington, *Social and Religious Themes in British Art 1840–1860*, 1984, pp. 204 ff.).

2 The artist's wife in her MS Catalogue, *op. cit.*, states that WAG 2104 was 'probably the first sketch for the large picture' and the 1881–2 Grosvenor Gallery catalogue also lists it as the 'study for the picture'; David Loshak, however, thought that it was a replica of the 1860s (Arts Council of Great Britain, *George Frederic Watts*, 1954–5 (28)); the artist does seem to have re-worked WAG 2104 during 1902–3 (letters from the artist to James Smith of 25 February 1902 and 8 October 1903, MS Watts Gallery, Compton).

3 Mrs. Russell Barrington, *G.F. Watts: Reminiscences*, 1905, p. 135; she identifies the bridge as Waterloo Bridge – this is apparently topographically correct (David Stewart, conversation with the compiler, 1988).

4 All the large paintings are now in the Watts Gallery, Compton; the other titles are *Under a Dry Arch*, *The Irish Famine* and *The Seamstress* (this last also inspired by a poem of Thomas Hood). The literature on this series is enormous, see particularly: Errington, *op. cit.*, pp. 180 ff.; Manchester City Art Galleries, *Hard Times*, 1987, p. 28 (by Julian Treuherz); Minneapolis Institute of Arts, *Victorian High Renaissance*, 1978, p. 63 (by Allen Staley); H.D. Rodee, *Scenes of Rural and Urban Poverty in Victorian Painting, 1850–1890*, 1975, pp. 151 ff. and T.C. Edelstein, *The Social Theme in Victorian Painting*, University of Pennsylvania doctoral thesis, 1979, pp. 174 and 188. For subjects based on Hood's *The Bridge of Sighs*, see Lynda Nead, *Myths of Sexuality*, 1988, pp. 168 ff.

5 WAG 2104 was probably *The Bridge* lent by Rickards to the Royal Manchester Institution in 1880; it is certainly listed on a schedule of paintings by Watts owned by Rickards (now at the Watts Gallery, Compton) where it appears as no. 33 *The Bridge of Sighs*, valued at £250.

6 The artist's wife in her MS Catalogue, *op. cit.*; Ionides was a close friend of the artist.

7 Letters from the artist to James Smith of 25 February 1902 and 8 October 1903 (MS Watts Gallery, Compton); there was some haggling over the price in subsequent letters.

8 This might have been the large finished painting now in the Watts Gallery, Compton, rather than WAG 2104.

9 This was certainly WAG 2104; see *Academy*, 21 October 1876, p. 416, and *Art Journal*, 1876, p. 45, which noted:

There is a sense of awe in the gloom which envelopes the figure, and the mystery of death clings round the impressive form. The 'Bridge of Sighs' sentiment is as tellingly conveyed here on canvas as it was by Hood in verse, and few people would be able to gaze on the picture for a minute or two without being almost emotionally impressed.

Chaos

WAG 2097
Canvas: 32 × 79 cm

This is a small version of a composition conceived in about 1848 to form part of the ceiling of the artist's so-called *House of Life*, which, in the form of a large frescoed hall, would recount the history of mankind. *Chaos* – also known as *The Titans*, *Cosmos* or *Chaos passing to Cosmos* – was to have been the first episode in the *House of Life* and is described thus by Mrs. Barrington:[1]

On the left is represented the period of Violence, the upheaving and disturbance previous to the regular course of things establishing itself in our planet. This passes in the middle of the picture into an indefinite period, a vaporous uncertainty of atmosphere, unborn creations. Light is still veiled by mists, and air and waters mingle. Here and there a figure in the swollen tides marks the beginning of the strides of time. In the third part of the picture, colossal forms, silent and quiescent, symbols of mountain ranges, suggest an established state of things. The current of time, in the middle part of the composition, indicated by detached figures, is now a continuous stream.

A very large number of versions of this subject exist, together with many drawings and studies;[2] the earliest version seems to be the one now in the Fitzwilliam Museum, Cambridge, and there are two much larger later versions, one now in the Tate Gallery, London, of about 1882 (inv. 1647) and one in the Watts Gallery, Compton (104 × 317 cm),

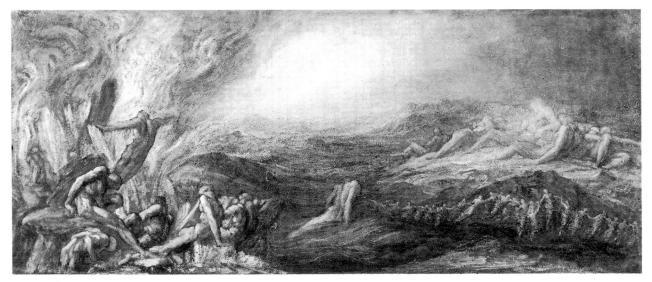

Chaos WAG 2097

left unfinished at the artist's death. These three versions – and the Walker Art Gallery painting – record the entire composition of *Chaos*, whereas others show only part of the design.

In 1896 the artist wrote to James Smith stating that he could not yet sell the Liverpool *Chaos* to him as he was using it for his continued work on the large version of the composition – presumably that now in the Watts Gallery, Compton;[3] the artist's wife[4] simply lists it as 'a small version, unfinished for many years, completed and sold to James Smith in 1900' – in fact Smith bought it in 1898.

REPR: There are two Hollyer photographs of *Chaos* (the complete composition) at the Watts Gallery, Compton; one of them might have been taken from WAG 2097 at some stage of its creation.

PROV: Bought from the artist by James Smith December 1898 (probably 600 guineas);[5] bequeathed 1923.

EXH: Manchester City Art Gallery, *G.F. Watts*, 1905 (54); Liverpool Autumn Exhibition 1922 (492).

1 Metropolitan Museum of Art, New York, *George Frederick Watts*, 1885, p. 41, reprinted in Mrs. Russell Barrington, *G.F. Watts: Reminiscences*, 1905, pp. 131–2. The earlier literature on this composition is listed in Minneapolis Institute of Arts, *Victorian High Renaissance*, 1978, no. 23, which contains a brief account of Watts's scheme; there is another modern account in Whitechapel Art Gallery, *G.F. Watts*, 1974, n.p.

2 Versions are listed by the artist's wife in her MS Catalogue (Watts Gallery, Compton) and in Fitzwilliam Museum, Cambridge, *Catalogue of Paintings, British School*, 1977, pp. 274–5.

3 Letter of 12 January 1896 (MS Watts Gallery, Compton).

4 MS Catalogue, *op. cit.*

5 Letter of 27 November 1898 (MS Watts Gallery, Compton).

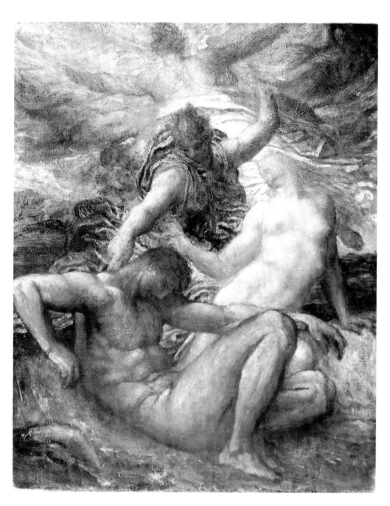

The Creation of Eve

WAG 2130
Canvas[1]: 43.7 × 54.3 cm

This is a study for the principal figures in the *Creation of Eve*; a large completed version of 1865–99 is in the Fogg Museum of Art (Cambridge, Massachusetts) and two smaller paintings – one unfinished, and both also begun in about 1865 – are in the Watts Gallery, Compton;[2] all these versions show the entire composition, while the Walker Art Gallery study – which is considerably closer in detail to the finished Compton version than to the Cambridge version – only includes the lower half.

The *Creation of Eve* with its pendant *The Denunciation of Adam and Eve* (or *After the Transgression*) formed a series from *Genesis* with *The Denunciation of Cain* (or *Death of Abel*).[3]

The iconography of *The Creation of Eve* was described in detail first by Mrs. Russell Barrington[4] and then in the Royal Academy, *Winter Exhibition*, 1905 catalogue (167); the angels (or spirits of air), having created Eve from Adam's rib, are rising back into heaven while one of them awakens Adam from his sleep by touching his shoulder.

REPR: W.K. West and R. Pantini, *G.F. Watts*, 1904, plate 49 (with slight differences). There is a Hollyer photograph apparently taken from WAG 2130 in the Watts Gallery, Compton.

PROV: Bought from the artist by James Smith 1896 (£200);[5] bequeathed 1923.

1 Canvas stamp of W. Eatwell, Dorset Street.

2 See Fogg Museum of Art, Harvard University, Cambridge, Massachusetts, *Paintings and Drawings of the Pre-Raphaelites and their Circle*, 1946, p. 110, no. 102, and Arts Council of Great Britain, *George Frederic Watts*, 1954–5, p. 35, nos. 51 and 52. See also the MS Catalogue compiled by the artist's wife, now in the Watts Gallery, Compton; she does not suggest a date for WAG 2130, which, like the large versions, was presumably begun around 1865; some extra work was certainly done on it in 1895–6 (letters from the artist to James Smith of 9 December 1895 and 6 January 1896, MS Watts Gallery, Compton).

3 For the series see particularly Arts Council of Great Britain, *op. cit.*, pp. 35–7 and Minneapolis Institute of Arts, *Victorian High Renaissance*, 1978, pp. 81–2. The version of *The Denunication of*

Adam and Eve belonging to this series is in the Fogg Art Museum, Cambridge, and that of *The Denunciation of Cain* is now in the Watts Gallery, Compton; a larger version of this last composition is in the Royal Academy. This series, together with the single figure Eve trilogy, were associated with Watts's *House of Life* project (see WAG 2097, above).

4 Metropolitan Museum of Art, New York, *George Frederic Watts*, 1885, pp. 41–2.

5 Letters from the artist to James Smith of 15 March, 29 July, August (*sic*) and 10 August 1896 (MS Watts Gallery, Compton). In fact Smith seems to have paid £1000, or possibly 1000 guineas, for both WAG 2130 and WAG 2096 *(Arion Saved by the Dolphin)*, see p. **449**.

The Magdalen at the Foot of the Cross
WAG 2107

The Magdalen at the Foot of the Cross
WAG 2107
Canvas: 103 × 77.5 cm

An earlier monochrome version[1] survives as a fragment in the Watts Gallery, Compton, where a drawing for the figure[2] and a plaster cast of a wax model used for the head of the Magdalen[3] are also located. The artist's wife[4] dated the design to 1866–8, but noted that both this and the earlier version were painted over several years. This type of emotional single-figure composition owed much to similar works of the 1850s by Ary Scheffer and Paul Delaroche.

REPR: A Hollyer photograph is in the collection of the Watts Gallery, Compton; it seems to show WAG 2107 before its completion.

PROV: William Carver sale, Christie's 22 March 1890, lot 129 (as *The Penitent*), bought Agnew (£420); Joseph Ruston; sold privately back to Agnew's March 1891; bought from Agnew's by James Smith March 1891 (£500);[5] bequeathed by him 1923.

EXH: Whitechapel Art Gallery 1884 (132); Birmingham Museum and Art Gallery, *G.F. Watts and Edward Burne-Jones*, 1885 (157) and *The Collection of*

Paintings, 1886 (67); Nottingham Museum and Art Gallery, *G.F. Watts*, 1886 (19); Liverpool Autumn Exhibition 1922 (481).

1 See Arts Council of Great Britain, *George Frederic Watts*, 1954–5, no. 46, where the fragment (head only) is dated to about 1866–8. The artist wrote to James Smith on 29 April 1892 (MS Watts Gallery, Compton) stating that this earlier version was a study for WAG 2107. A photograph of the first version when complete is stuck into the MS Catalogue compiled by the artist's wife (Watts Gallery, Compton).

2 See Arts Council, *op. cit.*, no. 139. The drawing is reproduced in R. Chapman, *The Laurel and the Thorn*, 1945, plate 22.

3 The artist's wife in her MS Catalogue, *op. cit.*, noted that this cast was very characteristic of the artist's 'sense of the beauty and pathos of a certain type of facial structure'.

4 MS Catalogue, *op. cit.*

5 James Smith's Catalogue (MS, Walker Art Gallery).

The First Whisper of Love
WAG 2103
Canvas: 61.2 × 51.3 cm

A watercolour sketch[1] and a small oil painting[2] of the subject both date from the artist's Italian years (1843–7).[3] This version dates from the late 1860s or even later;[4] yet another version, undated by the artist's wife,[5] was in the Wil-

The First Whisper of Love
WAG 2103

470

liam Graham sale, Christie's, 2 April 1886, lot 76, bought Lawrie (£325.10*s.*).

REPR: A Hollyer photograph now at the Watts Gallery, Compton, was perhaps taken from WAG 2103 before its final reworking by the artist; it may, however, represent one of the other versions.

PROV: Bought by James Smith from the artist June 1892 (300 guineas);[6] bequeathed 1923.

EXH: Whitechapel Art Gallery 1886 (213); Conway, Royal Cambrian Society 1888 (25); Liverpool Domestic Mission, *Loan Exhibition*, 1896 (5); Liverpool Autumn Exhibition 1922 (496).

1 Possibly the *Love and the Shepherd*, 19 × 14 cm, lent to the Royal Academy, *Winter Exhibition*, 1905 (134) by A.K. Hichens; however, the artist's wife in her MS Catalogue (Watts Gallery, Compton) lists the watercolour as one of the works left by the artist in Italy in 1847, and these works are supposed to have been destroyed.

2 Probably no. 95 at the 1862 Liverpool Academy, *Shepherd and Cupid*, price £210, and then lent by Lord Aberdare first to the 1881–2 Grosvenor Gallery exhibition (42) as *The First Whisper of Love* and then to the 1905 Royal Academy, *Winter Exhibition* (31) with the same title (42 × 34.3 cm).

3 M.S. Watts, *George Frederic Watts: Annals of an Artist's Life*, 1912, vol. 1, p. 69 and MS Catalogue, *op. cit.*

4 MS Catalogue, *op. cit.*, where WAG 2103 is noted as the largest version of the composition. In a letter to James Smith of 29 April 1892, the artist described WAG 2103 as a 'replica' (MS Watts Gallery, Compton).

5 She lists it (MS Catalogue, *op. cit.*) with no dimensions or any details of ownership or exhibitions. It is now in the Santa Barbara Museum of Art; for further details, see the Montreal Museum of Fine Arts, *Discerning Tastes: Montreal Collectors*, 1989, p. 161, no. 59; there dated to the 1860s or later and associated with the *House of Life* cycle (see WAG 2097, p. **466**).

6 Letters from the artist to James Smith of 29 April, 17 June and 29 July 1892 (MS Watts Gallery, Compton).

Orpheus and Eurydice
WAG 2111
Canvas: 31.7 × 47.3 cm

Through his music, Orpheus gained Pluto's permission to reclaim his wife, Eurydice, from the underworld, but Pluto insisted that he must not look at her until they were in the upper world again; Orpheus could not resist one glance and here he is striving ineffectually to prevent her falling back into the underworld.

This is a sketch[1] for the *Orpheus and Eurydice* completed in 1869 and last recorded in the Forbes Magazine Collection.[2] Drawings for this composition are in the Royal Academy and in the collection of David Loshak.

PROV: Bought from the artist by James Smith 1898;[3] bequeathed 1923.

1 The artist's wife in her MS Catalogue (Watts Gallery, Compton).

2 See C. Forbes and A. Staley, *The Royal Academy Revisited: Victorian Paintings from the Forbes Magazine Collection*, n.d., p. 142, no. 67, and Minneapolis Institute of Arts, *Victorian High Renaissance*, 1978, p. 75, no. 19, for lists of other versions and for related works by other artists. Specifically Frederic Leighton's *Orpheus* of 1864 (Leighton House) – showing Orpheus and Eurydice just before he looks at her – may have influenced WAG 2111. The Minneapolis catalogue also discusses the relation between this composition and Watts's own marital life. The Forbes Magazine version was engraved in E. Chesneau, *Artistes anglais contemporains*, 1883, p. 29, and in mezzotint by Frank Short in 1889 (Martin Hardie, *The Mezzotints and Aquatints of Sir Frank Short*, Print Collectors Club Publication, 1939, no. 18, p. 19, no. 54). As well as WAG 2111 and the Forbes Magazine picture there are two or more other half-length versions of this composition, one in the Fogg Museum of Art (Cambridge, Massachusetts) and one formerly owned by Ronald Chapman, which may have been the version sold at Phillips, London, 19 November 1991, lot 63 (61 × 102 cm) or the one sold at Sotheby's, 12 November 1992, lot 167 (53.8 × 73.7 cm). There are at least five versions of the full-length composition (differing considerably from the half-length composition), of which the earliest seems to have been the one

Orpheus and Eurydice WAG 2111

exhibited at the Dudley Gallery in 1872 (216); it subsequently passed into the C.H. Rickards collection (see *Academy*, 21 October 1876, p. 416) and was lot 40 at the Rickards sale on 2 April 1887. One of these five versions is now in a Boston private collection; see Boston Museum of Fine Arts, *Prized Possessions*, 1992, no. 159, plate 102.

3 The artist wrote to James Smith on 17 October 1898 (MS Watts Gallery, Compton) saying that WAG 2111 was 'not a very complete picture but much liked'.

Caroline Muriel Callander

Wag 2108
Canvas: 61.2 × 51 cm
Signed: *G.F. Watts*

The sitter (*c.*1861–1932) was the daughter of John Alexander Burn-Callander of Preston Hall, Midlothian; she married William Baird of Elie in 1883(?).[1] There is another version of this portrait in the National Gallery of Scotland; it is the same size as the Walker Art Gallery version, virtually identical in composition and of rather higher quality; it was, however, unknown to the artist's wife when she compiled her MS Catalogue; nor did she know the identity of the sitter in the Liverpool portrait, which she dated, quite wrongly, to 1863.[2] The sitter is, perhaps, about 10 years old, giving an approximate date of 1871 for the painting.[3]

PROV: C.H. Rickards sale, Christie's 2 April 1887, lot 22, bought Williams (£105); Agnew's, who sold it to James Smith 7 May 1887; bequeathed 1923.

1 These details are taken from the National Gallery of Scotland, *Catalogue of Paintings and Sculpture*, 1957, p. 293; there the sitter's marriage date is given as 1833 and it has been assumed that this is a misprint for 1883; the other details must surely be correct as the portrait was bequeathed to the National Gallery of Scotland by the sitter.

472

2 The MS Catalogue is at the Watts Gallery, Compton. Of WAG 2108 she wrote: 'Mr. James Smith enquired from Mr. Watts the surname of this little girl, but his memory did not serve him upon this point.' Watts was always reluctant to admit that he painted commissioned portraits. According to M.H. Spielmann, 'The Portraiture of G.F. Watts', *Nineteenth Century*, 1913, vol. 73, pp. 118–32, most of Watts's commissioned portraits date from his early career and the 1870s.

3 WAG 2108 was returned to the artist for relining in 1892; on that occasion it was signed and more work was probably done on it; Watts could not then remember when he had originally painted the portrait (letters from Watts to James Smith of 2, 4 and 21 September 1892, MS Watts Gallery, Compton).

Caroline Muriel Callander WAG 2108

Psyche deserted by Cupid[1]

WAG 2113
Canvas: 66.7 × 23.5 cm
Signed: *G.F. Watts. 1875*
Inscribed: *Psyche*

In the mid- or late 1860s,[2] Watts began work on three closely related compositions of standing female nudes in a tall narrow format, *Thetis*,[3] *Daphne*[4] and *Psyche*.[5] 'Long Mary', a favourite model of the artist, is supposed to have been the model for *Daphne* and *Psyche*.[6]

This is the study for the large painting finished in 1880 and it was completed in 1875,[7] as indicated by the signature. Two other versions are recorded, one at Athens and one owned in 1900 by a Mr. Johnstone.[8]

REPR: There are three Hollyer photographs of *Psyche* in the Watts Gallery, Compton; none correspond with WAG 2113 in its present state.

PROV: C.H. Rickards sale, Christie's 2 April 1887, lot 32, bought Agnew (£210); sold to James Smith 6 May 1887; bequeathed 1923.

EXH: Royal Manchester Institution 1880 (52); Grosvenor Gallery 1881–2 (120) as *A Study*.

1 This composition is generally described simply as *Psyche*, but the exact title is given in the 1880 Royal Manchester Institution exhibition catalogue (see Exhibited) and a feather from Cupid's wing or bow is at Psyche's feet, while their couch is behind her.

2 M.S. Watts, *George Frederic Watts: Annals of an Artist's Life*, 1912, vol. 1, pp. 235–6; see also her *MS Catalogue* (Watts Gallery, Compton).

3 Now in the Watts Gallery, Compton.

4 Unlocated.

5 For the influence of this format on Albert Moore, J.M. Whistler and Frederic Leighton, see Minneapolis Institute of Arts, *Victorian High Renaissance*, 1978, p. 71.

6 M.S. Watts, *op cit.*, vol. 2, pp. 44–5, describes 'Long Mary' and identifies her as the model for *Daphne* (but not specifically for *Psyche*). Minneapolis Institute of Arts, *op. cit.*, states that she was also the model for *Psyche* – or at least for the drawings for it; one of these drawings was

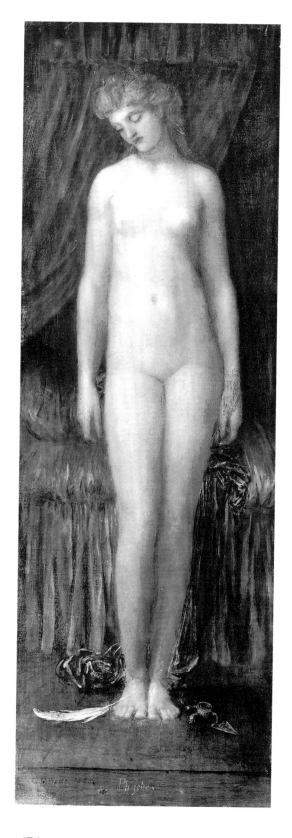

sold at Sotheby's (Belgravia) 20 October 1981, lot 60.

7 MS Catalogue, *op. cit.* The large painting is now in the Tate Gallery. Mrs Russell Barrington, *G.F. Watts: Reminiscences*, 1905, p. 93, notes that the Tate Gallery painting was begun in 1877.

8 MS Catalogue, *op. cit.* An 1892 drawing entitled *Psyche* was lent to the Royal Academy, *Winter Exhibition*, 1905 (133) by Andrew K. Hichens; it measured 34 × 14 cm.

The Rider on the White Horse
WAG 1741
Canvas[1]: 66.5 × 53.4 cm

The Rider on the Red Horse
WAG 1742
Canvas[2]: 66.5 × 53.4 cm

The Rider on the Black Horse
WAG 1743
Canvas: 66.3 × 53 cm

The Rider on the Pale Horse
WAG 1744
Canvas[3]: 66.5 × 53.4 cm

The subjects are taken from *Revelation* 6: 1–8. This series was conceived around 1868 and substantially completed by 1882;[4] a larger version of *The Rider on the White Horse* and an earlier version of *The Rider on the Black Horse* were exhibited at the Grosvenor Gallery in 1881–2, while in 1883, at the same gallery, all four Walker Art Gallery *Riders* were exhibited together as a series. No firm date seems to be available for the Liverpool *Rider on the White Horse*, but Watts was thinking of doing a version of the composition for Rickards in 1874[5] and a version was well advanced by 1876.[6] The Liverpool *Rider on the Red Horse* and *Rider on the Pale Horse* are dated by the New York catalogue to 1882 and by the New Gallery catalogue to 1883, while the Liverpool *Rider on the Black Horse* is dated by the New York catalogue to 1878.[7]

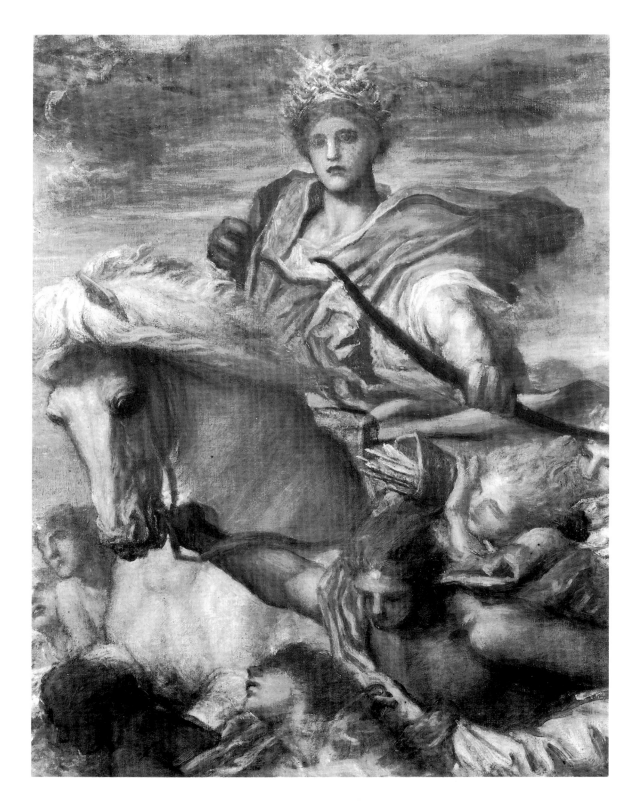

The Rider on the White Horse WAG 1741 (colour plate 15)

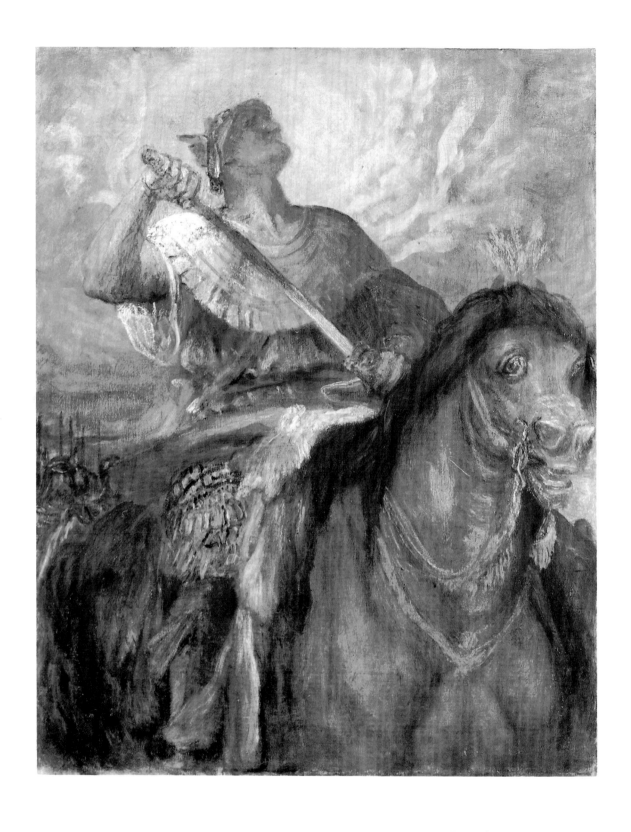

The Rider on the Red Horse WAG 1742

There is a larger and more finished version of *The Rider on the White Horse* in the South African National Gallery,[8] and a smaller version was completed in 1891.[9] An oil study for *The Rider on the Black Horse* is in the Ashmolean Museum, Oxford, and an earlier version was with the Fine Art Society in 1968.[10] A later version of *The Rider on the Pale Horse* (completed in 1897)[11] is in the Bristol City Art Gallery.

Mrs. Barrington considered Watts's four *Riders* to be among his finest works,[12] and critics at the 1883 Grosvenor Gallery were also enthusiastic; the *Art Journal*[13] described the Walker Art Gallery series as 'very great in both imagination and execution'; the *Athenaeum* referred to 'riders variously armed and terrible, full of energy and expression' and the *Academy* noted that Mr. Watts has 'some very powerful suggestions for a series of designs of the four horses of the Revelation';[14] even the *Magazine of Art*[15] described them as 'heroic and very nearly successful'.

The meaning of this series for Watts is far from clear. *The Rider on the White Horse* reappears in Watts's *Progress* of 1888–90 (York City Art Gallery) where he represents spiritual and intellectual advancement; similarly a distinctly optimistic interpretation of the series was published in H. Blackburn's *Grosvenor Notes*,[16] possibly with the artist's authority:

The horses represent the conquering spirits sent forth by God. The White horse is the spirit of Knowledge; a star is on the rider's brow, and he tramples clouds under his feet. The Red horse is the spirit of War; the rider clothed in flame. The Black horse is the spirit of Commerce; the rider holding the scales, from which light seems to come to him. The Pale horse is the spirit of Death and Hell; he moves amid the flames of ruin and signs of death. But he, like the others, is 'preparing the way for a new life in which the meek shall inherit the earth'.

REPR: (WAG 1742) W.K. West and R. Pantini, *G.F. Watts*, 1904, p. 10 (with slight differences).

PROV: (WAG 1741–1744) acquired by William Carver after 1886;[17] his sale, Christie's 22 March 1890, lots 124–6. (WAG 1741) acquired by James Knowles[18] by 1896; his sale, Christie's 29 May 1908, lot 402, bought Paterson (£273); James Smith who bequeathed it 1923. (WAG 1742) bought Mitchell (£236.5s.) from the Carver sale (lot 124); C.J. Galloway by 1896; his sale, Christie's 24 June 1905, lot 102, bought Paterson (£199.10s.); James Smith who bequeathed it 1923. (WAG 1743) bought James Smith (£388.10s.) from the Carver sale (lot 125);[19] bequeathed by him 1923. (WAG 1744) bought Ellis (£236.5s.) from the Carver sale (lot 126); purchased from Goupil and Co. by James Smith 1896;[20] bequeathed by him 1923.

EXH: Grosvenor Gallery 1883 (103–6); Whitechapel Art Gallery 1883 (138–41); Metropolitan Museum of Art, New York, *George Frederic Watts*, 1885 (85, 112, 119);[21] Birmingham Museum and Art Gallery, *G.F. Watts and Edward Burne-Jones*, 1885 (175–7) and *The Collection of Paintings* 1886 (85, 87, 89);[22] Nottingham Museum and Art Gallery, *G.F. Watts*, 1886 (29–31);[23] Liverpool Domestic Mission *Loan Exhibition*, 1896 (6);[24] New Gallery, *G.F. Watts*, 1896–7 (24, 28, 32, 36); Guildhall Art Gallery 1897 (98);[25] Royal Academy, *G.F. Watts*, 1905 (145, 146, 148, 149); Manchester City Art Gallery, *G.F. Watts*, 1905 (79, 90);[26] Liverpool Autumn Exhibition 1922 (447–50).

1 Winsor and Newton canvas stamp.

2 Winsor and Newton canvas stamp.

3 Winsor and Newton canvas stamp; frame label of Boussod, Valladon and Co.

4 The artist's wife in her MS Catalogue (Watts Gallery, Compton). The version of *The Rider on the Black Horse* formerly owned by C.H. Rickards was certainly in progress in 1871 (MS letter from the artist to Rickards of 4 October 1871, formerly at the Watts Gallery, Compton, now available as a microfiche at the Tate Gallery archives and elsewhere) and completed in 1872 – it was almost certainly the version sold at Sotheby Parke Bernet (New York) 7 April 1966, lot 80 (66 × 53.3 cm) and subsequently owned by the Fine Art Society; this version was dated 1872; according to the MS Catalogue, *op. cit.*, *The Rider on the Black Horse* was the first to be begun; Rickards's version was then exhibited first at the Royal Manchester Institution in 1880 (22) and subsequently at the Grosvenor Gallery in 1881–2, where the large version of the *Rider on the White Horse* (now in the South African National Gallery) was also shown.

5 MS letter from the artist to Rickards of 29 November 1874 (see note 4).

6 Mrs. Russell Barrington, *G.F. Watts: Reminiscences*, 1905, pp. 92–3.

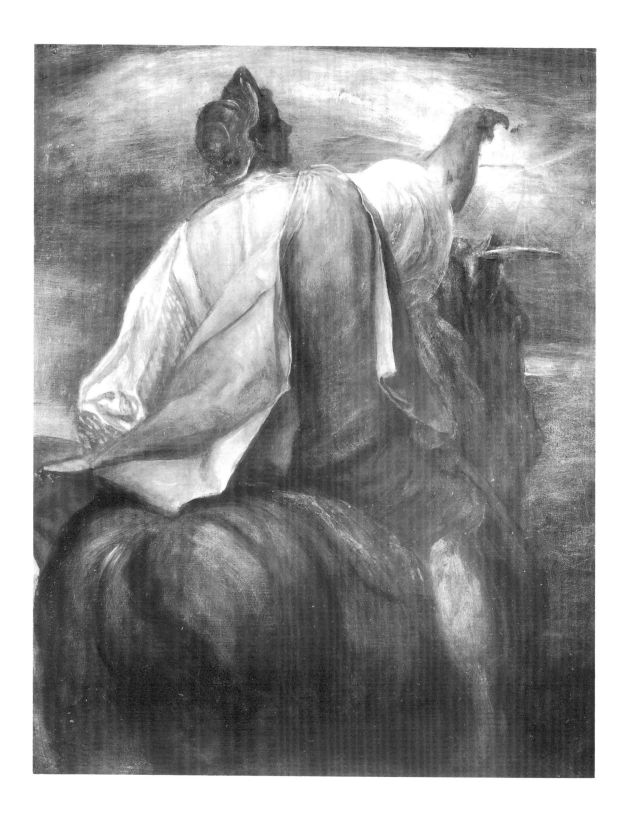

The Rider on the Black Horse WAG 1743

478

The Rider on the Pale Horse WAG 1744

7 See Exhibited.

8 Dated by the New York catalogue and by the artist's wife (MS Catalogue, *op. cit.*) to 1881 (probably the date of completion).

9 MS Catalogue, *op. cit.*, now unlocated.

10 See note 4.

11 MS Catalogue, *op. cit.*

12 Mrs. Russell Barrington, *op. cit.*, p. 165.

13 *Art Journal*, 1883, p. 203.

14 *Athenaeum*, 28 April 1883, p. 548; *Academy*, 6 May 1883, p. 316.

15 *Magazine of Art*, 1883, p. 352.

16 H. Blackburn, *Grosvenor Notes*, 1883, p. 28.

17 There is no actual evidence that Carver ever owned WAG 1741; it did not appear at his 1890 sale, although the large version of this composition (now South African National Gallery) was there as lot 123.

18 WAG 1741 hung in his dining-room at Queen Anne's Lodge, see Priscilla Metcalf, *James Knowles*, 1980, p. 361.

19 James Smith bought just this one *Rider* from the Carver sale but then proceeded to re-assemble the entire series in his own collection over the next eighteen years.

20 MS copy of James Smith's Catalogue (Walker Art Gallery).

21 WAG 1741 was not exhibited.

22 WAG 1741 was not exhibited.

23 WAG 1741 was not exhibited.

24 Only WAG 1744 was exhibited.

25 Only WAG 1741 was exhibited.

26 Only WAG 1743 and 1744 were exhibited.

The Court of Death

WAG 2098
Canvas: 127 × 80 cm
Signed and dated: *G.F. Watts/1881*

In the preface to the catalogue for the New Gallery exhibition, 1896–7,[1] the artist wrote:

In the several subjects relating to Death, the object has been to divest the inevitable of its terrors: the power has always been depicted as impersonal and rather as a friend than enemy . . . In the large design, 'The Court of Death'. . . the power does not act, but receives homage; the soldier surrenders his sword, the noble his coronet, the mendicant and the oppressed seek relief. Sickness lays her head upon the knee of Death, old age comes for repose, the child plays with the grave cloths unknowingly, and in the arms of the silent figure is the youngest possible child, the very beginning of Life being in the lap of Death. Two powers, Silence and Mystery, guard the entrance of the unknown.

In the foreground lies the open book of Life; a lion, as the type of physical power, crouches at Death's feet.

The composition was intended for the decoration of a cemetery or mortuary chapel,[2] but neither of the two large canvases was ever finished.[3] The first version was begun as early as 1853[4] and in 1864 was described by Ruskin as the 'new Trionfo della Morte Madonna'. According to the artist's wife, the Walker Art Gallery version was the first version to be completed; she states that the figure of the young woman laying her head on Death's knee (particularly the head and hand) was studied from May Prinsep in 1867–8 and that the painting was in progress by September 1868 and completed in 1881.[5] Her account may, however, be inaccurate, although she did have access to the artist's letters to C.H. Rickards of 1868–81.[6] These letters seem to indicate that a version of the *Angel of Death* (as the composition was then called) was begun for Rickards by September 1868; the price was agreed at £500 and Rickards made an advance payment; the painting was 'far advanced' in September 1869 and Rickards sent the artist a cheque for 500 guineas in September 1871; the completed painting went to the Dudley Gallery in the winter of 1871, but early in 1872 Rickards decided not to accept it and it probably went in 1874 to another Manchester

patron, Samuel Barlow, who was known to Rickards.[7]

By 1876 Watts had four further versions of the *Angel of Death* in progress and he again started to complete one of them for Rickards; this was certainly the Walker Art Gallery version, but probably not to be identified with the version of 1867–71 as the artist's wife believed; there were, however, a series of disagreements[8] between artist and patron over elements of the iconography; in May 1876 the artist refused to introduce a Cross[9] as he wished 'to appeal purely to human sympathies without reference to creed or dogma of any kind'; a month later Rickards wanted the baby held by Death to be omitted, but the artist protested that the whole meaning of the composition would be lost if this was done – he wanted to indicate that 'even the germ of life is in the lap of Death'; the picture, he contended, was never intended to suit 'the fastidiousness of modern taste'; finally in 1879

Rickards asked for some changes in his version to distinguish it from the Barlow version – this may explain the presence of the distinctive black man (or slave) in the Walker Art Gallery version;[10] ultimately Rickards received this *Angel of Death* in September 1881 and sent it almost immediately to the Grosvenor Gallery exhibition of 1881–2, where *The Times*[11] noted that in its 'power of composition', 'originality of conception' and 'grandeur of scale', the *Angel of Death* recalled 'the best days of Italian Art'.

PROV: C.H. Rickards; his sale, Christie's 2 April 1887, lot 19,[12] bought Agnew (£577.10s.); sold to Charles W. Carver; bequeathed by Mrs. C.W. Carver 1922.

EXH: Grosvenor Gallery, *Winter Exhibition*, 1881–2 (148); Manchester City Art Gallery, *G.F. Watts*, 1905 (145); Laing Art Gallery, Newcastle upon Tyne, *G.F. Watts*, 1905 (30); Liverpool Autumn Exhibition 1922 (49A).

1 New Gallery, *The Works of G.F. Watts*, 1896–7, p. 6 and no. 135. The artist in a letter to C.H. Rickards of 15 November 1871 particularly commended the review of the composition in *The Times*, 14 November 1871:

> *Mr. Watts has conceived the grave as 'Heaven's golden gate' and has painted the rich and poor that wait around it. Regal age brings its crown, heroic strength its sword, beggary its infirmities and its crutch, the maiden her unfulfilled dream of love, the child its innocence, the crone her burden of years. In the soft lap of death lies the regenerate soul, an infant embodiment of the life to be. The face and form of the dark-winged Angel, veiled in a shadow which is rather tender than terrible, are relieved against the golden splendour that floods the space beyond those awful portals which it is hers to open.*

2 Mrs. M.S. Watts, *George Frederic Watts: Annals of an Artist's Life*, 1912, vol. 1, pp. 228, 307–8. The first reference to this cemetery or mortuary chapel seems to be in the brief biography of Watts in the *Illustrated London News*, 9 March 1867, p. 239. It is just possible that the first title of this composition, and even perhaps the idea for it, were derived from John Bright's great 'Angel of Death' speech (February 1855) denouncing the Crimean War.

3 They are now in the Tate Gallery and in the Manchester City Art Galleries. *The Illustrated London News*, *op. cit.*, states that one of them was in progress in 1867. Other versions are now in Norwich Castle Museum and in the Watts Gallery, Compton, while yet another version was in the collection of Samuel Barlow. Barlow's version was certainly exhibited at the 1874 Manchester Autumn Exhibition (64) – see Watts Gallery Press-Cuttings p. 3, at Birmingham Museum and Art Gallery, *G.F. Watts and Edward Burne-Jones*, 1885 (118) and at *The Collection of Paintings*, 1886 (24); it was sold at Christie's 13 November 1992, lot 124, and then again on 25 March 1994, lot 72. Sketches for the composition were at Sotheby's (Belgravia) 20 March 1979, lot 39 (127 × 85 cm) and at Sotheby's (Belgravia) 3 February 1981, lot 205 (97 × 69 cm). The Watts Gallery, Compton, have four Hollyer photographs, one Emery Walker photograph and one postcard of various versions of the composition.

4 *Letters of the Hon. Mrs. Edward Twisleton*, ed. Vaughan, 1928, p. 106; M.S. Watts, *op. cit.*, vol. 1, p. 219.

5 See her MS Catalogue of Watts's work (Watts Gallery, Compton).

6 She stuck a photograph of the wrong version against the entry relating to WAG 2098 in her MS Catalogue, and a photograph of WAG 2098 appears against the entry relating to the Samuel Barlow version. If the artist's wife confused the photographs of the Barlow and Rickards versions of the *Angel of Death*, she may also have confused the two versions in her accounts of them. The letters to Rickards were formerly in the Watts Gallery, Compton; microfiches of them are now in the Tate Gallery archives and elsewhere.

7 Watts asked Rickards if Barlow wanted the *Angel of Death* on 1 February 1874, and Barlow had his version of the composition by late 1874 – see note 3, which also describes its later history.

8 These disagreements indicate that the artist's well-known praise of Rickards as a patron – quoted in M.S. Watts, *op. cit.*, vol. 1, p. 276 – should be accepted with caution. M.S. Watts, *op. cit.*, vol. 1, pp. 307–8 describes these differences in attitude between patron and artist and quotes from the artist's letters on the controversies over the Cross and the baby, but she minimizes the extent of the

disagreements. It is, however, true that all the three contemporary patrons involved with the *Court of Death* – Rickards, Barlow and T.C. Horsfall – were all Manchester men.

9 G.K. Chesterton wrote in his *G.F. Watts* of 1904 (1920 edn, p. 60): 'We cannot imagine the rose or the lion of England, the keys or the tiara of Rome, the red cap of Liberty or the crescent of Islam in a picture by Watts; we cannot imagine the Cross itself.'

10 M.H. Spielmann, 'The Works of Mr. George F. Watts', *Pall Mall Gazette*, Extra Number 22, 1886, p. 21, refers to a slave in the *Court of Death* composition; however his illustration (p. 7) of the composition does not seem to include a slave – certainly not the black figure in WAG 2098. No other version of the *Court of Death* seems to contain this black figure. WAG 2098 was described in the Grosvenor Gallery catalogue 1881–2 (148) as *Design for the larger composition*.

11 The review is quoted in R. Chapman, *The Laurel and the Thorn*, 1945, p. 100. Other reviews appeared in the *Art Journal*, 1882, p. 61, in the *Magazine of Art*, 1882, p. 181 (by Cosmo Monkhouse, who criticized the intellectual complexity of the composition), in the *Spectator*, 28 January 1882, p. 119 (describing the large version as 'the largest and grandest work in the exhibition') and in the *Contemporary Review*, February 1882, p. 284 (by Harry Quilter). The artist himself described the composition as 'his greatest and most complete design' (Spielmann, *op. cit.*, p. 21). There is also a long and interesting analysis of the *Court of Death* in Robert de la Sizeranne, *La peinture anglaise contemporaine*, 1895, pp. 103 ff.

12 The sale catalogue contains yet another long account of the composition and subject, probably written by Rickards; it does not mention the distinctive slave in WAG 2098. The compiler is indebted to Dr. David Stewart for help with this entry.

'A Villain, I'll be Bound'
WAG 2114
Canvas[1]: 66.7 × 53.5 cm

The artist's wife dated this painting to 1878–9.[2] *The Habit does not make the Monk* (Russell–Cotes Art Gallery, Bournemouth) painted by Watts some ten years later, has a very similar theme.[3]

PROV: William Carver[4] sale, Christie's 22 March 1890, lot 128 (as *Cupid*) bought James Smith (£199.10s.); bequeathed 1923.

EXH: Birmingham Museum and Art Gallery, *G.F. Watts and Edward Burne-Jones*, 1885 (136) and *The Collection of Paintings*, 1886 (50); Nottingham Museum and Art Gallery 1887 (735); Liverpool Domestic Mission, *Loan Exhibition*, 1896 (7); Royal Academy, *Winter Exhibition*, 1905 (188); Manchester City Art Gallery, *G.F. Watts*, 1905 (131).

1 Winsor and Newton prepared canvas stamp.

2 MS Catalogue (Watts Gallery, Compton).

3 See M.S. Watts, *George Frederic Watts: Annals of an Artist's Life*, 1912, vol. 2, p. 141. Cupid was also the subject of this painting.

4 The artist owned WAG 2114 until at least 1887.

'A Villain, I'll be Bound' WAG 2114

Europa

WAG 2129
Canvas: 67 × 77.2 cm
Signed: *G.F. Watts*

Europa is being carried off by Zeus, disguised as a bull, from Phoenicia to Crete.

According to the artist's wife, the composition was first designed in about 1855;[1] this version was probably substantially completed in the 1870s,[2] but was certainly re-worked in the early 1890s.[3]

Another smaller version, differing very considerably from the Walker Art Gallery painting, is now in the Watts Gallery, Compton;[4] according to the artist's wife, it is slightly later than the Liverpool version, having been begun in the early 1860s and then largely repainted in the late 1890s. A study for one of these two versions, but differing substantially from the Walker Art Gallery one, was in the Brinsley Ford Collection.

PROV: Bought from the artist by James Smith October 1894 probably for 800 guineas;[5] bequeathed to the Walker Art Gallery 1923.

EXH: Whitechapel Art Gallery 1894 (32); The Rembrandt Head (Dunthorne's Gallery) 1894; New Gallery, *G.F. Watts*, 1896–7 (104); Liverpool Autumn Exhibition 1922 (497).

1 See her MS Catalogue (Watts Gallery, Compton).

Europa WAG 2129

2 The artist's wife in her MS Catalogue, *op. cit.*, gives the approximate dates 1870–5; Mrs. Barrington saw a 'well-advanced' version in Watts's studio in 1878 (Mrs. Russell Barrington, *G.F. Watts: Reminiscences*, 1905, p. 93).

3 The artist wrote to James Smith on 14 September 1894 (MS Watts Gallery, Compton) stating that WAG 2129 was 'not absolutely a new design' and that it 'has been carefully and elaborately worked upon until it went to Dunthorne's' in 1894 (see Exhibited). Similarly the artist's wife in her MS Catalogue (*op. cit.*) noted that WAG 2129 had been 'worked upon considerably in the early 1890's'. The appearance of WAG 2129 before this final re-working is probably recorded in W.K. West and R. Pantini, *G.F. Watts*, 1904, plate 28 and in a Hollyer photograph now at the Watts Gallery, Compton; the principal alterations lay in Europa's drapery and in the background landscape.

4 Reproduced in R. Alston, *The Mind and Work of G.F. Watts*, 1929, plate 12, no. 28.

5 Letters from the artist to James Smith of 5 August, 14 September, 1 and 4 October 1894 (MS Watts Gallery, Compton); the artist justified the high price with the comment in his letter of 1 October that WAG 2129 was 'the best specimen of my work you or anyone else has'.

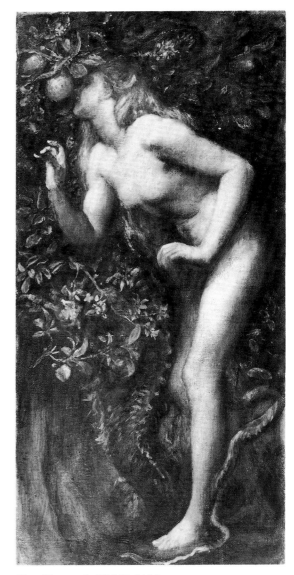

Eve Tempted WAG 2101

Eve Tempted

WAG 2101
Canvas: 57.7 × 29.5 cm

Eve Repentant

WAG 2100
Canvas: 78.8 × 31.8 cm

These two paintings are small versions of the second and third compositions in Watts's *Eve* trilogy; the final large works are all in the Tate Gallery. The artist described the series, begun in the 1860s, as follows:[1] 'Eve in the glory of her innocence, Eve yielding to temptation and Eve restored to beauty and nobility by remorse – form part of one design and can hardly be separated.'

The Walker Art Gallery *Eve Tempted* is not dated by the artist's wife;[2] it perhaps dates from the late 1870s or early 1880s; she lists four other versions of this composition in addition to the large Tate Gallery painting; a version (66 × 39.5 cm) was with the Fine Art Society in the 1960s; the Liverpool version lacks the leopard (?) – lying on its back at the lower left side of the composition – which can be found in most of the other versions.

The Walker Art Gallery *Eve Repentant* is recorded by the artist's wife[3] as 'carried on through the years 1868–78'[4] and as 'the most tender in quality of colour and the most complete version of this design'. As well as the

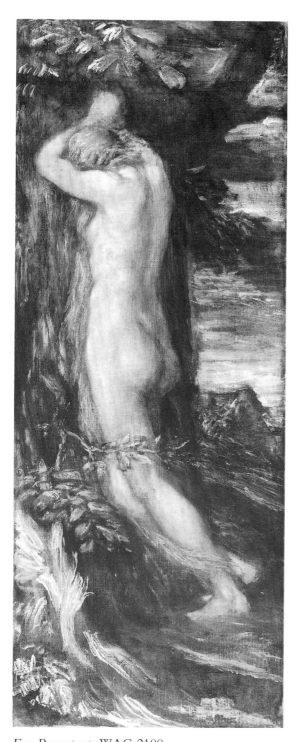

Eve Repentant WAG 2100

large Tate Gallery picture, she lists two other versions of this composition, both now in the Watts Gallery, Compton.

REPR: There is a Hollyer photograph in the Watts Gallery, Compton, which seems to have been taken from WAG 2100 rather than from any of the other versions of this composition.

PROV: (WAG 2101) C.J. Galloway[5] sale, Christie's 24 June 1905, lot 113, bought Paterson (£210); bequeathed by James Smith 1923. (WAG 2100) Bought from the artist by James Smith probably in 1898; bequeathed 1923.

EXH: (WAG 2101) Birmingham Museum and Art Gallery, *G.F. Watts and Edward Burne-Jones*, 1885 (135) and *The Collection of Paintings*, 1886 (43). (WAG 2100) Grosvenor Gallery, *G.F. Watts 1881–2* (58); Birmingham Museum and Art Gallery, *G.F. Watts and Edward Burne-Jones*, 1885 (127); Nottingham Museum and Art Gallery, *G.F. Watts*, 1886 (39); Liverpool Autumn Exhibition 1922 (22).

1 M.S. Watts, *George Frederic Watts: Annals of an Artist's Life*, 1912, vol. 1, p. 262. Mrs. Russell Barrington in *G.F. Watts: Reminiscences*, 1905, p. 132, stated that the Eve trilogy, together with another multi-figure *Genesis* series, were associated with Watts's *House of Life* scheme (see pp. **466–7**) and Watts wrote to C.H. Rickards to the same effect on 6 June 1873, see Arts Council of Great Britain, *George Frederic Watts*, 1954–5, p. 35 and Minneapolis Institute of Arts, *Victorian High Renaissance*, 1978, pp. 81–2. For the subject matter of the trilogy, see also Barrington, *op. cit.*, pp. 136–7, and M.S. Watts, *op. cit.*, vol. 2, pp. 138–9, 202–3. The date of the inception of the trilogy is very uncertain; the two large versions of the *Eve Repentant* (now Watts Gallery, Compton, and Tate Gallery) are listed by the artist's wife as begun (respectively) in 1868 and in the 1860s, while WAG 2100 is noted by her as also begun in 1868 (MS Catalogue, Watts Gallery, Compton); in her *George Frederic Watts, op. cit.*, vol. 2, p. 138, she states that the trilogy was designed 'some time in the sixties'; Mrs. Barrington, however, (*op. cit.*, pp. 92–3) remarked that even by 1876 only rough sketches of the trilogy existed.

2 MS Catalogue, *op. cit.*

3 MS Catalogue, *op cit.*; both the Tate Gallery version and the large Watts Gallery version were begun in the 1860s (together with WAG 2100).

4 Watts did some more work on WAG 2100 in 1898; he wrote to James Smith on 19 June 1898 telling him that 'the small Eve is nearly finished' (MS Watts Gallery, Compton).

5 WAG 2101 is listed in the *Catalogue of Paintings and Drawings collected by C.J. Galloway*, 1892, no. 174 (repr.).

Hope

WAG 2105
Panel[1]: 66 × 53.3 cm

The artist described the subject in a letter to Mrs. Percy Wyndham in 1885:[2]

I am painting a picture of Hope sitting on a globe with bandaged eyes playing on a lyre which has all the strings broken but one out of which poor little tinkle she is trying to get all the music possible, listening with all her might to the little sound, do you like the idea?

This is a sketch for the artist's most famous composition; there are two large versions of 1885–6; the first was sold at Sotheby's 26 November 1986, lot 55, and the second is now in the Tate Gallery.[3]
Loshak[4] believed that a sketch formerly owned by Mrs. Coombe Tennant,[5] and dated by him to 1865–70, was the first idea for this composition and that the conception dated from the artist's stay in Italy of 1843–7, but both assertions seem doubtful;[6] Loshak dated the Walker Art Gallery sketch to the late 1870s and Allen Staley[7] agreed with this dating, but again there seems to be no evidence for this proposed dating beyond Mrs. Barrington's statement that *Hope* was one of the compositions begun and finished between 1877 and 1886.[8] A friend of Mrs. Barrington sat for the figure of Hope and, according to Mrs. Barrington, inspired in the artist the idea for the composition.[9]

PROV: Given by the artist to Frederic Leighton;[10] his sale, Christie's 1 May 1897, lot 130, bought James Smith (£651); bequeathed 1923.

EXH: Liverpool Autumn Exhibition 1922 (34).

1 Frame maker's label: *W.A. Smith Carver and Gilder / 14 Charles St. London W.*

2 Minneapolis Institute of Arts, *Victorian High Renaissance*, 1978, p. 90, no. 30. Watts made a similar statement to Briton Rivière about the meaning of *Hope* – see M.S. Watts, *George Frederic Watts: Annals of an Artist's Life*, 1912, vol. 2, p. 150; for the meaning of the composition see also Arts Council of Great Britain, *Great Victorian Pictures*, 1978, p. 88, no. 63, and (particularly) G.K. Chesterton, *G.F. Watts*, 1904 (1920 edn, pp. 98–108). Chesterton noted particularly how unconventional and vital Watts's symbolism was in *Hope*, but Robert Goldwater in his *Symbolism*, 1979, p. 5, saw it as merely 'allegory in its traditional forms with conventional signs and symbols'.

3 For the version at the 1986 Sotheby's sale, see particularly, Barbara Bryant, 'G.F. Watts's first Hope', in *Sotheby's Art at Auction*, ed. Fogg, 1986–7, pp. 62–5. The artist's wife in her MS Catalogue (Watts Gallery, Compton) lists various other versions.

4 Arts Council of Great Britain, *George Frederic Watts*, 1954–5, p. 39, no. 65.

5 There is a photograph in the Witt Library.

6 See note 9.

7 Minneapolis Institute of Arts, *op. cit.*

8 Mrs. Russell Barrington, *G.F. Watts: Reminiscences*, 1905, p. 93.

9 Barrington, *op. cit.*, p. 37 and Mrs. Russell Barrington, *Essays on the Purpose of Art*, 1911, p. 358; this suggests a relatively late date for the original conception of this composition. Similarly the artist's wife suggests that the design for *Hope* was new in the early 1880s (M.S. Watts, *op. cit.*, vol. 2, p. 57).

10 The artist's wife in her MS Catalogue (Watts Gallery, Compton); she states that the occasion for the gift was an expression of admiration for the design from Leighton; for the friendship between Leighton and Watts, see M.S. Watts, *op. cit.*, vol. 2, pp. 254–5 and Barrington, 1905, *op. cit.*, pp. 192–4: 'Half my life is gone with Leighton.'

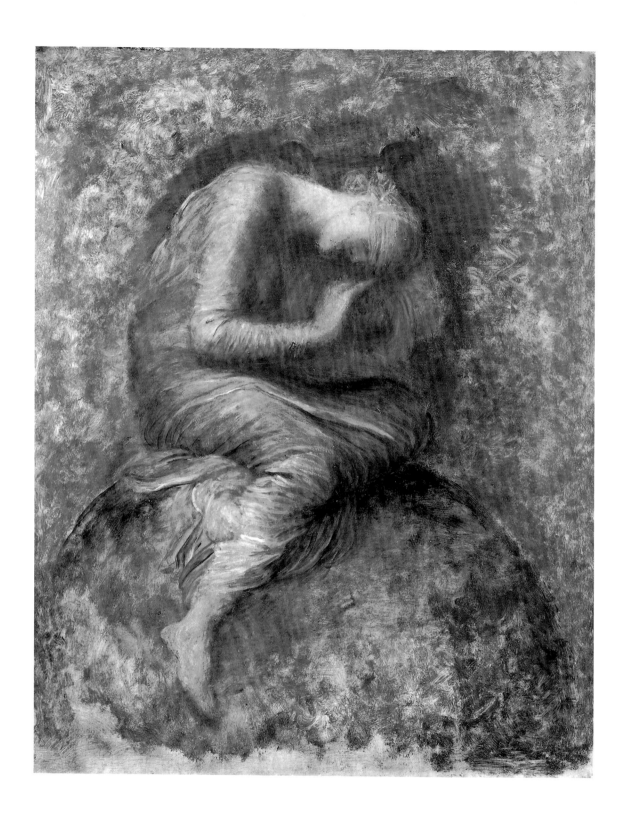

Hope WAG 2105

488

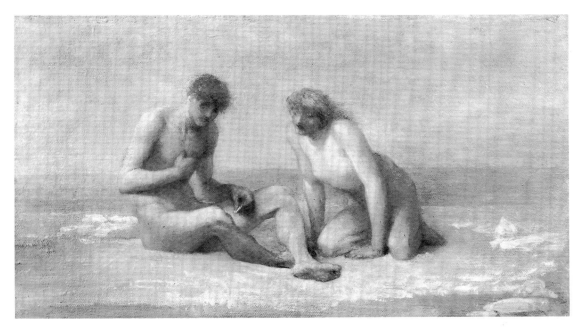

The First Oyster WAG 2102

The First Oyster

WAG 2102
Canvas: 33 × 61 cm

This is a sketch dating from 1882[1] for *B.C.* or *Tasting the First Oyster*[2] of 1882–3[3] (now in the Watts Gallery, Compton). The artist did more work on it in 1894–6, well after the completion of the large Compton version.[4] He painted this subject to refute criticism that his art was too serious and grave in nature.[5]

PROV: Bought from the artist by James Smith 1896 (150 guineas);[6] bequeathed 1927.

EXH: Conway, *Royal Cambrian Academy*, 1889 (31).

1 The artist's wife in her MS Catalogue (Watts Gallery, Compton).

2 Another alternative title is *Experientia Docet*.

3 This large version was first exhibited at the Liverpool Autumn Exhibition 1884 (729) as *B.C.*

4 Letters from the artist to James Smith of 5 August 1894, 12 January 1896 and 15 March 1896 (MS Watts Gallery, Compton).

5 MS Catalogue, *op. cit.*, G.K. Chesterton, *G.F. Watts*, 1904 (1920 edn, p. 165).

6 On 5 August 1894 the artist wrote to James Smith saying that his extra work on WAG 2102 would add 400 guineas to its price, but his letter of 15 March 1896 indicates a price of 150 guineas (MS Watts Gallery, Compton).

Katie

WAG 1624
Canvas: 66.3 × 53.3 cm
Signed: *G.F. Watts*

This is an 1882 study[1] for a full-length seated portrait (142 × 79 cm) exhibited at the 1883 Royal Academy (286).[2]

PROV: Fred C. Johnson.[3] (?) Thomas Bartlett sale, Christie's 29 November 1912, lot 44 (63 × 49.5 cm), bought Sampson (£115.10s.). Bought from S. Lever by James Smith 1915;[4] bequeathed 1923.

1 The artist's wife in her MS Catalogue (Watts Gallery, Compton). She refers to WAG 1624 as a 'portrait head'. In a letter dated 7 December she wrote to James Smith: 'Katie was painted at Brighton from a little girl Signor [Watts] admired

at some public entertainment' (MS Watts Gallery, Compton). Watts spent many winters at Brighton from the 1880s onwards.

2 Reproduced in O. von Schleinitz, *G.F. Watts*, 1904, p. 112, plate 96; there is also a Hollyer photograph of it in the Watts Gallery, Compton. The portrait was sold at Sotheby's 10 November 1981, lot 64. According to the *Athenaeum*, 5 May 1883, p. 575, the large portrait 'reproduced the attitude she assumed at a performance at the Aquarium'.

3 MS Catalogue, *op. cit.*, which also notes that the artist originally gave WAG 1624 to 'a collection of paintings given by artists for some charitable purpose'.

4 James Smith's Catalogue (MS Walker Art Gallery).

Ariadne in Naxos

WAG 2095
Canvas: 71 × 91.5 cm

Mrs. Barrington[1] described *Ariadne in Naxos* thus:

The particular time in the story of Ariadne, which the artist has chosen, is later on than that chosen by Titian in his famous picture of 'Bacchus and Ariadne' in the National Gallery in London. Oblivious of her union with Bacchus, Ariadne is rapt in a reverie while looking out into the blue mists of distant sea, into which the deserter Theseus had vanished. A sense of queenliness is meant to be expressed in her form and attitude. Her arm falls listlessly by her side, and she does not heed the touch of the bright maiden who comes through the wood behind her from the gay train of Bacchus to remind her of the revels, and to summon

her again to join the jovial company. The panthers that belong to the rout of Bacchus play at her feet.

This is a full-size later version of a painting (now in the Guildhall Art Gallery, London) which was begun in 1867 and completed in 1875. It probably dates from the early 1880s.[2] Later, Watts painted the same subject in an upright format with a quite different composition.[3]

There are drawings from the composition in the collection of Brinsley Ford. The influence of the Elgin Marbles – particularly the pediment figures – seems very clear.[4]

REPR:There are two Hollyer photographs for this composition in the Watts Gallery, Compton; one certainly reproduces the Guildhall Art Gallery version; the other may be taken from WAG 2095 before its completion.

PROV: Louisa, Lady Ashburton (by 1885); her sale, Christie's 8 July 1905, lot 5, bought Patterson (£525); James Smith who bequeathed it 1923.

EXH: Metropolitan Museum of Art, New York, *George Frederic Watts*, 1885 (107); Liverpool Autumn Exhibition 1922 (505).

1 Metropolitan Museum of Art, New York, *George Frederic Watts*, 1885, no. 107, p. 38, reprinted in Mrs. Russell Barrington, *G.F. Watts: Reminiscences*, 1905, pp. 130–1. The Guildhall Art Gallery version was first exhibited at the Dudley Gallery, *Winter Exhibition*, 1872 (70) as *Watching for the Return of Theseus*. Mrs. Barrington could also have compared the composition of WAG 2095 with that of Frederic Leighton's *Ariadne* painted in 1868 (formerly at Baroda). J.A. Kestner in *Mythology and Misogyny*, 1989, *passim*, draws attention to the large number of paintings of the

Ariadne in Naxos WAG 2095

deserted Ariadne in Victorian art (W.B. Richmond in 1872, Evelyn de Morgan in 1877, P.H. Calderon in 1895 and others); he relates this theme to the status of women in 19th-century Britain.

2 WAG 2095 is dated to about 1870 in Fogg Museum of Art, Cambridge, Massachusetts, *Paintings and Drawings of the Pre-Raphaelites and their Circle*, 1946, p. 110, no. 101; this seems much too early.

3 The earlier version is that at the Fogg Museum of Art dating from 1888–90; a later version of 1894 is at the Metropolitan Museum of Art, New York; see Fogg Museum of Art, *op. cit.*, for further details.

4 For this subject see Ian Jenkins, 'G.F. Watts's Teachers: George Frederic Watts and the Elgin Marbles', *Apollo*, 1984, vol. 120, pp. 176–81.

Dante Gabriel Rossetti
WAG 2134
Canvas[1]: 66.4 × 53.7 cm
Signed: *G.F. Watts*

This is an autograph[2] replica of the original portrait of 1870 or 1871 now in the National Portrait Gallery.[3] The replica was painted by Watts at some time between 1883 and 1892 to join his group of portraits of worthies, destined for the National Portrait Gallery as the 'Hall of Fame',[4] but ultimately, the original went to the National Portrait Gallery and this replica to James Smith (see Provenance).

REPR: There are two Hollyer photographs in the Watts Gallery, Compton, related to WAG 2134; one is annotated as representing WAG 2134 with this note: 'a copy or duplicate made by Signor entirely – no "laying in by any one else"'. The

Dante Gabriel Rossetti
WAG 2134

other might have been taken from WAG 2134 or from the National Portrait Gallery version.

PROV: Bought by James Smith from the artist in January 1893;[5] bequeathed 1923.

EXH: Manchester City Art Gallery, *Ford Madox Brown and the Pre-Raphaelites*, 1911 (296); Liverpool Autumn Exhibition 1922 (30).

1 Winsor and Newton canvas stamp.

2 M.S. Watts, *George Frederic Watts: Annals of an Artist's Life*, 1912, vol. 1, p. 269, and in her MS Catalogue (Watts Gallery, Compton): 'entirely by his own hand'. W.M. Rossetti wrote of WAG 2134: 'I think the original exceeds (as was natural under the circumstances affecting the two cases) in the look of personal presence and activity; on the other hand I think the duplicate exceeds in suavity of expression, and in the sort of beauty which accompanies this, and it is not less of a definite likeness.' (M.S. Watts, *op. cit.*, p. 270)

3 W.M. Rossetti gives the date as 'towards the summer of 1870' (*Dante Gabriel Rossetti, His Family Letters*, ed. W.M. Rossetti, 1895, vol. 1, p. 349), but M.S. Watts (MS Catalogue, *op. cit.*) has 1871. The National Portrait Gallery version is reproduced in Julia Cartwright, 'G.F. Watts', *Art Annual*, 1896, p. 29 (a view of the Gallery of Little Holland House with the Rossetti portrait propped up against a table) and in O. von Schleinitz, *G.F. Watts*, 1904, p. 71 (in fact this is possibly WAG 2134).

4 The original portrait of 1870–1 had been prised out of Watts's possession by D.G. Rossetti in 1875, probably as a present for Fanny Schott (see M.S. Watts, *op. cit.*, pp. 267–9; *Letters of Dante Gabriel Rossetti*, ed. Doughty and Wahl, 1967, vol. 3, p. 1349; W.B. Scott, *Autobiographical Notes*, 1892, vol. 2, p. 215; *Dante Gabriel Rossetti*, *op. cit.*) However, James Smith's Catalogue (MS Walker Art Gallery), asserts that Rossetti got the original portrait from Watts for Frederick Leyland rather than Fanny Schott. Indeed Leyland tried to buy the portrait from Schott around 1882 but would not pay the £200 then demanded by Schott, see *Selected Letters of William Michael Rossetti*; ed. R.W. Peattie, 1990, pp. 435–6. Fanny Schott certainly owned the original portrait by 1883 when she lent it to the Royal Academy *Winter Exhibition* (344), but Leyland subsequently acquired it and it was at his

sale of 28 May 1892 (lot 47, bought James Gow, £283.10*s*.); WAG 2134 was painted while the original was in Leyland's possession (M.S. Watts, *op. cit.*, p. 269). For the conception and execution of the 'Hall of Fame', see National Portrait Gallery, *G.F. Watts: The Hall of Fame*, 1975, in which the National Portrait Gallery version of WAG 2134 is reproduced as plate 50. For Watts, Rossetti justified his place in the 'Hall of Fame' as a poet not as a painter – see M.S. Watts, *op. cit.*, vol. 1, p. 267.

5 Smith had acquired the original portrait after the Leyland sale in 1892 and, at Watts's request, exchanged it with him for *I'm Afloat* (see p.**499**); Smith then purchased the replica portrait – WAG 2134; see letters from the artist to James Smith of 10 and 19 January 1893 (MS Watts Gallery, Compton); the original was presented by Watts to the National Portrait Gallery as part of his 'Hall of Fame'.

The Wife of Plutus
WAG 2135
Canvas: 66.7 × 54 cm
Signed: *G.F. Watts*

Plutus was the god of wealth and this painting was exhibited at the New Gallery in 1896–7 with this misquotation from Ecclesiastes 6: 7: 'And yet the soul is not filled'.[1] The pose in the *Wife of Plutus* is very similar to that used by Watts in his *Clytie* and the theme – unfulfilled longing – is substantially the same.[2] The painting has been generally dated to 1885 (or at least to the early 1880s),[3] although the drawings were made twenty years earlier.[4] Lot 154 at Sotheby's 14 December 1983, *Study of a Reclining Nude*, 64 × 76 cm, may be a sketch for it. The *Athenaeum*[5] critic at the 1889 New Gallery exhibition observed: 'The Wife of Plutus, a study, heroic size, of rich carnations must be accepted as such and no more. Its proportions need revision and the face puzzles us in more ways than one.' George Bernard Shaw, however, writing in the *World*,[6] described the painting as 'a masterpiece'.

REPR: *The New Gallery: An Illustrated Catalogue*, ed. H. Blackburn, 1889, p. 48; Pall Mall Gazette, *Pictures of 1889*, p. 73. A Hollyer photograph corresponding more or less exactly to WAG 2135 is in the Watts Gallery, Compton.

The Wife of Plutus WAG 2135

494

PROV: Bought from the artist by James Smith in April 1890 (£525);[7] bequeathed 1923.

EXH: New Gallery, *G.F. Watts*, 1889 (184); Manchester City Art Gallery, *Autumn Exhibition*, 1889 (282); New Gallery, *G.F. Watts*, 1896–7 (85); Glasgow 1901 (366); Manchester City Art Gallery, *G.F. Watts*, 1905 (76); Royal Academy, *Winter Exhibition*, 1905 (83); Liverpool Autumn Exhibition 1922 (488).

1 M.S. Watts, *George Frederic Watts: Annals of an Artist's Life*, 1912, vol. 2, p. 46, refers to WAG 2135 as *The Wife of Midas*, although in her MS Catalogue (Watts Gallery, Compton) she has *The Wife of Plutus*. Both Plutus and Midas were of course closely identified with wealth, but their wives are not distinctly recorded. The theme of WAG 2135 (and indeed of chapter 6 of Ecclesiastes) is the futility of possessions and of wealth. On 11 April 1890 Watts wrote to James Smith, who purchased WAG 2135 from him (MS Watts Gallery, Compton):

Although I do not wish to preach, indeed I purposely avoid in my work every intimation of a doctrinal nature wishing to speak to every thinker without reference to creed, & though I would also avoid being didactic as a rule my work is intended to convey some definite idea, 'The Wife of Plutus' I wish to suggest the disease of wealth. Wealth only wallowed in, to speak somewhat grossly; I feel very strongly that wealth like strength or any other possession is a fine thing & may be used for general benefit becoming a noble personal distinction, but if cared for only self-gratification is one of the most valueless since it forms no part of the possessor's personality.

This theme recurs in Watts's paintings – see Patricia Matthews, 'The Minotaur of London', *Apollo*, 1986, vol. 123, p. 338, but as a personal characteristic of the artist it is not much in evidence in Watts's letters to James Smith.

2 The artist's wife in her MS Catalogue and in her *Annals* (*op. cit.*) noted that the drawings for WAG 2135 were made at the same time as those for *Clytie* (*c.*1865) and from the same model ('Long Mary').

3 Royal Academy catalogue, *Winter Exhibition*, 1905, no. 83; M.H. Spielmann, 'The Works of Mr. George F. Watts', *Pall Mall Gazette*, Extra Number 22, 1886, p. 32; MS Catalogue, *op. cit.*; Mrs. Russell Barrington, *G.F. Watts:*

Reminiscences, 1905, p. 93, says that it was begun and finished between 1877 and 1886. D.G. and W.M. Rossetti may, however, have seen WAG 2135 on 18 July 1869 on a visit to the Prinseps; W.M. Rossetti wrote in his diary that they saw 'Watts's Endymion, Daphne, Millais, Clytie (same composition in painting as the bust, perhaps his most vigorous piece of flesh painting)' (*Rossetti Papers*, ed. W.M. Rossetti, 1903, p. 403).

4 See note 2.

5 *Athenaeum*, 11 May 1889, p. 606.

6 S. Weintraub, *Bernard Shaw on the London Art Scene*, 1989, p. 278.

7 Letter from the artist to James Smith of 11 April 1890 (MS Watts Gallery, Compton).

Arion Saved by the Dolphin
WAG 2096
Canvas[1]: 28.5 × 41.5 cm
Signed: *G.F. Watts*

Arion, threatened by murderous sailors, played his cithara; a dolphin, attracted by his music, saved him from drowning when he jumped into the sea.

This is a small variant of the fresco executed in 1856 for the Earl and Countess Somers at 7 Carlton House Terrace; the fresco is now at Eastnor Castle. Three such variants were painted by Watts and this one seems to have been the last; the first, begun in 1856, was formerly owned by Aleco Ionides until it was sold by the Goupil Gallery in 1895; presumably it was this version that was exhibited at the Grosvenor Gallery 1881–2 (63); the second was given by the artist to the Hon. Alfred Lyttleton; the Walker Art Gallery variant was completed in 1896 but Watts had 'worked upon it for years'.[2] There is also a large unfinished version of this composition in the Watts Gallery, Compton.[3]

REPR: There is a Hollyer photograph of one of the small versions of this composition in the Watts Gallery, Compton; it probably reproduces WAG 2096.

PROV: Bought from the artist in 1896 by James Smith for £1000 (or possibly 1000 guineas); the price included *The Creation of Eve* (WAG 2130).[4]

EXH: New Gallery, *G.F. Watts*, 1896–7 (117); Royal Academy, *Winter Exhibition*, 1905 (81); Manchester City Art Gallery, *G.F. Watts*, 1905 (113); Liverpool Autumn Exhibition 1922 (47).

1 The artist wrote to James Smith in August 1896 (MS Watts Gallery, Compton) to tell him that the frame of WAG 2096 had 'appropriately carved sea shells'.

2 The artist's wife in her MS Catalogue (Watts Gallery, Compton). In various letters to James Smith of 26 October 1895, 6 January 1896 and 29 July 1896 (MS Watts Gallery, Compton) the artist explained to Smith that he had 'laboured almost unceasingly' on WAG 2096 and had, in particular, both introduced six new figures and much improved the finish; in part he was trying to justify his price for WAG 2096.

3 David Loshak, letter to the Curator of the Walker Art Gallery, 3 November 1960; it is not recorded in the various catalogues of the Watts Gallery and measures 180 × 244 cm.

4 The price was established only after much haggling in letters from the artist to James Smith of 26 October 1895 and 6 January, 29 July and 10 August 1896 (MS Watts Gallery, Compton); the artist told Smith that WAG 2096 was a much more substantial work than the Ionides version (which had apparently just been sold for 500 guineas) and that he needed the money to assist Giovanni Costa who had recently lost his money in a bank failure; the price for WAG 2096 on its own seems to have been £800. For WAG 2130, see p. **468**.

Arion Saved by the Dolphin WAG 2096

View of Naples, the Bay and Mount Vesuvius WAG 2133

View of Naples, the Bay and Mount Vesuvius

WAG 2133
Canvas: 87.3 × 143.5 cm
Signed: *G.F. Watts/1892*

This was described by the artist's wife[1] as 'a first impression of Naples from the roof of the Hotel Nobile'. Watts made studies in gouache of Naples from the roof of this hotel during convalescence there between February and March 1888; he also worked in this period from his bedroom window in the Hotel Bristol, having left the Hotel Nobile for this hotel which was higher up and had better views over the city.[2] The Walker Art Gallery painting seems to have been begun in Naples but was then brought back to England and carried further in the summer of 1888; completion was achieved in 1892.[3] There is an oil sketch for it in the Watts Gallery, Compton (28 × 46 cm), and another sketch was owned by John Witt in 1966; a further related composition shows the Bay of Naples without the city (versions in the Watts Gallery, Compton, and York City Art Gallery).

REPR: There is a mezzotint by Frank Short made in 1895 (E.F. Strange, *The Etched and Engraved Work of Frank Short*, 1908, p. 45, no. 176) and there are three Hollyer photographs in the Watts Gallery, Compton; one of these is certainly taken from WAG 2133; the other two may be taken from another unrecorded version of it or may show WAG 2133 before completion; WAG 2133 is also reproduced in O. von Schleinitz, *G.F. Watts*, 1904, p. 118, plate 102, in J.E. Phythian, *George Frederic Watts*, 1906, p. 138 and in Walter Bayes, *The Landscapes of George Frederic Watts*, n.d., plate X.

PROV: Acquired by the Reverend S.A. Thompson Yates by 1896; bequeathed 1904.

EXH: New Gallery, *G.F. Watts*, 1896–7 (116); (?) Paris, *Exposition Decennale des Beaux Arts*, 1889–1900 (*Exposition Universelle*, 1900) (265).[4]

1 MS Catalogue, Watts Gallery, Compton.

2 M.S. Watts, *George Frederic Watts: Annals of an Artist's Life*, 1912, vol. 2, p. 111. The Hotel Bristol was in the Corso Vittorio Emanuele with superb views over the city; the Hotel Nobile was

in the Rione Principe Amadeo with good, but less extensive, views; see Augustus J.C. Hare, *Cities of Southern Italy and Sicily*, 1883–4, p. 81.

3 Mrs. Russell Barrington, *G.F. Watts: Reminiscences*, 1905, p. 180. WAG 2133 is dated 1892 on the canvas, and this is the date assigned to it in the 1896–7 New Gallery catalogue (see Exhibited).

4 The name of the lender is not indicated in the catalogue; possibly, therefore, WAG 2133 was not the work exhibited.

Cupid Asleep

WAG 2099
Canvas[1]: 66 × 53.3 cm
Signed: *G.F. Watts/1893*

This was painted in 1891–2,[2] and presumably it was finally completed in 1893; *Promises* (see p. **500**) was probably painted as a pendant to it.

REPR: There is a Hollyer photograph of WAG 2099 in the Watts Gallery, Compton.

PROV: Bought in 1893 from the artist by the Reverend S.A. Thompson Yates through Dunthorne's Gallery (The Rembrandt Head) 1893; bequeathed 1904.

EXH: Dunthorne's Gallery (The Rembrandt Head) 1893; Guildhall Art Gallery 1900 (76).

Cupid Asleep WAG 2099

1 Winsor and Newton canvas stamp.

2 The artist's wife in her MS Catalogue (Watts Gallery, Compton).

I'm Afloat[1]

WAG 2106
Canvas[2]: 66.7 × 54 cm
Signed: *G.F. Watts/1892*

The figure in *I'm Afloat* is nearly identical to (but considerably larger than) the putto at the bottom left of Watts's *A Greek Idyll: Acis and Galatea* of 1881–4 now in the Manchester City Art Galleries. For *I'm Afloat* the artist has, however, added wings and a quiver, thus turning the figure into Cupid.

This painting is listed by Julia Cartwright,[3] as one of the artist's pictures 'in a lighter vein'. The critics, however, particularly admired its technical qualities; the *Magazine of Art*[4] found it 'precious in the quality of colour', while George Moore[5] wrote at the 1892 New Gallery exhibition:

I'm Afloat WAG 2106

There hangs one of the most beautiful pictures that this great painter has ever painted – a very simple thing indeed, merely a Cupid floating in the sea. The rosy flesh of the Cupid, and the rosy head, beautifully executed in a faint wavering modelling, full of the painter's idea, are the perfection of sensuous beauty, and their beauty is enchanced by a sky and sea lost in golden mist.

Characteristically, the critic of the *Athenaeum*[6] explained the subject matter:

Mr. Watts also exhibits in this gallery Afloat, *a charming child-genius, buoyant and playful upon a summer sea. Grasping a tiny bow, he has let slip his quiver and its parti-coloured arrows, and while they drift past him, lifted by the wavelets, he watches them with infantile glee, that is depicted with genuine spirit. The firm touches, solid workmanship, and pure tones and colours of all these pictures indicate that the painter has quite recovered his health, and more than justify those warm congratulations which the public will join us in offering to him.*

The artist's wife listed *I'm Afloat* as painted at Limnerslease during the winter of 1891–2.[7]

REPR: There is a Hollyer photograph in the Watts Gallery, Compton. See also H. Blackburn, *New Gallery: An Illustrated Catalogue*, 1892, p. 30, Black and White, *Handbook to the Royal Academy and New Gallery*, 1892, p. 163 and Pall Mall Gazette, *Pictures of 1892*, p. 106.

PROV: Bought by James Smith from the artist for 200 guineas and Watts's original *Dante Gabriel Rossetti* (WAG 2134, see p. **492**) 1892;[8] bequeathed 1923.

EXH: New Gallery 1892 (24); Liverpool Autumn Exhibition 1892 (1036); Royal Academy, *Winter Exhibition*, 1905 (226); Manchester City Art Gallery, *G.F. Watts*, 1905 (226); Liverpool Autumn Exhibition 1922 (477).

1 The original title was *Afloat*.

2 Frame maker's label of Smith and Uppard, Mortimer Street, London. Watts often used this firm as his agents for moving and packing pictures.

3 Julia Cartwright, 'G.F. Watts', *Art Annual*, 1896, p. 16; for other humorous works by Watts, see

pp. **483** and **489**. *Good Luck to your Fishing* is particularly close in spirit to WAG 2106.

4 *Magazine of Art*, 1892, p. 290 (by M. Phipps Jackson).

5 *Speaker*, 7 May 1892, p. 556.

6 *Athenaeum*, 30 April 1892, p. 574.

7 The artist's wife in her MS Catalogue (Watts Gallery, Compton).

8 Letters from Watts to James Smith of 6 January, 29 July, 1 August and 2 September 1892 (MS Watts Gallery, Compton). WAG 2106 was not delivered to Smith until 1893; see the letter of 31 December 1892 from the artist's wife to James Smith (MS Watts Gallery, Compton).

Neptune's Horses

WAG 2110
Board[1]: 58.5 × 32.5 cm

This is a sketch for the *Neptune's Horses* of 1892 (140 × 59.5 cm) formerly owned by Lord Binning; the subject was suggested to Watts when he was in Malta some years earlier.[2]

PROV: Laurence W. Hodson sale, Christie's 25 June 1906, lot 176, bought Paterson (£136.10*s.*); bequeathed by James Smith 1923.

1 Frame maker's label: Robert Dunn's (?), Vigo Street, London.

2 The artist's widow in her MS Catalogue (Watts Gallery, Compton). Lord Binning's painting is reproduced in O. von Schleinitz, *G.F. Watts*, 1904, p. 122, plate 105, and in the form of a Hollyer photograph (Watts Gallery, Compton). According to Walter Crane, *An Artist's Reminiscences*, 1907, p. 408, Watts's *Neptune's Horses* and Crane's painting with the same title were conceived independently of each other; both paintings were at the 1893 New Gallery; the best version of Crane's composition is now in Munich – for further details see P.G. Konody, *The Art of Walter Crane*, 1902, pp. 93, 99, reproduced on p. 92. Lucy Kemp-Welch's *Sea Horses* of 1896 (now in the Russell-Cotes Art Gallery, Bournemouth) has a very similar composition.

Promises

WAG 2112
Canvas: 67 × 54 cm
Signed: *G.F. Watts 1893*

Promises was painted in the summer of 1892[1] and was presumably finished in 1893; it seems to have been intended as a pendant to *Cupid Asleep* (see p. **498**) and was well received by the critics. Claude Phillips wrote in the *Academy*:[2]

An unwonted freshness and brilliancy of colour, if not a sufficient conciseness either of draughtsmanship or modelling, distinguishes Mr. Watts's Promises. A bright Eros with rainbow-hued wings – too young as yet to be dangerous – is bountifully scattering before

Neptune's Horses WAG 2110

him to invisible lovers masses of fresh, sparkling roses, the pink hue of which makes a charming harmony with his own fair flesh. In this title, Promises, we have a curious instance of the literary element over-stepping its proper boundaries in fine art, though Mr. Watts oversteps with such a tender grace that we wish him almost to sin again. The picture itself is an Eros scattering roses broadcast to an invisible world; it is the name and the name only, that conveys this suggestion of the fallacious, the unstable – of lovers' vows writ in running water – and that lends, by suggestion, a bitter-sweet charm to the whole.

The critic of the *Athenaeum*[3] was also concerned to elucidate the meaning of the composition:

Promises *represents a ruddy infant surrounded by branches laden with roses in full bloom, the type of life's hopes and troubles. A thoughtless public, not* enamoured of allegory, even when it is depicted by artists of the first calibre, will perhaps disregard the emblems of Mr. Watts, and confine its admiration to the chiaroscuro, colour, and beautiful expressions of this charming nudity.

A red chalk drawing for *Promises* was formerly owned by John Russell Taylor[4] and a version apparently differing slightly from the Walker Art Gallery painting was reproduced by Julia Cartwright.[5]

REPR: H. Blackburn, *Academy Notes*, 1893, p. 55; Pall Mall Gazette, *Pictures of 1893*, p. 6; *Royal Academy Pictures*, 1893, p. 55; Black and White, *Handbook to the Royal Academy and the New Gallery*, 1893, p. 92.

PROV: Acquired by the Reverend S.A. Thompson Yates by 1895; bequeathed 1904.

EXH: Royal Academy 1893 (148); Royal Birmingham Society of Artists, *Autumn Exhibition*, 1893 (324); Grafton Gallery, *Fair Children*, 1895 (191).

1 The artist's wife in her MS Catalogue (Watts Gallery, Compton).

2 *Academy*, 6 May 1893, p. 399.

3 *Athenaeum*, 29 April 1893, p. 544.

4 MS Catalogue, *op. cit.*

5 In 'G.F. Watts', *Art Annual*, 1896, p. 24.

Love and Death WAG 2131

Love and Death
WAG 2131
Canvas: 92 × 46.5 cm

The subject was inspired by the death of the eighth Marquess of Lothian in 1870. Love, standing on the threshold of the House of Life, vainly tries to prevent the entry of Death.[1]

The first completed version of 1868–70 is now in the Bristol City Art Gallery, but there is a larger version completed in 1877 in the Whitworth Art Gallery, Manchester.[2] The artist's wife lists a total of twelve versions.[3] According to her,[4] the Walker Art Gallery version dates from 1893 and indeed the artist wrote to James Smith on 13 August 1893 about progress on it: 'I cannot please myself . . . and work upon it most constantly'; the painting was 'nearly finished' in June 1898 and the price was agreed in January 1900.[5]

PROV: Painted for James Smith 1893–1900 (800 guineas);[6] bequeathed 1923.

EXH: Manchester City Art Gallery, *G.F. Watts*, 1905 (30); Liverpool Autumn Exhibition 1922 (29).

1 For the iconography, see particularly Minneapolis Institute of Arts, *Victorian High Renaissance*, 1978, no. 20, pp. 76–8; New Gallery catalogue, *G.F. Watts*, 1896–7, no. 126; Mrs. Russell Barrington, *G.F. Watts: Reminiscences*, 1905, pp. 133–4; G.K. Chesterton, *G.F. Watts*, 1904 (1920 edn, pp. 140–1) – 'it is the great masterpiece of agnosticism'.

2 These dates are taken from Minneapolis Institute of Arts, *op. cit.*, but see also Barrington, *op cit.*, p. 133, and M.S. Watts, *George Frederic Watts: Annals of an Artist's Life*, 1912, vol. 1, p. 283, vol. 2, p. 87.

3 MS Catalogue (Watts Gallery, Compton). The artist wrote to John Reid on 7 December 1899 about these versions; after listing a number of them, including WAG 2131, he went on: 'None of these are exact replicas of the others; generally done for the purpose of experimenting with some changes of colour or arrangement, and all of them

are absolutely my work from beginning to end, as indeed all my pictures are, for I have never had pupils or assistants.' (J.L. Caw, *Catalogue of the Collection of Pictures belonging to John Reid*, 1913, p. 43). These versions have been sold recently: (1) Christie's 25 April 1975, lot 32 (66 × 34.2 cm); (2) Sotheby's (Belgravia), 1 July 1975, lot 85 (53.5 × 27 cm); (3) Sotheby's (Belgravia) 9 March 1976, lot 48 (130 × 70 cm); (4) Sotheby's (Belgravia), 24 October 1978, lot 16 (134 × 77.5 cm); (5) Sotheby's (Belgravia), 9 April 1980, lot 55 (90 × 42 cm); (6) Sotheby Parke Bernet (New York), 28 October 1982, lot 88 (251.5 × 117.5 cm).

4 MS Catalogue, *op. cit.*

5 Letters from the artist to James Smith of 13 August 1893, 19 June 1898, 3 and 14 January 1900 (MS Watts Gallery, Compton).

6 See note 5; Smith wrote in his Catalogue (MS Walker Art Gallery):

This subject first drew my attention to Mr. Watts's work. It so seized me that I lost no opportunity of seeing his work. It gave me a new interest in life and a desire to possess some of his work. I came to know and honour him; telling him one day of this, he voluntarily said he would paint me a replica of the picture. This is it.

Watts's 'voluntary' offer did not prevent him charging Smith 800 guineas for the replica. For James Smith as a patron, see Edward Morris, 'James Smith of Liverpool and Auguste Rodin', *Patronage and Practice*, ed. P. Curtis (Tate Gallery, Liverpool), 1989, pp. 67 ff.

Love and Life
WAG 2132
Canvas[1]: 66.5 × 37.5 cm

Love in the form of an angel is protectively guiding the fragile figure of Life up the rugged pathway from the baser existence to the higher region of thought and character.[2] The first version of this composition probably dates from 1882–4 and was formerly in the Smithsonian Institution, Washington, D.C.[3] Other versions – including large paintings in the Musée d'Orsay, Paris, and the Tate Gallery – are listed by the artist's wife.[4] The Walker Art Gallery version was commissioned by James

Smith in 1894, not begun before October 1895, but offered definitely to Smith in December 1895; it was finally completed in January 1904 and thus was among the artist's last works.[5] It differs slightly from earlier versions in that the angel's wings enclose and enfold the figure of Life more comprehensively than in the paintings of the 1880s.

PROV: Commissioned from the artist by James Smith 1894, but not finally delivered to Smith until January 1904;[6] bequeathed 1923.

EXH: Liverpool Autumn Exhibition 1922 (19).

1 Winsor and Newton canvas stamp.

Love and Life WAG 2132

2 For the iconography, see Minneapolis Institute of Arts, *Victorian High Renaissance*, 1978, no. 30 and M.S. Watts, *George Frederic Watts: Annals of an Artist's Life*, 1912, vol. 2, pp. 234–5.

3 Apparently sold at Sotheby's (New York) 21 May 1987, lot 164, and again at Sotheby's (London) 19 June 1991, lot 237.

4 MS Catalogue (Watts Gallery, Compton); a version, stated to have been in the 1889 *Exposition Universelle*, Paris, was sold at Sotheby's (New York) 26 October 1983, lot 101 (144.5 × 57.3 cm) and another version was sold at Sotheby's (Belgravia) 19 March 1979, lot 30 (115 × 75 cm).

5 Letters from the artist to James Smith of 1 December 1894, 26 October and 9 December 1895 – 'I will have the Love and Life at your disposal (not compromising you)' – 15 and 21 January 1904.

6 See note 5.

Miss Lilian MacIntosh WAG 2109

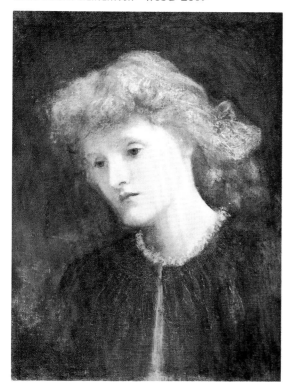

Miss Lilian MacIntosh
WAG 2109
Canvas: 49.5 × 38 cm

The sitter (*c*.1879–1972) came under the guardianship of the artist and his wife after her father's death around 1889;[1] she married Michael Chapman. This portrait dates from 1895.[2] Many other portraits of her by Watts exist; a distantly related but undated sketch (about 51 × 41 cm) is in the Watts Gallery, Compton, which also has a large three-quarters length finished portrait of her dating from 1904 (152.5 × 101.5 cm);[3] a portrait of 1897 (75 × 62 cm) was formerly owned by the sitter[4] and an oil sketch of about 1900 was sold at Sotheby's (Belgravia) 23 March 1981, lot 82 (142 × 82 cm); there is also a pencil drawing (14 × 11.5 cm) formerly owned by Andrew Hichens.[5]

PROV: Bought from the artist by James Smith 1898;[6] bequeathed 1923.

1 Wilfrid Blunt, *England's Michelangelo*, 1975, p. 210. For further details about her, see M.S. Watts, *George Frederic Watts: Annals of an Artist's Life*, 1912, vol. 2, pp. 208–9.

2 The artist's wife in her MS Catalogue (Watts Gallery, Compton).

3 See M.S. Watts, 1912, *op. cit.*, vol. 2, p. 314.

4 Exhibited at the Royal Academy, *Winter Exhibition*, 1905 (222) as lent by the artist's executors.

5 Exhibited at the Royal Academy 1905, *Winter Exhibition* (116).

6 James Smith's Catalogue (MS Walker Art Gallery).

WEBB, E.W. (active *c*.1840–*c*.1850)
A Brown Thoroughbred in a Landscape
WAG 2361
Canvas: 47 × 61.5 cm
Signed: *E.W. Webb Lemington 1845* (?)

E.W. Webb exhibited pictures (including one sporting painting) in 1850 at the Royal Acad-

emy and at the British Institution from an address at Thistle Grove. Two paintings, *Following the Scent* and *The Kill*, both signed by him and inscribed *Leamington Spa*, were sold at Christie's 27 June 1980, lots 39 and 40. He should not be confused with William Webb, another sporting artist, who was born at Tamworth in about 1780 and died at Melton Mowbray in about 1845.[1]

PROV: Walter Stone[2] bequeathed by Miss Mary Stone 1944.

1 See Judy Egerton, *The Paul Mellon Collection: British Sporting and Animal Paintings*, 1978, p. 234.

2 *The Walter Stone Collection of Sporting Pictures at Whitton Hall, Westbury, Shropshire*, 1938, no. 57.

WEBB, James (1825–1895)
Bamburgh Castle
WAG 2968
Canvas: 122.5 × 184.8 cm
Signed: *James Webb*

The artist seems to have been fond of this subject. He exhibited views of Bamburgh at the 1858 Royal Society of British Artists exhibition (129) – possibly the Walker Art Gallery painting[1] – and at the 1875 Royal

Academy exhibition (259). The 1875 painting seems to have been owned by Bernard Bivall in 1968;[2] its composition is not related to that of the Walker Art Gallery painting. A view of Bamburgh Castle by Webb of 1862 is in the Bristol City Art Gallery and yet another undated view (76.2 × 126.9 cm) was sold at Christie's 26 April 1974, lot 13 – these two paintings are again quite different from the Walker Art Gallery picture, of which, however, a small version was purchased by A.M. Greenslade[3] from Sotheby's 11 January 1967, lot 185 (25.5 × 38.1 cm). This small version is not identical to the Walker Art Gallery picture – in particular, in the former the castle keep is much more accurately represented and there are more ships at the extreme left – but the two compositions are generally very similar. A *Bamburgh Castle* by Webb dated 1863 was in the J. Burton and Sons sale, Christie's 20 May 1882, lot 91, bought Vokins (£105) and the same picture may also have been in the J.G. Marshall sale, Christie's 26 February 1881, lot 118, bought Southgate (£141.15s.).

The Walker Art Gallery painting is certainly not a very accurate view of the castle; the height of the castle above the sea is exaggerated – the whole building being in fact lower and more elongated – and the central keep is in reality much lower and more squat.[4] The purpose behind the painting may have been symbolic rather than representational. Thanks

505

Bamburgh Castle WAG 2968

to money provided by Lord Crewe's estates, the castle had served as a major lifeboat and coastguard station from a very early date,[5] the sea around the castle being exceptionally dangerous. The loss of the *Forfarshire* and the celebrated rescue of some of her passengers and crew by Grace Darling in 1838 had occurred only a few miles from Bamburgh, where the heroine was eventually buried. Here Webb has painted the brightly lit castle rising above the stormy dark sea with a dismasted ship beneath the castle and sailors struggling against the waves in the foreground as if to emphasize the castle's life-saving role for seamen in the area.

PROV: Presented by C. Chaloner Smith 1874.[6]

EXH: (?) Royal Society of British Artists 1858 (129).

1　This 1858 painting is not described in the review of the Royal Society of British Artists exhibition published in the *Art Journal*, 1858, pp. 141–2.

2　Advertisement in *Connoisseur*, August 1968, noting that the painting was dated 1874.

3　Letters from A.M. Greenslade of April and 8 May 1970.

4　N. Pevsner, *The Buildings of England: Northumberland*, 1957, plate 36, shows the same view as WAG 2968.

5　See W.S. Gibson, *Dilston Hall and a Visit to Bamburgh Castle*, 1850, pp. 175–218.

6　There is an Arthur Tooth label on the back of WAG 2968.

WEIR, William
(active *c*.1855–1865, died 1865)
The Blind Fiddler
WAG 1333
Panel: 57.3 × 78.7 cm
Signed: *W WEIR 1864* (?)

This is a copy after David Wilkie's 1806 painting with the same title, now in the Tate Gallery.

PROV: Presented by Edward Samuelson 1886.

WHAITE, Henry Clarence (1828–1912)
The Bard
WAG 1484
Canvas: 46 × 61 cm
Signed: *H. Clarence Whaite*

The Bard
WAG 1484

507

The artist spent much of his life in North Wales; he owned a house near Conway, where he died, and he was the first President of the Royal Cambrian Academy at Conway from 1885 until his death. This very informal representation of a Welsh bard in communion with nature presumably reflects the influence of Welsh culture on him.

PROV: Purchased from the artist 1907.

EXH: Liverpool Autumn Exhibition 1907 (1180).

The Heart of Snowdon
WAG 2969
Canvas: 142.2 × 173.3 cm
Signed: *H. Clarence Whaite*

This is one of the most powerful of Whaite's imaginative evocations of the grandeur of mountain scenery – often, as here, based on the Snowdon range.[1]

PROV: Presented by Harold Rathbone on behalf of a group of subscribers.

EXH: Liverpool Autumn Exhibition 1907 (58); Manchester City Art Gallery, *Pictures and Watercolours by H. Clarence Whaite, Anderson Hague, Frederick W. Jackson and Tom Mostyn*, 1908 (61).

1 There is an analysis of a much earlier painting by Whaite of this type in Arts Council of Great Britain, *Great Victorian Pictures*, 1978, p. 89. See also the obituary of Whaite in the *Manchester Guardian*, 6 June 1912:

From nature to Turner and from Turner back to nature through year after year – here is the secret of his art . . . Mr. Whaite's art has – what much later landscape painting has lacked – conspicuous qualities of design, and he loved to present his landscapes under some striking if not unusual condition of light and colour. Many recent landscape painters have been content to reproduce the effect of ordinary light on some commonplace fragment of landscape, and with little more of art than is implied in the mere representation . . . If we asked ourselves why many of Mr. Whaite's works will not rank as masterpieces we should perhaps reply that he sometimes attempted more than art could compass, that he endeavoured to express in one picture so much thought and emotion that its unity was endangered if not destroyed . . . But his failures were better than many men's successes . . .

Eel Bucks at Goring WAG 2971

WILLIAMS, Alfred Walter 1824–1905
Eel Bucks at Goring
WAG 2971
Canvas[1]: 127.5 × 101.5 cm
Signed: *AWW 1844* ? (in monogram)

Williams exhibited a number of paintings of eel traps along the upper Thames in 1844–6.[2]

PROV: Presented by the Melly family[3] 1944.

1 Canvas stamp: Prepared by Charles Roberson, Long Acre, London; stencil CR/1239.

2 See Jan Reynolds, *The Williams Family of Painters*, 1975, p. 149.

3 WAG 2971 was part of the decoration of the Melly drawing room established at the family home, 90 Chatham Street, Liverpool by George Melly and his wife Sarah Bright between about 1852 and 1886. Melly was Liberal Member of Parliament for Stoke on Trent 1868–74 and was notable for his philanthropic work in Liverpool.

Opposite:
The Heart of Snowdon WAG 2969

WILLIAMS, John Haynes (1836–1908)
The Ancestor on the Tapestry
WAG 2970
Canvas: 92 × 155.5 cm
Signed: *Haynes Williams 1876*

The artist's own explanation[1] of this painting stated: 'A young Spaniard, heir to a great name and large estates, is walking down a tapestried room with his mother and lady attendant when an old servant, or steward, of the family points out an ancestor on the tapestry.' The mother is wearing a mantilla and in the background appears a Spanish cabinet or *bargueno* to indicate the Spanish setting. The artist was in southern Spain from 1862 to 1864 for 'the study of Spanish life and character', and often returned there in order to begin paintings of Spanish subjects which he later

finished in London for exhibition.[2] As W.W. Fenn pointed out, the artist is here re-creating an 18th-century scene from his imagination rather than just depicting contemporary Spain.[3]

The critic of the *Academy*[4] merely described Williams's painting, but the *Architect*[5] was severe:

Among good pictures in the genre *of history should have been included* In the King's Cause, *by S. LUCAS, and a more trivial but pretty subject, by HAYNES WILLIAMS, the* Ancestor on the Tapestry. *In fact, the number of artists who can do the demi-semi-historical by dint of a fair stock of properties and a good knack at drawing and posing the figure on a moderate scale is becoming extensive – too extensive, the public being lightly satisfied with such half-way work.*

Perhaps the most interesting review was published by the Liverpool periodical, the *Porcupine*,[6] shortly after the painting had been acquired by the Walker Art Gallery:

The Committee, by the purchase of this truly noble work, have conferred an inestimable blessing upon the community. Stagnation in this short life is quite impossible; we are all momentarily becoming either better or worse citizens, and it is equally impossible for even the dullest perception to see this exquisitely tender representation of refined life without being raised a little in the scale of humanity.

A smaller version attributed to G.G. Kilburne was sold at Sotheby's (Belgravia) 6 December 1977, lot 114 (67.5 × 113 cm).

REPR: H. Blackburn, *Academy Notes*, 1876, p. 55; F. Wedmore, 'The Work of Haynes Williams', *Art Journal*, 1894, p. 289.

PROV: Purchased from the artist 1876 (£350).

EXH: Royal Academy 1876 (574); Liverpool Autumn Exhibition 1876 (24).

1 H. Blackburn, *Academy Notes*, 1876, p. 54.

2 MS letter from the artist to the Curator of the Walker Art Gallery, 21 February 1878. See also F. Wedmore, 'The Work of Haynes Williams', *Art Journal*, 1894, pp. 289–93 and W.W. Fenn, 'Haynes Williams', *Magazine of Art*, 1881, pp. 484–8.

The Ancestor on the Tapestry WAG 2970

3 Fenn, *op. cit.*, p. 487.

4 *Academy*, 1 April 1876, p. 319.

5 *Architect*, 27 May 1876, p. 340.

6 *Porcupine*, 16 September 1876, p. 394.

WILLIAMS, Terrick John (1860–1936)
Evening, Concarneau
WAG 4434
Canvas: 76.2 × 96.5 cm
Signed: *Terrick Williams 1901*

This seems to be one of the first of a large number of Concarneau scenes painted by the artist in 1901–13.[1]

PROV: Alfred Booth;[2] presented by Mrs. H. Whitting 1960.

EXH: Royal Academy 1902 (415); Liverpool Autumn Exhibition 1902 (221); (?) Walker Art Gallery, Liverpool, *Historical Exhibition of Liverpool Art*, 1908 (620).

1 His first visit to Brittany seems to have been in 1898; see Caroline Simon, *The Art and Life of Terrick Williams*, 1984, p. 65, and the lists of his exhibits at the Royal Academy and the Royal Society of British Artists exhibitions 1884–1913. There were many Concarneau scenes at the Terrick Williams *Memorial Exhibition* held at the Fine Art Society in 1937. For Concarneau as a sketching ground, see M. Jacobs, *The Good and Simple Life*, 1985, pp. 64 ff.

2 Alfred Booth lent *Evening, Concarneau* by Williams, $27\frac{1}{2}$ × 35 in., to the 1908 Walker Art Gallery, *Historical Exhibition of Liverpool Art* (see Exhibited); the *Evening, Concarneau* (221) at the 1902 Liverpool Autumn Exhibition (see Exhibited) was sold from that exhibition for £40 to an unknown purchaser.

Festa Notturna, Venice
WAG 2273
Canvas[1]: 92 × 127.5 cm
Signed: *Terrick Williams*

The church is Santa Maria della Salute seen from the opposite bank of the Grand Canal. *Festa Notturna, Venice* was painted in 1925–6,[2] and in 1925 A.L. Baldry[3] wrote of Terrick Williams's art: 'It is characteristic of him that in the majority of cases he chooses aspects of nature which present particular difficulties to the painter, effects of twilight or sunshine, elusive combinations of colour, subtleties of

Evening, Concarneau
WAG 4434

Festa Notturna, Venice WAG 2273

aerial tone, which demand exceptional sensitiveness of observation.'

A sketch for this composition, dated 1925 and apparently exhibited at the Royal Academy in 1934 (524), was sold at Sotheby's (Billingshurst) 24 May 1988, lot 355 (25.5 × 40 cm).

REPR: *Royal Academy Illustrated*, 1926, p. 42; Liverpool Autumn Exhibition catalogue, 1926, p. 18.

PROV: Presented by George Audley 1926.

EXH: Royal Academy 1926 (200); Liverpool Autumn Exhibition 1926 (936).

1 Canvas stamp: Roberson and Co., 88 Long Acre.

2 Inscription on the back of the canvas.

3 A.L. Baldry, 'The Work of Mr. Terrick Williams', *Studio*, 1925, vol. 90, p. 115.

WILLIAMS, William Oliver
(active 1851–1863)

At the Well
WAG 461
Canvas: 59 × 41.5 cm

Despite its traditional title this painting might have been *Crossing the Ford*, which the artist exhibited at the 1863 Royal Academy (582) or *A Welsh Girl*,[1] shown by him at the 1861 Liverpool Academy (12). The artist seems to have been trained in Birmingham but to have specialized in Welsh scenes.

PROV: Bequeathed by John Elliot 1917.

1 Christine Stevens, letter to the compiler, 18 August 1994, writes: 'There is nothing immediately identifiable as Welsh dress in the painting, although I believe that it could just be an artist's extremely romanticized version of Welsh rural dress.'

512

Landscape with Haymakers WAG 2964

WIMPERIS, Edmund Monson[1]
(1835–1900)
Landscape with Haymakers
WAG 2964
Canvas: 61 × 94.2 cm
Signed: *E.M. Wimperis 91*

PROV: Robert Mason of Wavertree, Liverpool. Presented by J.H. Day 1939.

1 His second Christian name is often listed as Morison.

At the Well WAG 461

513

The Admonition WAG 2965

WOODS, Henry (1846–1921)
The Admonition
WAG 2965
Canvas: 92.7 × 115.5 cm
Signed: *Henry Woods Venice 1907*

Woods may have known J.D. Linton's *The Admonition* (1883) in which a young woman and a prince are admonished by a bishop in front of a poet and a fool within a grand 16th-century interior.[1]

PROV: Purchased from the artist 1907 (£300).[2]

EXH: Royal Academy 1907 (248); Liverpool Autumn Exhibition 1907 (738).

514

1 Reproduced in the *Magazine of Art*, 1883, p. 375. WAG 2965 may have been conceived as a Neo-Venetian parody of Linton's enigmatic watercolour. Woods seems to have been the only British member of the Neo-Venetian school of the 1880s to continue painting the subjects favoured by this school well into the 20th century – see James Greig, 'Henry Woods', *Art Annual*, 1915; WAG 2965 is reproduced on p. 12; Woods lived in Venice from about 1880 until 1915; William Logsdail painted a few Venetian scenes after 1900, but Luke Fildes did hardly any after 1890.

2 This was one of the purchases denounced by Frank Rutter in *The Sport of Civic Life*, ed. Sharpe, 1909, p. 10.

WOODVILLE, Richard Caton
(1856–1927)

Maiwand 1880: Saving the Guns

WAG 140
Canvas: 133 × 199 cm
Signed: *R. Caton Woodville 1882*

Towards the end of the Second Afghan War (1878–81) a British brigade under Brigadier-General G.R.S. Burrows was decisively defeated by an Afghan force commanded by the Sirdar Ayub Khan, a younger son of Shere Ali, Amir of Afghanistan 1863–6 and 1869–79; the engagement took place on 27 July 1880 near Maiwand, only about forty-five miles from the well-fortified British base at Kandahar. In this painting the men of E/B Battery, Royal Horse Artillery, are bringing their guns out of the action just ahead of the pursuing Afghans; their commander at this time was Captain J.R. Slade, Major G.F. Blackwood having been wounded in the battle; these four guns eventually reached Kandahar safely, although two others were abandoned on the battlefield; in all, the British lost about one thousand men killed.[1]

Royal Horse Artillery Saving their Guns at the Battle of Maiwand by James Prinsep Beadle (oil on canvas) of 1893 is at the National Army Museum, while yet another painting of the saving of the guns at Maiwand was exhibited at the Raymond Groom Gallery (46 Pall Mall) in 1893; it was by Godfrey Douglas Giles, who was apparently at the action in 1880.[2] A watercolour by Ernest Crofts of about 1880, *Sergeant Patrick Mullane Helping to Save the Guns, Maiwand, 1880*, is in the Anne S.K. Brown Collection, Brown University Library, Providence, Rhode Island.

At the 1881 Royal Academy, Woodville exhibited *Candahar: The 92nd Highlanders and 2nd Goorkhas storming Gaudi Mullah Sahibdad*; this presumably depicted the attack on Baba Wali Kotal during the Battle of Kandahar of 1 September 1880.[3] Woodville also contributed to the *Illustrated London News* a number of illustrations depicting the Afghanistan Campaign of 1880; for example, *The War in Afghanistan: Battery of Horse Artillery: Detach-*

Maiwand 1880: Saving the Guns WAG 140 (colour plate 16)

ment of the *66th Regiment on the March* appeared with his signature on 7 August 1880 (pp. 144–5) and on 14 August 1880 (p. 153) there was his *The Afghan War: Guns crossing the Khojak Pass on the Road to Candahar from a Sketch by Brigadier General Fane.*

Maiwand 1880: Saving the Guns was painted 'with a smashed ankle, with an open wound right through it, seated sideways on a dining-table, my leg extended and my body turned to the left, in an excruciatingly tiring position'.[4] There is a drawing for the wounded British horseman on the right of the painting.[5]

Woodville's picture was well reviewed when first exhibited at the Royal Academy – it was felt that a British defeat had been portrayed with considerable realism; *The Times*[6] wrote:

Mr. Caton Woodville's picture of 'Maiwand: Saving the Guns' is a work of another and far finer stamp, though it is hardly likely ever to attain the popularity which has attended Mrs. Butler's painting. There is a good reason for this, as Mr. Woodville is anything but a sentimentalist and his work is far too true to the real facts of the case to be thoroughly pleasant. There are some things that people do not like to be told or shown, and this painter's rendering of the war is as stern and uncompromising as speech from John Knox or criticism from Ruskin. Mr. Woodville was a special artist of the 'Graphic' in the war of which he here depicts one incident, and his picture has upon it the ineffaceable stamp of reality. He has selected the moment when the retreat is fast becoming a flight, and the guns and those saving them are tearing across the picture at full speed. The composition is full of magnificent pieces of expression, of which, perhaps, the finest is that of the near-side driver, whose hands and limbs are mechanically urging his horse to its fullest speed, while his whole energy of mind is concentrated on the dangers ahead. Very fine, too, is the look of responsibility and decision in the officer's face, as he turns in his saddle to give an order to someone in the rear. The part of this picture, however, which constitutes its greatest merit, and which places it in a category by itself among the battle pictures of the Academy, is the intense grasp of the situation which the painter has evidently possessed. Each incident of the flight, vividly as it is rendered, is swept into unity with the main impression, and the manner in which the clearest personality of each actor in the scene exists in due relation to its main spirit, and helps, instead of frittering away the main impression, is one of the greatest triumphs we know of in battle painting. It is much to get a picture which shows us such a scene as it was, with every

detail both of life and death worked out conscientiously and successfully; but it is much more to get a picture which has power to reproduce for us, not only the individual emotions and incidents of the day, but also the general atmosphere of daring and endurance which alone could give reality to the whole.

Despite, however, representing a British defeat with considerable accuracy, Woodville's painting still has the flamboyant militarism characteristic of colonial battle scenes of the 1880s and 1890s – so different in mood from the sober realism of most Crimean War battle painting earlier in the century.[7]

REPR: H. Blackburn, *Academy Notes*, 1882, p. 52; photo-aquatint (Goupil and Co.).

PROV: Purchased from the artist 1882 (£450).

EXH: Royal Academy 1882 (567); Liverpool Autumn Exhibition 1882 (74).

1 T.A. Heathcote, *The Afghan Wars*, 1980, pp. 148 ff. More detailed accounts of the Battle of Maiwand are in Leigh Maxwell, *My God – Maiwand*, 1979, and in B.P. Hughes, *Honour Titles of the Royal Artillery*, c.1976, pp. 153–9, which quotes Slade's own account of the event.

2 *The Times*, 8 May 1893. The painting is reproduced in Hughes, *op. cit.*, p. 154 and in Maxwell, *op. cit.*, p. 103; it is not now in the Royal Artillery Institution as was stated by Maxwell, *op. cit.*, p. x (Brigadier R.J. Lewendon, letter to the compiler, 20 January 1986); a key plate identifying the soldiers in Giles's painting is in the regimental scrap-books of the National Army Museum. Giles is not listed as a participant in the battle by Maxwell, *op. cit.* Elizabeth Butler's *Rescue of Wounded: Afghanistan* (1905), now owned by the Army Staff College, probably depicts the rescue of wounded gunners during the British retreat after Maiwand (see National Army Museum, *Lady Butler*, 1987, p. 132, no. 90). For all the paintings and illustrations of Maiwand see particularly Peter Harrington, *British Artists and War*, 1993, pp. 201–3, who also mentions a painting by James Magnus showing the saving of the guns.

3 This painting is reproduced in Heathcote, *op. cit.*, pp. 160–1, as the *Battle of Kandahar 1 September 1880*; it was sold at Christie's 29 July 1977, lot 36, and 23 October 1987, lot 100; R. Caton

Woodville, *Random Recollections*, 1914, p. 83, identifies the subject as the second Battle of Kandahar. Woodville's *Cruel to be Kind: Royal Artillery in Afghanistan 1880* of 1882 (oil on canvas) is now in the National Army Museum.

4 Woodville, *op. cit.*, p. 83. Woodville's disability while painting WAG 140 is also noted by G.P. Jacomb-Hood in his *With Brush and Pencil*, 1925, p. 111, but he refers to the artist being in bed with a broken leg and misdescribes the painting.

5 Witt Library reproduction from an unidentified source.

6 *The Times*, 3 June 1882. The assertion that Woodville was a special artist of the *Graphic* does not seem to have been accurate; he contributed drawings for reproduction in the *Illustrated London News* relating the wars in Afghanistan, but there is no evidence (at least in his *Random Recollections*, 1914) that he was actually in Afghanistan at the time. The reviews of WAG 140 in the *Spectator*, 1 July 1882, p. 863, and in the *Art Journal*, 1882, p. 212, deplored the fact that the painting recorded a defeat rather than a victory. The *Athenaeum*, 27 May 1882, p. 672, commented on the 'delineation of hideous wounds' and on the 'ugliness of the horses'; WAG 140 was thought the equal of Mrs. Butler's battle paintings but inferior to those of many French artists.

7 See M.P. Lalumia, *Realism and Politics in Victorian Art of the Crimean War*, 1984, p. 148. The same is true of Woodville's Omdurman battle scene catalogued below.

The Charge of the 21st Lancers at the Battle of Omdurman 1898

WAG 152
Canvas: 153.4 × 245.8 cm
Signed: *R. Caton Woodville 1898*

The Battle of Omdurman, 2 September 1898, in which a British army under Kitchener routed the forces of the Khalifa Abd Allahi, effectively terminated the Sudan campaign of 1896–8 and gave Britain once more control of the Sudan, control which had been lost with the death of General Gordon in 1885. The Charge of the 21st Lancers was never explicitly ordered by Kitchener. In it the regiment was attempting to cut off a large group of the Khalifa's men from Omdurman at the end of the first phase of the battle. The group was much larger than was realized and during the charge the Lancers were ambushed by about two thousand of the Khalifa's men hidden in a wide, deep, dry river bed (about twenty feet broad and six feet deep) into which the Lancers rode; they lost seventy men dead and wounded, together with 119 horses; the Khalifa's forces, under Osman Digna, only suffered losses of about thirty, or perhaps sixty, men. Frank McCombie[1] has written:

Of the many isolated incidents recorded of the battle, the charge of the Lancers drew most attention. It was costly and could have been avoided, and its tactical value was minimal. It appealed to the public, however, as the only incident in which the British gave fair play to their gallant opponents. Here 320 men fought against odds of at least 7 to 1, and held the field. Elsewhere it was, in the kindest view, more a matter of mass-extermination at long range. The British public – more fair-minded than it has often been allowed – felt an acute embarrassment about Omdurman, and seized upon the charge of the Lancers as the one incident about which they could feel some pride: rightly or wrongly.

Artists also concentrated on the charge for pictorial effect as well as for moral reasons and thus the least successful part of the battle – from the British point of view – received the most coverage.[2]

Woodville's painting presumably depicts the clash between the Lancers and the Khalifa's riflemen who were posted just in front of the river bed; Zulfo[3] records the presence of a few mounted emirs among the Khalifa's forces.

A key plate was produced to accompany the engraving of the painting (published by Thomas McLean in 1899) and from it the figures can be identified; from left to right Corporal Swarbrick is impaling one of the Khalifa's men on the ground with his lance; Captain Kenna is brandishing his sword in the air; the head immediately to the right of Captain Kenna is unidentified but the next head to the right is that of Private Pedder; beneath Private Pedder and just to the right of him Lieutenant Grenfell has been wounded and is falling backwards; Rough-Riding Sergeant-Major Hutton is trying to support Lieutenant Grenfell with one hand on the lieutenant's head; the soldier wearing a helmet and just to

The Charge of the 21st Lancers at the Battle of Omdurman 1898 WAG 152

the right of Sergeant-Major Hutton is Private Brown, whose horse's head is rearing upwards; to the right of him and conspicuously grasping his lance is Private Byrne; Lieutenant De Montmorency is the figure on the white horse about to engage the mounted emir; Sergeant Hicks is just visible behind and to the right of him; the mounted emir is described as the 'Dervish Chief in Command'; to the right of him with his sword held behind his head is Trumpet-Major Knight; Colonel Martin is leading the charge on the extreme right pointing forwards but looking backwards. In fact, few of these soldiers can ever have been as close to each other as their positions in the painting suggest. Woodville has arbitrarily gathered together those who eventually received awards for gallantry. Furthermore, Kenna never waved his sword; he used his pistol; De Montmorency rode one of his polo ponies not a large charger. Not only officers but also other ranks are well represented in Woodville's painting – reflecting the 'democratic' trend in battle painting during the late 19th century.

Although Woodville was the first artist to exhibit a painting of the charge, a considerable number of other paintings and illustrations were made:

1 *21st Lancers – 'Charge'* by Adrian Jones (1899), oil on canvas, 60 × 120 in., now in the 17th/21st Lancers Museum at Belvoir Castle, Leicestershire.[4]

2 *The 21st (Empress of India's) Lancers at Omdurman* by W.B. Wollen (1899), oil on canvas, 46 × 72 in.[5]

3 *Charge of the 21st Lancers at Omdurman* by G.D. Rowlandson (1898), oil on canvas, now in the 17th/21st Lancers Museum at Belvoir Castle.[6]

4 *Charge of the 21st Lancers at Omdurman* by Allen Stewart, oil on canvas, now in the Cavalry and Guards Club, Piccadilly, on loan from the 17th/21st Lancers Museum; it was apparently no. 623 at the 1900 Royal Academy exhibition.

5 *Charge of the 21st Lancers at Omdurman* by Edward Matthew Hale (1899), oil on

canvas, now in the National Army Museum.

6 Illustrations by John Charlton published in the *Graphic*, 24 September and 1 October 1898, pp. 403 and 437 – stated to be based on sketches provided by eye witnesses. Illustrations by Woodville in the *Illustrated London News* for example, 1 October 1898, pp. 482–3, do not show the charge itself.

7 *Charge of the 21st Lancers at Omdurman* by Stanley Berkeley (1898), photo-engraving by Franz Hanfstaengl for Henry Graves and Son, 1898.

8 *Charge of the 21st Lancers*, a chromolithograph after A. Sutherland, published by G.W. Bacon and Co., 1898.[7]

9 *Charge of the 21st Lancers at Omdurman* by Robert Hillingford (engraved for Brooks and Sons, 1898).

These paintings and illustrations generally portray a traditional cavalry charge rather than the less dignified sharp descent into the river bed, although Woodville's *Charge* and the paintings by Rowlandson and Hale give some idea of the actual ambush. However, the former omits the packed ranks of the Khalifa's men who, at certain points, stood twelve to fifteen deep. Woodville's watercolour sketch at the Brown University Library, Providence, Rhode Island (Anne S.K. Brown Collection) – entitled *21st Lancers at Omdurman 1898* and showing just one trooper – is not related to the Walker Art Gallery painting.

Caton Woodville's *Gordon's Memorial Service at his Ruined Palace in Khartoum the Day after the Battle of Omdurman* of 1899 is now in the Royal Collection,[8] and Robert Talbot Kelly's *Flight of the Khalifa after his Defeat at the Battle of Omdurman* is in the Walker Art Gallery.[9]

The critic of the *Athenaeum*[10] provided this review of Woodville's painting when it was exhibited at McLean's Gallery in 1898:

In the same gallery [McLean's, the Haymarket] may be seen Mr. R. Caton Woodville's Charge of the 21st Lancers at Omdurman, *a large picture, containing many figures and fiery incidents, which is to be engraved, prints from it being published. The deeds of the central squadron on that memorable occasion*

afford the painter an occasion for displaying his skill as a battle painter. The design is energetic, while there is little or no exaggeration of the furies of a battle, and there are signs throughout the work that Mr. Woodville has expended upon his figures much more than the care which in a London exhibition ordinarily suffices for a popular battle piece. At first sight the picture strikes us as lacking concentration of all sorts, i.e., of gesture, effect, and, above all, coloration. Apart from this it is nearly all that, judging by its own standard, we could wish for. Some interesting points attract us, especially the figure of the stalwart desert warrior in the middle of the fight, who is clad in armour that may have belonged to a member of the luckless host of St. Louis, but is perhaps a little too late for the date of the last of the Crusades. The quaint drums of the desert children, the cross-hilted swords, and the almost useless buckles are worth noting.

REPR: A photo-engraving apparently by J. Bishop Pratt should have been published by Thomas McLean on 2 September 1899 (the anniversary of the battle), but in fact appeared later in the year.[11]

PROV: Thomas McLean; presented by Sir Alfred L. Jones 1901.

EXH: McLean's, Haymarket 1898; Whitechapel Art Gallery, *Spring Exhibition*, 1901 (39).

1 Frank McCombie, letter to the compiler, 10 February 1986. Mr. McCombie has provided much extra information for which the compiler is most grateful.

2 For the Charge, see in particular, W.S. Churchill, *The River War*, 1899, vol. 2, pp. 130 ff.; Randolph Churchill, *Winston S. Churchill*, 1966, vol. 1, pp. 414 ff., P. Ziegler, *Omdurman*, 1973, pp. 144 ff. and Ismat Hasan Zulfo, *Karari*, 1980, pp. 192 ff. Woodville may have actually used the account published by G.W. Stevens in his *With Kitchener to Khartum*, 1898, pp. 271–95.

3 Zulfo, *op. cit.*, p. 197. Some of the Khalifa's horsemen appear in contemporary illustrations published in the *Graphic* and *Illustrated London News* during September 1898; they do not have the fantastic armour depicted in WAG 152. McCombie, *op. cit.*, states, however, that there was an emir dressed in ancient chain-mail (though not in the complete panoply shown in WAG 152); he was attacked by Lieutenant Wormald (attached from the 7th Hussars) and was eventually killed by a trooper who drove his lance through him.

Woodville of course did not see the battle – nor any other battle, it seems; a cine camera was available during the conflict – for the first time during a major engagement – but it certainly did not record the Charge of the 21st Lancers, and in any event photography was subject to censorship; for all these points, see J.O. Springhall, 'Up Guards and at them' in *Imperialism and Popular Culture*, ed. J.M. Mackenzie, 1986, pp. 58–9.

4 Reproduced in Liverpool Autumn Exhibition catalogue, 1899, p. 118.

5 Reproduced in *Royal Academy Pictures*, 1899, p. 15.

6 Reproduced in the *Belvoir Castle Guide*, 1974, p. 5.

7 See Peter Harrington, *Catalogue to the Anne S.K. Brown Military Collection, Vol. 1: the British Prints, Drawings and Watercolours*, 1987, no. 293c, p. 77. The regimental scrap-books at the National Army Museum also contain reproductions of illustrations by other artists of the Charge of the 21st Lancers. For paintings of the charge, see particularly, Peter Harrington, *British Artists and War*, 1993, pp. 264–9; Harrington lists some representations of the charge by minor artists not listed here and reproduces many of the paintings.

8 See R. Caton Woodville, *Random Recollections*, 1914, p. 78. This painting was commissioned by Queen Victoria, no doubt partly for political reasons.

9 Walker Art Gallery, Liverpool, *Merseyside: Painters, People and Places*, 1978, pp. 134–5.

10 *Athenaeum*, 24 December 1898, p. 905. Lieutenant De Montmorency also went to see it at McLean's Gallery with his mother and two sisters; he recorded in his diary for 17 January 1899: 'saw Caton Woodville's picture of our charge at 7 Haymarket', but added no further comment (McCombie, *op. cit.*).

11 Harrington, *op. cit.*, 1993, p. 266.

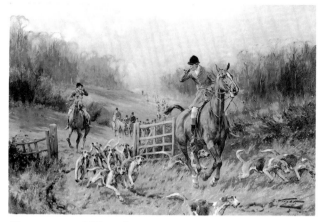

Huntsmen and Hounds going away in Full Cry
WAG 2163

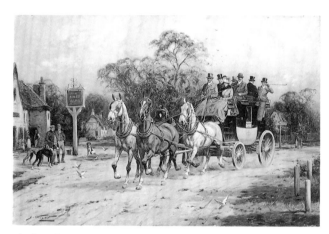

A Coach passing the King's Arms WAG 2316

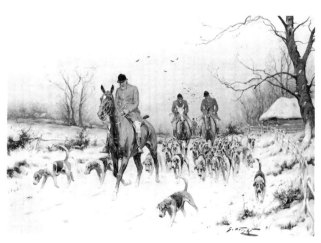

Huntsmen and Hounds returning Home in the Snow WAG 2317

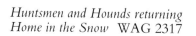

WRIGHT, George (1860–1942)

Huntsmen and Hounds going away in Full Cry

WAG 2163
Canvas[1]: 41 × 61 cm
Signed: *G. Wright*

A Coach passing the King's Arms

WAG 2316
Canvas: 40.8 × 61.3 cm
Signed: *G. Wright*

Huntsmen and Hounds returning Home in the Snow

WAG 2317
Canvas: 25.8 × 36 cm
Signed: *G. Wright*

PROV: Walter Stone;[2] bequeathed by Miss Mary Stone 1944.

1 Canvas stamp: *G. Rowney and Co. / Quality A canvas.*

2 J.G. Ellis, *The Walter Stone Collection*, 1938, pp. 33–4, nos. 61–3.

WYLLIE, William Lionel (1851–1931)

Blessing the Sea

WAG 2378
Canvas: 76.5 × 127.3 cm
Signed: *W.L. Wyllie 1876*

The artist spent the summers of his early life on the French coast around Boulogne[1] and this painting presumably represents one of the ceremonies frequent in that area.[2] Panoramic beach scenes seem common among early works by Wyllie.[3] He exhibited another oil painting entitled *Blessing the Sea* at the Dudley Gallery in 1874[4] and seems to have returned to this subject in 1885 with yet another *Blessing the Sea* (Christie's 13–14 November 1986, lot 35).[5] Wyllie must have known Alphonse Legros's *La bénédiction de la mer* (1872) exhibited at the 1873 Royal Academy; it has, however, a very different composition – although as in Wyllie's painting the priest is a small distant figure; it is now in Sheffield City Art Galleries.

Wyllie's painting was noticed by W.M. Rossetti[6] at the 1876 Royal Academy, although it was very badly hung:

Blessing the Sea WAG 2378

521

W.L. Wyllie, Blessing the Sea; *a crowded bird's-eye view, very like the thing, and very like a Japanese picture of any similar subject matter – a fact which tells equally to the credit of the Japanese and of Mr. Wyllie, who has not been working in any merely imitative spirit, but for the genuine truth of the thing; a capital performance this – unfairly hung, and not the only instance of such Academic malfeasance.*

PROV: Presented by George Audley[7] 1925.

EXH: Royal Academy 1876 (871); Liverpool Autumn Exhibition 1924 (982).

1 R.W. Whitlaw and W.L. Wyllie, *Lionel P. Smythe*, 1923, pp. 57 ff.; M.A. Wyllie, *We were One: A Life of W.L. Wyllie*, 1935, pp. 4 ff.; R. Quarm and J. Wyllie, *W.L. Wyllie*, 1981, pp. 22 ff.

2 Arts Council of Great Britain, *Marine Paintings*, 1965, no. 42, states that studies for WAG 2378 were made at Ambleteuse. One of these studies may be that reproduced as plate 24 in Quarm and Wyllie, *op. cit.*, p. 58; it is now in the National Maritime Museum, Greenwich (D1846, watercolour, 123 × 205 mm). Wyllie's *Landing Fish, Ambleteuse* (1873) was at Sotheby's 22 November 1983, lot 72. Roger Quarm, Letter to the compiler, 29 October 1985, states that there is no firm evidence that WAG 2378 or its related studies were made at Ambleteuse; however, members of the Wyllie family still alive in 1965 may have indicated to the compiler of the Arts Council catalogue that WAG 2378 was based on Ambleteuse.

3 Quarm and Wyllie, *op cit.*, plates 18, 19, 22. In his *Nature's Laws and the Making of Pictures*, 1903, pp. 2 ff., the artist discussed the application of the laws of perspective to these flat panoramic pictures. His father, W.M. Wyllie, also painted beach scenes of this type in the 1870s, see Quarm and Wyllie, *op. cit.*, plate 8.

4 Quarm and Wyllie, *op. cit.*, p. 129.

5 A sketch for the 1885 composition was sold at Christie's 5 October 1984, lot 10, and was subsequently with the Alpine Club Gallery. It is just possible that this 1885 painting might be a repetition of the 1874 Dudley Gallery composition, as by the mid-1880s the artist seems to have lost interest in this type of subject.

6 *Academy*, 13 May 1876, p. 466.

7 M.A. Wyllie, *op. cit.*, p. 32, stated that WAG 2378 was bought in 1876, presumably from the Royal Academy, and subsequently passed through various other collections before it was acquired by Audley; its purchase in 1876 was of considerable importance to the artist as he was in financial difficulties during the 1870s.

Passing of a Great Queen
WAG 128
Canvas: 152.7 × 214.3 cm
Signed: *W.L. Wyllie*

Queen Victoria died at Osborne on the Isle of Wight on 22 January 1901, and her body was taken across the Solent from Cowes to Gosport on 1 February, passing between lines of saluting warships. The artist made the necessary studies for this painting from the flagship, H.M.S. *Majestic*, which just appears on the extreme right with little more than its flag visible;[1] behind it is H.M.S. *Prince George*, then H.M.S. *Mars*; H.M.S. *Hannibal* is just visible behind H.M.S. *Mars*; in the foreground, to the right of centre, is the destroyer H.M.S. *Kestrel* with H.M.S. *Fawn*, another destroyer, immediately behind it; moving further to the left the small royal yacht, *Alberta*, with the Queen's coffin on board, is in front of two more royal yachts, the *Victoria and Albert* and the *Osborne* (with only its masts visible); just to the left of the *Victoria and Albert* and behind it is the German imperial yacht, the *Hohenzollern* (again with only its masts visible); to the left of the *Alberta* and on the far hroizon are first, the *Dom Carlos* (Portugal), the *Hatsuse* (Japan), the *Depuy de Lomé* (France) and the *Nymphe* (Germany); in front of the *Nymphe* and in the left foreground is the destroyer H.M.S. *Vulture*.

Reviews of the painting at the Royal Academy were conventional, praising Wyllie's journalism; the *Magazine of Art*[2] wrote:

This is excellent journalism indeed, sincere, able, convincing, true – it is painted history, with that just admixture of art as does not sacrifice to effect the hard facts of a mighty demonstration. To be sure, Mr. Wyllie has attempted the impossible; we cannot hear the guns nor feel the great choking stillness, but we

Passing of a Great Queen WAG 128

can indeed see the scene that struck the artist's eye, and we bend the head once more in reverent memory.

The *Times*[3] also noted the blend of fact and fantasy in the painting.

Mr. Wyllie has found himself obliged to take some liberties with the facts in his 'Passing of a Great Queen'; the necessities of a moderate-sized canvas have compelled him to bring the ships much closer together than they actually were. But for this permissible manipulation with prosaic fact, we find the picture to be at once truthful and interesting; Mr. Wyllie, indeed, has done well this year, both here and in another work to which we may refer on a later occasion.

There are various pen and ink studies of the event by Wyllie at the National Maritime Museum, Greenwich; one of these is very close to the final version.[4] A pencil and watercolour study was sold at Christie's 16 December 1986, lot 199 (9 × 13⅞ in.).

REPR: An etching by the artist for the Art Union of London, 1901;[5] *Royal Academy Pictures*, 1901, p. 153.

PROV: Purchased from the artist 1901 (£450).

EXH: Royal Academy 1901 (272); Liverpool Autumn Exhibition 1901 (227).

1 M.A. Wyllie, *We were One: A Life of W.L. Wyllie*, 1935, pp. 173–4; Art Union of London, *Description of the Engraving Victoria Victrix*, October 1901; M.A. Wyllie recorded that 'the pathos and dignity of the whole scene affected him greatly and as he sketched the mournful pageant a lump came into his throat'.

2 *Magazine of Art*, 1901, p. 338; the review in the *Art Journal*, 1901, p. 179, was on similar lines.

3 *The Times*, 4 May 1901.

4 National Maritime Museum, Greenwich, *The Caird Collection of Maritime Antiquities*, 1933–7, vol. 1, pp. 114–5, nos. 37, 56, 97 and 102; no. 56 is reproduced in R. Quarm and J. Wyllie, *W.L. Wyllie*, 1981, p. 96, fig. 73; no. 102, (grey wash over pencil, 319 × 487 mm) is the one very close to WAG 128 and is probably the drawing for it; nos. 56 and 97 were reproduced in the *Graphic, Royal Funeral Number*, 6 February 1901, as (respectively) *Alberta steaming into Portsmouth Harbour* (p. 9) and *Alberta passing through the Fleet at Spithead* (between pp. 28 and 29); perhaps no. 102 was found unsuitable for reproduction in the *Graphic* and was therefore used for WAG 128.

5 With the title *Victoria Victrix*; Wyllie, *op. cit.*, pp. 173–4, states that this etching was very successful and revived the fortunes of the Art Union as well as providing the artist with an extra fee of £100 beyond the agreed price; L.S. King in *The Industrialization of Taste*, 1985, p. 237, notes, however, that subscriptions to the Art Union only rose by 550 following the use of WAG 128 as the Art Union annual engraving.

YEAMES, William Frederick (1835–1918)
'And when did you last see your father?'
WAG 2679
Canvas: 131 × 251.5 cm
Signed: *W.F. YEAMES 1878*

The artist wrote of this painting:[1]

I had, at the time I painted the picture, living in my house a nephew of an innocent and truthful disposition, and it occurred to me to represent him in a situation where the child's outspokenness and unconsciousness would lead to disastrous consequences, and a scene in a country house, occupied by the Puritans during the Rebellion in England, suited my purpose.

James Lambe Yeames and Mary Helen Stephen-Smith, nephew and niece of the artist, were the models for the boy and the weeping girl; as they were indeed living with their uncle at that time, it seems reasonably certain that James Lambe Yeames (born 1873) was the 'nephew of an innocent and truthful disposition' who inspired the picture; Sir Henry J.S. Cotton is stated to have been the model for

the interrogator at the extreme right.[2] The carpet on the table can be identified as a Tekke ensi, made in Turkmenistan in the 19th century; such carpets were certainly known in the West by 1878 but can rarely be found in 19th-century paintings.[3] The breast plate and helmet worn by the soldier were in the collection of the artist and his descendants until about 1945 and, according to family tradition, the jewel casket in the painting was based on the work-box of the artist's wife.

There was sharp disagreement among the critics at the 1878 Royal Academy on the merits of Yeames's picture – nor did they even agree about the likely reply of the boy. The *Art Journal*[4] wrote:

W.F. YEAMES fills the place of distinction in this part of the room with a capitally conceived subject representing five Roundheads – commissioners and soldiers of the Long Parliament – in a manor-house, seated in solemn conclave round a table, questioning the inmates as to the whereabouts of the Royalist owner. The little boy, in pale blue dress, who is now being examined, with his little sister crying behind him, and his mother and aunt tremblingly anxious in the distance, is the scion of the house, and we know before he speaks that a clear, frank answer will ring out to the insinuating question, 'And when did you last see your father?' Mr. Yeames did quite right in not making the presiding commissioner a truculent-looking man. We like the picture very much, even if the perspective is proved to be mathematically wrong.

The critic of *The Times*[5] broadly agreed, but in a somewhat more patronizing manner:

A good work in the school of historical painting associated with the name of Delaroche is Mr. Yeames's incident from our great Revolutionary War. Commissioners of the Parliament, in a Royalist manor-house, are questioning the inmates as to the whereabouts of the head of the family, seriously compromised. A brave little boy of six or seven is at the table. Asked, 'When did you last see your father?' he meditates his answer, collected and cautious, with the intelligence that bespeaks the experience of a troublesome time. His little sister, less mistress of herself, in the grasp of a not unkindly soldier, cries and hides her face. A little in the background the mother of the boy, and a girl who may be her sister, listen with anxious faces for the boy's answer. The faces of the Commissioners are well conceived; there is a sour divine, a keen, weazel-faced interrogator, an ascetic but intellectual and scholarlike man in black who acts as secretary,

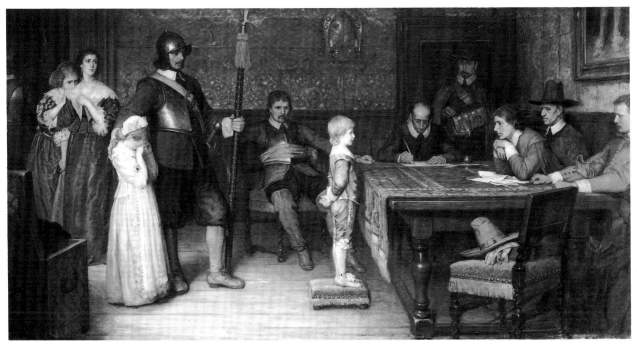

'*And when did you last see your father?*' WAG 2679

and a stalwart captain, through whose sternness pierces some of the sympathy of a brave man with the brave boy and unhappy women. The picture, like all that Mr. Yeames does, is unaffected in conception, unpretentious in execution, tells its story distinctly and with well-matured technical skill, and is an eminently honest and creditable example of illustration by painting of an epoch of English history – the sort of work which we may yet, let us hope, live to see employed in our municipal halls and chambers, to help people to something like a realization of the life of the past, akin in painting to a well-written historical novel. For artists of Mr. Yeames's quality of imagination and technical accomplishment there is no work so suitable as this, and none so likely to give the painter a sense that his art had still a function besides portrait painting and landscape.

The *Saturday Review*,[6] however, did not even see much technical merit in the painting:

Another picture of some importance from its size and position, is Mr. Yeames's 'And when did you last see your father?' which represents a little boy being questioned by the commandant of soldiers under the Long Parliament. This is not a very new subject, but it is one which is capable of being made highly interesting. Neither in his conception nor in his execution does the painter seem to have reached the degree of success which might fairly be demanded. The opportunities for expression in the faces of the various personages have been strangely missed or misused; the colour seems false throughout the picture, and all the textures have a strange resemblance to each other.

The brief comment in the *Spectator*[7] is perhaps the most accurate: 'a good, industrious work, chiefly concerned with clothes and accessories'.

The later fame of the painting seems to have been established only very slowly, although apparently the artist became a member of the Royal Academy largely on the strength of it.[8] In his 1881 article on Yeames, W.W. Fenn[9] embroidered the story somewhat and concluded: 'Nothing could have been more pathetic or better than the situation whilst it afforded an opportunity for the display of the artist's characteristics and powers to the utmost . . .' In 1889 the London Art Union

used the picture for the annual engraving which it distributed free to all its subscribers, but the popularity of the subject did little to improve the Art Union's declining fortunes.[10] A popular song, *The Young Royalist*, based on Yeames's painting, was published in 1898; the words were by F.E. Weatherly and the music by Stephen Adams.[11] In 1934, Madame Tussaud's in London produced a waxworks tableau based on the picture; new versions were produced around 1955 and in the 1960s, while a fourth display was dismantled only in about 1990. The subject and composition were widely used by political cartoonists in the 20th century, reflecting their belief that the painting was very widely known.[12] About 120 applications to reproduce the picture were made to the Walker Art Gallery in the period 1887–1938; a considerable number of these related to illustrations for popular history books.

The appeal of the English Civil Wars as a subject for 19th-century artists and, in particular, the attractiveness for them of the Royalist rather than the Parliamentarian side, are analysed by Roy Strong; he draws attention especially to Walter Scott's *Woodstock* of 1826 and to the paintings by C.W. Cope in the Houses of Parliament of the 1850s and 1860s.[13]

There was a sketch for *And when did you last see your father?* on the back of the artist's *Playing with the Kitten*, which was sold at Sotheby's 14 July 1983, lot 209, and is now in the Forbes Magazine Collection. There are many pentimenti all over the Walker Art Gallery painting (soldier's helmet and boots, the back of the weeping girl's dress, the back of the foreground chair, the hat of the seated interrogator, etc.).

REPR: H. Blackburn, *Academy Notes*, 1878, p. 37; G.R. Halkett, *Notes to the Walker Art Gallery*, 1878, p. 61; *Magazine of Art*, 1878, opp. p. 224; *Deutsche Illustrierte Zeitung*, 1885, vol. 2, pp. 432–3.

PROV: Bought from the artist 1878 (£750).

EXH: Royal Academy 1878 (329); Liverpool Autumn Exhibition 1878 (279); Berlin International Exhibition 1886; Glasgow International Exhibition 1901 (606).

1 Mary H. Stephen-Smith, *Art and Anecdote: Recollections of William Frederick Yeames*, 1927, pp. 173–4; the author was the model for the weeping girl in the painting and she emphasizes that its appeal to the public lay in the general uncertainty about the likely next event in the drama. For both the background and the subsequent fame of WAG 2679, see particularly the Walker Art Gallery 1992 exhibition catalogue, *And when did you last see your father?* by Edward Morris and Frank Milner.

2 See *Belfast Telegraph*, 19 May 1952, for J.L. Yeames's own account of the painting and his letters to the Walker Art Gallery of 7 and 15 June 1955 and 21 April 1959. James Lambe Yeames also sat for the figure of Arthur in Yeames's *Prince Arthur and Hubert* of 1882, now in the Manchester City Art Galleries. For Sir Henry J.S. Cotton (1845–1915), see his *Indian and Home Memories*, 1911, pp. 149–54, where his friendship with Yeames is recorded; Elizabeth Stordy stated that he was the model for the interrogator and provided this reference (letter to the compiler 2 January 1992).

3 See 'And when did you last see your father?', *Hali*, vol. 1, 1978, p. 92 and 0. Ydema, 'De Tekke ensi', *Antiek*, 1988, vol. 23, December, pp. 274–8. The artist's childhood in Russia may have familiarized him with rugs of this type.

4 *Art Journal*, 1878, p. 167. W.M. Rossetti in the *Academy*, 11 May 1878, p. 423, bestowed similar praise on WAG 2679, but he did not like the boy's face 'which has a soapy sort of look'. Rossetti, however – unlike the *Art Journal* critic – thought that the boy was about to tell 'a filial lie of bulk and down-rightness adequate to the circumstances'.

5 *The Times*, 11 May 1878; the *Illustrated London News*, 11 May 1878, p. 434, also gave carefully qualified praise to WAG 2679.

6 *Saturday Review*, 1 June 1878, pp. 691–2.

7 *Spectator*, 1878, p. 730; in its concern with period clothes and accessories WAG 2679 was very typical of the St. John's Wood School. See Bevis Hillier, 'The St. John's Wood Clique', *Apollo*, 1964, vol. 79, pp. 490 ff.

8 A. Chester, 'The Art of W.F. Yeames', *Windsor Magazine*, 1906–7, p. 597.

9 W.W. Fenn, 'William Frederick Yeames', *Magazine of Art*, 1881, p. 199.

10 See L.S. King, *The Industrialization of Taste: Victorian England and the Art Union of London*, 1985, p. 236. In fact, WAG 2679 was reproduced as a Goupilgravure, not as an engraving.

11 W. Latto, letter to the compiler, 10 January 1977; in this song the father is already dead, having been killed fighting for the king.

12 For example, the *Daily Express* (Strube) 29 April 1926, the *Guardian* (D. Low) 16 March 1960 and the *Liverpool Daily Post* (Raymond Jackson) 29 September 1982. Many other examples are reproduced in Morris and Milner, *op. cit.*, pp. 110–22.

13 Roy Strong, *And when did you last see your father?*, 1978, pp. 136 ff.; the Civil War paintings in the new Houses of Parliament were intended to give equal credit to Royalists and Parliamentarians and there was no intended Parliamentarian bias as Strong suggests. The early chapters of W.M. Thackeray's *Henry Esmond* (1852) were probably more familiar to the public of the 1870s than Scott's novels and the popular appeal of Captain Marryat's *Children of the New Forest* (1847) – with its extended accounts of confrontations between Royalist children and Parliamentarian officers – must also have been significant. Marryat's *Peter Simple* (1834) was almost certainly the source for Yeames's *Prisoners of War* (1883) now in the Glasgow Art Gallery and Museum (Stephen-Smith, *op. cit.*, p. 203). There is a useful list of other British 19th-century historical genre paintings involving the Royalists in Strong, *op. cit.*, p. 166; Marcus Stone's *Stealing the Keys* of *c.*1866, now in the Art Gallery of New South Wales (inv. 913) must have been an influential example of this type.

527

APPENDIX 1:

Victorian and Edwardian Paintings formerly in the Collection but subsequently Stolen or Destroyed

Brown, Alexander Kellock, *Winter Evening in the Glen*, 112 × 142.5 cm

Buchanan, James, *Scriptual Consolation*, 27.9 × 33.2 cm

Burr, Alice, John or Alexander, *Blindman's Buff*, 43 × 59.5 cm

Dixon, Alfred, *A Stowaway*, 136 × 209.5 cm

Gow, Andrew Carrick, *A War Dispatch at the Hotel de Ville*, 152.5 × 99 cm

Halswelle, Keeley, *Glen Sligachan and the Cuchullui Hills, Isle of Skye*, 106.5 × 180 cm

Leader, Benjamin Williams, *Fast falls the Eventide*, 109 × 180.5 cm

MacWhirter, John, *There is a Silence in the Solemn Woods*, 117 × 183 cm

APPENDIX 2:

Dates of Canvases derived from the Roberson Archive

Some of the artists represented in this catalogue bought their stretchers and canvases from the London artists' colourmen, Roberson and Co (or Charles Roberson). The records of many of these purchases survive in the Roberson Archive at the Hamilton Kerr Institute and are here detailed by permission of the Syndics of the Fitzwilliam Museum, Cambridge and thanks to the generous assistance of Sally Woodcock and Judi Churchman. The following list provisionally relates paintings in this catalogue with records of particular stretchers or canvases provided to the artist in question by Roberson. The dates of delivery to the artist and the sizes of the canvases or stretchers, as recorded by Roberson, permit these identifications to be made with reasonable certainty especially with large canvases or stretchers and with those of unusual format. The sizes of the canvases and stretchers as recorded by Roberson have here been converted from inches to centimetres to permit easy comparison with the actual sizes of the canvases and stretchers in the Walker Art Gallery and at Sudley House. The indexing of the Roberson Archive is not yet finished so this list should not be regarded as complete. Existing canvases have not been examined to check whether or not they correspond with the canvases described in the Archive, except where an asterisk appears in the final column; the asterisk indicates that the details in the Roberson Archive broadly correspond with the canvas or panel.

Details of paintings in this catalogue			Details from Roberson Archive of transactions thought to relate to the paintings in the first three columns		
Name of Artist	Brief title of Painting	Inventory Number	Date of Delivery	Dimensions of Canvas or stretcher	Items delivered or work done
Armitage, Edward	Julian the Apostate	WAG 3071	29 January 1875	177.8 × 274.3	Stretcher
	Serf Emancipation	WAG 3072	10 July 1876	177.7 × 310	Stretcher
Crane, Walter	Triumph of Spring	WAG 1802	30 August 1879	40.6 × 146.1	Stretcher, covered linen and white cartoon
Creswick, Thomas	Evening	WAG 215	17 May 1850	96.6 × 127	Two canvases*

Egg, Augustus	Charles I raising his Standard	WAG 1490	9 June 1852	35.5 × 45.7	Canvas★
Faed, Thomas	In Time of War	WAG 2912	8 September 1875	133.4 × 182.9	Reducing Stretcher
	Free from care	WAG 223	6 February 1878	61 × 45.8	Two canvases and stretchers
	When Children are Asleep	WAG 2816	11 December 1884	152.4 × 109.2	Canvas and stretcher
Fildes, Luke	Fanny, Lady Fildes	WAG 2120	15 July 1886	142.3 × 105.4	Reversed single primed canvas on stretcher
Gilbert, John	Richard II resigning the Crown	WAG 2925	9 March 1875	160 × 121.9	Canvas and stretcher
	Horse Pond at Tarring	WAG 707	13 October 1882	38.1 × 91.4	Roman canvas and stretcher
	The Standard Bearer	WAG 2919	22 January 1884	121.9 × 91.5	Roman canvas and stretcher
	Don Quixote discourses	WAG 2924	6 December 1888	121.9 × 152.5	Stretcher covered with linen cartoon and antiquarian N. (probably a type of paper)
Halswelle, Keeley	Contadine in St Peter's	WAG 236	16 December 1870	39.3 × 61	Two canvases
	Flying Scud	WAG 2835	16 February 1884	104.1 × 177.8	Stretcher
Hemy, Charles Napier	A German Birthday Party	WAG 715	10 April 1872	91.5 × 137.2	Two single primed canvases and stretchers
Holl, Frank	A Fisherman's Home	WAG 2933	18 January 1881	101.5 × 127.1	Single primed canvas and stretcher
Hook, James Clarke	A Thorn	WAG 717	14 October 1870	83.8 × 137.2	Stretcher
	Hard Lines	WAG 511	9 October 1875	75.6 × 130.2	Stretcher
Lear, Edward	Bethlehem	WAG 1534	1 September 1860	70.5 × 115.6	Extra primed fine white canvas★
Leighton, Frederic	Study	WAG 258	8 July 1876	63.5 × 72.4	Reversed canvas and stretcher
	Elijah	WAG 147	10 May 1877	233.7 × 209.5	Double canvas and stretcher
	Perseus and Andromeda	WAG 129	9 June 1890	233.7 × 124.5	Covered reversed single primed canvas and stretcher.

				30 June 1890	243.9 × 137.2	Extra fine linen single primed prepared canvas and stretcher
Lejeune, Henry	Contemplation	WAG 259	28 October 1850	30.6 × 25.4	Two panels	
			6 January 1851	30.6 × 25.4	One panel	
			23 January 1851	30.6 × 25.4	Seven panels	
			11 June 1851	30.6 × 25.4	Six panels	
Moore, Albert	Shells	WAG 2286	27 January 1870	157.2 × 69.8	Two canvases prepared to order★	
	A Summer Night	WAG 2125	20 July 1888	132.1 × 237.5	Single primed canvas on stretcher	
			23 March 1889	131.5 × 227.4	Stretcher	
Morris, Philip Richard	The Shepherd of Jerusalem	WAG 2908	19 December 1870	243.9 × 106.7	Stretcher to fold in half	
Naish, John George	Boulders at Rest	WAG 2703	26 August 1880	106.7 × 152.5	Stretcher and stretching own canvas	
Ouless, Walter William	Henry Stacy Marks	WAG 2574	28 August 1873	86.3 × 111.8	Single primed grey canvas and stretcher	
Perugini, Charles Edward	Faithful	WAG 2710	4 June 1878	125.7 × 99	Single primed canvas on stretcher	
	Poenies	WAG 1622	7 September 1886	76.1 × 58.4	Stretcher★	
Phillip, John	Gypsy Sisters	WAG 285	21 January 1854	74.3 × 58.7	Extra primed double canvas	
Potter, Frank Huddlestone	Embers	WAG 2716	3 June 1875	50.2 × 33.1	Prepared panel	
			4 November 1875	50.8 × 33.6	Prepared panel	
Prinsep, Valentine	Leonora di Mantua	WAG 2723	24 September 1872	162.6 × 121.9	Stretcher	
			21 December 1872	162.6 × 121.9	Stretcher and canvas	
Richmond, William Blake	Venus and Anchises	WAG 3082	16 February 1888	149.8 × 294.7	Lining picture measuring 121.9 × 279.3, adding canvas and enlarging it, preparing and stopping.★	
Strudwick, John Melhuish	Circe and Scylla	WAG 303	28 July 1885	99.1 × 69.8	Single primed canvas over reversed single primed canvas on stretcher	

Strudwick, John Melhuish (*Cont.*)	Love's Palace	WAG 304	18 August 1891	63.5 × 114.3	Single primed canvas over reversed single primed canvas and stretcher
	Saint Cecilia	WAG 306	30 April 1895	34.2 × 26.7	Two prepared panels
Ward, Edward Matthew	Antechamber at Whitehall	WAG 138	5 January 1860	160 × 228.6	Extra primed cloth over prepared extra primed cloth and stretcher★

INDEX

Bold type indicates a catalogued artist; all works of art are indexed in italic type and illustrated works only appear twice: under the artist and under the title. Non-illustrated works appear as subheadings under the artist but not as main headings in their own right.

Numbers in italic refer to illustrated pages or colour plates and references to notes are indicated by n *following the number. Exhibitions, galleries and museums are indexed under their town or city of location.*